Professor Robert F. Blo

June 1993

Professor Robert F. Blo

June 1993

W9-COL-110

MODERN SCULPTURE

Tradition and Innovation

A. M. HAMMACHER

MODERN SCULPTURE

Tradition and Innovation

Enlarged Edition

HARRY N. ABRAMS, INC., *Publishers*, NEW YORK

Enlarged edition

Project Director: MARGARET L. KAPLAN
Editor: NORA BEESON
Design Coordination: DIRK LUYKX
Photo Research: BARBARA LYONS
Translator: MARY CHARLES

ISBN 0–8109–0890–5
Library of Congress Catalog Card Number: 87–73423

Original edition published under the title *The Evolution of Modern
Sculpture*, designed by Arno Hammacher

Copyright © in 1988 by Harry N. Abrams, Incorporated, New York

A Times Mirror Company

Printed and bound in Japan

CONTENTS

Foreword to the Enlarged Edition

The idea of a new edition of my book was heartening, but there were problems. It was suggested that I enlarge its contents by adding a concise chapter on sculpture since the 1960s. This new chapter was to deal not only with the chronologically extended output of young artists who had since become more mature, but also with the seemingly incoherent work produced by a new generation, sculpture that is as full of imperfections and errors as it is rich in new and surprising prospects. These works form a labyrinth, which, like any labyrinth, causes one some moments of terrifying doubt about finding the way out and then proves to have a center after all: the heterogeneous and the homogeneous adding up to a new, vastly differentiated, sense of space—the old nineteenth-century space exploded into a plurality of spaces.

I have retained some of the principles adopted in the main text. No attempt has been made at providing a complete account but rather one that is selective and based on my many encounters with sculpture since the 1960s that have invited me to reflect upon what is stirring in our space consciousness. I have curtailed descriptions and there is no emphasis on national characteristics in the choice or the interpretation of subject matter. The existing documentation on the past twenty-five years evoked a desire to avoid as much as possible the fashionable prefixes "trans" and "post" (Postmodernism, Postfuturism, Transexpressionism, Postexpressionism). It is an easy way of dismissing phenomena that require examination leading to insight rather than vague chronological classification of an art historical nature.

Since 1960, not only sculpture but other disciplines as well have reached a fin-de-siècle phase, a concept that needs to avoid straight away the odor of nostalgic love associated with the fin-de-siècle of the nineteenth century. In those days, the sculptor Rodin towered like a giant above a tired and sophisticated civilization. In quality as well as in inventiveness, Rosso and above all Degas were certainly of the first order and important to the problems that were to arise in the twentieth century, but they failed to match the impressive variety of Rodin's output.

The fin-de-siècle period, at which we have now arrived, has not been marked by either giants or near-giants. Some gifted artists, vital, courageous, and inspiring, developed a number of specific spatial problems for sculpture, problems that were identified as such and then evolved with more or less fortunate results. In some instances, the end results appeared to be reckless, technically imperfect; in others, they gradually approached a perfection resting on earlier inventions.

After 1960, activities relating to space reached a common level, both in Europe and America. Americans played and continue to play a remarkable part in this process of space explosion and exploration, which evokes further spaces. Between architecture and painting, sculpture acquired a stronger and more autonomous discipline, which in recent years has been directed largely toward the countryside, parks, gardens, and squares. But the antiquated and not easily suppressed longing for a place in a museum did not disappear. The purchasing policies of museum directors did not, on the whole, appear to be particularly sculpture-minded and therefore proved less stimulat-

ing than those operated by individuals, institutions, and boards representing bodies other than museums. There was an almost inexplicable increase in commissions for what we may term geographic spaces as distinct from those appertaining to architecture, museums, and so forth. In the first half of the century, public urban sites were almost unavailable for works by pioneers, even those whose modernism was moderate. It may be, I am not sure, that this amazing later upsurge is in part a politico-cultural phenomenon. Even if it is a peripheral movement, the original sculptural activity and preoccupation with spatial perception continue in sculptors' studios, most of the time independently of academies but by no means dissociated from sculpture's potential place and function in geographic spaces. The developments now taking place in regard to sculpture and its environment, in a broad sense in regard to concepts of space, require an analytic and sociologic orientation that is already far advanced in the case of architecture.

In literature, there are also concrete indications of a sensitive and associative perception of local space, somewhat analogous to the new sense of space in sculpture (see, for example, Georges Perec [Note 99] and also Rainer Maria Rilke with his astonishing early space awareness). All this provides a complex context for the activities of sculptors who do not fight shy of a new grammar based on spatial experiments or of a verbal accompaniment to this process. My work is not a chronology, not a series of potted biographies, but a walking tour with reflections that occurred in the course of perambulating past a number of sculptures, either selected or encountered, that aroused more than mere curiosity on my part. Toward the end, I became more convinced than ever that in spite of extensive catalogues we just have a limited experience and knowledge—and in such "knowing" I include "seeing." In spirit, therefore, my final chapter merely brings this book to an end, but without conclusions. How long further developments will continue is a secret. Sculptors, we hope, are working on new perspectives, which will require fresh interpretations from lovers of spatial adventures.

A. M. HAMMACHER
1987/88

7

Foreword

The evolution of sculpture in the twentieth century began slowly and gradually, so gradually in fact that a survey of the first two decades of the century leaves us with the impression—despite the Cubist, Futurist, and Constructivist experiments—that sculpture was still dominated by the pictorial qualities that had characterized the nineteenth century. Yet the sometimes almost overwhelming development of sculpture has definitely made it impossible for the century to be stamped with the mark of the pictorial, whatever may come hereafter. In the Space Age, as it is already being called, the pictorial has ceased to dominate.

The second half of the century is proving to be even more varied than the first, and we are still too close to these phenomenal events in sculpture to be able to achieve historical perspective. Nevertheless a considerable body of literature—monographs, surveys, a dictionary—has appeared in the last ten years. This literature has been of great use to me, aside from serving as a starting point for critical counter-statement.

What has prompted me to try to find a way through the labyrinth of personal styles that confront us, especially since 1945, has been chiefly my own experience of almost forty-five years of viewing sculpture and of invaluable conversations and correspondence with sculptors of various schools and periods (Csaky, Moore, Hepworth, Lipchitz, Pevsner, Wotruba, Pan, to mention only a few). Secondarily, I have been influenced by the historical literature on the subject, in particular, Focillon's work on Romanesque sculpture.

It is understandable that there should be a desire to determine the starting point of a development that has manifested itself in such a multiplicity of personal styles. It is equally understandable that many critics, writers, and even sculptors have sought the origin of modern sculpture in the great modern and personal style of Rodin. But analysis reveals that the work of Rodin was a stage rather than a beginning; it can be regarded as a beginning only if we limit our study to the academic and Romantic statues of the nineteenth century.

There is no reasonable basis for limiting the search for the origin of the new ideas in sculpture to the nineteenth century. Rodin himself was formed by influences that go back to earlier periods. Thus it seemed warranted to include the creative personality of Michelangelo, whose work and whose individual reactions and reflections are known to us. My conviction as to the importance and significance of Michelangelo for modern sculpture was confirmed by a conversation with Henry Moore.

It is always the aim of the art historian to trace a coherent development; the present study, while it attempts to approach modern sculpture by discovering relationships, showing lines of development, and indicating central problems, aims primarily at vivid description of visual and psychic emotions—emotions afterwards reconsidered and brought into perspective. Such an approach lays one open to the charge of making choices that are too personal, based on the shock of powerful sensations, optical and mental. The experiences that have gone into the making of this book have indeed involved personal

choice, and I accept the fact that other writers would have chosen otherwise. It seemed to me preferable to limit myself to personal experience rather than to pursue the goal of completeness, a goal which could only be illusory in view of the constantly increasing volume of work. Thus I have not attempted a history or a dictionary of modern sculpture—an effort that would be premature at this time. (This is by no means to deny the usefulness of such a work as Michel Seuphor's, which is a remarkably rich source of information and comment.)

The reader interested in the evolution of modern sculpture along national lines will note certain omissions, particularly among the Americans. As for the French and the Italians, here too certain figures will be missed by everyone familiar with the field, especially the artists themselves. Modern sculpture has been dealt with here as an international, or supranational, movement, and the aim has been to choose examples that would reveal the evolution of personal styles since Michelangelo, styles that show a relation in time and space with reference both to the past and to the future.

In general, the present work is related in its approach to Eduard Trier's in his well-known *Form and Space* (which, because it often takes only the work itself as a starting point and does not go beyond it, seems to me to require a complement), and it continues the work of relating the various phenomena of twentieth-century sculpture begun by Carola Giedion-Welcker in her noteworthy *Contemporary Sculpture: An Evolution in Volume and Space*. In an entirely different sense I owe a great deal to Herbert Read's way of looking at things—as art critic, psychologist, philosopher, and poet. He has always delved deeply into the aesthetic of sculpture. In this area I have benefited too from the work of Edouard Jaguer, who, in his succinct but rich *Poétique de la sculpture, 1950–1960*, found subtle formulations for his experiences in a new and difficult domain, one that art criticism cannot satisfactorily deal with in the terminology of an earlier period.

The publishers have been of great assistance in the laborious and time-consuming search for illustrations. It was by working together that we were able to assemble as many photographs as we have that show the sculptural qualities with which this book is concerned.

For technical reasons, more years than expected have elapsed between the completion of the text and its publication. If some post-1960 developments do not therefore appear, this does not alter the validity of the original plan, which was to trace the seeds that had brought about the rich and complex flowering of twentieth-century sculpture.

Finally, these acknowledgments should not omit mention of the greatest stimuli to my writing—the landscape and culture of Tuscany and Emilia. It was in the light and atmosphere of these provinces that I was able to complete the greatest part of the text, through the hospitality of friends in Fiesole and Pieve di Camaiore.

A. M. HAMMACHER
1969

9

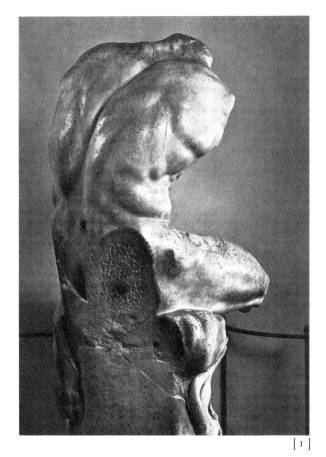

[1]

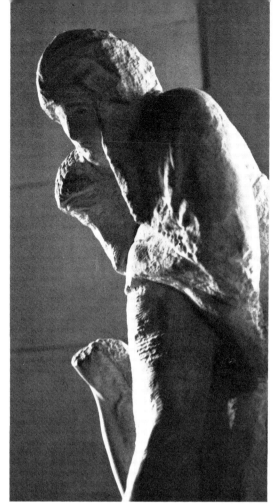

[4]

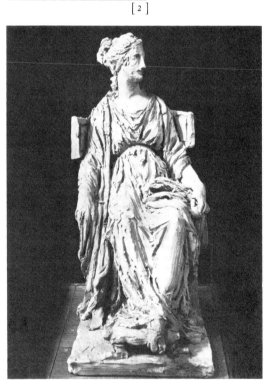

[2]

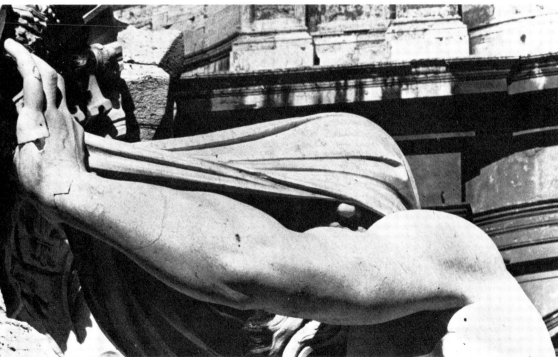

[3]

1

From Michelangelo to Rodin

During the decade before Auguste Rodin's death, in 1917, Paris had been a pole of attraction for young and talented sculptors from far and wide. Each of these artists had to work out his own attitude toward sculpture, an art that Rodin had, in an atmosphere of public indifference and artistic sterility, resurrected and even restored to a semblance of its former greatness. Today, more than half a century later, it is apparent that a highly diversified group of powerful sculptors was to emerge from among the young men who were persevering under difficult circumstances. At first they broke away from Rodin; later, as they matured and looked back, they felt a new respect for him and his work.

In studying the history of modern sculpture, it has therefore been tempting for writers to begin with Rodin. Such a starting point seems obvious. Actually, it is far from certain that the new sculpture did begin with him. In any case, each writer had to ask himself what Michelangelo and the Gothic had meant to Rodin. Another problem was Rodin's relation to Impressionist painting. The question of Medardo Rosso and his possible influence on Rodin—a question brought to the fore by the Italians in particular—remained confused by all sorts of sentimental and unobjective thinking. Had not Edgar Degas, before Rodin, done much for the development of nonacademic sculpture? As early as 1870, Albert Bartholomé had seen Degas making a relief; in 1881 the *Fourteen-year-old Dancer* was exhibited. After that, Degas no longer exhibited sculpture; nevertheless his modeling in wax and clay continued and, indeed, increased. Moreover, even Rodin's fame could not completely overshadow the work of Géricault and the later Romantics and, especially, of the sculptors François Rude and Jean-Baptiste Carpeaux. In short, Rodin's artistic environment opened wide possibilities in the search for the paternity of the new sculpture.

The concept of paternity in the development of art is an engaging one. It is also misleading, for it oversimplifies. Influences exerted by Rodin's work can of course be pointed out, even after 1917, but many

[1] APOLLONIOS. *Belvedere Torso*. c. 150 B.C. Marble, height 62 ⅝". Vatican Museums, Rome. [2] MICHELANGELO. *Rondanini Pietà* (detail). 1555–64. Marble. Castello Sforzesco, Milan. [3] GIANLORENZO BERNINI (executed by JACOBUS ANTONIUS FANCELLI). *The Nile* (detail, *Fountain of the Four Rivers*). c. 1647–51. Stone, over lifesize. Piazza Navona, Rome. [4] ANTONIO CANOVA. *Elisa Baciocchi* (*Polinnia*). 1812. Clay, 12 ⅝ × 10 ¼". Fondazione Querini, Venice

[5] MICHELANGELO (attributed). *Torso* (portion of a Crucifixion.) 1530–40. Bronze, height 7 1/8″. State Museums, Berlin

other and more important sculptural links having nothing to do with Rodin remain to be established. The notion of uncomplicated paternity can therefore be quietly abandoned.

Viewed from a broader perspective, Rodin's position and his relation to the past and to the future must be considered in a new light. His figure at the threshold of the great sculptural awakening in the twentieth century poses the problem of a tradition running through the past of Western Europe. Every approach to the young sculpture of the twentieth century must ultimately concern itself, via Rodin, with Michelangelo, whose deeply self-conscious personality and work continued to ferment in Rodin and thus played an essential role in the genesis of the new sculpture.

Among the sculptors of Western Europe, Michelangelo is the first who is accessible to us today, not only through his work [2, 5–9, 12], but also, through his letters and poems, as a human being—his relations with his patrons, his way of life, his doubts, his critical reflections, his personal and artistic anxieties. We hear of his long sojourns, sometimes for months on end, at the Carrara marble quarries, where he drew inspiration from the living stone. We know of his deliberate withdrawal, his imposing solitude, the mighty compulsion of his creative force, which was stronger than the man himself. We see him rejecting the system of studio assistants whenever possible, for he wished always to work alone and unobserved. He marveled at the sculptors of antiquity, and his attitude toward the ancients was more candid and free than that of the other Renaissance artists, from whom he sprang but whom he also outgrew; he cast off the spell of their awe-struck veneration so that his own appreciation might be more critical.

Although Rodin had to turn mainly to Michelangelo and the Gothic artists for help in solving his own artistic problems, he did not initiate the revival—or the reinterpretation—of Michelangelo in the nineteenth century. This had been begun earlier, near the beginning of

13

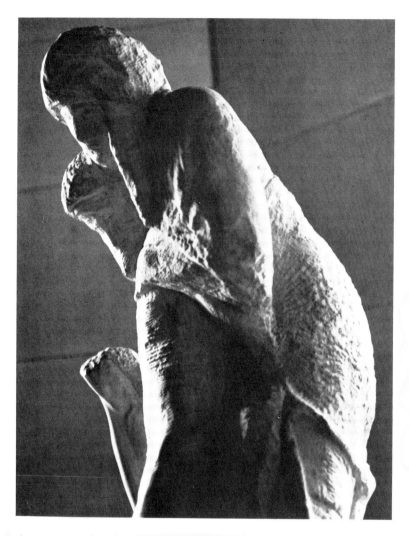

Michelangelo's work is different from confronting the collectively anonymous art of the Middle Ages. In any work by Michelangelo the artistic form is not the only thing that matters; there is also the demon of creativity. The creative act itself becomes perceptible. A work of art belongs to the objective world, but the objective interpretation of the world is affected by the subjective, which is dominated by the possessed personality.

In visualizing Michelangelo in his imagination Delacroix did not restrict himself to the factual. He lived a *new* Michelangelo, admiring him, feeling himself akin to the earlier artist, but at the same time examining him critically. The kinship lies as much in the spirit of the Romantic period as in Delacroix himself; Romanticism strengthened the feeling for the centrality of the inner life. Delacroix experienced the shock of Michelangelo's work only at second hand. Just as Van Gogh could write lyrically about Giotto without ever having been in Italy and without ever having studied his work directly, so Delacroix—equally unfamiliar with Italy—seemed able to fathom the depths of Michelangelo's spirit. It was not only his intuition that summoned up the image of a living Michelangelo; it was, above all, his Romantic feeling of isolation and his comprehension of the vague and the incomplete. Through Delacroix we become fully aware of the new nineteenth-century interpretation of Michelangelo and his work. This image is woven into the emotional and intellectual pattern of the first half of the century in a way that enabled Rodin to offer a variant of it.

Rodin's version of Michelangelo is less accurate than the earlier one of Delacroix. For Rodin, Michelangelo was a late Gothic artist. How he conceived such an idea we do not know. Rodin saw an intense Gothic in Rembrandt also, and in his later years he felt himself to be one of the last descendants of the Gothic. To grasp what Rodin meant, we must of course free ourselves from the usual definitions of Gothic and Renaissance.

In the theories of the Swiss art historian Joseph Gantner[2] we can attempt to find the explanation of Rodin's ideas on the general spiritual attitude of Gothic artists. The idea of the sublime, alive only in the spirit and unrealizable in images created by man, is indeed a common point of departure for explaining why achievement falls

the century, by the writer Stendhal in his *Histoire de la peinture en Italie* (1817). Stendhal prophesied that, as a sequel to the eighteenth-century aversion to Michelangelo, "the thirst for energy will bring us back to his masterpieces." He saw "a growing thirst for strong emotions" as the true character of the new century. "Strong emotions will be the new pursuit." He knew that "neither Voltaire nor Madame du Deffand had any feeling for Michelangelo." But "the taste for Michelangelo will revive."

Following fairly soon upon Stendhal's prediction was an even more important and creative testimony. For Delacroix, Michelangelo, more than a model, was an artist with whom he carried on imaginary conversations throughout his life, a touchstone for his own complex spirit and for the problem of the artistic personality of his time. It is not necessary to go so far as Charles de Tolnay[1] and to assume in Delacroix a self-identification with Michelangelo. Confronting

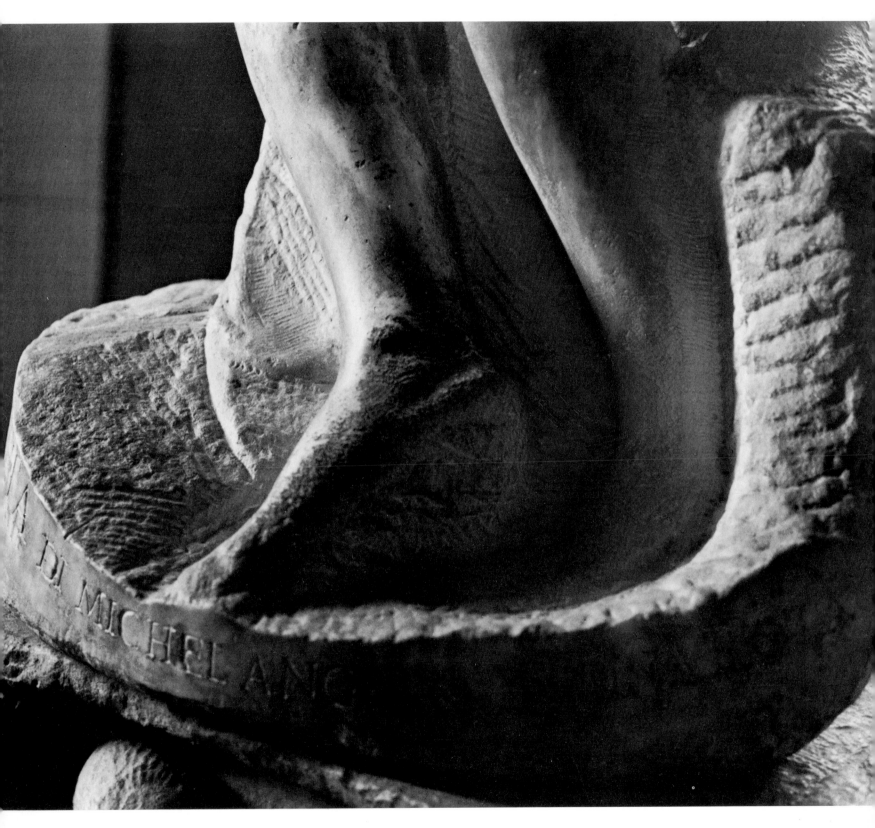

[10] *Eve*, from the lintel of the north doorway, Cathedral of St. Lazare, Autun. 12th century. Stone, 28 3/8 × 52″. Musée Rolin, Autun
[11] *St. Joseph*, from the Bronze Doors of Bishop Bernward for St. Michael's. 1015. Hildesheim Cathedral

short of conception. With Michelangelo, to a degree unknown until his time, the *infinito*, the never-completed, determined the form of a work. This is the theoretical bond by which Michelangelo can still be tied to the Middle Ages, but it does not account for his technique or his opinions as a sculptor. For him the *infinito* had several sources, not all of them spiritual in nature. Technical and factual elements mingled with psychological motives. In itself the *infinito* did not present a problem for him: it was the natural result of circumstances and of a mental attitude. With one exception, Michelangelo never created his statues for free, natural, and unlimited outdoor space. His sculptures were intended for architectonic space; they are not really conceivable without walls, backgrounds, roofs. In this lies another, and somewhat weak, Gothic element which may have appealed to Rodin, for his approach to the Gothic, considered spatially, is Romantic. When we read that he "experienced church spaces," the words reveal, far more than does his intellectual argumentation, not only the intuitive but the entire Rodin, who did not lose touch with the vital spatial experiences of his youth.

Whatever the case with Delacroix, there can certainly be no suspicion of Rodin's having identified himself with Michelangelo. He understood nothing of Michelangelo's rejection of the worldly life, nothing of his deep antipathy for the peripheral, which stemmed from his conviction that the inner life was central and all-important. Rodin was too responsive to the sensual to be able to comprehend Michelangelo's sense of bearing life's ever-heavier burden toward death. For this reason an essential element in Michelangelo's spiritual activities escaped him entirely. The only renunciation Rodin could grasp was that of scholastic ascetics and mystics—a far cry from his own inclinations.

Rodin discovered a more positive view of life among Gothic sculptors and cathedral builders [10, 38, 44, 50]. It should not be forgotten that in his youth he had assisted in the Gothic restorations carried out by Viollet-le-Duc. His first reaction to the experience

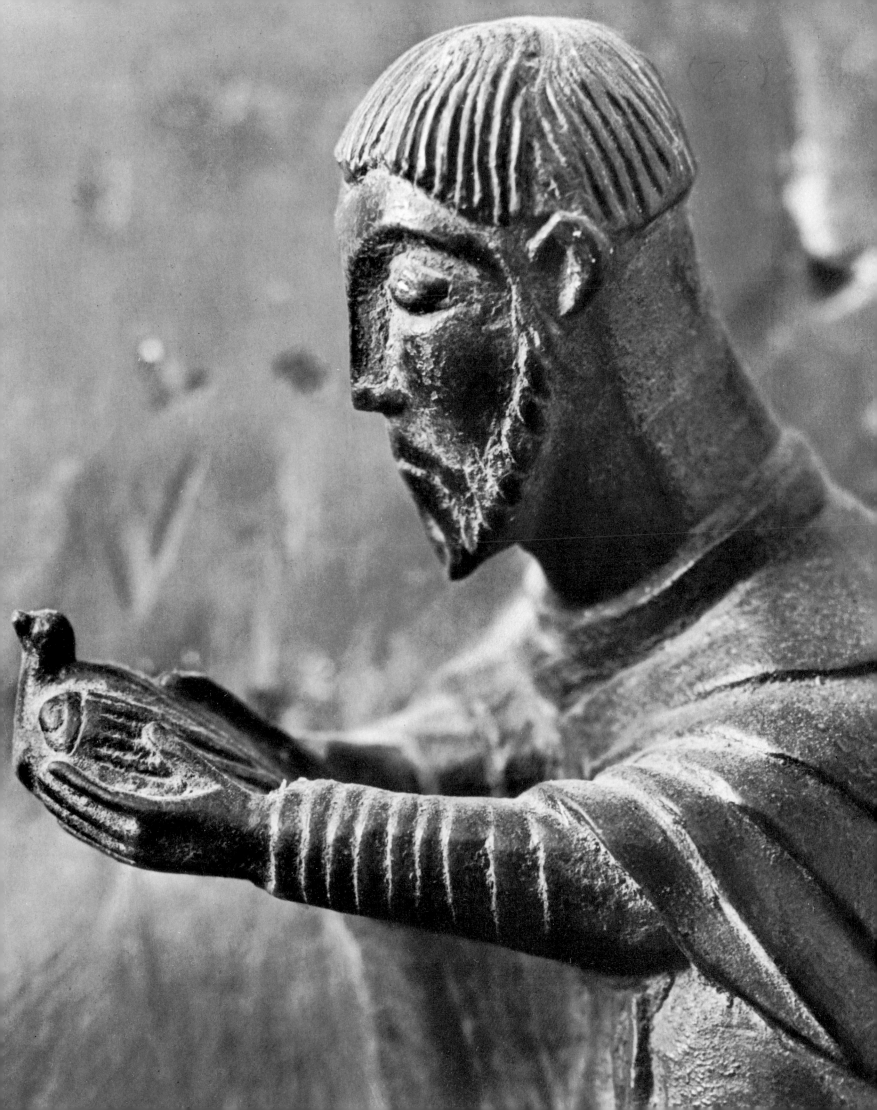

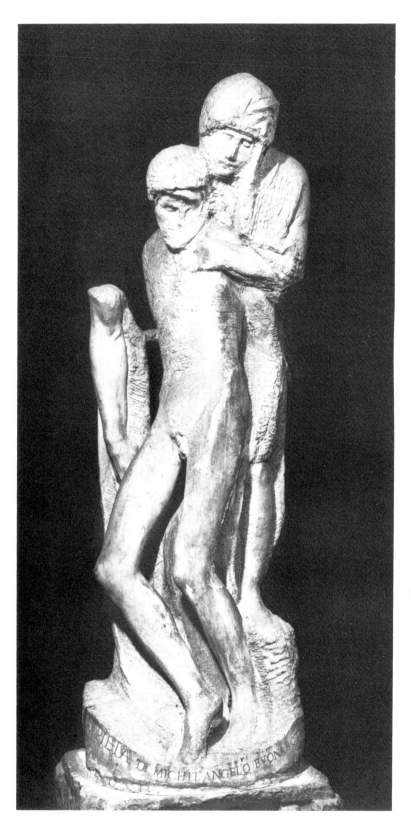

was to detest the Gothic. It should be borne in mind that this was in keeping with his time, that he shared in a general suspicion of the Gothic. Only later, but then with full abandon, did he begin to love the Gothic and to allude to it in his lyrical raptures about the French landscape, with which it is so closely associated.

Once Rodin's eyes were opened to the Gothic, it became for him a source of inspiration. From that time dates the almost pagan ecstasy with which he built up his own art. To materialize his own vision, he mingled, without sharp discrimination, the grandeur of cathedrals with the flourishes of Mannerist and Baroque painting and sculpture (Tintoretto, Rubens, the Sistine Chapel, Michelangelo's "slaves"). In this lack of discrimination Rodin was still a man of the nineteenth century. It took a Jakob Burckhardt, with his lucid vision of all that the term Renaissance implied, to distinguish clearly between what did and what did not belong to the Renaissance. Like Rodin, Burckhardt considered the Sistine Chapel a negative rather than a positive aspect of Michelangelo's total achievement as an artist. Indeed, he went farther: "Of all that makes life dear to us, very little appears in Michelangelo's work."[3]

As the nineteenth century grew older, sculptors felt the need to draw away from Michelangelo's compelling presence. Medardo Rosso (1858–1928) had a pronounced distaste for anything that smacked of the Renaissance and an equally pronounced taste for the collective and anonymous in Etruscan and Gothic art. Emotionally and intellectually he mistrusted and criticized all nationalistic and individualistic tendencies, since he believed that they led to a limited artistic vision. (In this respect Rosso represents, along with Delacroix and Baudelaire, the nineteenth-century cosmopolitanism rejected, for example, by Courbet, whose physical and mental makeup had been molded by Doubs, the region in which he was born.)

Rosso was in fact the first sculptor to detach himself from the Renaissance and Michelangelo. He did so not only because he was concerned with different sculptural problems, but also because his whole nature was different. Yet his contemporaries did not regard him as a pioneer, and he was understood only by the young Futurists of Milan in the years before World War I, among them Umberto Boccioni, who hailed him in the *Manifesto tecnico della scultura futurista* (Technical Manifesto of Futurist Sculpture) of 1912.

Antoine Bourdelle (1861–1929), Rodin's assistant and friend, displays the typical dichotomy of the transition from the nineteenth to the twentieth century. Though still greatly respecting Michelangelo, he nevertheless had doubts. In 1922, as a mature sculptor with personal convictions, he visited Italy, whence, under the influence of

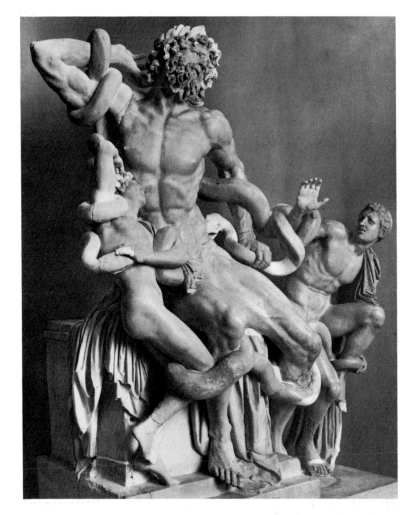

fresh observation, he wrote André Suarès a series of remarkable letters criticizing and repudiating Michelangelo in the sharpest terms.[4] Just as with Rodin, Bourdelle's own artistic lineage kept cropping up. To him nothing was superior to French Romanesque and Gothic art, and he never failed to tip the balance in their favor against the Renaissance and Michelangelo. He exclaimed to Suarès: "God is in the stones of Reims. O Vézelay, O purest stones of France! You are the holy place." And further: "Neither Donatello nor Michelangelo, and still less Ghiberti with his Baptistery doors surrounded by bronze string beans, belongs to the law of the language of great sculptors." He summarized his initial impressions as follows: "My first examination of the Italian style and accent, of the pronunciation of its lineal verb, is in favor of French Romanesque and Gothic art. And not in favor of Michelangelo."

But upon further examination Bourdelle changed his mind. Inclined to esteem Michelangelo more as painter than as sculptor, he finally recognized the totality of his artistic personality and proclaimed him, as poet and philosopher, the rainbow of Italian genius, an inspired prophet, an Ezekiel. And although he was disenchanted by the Medici chapel in Florence and the colossi of the tomb for Pope Julius II, he was profoundly impressed by Michelangelo's metaphysical profundity. He could not escape the fact that Michelangelo as poet, as artistic personality, was of unassailable greatness. Standing before the reputed self-portrait in the Pitti Palace, he felt "the pain of such a face, which seems to be atoning for Genius Every adolescent is merely a shadow before this ravaged old man."

With the birth of twentieth-century sculpture, some younger sculptors wanted to forget about Michelangelo. But no final evaluation can be essayed without reference to Adolf Hildebrand (1847–1921), whose academic position and reputation in Munich did much to maintain the classical tradition. By stressing its background and history, Hildebrand conscientiously renewed this tradition, in his publications and in teaching young sculptors. In *Das Problem der Form in der bildenden Kunst* (1893), the creator of the monumental Wittelsbach fountain in Munich critically analyzes the Neo-Classicism of Antonio Canova and attacks, as a matter of principle, the statuary cult of the nineteenth century. He propounds again and again the great qualities he finds in Michelangelo. His prose is methodical, plodding,

Teutonic, yet wholly sincere and without presumption. His professional and technical arguments are thoroughly sound. He corrects Vasari's description of Michelangelo's working method, demonstrating from his own experience that the master's technique had been to start on a front surface of his block and then to work gradually into the deeper layers. At the end of the nineteenth century, Hildebrand kept the best of Michelangelo alive.

In 1909, Arturo Martini (1889–1947), the most important figure in Italian sculpture immediately after the Futurists, went to Munich to study with Hildebrand, who must have confirmed him in his own ideas about Michelangelo. What these ideas were Martini makes clear in his letters[5]; to Count Luigi Zaubi Nuldi, with whom he was planning to compose a "theatrical work about Michelangelo," he wrote in 1918: "In him everything is mystery, his body is shadow, his spirit is hell, his work a curse and a repentance." The very things about Michelangelo that Rodin had disliked and rejected, Martini

21

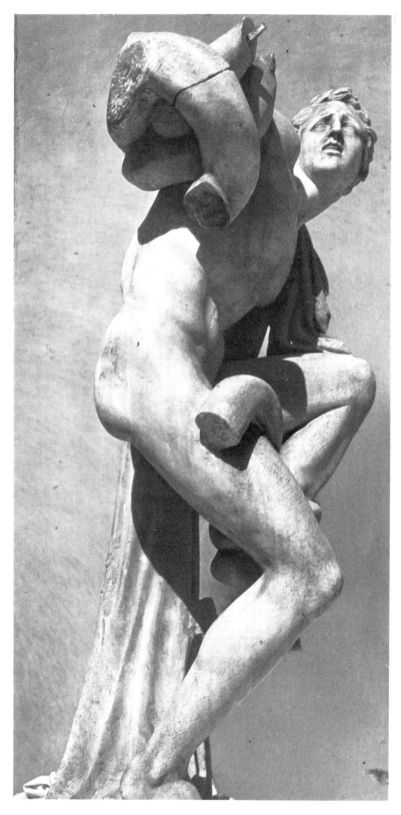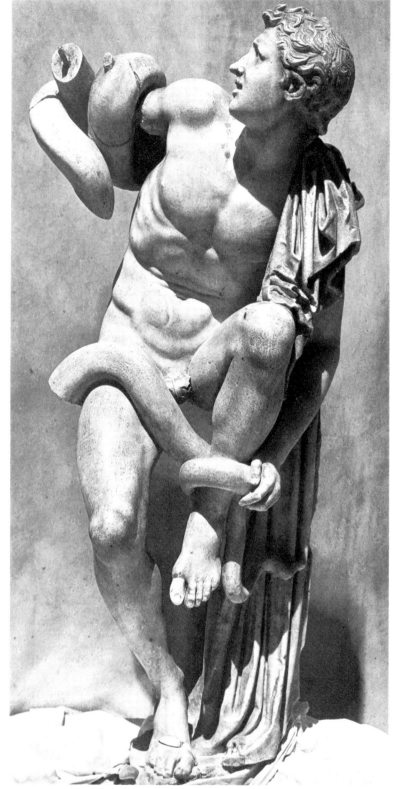

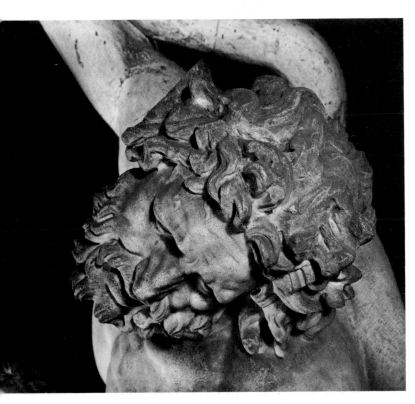

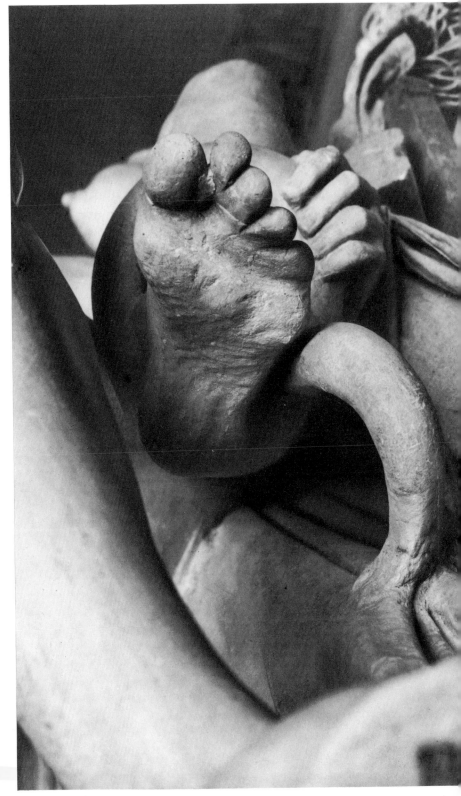

[14-17] AGESANDER, ATHENODORUS, AND POLYDORUS OF
RHODES. *Laocoön* (details). Vatican Museums, Rome

understood. He knew that inner world where life's central force was
so intense that the periphery became a torment, an increasing meta-
physical torture.

This deep temporal agony—which ultimately affected Michelan-
gelo's spatial form and caused him, each time with a different argu-
ment, to postpone the completion of a work—is not the same thing
as the dissatisfaction with the times that underlies the restlessness
of creative artists today. Yet the difference is not great enough to
prevent these modern artists from understanding the human back-
ground of Michelangelo's struggle. That the aftereffects of Michel-
angelo's achievement are at work in the twentieth century is thus a
fact not to be ignored. They are all-pervasive, if we exclude what was
happening in Paris among the Cubists at about the time Martini was
working with Hildebrand. Cubism had no room for a Michelangelo,
and the young Cubists also withdrew from the shadow of Rodin,
but Michelangelo was still a powerful presence for later sculptors,
as he had been for Rodin.

The lives of Stendhal the writer, Delacroix the painter, and the
sculptors Carpeaux, Rodin, Hildebrand, Bourdelle, and Martini cover

23

a period of more than a century. They saw Michelangelo not as a museum figure but as a troubled modern personality in whom the creative force was compelling, lacerating, and centripetal.

There was another aspect of Michelangelo that makes him relevant to our time. Examining the late-nineteenth- and early-twentieth-century affinity for archaic forms in the structural sense, we can perhaps draw an analogy with the Romans' affinity for late Greek culture. Unfortunately, we know little about the specific reactions of the Romans in this respect. Not until the sixteenth century do we begin to know of individual reactions in Europe to archaeological findings in Rome. From then on we are aware of the reactions of a period not only as expressed in official reports but also on the part of individual creative artists. An example is the story of the reaction to the discovery of the renowned sculptural group the *Laocoön* [13]. This work was praised and overpraised from the day it was found until the nineteenth century, when enthusiasm began to wane. Once Antonio Canova [4] and Bertel Thorvaldsen [35] started their search for a quieter and more sober classicism, the general admiration for the *Laocoön*—shared unwaveringly by William Blake and Goethe—began to subside.

Visitors to the Vatican Museums often pass by this group hastily and unmoved. They little imagine the excitement in Rome on January 14, 1506, when laborers in the neighborhood of San Pietro in Vincoli broke open a walled-up space in a vineyard and discovered a large statue that had remained vaulted in behind the bricks for uncounted centuries. The curiosity of Pope Julius II was aroused by reports of the discovery, and he sent the papal architect, Giuliano Sangallo, to inspect the work and supervise the excavation; Sangallo went off to the site with his nine-year-old son Francesco and his friend Michelangelo, then thirty-one years old, who happened to be visiting him.

The excavation site proved to be a portion of the Domus Aurea, once the luxurious villa of Nero. When the Sangallo party arrived, the architect ordered that the hole be made larger so that the statue could be removed. As the mighty work, which was broken into four blocks, was brought into the daylight, the whole company looked on with awe. Particularly affected were Felicei de Fredio, the discoverer, and Michelangelo. The subject of the group—the priest Laocoön and his two sons in their death struggle with the serpent—was recognized at once, and for the time being all conversation was taken up with speculations about who had made the statue and how it had come to be where it was.

The work made a deep impression on Michelangelo, one can only guess why. Perhaps he experienced a shock of self-recognition, since the violence of wrestling bodies was a basic problem for him—a wholly internal problem, unlike the external approach of the creator of the *Laocoön*. Examination showed that the priest's right arm was missing, as well as parts of the arms of the two sons. Reconstruction presented great difficulties, and the style of the whole disheartened Michelangelo. However, he may have attempted to complete the missing arm; the reconstruction has been ascribed by some to him, by others to Giovanni Angelo Montorsoli.

The *Laocoön* was copied and recopied, and its influence on the minor plastic arts was very great. The Laocoön motif appeared even on jewelry. The cult was such that Titian called it a monkey show. In the eighteenth century, German scholars subjected the group, in its restored form, to close scrutiny. Winckelmann dated it from the time of Alexander the Great, but Lessing placed it in the period of Titus. At long last, in 1960, in a brilliantly conducted excavation by Filippo Magi, the missing arm of Laocoön was rediscovered and recognized. Before it was joined to the statue, the whole group was taken apart and photographed from every angle. The investigation revealed that the original arm was an essential element of the composition. It differed notably from the reconstructed arm, which, weaker and more theatrical, had lessened the statue's tension. Thus all earlier judgments passed upon the group had been based on a poorer composition. Only the onlookers at the excavation, of whom Michelangelo was one, had fully realized the significance of the missing part.

The new dating assigns the *Laocoön* to about 50 B.C. This date is important to us only because it sets a more precise historical limit, but to those living at the time the statue was excavated, the style, the dating, and the identity of the sculptor were absorbing problems. Ancient Greece was then a nearly unknown factor. The Greece that Michelangelo and his contemporaries were coming to know through archaeological discoveries was in the main Hellenistic, as was the inspiration they derived from these findings.

Even in photographs, the *Laocoön* group, disassembled [14–17], affords a new view of the statue, which is basically a highly developed relief: we are able to experience something of the shock and excitement felt by Michelangelo and his friends when the great pieces appeared in all their plastic power—a power that appears more positive and dynamic in the fragments than in the reconstructed whole—and we come closer to understanding how the imagination of a creative artist like Michelangelo must have been stimulated by the very incompleteness of the work. It was not the later, incorrectly restored museum piece of art history, not a stylistic historical analysis,

24

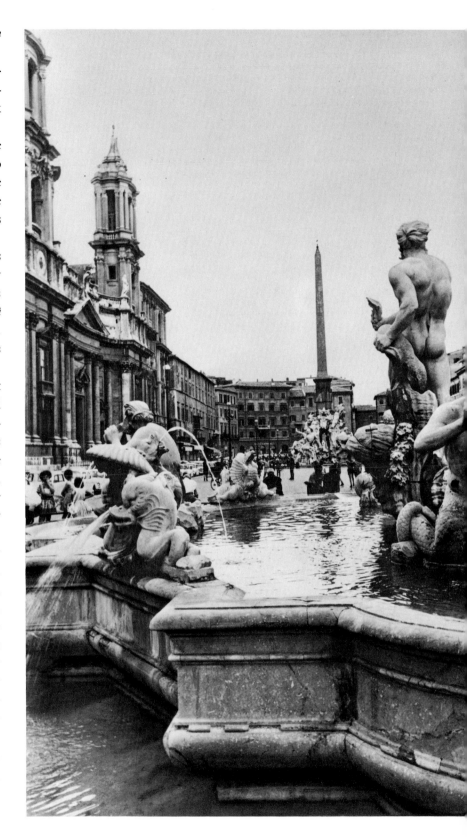

[18] GIANLORENZO BERNINI. *Fountain of the Moor* and *Fountain of the Four Rivers*, with obelisk. Piazza Navona, Rome

that struck a spark in him; it was the fragments, the gaps, the emergence of the damaged group in all its plastic nakedness from the dusk of centuries into the light of his own day.

A comparable temper is at work in the creative spirits of the twentieth century; they respond aesthetically and technically to archaeological and anthropological knowledge and extend it to the artistic imagination. These artists convert the historical into the contemporary not by leaning on the archaic but by reliving it in its original power.

The complex problem of the uncompleted ushered Michelangelo's image into the nineteenth century and has continued to occupy artists and art historians of the twentieth century. For the purposes of this book, the problem is best illustrated by the *Rondanini Pietà* [12], so called after the palace in Rome where the work was discovered. Michelangelo must have worked on it until a few days before his death; he was carving it from an ancient column.

In *Der Cicerone* (1855), his great book on Italian art, Jakob Burckhardt rejected the *Rondanini Pietà* completely. Although he appreciated Michelangelo's modern, restless, subjective, antihistoric, and virtually inexhaustible creative powers, he deplored that these qualities had been achieved at the cost of the enduring classical virtues. He felt that the *Pietà* block had been totally bungled by the master, that he had willfully exaggerated the deformities of the bodies in order to release the figures. In Burckhardt's view, the statue would better have remained unseen. Its essence escaped him.[6]

But Burckhardt's rejection was not the final word. Sensitized by the development of modern sculpture, we now have a positive and entirely different view of the *Pietà* and its creator. As early as 1903, art historians (Wilhelm Worringer initially) began to arrive at a deeper insight. No other piece of sculpture belongs so fully as this to the near-absolute of an inner world. In every respect it is at the threshold where the work of art either ceases to exist as form or shyly begins to live. It is at the threshold where sculpture no longer wholly corresponds to Michelangelo's method of working from the surface inward. In this *Pietà* the forms scarcely appear on the surface. They recede from the periphery. They deny volume, tension, counterpoint. They fade into shadows [2]. They are the greatest denial of everything that Greco-Roman sculpture proclaimed [1, 13]. This work has broken with the ancient world. Its structure has become highly unstable; the law of proportions has been abandoned. What Michelan-

25

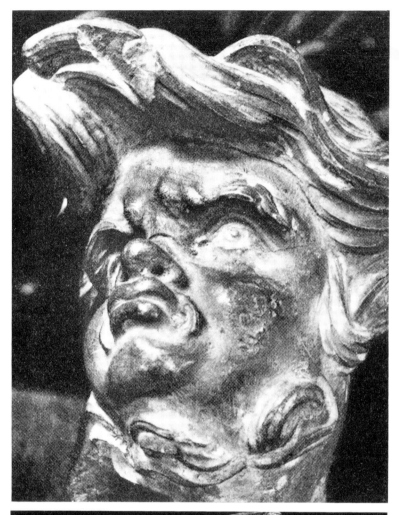

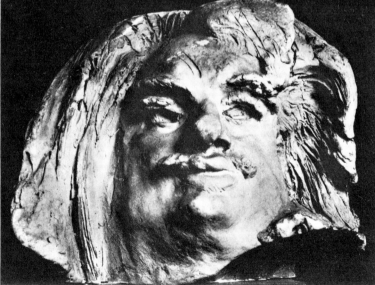

[19] GIANLORENZO BERNINI. Original head of central figure, *Fountain of the Moor*. Travertine. Palazzo Venezia, Rome

[20] AUGUSTE RODIN. Study for the head of the *Balzac*. 1891–98. Plaster. Musée Rodin, Paris

[21] GIANLORENZO BERNINI (executed by ANTONIO MATI). Water Demon (central figure of *Fountain of the Moor*). c. 1655. Stone, over lifesize. Piazza Navona, Rome

gelo does with the two figures is to build up one new human figure, which is utterly unlike Donatello's figures, with their tense, youthful power, and which conflicts with the late Renaissance theory of sculpture.

Here is a new, twofold human figure reduced by life's afflictions to a horribly still minimum. The Virgin, placed higher than the Christ, forms an arch of security and support over him as the world of the Mother flows into that of the Son. From the back it is possible to see how dominant is this arching; it is like a cupola or shell. The Virgin's enigmatic glance is directed downward from this cupola and is repeated in the even more unfathomable expression of Christ. Mary's right arm supports her Son; the left, just emerging from the block, is placed on his rounded shoulder. And yet it is as if Christ were supporting her. He bears, and still he cannot bear. His elongated, jagged, expressive legs can carry no weight; their lines extend above the hips, just above the middle point, where the volume is given a light twist and is narrowed. As the viewer's eye moves upward from the feet and along the legs, which are the most finished part of the sculpture [9], it is drawn to the torso, which yields as if to an invisible pressure. Above it arch the two heads, carved in increasingly sketchy planes.

In studying the hollows, one is again struck by the fact that the figures are contained as if in a shell, thus forming a unit. In outline, their basic form is a crescent [6]; at the back, this rounding tends to enclose and shelter the whole. The striking thing about the *Rondanini Pietà* is its absolutely concentrated form, which never veers to the outside but follows a movement turned in upon itself.

In no other work is the presence of the old sculptor so palpable as in this *Pietà*. Michelangelo left his hallmark on it everywhere—in the chipping away of larger and smaller segments; in the rawness of the stone where the rebellious marble's power asserts itself against the strength of the guiding hand; in the gradually finer and finer carving and polishing of the legs, as if invoking the upper parts, which shudder with desire for release. The complete and the uncompleted no longer play an essential role. The act of creation itself here becomes

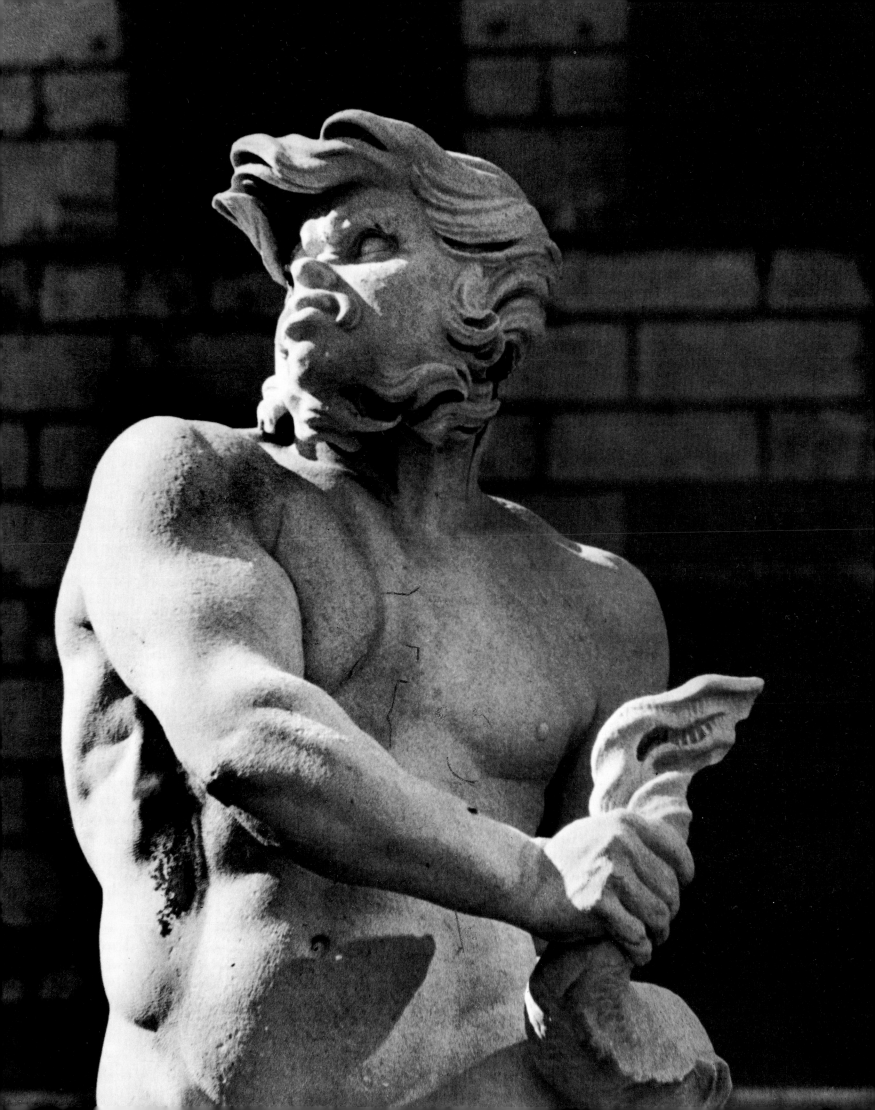

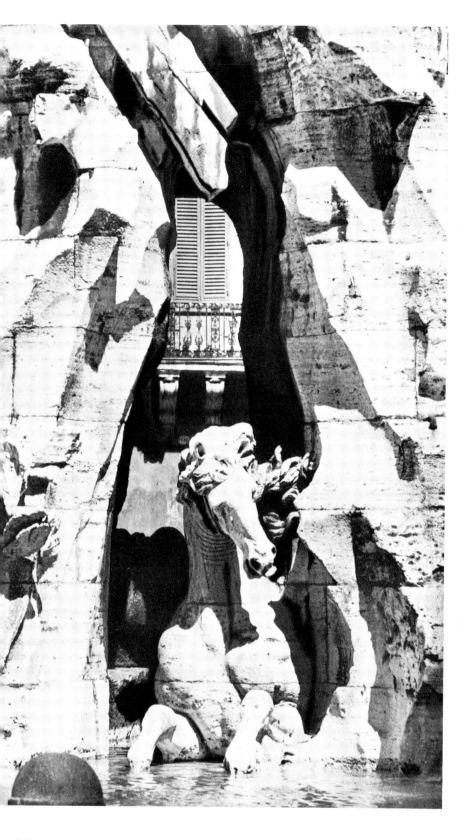

visible, and creation comprises both the *finito* and *infinito*. The miracle is the revelation not only of the artist's creativity but of the stone's [7, 8]. In all that it grants and withholds from the sculptor it displays its original potentialities. The stone is in itself perfection, a completion. The finite and the infinite, the *finito* and the *infinito*, merge figuratively and literally into each other.

The movement which originates in this miraculous block is upward and lightly turning. It might almost be called Baroque. But the essence of this *Pietà*, which is the ultimate of inward-directed motion, is too remote from the Baroque to permit us to relate it to this particular one of the developments that came between Michelangelo and Rodin and helped open the path which modern sculpture was to follow. Contemporary criticism often treats the Baroque less as a historical phenomenon than as a vague aesthetic definition of predetermined external manifestations. Guided in large part by its art historians, the nineteenth century ultimately rediscovered the Baroque. Its artists—not excluding Rodin—also participated in this rediscovery, though less consciously. The main factors in the shaping of Rodin's personal vision were the Greeks, the Gothic, Donatello, and Michelangelo. And also Gianlorenzo Bernini [3].

According to Judith Cladel,[7] Rodin spent more and more time looking at Bernini each time he was in Rome in his later years. My own belief is that he had been attracted by Bernini much earlier, had long been disturbed by him, presumably without being fully aware of it. In the creative process the unconscious effect of a strong impression, even if gained from a brief encounter, often plays a more important part than a directly demonstrable influence that has penetrated the consciousness and been given verbal expression. It may be that once set down in words, an influence loses some of its image-forming power.

The eighteenth and nineteenth centuries disliked the Baroque and were unable to distinguish it clearly from Mannerism. J. W. Winckelmann, after making the obligatory obeisance to Bernini's genius, never failed to take critical potshots at the Baroque, little disguising his distaste. Winckelmann's opinion prevailed among art historians until Heinrich Wölfflin published his *Renaissance und Barock* (1888). After that, artists and art historians gradually came round to a greater and deeper appreciation of the Baroque; by the end of the century it

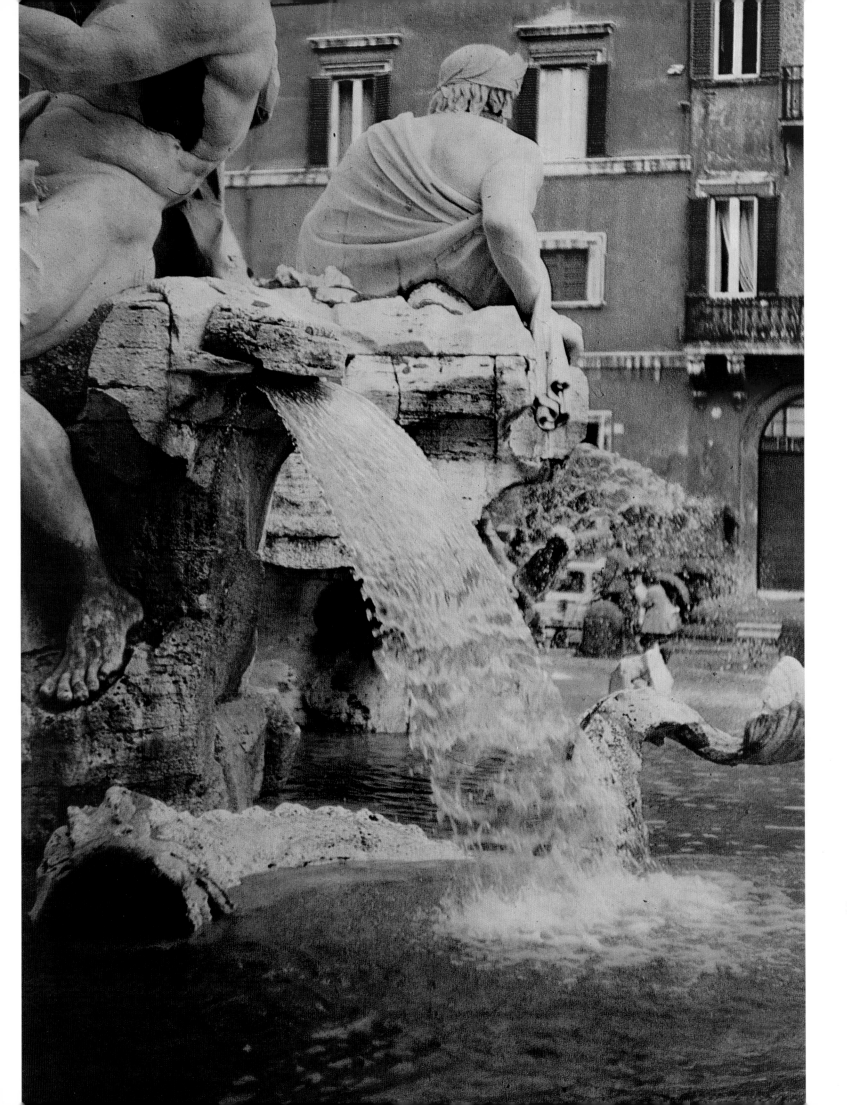

[24] GIANLORENZO BERNINI. *Fountain of the Four Rivers* (detail of the rocks). Piazza Navona, Rome. [25] GIANLORENZO BERNINI (executed by C. PURRISIMI). *Fountain of the Four Rivers* (detail: The Lions' Grotto). c. 1647–51. Travertine. Piazza Navona, Rome

was temporarily restored to grace. In particular, the understanding of the painters El Greco and Tintoretto developed into an emotional, expressionistic appreciation. The time was also ripe for Bernini's sculpture and architecture. Rodin is an example of an artist slowly becoming aware of the significance of Bernini's Baroque art.

During the period in which Rodin created his *Monument to Balzac*, remarkable surface movements appeared in his work, powerful archings in which light and dark took on positive forms that are not far from Bernini. From the first sketches for the *Balzac* [20] to the alluring cast for the monument itself there is a quality strongly reminiscent of the central figure [19, 21] in Bernini's *Fontana del Moro* on the Piazza Navona in Rome [18]. And very close to Bernini is Rodin's remark, "But take care to notice that shadow does not exist in itself. It is a garment that attaches to the form. If the form is good, the shadow, which is its manifestation, will be expressive. Give me beautiful forms, and I shall have beautiful shadows."[8]

Seen in relation to Rodin's handling of light in the nineteenth century, Bernini's treatment of it in the seventeenth merits the closest attention. Even in the twentieth century an increasing number of sculptural forms are related to Bernini's. For example, many sculptures are based upon the "cave" feeling characteristic of Bernini [22]; in these, light appears actively to penetrate the form, as is seen in works by Gaudí [304], Lipchitz [183], Moore [254], Hepworth [281]. Another case in point is a sketch by Bernini (Chigi Library, Rome) for the base of the obelisk he was commissioned to erect on the Piazza Minerva. This base has the form of a rock: the whole design is a whimsical rhythm of light and shade with an impetuous, upward thrust that undeniably reveals passions and tensions such as those at work in a sculptor like Umberto Mastroianni [394] in the second half of the twentieth century. Bernini's tempestuous imagination evoked countless possibilities that exceed the bounds of sculpture; one can discover in him, if not a direct influence, the source of some of the radicalism of modern sculpture.

To Winckelmann and his followers in the eighteenth century, beauty was synonymous with the imitation of classical forms. Hence they saw in Bernini's sculpture no more than an increasing dominance of pictorial values, or an overpreoccupation with nature, leading to an exaggerated sensuality and an alienation of the beautiful. Their

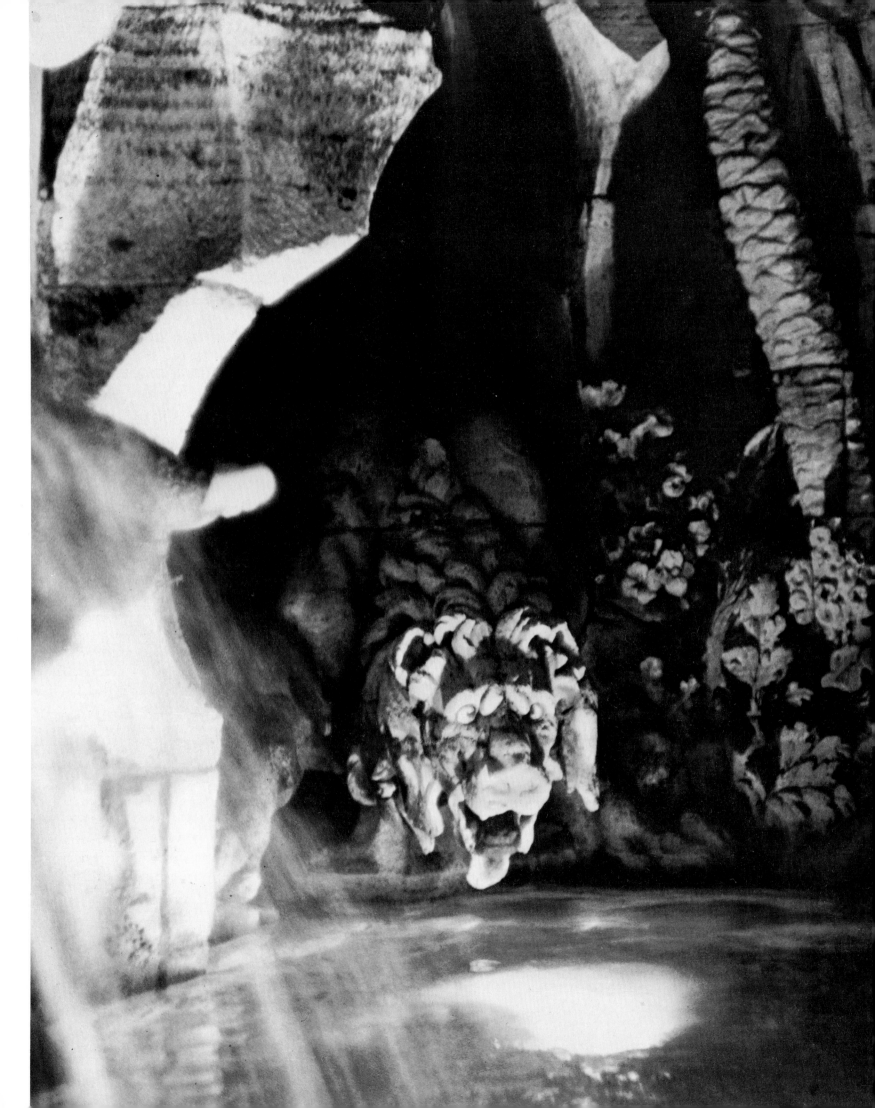

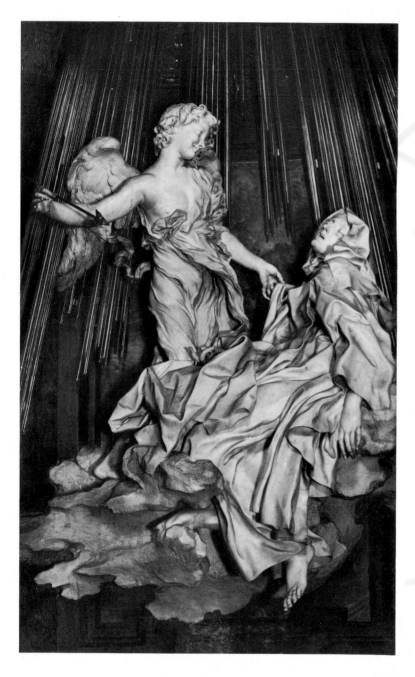

[26] GIANLORENZO BERNINI. *The Ecstasy of St. Theresa.* 1645-52. Marble, lifesize. Cornaro Chapel, Santa Maria della Vittoria, Rome
[27] GIANLORENZO BERNINI. *The Ecstasy of St. Theresa* (detail)

with that of his contemporary Nicolas Poussin. As Rudolf Wittkower has pointed out,[9] Bernini started from a classical example and then went on to give his imagination ever freer rein, whereas Poussin academically revised his original free conception till it fitted a classical formula. If, as Jacques Lipchitz has said, there are to be found in Rodin "all the treasures and all the riches . . . all the technical innovations, all liberties, all audacities, all the intuitions,"[10] it must not be forgotten that behind Rodin stands that ingenious inventor, the seventeenth-century master of the Baroque, Bernini.

Visitors to the Roman church of Santa Maria della Vittoria find there, in the chapel that Bernini built for Cardinal Cornaro, the altar sculpture portraying St. Theresa with the Angel of the Annunciation. This group is admired by some and condemned by others as "dizzily erotic." These conflicting reactions can be understood if it is borne in mind that Bernini worked on this piece from 1645 to 1652, less than a century after the death of Theresa of Avila, in 1582. Memories of her were still vivid in the seventeenth century; her mystical life and visions still aroused strong emotions.

To depict the ecstatic in sculptural form, Bernini had to sacrifice volume to light and movement. In the *Ecstasy of St. Theresa* [26, 27] there is a sinking away, a melting of the volume, a falling back of the major figure. The robe with its folds is the actual figure; there is no body, save the loosely hanging hand and the foot, which is the lowest point of an irregular triangle. Except for the upright angel with the arrow, everything is weightless. The face of Theresa in ecstasy has indeed—and this is what has offended many—an expression that might be considered erotic as well as mystical. There is no doubt that the expression Bernini gave Theresa is analogous to those of the ecstatic faces discussed by Salvador Dali[11]; the *Theresa* could easily have been included.

We may assume that Bernini, who was continually the object of harsh criticism and hostile intrigues, was usually held in check by orthodox friends. The erotic component of ecstasy which is revealed so directly and candidly in the *Theresa* could not have escaped unnoticed. It was simply accepted in the spirit of the times, for in the wonderfully ambiguous atmosphere of the seventeenth century the blending of the sacred and the profane was far from rare. The true innovation was that *sculpture* had found the form for expressing ecstasy.

In the twentieth century it is the Surrealists who point up this

criticism, applicable as it may have been to Bernini's successors, was not applicable to Bernini himself: in his art, Bernini sought to make of the sculptural motifs and materials available to him instruments capable of expressing his own bounding Baroque vitality and sublime imagination. His venture transcended every former aesthetic and was fraught with risks.

It is particularly enlightening to compare Bernini's working method

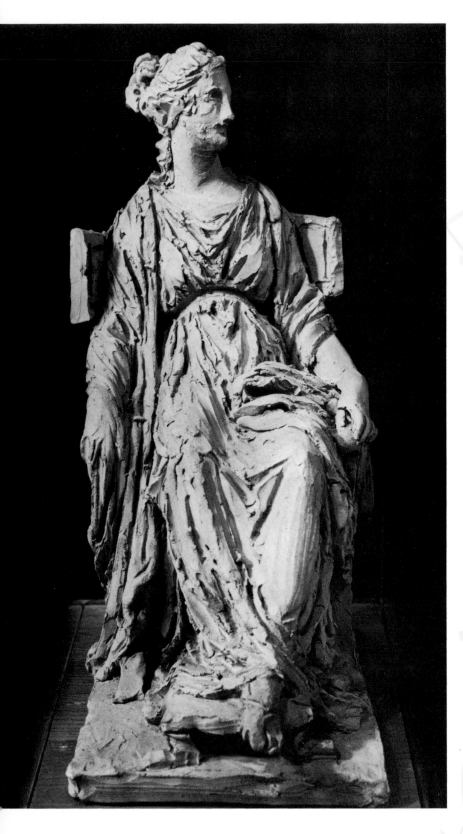

interpretation of the Baroque. "The world of images provoked by ecstasy is infinite," says Dali, speaking from the Surrealist point of view. It was also in this century that Max Raphael judged the Baroque, with all its contrasts, not a style but a state of mind. He wrote: "The Baroque carried Christian spiritualism, which has always presented an erotic character alongside its asceticism and even within it, to the most extreme subtleties of sexual life. One need only think of Bernini's *St. Theresa*, Correggio's *Leda*, etc. The Baroque is the materialization of the Sacred, the union of the spiritual and the sexual."[12] But, however this may be, we discover the essence of Bernini's work abstracted in Theresa's enchanting robe, that brilliantly controlled surface full of the half hollows and roundings of the folds. Everything on that surface is controlled light and shadow. The sculptor has created an instrument for an exactly written melody.

Yet Bernini did not see the tension between the angel and Theresa. This tension, present in every true Annunciation by earlier artists, is missing here. Bernini experienced something different; he saw the poetry of light, catching it up sketchily in the half shadows of the clouds and then letting it merge into the robe, which itself expresses the rapture of an experience of light bordering on the mystical. The sculpture that develops here neither spans a space nor asserts itself as a tense volume: it is a sculpture reduced to a form that receives and welcomes light and is wholly directed to it. Bernini lets the light of nature stream in from above through a simple window, visible only from outside the church; the light spreads over the altar, transforming everything. It is not Theresa but the light that is the mystic element embodied in the group. This accounts for the tendency of the volume to sink away, to disappear into infinity without contours —an abandonment of all volume for the sake of the dynamic force of light. Theresa's ecstasy was Bernini's ecstasy, which he materialized in the subtle transitions of the robe, moving from front to back and attaining a fluid dynamism.

In his exuberant fountains Bernini also gave expression to the communion with light, the coitus of earth and light. Moreover, his fertile imagination captured the liquescence of water, mastering it in a daring game that included light and sound. With a Baroque fantasy analogous to the inventiveness of the Baroque theater, he designed rugged sea monsters, leading them into the water from grottoes, sometimes with Gaudí-like effects. The plastic element here originates in an awareness of space and its archetypes—rock and cave. Yet not one of these forms ever becomes an ultimate form, because each is washed over, partly canceled, made misty by the splashing water. This is not accidental; it is an essential component of the

sculpture. Like no one before or after him, Bernini dared involve the element of fluid motion in sculpture [22–25].

The aftereffects of Bernini's art were profound but did not work to the advantage of sculpture. In the eighteenth century, as has been pointed out, the reaction against the Baroque found a learned and fanatical spokesman in Winckelmann, whose first work, *Gedanken über die Nachahmung der Griechischen Werke in der Malerei und Bildhauerkunst* (Thoughts on the Imitation of Greek Works in Painting and Sculpture), appeared in 1755. In 1763 appeared his treatise *Empfindung des Schönen* (Experience of the Beautiful). His influence was unexpectedly great.

Winckelmann, who never visited Greece, went to Italy in the autumn of 1755, shortly after the *Gedanken* appeared. There he was confronted with the problem of the distinction between Greek and Roman art, a problem which had also played a role in the Baroque. According to Sir Anthony Blunt (1961), Poussin and Duquesnoy had distinguished between Greek and Roman and had condemned the Roman. These two artists were no doubt exceptional for their time. Winckelmann's knowledge of ancient art was purely academic, with the result that his consideration of it lacked immediacy. His manner of observation and argumentation was influenced by an insistent northern longing for the south and a dream, based on no reality, of Greek harmony. Later, Hölderlin was to compose his poems out of a similar dream. Winckelmann judged everything by his formula *edle Einfalt und stille Grösse* ("noble simplicity and quiet grandeur").

Thus began the drifting away from Bernini, and from Michelangelo too, toward tranquillity, purity, and simplicity. G. E. Lessing followed in the footsteps of Winckelmann, and, as always, the *Laocoön* served as a basis for various views on the character, nature, and boundaries of the different arts. In 1779 a twenty-two-year-old sculptor from Possagno, near Venice, made his first trip to Rome. This young man was Antonio Canova (1757–1822). To a certain extent, he was to apply Winckelmann's theories in actual practice. Canova, although an admirer of Bernini, was the first sculptor in Rome to stop following him exclusively. He was also the first to go straight to the ancients, without, however, accepting Winckelmann's dogma regarding the imitation of Greek art.

It used to be argued that Canova was opposed to Bernini and his

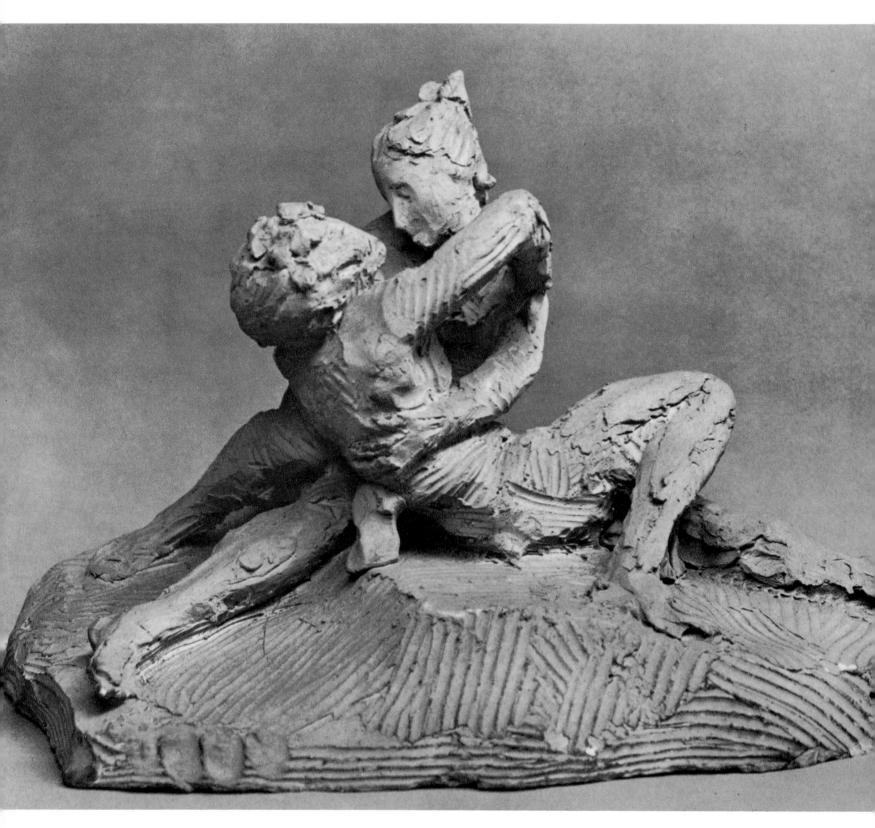

influence, but this can no longer be maintained. It is a fact that he found his models more in the ancients than in the offshoots of the Baroque and the Rococo. Using Winckelmann's formula, he idealized his portraits of such contemporaries as Napoleon and Goethe. Yet he continued to regard with a critical eye the slavish copying of classic art which was the great fashion and an important means of livelihood in his time.

Canova sought out Cavaceppi, a famous copier of ancient marbles, in 1779 but was not enthusiastic about his work. He was himself industriously copying and measuring architecture, sculpture, and paintings on his journeys to Naples, Pompeii, Paestum, and Tivoli. He copied the antiquities on the Campidoglio and in the Vatican, and the *Dioscuri* (Castor and Pollux) on Monte Cavallo. His favorite models were the *Belvedere Torso* [1] and the *Apollo Sauroctonus,* both in the Vatican. During his visit to London in 1815, he examined admiringly the sculptures from the Parthenon that Lord Elgin had brought to the British Museum early in the century [32].

Canova's sketchbooks are a fascinating revelation of the wide range of his interests. At Innsbruck he looked at northern medieval sculpture in the Hofkirche. Whenever he could, he sketched Egyptian statues, thereby helping to set the course of a newly developing interest. He eagerly studied the frescoes of Giotto and his followers

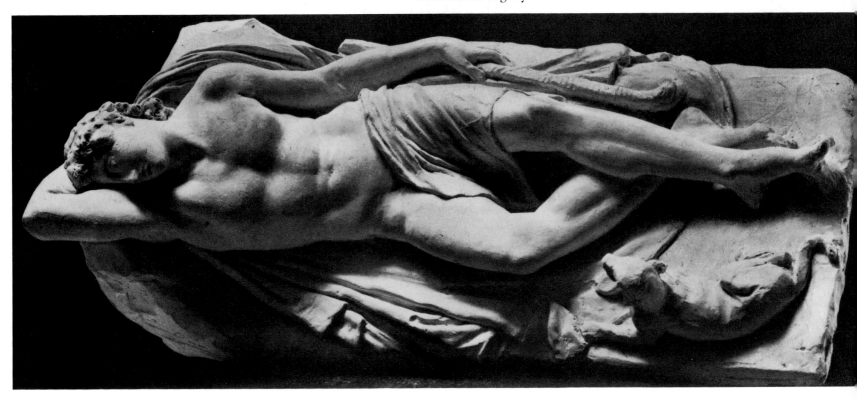

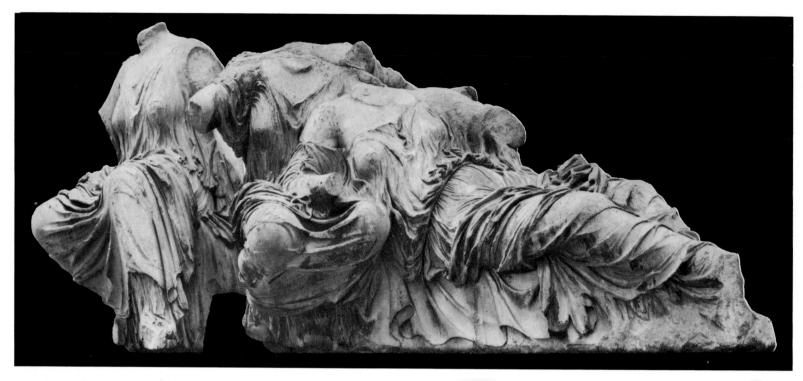

and those of Lorenzetti, Ghirlandaio, and Raphael, as well as Donatello's sculptures. In England he was particularly interested in viewing the works of Reynolds, Lawrence, Fuseli, and Goya. He also respected such lesser sculptural deities as Conradini, Marinali, and Rusconi—so that he cannot be charged with regarding the Baroque as decadent, as was the fashion in his day. What was new in Canova was the diversity of his interests—more like those of the nineteenth than of the eighteenth century—which are attested to by the products of his abounding talent in drawing. This diversity is absent from his sculpture, in which he practiced a classicism that led to a disastrous academicism in European plastic art. The dualism in Canova gives

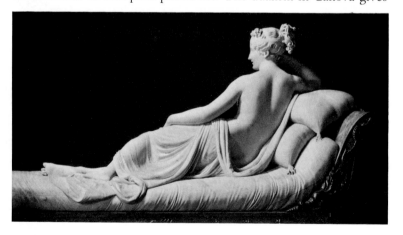

[32] *Three Goddesses*, from the east pediment of the Parthenon, c. 438–432 B.C. Marble, over lifesize. British Museum, London
[33] ANTONIO CANOVA. *Venere Vincitrice (Venus Victorious)*. 1808. Marble, lifesize. Borghese Gallery, Rome. [34] ANTONIO CANOVA. *Venere Vincitrice* (detail)

his personality a tension and an importance that escape recognition if he is evaluated only on the basis of the official sculpture that left his studio, in which he employed many assistants. A study of his drawings reveals a surprising vitality, a mobile, indeed passionate, hand, which noted down everything he saw on his journeys and sketched whatever attracted his active mind. Sketching was the direct expression of his free spirit; he was not hampered by preconceived formal ideas [29].

Almost as powerful as the drawings are his small models, chiefly in clay [28, 30, 31]. Canova called working in clay *fare invenzioni* ("making inventions"). In these models we find the Canova he suppressed in the large official works. The official Canova disliked what he called the "fluttering" of Bernini's Baroque imitators; he wanted "no hollows, no rocks, no wrath, no gilt." Unhampered by academicism, Canova closed up the volume again and built living figures in his little clay "inventions." We know from his sketchbooks that he could make precise anatomical drawings of horses as well as of human

38

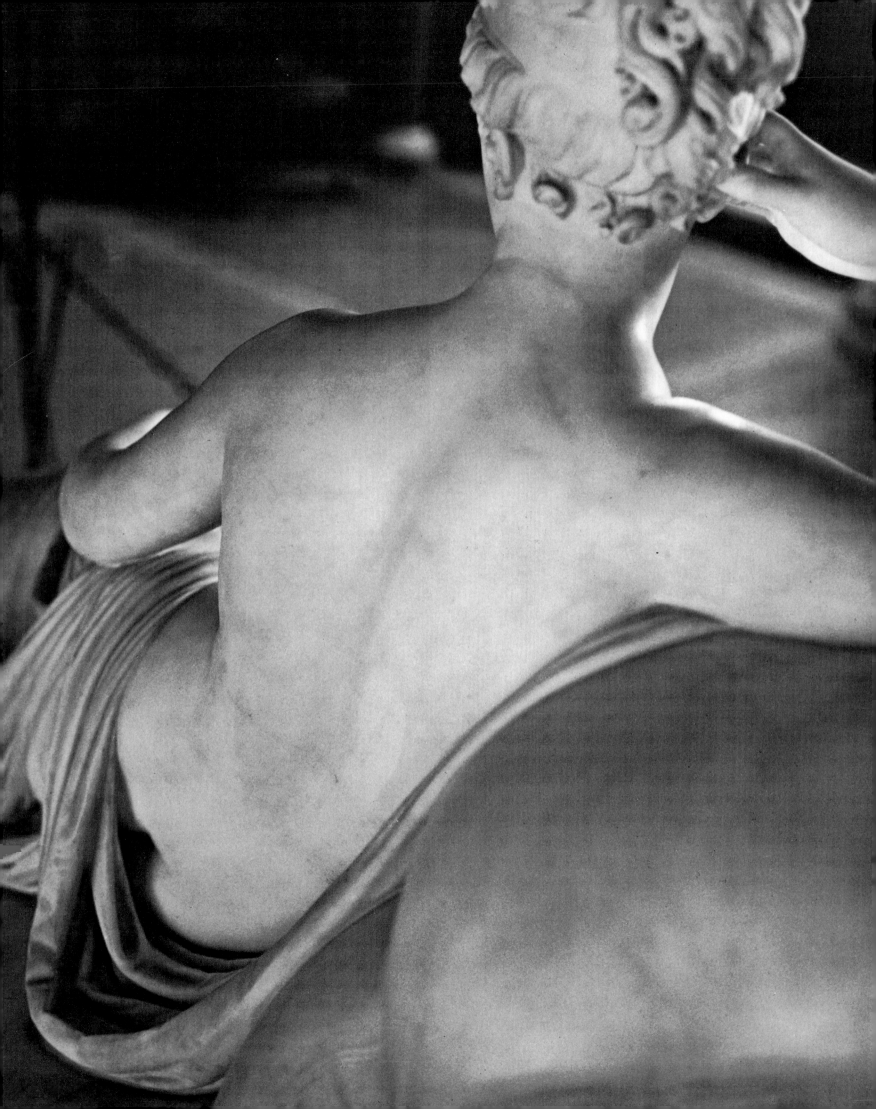

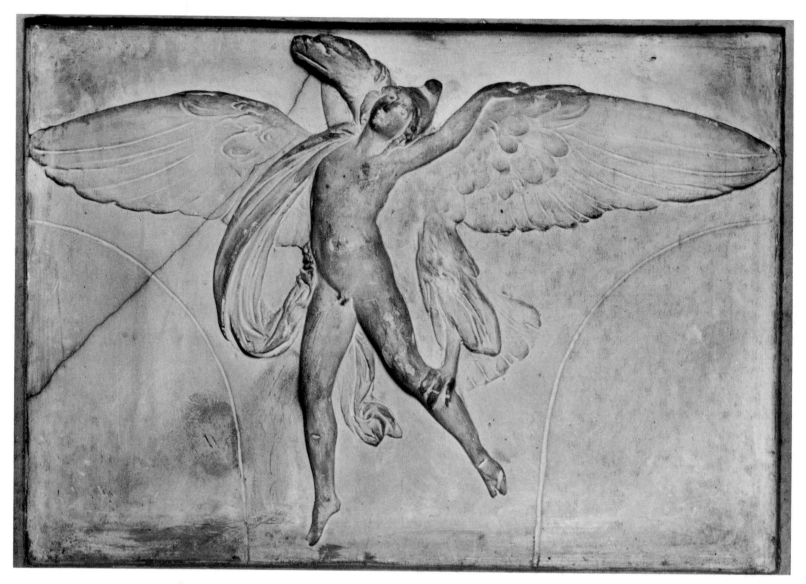

beings. We know that he had a mastery of the fall of folds (*il panneggio*), and when he let himself go in the plaster sketches (*bozzetti*), he played with this knowledge and was close to the modern spirit. The academic decay set in when his assistants made a half-size model after his small model or drawing and began to block out the full-scale design on the marble or stone with the pointing machine. Their precision was too great and the task too easy. All spontaneity was destroyed; the stone was deprived of its character.

Canova, with his dual personality, was less rigid than Winckelmann's fervent followers in his belief in the ancients, and attempted to interpret classical art in his own way and thereby to create an international style suited to his own time. His contemporaries not

only thought his work sublime, heroic, and Greek but also saw in it his own qualities of simplicity and calm. To them he was the ideal sculptor. And yet, only a few generations later, toward the end of the nineteenth century, Hildebrand criticized him severely, especially for including architectural elements in his sepulchral monuments.

Canova expressed himself most completely in the reclining figure of Napoleon's sister Pauline [33, 34], who married Prince Camillo Borghese in 1803. The artist made more than one preliminary sketch for this statue (whose style and motif Jacques-Louis David echoed in his *Madame Récamier*). Prud'hon greatly admired this work, in which Canova achieved a refined sensuality and quiet charm that perfectly embodied his era's ideal of beauty. The title, *Venere Vincitrice*

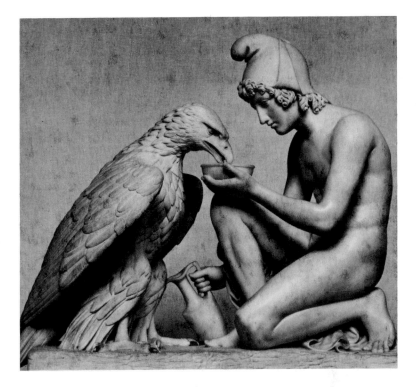

(Venus Victorious), indicates his point of departure in portraying a celebrated contemporary. Knowing Canova's *bozzetti* and drawings, we realize how seldom in his search for sublime, pure form he was able to express his fine, nervous, observant nature. In *Venere Vincitrice* he succeeded.

The Dane Bertel Thorvaldsen (1770–1844) and the German Johann Gottfried Schadow (1764–1850), each of whom followed Canova in his own way, complete the picture of the new classicism. Both of them were also able to draw, though they did not have Canova's rich versatility and mastery in this medium. Thorvaldsen [35, 36] also differed from Canova in his more pronounced affinity for archaic Greek sculpture and his greater reserve and selectivity in regard to Roman sculpture. Some of Thorvaldsen's reliefs show the first archaic Greek influences to be seen in nineteenth-century art, but the innovation had no influence of any significance. The Danish sculptor had a great knowledge of classical art, and in 1816 he was commissioned by Maximilian I, king of Bavaria, to restore the famous Aegina sculptures, which had recently been discovered and brought to the Glyptothek in Munich.

Thorvaldsen was responsible more than Canova for expanding sculpture's historical background. He found stimulation not only in classical monuments; his own collection, now preserved in the Thorvaldsen Museum in Copenhagen, contains, in addition to Greek works, a large number of Egyptian sculptures and Etruscan and Roman statues, jewelry, coins, and vases. He was typical of the sculptor-collector of the early nineteenth century and is comparable to Rodin, Epstein, and Lipchitz—later by nearly a century.

Among German sculptors, mention should also be made of Christian Daniel Rauch (1777–1857). In 1804 Rauch went to study in Rome, where he was first attracted by Canova's work and then, much more strongly, by Thorvaldsen's. He too found in archaeology a stimulus for his own art. Wilhelm von Humboldt, then Prussian resident minister in Rome, befriended him and commissioned him to restore a number of ancient sculptures.

Dislike of the numbing and impoverishing influence of the nineteenth-century academic style has led many to reject all Neo-Classic sculpture. Yet, hidden under the official sweetness and nobility of much of this art are lovely and refreshing qualities. When we look to the drawings and sketches, we realize that the outstanding artists were beginning to acquire a more than ordinary interest in archaic sculpture [39].

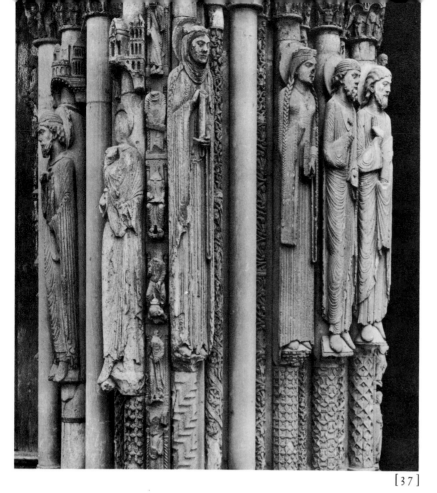

[37]

[38]

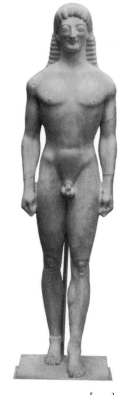

[39]

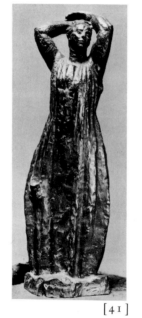

[40]

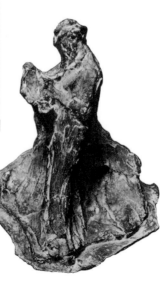

[41]

[42]

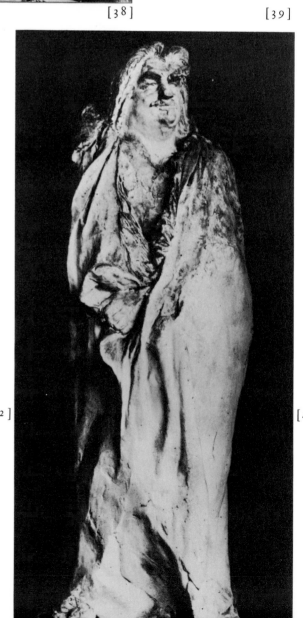

[43]

2

Rodin, Bourdelle, Maillol, and Rosso: Their Sources in Earlier European Art

Rodin (1840–1917) was born in a century that expressed itself pictorially. Like a St. Christopher, he laboriously bore the poor little child that sculpture then was across the pictorial stream of colors and the illusion of space to the far shore of the century. To do this required faith—faith in space as a reality and faith in the necessity of expressing oneself in depth. The burden was heavy, for Rodin also bore a past—the Greeks, the Gothic, the Italians. Everything he did was old. What the contemporary Impressionist painters were doing was much younger. Monet and Renoir sparkled with life, played a young light

over the world, observed the reflections of water, watched people amusing themselves in gardens. During this time Rodin was making *The Man with the Broken Nose* (1864, 1874), the youth wearily stretching himself as he awakes, that is, *The Age of Bronze* (1876), the dusky *Ugolino* (1882).

Rodin was further burdened with the misconceptions of his time concerning certain historical periods. He had every reason to feel spiritually fatigued. In the notebooks he kept late in life, he wrote the following remarkable statement: "Europe, like an old, weary Titan, changes its stance and consequently its equilibrium. Will it be able to adapt to new conditions, or will it lose, rather than change, its equilibrium?"[13]

It is these notebooks (which Rodin never planned to publish) that comprise the magnificent volume entitled *Les Cathédrales de France*. The book contains the thoughts and impressions of a gifted artist who has traveled extensively through the rich land of France on visits to his beloved cathedrals. He does not describe them but enters into their spirit, just as he permits them to enter into his innermost being, where they release a throng of spatial emotions and memories.

Although the book teaches us little about the cathedrals themselves,

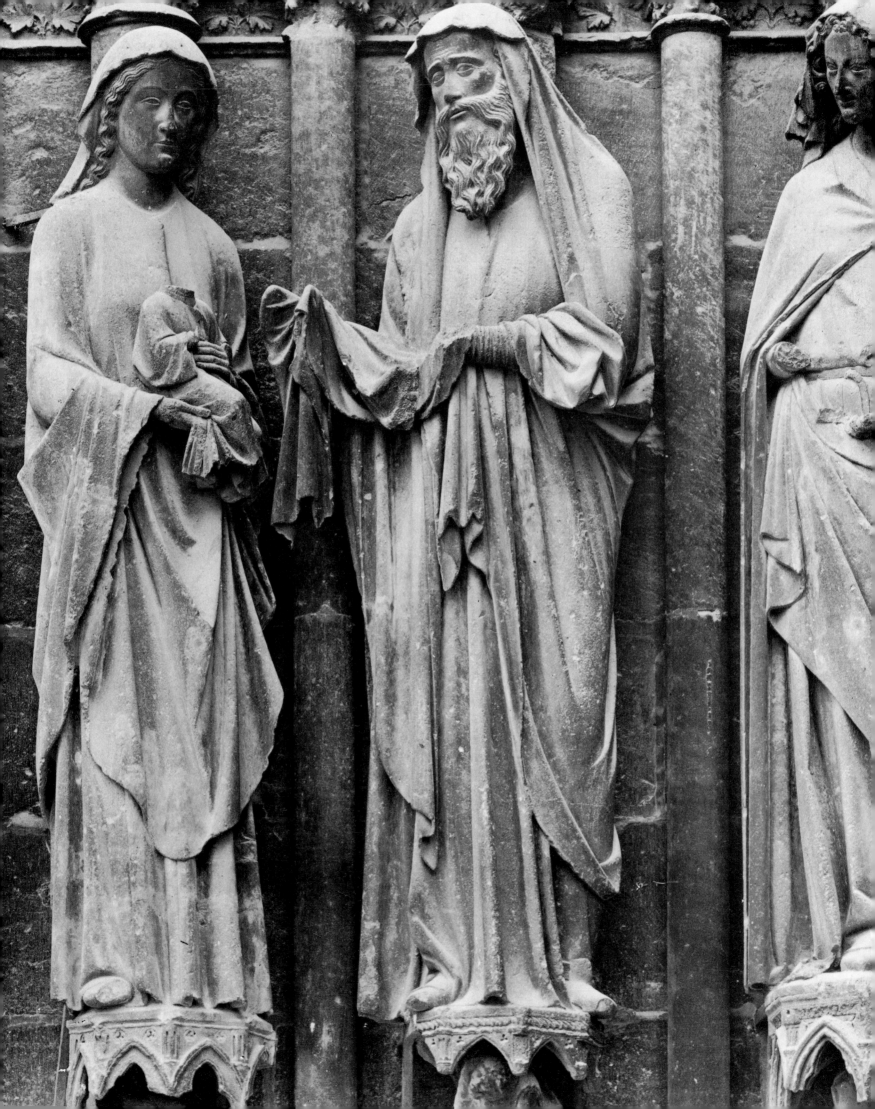

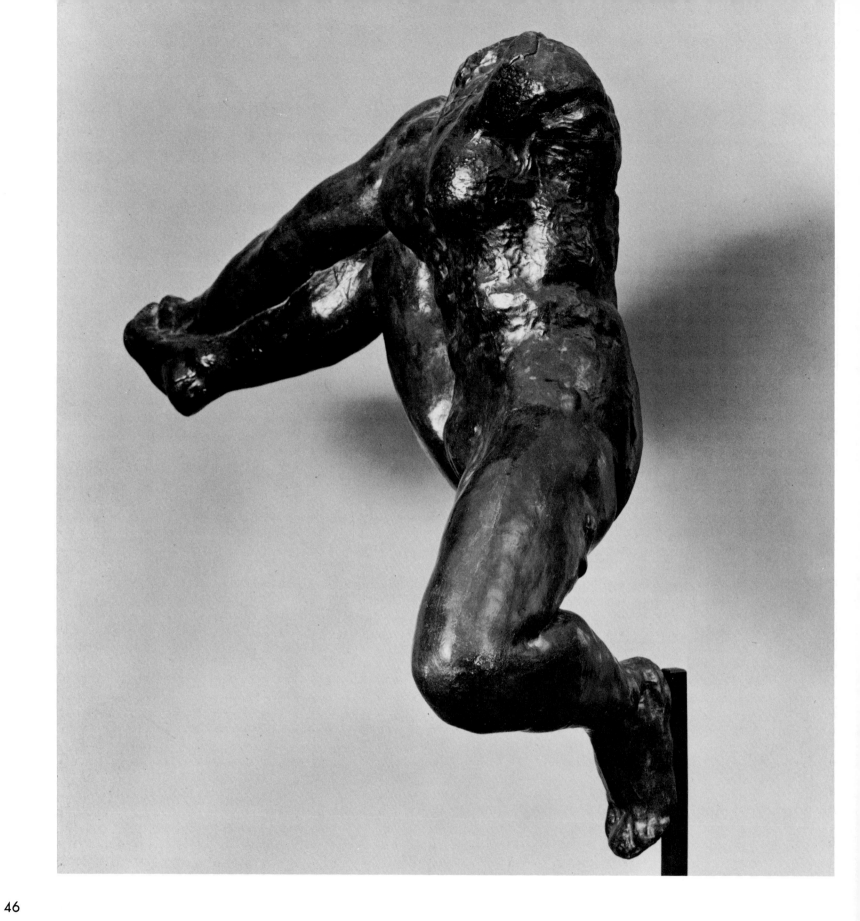

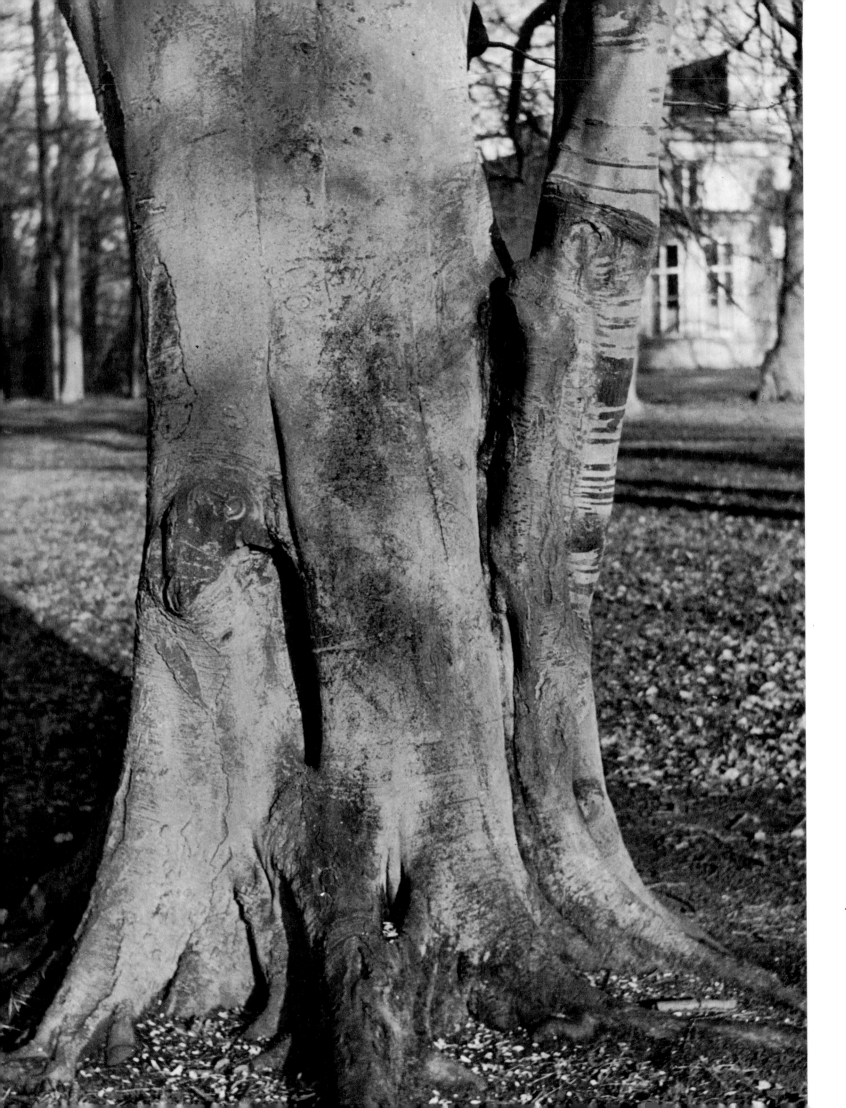

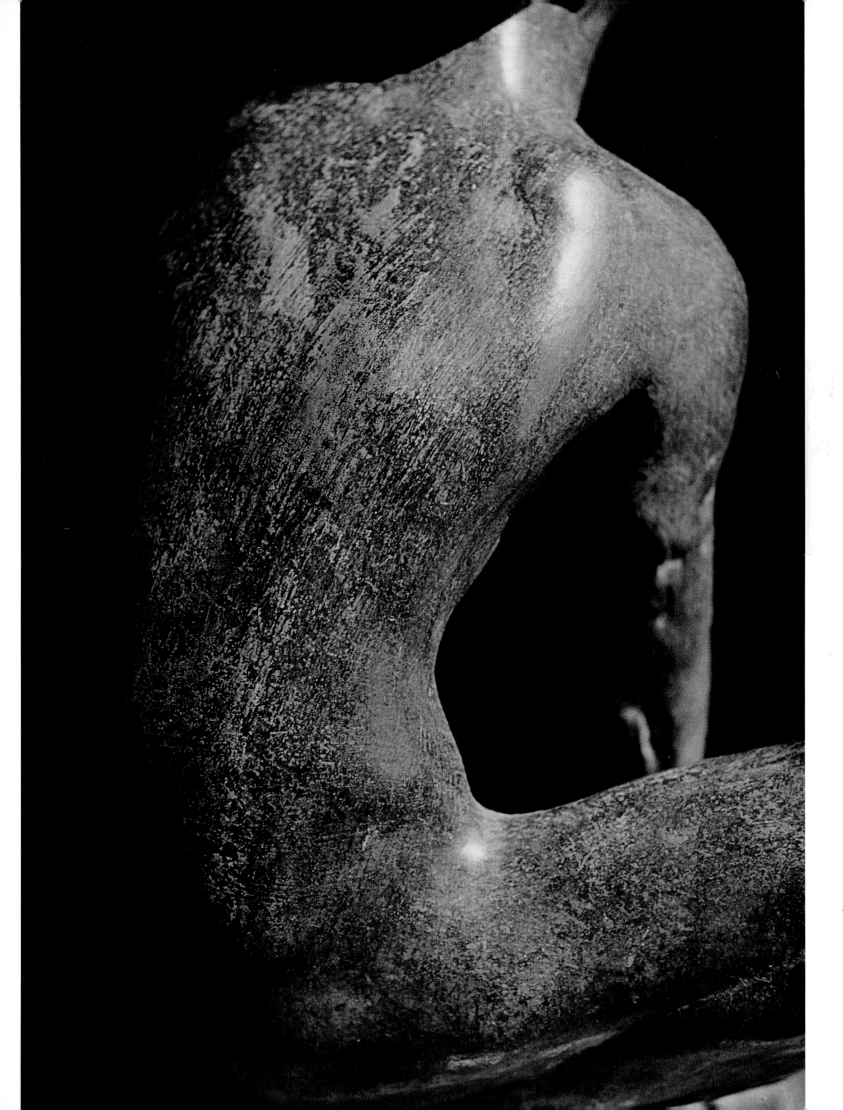

it does give us an insight into the formation of a poetically and creatively charged view of architecture and sculpture, which became a kind of frieze in Rodin's psyche. It is from this inner landscape that he speaks of weary old Europe as a faltering Titan. He himself is that Titan. He himself falters under his burden, which no amount of fame can lighten. He will undertake to transmit a consciousness of depth, a consciousness of space, not as a painted illusion but as reality, and he will project this reality, without any structural relation to society and without architecture of any sort, in his figures of people. In spirit and form, these notebooks reveal a last, dramatic re-evaluation of what once was, and a rejection of academicism, rather than the opening of a new perspective. The new areas were not for Rodin to discover. They would be opened up, in all their youth, vitality, and power, by other, somewhat younger, artists living and working in his immediate environment. The younger Greece which these artists rediscovered was to give a new definition and meaning to the term archaic.

Rodin's discoveries, or, if one prefers, his flashes of self-recognition, were concentrated upon the Gothic, especially of France, and certain Renaissance figures. He was acutely aware of Michelangelo, perhaps less aware of Donatello, whose impact on his work is nonetheless clear. As for his attitude toward Bernini, we know at least that he regarded this sculptor with undeniable admiration, particularly as he himself grew older. Rodin speaks of the Romanesque, which lived for him, but only as a somber, heavy beginning [11, 49] out of which the clarity of the Gothic arose [10, 37, 38, 44, 50, 59]. For him the Gothic meant religion and art at their fullest, an inexhaustible source of sublime spatial experiences. It was not only the Gothic treatment of the human form that moved him; he had the same kind of emotional understanding of Gothic architecture. It would be slighting the value of the spatial experiences he recorded to judge them merely as historical conceptions of style or as aesthetic evaluations. They are circumscribed by the limited knowledge of art history in the nineteenth century, but Rodin enriched this knowledge with a deep sculptural intuition, and his reactions were colored by his earlier personal spatial experiences, going back to archetypes of space and architecture—cellar, crypt, attic, corridor, cave, rock, forest, tree.

Thus the primeval feelings of space that Rodin cherished, though actually having other origins, were aroused by the Gothic. These impressions were closely allied to his deep-rooted feelings regarding light, dark, and space. He was the last of the artists of the late nineteenth and the early twentieth century to be deeply affected by the

[49] *Eve* (*The Fall of Man*), from the Bronze Doors of Bishop Bernward for St. Michael's. 1015. Hildesheim Cathedral

[50] CLAUS SLUTER. *The Moses Well.* 1395–1406. Stone, height of figures c. 6'. Chartreuse de Champmol, Dijon. [51] AUGUSTE RODIN. *The Gates of Hell* (detail). 1880–1917. Bronze. Kunsthaus, Zurich

Gothic. Rodin thus brought a period to an end. He felt this himself and, indeed, extended his awareness to the whole art of sculpture. "I am one of the last witnesses of a dying art. The love that inspired it is spent."[14] This statement is the keynote of the master. As we shall see, some thirty years later the talented young Italian sculptor Arturo Martini was to restate Rodin's prediction, though in somewhat different terms.[15] Fortunately, life's creative power has always been stronger than prophetic convictions or intimations of doom. In the years between Rodin's dire prophecy and Martini's, sculpture came to life in ways so varied, so full of contrasts, adventures, and discoveries, that no other period is comparable in richness.

Did Rodin's conviction that he represented a last stage cut him off from what was emerging? He, unlike Maillol and Bourdelle, was not moved by the discoveries of archaic Greek art. Strictly speaking, he appreciated only Maillol among the younger artists. The Cubist avant-garde was distasteful to him. Yet his own century, the nineteenth, disturbed him. He found it flat. It had neglected depth, one of the three geometric dimensions, even in the character of individuals. Again, it would be wrong to take his magisterial rejections at face value; if one fails to examine Rodin's further statements on these points, one misses the uncertainties that make him so much more human, responsive, and approachable than he at first appears.

How carefully posed is his question whether Europe, the old, weary Titan, will, in changing its stance, lose its equilibrium or adapt to new conditions! How strange that, for all his antipathy to the new age, which, he felt, lacked taste but by no means grandeur and courage, he remained open to one aspect of modern man—that new breed, the aviator. And when, heavy with dark thoughts, he leaned out the window of his studio on the hill in Meudon early of a spring morning, he would be comforted by the knowledge that his entire throng of sculptures awaited him within, eager for his glance and ready to work with him. Weary old Titan that he was, he would turn back to his collection, which included his own work [45, 47, 48, 53–57, 60].

Indeed Rodin's creative power had something gigantic about it. The procession of figures that marched out of his studio was a gesticu-

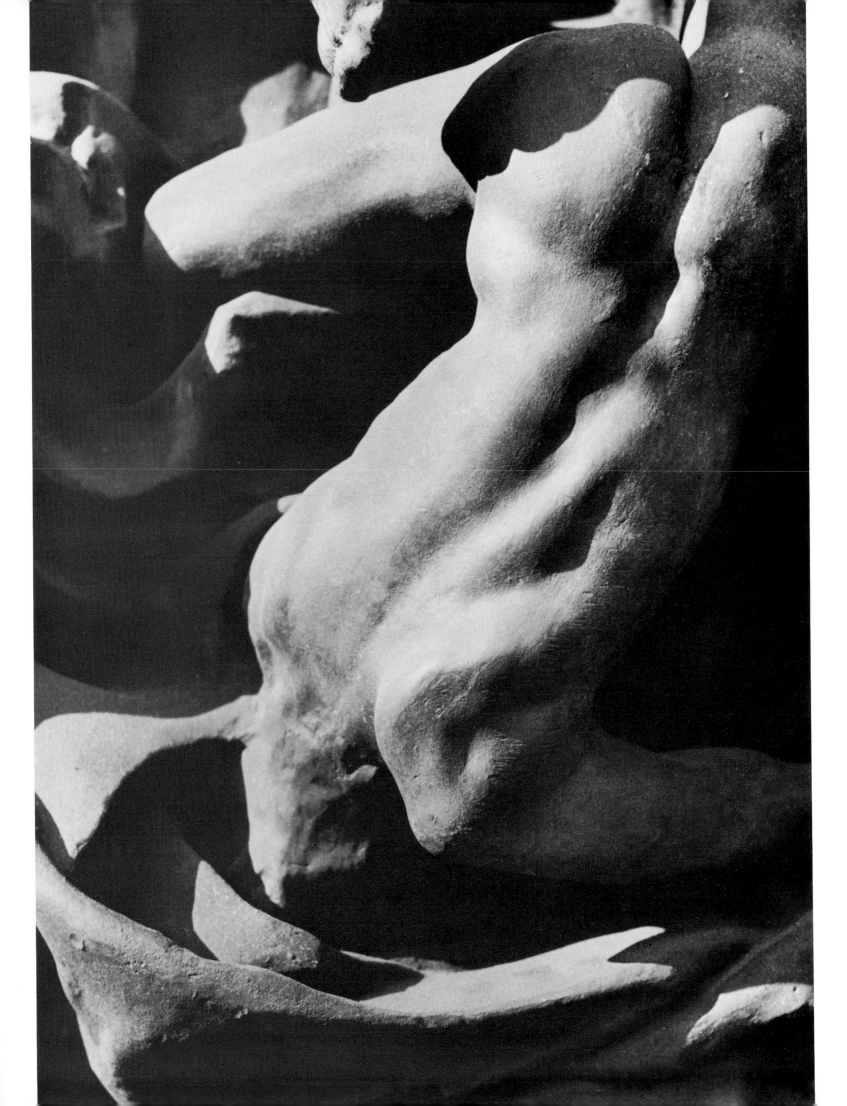

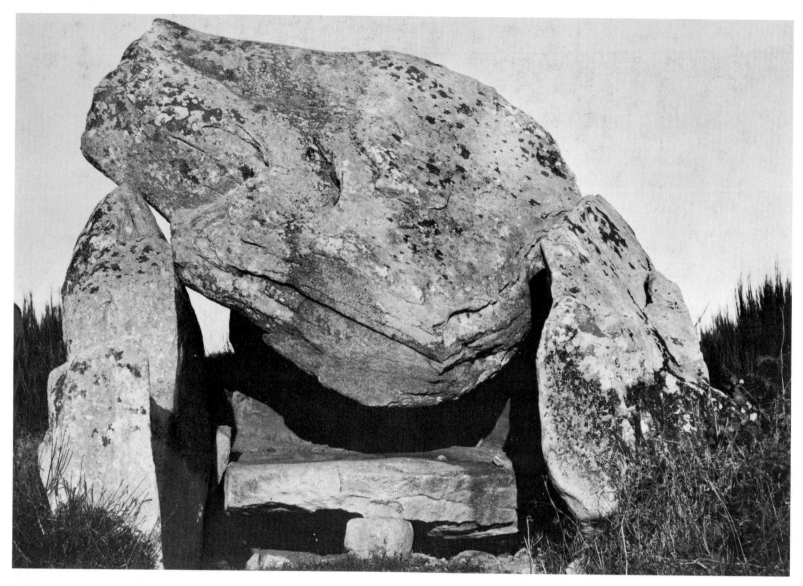

lating multitude. If one imagines them assembled in the salons of the Hôtel Biron in Paris or the sculptor's studio in Meudon, one hears in the background the rhythm and orchestration of a Wagnerian theme. In the figure of the *Age of Bronze* youth, an ancient past seems to awake to a new springtime. Rodin originally called this piece *Man Awakes to Nature*; the change in title apparently originated in a broadening of perspective. Although the revised title suggests the dusk of archaic times, there is nothing archaic about the form.

Rodin's collection contained works of all periods: he was not the specialized collector that Lipchitz was to become later in Paris and Epstein in London. In gathering together, without great selectivity, everything he found beautiful or important, anywhere, he was

entirely a man of the nineteenth century. This impulse to surround himself with as many styles as possible corresponded to the tendency of nineteenth-century architects to dip nostalgically first into one period and then into another, not always simply to imitate but to absorb into their designs the style and atmosphere of other cultures. Amidst the "people of his sculptures," Rodin's creative urge came to life again. In his experiences of space and form one discerns more than a search for tradition; one discerns his deep-rooted feelings for all

54

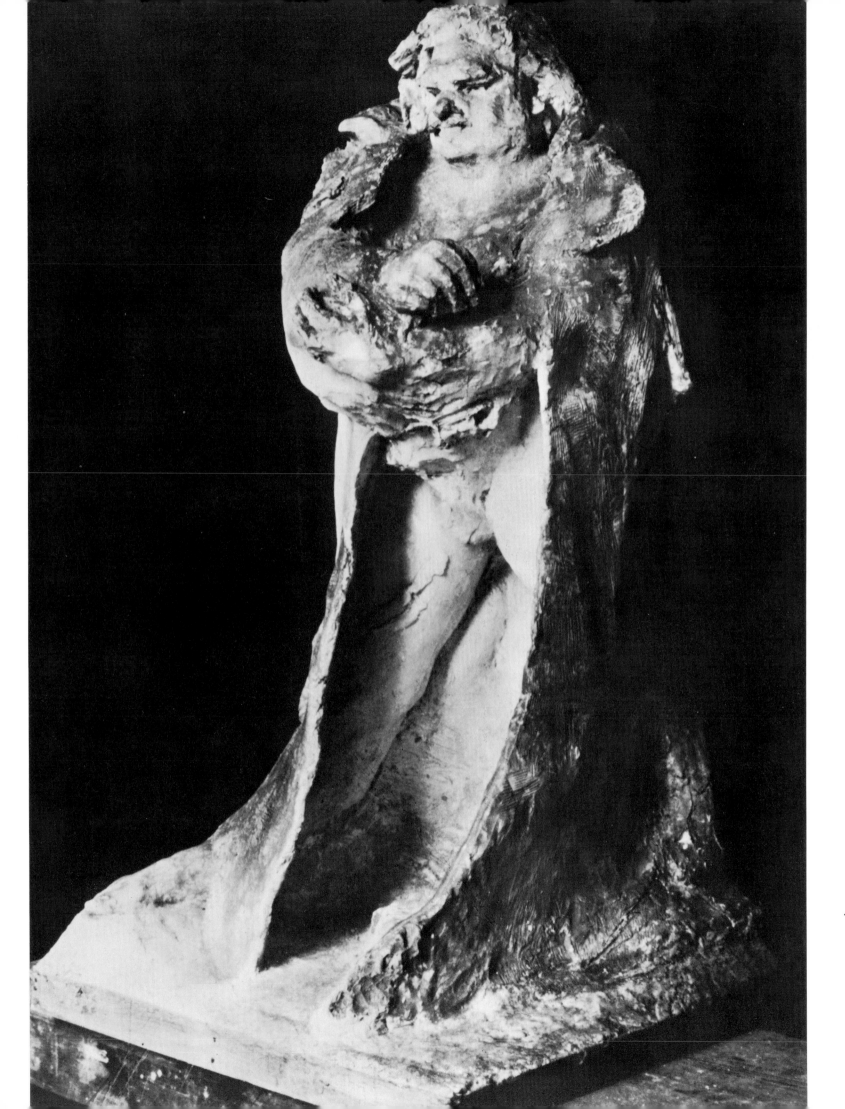

55

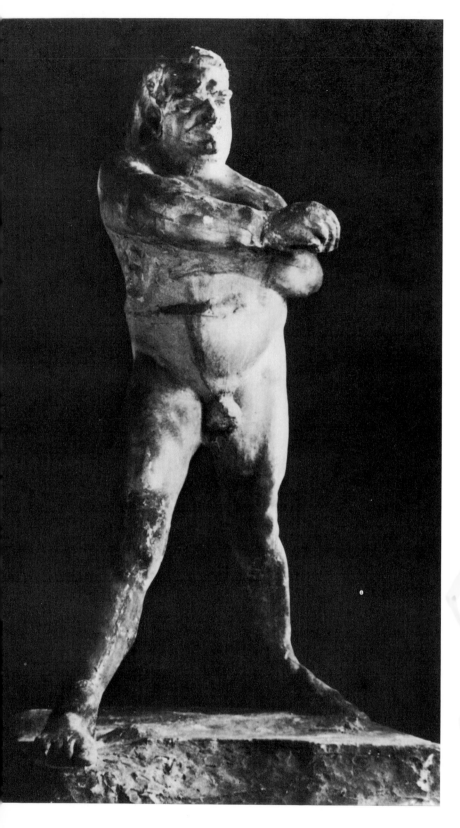

that light and dark and space can mean, feelings that he embodied in images exemplifying his own creativity. Averse to schools, he was faithful to tradition, but in a singular way.

The archetypes of space to which Rodin alludes repeatedly in his notes on his visits to cathedrals are sometimes associated in his thoughts with prehistoric times. In his own way, he found points of support, affinities with a distant past, that might be compared with the archaism of the younger artists. He thus united the new and the old.

It is poignant to see Rodin torn between belief and disbelief, between certainty about an admired and thrilling past and uncertainty about the future. He grew with his time: he conquered his own disdain of the barbaric Gothic, his uncritical adoration of the Renaissance. As he himself expressed it, he had progressed from Phidias and Michelangelo to Chartres. Yet the Greeks continued to ferment within him. What is most remarkable is the power of personal experience and memory, which he never fails to summon up: "Where did I learn to understand sculpture? In the woods by looking at the trees, along roads by observing the formation of clouds, in the studio by studying the model, everywhere except in schools. And what I learned from nature, I have tried to put into my works."[16]

Sometimes he pinpoints the memory. He mentions the forest of Soignes, near Brussels. The fact that scholarship repudiates the supposed relation between the forest and Gothic troubles him not in the least; he feels too strongly the truth of his own earliest emotions in closed spaces, which stifled him and at the same time fired his imagination. The Gothic was the forest of his childhood: "The forest where I dreamed in my youth is severe. It has no birds. Its horizon is almost entirely closed, limited by a wall of trees."[17] He returns again and again to trees [46]. In these poetically moving pages about the cathedrals, Rodin's associations with forests recur repeatedly: "One seems to walk in a forest at night beneath trees of winter."[18] The image of the forest is combined with human anxieties, which sometimes develop into a cosmic fear. "I repeat that, if one did not hold onto the feeling for order amid perspectives sketched by the errant light, fear would be invincible."[19]

The sculpture and architecture of the Romanesque and Gothic periods remind Rodin of the much older, rough, half-worked megaliths that had been erected vertically or been superimposed on each other in prehistoric times. He speaks vaguely of Druidic stones, of dolmens [52], of menhirs [145]. Although the exact purpose of these groups of stones is still not definitely known, it is certain that they are not the romantic ruins of enclosed temple spaces that Rodin

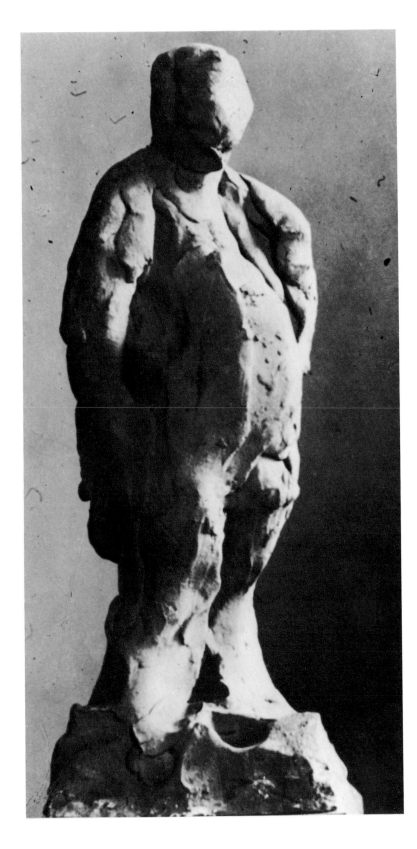

[54] AUGUSTE RODIN. Nude study for the *Balzac*. 1891–98. Plaster, height 33½". Musée Rodin, Paris. [55] AUGUSTE RODIN. Sketch, *Balzac Standing*. 1892–95. Terra cotta, height 8". Musée Rodin, Meudon

[56] AUGUSTE RODIN. Study for the head of the *Balzac*. 1891–98. Plaster. [57] AUGUSTE RODIN. Study, *Balzac in His Dressing Gown*. c. 1895. Plaster, height 9′ 10″. Musée Rodin, Paris. [58] AUGUSTE RODIN. *Balzac*. 1891–98. Bronze, height 9′ 10″. Musée Rodin, Paris

may have thought them to be. They are perhaps the remains of open sanctuaries, stones set up in the Neolithic period in connection with a cult of the sun, or of grottoes built for the dead: a category that lies between architecture and sculpture [385, 386].

Of his visits to Melun, Amiens, Reims [44], Rodin's chief memories are of old, primitive spaces, of cellars, crypts, corridors, grottoes, rocks—Romantic images, but at the same time archetypes of space. "In the Cathedral there is all the simple beauty of the menhir, which foretells it. Incontestably, Romanesque and Gothic blocks recall, in larger size, the Druidic stones. So do great trees have their part in the creation of Cathedrals. Were not the enormous logs that upheld the Gallic huts prototypes of buttresses, or buttresses themselves?"[20]

He revisited the cathedral of Reims at night. In the dark, the images of caves reappeared: "The unknown is the mystery of this spectacle. One thinks of a forest, of a grotto, but this is nothing of that sort: this is something absolutely new, which it is impossible to define at once.... The chapels are transformed by the struggle between darkness and light. This one is a somber grotto where there seem to be only shells set out along the ribs of the arches."[21] "I walk in remotest antiquity."[22] The series of carved-stone statues near the portals of the cathedral of Reims prompted his imagination again to transform the historic Gothic style, and exotic lands loomed up: "They are no longer of the time of their carving. Their aspect constantly changes, and for me these figures have a singularly new and a foreign accent: I think of Hindustan, of Cambodia."[23]

In Chartres, Rodin was gripped by the oldest memories of all, going back to his student days. Then he asked himself what his own work, particularly the *Balzac*, owed to the old masters. "Did I not approach you a little, Greek masters, Gothic masters, through the statue of Balzac, which, whatever one may say of it, is nonetheless a decisive step for sculpture in the open air?"[24] Sometimes these great monuments of architecture call up animal images. He refers to the cathedral of Mantes as an immense creature with a thousand paws.[25]

The cathedrals did not impel Rodin to write descriptions of them,

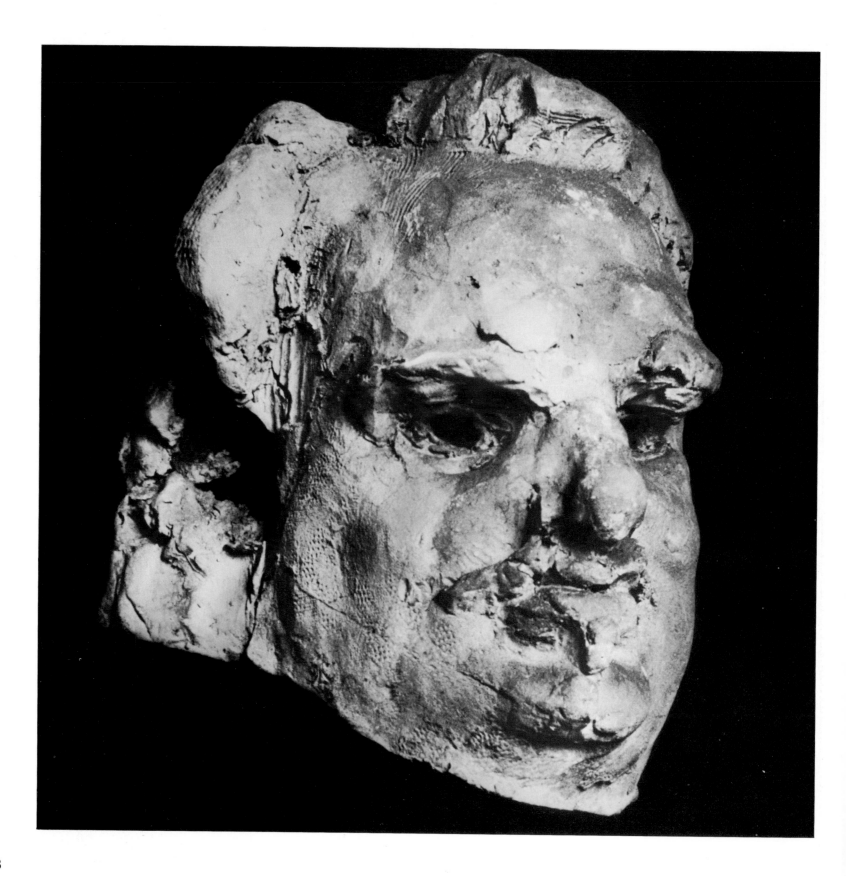

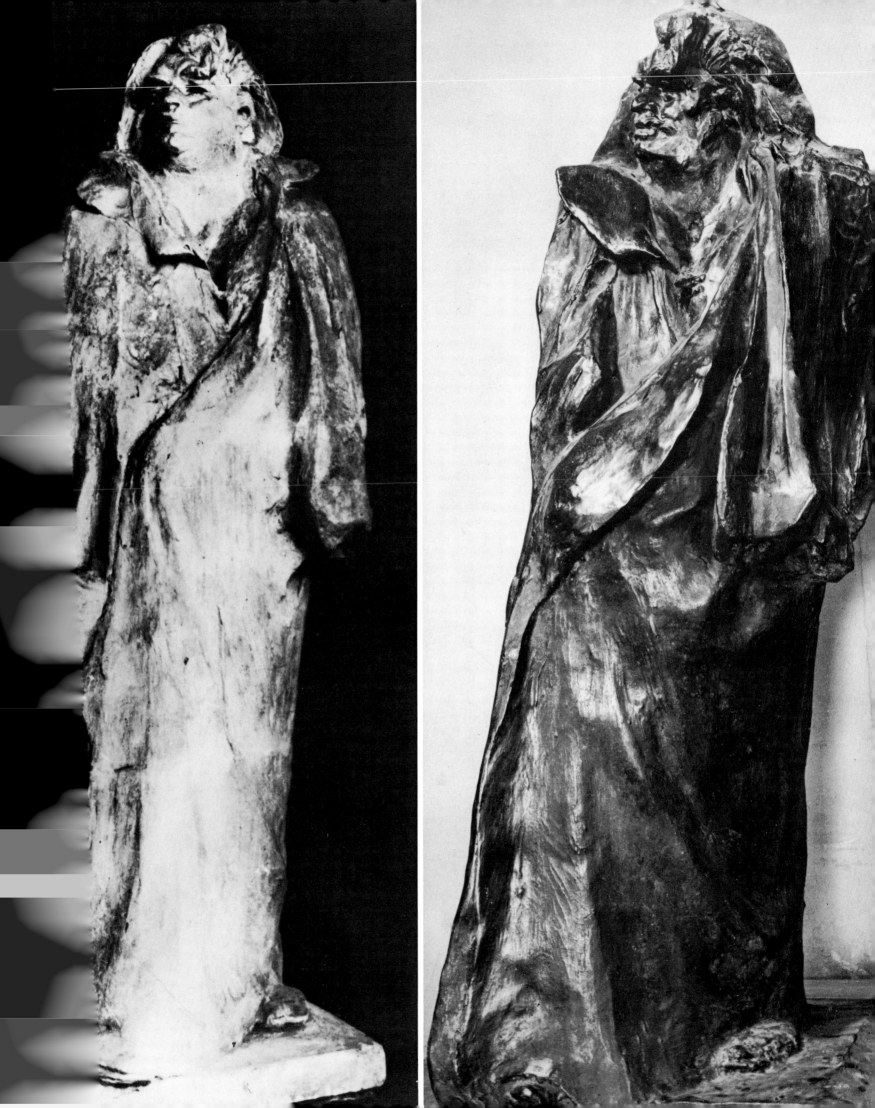

[59] *Prophet* (detail), from the choir stalls of Bamberg Cathedral. c. 1250. Sandstone. [60] AUGUSTE RODIN. *Benoit XV.* 1915. Bronze, height 10¼″. Musée Rodin, Paris

Tree and forest define his feeling of isolation. One of the preliminary studies for the *Balzac* was actually the figure, scarcely human, of a tree rising out of the earth, the figure of a willow split asunder, in which an animal and primitively human Balzac conceals himself as if he were the spirit of the tree. A thunderstorm appears to be concentrated around this tree: there is a terror in the frenzied features of the mask, a fury in the tearing hands. Bourdelle saw all this when he said of the *Balzac:* "He waits . . . waits in his prison of branches."[26] *The Burghers of Calais* (1884–86) is, similarly, a forest, a group of figures containing darkness in and around and under themselves; the darkness is locked in among the figures like a binding medium. So too the *Man Walking* (1888) is one of the moving trees of Birnam Wood advancing over the heath. There is something immeasurable in these figures, something that derives from a dark rather than a luminous space.

In their deepest essence these three sculptures exist without the support or protection of any kind of architecture. Rodin, who talked about Gothic architecture all his life, could not tolerate architecture so far as his own work was concerned. The space that his sculptures conjure up is neither Gothic nor Greek. The *Balzac*, the *Man Walking*, and the *Burghers of Calais* remain essentially bound to the forest, the grotto—those primeval, romantic spaces that suggest infinity by uniting turbulent darkness and turbulent light.

The artists who came to maturity shortly after Rodin, the Bourdelles and the Maillols with their archaic dream [39, 61, 72, 73, 80], belong either to a different order—a less cryptic one, a measurable order closer to architecture—or else to an Arcadian landscape. In Antoine Bourdelle (1861–1929), who took a stand against the condemnation of his work as "archaic," we observe for the first time a sculptor consciously committing himself to the very archaism of which he has been accused. The charge of archaism, raised in 1912, was directed chiefly against Bourdelle's decorations for the new Théâtre des Champs-Elysées [62], built by Auguste Perret (1874–1954), who had taken over and altered the plans of the Belgian architect Henry van de Velde (1863–1957). Bourdelle had been chosen to carry out the statuary and ornamentation while Van de Velde was still being considered for the work. When Perret took over, he accepted this choice and joined forces with the sculptor. After completing the reliefs and paintings, Bourdelle answered the charge of archaism in a

as has been said. The Gothic lived in him, in the spirit of the nineteenth century. But he was not interested in studying the Gothic, in dissecting it, as Viollet-le-Duc had done. He sought something altogether different. The sculptures and the spaces became personal experiences that carried him back to his own depths as a human being and as a sculptor. Primeval space, which had become a reality for him in his youth as a dream of a forest, is not an open but a closed space, soundless, somber, yet unlimited by the great darkness within it.

To Rodin, trees, and more especially the forest, were plastic elements of the first order. He lived in and amidst them. In all his descriptions of space—caverns, grottoes, cellars, crypts—darkness dominates. His light always emerges from the tension that the dark creates. He differs essentially from the Impressionists in the very nature of his experience of light. Impressionist painting placed light foremost; for Rodin, light could exist only by virtue of darkness.

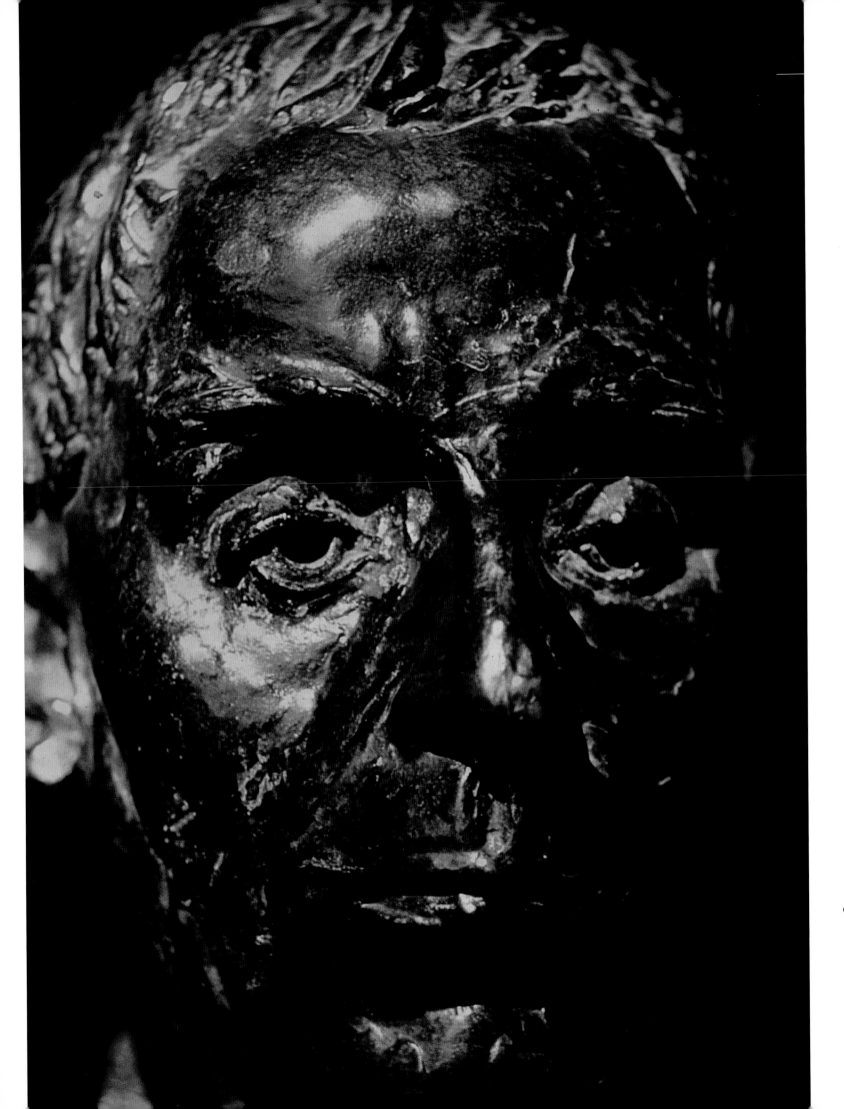

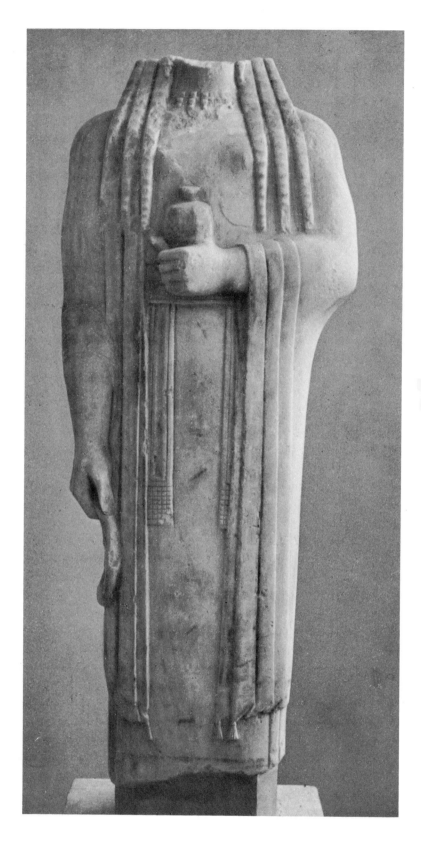

spirited defense that affords an insight into the relation of the artist
of the day to the archaic Greek past. Bourdelle wrote that his critics
regarded archaism as "something dead, far away," whereas he
regarded it as timeless and considered the censure a title of honor.
"All synthesis is archaism. Archaism is the opposite of the word copy.
It is the born enemy of the lie—of the whole art of make-believe, of
the foolishly loathsome that changes marble into a corpse. The
archaic is not naïve, the archaic is not frustrated. . . ."[27]

Archaism as a concept becomes charged with emotion that leads
to the image of a style. Bourdelle sees an archaic world as something
new and youthful. His discovery of it bears directly upon his own
new life, in which the archaic image is taken up not as a past but as
a living present in which the image is not described, not studied, but
lived [41, 62–66].

The art historian in studying a particular influence deals with
similarities and dissimilarities between the source of influence and
the work it has presumably affected. It is difficult for the historian
to go farther unless he investigates the emotional and psychological
value which the source of influence may have had for an artist. To
a considerable extent the artist himself produces this value, not by
imitation or analysis but by the force of a complex aesthetic image
already present to his mind's eye. This image has a poetically creative
value for him that need not always be precisely delineated; it may
hover half-expressed until translated into a form by the imagination.
It is this inward image and not the object known to art history that
matters most to the artist. Strictly speaking, the influence of the
past is no longer the past but a new present. The artist has, as it were,
drawn the past to himself, and it confirms the new image that has
arisen within him. It is not the object itself that is the essence of
the influence but rather this process of renewal and confirmation to
which every true influence gives rise. The object and its echo in the
new work of art can be established and described, but not explained.

Bourdelle's reaction to the criticism of archaism was thus no blind
lyricism; it was a stating of the metamorphosis of a past into a current
creative process, a metamorphosis that was taking place partly in the
poetic image of the archaic world formed by the artist himself. And
this formation was not the product of intellectual study; rather,
it sprang from his own creative and psychological state.

Bourdelle speaks with palpable warmth of "primitive Greece"

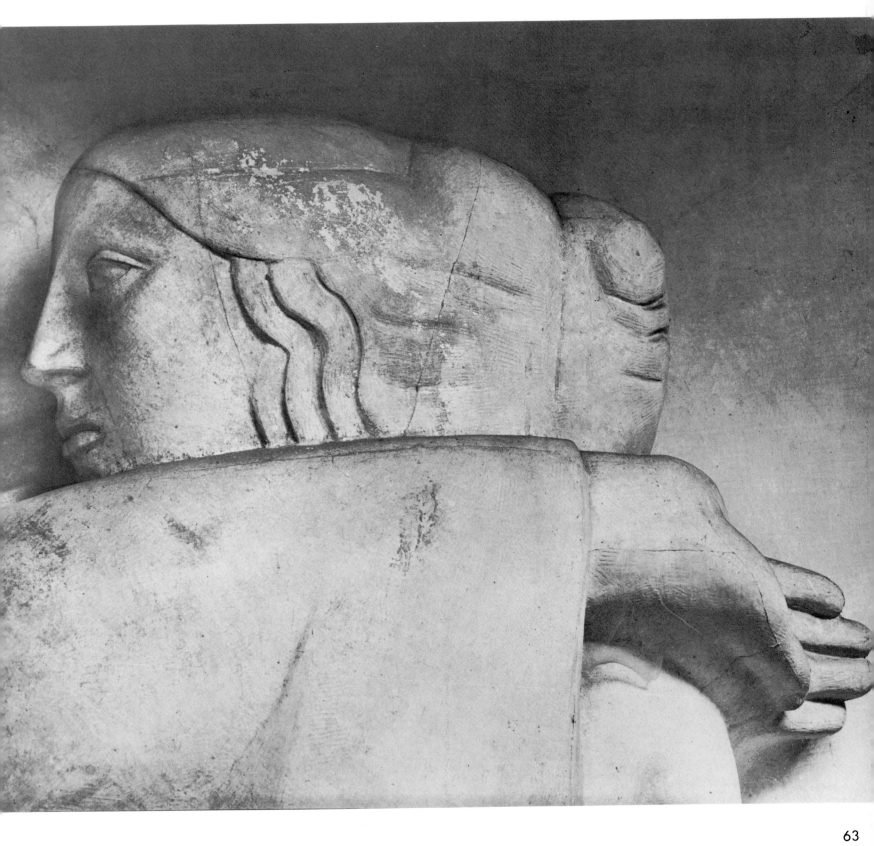

and "the great archaic art."[28] In doing so, he turns against the general adoration of Hellenistic sculpture [1, 13, 14–17], though without really defining what he himself admired. We learn of his own predilections not from his slogan "How new are ancient times" but from his admiration for Phidias and the temple of Olympia [117], which Maillol also loved profoundly. "A Olympie, Peonios et Alcamène sont le cercle et le centre où tous les devenirs naissent à la beauté."[29] In order not to misunderstand the meaning of this deep admiration, we must see it in connection with Bourdelle's conviction that life itself, the reality of his own surroundings, was an inexhaustible source of inspiration.

His critical opponents held that his work [63–66] was based primarily on pre-Periclean sculpture and that it deviated from the academic ideal, which had a rigid Greco-Roman base. They probably also were mindful of his small collection of archaic Greek heads from the sixth and fifth centuries B.C., pieces that he had purchased not for historical reasons or for their value but because he respected and admired them and found in them food for his dream. While Bourdelle was certainly no friend of the official pedagogy, he cared just as little for imitative archaic style. To understand him, one must be aware of his spontaneous southern zest for life and his vision of his surroundings. To his pupils he said: "Your clothing itself, your blouses, your aprons, and your coats often have the softness and sometimes the grandeur of the most beautiful marbles of the present, all the exuberance of the marbles of the past."[30]

He also pondered often on the old French craft of cabinetmaking as his father, from whom he had learned it, had practiced it. Such craftsmen still knew what a tree was and how to get the best wood for carving chests, buffets, and choir stalls. In this knowledge Bourdelle saw the source of what had long been fading in his own time, the lovely unity of everyday life, of the things of that life and the craftsmanship of those who made them. He built a bridge to the youthful spirit of past styles, styles that were a beginning. "We have a kind of honor code of work exactly the same as that which ruled the hand in the medieval court . . . a tradition springing from the deepest depths of the race, a history, an absolute, a code requiring that a chair leg be well made. Each part of the chair that cannot be seen should be made just as perfectly as the parts that can be. This is the ruling principle of the cathedrals."[31]

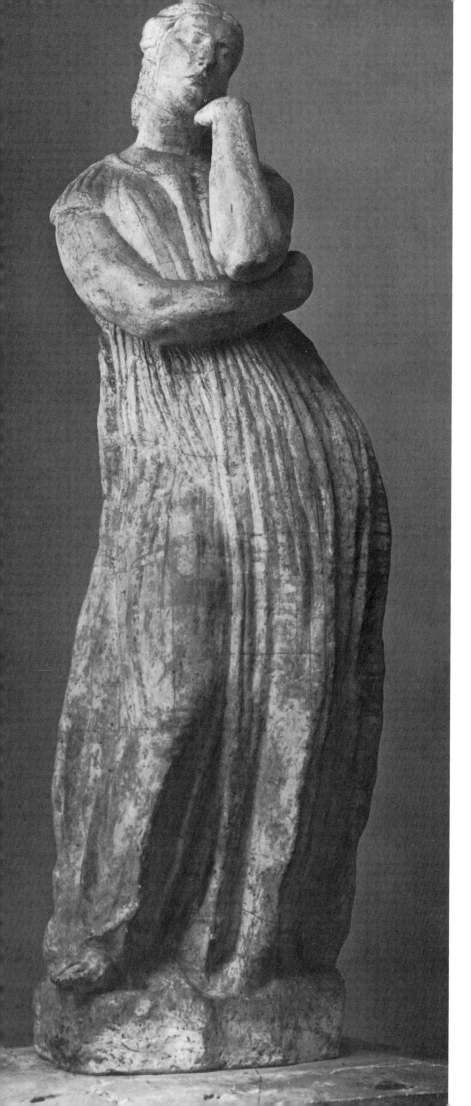

[65] ANTOINE BOURDELLE. *Penelope.* 1907–12. Bronze, height 48″. Musée National d'Art Moderne, Paris. [66] ANTOINE BOURDELLE. *The Wind.* 1906. Bronze, height 9 ½″. Musée Bourdelle, Paris

At the time when Bourdelle was expressing this sentiment, French literary figures were also deploring the disappearance of fine craftsmanship. Reading Bourdelle, one cannot help being reminded of the theme of the nobility of work as it appeared in the poetic writings of Charles Péguy (1873–1914).

Aristide Maillol (1861–1944) was born in the same year as Bourdelle and was his friend. But he turned to sculpture later [40, 67, 68, 118]. As a young painter he had, like Bourdelle, admired the decorative art of Pierre Puvis de Chavannes (1824–98), and early in his career he showed a tendency to approach the ancients in a modern manner.

Maillol had been a sculptor for eight years when, in 1908, he visited Greece with Count Harry von Kessler of Weimar and the Austrian poet and dramatist Hugo von Hofmannsthal. His reaction to the Greeks differed little from Bourdelle's. He too turned away, but violently and with lyrical contempt, from such famous sculptures as the *Hermes* of Praxiteles. To him it was a hack piece made of what looked like laundry soap and polished so highly as to lose all character —hence it was the darling of the public. He preferred the temple of Zeus at Olympia [117], which he considered primitive, to the Parthenon itself [32]. He said of the temple: "It is an art of synthesis, an art superior to the work of the flesh which we moderns seek."[32]

The reactions of the third of these contemporaries, Medardo Rosso (1858–1928), were somewhat different and rather confused. Rosso too really rejected the Renaissance and had an undisguised aversion to Florence. He preferred the Gothic, the Byzantine, the Etruscan. Like Maillol, he castigated the current taste for renowned works of sculpture, which he called paperweights. The Romanesque and the Gothic were far more positive supports for Bourdelle than they were for Rosso, who gave no thought at all to architectonic elements.

In general, these three sculptors display a clear shifting of attention to pre-Renaissance stylistic periods—in the case of Maillol and Bourdelle to the archaic Greek world. This shift meant a growing consciousness of earlier, still constrained forms, which these artists valued above those of the ripe and overripe styles that dominated art and art education after the Romans and the Renaissance. Although somewhat subdued in Bourdelle, the tendency to reject the spirit of the Renaissance is nevertheless present in all three; and in Medardo Rosso it is especially pronounced. It must be pointed out, however,

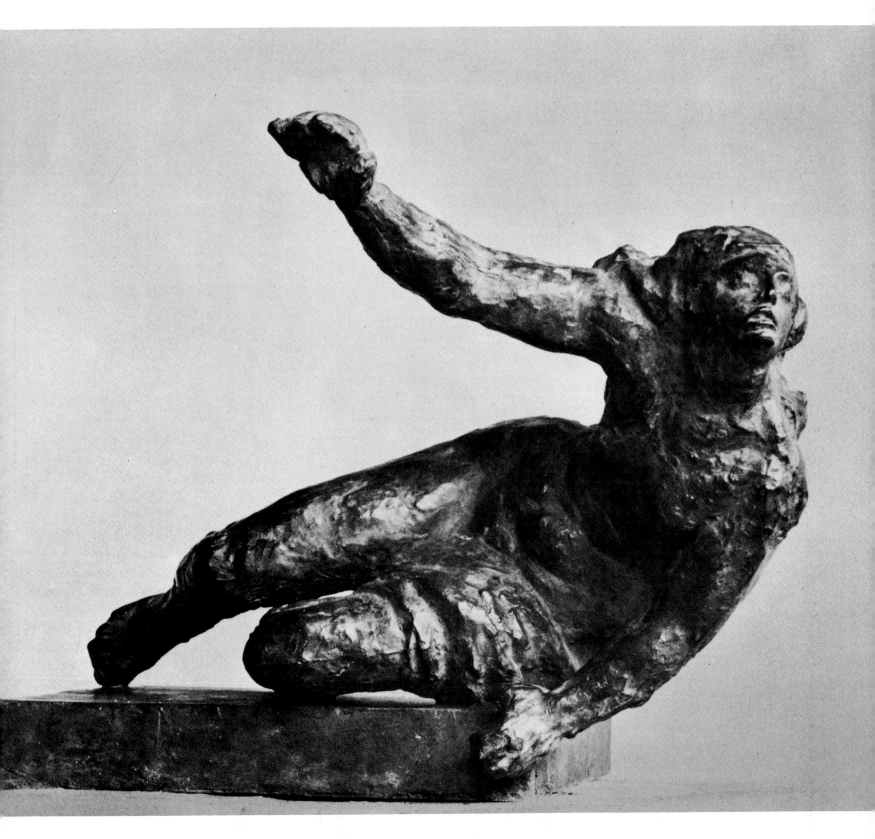

that for them the Renaissance did not include the time of Giotto.

With respect to the world of the older Rodin—and of the Belgian sculptor Constantin Meunier (1831–1905) and the German Adolf Hildebrand (1847–1921)—the shift meant a changing relation to the past. In the case of younger artists like Maillol, it was much less a search for something unknown than for the clarification of knowledge that had grown clouded. The clarification of one's own inner life can also be furthered by rejection, for it often frees one from the authority of established opinions and the pressure of admiration. The shock of the different, felt as a contrast to one's own self, can result in illumination and thus belongs in the category of that much-misused concept, influence. The shock of recognizing the related can likewise lead to a clarification of one's own self.

Bourdelle, Maillol, and Rosso admired Rodin's immense productivity and, at the same time, suffered from it. But their creative drive was differently oriented. In any event, they did not think that the world of the new sculpture began with him. They had already acquired a subtle feeling for space different from Rodin's as well as a different feeling for material and a new conception of the use of light. Of the three, Rosso was the first to be conscious of his own new attitude, and before 1900—between 1884 and 1895—he had left his mark on sculpture [42, 69, 70, 71, 131, 133]. Eighteen years younger than Rodin, he had already expressed himself clearly before the completion of the *Balzac*. Maillol and Bourdelle required a longer incubation period, and they did not attain their full strength until after the turn of the century, when Rodin was at the height of his power and fame. But they had in common with Rosso—who, though only three years their senior, had matured earlier—the changed historical approach, the new affinity, so different from Rodin's attitude toward the classical and the Renaissance.

An Arcadia had been discovered. The academic idea of a polished and ennobled Greco-Roman beauty had lost its hold. In their own way, Romantic sculptors such as François Rude (1784–1855), Antoine-Louis Barye (1796–1875), and Jean-Baptiste Carpeaux (1827–75) had earlier tried to attack the academic views, but they had been penalized when they ventured outside the official frame. In Brussels, Rude had perceived the disastrous influence exerted by the academicism of G. L. Godecharle (1750–1835). Carpeaux in turn mistrusted the cult of the academic and held that real sculpture was being neglected. But neither he nor Rude could lay aside his adoration of

the Renaissance and of Hellenism. Such a renunciation could occur only later. The radiance of the classical world, which had also shone in the Gothic Christian culture of Europe and had attained a new brilliance during the Renaissance, dwindled into twilight in the late nineteenth century. This is clearly apparent in the Symbolists, who were later to hail Nietzsche. Vainly opposing the tide was an attempt to revive, in the liturgical spirit and by the use of mystical Latin, an old world in which classic and Christian values were blended, a trend in which the French poet and critic Remy de Gourmont (1858–1915) participated. "The wreck of the old Holy Roman Empire fading away"[33] was, for many, a painful reality.

At the same time, archaeologists were unearthing treasures from cultures other than the classic. But a barrier seemed to separate these scholars from the artists. The course of nineteenth-century sculpture remained unperturbed; an aesthetic re-evaluation of the ancient cultures was not yet under way, though the Romanticism of the early nineteenth century had held latent promise of this. The interest of Eugène Delacroix (1798–1863) in exotic Africa and the world-wide travels of such artists as the Austrian Thomas Ender (1822–75) had created a certain atmosphere but did not fundamentally change Western European aesthetics.

As we shall see, sculpture was affected to a certain extent by the yearnings of Paul Gauguin (1848–1903) for the aspects of unspoiled primitive life outside Europe. All things considered, however, Gauguin was not able to renew the forms of sculpture. Moreover, his idea of a decline of European culture and his search for a remedy outside Europe were not entirely new. As early as 1858, Delacroix had asserted that civilization was sick and that the refined culture which still clung to the classics but was beginning to disappear under the impact of a new barbarism was heading for disaster. In clear-sighted moments, Delacroix even saw the inevitability of a mystic social revolution in the future. Unlike many contemporaries, he saw more in barbarism than Gauguin later found in Patagonia.

But Gauguin did represent an advance. For him the aesthetic appreciation of certain exotic regions was creatively charged. By emphasizing the exotic motif and dwelling more on content than on form, he called attention to something that sculpture had not known before. To Gauguin, form was a relief translated from the two-dimen-

70

[70] MEDARDO ROSSO. *Paris by Night: Boulevard Impression.* 1895. Plaster, probably lifesize (destroyed during World War I)
[71] MEDARDO ROSSO. *Conversation in the Garden.* 1893. Wax-covered plaster, height 17″. Collection Gianni Mattioli, Milan

sional and linear composition derived from his painting. The fact that he cut directly into wood and modeled ceramics—and did not bother about academic rules—was extraordinary. Yet his work revealed little more than that something was in the wind. Before this "something" could emerge, other changes had to take place in European sculpture. New forms had to break through. The third dimension had to become a new reality, a reality that did not stop halfway, at pictorial or graphic modeling.

Why at a certain point the artistic sensitivity to forms from outside Europe became so much more powerful than before we do not know, but there is an undeniable connection between the flowering of

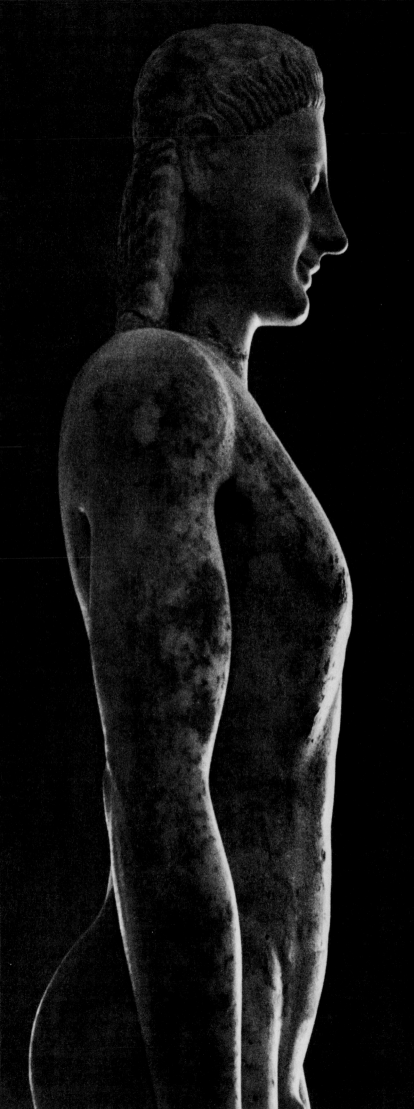

[72] *Kouros*, from the Volomandra Group (detail). 560–550 B.C. Marble. National Archaeological Museum, Athens. [73] *Calf-Bearer* (detail). c. 570 B.C. Marble. Acropolis Museum, Athens

sculpture in the twentieth century and the creative stimulus provided by the aesthetic discovery and new experience of archaeological and ethnographic material. This beginning was still limited and more or less idyllic. Doubt had begun to undermine the conviction that Europe, with its heritage of classical civilization and its Christian view of life, had a central and superior position. Masterpieces by anonymous creators, works that ignored the established classical rules, were being discovered.

When the newly revitalized sculpture stepped out of the shadow of Rodin, it glowed for a time in a kind of Arcadian light. Although with Delacroix, Van Gogh, Gauguin, and Cézanne there may have been a growing presentiment of war and revolution, sculptors now began to give new content to the concept of the archaic. After Rodin's heavy, tormented, exhausted figures, they sought the youthful, the figure still constrained but at the point of release, the figure in the state of becoming. They felt the symbolism of the "archaic smile" and grew aware of what Delacroix had so splendidly called "the eternal youth of the true masterpiece." The process began to define itself. These sculptors did not confine themselves to the archaic Greeks. Other archaisms, other cultures antedating the Greek, exercised their fascinating force. Prehistory began to exert an aesthetic and magical effect. Rodin's hinterland had been formed primarily by the Gothic, with a few later figures from the Renaissance and Baroque schools. His admiration for the Gothic vaguely encompassed the Romanesque, but this earlier age became a prime mover of the imagination only for the next generation. And thus the path led back to prehistory. The hinterland of the new sculpture became infinitely more complex than that of a sculptor like Michelangelo could have been.

[74]

[75]

[76]

[77]

[78]

[79]

3

The Painter-Sculptors:
Their Sources in Archaic
and Primitive Art

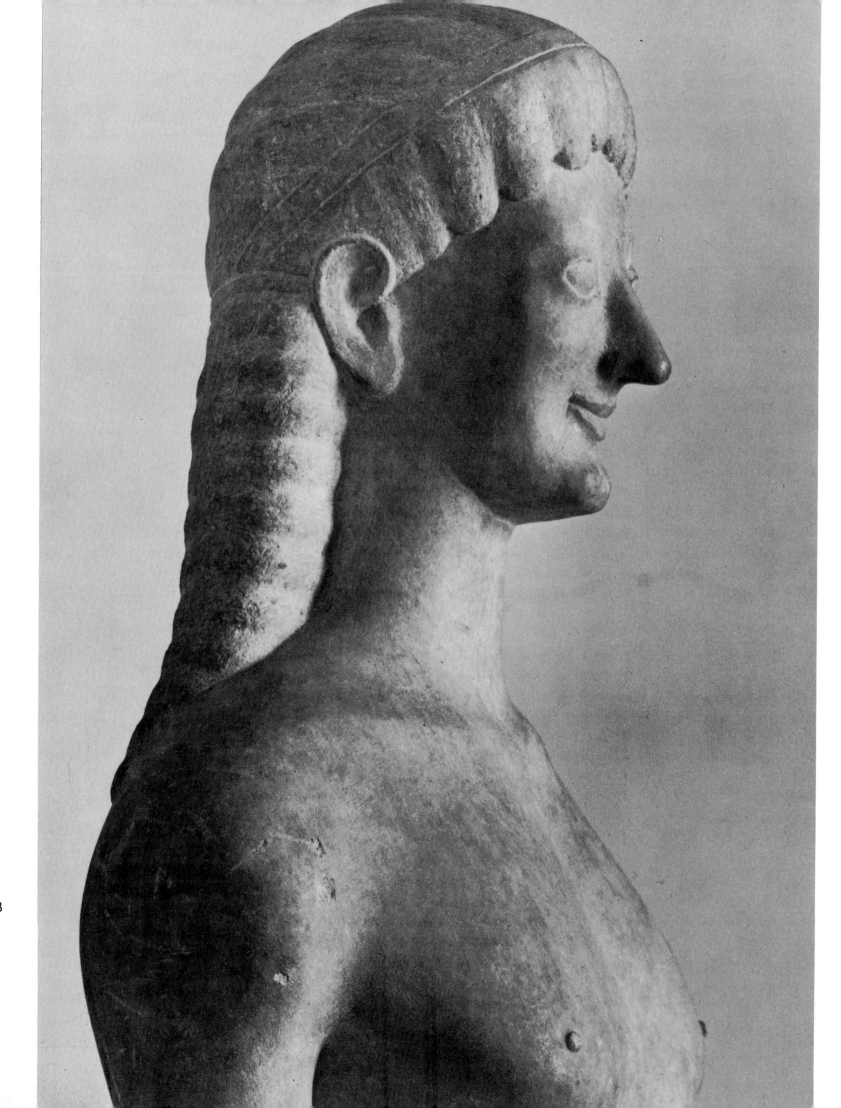

At the beginning of the twentieth century, the unequivocal rejection of classical Greek and Roman art and of the Renaissance and Michelangelo, and the equally unequivocal approach to archaic Greek art, marked the beginning of a new archaism not yet conscious of its own nature. Anyone examining this new archaism as it delved ever deeper into the past, as far as the earliest prehistoric periods [81, 83, 85], may well ask what motivated it. An art was developing that was not bound to any one period or style but assimilated a multitude of historical and stylistic solutions.

As Gisela M. A. Richter points out, in one of the soundest studies of archaic Greek art yet made,[34] the whole archaic Greek world was astir, not only in sculpture but also in literature, philosophy, and

politics. Since her concern is historical, she does not examine the conflict of opinion behind the growing admiration for it, and touches only briefly on the significance of this art for our own time. But she recognizes the new element at work—the acceptance for the first time of an idea—and the fact that European culture was born in this environment. These are among the facts that make an understanding of archaic Greek art a help to the understanding of our own artistic background.

To the Greek avant-garde artist of the seventh century B.C., the great achievement was to shake himself free of a formalistic tradition closely related to the Egyptian. He sought a freer and more natural form, the beginning of movement, a movement aroused, as it were, from a stiffness that had become inviolable law. Insofar as he was not a reactionary, the archaic Greek discovered a new territory, an anatomy, that revealed the human body as an organic, vital unity with dynamic possibilities. No longer was it simply a whole made up of parts existing only in abstract, numerical relation to one another.

Archaic Greek sculpture is attractive in its evolution precisely because it stands at the threshold of that new territory. It has not yet entered. It is young, it is really new; it gave birth to the cryptic archaic smile, which has never been satisfactorily explained but which seems to express a view of the world at once delighted and apprehensive. Until naturalism took over, the power of an idea, of a perfect form, of a radiant beauty remained predominant. With a tension that

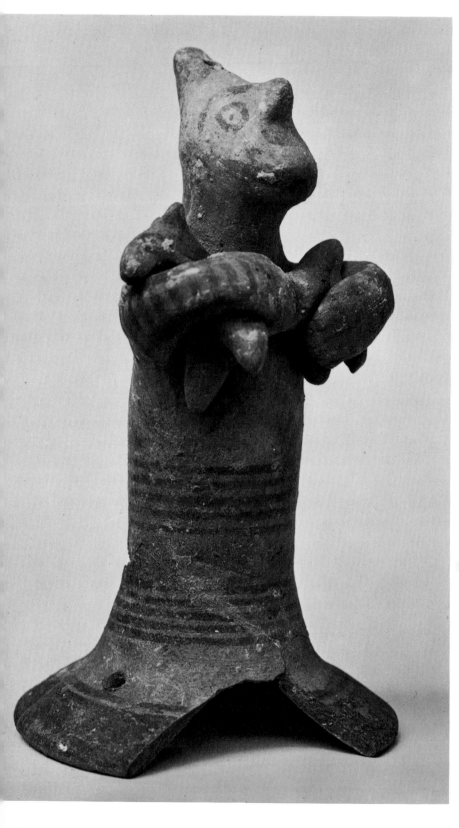

[81] *Votary Presenting a Kid,* from Cyprus. c. 1200 B.C. or earlier. Terra cotta, height 6 5/16". Metropolitan Museum of Art, New York (Cesnola Collection). [82] *Figure,* found in Lake Sentani, New Guinea, 1929. Wood, height 46". Private collection, Paris. [83] *Venus of Lespugue* (from Haute-Garonne, France). Aurignacian, c. 20,000–15,000 B.C. Ivory, height 5 3/4". Musée de l'Homme, Paris

is not yet movement but movement *in posse,* the young figures of archaic Greek sculpture stand at a point between the sensual world and the abstract idea [80]. The impulse to develop this movement, to win release from old formulas, could not be checked, but it was still curbed by lack of experience and technique.

To a certain degree, such artists as Maillol and Bourdelle were able to maintain a harmonious relation with archaic Greek culture. Succeeding generations, however, showed no tendency to identify themselves with or to strive toward the idea that gave archaic Greek art its power and tension. Indeed, there were indications of an opposite trend. The young artists of the twentieth century were little concerned with the development of classical form latent in its archaic beginnings: their reaction to the archaic world was creative, not historical. Indeed, they turned deliberately away from the art that emerged from archaism. Without yet realizing the consequences of this attitude, the new avant-garde was clearly not seeking the cradle of European sculpture in the archaic Greek. It was after something altogether different, something that veered off in other directions toward an unknown world. No one knew what was to grow out of its pursuits. What did powerfully attract these younger artists was the element of the new, the young—the shaking off of the old—that gave archaic Greek sculpture its tension. When Guillaume Apollinaire, in his critical defense of early Cubism, proclaimed "the new" to be fundamental, this element threatened to deteriorate into dogma, to become a goal rather than a consequence. But before "the new" was thus consecrated, it had been perceived and experienced through the archaic world.

The pre-Cubist artists looked for inspiration not to the historical evolution of an anatomically natural figuration but to the greatness and unity of a style based, they thought, more on collectivity than on individualization, on objective rather than subjective representation. These twentieth-century artists derived a kind of bastard archaism from archaic Greek sculpture, defying—or at least deviating from—the findings of art history, for scholarly investigation has established that the Greek avant-garde of the seventh century B.C. was activated by its discovery of nature. Yet the concept of nature that gave

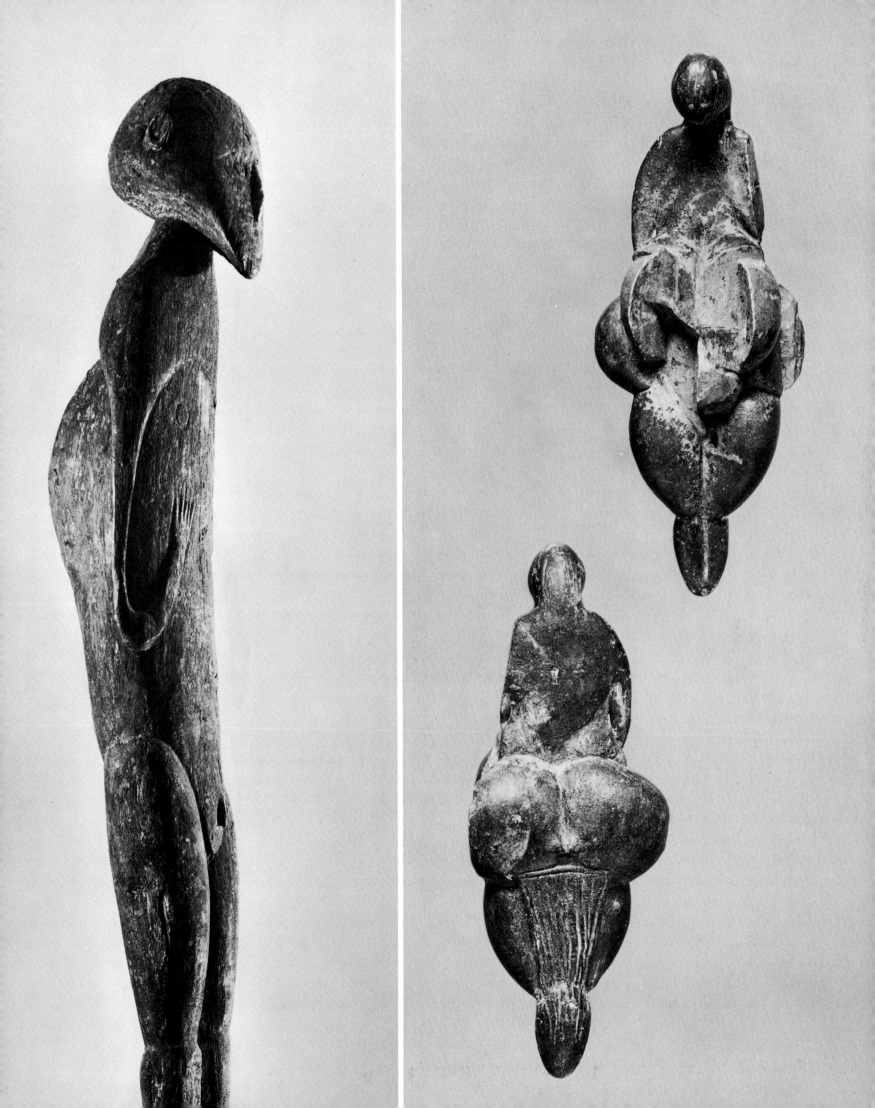

content to art as it evolved from archaic Greece to Renaissance Europe is quite different from "nature" as perceived by the twentieth century. Thus there can be no question of the latter-day artists attempting to imitate, or even consciously to interpret, archaic styles; what they did was to recognize the aesthetic possibilities that these forms revealed, possibilities that had remained undiscovered because of the complete hegemony of classical and Hellenistic art.

The generations coming after them went farther in this direction, their development aided by the great advances in archaeology and ethnology. The knowledge gained from excavations and expeditions opened new vistas for sculpture. Nearly all the new discoveries appealed to the artists—prehistoric "Venus" statuettes [83], Cycladic figures [85, 111, 141, 142], the neolithic worked stone of the dolmens [52] and menhirs [145], art from ancient China, Peru, Mexico [244, 404], Egypt, Mesopotamia. The generations following Rodin had at last found the key to the pre-Greek world. There were no more boundaries.

Among the new sculptors the archaic is encountered in all kinds of forms and treatments. As often happens, the excitement was twofold: a genuine attraction to prehistoric and primitive art, and a last rebellion against academic rules and rationalism. The aesthetically sensitive person intuitively sought new territory in a non-European antiquity, for he was not yet able to express clearly whatever was new in his own time. The discovery of archaic forms was not immediately accompanied by a revelation of archaic content. Everyone interpreted the meaning of the forms in his own way. Yet, aesthetic archaism did have a psychological effect, which was primarily a release from traditional concepts—from the weight of the Renaissance on one man, of Hellenism on another, of a vague academicism on a third. In 1902, Paul Klee (1879–1940) wrote vividly about this in his diary.[35] He yearned to be reborn into an existence in which he would know nothing of Europe. He wished to escape the European sense of overriding superiority in all things spiritual and artistic. This impulse toward oblivion and a new awakening was a sort of seeking for catharsis.

Aesthetic archaism helped many artists to recall anew the memory of a remote past, a past that seemed innately familiar and secure. It was indeed like recognizing the anonymous youth of creative humanity, to which creative artists felt they belonged. In this aesthetic and psychological development, the art of sub-Saharan Africa played a separate role, one differing from that of archaic Greece. The early Greeks were discovered by artists dedicated solely to sculpture. (It matters little that Maillol, like so many others, began as a painter;

after 1900 his life was anchored in sculpture. And it was he, with Bourdelle, who began to look beyond Hellenism, the Romans, the Renaissance, and the Baroque.) The wood sculpture of Africa and the South Pacific [74, 75], on the other hand, was discovered for the most part by painters—a few nineteenth-century painters who remained painters and turned only incidentally, for longer or shorter periods, to sculpture. That painters felt the need to express themselves three-dimensionally was a phenomenon of the time, a prelude to the twentieth century.

Théodore Géricault (1791–1824) was one of the earliest to develop a sculptural power matching the passionate greatness of style that Stendhal had prophesied for the nineteenth century. Little is known of Géricault's sculptural ideas, and he died too young to have had much influence or to have left a large body of work. Yet what little he left has an unmistakable Rodin-like quality completely free of the classical and antique world [86]. It was the Romantics who continued his revitalizing of sculpture. With ever greater insistence and for varied reasons, painters sought three-dimensional expression. Although their efforts did not further sculpture technically, the boldness of their attempts did bring movement into a strongly academic, indeed often static field.

We know what Honoré Daumier (1808–79) did in sculpture. Let us not exaggerate his achievement; it was the result of his need for concrete visual support for his paintings and caricatures. His reliefs [87] are more pictorial than sculptural, and the deformations of the heads that he modeled for his work as a satirical caricaturist were not form-renewing. His plastic work was clearly in the service of his drawing and painting.

We also know the achievements of Edgar Degas (1834–1917). He too expanded the motifs of his drawing and painting into the third dimension. Deliberately rejecting technical assistance and academic instruction, he stubbornly tried to develop his own technique. And he had his failures. After the poor reception of the *Fourteen-year-old Dancer* in 1881, he concealed but did not abandon his sculptural activities, as has been noted. We are now aware that his statuettes of nudes attained a quality rivaling Rodin's in their rich variety of pose and gesture [88, 89]. His work was not Impressionistic; it had structure. It fixed positions, not movements—or, to put it otherwise, it made choices among movements. Everything Degas did was freer and livelier than the pieces turned out by the academies. Yet even he continued to work in the spirit of the Renaissance.

Nor was the painter Auguste Renoir (1841–1919) able to play an innovating role as a sculptor. Unlike Degas, he was willing to accept

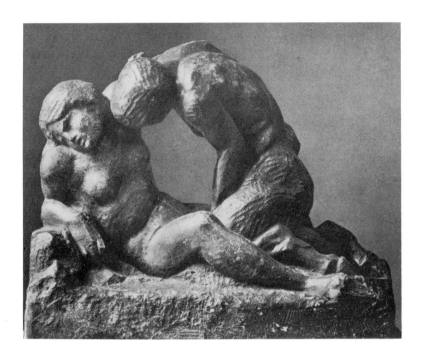

assistance, that of an academically trained Italian helper, and this influence shows in his work. His sculptures do carry on a tradition impressively, but they are not revitalizing. They duplicate his paintings in three dimensions, giving substance to the lovely femininity typical of nineteenth-century France. These figures are warm and radiant with a natural sensuality, ripe but not overblown. Behind Renoir's women are the Dianas of the School of Fontainebleau, the figures of Jean de Coisevox and Jean Goujon.

Of the late-nineteenth-century painters, Paul Gauguin (1848–1903) was the first to be daring and independent enough not only to see the exceptional qualities of non-European wood sculpture but also to find it a new source of inspiration. As in the case of Daumier, we should not exaggerate. Gauguin's efforts in sculpture (mostly about 1889–90) never really went beyond the bounds of his painting but were an extension of it, primarily in relief [91]; they were stylizations, three-quarters Gauguin and one-quarter imitative forms derived from Tahitian models. (A refined marble bust of his wife, Mette Sophie, that he had made in 1877, a charming work deviating in no way from tradition, remained an exception in his oeuvre.) New ideas came to him only after he encountered the things that were being made in Tahiti and, before that, the native religious folk sculpture of Brittany, where the Pont-Aven group became interested in polychrome wood reliefs. Emile Bernard (1868–1941), for example, made decorative panels from 1888 on. Gauguin himself symbolically recorded his affinity with the primitive Breton wood carvers by inserting a portrait of the Dutch Pont-Aven painter Meyer de Haan

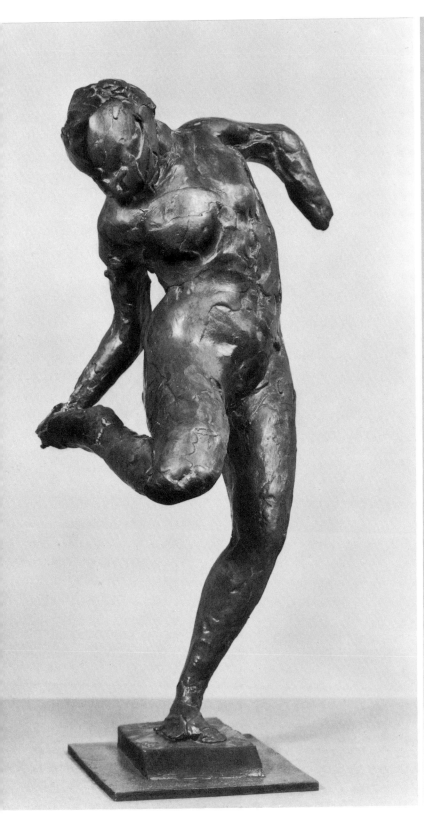
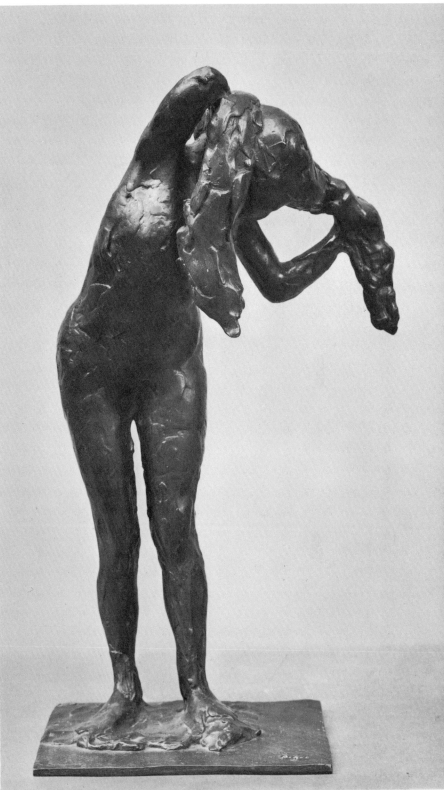

85

[90] PAUL GAUGUIN. *Double Vessel.* c. 1886. Ceramic, height 6″. Collection Poul Lunøe, Copenhagen. [91] PAUL GAUGUIN. *Idol with Pearl* (rear view). 1895–98. Bronze, height 9½″. Courtesy Marlborough-Gerson Gallery, New York. [92] ERNST LUDWIG KIRCHNER. *Standing Nude* (detail). 1908–12. Yellow painted wood. Stedelijk Museum, Amsterdam

in one of his reliefs, giving him a Verlaine-like expression. Ceramics also interested Gauguin [90], as they did the Belgian Divisionist painter Alfred William Finch (1854–1930), who attempted to achieve Pointillist effects in pottery.

Around 1890 there was a general tendency to translate problems of painting to other techniques, indicating a need to work in three dimensions. At the same time, Gauguin aroused in sculptors a great nostalgia for primitive art—primitive by no means technically, but only in contrast with the classical standards of European academies. His was the first effort to bring a foreign element into European sculpture.

In the twentieth century it was again the painters rather than the sculptors who led the way. This time the focus was not archaic Greek sculptures in stone but the wood carvings of non-European peoples [74, 75, 82, 94]. In 1904, Ernst Kirchner (1880–1938), Emil Nolde (1867–1956), Karl Schmidt-Rottluff (born 1884), and Erich Heckel (born 1883) in Germany, and, in 1906, Picasso and Matisse in France found fresh stimulus in African and South Pacific sculpture. Such artists as Jacob Epstein, Maurice de Vlaminck (1876–1958), and André Derain (1880–1954) quickly followed this lead; moreover, they assembled magnificent collections.

What attracted artists to this art? In the first place, it was probably the wood, which was more congenial to them than the stone of the Greeks. They liked wood, polychromed or plain, with a high patina. Secondly, it was the forms, which bore evidence of a technique abandoned by the academies, the *taille directe* (direct carving), and which, in addition, were not limited to the basic cylinder of archaic Greek sculpture but embraced the cube and the sphere, with roundings and hollowings.

That painters were particularly sensitive to these basic forms does not seem so strange if one thinks of the influence of Cézanne (1839–1906), not only on the Cubists but also on other artists, and of the remarks that Emile Bernard elicited from him. Cézanne prepared the way for the greatest of his successors, enabling them to discover a language of form—as Kirchner, Matisse, and Picasso proceeded to do—by approaching African and South Sea sculpture both aesthet-

kind of intermediate solution to a problem they were unable to work out independently. In so doing, Kirchner [92] and Schmidt-Rottluff [93] performed a great service: they showed how to evoke another world. So far as sculpture was concerned, however, their solution meant no more than breaking with one tradition and accepting another. The great tradition they sought to adopt was too alien, and their own Expressionism too subjective, for the attempt to succeed. In their superficial approach to African art they proved themselves primarily painters and not sculptors. It was not enough merely to imitate forms that had arisen in social climates and out of intentions remote from those of twentieth-century Europe.

Of the German Expressionists, Emil Nolde (1867–1956) was best qualified to speak of primitive art, having had personal experience of it. In 1913–14 he served as ethnographic draftsman on a Colonial Service expedition to the German South Pacific possessions. For years before this he had spent much time sketching in ethnological museums. He knew little about the objects he drew but understood intuitively that this "art of the people of nature," as he called it, grew out of a world totally different from classically oriented Europe. The sharply defined standards of the academies simply allowed no place for this art. Nolde did not agree; he felt that concern with these objects should not be confined to scholarship and science, and as early as 1912 he urged that they be placed in museums of art. He became aware of the element of magic in primitive art when a Papuan in German New Guinea whose portrait he had drawn attempted to kill him, but this incident did not make him feel that the native culture was inferior to that of Europe. What he deplored was the tendency of the whites to open the region to trade without making any attempt to understand the harmonious and beautiful values they might thereby destroy. Basically, however, Nolde's journey served merely to strengthen his own Teutonic self-consciousness. Native art, he observed, was "unreal, rhythmic, ornamental, as is the primitive art of all races— including that of the Germanic peoples in their infancy." Of the pieces he himself carved in wood, he wrote: "The material my hand created there on the islands and among the aborigines remains wholly North German in feeling and representation; it is like old German sculpture—just as I am myself."[36] Nolde was also impatient with the members of the Brücke group, who wished to be more exotic than the exotics. He was clearly in tune with archaism and wary of

ically and creatively. In this connection, Werner Hofmann has pointed out the Expressionists' predilection for woodcuts, from which they progressed easily to wood sculpture. This scholarly explanation does not invalidate the fact that, through Cézanne and the pre-Cubists, many other artists were strongly attracted to African forms. Actually the African and South Sea influences in sculpture, which were introduced mainly by painters, branched off in two directions.

The painters of the German Expressionist group known as Die Brücke (active 1905–13) found the most direct—and naïve—way of emphasizing their desire to be vehemently expressive: they took over African art not literally but so recognizably that it provided a

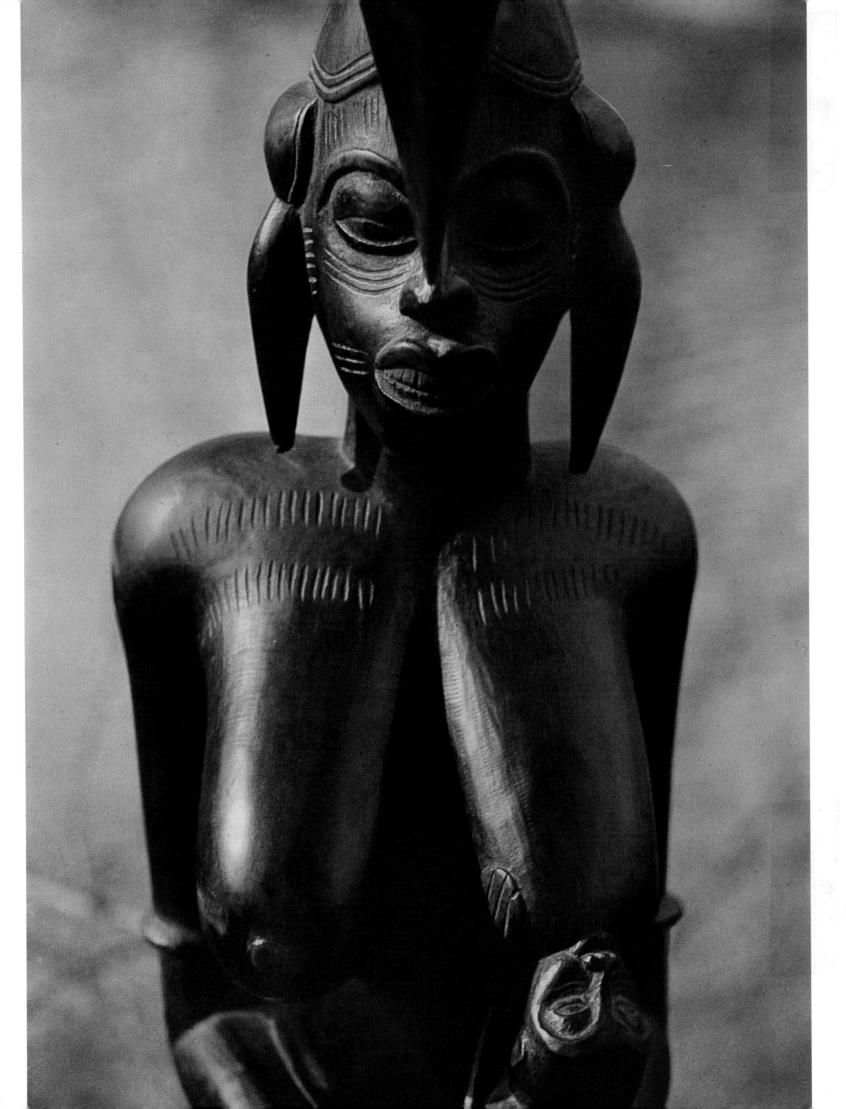

90

imitation, but he did not go deeply into the true character of South Sea art. The German writer Carl Einstein deserves credit for being the first to examine critically the remarkable differences between European and primitive sculpture. In his *Afrikanische Plastik* of 1915, he drew attention to and criticized the African elements in the work of Die Brücke. We know now that his judgment was correct, for these Expressionist sculptures were a phenomenon of the time, a side street leading to a dead end.

In a certain sense, the same is true of the work of Jacob Epstein (1880–1959), who was born in New York of Russian Polish parents and migrated to London by way of Paris. In the French capital he had begun to assemble a modest collection of Greek and exotic sculpture, which he greatly enlarged subsequently in London. His collection, chosen in accordance with the canons of his own discriminating taste, bears witness to the discovery by important early-twentieth-century sculptors of the great artistic merit of objects until then considered to be of only archaeological or ethnological interest. Epstein knew Brancusi and Modigliani in Paris, and for a short time his own work displayed influences of African plastic art, which was no more native to him than to the German Expressionists.

Avant-garde critics currently tend to minimize Epstein's importance, but we must be cautious in passing judgment. His nature was such that he scorned the problems that the new sculpture, having abandoned academic standards, was trying to solve, though in his younger years he had himself wrestled earnestly with the same problems and had turned out a few remarkable sculptures [152, 158, 159]. Moreover, all his life he lovingly continued to build his collection, not as a curiosity or a private museum but as something essential to his warm, open, creative spirit. His collection, and his early work, must be taken into account in any consideration of his artistic personality as a whole, whatever assessment is made of the sculptures (mainly portraits) later produced according to the "Epstein formula."

The forms that Epstein created do not at all imply a rejection of other possibilities. His sculptures consist mainly of portraits [77, 95, 96] and a few figure groups of dramatic expressiveness. He roughened the surface and heightened the effects of light and dark, thus producing sharper contrasts, which sometimes gave his work great style. Archaism disappeared completely; his forms took on a pictorial quality which became typical of his work.

In France, as has been noted, the influence of African and other exotic plastic art is immediately apparent in the sculptural enterprises of two painters, Matisse and Picasso. Other painters also took to sculpture, with varying if limited results. Vlaminck went only as far as collecting. In 1907, Derain produced a squatting, blocklike figure which showed that he understood the principle of simplification of form in stone, a problem that Brancusi struggled with from 1907 on. But Derain developed the idea no farther: the figure remained one of the rare sculptural products of this period by a painter interested in plastic problems. Excited by non-European sculpture, he remained an experimenter, a perfect example of the painter seeking genuine and vital contact with the three-dimensional world.

Artists who could not give themselves wholeheartedly to this world continued to experiment in a limited way. Among them was Amedeo Modigliani (1884–1920). In 1909 he spent a great deal of time with Brancusi, for he too felt the need to express himself in sculpture, and no doubt Brancusi taught him many things. By this time Brancusi was completely himself, that is, free from Rodin's ideas;

[97] AMEDEO MODIGLIANI. *Head for a Doorpost Decoration.* 1913. Stone, height 24". Victoria and Albert Museum, London
[98] PABLO PICASSO. *The Absinthe Glass.* 1914. Painted bronze, height 8⅝". Courtesy Marlborough-Gerson Gallery, New York

to some extent he had even overcome his own archaistic stylization [143]. Modigliani probably drew on three sculptural sources: African masks; archaic stone sculpture, including some heads from the Khmer culture of Cambodia; and, above all, the work of Brancusi, as is shown by the stone heads of 1907–8, a later head with a lock of hair on the forehead, and the *Sleeping Muse* of 1909 [135]. Modigliani also knew Lipchitz and Picasso well. He was thus surrounded by highly cultivated and creative personalities. Yet, for his borrowings, he turned unhesitatingly to Brancusi. As can be seen from his paintings, this was hardly a choice at all; rather it was a compulsion that sprang from his innate desire to create a type of placid feminine beauty. His drawings (of which Epstein owned several fine examples dating from the time of Modigliani's close association with Brancusi in Paris) have such strong Brancusi-like linear qualities that they justify the question as to whether the renowned melodic line and stylization of his paintings represent a reworking of his sculptures or vice versa. In any event, Modigliani's work in the two media can no longer be considered independently, for there was certainly an interaction.

Modigliani's sculptural production between 1909 and 1912 is unique in its power. Despite his closeness to Brancusi, a far more important sculptor, Modigliani found his own form. In the vertical heads, with their long, sharp nose lines and precise little mouths, and in the carefully preserved character of the stone, he attained a quiet, refined beauty turned in upon itself [79, 97]. His work actually has little to do with the problems Brancusi solved almost completely in his inclined, egg-shaped heads [135].

It is in the work of the two painters who consistently returned to sculpture, for shorter or longer periods—Matisse and Picasso—that the second direction in which the effects of African and South Sea art operated can be traced. In the first place, both Matisse and Picasso understood better than the painter-sculptors of the Brücke group that foreign elements could not be translated literally into European sculpture. Such a solution betokened no renewal: its results might have historical interest but as art objects they would inevitably be of lesser quality than the originals.

Neither the art of Henri Matisse (1869–1954) nor that of Pablo Picasso (born 1881) can be compartmentalized as painting on the one

[99] HENRI MATISSE. *La Serpentine*. 1909. Bronze, height 22 ¼".
Museum of Modern Art, New York (Gift, Abby Aldrich Rockefeller)
[100] HENRI MATISSE. *Tiari*. 1930. Bronze, height 8". Museum of
Modern Art, New York (A. Conger Goodyear Fund)

hand and sculpture on the other. It is understandable, however, that
this division should frequently be made. Until recently Picasso had
consistently opposed exhibitions exclusively devoted to his sculp-
ture; the public has had to be satisfied with viewing individual pieces
in museums or collections. This is not true of Matisse, to whose
plastic work a number of exhibitions have been devoted.

The two artists approached sculpture initially in different ways.
Matisse clearly wished to follow the nonexperimental system tradi-
tional in France. He greatly admired the work of Antoine-Louis
Barye, the sculptor of animals at rest and in motion and a master of
structure and musculature, and he did not escape Rodin's influence,
for he took lessons at the studio of the Ecole de la Ville de Paris under
the celebrated master Bourdelle. Matisse was thirty-one before he
undertook sculpture. He chose to become a modeler and to cast in
bronze for his final result.

Picasso's biographers mention no teachers of sculpture. The artist
apparently required no instruction until he turned to metal sculpture
in 1929. From then until 1932 he received technical assistance from
his friend and fellow Spaniard, Julio Gonzalez (1876–1942). He learned
to model and had his work cast in bronze. Much earlier, in 1914, he
had decided to have the wax model of *The Absinthe Glass* [98] cast in
bronze, even though, at the time, he was also using other materials in
working out ideas derived from the assembling of collages. Except
for a number of sculptures in metal and wood, Picasso has remained
primarily a modeler. In form and material, however, his production
[76, 105–109] is more varied than that of Matisse.

In the case of both painters it is important to trace the frequency
with which periods of producing sculpture interrupt their painting.
For neither of them did sculpture ever replace painting. Artists
completely devoted to sculpture—Zadkine, Lipchitz, Brancusi,
Moore, Hepworth, for example—have probed its depths and re-
sponded to its imperatives. Not so Matisse and Picasso, for whom
painting was the dominant art; it was the interaction of the two-
and the three-dimensional that formed the basis of their achieve-
ments in sculpture.

Georges Braque (1882–1963) too—even more than Matisse and
Picasso—remained anchored in painting, deserting it only incidentally
for experiments in sculpture. He made his first such experiment at

the fairly advanced age of thirty-eight. From the point of view of the history of sculpture, that work and his more frequent works after 1939 contributed nothing essential to spatial art. His sculptures are predominantly reliefs with archaic tendencies. As in his finest paintings, the most important aesthetic qualities are the linear definition and the surface quality; the spatial expression is less distinguished.

Among the painters, Matisse and Picasso seem to be the only ones who concerned themselves with the contemporary problems of space: both were dissatisfied with the flat surface. Matisse began with standing bronzes not unlike those of Rodin. But even then he permitted himself expressive liberties with the proportions of the human body. As in his drawings and paintings, he strove for a totality of the figure by accentuating the linear qualities at the expense of volume. To achieve this spatially, he weakened the anatomical foundation, making the structure of secondary importance and permitting an undulating, continuous line to determine the silhouette and the volume. The surface is broken into a number of planes, here and there rounded and hollowed. A torso that Matisse made in 1906 is still somewhat cramped because of the elimination of accents, but it shows signs of a new mannerism; in the well-known *La Serpentine* of 1909 [99], that mannerism has reached maturity. It is not related to Fauvism in painting, as has been suggested. Strictly speaking, there was nothing spatial about Fauvism; it rejected chiaroscuro effects and was based on a simplification of color. In the *Serpentine* Matisse developed a spatial arabesque based on a play of light and shade with a lyrical lineation. This was a kind of prelude to the effects that appeared in his post-Fauvist drawings and paintings. In Matisse's case sculpture was not an expansion of what he had achieved in painting by 1905 but an intermezzo, after Fauvism, that helped him to advance in his drawing and painting. He was not directly influenced by African art, although he admired it greatly; indirectly, his observation of the non-European anatomical liberties taken in Negro sculpture may have encouraged him to seek freer ideas.

Matisse's series *Head of Jeanette I, II, III* (1910–13) and the *Head of Marguerite* (1915) indicate that not whole figures (the *Serpentine* was important but not yet worked through) nor torsos but heads (the heritage of nineteenth-century portrait sculpture) were problems of prime importance to the painter-sculptors and sculptors. Heads

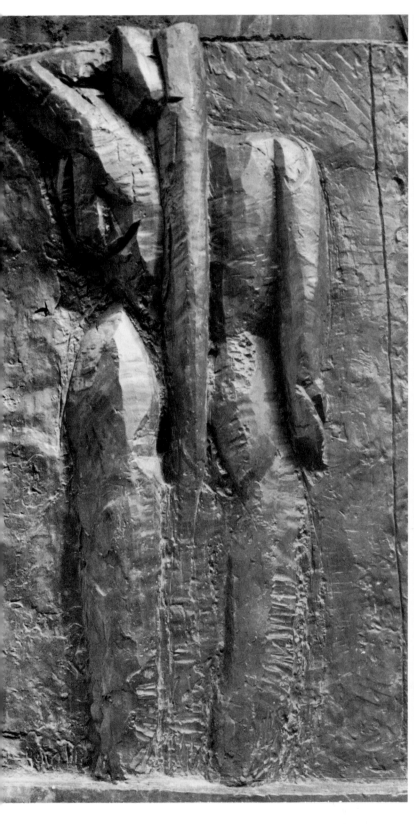

were indeed the starting point for their experiments in three-dimensionalism: Picasso's heads (the *Self-Portrait* of 1906, *Harlequin* of 1905, and *Woman's Head* of 1909 [108]); Brancusi's inclined heads, from 1907 on; Modigliani's series of 1910; Boccioni's *Antigrazioso* (*The Artist's Mother*) of 1911; Duchamp-Villon's *Baudelaire* of 1911 [121]; Freundlich's series of 1910–12.

In Matisse's *Head of Jeanette* series there is a definite shift from portrait sculpture to the new theories of form. He went far in overemphasizing certain parts of the face, especially the nose, eyes, eye sockets, cheeks, and forehead, but left the structure of the bust unchanged. The faces remain expressive; unlike Daumier's faces, they do not become caricatures. One knows that the spatial quality, always with a pictorial effect, is in command here. Linked in a plastic unity, the nose and forehead compellingly dominate the face, giving sexual force to the whole sculpture. This characteristic feature may have derived from non-European models. When, in the 1930's, Picasso created similar heads, with greater simplicity, smoother surfaces, and fewer pictorial details, he may have had in mind, consciously or unconsciously, these heads that Matisse made twenty years earlier.

Duchamp-Villon is not to be included in this company because there is nothing pictorial in his handling of surfaces. His structure is strictly organic, his form controlled and monumental, without distortion. The 1911 head of Baudelaire [121], for instance, is a demonic mask of great power. The high tension of the volume recalls the best African heads (of the Fang, for example).

Matisse remained sensitive to non-European sculpture all his life, and perhaps his sojourn in the Pacific islands in 1930 had an influence on his sculpture. His plastic work until 1911 [104] cannot be considered apart from his painting. The exhibition of his sculpture and painting held at the Museum of Modern Art in New York in 1961 clearly raised the problem of their reciprocal influence.

Picasso's sculpture up to 1914 can be separated just as little from his Cubist painting. What he did after Cubism—around 1928—will be discussed later. His work was more varied than that of Matisse. Yet in the period up to 1914 Matisse definitely went farther in dealing with space. The painter in Picasso was dominant, at the time, in his sculpture as well as his other works. Although hints of space appear in his paintings and gouaches, the resolution is always pictorial. It has been observed more than once that the surface analysis of his modeled *Woman's Head* (1909) introduced the Cubist pictorial formula into sculpture; yet, literally and figuratively, the work remains a surface experiment [108].

Picasso is known to have been inspired by Iberian sculpture of the fourth to the second century B.C. and to have been drawn to African sculpture by Matisse. He has never admitted his relation to African art in so many words, although virtually all art historians set out by establishing this relation as exemplified by the painting *Les Demoiselles d'Avignon* of 1906–7. The abrupt change of style in *Les Demoiselles* is attributed by John Golding[37] to Picasso's contact, via Matisse, with African Negro art. It matters little that Picasso himself says that he first saw African art at the Trocadéro in Paris, *after* he had painted *Les Demoiselles*.

Picasso cannot be called a great collector, for he has always assembled the green with the ripe. He owned some Iberian sculptures for a while—long enough for non-European art to become a source of inspiration for him. Like Nolde in Germany, he discovered in primitive art not merely new sculptural possibilities but also a whole new world that evoked in him a nostalgia for a better society. This art stimulated his Cubist ideas in painting [84], but which works influenced him most no one can say. In any event, the latent and early Cubist recognized something of himself in African and South Pacific works, and the experience had a profound psychological effect upon him and led to a change in the form of his art. From then on, the most important young artists laid aside their superiority complexes with respect to non-European cultures, and Europe adjusted itself artistically to a wider context.

[105] PABLO PICASSO. *Figure.* 1931. Bronze, height 16½″
[106] PABLO PICASSO. *Mask.* 1901. Bronze, height 7¾″. Marlborough-
Gerson Gallery, New York. [107] PABLO PICASSO. *Goat Skull and Bottle.*
1951–52. Painted bronze, 31×37⅝×21½″. Museum of Modern
Art, New York (Mrs. Simon Guggenheim Fund)

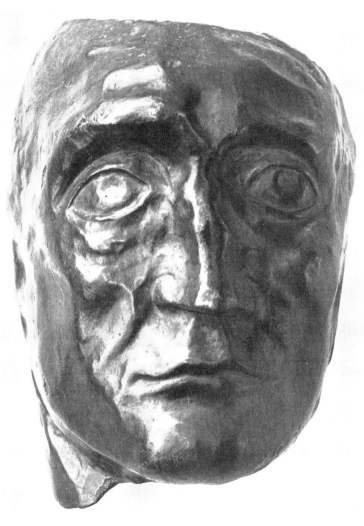

It is easy to find traces of inspired observation of primitive art in Picasso's early Cubist paintings after *Les Demoiselles d'Avignon*; it is difficult, however, to find similar traces in his sculpture of the same period. Certain effects in his sculpture did derive from his paintings and deserve consideration. As sculptor, Picasso limited himself originally to portrait heads. All his modeled heads were essentially portraits, just as the Cubistically analyzed *Ambroise Vollard* (1909–10) was in reality a painted portrait. Primitive masks make clear that portraiture puts a brake on form, but it did not put a brake on Cubist stylization of the surface. Picasso began more consciously to utilize the play of light and shade by enlivening his surface modeling in a manner much like Rodin's. He also attempted to transfer to modeling the things he had learned in his pictorial experiments. He succeeded only in part. In his paintings, there was indeed tension in the space around the object, a tension resulting from the projection of various points of view. In his sculpture, however, he was unable to carry this principle through. He could only compel the spectator to move around the statue, and that was nothing new. Boccioni's Futurist principle, which sought a synthesis of movements, an interpenetration of planes, and a continuation of the object in space, did not appear

[108] PABLO PICASSO. *Woman's Head*. 1909. Bronze, height 16¼". Museum of Modern Art, New York. [109] PABLO PICASSO. *Baboon and Young*. 1951. Bronze, height 21". Museum of Modern Art, New York (Mrs. Simon Guggenheim Fund)

in Picasso's Cubist heads until 1910. (The first Futurist exhibition in Paris was held in 1909.) In other words, Picasso carried the Cubist principle farther in his painting than in his sculpture.

For the surface of his sculpture, he took over an external aspect of pictorial Cubism. He thus raised the question of what sculpture could do with the Cubism of painting. He raised the question, but he did not answer it consistently. Picasso continued to have an instinctive respect for structure. This respect is most evident later, when, freed to a certain extent from theoretical considerations, he made such typical sculptures as the various versions of *The Goat* and *Man with Sheep*.

The dissatisfaction with the flat surface that moved Matisse and Picasso was also felt by Braque and by Juan Gris (1887–1927), who with Picasso formed the triad that made Cubism one of the fundamental movements of modern art. In Matisse the desire for three-dimensional expression led only to linear and pictorial effects and to a certain renewal of his modeling. It carried Picasso no farther than a restricted application and expansion of what he had experienced on the flat plane. More was needed than this impulse on the part of the new painters if sculpture was to share in the twentieth-century renaissance, in an atmosphere such as Boccioni described so well in his exuberant and lyrical manifestoes and essays, an atmosphere shot through with the delirium of freedom and a great longing for the new. But even this challenging climate would not have been enough had there not also been, among both old and young artists, a number of reflective, concentrated, and quiet personalities, sculptors totally devoted to their art and its possibilities, and capable of raising sculpture from the sphere of painting into that of the wholly spatial. There were three: Umberto Boccioni (1882–1916), who overcame archaism and, with inimitable Italian and youthful *élan*, disdaining to view sculpture as the child of painting, gave it its own problem of movement in space to solve; Constantin Brancusi (1876–1957), who lived in peace amid the restless Cubist and Futurist vibrations and let his own pure, absolute form slowly mature; and Raymond Duchamp-Villon (1876–1918), who in the youth of Cubism and Futurism developed a monumental greatness of style, a French mastery of sound, lucid, and tense form.

[110]

[111]

[112]

[113]

[114]

4

Duchamp-Villon, Boccioni, and Brancusi

Raymond Duchamp-Villon and Umberto Boccioni were victims of World War I. Duchamp-Villon was born in 1876, the same year as Brancusi, and died in 1918, in his forty-second year. Boccioni was only thirty-four when he died, in 1916. Both lives were tragically short; for the difficult profession of sculpture, in which artists seldom ripen early, their life spans were minimal, and neither produced a large body of work. Yet what they achieved between 1911 and 1914 was of inestimable value and surpassed the creations of the Fauve, Expressionist, and Cubist painter-sculptors of the same period.

Boccioni was also a painter, but his solutions of spatial problems did not bog down in the pictorial. Moreover, neither of these artists

[110] *Mask*, from Madagascar. Wood, height 10″. [111] *Female Statuette*, from the Cyclades. c. 2500 B.C. Marble, height 10″. Metropolitan Museum of Art, New York (Fletcher Fund, 1934). [112] CONSTANTIN BRANCUSI. *Maiastra*. 1912. Bronze, height $24\frac{1}{2}$″. Collection Peggy Guggenheim, Venice. [113] UMBERTO BOCCIONI. *Unique Forms in the Continuity of Space*. 1913. Bronze, $44\frac{1}{2} \times 35\frac{3}{8} \times 16\frac{1}{8}$″. Collection Gianni Mattioli, Milan. [114] RAYMOND DUCHAMP-VILLON. *The Great Horse*. 1914. Bronze, height 40″. Museum de Sculpture en plein air Middelheim, Antwerp

[115] RAYMOND DUCHAMP-VILLON. *Female Torso.* 1907. Plaster, 54¼×26×23½". Musée National d'Art Moderne, Paris

[116] RAYMOND DUCHAMP-VILLON. *The Athlete.* 1910. Bronze, 24×13¾×15¼". Musée National d'Art Moderne, Paris

had difficulty because of archaism. Duchamp-Villon, at least, was firmly convinced that sculpture had reached a point at which the past was no longer useful: it could no longer deal with the problems and demands of the new sculptors. For the first time since Maillol and Bourdelle—and Wilhelm Lehmbruck [149, 161–163]—we see an artist casting off archaic bonds completely and attempting to wrest a new form from his own age and his own resources.

Duchamp-Villon had studied medicine, but as early as 1898 he felt a vocation for sculpture. He began in the tradition of Rodin, but by 1907, when the three remarkably talented brothers—Raymond Duchamp-Villon, Marcel Duchamp, and Jacques Villon—were at the center of the avant-garde movement in Paris, Raymond was moving rapidly away from Rodin. The large *Female Torso* of 1907 [115] represents a definite departure from Rodin's dynamic surfaces; the strong, bent figure is simpler in outline, the whole is lucidly analyzed in a few main parts, and, most important, the modeling is schematic, sleek, and powerful.

In the Cubist milieu, the great contribution and the great force of Duchamp-Villon was that he assimilated Cubist theory in such a way that his sculpture was not an extension of Cubist painting and African sculpture. Rather, it posed its own problems.

107

The motif of Maillol's relief *Desire* [118], of 1904, is similar to that of Duchamp-Villon's relief *The Lovers* [119], which dates from 1913. It is evident from a comparison of these works that between 1907, the year of the *Female Torso* [115], and 1913 Duchamp-Villon made a real step forward: he broke up the anatomic totality of the body and reset the parts in a new relation. He abstracted without becoming wholly abstract. Close examination of *The Lovers* from both the front and the side reveals that the parts are not placed against or within the shell-like surface but come strongly to the fore as three-dimensional forms. The contours are powerfully hollowed out of the surface. Duchamp-Villon was here at the point of releasing the relief form.

Between the *Female Torso* of 1907 and *The Lovers* of 1913 stands the *Athlete* of 1910 [116]. This piece is not at all Rodinesque; it is related to the Greeks. The pose is the same as that of the Hellenistic gladiators of the first century B.C., but the head of Duchamp-Villon's athlete and the treatment of the volume clearly derive from Greek heads of the fifth century B.C. In the time of full Cubism in painting, Duchamp-Villon apparently immersed himself in this atmosphere deliberately and

persistently; there is nothing to indicate that he was soon to take the step that led to *The Lovers*.

The impressive head of Baudelaire [121] dates from 1911. For the first time, a great style seems assured. The piece shows some affinities with African sculpture—a mask from Madagascar, for example [110]. The portrait character is maintained despite the domed forehead, the exaggerated eyes, the simplified form. This work is an advance, but not according to Cézanne's formula of cylinder, sphere, and cube; nor does it follow the formula of the Cubist painters of 1911. Duchamp-Villon did not translate such values as these into the three-dimensional, as is often suggested.

During 1912, the year of his second *Athlete*, Duchamp-Villon expressed himself more distinctly. He had certainly seen the series of *Jeanette* heads that Matisse had produced beginning in 1910. Under their influence he so exaggerated every element of the large head called *Maggy* [122]—the skull, the neck, the nose, the eyeballs, the lips, the cheeks—that they became one synthesized form. This head is strong but not beautiful; it is better in profile than in full face. The

[117] *Athena* (with arm of Hercules). Metope from the Temple of Zeus, Olympia. 470–456 B.C. Marble. Louvre, Paris. [118] ARISTIDE MAILLOL. *Desire.* c. 1904. Stone, height 47 $\frac{1}{4}$". [119] RAYMOND DUCHAMP-VILLON. *The Lovers.* 1913. Original plaster, 27 $\frac{1}{2}$ × 46 × 6 $\frac{1}{2}$". Museum of Modern Art, New York. [120] MARCEL DUCHAMP. *King and Queen Surrounded by Swift Nudes.* 1912. Oil on canvas, 45 $\frac{1}{2}$ × 50 $\frac{1}{2}$". Philadelphia Museum of Art (Louise and Walter Arensberg Collection)

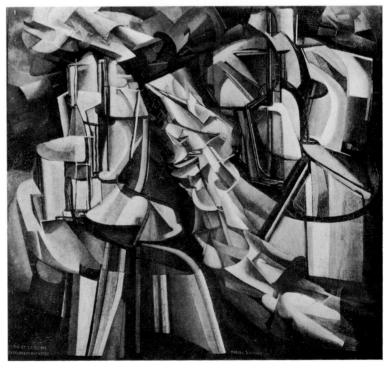

109

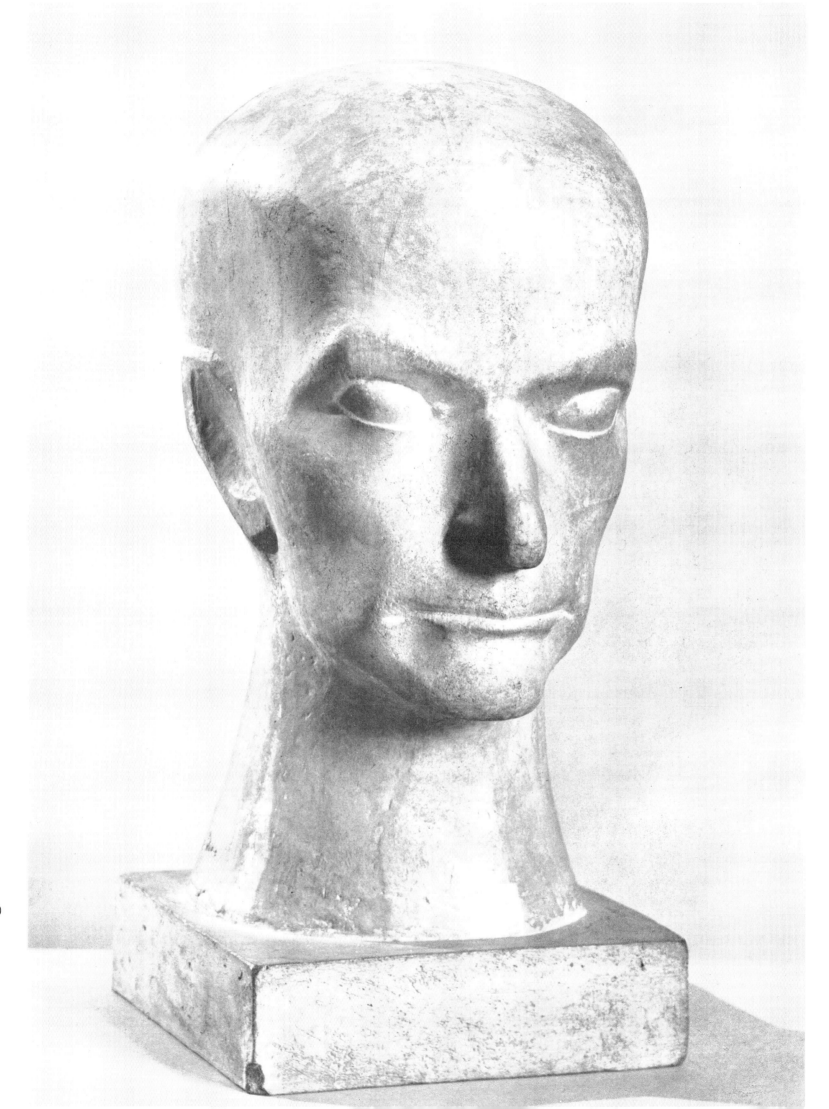

[121] RAYMOND DUCHAMP-VILLON. *Baudelaire*. 1911. Plaster, height 15¾". Musée Municipal d'Art et d'Histoire, Saint-Denis
[122] RAYMOND DUCHAMP-VILLON. *Maggy*. 1912. Bronze, height 28¼". Musée National d'Art Moderne, Paris

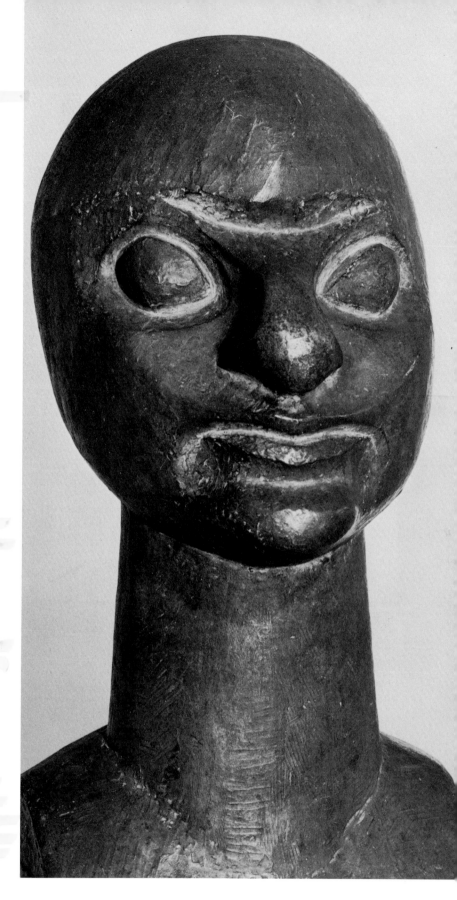

sphere and the cylinder begin to be felt in it, and it represents a definite progression toward *The Lovers*. Thus the break with anatomical totality was not sudden but gradual.

After *The Lovers*, Duchamp-Villon made great strides, although his production was limited to a few works. The *Great Horse* of 1914 [114, 124] retains only a memory of its starting point, a horse in motion, but the form lucidly represents the power of that motion. The sculptor's penchant for forward-leaning structure, evident as early as 1907 (*Female Torso*) and 1910 (*Athlete*), reappears in the *Horse*. The "haunch" bolts obliquely, in rising planes, from a six-sided, irregular base (cf. Boccioni's *Development of a Bottle in Space* of 1912 [130]), and then we see two types of movement being generated, the zigzag and the spiral. Yet the surfaces are smooth and taut, and the lines, not straight but curving, never form rectangles. Geometry is here replaced by a form which, despite its tautness, is organic. This work with its non-Expressionist form, complex yet controlled and lucid, reveals Duchamp-Villon as an indisputable master in harmonizing the asymmetrical and irregular.

Duchamp-Villon's sculpture shows a relation to the work of only one painter of the period, his brother Marcel Duchamp (1887–1968). According to most art historians, Duchamp should be counted among the 1911 Cubists, though he never wholly subscribed to Cubism, being far too individualistic and independent. His renowned canvas *Nude Descending a Staircase* dates from 1912 (as does the *King and Queen Surrounded by Swift Nudes* [120]). In the years following, he continued to shock and to protest by exhibiting "the object"—the urinal, the ready-mades—in a way that challenged and undermined the concept of art. For instance, a careful examination of Duchamp's canvases, from *Nude Descending a Staircase* to *The Bride*, reveals well-defined forms and a "translation" of the human body by means of these forms. The rendering of movement in these paintings was Futurist, not Cubist. The two brothers thus influenced each other.

In comparison with what other sculptors were doing from about 1910 to 1914, Duchamp-Villon arrived at a clear and powerful form: the movement on the surface of Picasso's sculptures and Matisse's more linear forms belong to another, more restricted order. Duchamp-Villon created figures that belong to the realm of Cubism and Futurism, but his inventive solutions go well beyond the achievements of

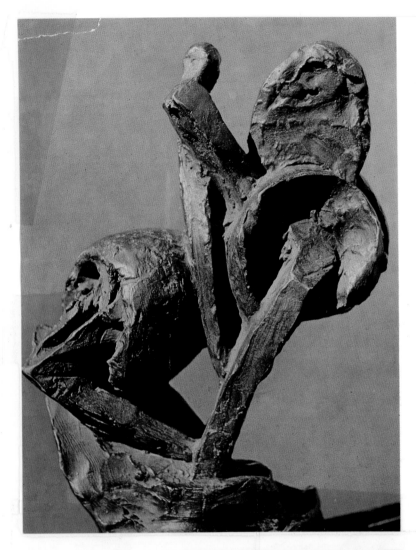

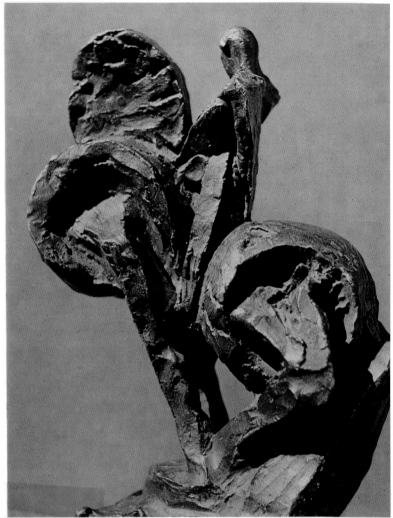

these movements in painting. He gave sculpture a new, monumental style of its own which was not architectonic but which did have an authentic and original idiom. His well-known attempt to create a Cubist architecture was more a sign of his versatile spirit than of an architectonic renewal. It is noteworthy as a step toward architecture taken by a sculptor—a phenomenon that has assumed the proportions of a boom in recent years.

One of Duchamp-Villon's last works (1917) was the little clay *Portrait of Professor Gosset* [126]. It is very small, but the spatial impact is exceptionally powerful. No other sculpture from those years is so simple in effect—a profound metamorphosis from the natural data of a human head to absolute basic form. This piece did not, indeed could not, derive from primitive masks. If the *Baudelaire* [121] was unitary in its stylization, the *Gosset* has been converted into two forms

[123] RAYMOND DUCHAMP-VILLON. *Rider* (two views). c. 1914. Bronze, 10 1/4 × 4 × 7 1/2". Stedelijk Museum. [124] RAYMOND DUCHAMP-VILLON. *The Great Horse*. 1914. Bronze, ht. 40". Galerie Louis Carré, Paris

conceived and executed wholly in three dimensions. It may not be a portrait in the usual sense, but it can be surmised that these singular forms capture the man's expression. In the *Baudelaire*, Duchamp-Villon bound skull, forehead, and nose into organic unity. In the *Gosset* he formed a second unity in the lower jaw and cheeks, and under the great domed skull the eyes lie like caverns.

The *Seated Woman* of 1914 [125] and the *Horse* [114] clearly show Duchamp-Villon's duality, which created a tension in the figures, a tension that influenced the form. Movement is no longer suggested as an element; it becomes a symbol in the third dimension. A master

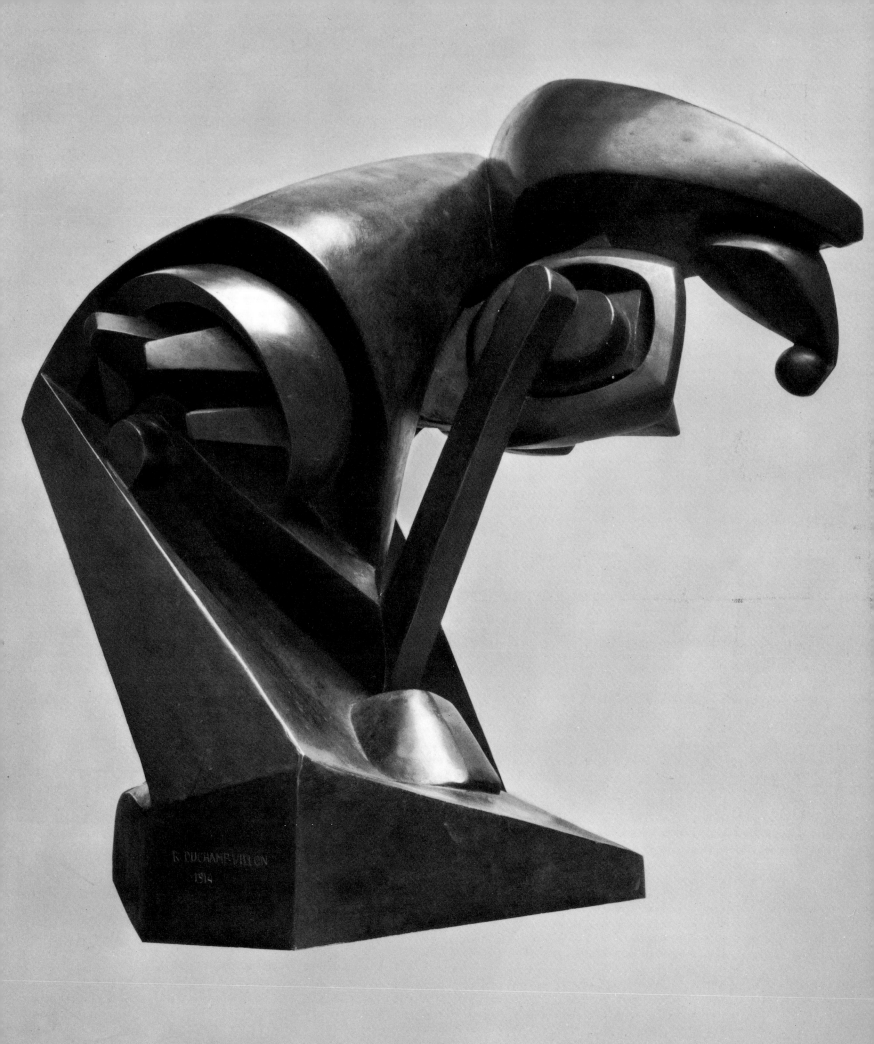

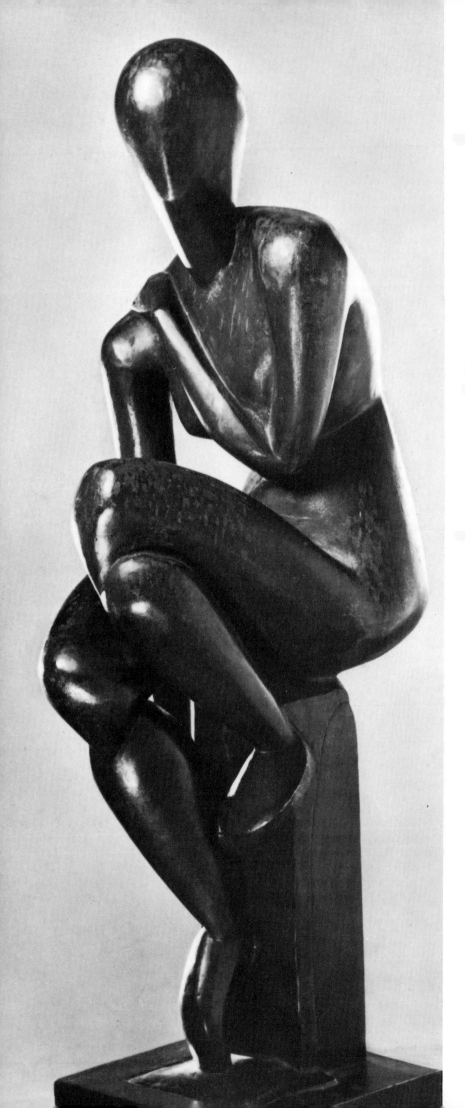

of dissection, no doubt as a result of his medical studies, Duchamp-Villon was yet able to give each part a sculptural form that was significant not only in itself but also in relation to the other parts; his tendency toward balance and tension makes him classical. The limited extent of his oeuvre should not deprive this artist of genius, so deplorably cut off in his prime, of a high and honorable place in the history of art.

Alongside Duchamp-Villon stands Boccioni (1882–1916), whose body of experiments, if less unified, was no less important. A member of the avant-garde and a propagandist by temperament, he had a talent for words and a restless urge to write manifestoes and proclamations. In his creative work he had neither the distinctively French control nor the classic assurance that marked Duchamp-Villon's language of form. Yet he too, in a period of a few years and with a small number of sculptures, succeeded in working out with challenging conviction his ideas of what the new sculpture should be.

Whereas Duchamp-Villon's sculpture can be admired as form and shape apart from its theoretical value, a theoretical aura clings to Boccioni's works. In the years before World War I he expressed his ideas about the emerging possibilities for art more vigorously and more comprehensively than any other artist. In his *Manifesto tecnico della scultura futurista* (Technical Manifesto of Futurist Sculpture), of April 11, 1912, he formulated a complete summary of the possibilities, and impossibilities, for sculpture. His writings, now half a century old, still move the reader: in vital, aggressive, and often poetic prose, he subjected the products of his own and preceding generations and of the great Italian past to a flood of trenchant criticism.

Boccioni's work must be seen in the light of his total activity as propagandist, draftsman, painter, and sculptor. He, like Duchamp-Villon, discarded archaism and found his center of gravity in the present. In this regard he made a number of critical remarks about the recent past which indicate that he was not entirely liberated from it but was attempting to break away. One must take into account the specifically Italian reaction to the overawing Roman and Renaissance past. In his own reaction, Boccioni was ambivalent, as is apparent, for example, from his attitude toward Michelangelo. At times he

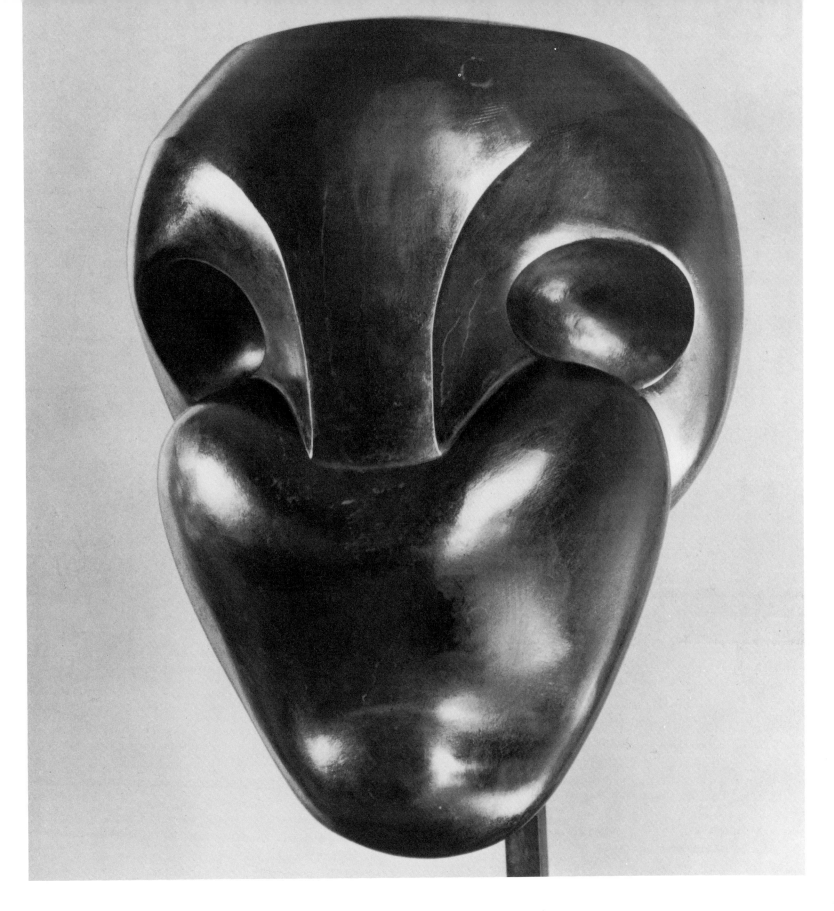

115

rejected his great predecessor and at other times he was violently attracted to him. He loathed the Trecento and, even more, the Quattrocento; neither was of any interest to the modern world. "Beethoven, Michelangelo, Dante—they turn one's stomach."[38] He had had enough of "the heroic type." He proposed, instead, the exalting of Seurat-like subjects (which had actually been introduced earlier by Courbet and the Impressionists as an attack on sacred, mythological, and historical subjects): ordinary people leading ordinary lives, preferably antisocial figures from the border zone where clowns, acrobats, and circus folk live. With all this, he remained open and unfaddish in his tempestuous love for his own time.

Boccioni could not really escape Michelangelo. Despite all the horrors of bad imitations, he thought that Michelangelo's genius had been understood by very few: this last colossus of Christian-pagan art was *troppo appassionatamente astratto* ("too passionately abstract").[39] Yet even so seemingly radical a Futurist as Boccioni could not deny the greatness of his vision.

In his criticism of the renewal in sculpture since Meunier, Rosso, Rodin, Bourdelle, and the Cubists, Boccioni shows his clear sense of discrimination.[40] While he admired Rodin's grand lyricism, he would have none of the irresolution of *The Burghers of Calais.* He thought that Rodin was too heavily burdened with Donatello and Michelangelo. He pointed out, correctly, that what Meunier had done was to

adapt the heroic Greek style to mineworkers, seamen, and warehouse laborers, and that even though his subjects were new, they could not in themselves bring about a renewal. Meunier could not break loose from the Parthenon style.

Bourdelle was more important to Boccioni, who keenly appreciated his introduction of abstract architectonic elements into the sculptural block. But Boccioni was disappointed that the French sculptor could not shake off archaic influences (among which he included the anonymous sculptors of Gothic cathedrals). This observation reveals that a change was taking place in Boccioni; like Duchamp-Villon, he was rejecting the psychological and aesthetic state of mind bred by archaism and was seeking a new form of expression. The Futurists called this development "the ecstasy of the new and the innovating delirium of our age."[41]

Concurrent with the withdrawal from archaism was a dwindling of interest in African and South Pacific art. Although such art was still of value to the new age, it was no longer of prime importance. Boccioni criticized Archipenko for "holding back"; he thought that Archipenko, as a pure Russian, should free himself from the past and from African and Oriental sculpture.[42] He appreciated Archipenko's destructive achievements but deplored the curtailment of his constructive efforts by outside influences. In these telling criticisms he reveals much of his own struggle.

How did Boccioni think things would develop? That he rejected decorative stylizations is self-evident. Rosso's Impressionism had shown sculpture how to relate diverse elements in a shimmer of surfaces; this was rendered in sculpture as the atmosphere evoked by people and things. But it did not go far enough. Boccioni missed an architectonic element in Impressionism—a center, a central force. Still he granted that Rosso, although too limited by Impressionism, had transcended his limitations in pointing a way to a renewal in sculpture. Boccioni was not blind to the pictorialism of Rosso's work. Nor did he think its relief character a positive value. Yet Rosso was truly revolutionary because he tried to unite things and their planes and to continue them into space. He made atmospheric planes which did not enclose sculpture in neat lines but kept it open. In his style the element of motion was not suggested by the illusion of movement created by the position of a figure; it was realized as a plastic rhythm.

As Boccioni saw it, Rosso, in attempting to reproduce the light

118

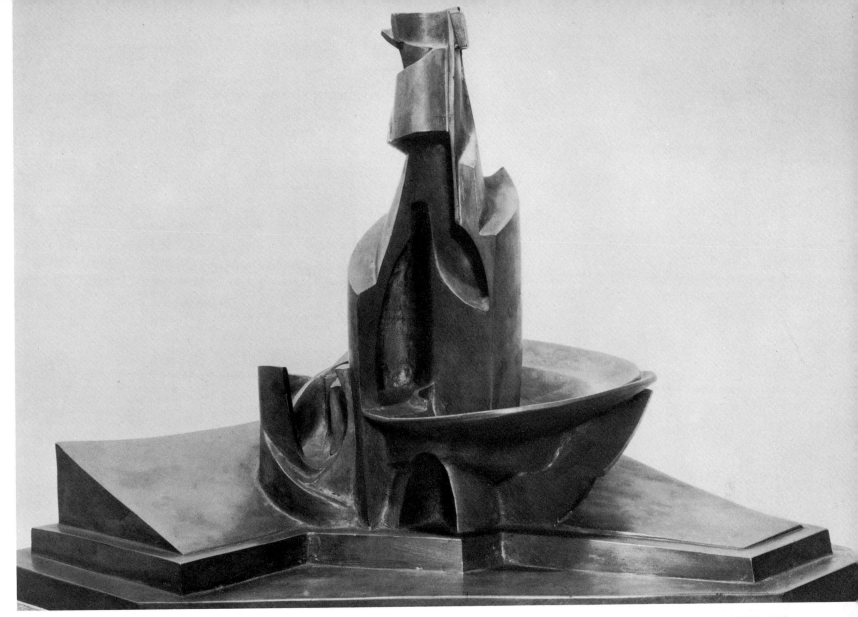

[129, 130] UMBERTO BOCCIONI. *Development of a Bottle in Space* (and detail from above). 1912. Bronze, height 15". Collection Gianni Mattioli, Milan

touch of Impressionist painting, deprived his sculpture of universality. Nevertheless it was a moment of historic importance when Rosso, by actually capturing light in the modeled surface, and no longer isolating it from space, succeeded at the same time in releasing the figure from space. Thus, for example, the surface of a child's forehead could acquire a much wider spatial significance [133]. The real object now approached its spatial ideal.

Boccioni then developed his own Futurist idea of composing interpenetrating objects. He strove for the same effect the Impressionists were attempting to achieve with color. Forms and planes lose their

independence in his work [113, 127, 128, 129, 130, 132] and resolve themselves in a spatial synthesis by means of interpenetration. Interior and exterior no longer exist; everything is simultaneous and blended, and leads to synthesis. Motion became Boccioni's ideal. He wanted to bring movement into architecture too. Cubism was static. At this point, Boccioni hit upon one of Brancusi's basic ideas: "The pyramid is fatal."[43]

Carrying out this idea meant that Boccioni could no longer close up the circumference of a sculpture. He wanted to let the outline "go up in smoke," as, for example, in a range of colors from black to gray. But here his mastery of form failed him. In his sculptures he was obliged to stop somewhere; hence his planes usually taper to a point, and a multitude of contrasting directions develop, depriving the sculpture of a center. Since he charged Impressionism with lacking centrality, it may be that he felt the lack in his own work as well and this led him to conceive the idea of a spiral. With this solution, however, he did not go much beyond the result he had achieved in the *Development of a Bottle in Space* of 1912 [129, 130], his best work, "the intensified forms of a bottle," as he described it. At the same time, he made *Development of a Bottle in Space by Means of Form*. Both works were exhibited at the Galerie La Boétie in Paris, in June and July of 1913, along with his drawings.

Boccioni's contact with Paris influenced him, but he cleverly kept clear of the analytical attitude of the Cubists. He rejected their method as "Baroque-izing analysis."[44] Instead of the external Baroque-ism of Analytical Cubism, he sought the internal simplicity of synthesis and the dynamic line of force, which to him was the straight line. But he would not accept anything archaic, primitive, Egyptian—in a word, regressive.

Boccioni had a remarkably far-reaching vision simply because his spirit was mercurial and relentlessly curious. But he was unable to accomplish all that he wanted to. He talked about transparent planes long before Gabo and Pevsner began to construct. He was all for abolishing the closed volume, mistrusting definitive lines and rounded-off volume. He wanted to get away from the heaviness of marble and bronze, and he felt the materials of sculpture should not be limited by predetermined aesthetic ideas. He mentioned at least

twenty materials—including glass, wood, cardboard, iron, cement, mirror glass, electric light—capable of arousing the plastic emotion. It is true that Boccioni was not the only artist to think of these things; such ideas were in the air. Through his acquaintances in Paris he knew, of course, of Braque's and Picasso's daring experiments in painting, the introduction into their collages and reliefs of sandpaper, nails, curtain material, wallpaper, newspaper clippings, and other objects. The break with the traditional materials of sculpture, however, had never before been proposed with such vigor. Boccioni's work really summarized what the Russians—Tatlin, Rodchenko, Gabo, Pevsner, and Archipenko—began shortly to do with new materials.

His active imagination also suggested such subjects for sculpture as "the ticktock and balanced movement of a clock"[45] and the up-and-down motion of a piston in a cylinder. Anyone who watches such artists as Jean Tinguely [329] and Wander Bertoni at work will recognize the prophet Boccioni behind them. His spirit and example had not yet found direct followers when the savagery of war put an end forever to his brilliant career, still in its beginnings. Only now is it apparent that the concept of motion has become basic to sculpture. Many sculptors have tried to work out this concept in practice, with indifferent success; only a few have been able to develop it.

Constantin Brancusi (1876–1957) was the third great power in

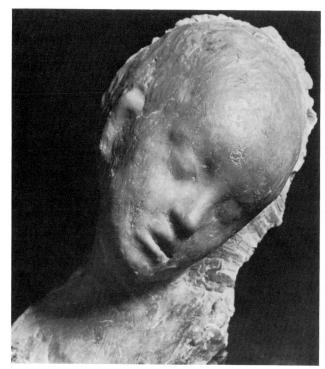

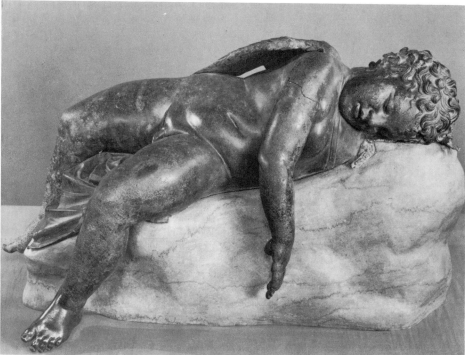

the new sculpture. He was lucky enough to enjoy a long lifetime, in the course of which he produced a relatively small but compact body of work. His production covered about two hundred works; his themes were few, even compared with those of Duchamp-Villon and Boccioni, whose lives were cut short. But Brancusi's work has very great depth.

His development may be sketched chronologically. In 1906 he was still working in an archaistic mode. In 1907 and 1908 *The Prayer* represented an introspective simplification. During 1909 and 1910, after the several versions of the *Sleeping Muse* [135], he veered toward a nearly absolute form. Thus within a period of four years Brancusi moved from a veiled form and expression and from the incomplete and rudimentary to a clearer, concentrated form. From then on he never wavered, and his style underwent virtually no further changes. His development was a process that entailed a gradual release from old content and old forms.

Brancusi was contemplative by nature, and he may have sensed that he had many years to live. In any case, his work was based on a conscious movement from a center outward and then a return from the periphery to that center. But to develop completely, this inner power of Brancusi's needed the environment that he found in Paris. Among the people he spent time with was Henri Rousseau (1884–1910), who was highly regarded by the Cubists; his association with

[133] MEDARDO ROSSO. *Sick Boy.* 1893. Wax-covered plaster, height 11″. Staatliche Skulpturensammlung, Dresden. [134] *Sleeping Eros,* said to be from Rhodes. c. 250–150 B.C. Bronze, $17^{1}/_{16} \times 30^{3}/_{4}$″. Metropolitan Museum of Art, New York (Rogers Fund, 1943) [135] CONSTANTIN BRANCUSI. *Sleeping Muse.* 1909. Bronze, $10^{5}/_{8} \times 11^{3}/_{4} \times 6^{3}/_{4}$″. Musée National d'Art Moderne, Paris

Rousseau was doubtless a more intense experience than the relation of the many people drawn to the Douanier solely by his eccentric behavior. Probably Brancusi responded as an artist to the quality of Rousseau's paintings, in addition to being attracted by his singular attitude toward life, in which childlike naïveté, native shrewdness, and simple vanity were mingled. To remain childlike was, of course, one of Brancusi's principles ("when we cease being children, we are already dead"), and his constant endeavor.

In a sense, Brancusi had to undergo a long, slow process of liberation from the past, for he was academically grounded in the tradition of the Greeks, the Romans, and the Renaissance. The motif of the inclined female heads reveals the whole process of his unshackling. As Carola Giedion-Welcker has remarked, a derivation from the Hellenistic head *Erinys Asleep* in the Museo Nazionale in Rome is not impossible.[46] A youthful work, *Laocoön's Head* (1898), produced while Brancusi was still a student at the art academy in Budapest, indicated

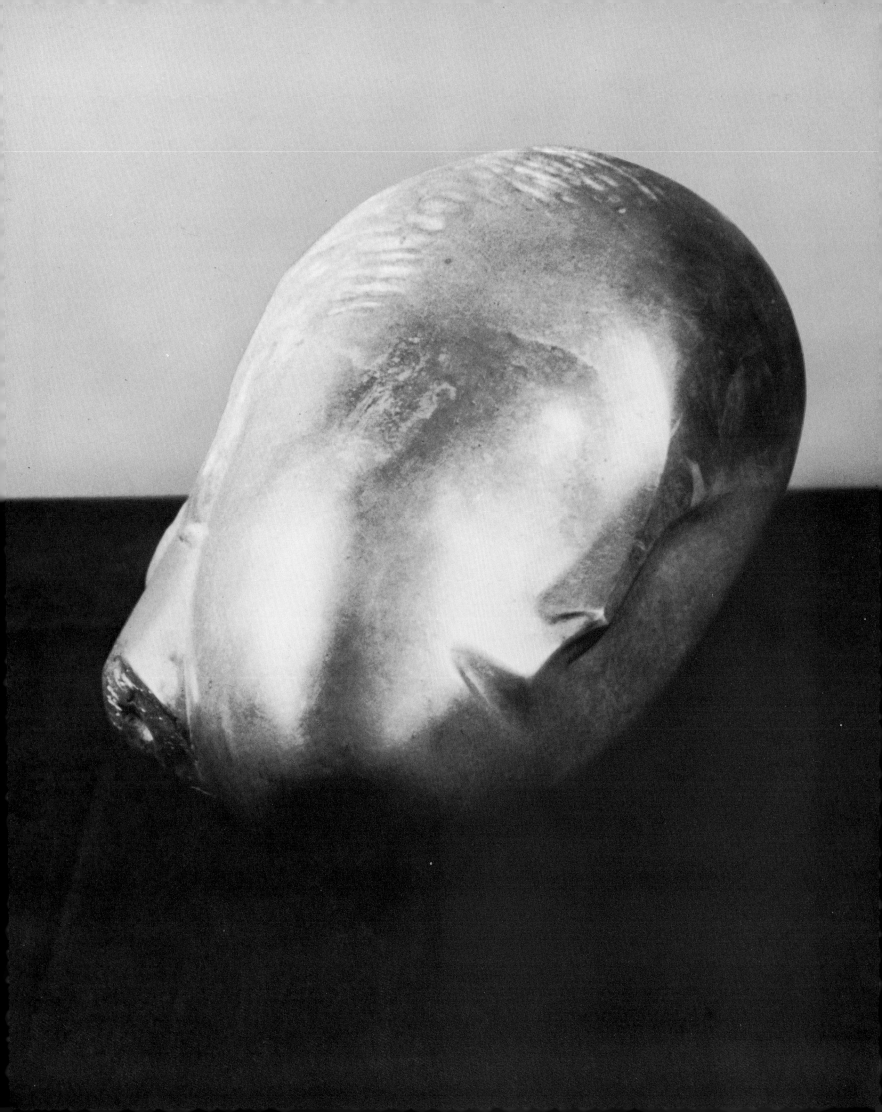

[136] CONSTANTIN BRANCUSI. *Mademoiselle Pogany*. 1912. Chalk drawing, 21 1/2 × 16 1/2″. Philadelphia Museum of Art (Gallatin Collection). [137] CONSTANTIN BRANCUSI. *Mademoiselle Pogany*. 1913. Bronze, height 17 1/4″. Museum of Modern Art, New York (Acquired through the Lillie P. Bliss Bequest). [138] CONSTANTIN BRANCUSI. Study for *The New-Born*. 1914. Pencil and gouache on beige paper, 14 3/4 × 21 3/4″. Philadelphia Museum of Art (Louise and Walter Arensberg Collection)

that he was acquainted with the famous works of sculpture, probably through reproductions and plaster casts. Luckily, he knew more. He had learned the craft of the cabinetmaker, and his feeling for musical tone and functional construction was so advanced that as a boy he was able to make himself a violin. In his handling of wood it is apparent that he never forgot his early contacts with raw materials and with farmwork in southern Rumania, a fact confirmed by certain details of his studio, which has been reconstructed in the Musée d'Art Moderne in Paris. But when Brancusi first came to Paris, in 1904, he did not take material as such as his starting point; he concentrated primarily on form, and if the material—marble or stone—played a role, it was still in a Rodinesque manner. Form arose from the unworked or half-worked block and had nothing to do with the vitality of the material itself. We see Brancusi wavering between, on the one hand, the aesthetic influence of Rosso and Rodin and, on the other, his own youthful background, rooted in a completely different world whose significance had not yet come into focus for him.

In an early work, the 1907 bronze bust of a boy with his right shoulder hunched high (*Torment*), the position of the head is more reminiscent of Medardo Rosso than of Rodin. The first version of the *Sleeping Muse* (1906) is barely chipped out of the marble; it recalls both Rodin's *infinito* in technique and Rosso's veiled expression [133]. Rosso's oblique heads and motifs of sick or laughing boys and of languishing, veiled women were surely known to Brancusi; Rosso was on the selection jury for the Salon d'Automne of 1906, in which Brancusi exhibited.

In that year and for some time thereafter Brancusi was apparently excited by archaic forms and expressions. He went even farther back into prehistoric times than had Bourdelle and Maillol. *The Kiss* [143], *Wisdom*, and the *Head of a Girl*, all dating from 1908 and carved in stone, are all block figures. The slight naturalistic detail expressed in *Wisdom* is elaborated in *The Kiss*. The wavy lines of the hair and the treatment of the arms and eyes recall the graphic treatment of megalithic gravestones [145].

In these years Brancusi was still under the influence of archaism, an influence probably predating his arrival in Paris. The museums in Prague and Budapest had large collections of objects of early and late prehistoric origin. His familiarity with the folk art of his own country had probably been more important in the formation of his style than his anatomy lessons at the academy.

Taille directe (direct carving) played a major role in Brancusi's development—but not direct carving as Bourdelle and many others had conceived it. They wished to revive sculpture as a monumental element in a new relation with architecture, and they thought of direct carving as one of the means of supplanting the cult of modeling, which weakens form. Brancusi was skeptical about this idea. "Direct carving is the true road to sculpture, but also the wrong way for those who do not know how to walk. And ultimately, direct or indirect carving means nothing; it is the finished work that counts."[47]

In this way Brancusi formulated his attitude toward one of the ideas abroad in Paris when he arrived. The contemporary currents and crosscurrents are recorded better in his drawings than in his sculpture: Art Nouveau curlicues, linear treatment in the manner of Matisse, reworkings of Rodin in the refinement of his watercolor technique, with a gossamer play of lines. The features most characteristic of Brancusi are the tensed arcs of thin lines and the accentuation of oval masses by heavy lines or gouache modeling [138]. These are typical sculptor's drawings: the circumference is noted, and the concavities and convexities are indicated by light hatchwork, as in the *Mademoiselle Pogany* [136].

In the singular mixture of archaism and modernity of the years 1910 and 1911, Brancusi took a decisive step toward the purity of form that was to characterize *The New-Born* [138]. It was never absolute. Brancusi continued to evoke the figurative, not only by his choice of subjects (*Narcissus, The Bird, Prometheus, The New-Born, The Fish, The Endless Column, Socrates, Leda, The Prodigal Son, The Miracle,* etc.) but also by the schematic circumscription of form or a single, minimal but essential hint of an eye or a mouth. These figures belong both to their own time and to a distant past. The wood sculptures in particular [148] have an aura that suggests African and Oceanic sculpture. However, a work by Brancusi could never be confused with an actual primitive work; his content is completely different from

125

[139] CONSTANTIN BRANCUSI. *Rooster*. 1924. Bronze, 40 1/2 × 8 1/4 × 4 3/8″. Musée National d'Art Moderne, Paris. [140] CONSTANTIN BRANCUSI. *Sculpture for the Blind*. 1924. Marble, 6 × 12 × 7″. Philadelphia Museum of Art (Louise and Walter Arensberg Collection)

the content of the ritual-bound forms of the non-European societies.

Brancusi's marble figures are reminiscent of the Cycladic statuettes [141, 142], those uniquely attractive prehistoric figurines about which so little is known. I believe it was not until about 1911, when they began to be of increasing importance to Brancusi, that he used the figures from the Cyclades as models. What probably attracted him in these nearly abstract works was that the figuration really lies in an extraordinarily sensitive handling of the marble and in the purity of the forms. By this time he had succeeded in attaining a mirroring surface that, as it were, embodied light in form. Rosso had not achieved more than an Impressionistic gathering up of light in a quasi-pictorial surface treatment; Brancusi achieved a transformation of light in an absolute sense. The form is elevated—especially in his birds, which are slender and tapering—to a new dimension by an intense involvement of light [112, 139, 146, 147]. Everything in the surroundings is reflected and transformed. In addition, the form glows with a power and a tension that derive from the treatment of the whole.

Broadly considered, Brancusi expressed himself in variations on a few ancient themes. To one group belong the ovoid compositions and cylinders, which always display vigorously closed volumes [137]. To the other group belong the numerous variations on what might be called the two-part theme. The latter began with *The Kiss* [143], which, going beyond its title, represents the union of masculine and feminine. Brancusi imagined the stone as two halves, each separately visible, which together formed one. The idea recurs frequently. The columns that Brancusi conceived evolved not from tradition but from his own world. They seem always longing to return to a primeval beginning, as to a lost paradise. These pillars are *The Kiss* carried to its logical conclusion. There is a clear tension in them between two united halves which dissolve into a form, namely a circle, that acts as a center. Yet the circles are broken. The thought is pursued as far as the remarkable *Gate of the Kiss* (1937) in the Rumanian city of Turgu Jiu near the village where Brancusi was born. In the block of stone that caps the gate are chiseled lines resembling the lines on the version of *The Kiss* that serves as a funerary monument (1908) in the Montparnasse Cemetery in Paris. Here is a fascinating example of how something that begins as pure decoration

127

becomes a symbol. Anyone can grasp from the strangeness of the simple forms and lines that this is neither an ordinary ornament nor merely an abstract element like the usual geometric inscriptions. It is the writing and the signature of Brancusi, who, starting from the basic masculine and feminine in human life, has given form to a common wisdom. In his studio were many variations, small and large, of this two-part unity that began with *The Kiss.* It is one of the marvels of our time that, in the heart of Paris, in the first half of this century, there was consummated in one man a union of the figurative and the symbolic whose origins go back thousands of years to the Mediterranean culture in which our writing was born.

What Brancusi did was to feel and give creative form to the need for liberation in the very world of form. He was a liberator because of his bold desire for simplicity, always the most difficult thing to achieve, and his attainment of it. He was a liberator, too, because he was not afraid to restrict himself to a few motifs and because he had an innate feeling for the primeval origin of things, for the beginning, the mystic beginning, of all life and all form. That yearning for the primeval was of course always linked, to a certain extent, with archaism. But it was so much a part of Brancusi's whole existence that we cannot call it archaism in the usual sense of the word.

The primeval form that he conceived always evolved rapidly until it attained a modern perfection and style, which the more critical might say had lost much of the primeval. It could not be otherwise. Even Brancusi could not shut out aestheticism. But that did not matter, for everything his hands made contained suggestions of a distant time and of deep-seated feeling. No other sculptor has ever given such freedom to the younger artists of his time. In a more concrete sense, he had his own manner of giving liberating meaning to light through volume. He really did not want to capture light: he created an object through which he adored it.

Brancusi succeeded best with closed volumes; he seldom used perforation, and then only in wood (*Chimera,* 1913–18; *Socrates,* 1923), never in stone or marble. The function of the smooth, polished surface with regard to light is to open the boundaries of the volume by means of reflection and thereby to associate the volume with, and take it up in, total space [146]. The same result was to be achieved in a

[144] CONSTANTIN BRANCUSI. *Seal*. 1943. Marble, 63 × 43 × 13 3/8″.
Musée National d'Art Moderne, Paris. [145] Statue menhir, from Saint-
Germain-sur-Rance. Stone. Musée National d'Antiquités, Saint-
Germain-en-Laye. [146] CONSTANTIN BRANCUSI. *Bird in Space*. 1925.
Polished bronze, height 60″. Collection W. A. M. Burden, New York

131

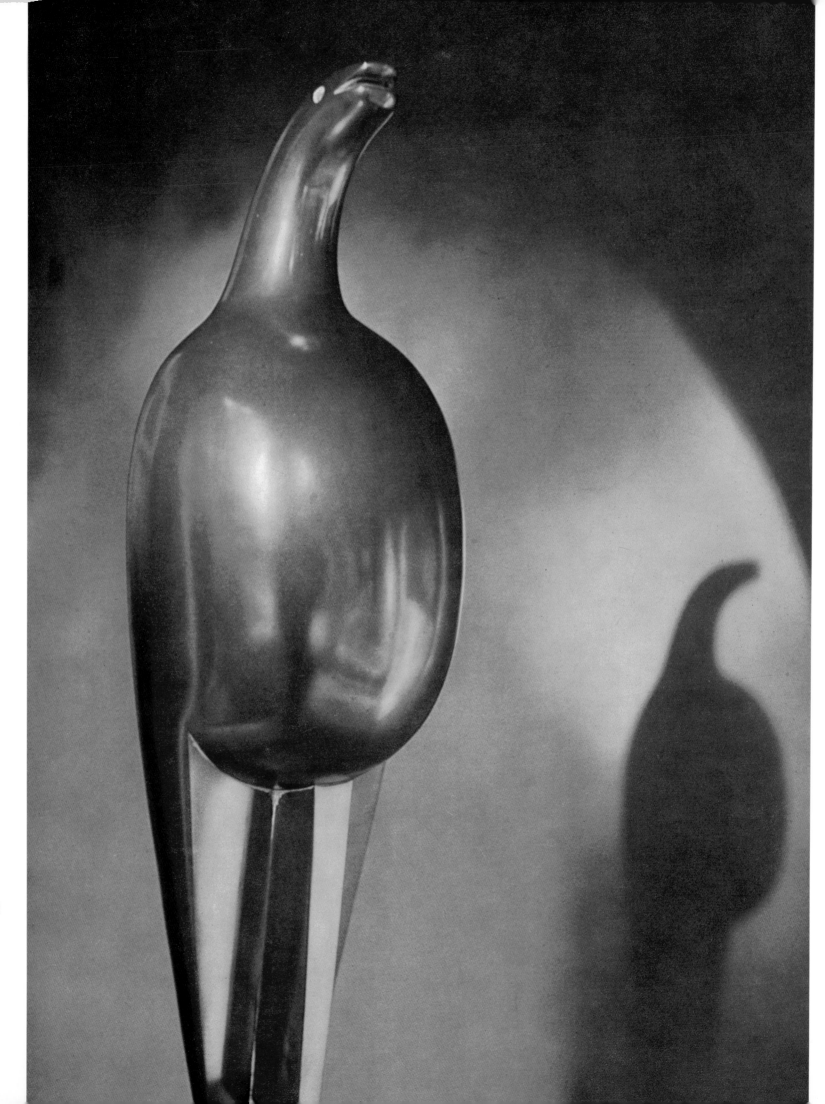

[147] CONSTANTIN BRANCUSI. *Maiastra*. 1912. Bronze, height 24½".
Collection Peggy Guggenheim, Venice. [148] CONSTANTIN BRANCUSI.
King of Kings. 1937. Wood, height 9′ 10⅛". Solomon R. Guggenheim
Museum, New York

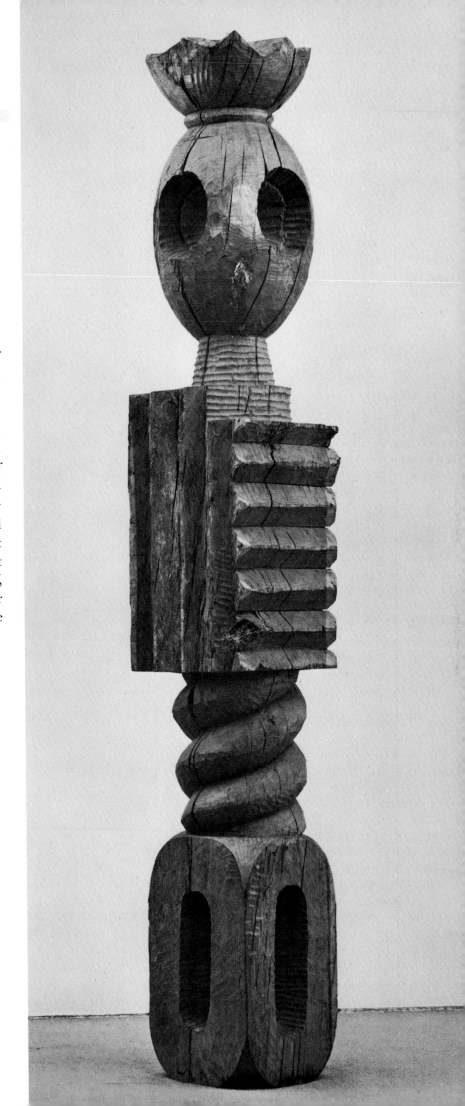

completely different way by Lipchitz and later by Hepworth [280]
and Moore. They bored through the volume and thus brought light
into the interior of the sculpture and let space go through it [255].
Lipchitz made use of transparency [181], and Gabo [194] and Pevsner
[193] of transparent and translucent materials.

Brancusi expressed himself succinctly, as was his custom, about
polishing: "Polishing is a necessity demanded by the relatively
absolute forms of certain materials. It is not compulsory. It is even
very harmful for those who prepare beefsteak."[48] For a time, the young
Lipchitz had a studio next to Brancusi's and often heard the sound of
polishing, polishing, polishing. Brancusi apparently felt no sym-
pathy at all for what Lipchitz was doing. The feeling was mutual:
Lipchitz heard the polishing, but he did not believe in it.

Development was rapid in those days, and Boccioni, Brancusi, and
Duchamp-Villon accomplished a number of essential things and in-
dicated directions, setting the stage for younger men. The work of
the three was known to sculptors through studio visits and exhibi-
tions. The depth given to sculpture in the first quarter of this century
was achieved in a few years' time (the term "generation" must be used
cautiously). Those who were now to develop the possibilities that
had been indicated cannot be classified only as Cubists; important
things were happening on the periphery of Cubism. In Cubism itself,
apart from what the painters were doing sculpturally, a small number
of extremely important sculptors, important in every sense of the
word, began to assert themselves.

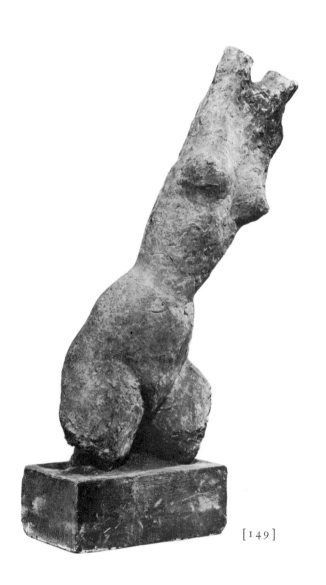

[149]

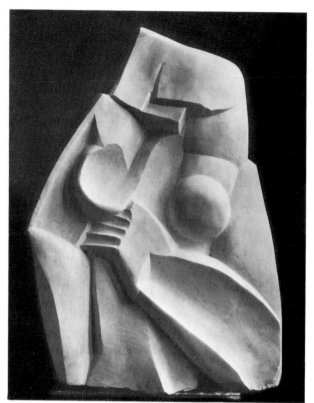

[150]

[151]

[152]

5

The Threshold of Cubism

Exactly how important a role did Cubism play in the decisive years when a powerful new sculpture was developing in Europe? All too often the renaissance of sculpture is attributed almost exclusively to Cubism.

It has become clear that in the period before Cubism, and also during its heyday, the conception of space and form broke away from the Greco-Roman ideal as a result of the discovery and experience of the amazing art produced in more and more remote periods, from the archaic to the prehistoric. As we have seen, modern sculpture did not start all at once with Rodin but evolved from a dialogue, or debate, between space and shape which had begun long before Rodin and which had varying results. The new ideas and tenets, strongly manifest early in the twentieth century, gave birth between 1909 and 1912 to the Analytical Cubism of Picasso and Braque. These artists, though primarily painters, were so taken up with the prob-

lems of space and objects in space that they could not refrain from making little forays into the world of sculpture. To identify the problem of sculpture with Cubism (as is often done) is to refer everything to Picasso and Braque and to fail to do justice to the art of sculpture and to its glorious and independent past. What Brancusi, Boccioni, and Duchamp-Villon achieved up to 1914 certainly involved an awareness of the Cubism of the painters, but everyone agrees that not even Duchamp-Villon's *Horse* [114] can be called a Cubist sculpture in the full sense of the word. The sculpture deriving from Cubist painting (Picasso, La Fresnaye, Braque, Laurens) had not yet developed the autonomous language that the sculpture of any age must attain if it is really to exist. The artists whose achievement in sculpture was really notable—Matisse, even Derain; especially Brancusi, Boccioni, and Duchamp-Villon; and perhaps Elie Nadelman—were the product of something other than the Analytical Cubist experiments. In general, the problem cannot be regarded as that of transposing the discoveries of Analytical Cubism from painting [84] to the tridimensionality of sculpture; this would doom sculpture to be a timid, second-rate art concerned only with the plane and the surface of things—a surface phenomenon in the literal sense. Actually the young sculptors were faced with the problem of finding the formal power, inherent in sculpture itself, that would accord with a transformed, twentieth-century feeling or notion of space and with twentieth-century ideas.

[149] WILHELM LEHMBRUCK. *Female Torso.* 1914. Cast stone, height 30¾". Collection Frau A. Lehmbruck, Duisburg. [150] OSSIP ZADKINE. *Mother and Child.* c. 1913. Marble, height 23½". Collection Joseph H. Hirshhorn, New York. [151] ALEXANDER ARCHIPENKO *Woman Combing Her Hair.* 1915. Bronze, height 13¾". Museum of Modern Art, New York (Acquired through the Lillie P. Bliss Bequest) [152] JACOB EPSTEIN. *Mother and Child.* 1913. Marble, height 17¼". Museum of Modern Art, New York (Gift of A. Conger Goodyear)

[153] ELI NADELMAN. *Man in a Top Hat.* c. 1927. Painted bronze, height 25¾". Museum of Modern Art, New York (Abby Aldrich Rockefeller Fund)

The founding of a new sculpture was the challenging and inspiring task of the sturdy, ambitious young sculptors who had come to Paris after Brancusi, among them Lipchitz, Archipenko, Zadkine, Csaky, and, later, Gabo, Pevsner, and Freundlich. No one of these allowed his creative urge and thinking to be determined exclusively by Futurism or Analytical Cubism, but they all took these movements into account. The urge to carve was still authentic; it had its own drive and vision. It was, to be sure, influenced by Cubism and Futurism, but was not derivative.

Many detailed studies would be required, in particular an objective appraisal of the accuracy of datings, before a true history of the sculpture of the period of Cubism could be written. It can be established, to be sure, that the Synthetic Cubism that "began" (a useful, though only relative notion) in 1912 bore a close relation to the new sculpture that had "begun" in the meantime. In the period up to 1918 there is a close connection between the sculptural and the pictorial that can be demonstrated as well as sensed, though only in a few cases, for sculptors in the Cubist sphere of influence rarely took part in the important exhibitions.

In the spring of 1910 the Cubists exhibited in the Salon des Indépendants and, later that year, in the Salon d'Automne. The only sculptors represented were Archipenko and Duchamp-Villon. In the spring of 1911 there was only Archipenko; in the autumn, Csaky and Duchamp-Villon exhibited. Things were not much different in 1912, except that Archipenko and Duchamp-Villon also showed their work with the group of the Section d'Or. In 1913 the Futurists exhibited in Paris. Among Cubist painters a great deal of attention was paid in 1912 to the appearance of the collages and *papiers collés* that Picasso and Braque had begun to make. These (the collage generally attributed to Picasso, the *papier collé* to Braque) represented a turn away from Analytical Cubism to another technique; the artists freed themselves from the nature of the objects in order to arrive at an inversion of values in which the objects played a secondary role as objects but at the same time had an existence of their own, a freer and more compositional existence in the new composite object. Moreover, the tradition of working on a plane with only brushes and paint came to an end; other materials could be used as well.

In addition, the Cubists played a game with the transparent and the opaque, a game that had nothing to do with nature. Robert Rosen-

blum has given an excellent analysis of this in *Cubism and Twentieth-Century Art.*[49] A simplification took place, an alteration of the color; a flatter quality dominated. A parallelism of planes was introduced. A painted relief was born and, by the use of such materials as wood, newspaper, objects, or parts of objects, readily grew into a sculptural still life, which was often made of paper. This was seen for the first time in Picasso's *The Guitar* (1912).

The Absinthe Glass (1914 [98]) by Picasso is still the clearest indication of why these objects are not true sculpture but, as it were, parts of paintings, retaining a preponderantly pictorial effect in three dimensions. This is due to the pictorial origin of the forms, which by 1914 were being eliminated from sculpture and returned to the two-dimensional medium.

One of the first artists to come to Paris from Eastern Europe and to quicken the world of art after Rodin was Warsaw-born Elie Nadelman (1882–1946). During his first years as an artist he explored the

137

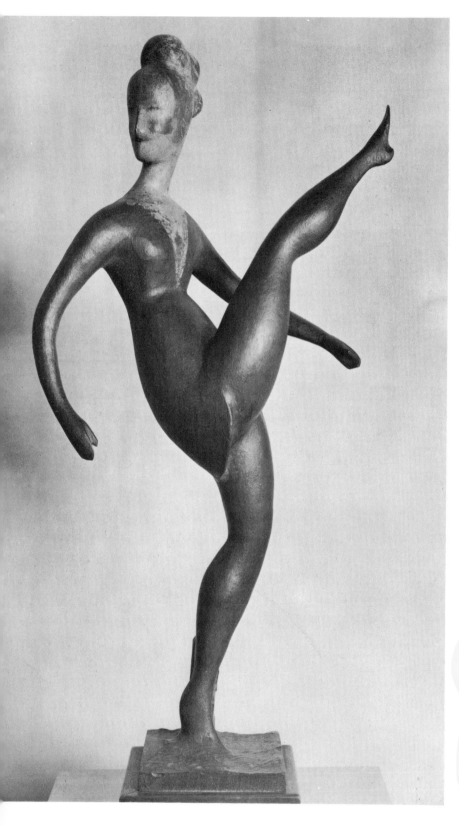

past. His interests crystallized in Munich in 1902, when he came into contact with the Greek sculptures of the fifth century B.C. from the temple at Aegina. However, he probably received even more determining impressions in the Bavarian National Museum's display of dolls and folk art from Bavaria and Thuringia. Working in Paris (1905), he was resolved to be completely independent and had to assimilate his great admiration for Rodin as he set about mastering the basic problems of sculpture. A process of analytic search was going on in the mind of this withdrawn, introspective young Pole, who owed nothing to the French. He was driven by the urge to start from the beginning, not unlike the Cubists some years later. According to André Salmon, one of the few who did him full justice and was aware of his essential contribution, "Elie Nadelman did not draw away from Greek antiquity, but stood up in face of it to deny it."[50] Salmon also appreciated the grace of Nadelman's earliest production, so much so that he was merciless when Nadelman returned from America to Paris in 1920 with a show that displayed a fashionable academicism.

Nadelman called his efforts between 1905 and 1915 a "research in volume" or "accord of forms." Through all his work runs the archaic influence of the early Greeks. In 1909 he arrived at a mannerism based on a system of curves—a clear, intellectual approach to the problem of form. This manner was already evident in a 1905 series of drawings shown, along with a head (later destroyed) and a number of figures, at Drouet's in Paris in 1909 and included in the famous Armory Show of 1913 in New York. The show at Drouet's had repercussions and in certain ways it was decisive for his further development. Nadelman's entire attitude was ambivalent. In his drawings—which, it is assumed, were brought to Picasso's attention by Leo and Gertrude Stein, who saw a good deal of Nadelman, as they did of Picasso—his analytical spirit dissected heads into segments that show a relation to Picasso's bronze *Woman's Head* of 1909 [108]. Other simplifications of the form and the high polish of the surface call to mind the works of Brancusi.

Nadelman himself was convinced that it was his drawings, before Cubism's more external application of abstraction, that had given art its revolutionary turn. Originally considered a member of the avant-garde, he was critical of the Futurists and Cubists, who feared, with reason, that he was too deeply involved in the archaic. But when we study the impetus that Brancusi, Duchamp-Villon, and Boccioni gave the new movement, and then examine what Nadelman did between 1909 and 1918 [154, 155], it is evident that only his earliest works, those he produced from 1905 to 1909 under the influence of archaic sculpture, had a guiding function. The man lived on the

138

threshold of the new. He was so gifted that he was capable of many things: Hellenistic idealizations, reminiscences of the charm of Tanagra statuettes, curious ironic stylizations of the fashion of the time [153], prehistoric evocations, modern foreshadowings of later Marinis. When, at the outbreak of World War I, Nadelman was able to go to New York, via England, he had come to the end of a period which, though it was merely a prelude to Cubism proper, was too stimulating to be omitted, as it too often is, from a historical account.

Another artist who demanded more of himself than would appear from his work was Alexander Archipenko (1887–1964). Like Nadelman, he worked on the periphery of Cubism and strove to give sculpture a new form. Archipenko was born in the Ukraine and came to Paris in 1908, remaining there until 1921. He, too, with playful ease and happy inventiveness, made his contribution, in intermediate fields, to a more autonomous sculpture during a transitional period. His "sculpto-paintings" of 1912 contributed to the three-dimensional development arising out of the collage. He used such materials as glass, wood, metal, and papier-mâché, aiming at a fusion of color and form. As he explained,[51] the sculpto-paintings have a unity of color and form and are distinct from the old polychromy used by sculptors since the Gothic. He saw this technique as a new means—which it was not. Braque and Picasso were preoccupied with the same problems, and Tatlin made his first "painting-reliefs" in 1913–14 [196]. Archipenko's solutions were daring, but with respect to form, freer applications of color can be observed in some African masks. He made whole series of these sculpto-paintings. Particularly in 1919–20 they reveal his too insistent tendency to return to painting. Between the first *Médrano* of 1912 and the *Seated Woman* of 1916 he produced typical transitional forms [157].

Archipenko handled and developed the play of concave and convex in sculpture with a virtuosity all his own. What Cubism had discovered—the equal value of the raised and the depressed, and the concretization of space, which, formerly indeterminate, was made determinate—had not yet led to satisfying results in three dimensions. After 1913, and especially in 1915, in the various versions of *Woman Combing Her Hair* [151, 156], Archipenko succeeded in finding an elegant solution.

In the little more than fifty years that have elapsed since the beginnings of Cubism and abstraction, questions of priority have already been raised. It is natural for the question to arise as to which artists were the first to work out certain principles in a period of transition. This is the type of question that art history, concerned as it is with chronology, is expected to answer. But determinations

[154] ELI NADELMAN. *Dancer.* c. 1918. Painted wood, height 28¼". Robert Isaacson Gallery, New York. [155] ELI NADELMAN. *Horse.* c. 1914. Bronze, height 11¾, length 12½". Collection Paul Magriel, New York

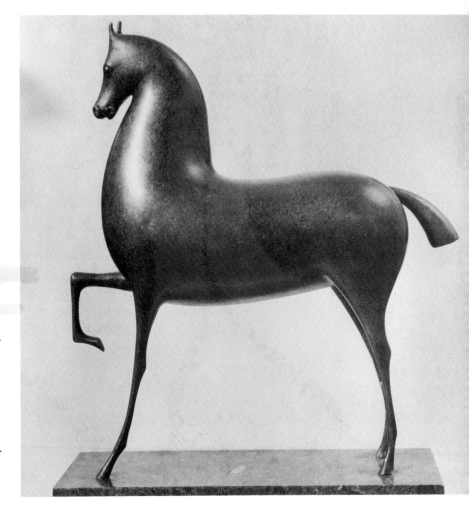

139

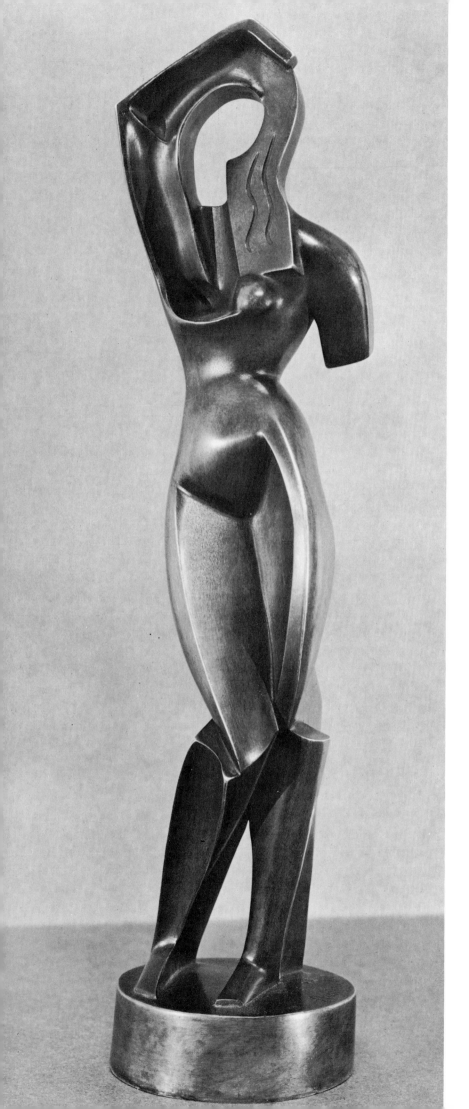

such as these can only be made in conjunction with judgments of value. The marvel of quality, which has never been measurable, is what is most important in the life of art. A notion that is in the air is often first formulated and applied by a minor artist; it is only when it is taken up by a great creative talent that it is fully exploited and becomes significant. When the debate as to priority begins, useful detective work is frequently done, but as a rule quality tends to be ignored.

So far as the concave-convex is concerned, it was not an invention of Picasso's or Matisse's or Archipenko's; it appears in the art of all ages. Interest in it followed naturally from the interest in African Negro and archaic art on the part of creators, not of collectors, in the Cubist period, when the concept of pictorial space was being revised. An effort was made to extend the principle involved into twentieth-century sculpture as well. Archipenko was able to accomplish this because the principle was in accord with his talent, as is evident in what he produced as early as 1909: he created smooth volumes in a state of tension, a tension that was simple but at the same time sensual and artificial. Later, the sensuality became more refined and, in the figurative element, elegant. Up to 1911 the volumes were compact (*Draped Woman, Seated Woman, The Sea among the Rocks*). Even in this period his form was exaggeratedly stylized with linear effects, indicating a highly developed aesthetic and sometimes almost decorative sense. His deformation is Expressionistic. The *Suzanne* (1909), with its heavy hips and large hands, is a splendid example of early Archipenko, while *The Kiss* (1910) shows the stylizing aesthetic curves that were later emphasized even more. By 1912 he had left the Cubist group.

In any ambience Archipenko always remained himself. When in 1913 he made the concave an element of the new sculpture, nature was clearly his starting point; the hollowing out was successful because his stylizing line came to his aid. The resultant simplification is at the same time elegant. One would seek it vainly in the ambience of Picasso and Braque. Archipenko contributed his stylization of nature to Cubism; he did not derive it from Cubism.

In 1913 and 1914 Duchamp-Villon and Archipenko went similar ways, the former with *The Lovers* [119] and the *Seated Woman*, the latter with *The Boxers* and *The Gondolier*. As has been suggested, it serves little purpose to inquire who was first, considering how essential is the qualitative difference between apparently similar works. Archipenko is rigorous, almost intellectually stylizing, in keeping with his strict conception of form. Duchamp-Villon has more breadth in his spatial form, and his forms, more fluid and finer, display a more

[156] ALEXANDER ARCHIPENKO. *Woman Combing Her Hair.* 1915. Bronze, height 13 ¾″. Museum of Modern Art, New York (Lillie P. Bliss Bequest). [157] ALEXANDER ARCHIPENKO. *The Bather.* 1915. Sculpto-painting (painted wood, paper, and metal), 20 × 11 ½″. Philadelphia Museum of Art (Louise and Walter Arensberg Collection)

[158] JACOB EPSTEIN. *Mother and Child.* 1913. Marble, height 17 ¼″. Museum of Modern Art, New York (Gift of A. Conger Goodyear). [159] JACOB EPSTEIN. *Marble Doves.* 1914–15. Marble, height 29″, length 26″. Private collection, London

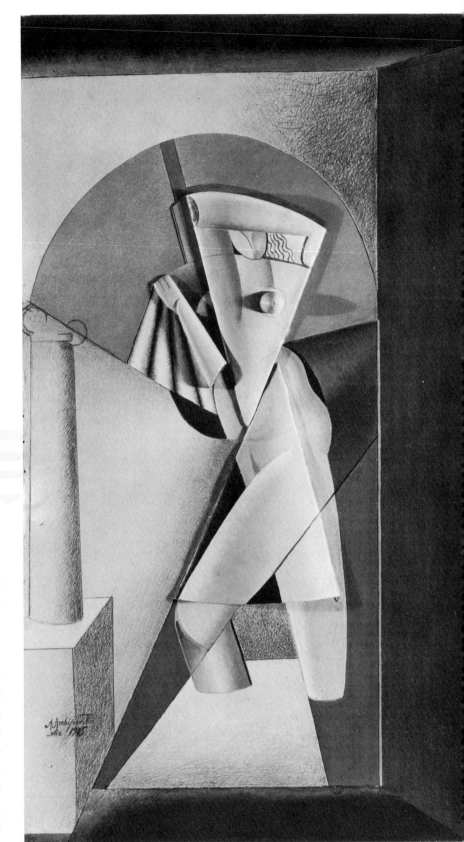

powerful and sensitive swelling of the volumes. In the background of both artists is Boccioni. What Boccioni put forward as a program in his 1912 manifesto—the expansion of sculpture with new means in order to pave the way for a sculpture of our time—Archipenko carried out concretely. Perhaps it was because so much inventiveness and such vision were called for that sculpture could not yet be brought to birth and lay, like an unborn dream, still entangled in time. In 1921 Archipenko went to Berlin to teach. Two years later he was using his pedagogic gifts as head of an art school in New York.

After Duchamp-Villon, it was the Russians who gave impetus to sculpture in Paris. Italy, where the sculptural development had begun so brilliantly and powerfully, in Milan, had lost the exuberant Boccioni, its outstanding artist, in the war, as France had lost Duchamp-Villon. Italy still had Roberto Melli (born 1885), who, though chiefly a painter, had, in the years 1910–14, produced notable sculptured portraits which stand somewhere between relief and the three-dimensional and which seek forceful and personal solutions for sculpture. Melli showed that further progress was possible after Rosso's Impressionism. He broke away from the traditional approach, as is apparent in such works as the bronze *Lady with Black Hat* (1913). However, he did not go beyond such efforts, and his further development was mainly as a painter and critic.

England had its first contact with the problems of the new sculpture in Jacob Epstein (1880–1959), who had left America for Paris in 1902, and settled in London in 1905. During a second stay in Paris (1912) he became a close friend of Modigliani's and came into contact with Brancusi and Picasso. At that time he began to lay the groundwork of his collection of African and other sculptures, a collection that he kept expanding until his death. In 1912 he also met Paul Guillaume, who had a fine eye for quality in African and Polynesian work. Undoubtedly Epstein shared the contemporary widespread interest in the archaic. As a young student at the Ecole des Beaux-

141

[160] HENRI GAUDIER-BRZESKA. *Red Stone Dancer*. 1914. Waxed stone, 33 1/2 × 8 × 6". Tate Gallery, London

[161] WILHELM LEHMBRUCK. *Kneeling Woman*. 1911. Bronze, height 6' 2". Collection Frau A. Lehmbruck, Duisburg

Arts in Paris (1902), he had been fascinated by early Greek and Cycladic sculpture (an influence apparent in the *Mother and Child* of 1913 [152, 158]) and by Egyptian and Iberian work, for example, *The Lady of Elche* in Madrid. With a master's eye he saw the great qualities of what sculpture had produced in important periods of civilization in Europe and elsewhere.

Epstein understood how his own time would have to develop. Between 1911 and 1913 he produced some remarkable works—the *Marble Doves* [159], for example—under the influences, equally strong, of Cubism and African Negro sculpture. Later he felt an urge to produce, in addition to portrait work, large, pure, strong volumes, as in *Genesis* (1931) and *Adam* (1939). How genuine were all these artistic impulses in Epstein (who was often attacked and was always a controversial figure in England) is attested by Henry Moore, who, as a young and unknown sculptor went to see him in the mid-1920's. Epstein was enthusiastic and bought Moores, then and later.

Fully open to the message of his time, Epstein knew the great traditions thoroughly and was completely involved in monumental sculpture. Yet, except for some designs in a larger style (*The Hudson Memorial–Rima*, Hyde Park, 1925; *The Statue of Night*, Underground Headquarters Building, Westminster, 1929; *Madonna and Child*, Cavendish Square, 1950), he expressed himself best in portraits [77, 95, 96] and in certain larger figures, in which his admiration for Donatello and Rodin can be sensed. His warm feeling for and vision of man, about which Henry Moore wrote so spontaneously and appreciatively,[52] was best expressed in a form that was a more Expressionistic continuation of Rodin's turbulent forms and, at the same time, involves shadings and details producing an almost pictorial and sometimes a violent, dramatic effect. As Moore said, Epstein had taken the beating for artists who were to follow in England. And in sculpture, in the absence of a sculptural tradition and a conception of the art, greater resistance had to be overcome than anywhere else.

Epstein had a powerful will. Like Rodin, he felt the attraction of a mighty past, as his collection shows. After an initial interest in Brancusi and Cubism, he, like Nadelman and Archipenko, sought other solutions. Epstein's nature was opposed to abstraction, and he was not concerned, as were young Lipchitz and Laurens after him, with the problem of space posed by the Cubist painters.

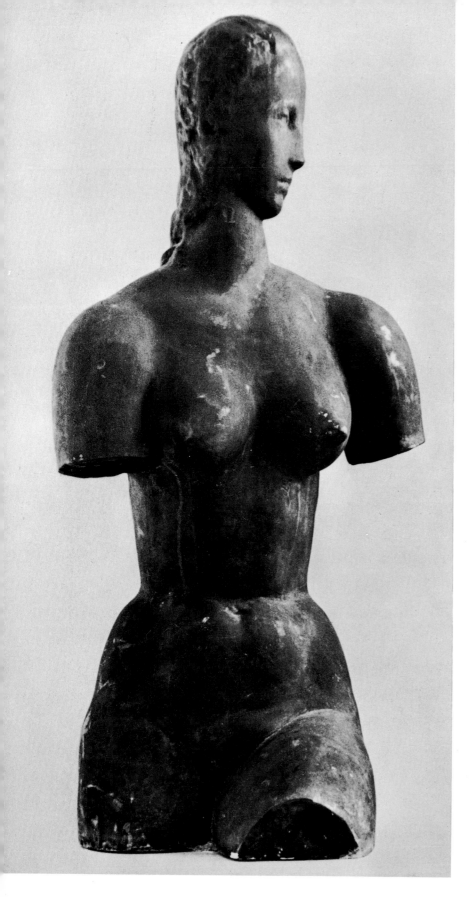

[162] WILHELM LEHMBRUCK. *Torso of a Girl.* 1913–14. Cast stone, height 38″. Wallraf-Richartz Museum, Cologne
[163] WILHELM LEHMBRUCK. *Seated Youth.* 1918. Bronze, height 41″. Städtisches Kunstmuseum, Duisburg

Epstein was hostile to Futurism, perhaps because of the negative impression made on him by the great to-do accompanying Marinetti's appearance in London. He was too solidly anchored in the old craft, too convinced of the values of tradition (which to England still looked sufficiently revolutionary after the way he introduced them), to understand the Italians' need for liberation from historical pressures.

In like manner, Epstein looked askance at the fashionable enthusiasm that greeted young Henri Gaudier-Brzeska (1891–1915), who was completely open to the new modes of representation and abstraction [160]. As a native Frenchman, Gaudier-Brzeska was familiar with these, but he transplanted them, so to speak, in the artistic soil of the London of 1912. Epstein may have been right in calling him a "follower of styles," but such followers were cultivating ground that, as we shall see, was to prove fertile. Gaudier-Brzeska, who lived only to the age of twenty-four, was undoubtedly a great and exciting talent. He was not of the magnitude of, for example, Duchamp-Villon, and was condemned at first in Paris, but his short life was, especially for the London artists, an unmistakable ferment. This nervous, unpredictable man was rich in possibilities that, owing to his untimely death in the war, came to naught.

From 1910 to 1914 Cubism operated as a magnetic field, attracting and then repelling figures who, in any case, came to know themselves in the course of their experience. Among them was Wilhelm Lehmbruck (1881–1919), who came from the mining district of Duisburg. No one would think of including him in a history of Cubism, and yet he is another of the marginal figures who made a solid contribution to the shaping of the new sculpture in a climate that had been created by Maillol, Brancusi, Modigliani, and the Cubists themselves. Keeping intact his ponderous North German nature, he took up his own position in the explorations of new possibilities for sculpture.

Lehmbruck expressed ideas in three dimensions by means of the human figure and without any tendency toward abstraction, ideas that attest to emotional attitudes and feelings typical of the second decade of the century. His works would be dated were it not for the stillness they impart—a silence that does not characterize the work of anyone associated with the Cubist group.

Brancusi, Duchamp-Villon, Boccioni, and, later, Lipchitz were

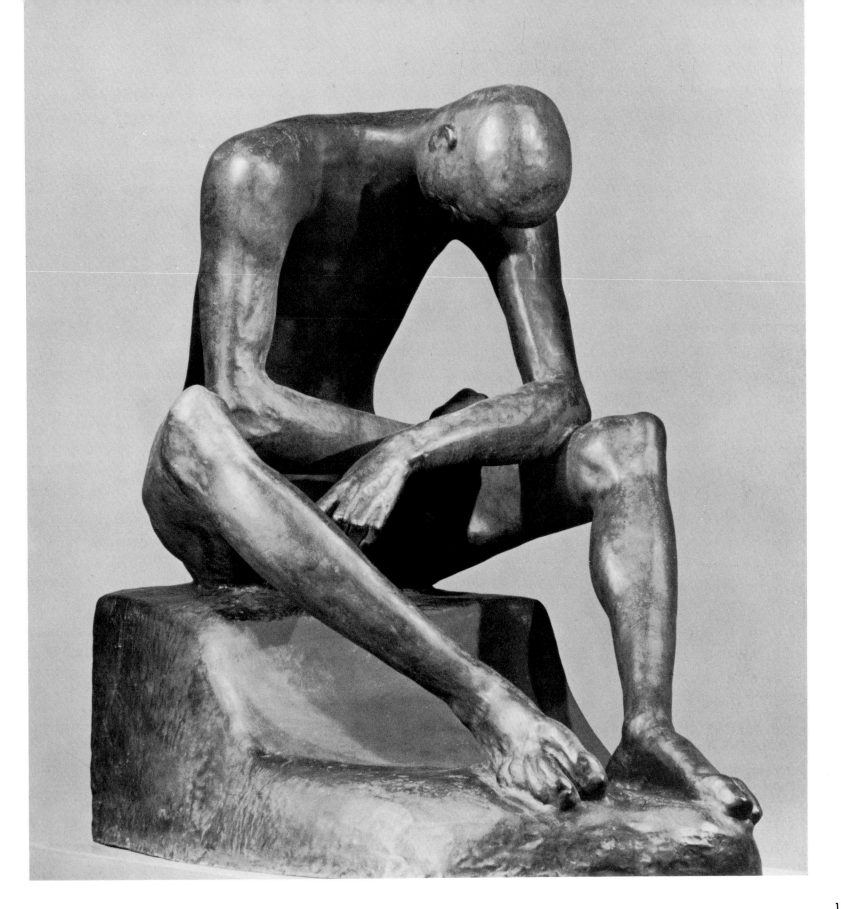

eagerly concerned with processes of refinement or simplification. Lehmbruck, however, is an elegiac, negative, Rilke-like figure in sculpture, one who gives voice more to nostalgia than to the future. It is firmly established that he was well acquainted with the work of the Belgian sculptors Constantin Meunier (1831–1905) and Georges Minne (1866–1941). In this connection, mention may be made of the authority that Henry van de Velde, architect and propagandist, had begun to acquire in the Ruhr region, where, through his influence and that of Carl Osthaus, founder of the Folkwang Museum in Hagen, Belgian art came to be known and admired.

In a noteworthy study[53] of Lehmbruck's Paris period (1910–14), Hans Trier adduces evidence pointing to the possible influence of Modigliani. Lehmbruck frequently visited Brancusi's studio, where Modigliani was working. According to Trier, Lehmbruck also knew Matisse and Derain. All this is in connection with what is called a "Gothic" trend. In Brancusi's studio Lehmbruck certainly saw the leaning torso of the *Narcissus* (1913) and the reclining heads (from 1906 on [135]). In fact, the sharp forward inclination seen in the 1914 *Female Torso* [149] appeared as early as 1907 in the work of Duchamp-Villon [115]; it has a curve that appeared later in the much more abstract *Horse* [124]. No such evidence of introspection and self-indulgence is to be found in Maillol, whose sculptural signature remains the vertical of the *Île de France* and the horizontal of the Cézanne monument. The curve of such figures as we see in his *Night* and *Idea* is arrested at once by the line of the drawn-up knees.

What was called Gothic was in reality the appearance of a modern mannerism. This mannerism, evident in many artists, was no longer Art Nouveau or Expressionism. A surrender to a stylization intended to be both expressive and beautiful, it took many forms akin to Cubism in Modigliani, Minne, Archipenko, and Matisse. Psychologically, it can probably be explained as the outgrowth of a suppressed longing to return to the late nineteenth century, to the autumnal moods of, for example, Gustave Klimt and Egon Schiele in Austria. The harrowing, sometimes perverse moods evident in Lehmbruck's drawings and prints are expressed with a will to be up-to-date, despite everything, and, at the same time, a fear of the new and a desire to escape it. The boldness is derived from other artists; it was the Expressionists and the Cubists who incited others to bold

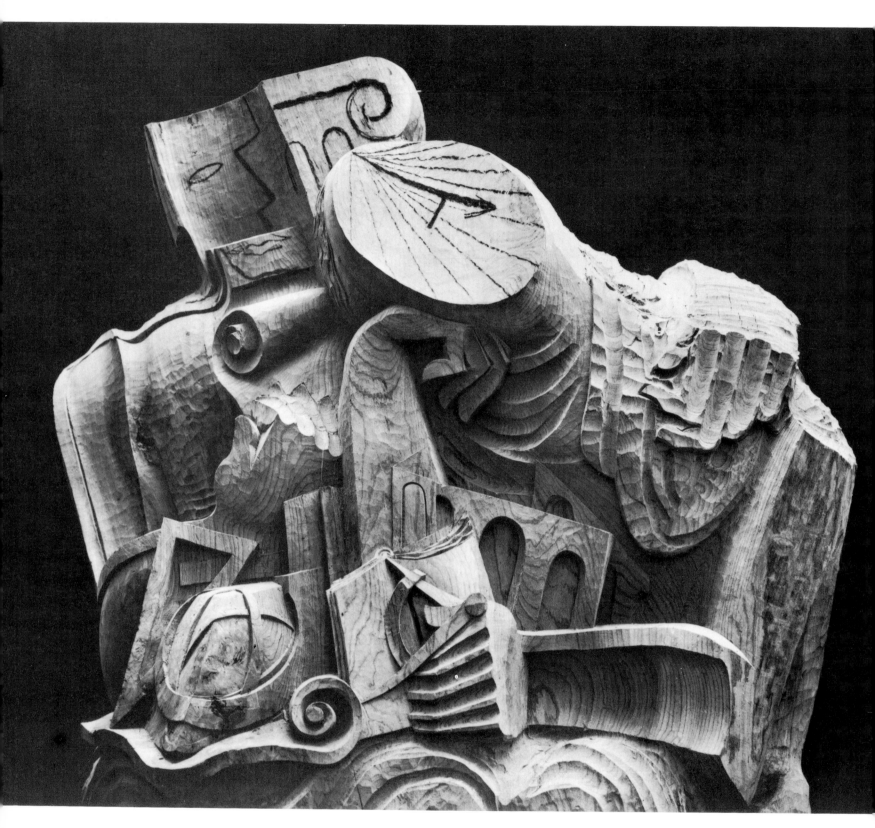

150

[166] OSSIP ZADKINE. *Homo Sapiens* (portion). 1934. Wood. Musée National d'Art Moderne, Paris. [167] OSSIP ZADKINE. *Head of a Woman*. 1943. Quartz. Collection John Stephan, Newport, Rhode Island

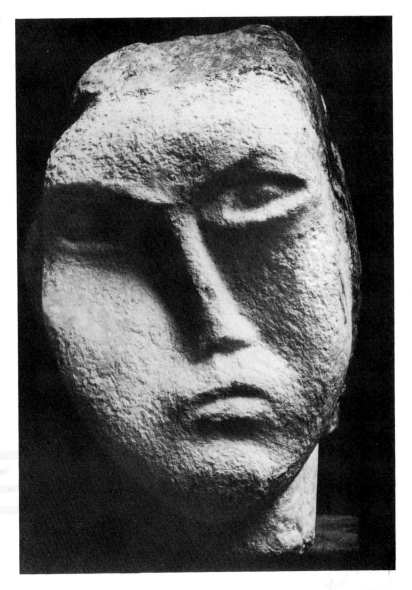

solutions and greater freedom. Lehmbruck's fine elegiac mannerism of 1911 [161] seems to have been the result of his daring to be himself at last, of his being given courage by the powerful ferment of the Paris atmosphere. The fact that he deviated from the example of Maillol was simply a sign of self-fulfillment and of heightened awareness of his German temperament. Lehmbruck had nothing of Maillol's overt sensuality. What lived hidden in Lehmbruck remained unseen, but his depth now manifested itself in a freer linear form. He wished to go beyond the archaic and work toward a primeval beginning, but, unlike the Spanish and Russian artists in Paris, he allowed himself, in keeping with the example of the Romantic German past, to be guided by the flow of his feelings. Besides, he was more sensitive to the surface and the silhouette than to the tension of the volumes. "Hence, there is no monumental architectonic art without outline or without silhouette, and silhouette is nothing other than surface."[54] Essentially his views were much the same as those of Adolf Hildebrand, who saw relief as the core of the matter. What was new in Lehmbruck was the style, which brought a deep elegiac mood into sculpture [162, 163].

A final figure to be included among the artists who discovered their style in the ambience of Cubism is Ossip Zadkine (1890–1967), who was born in Smolensk. Zadkine could almost be included in the Cubist school were it not for the fact that after a side glance at Cubism he went through a distinctly personal evolution in which there can be no question of any identification with that movement. Moreover, he never felt the need to free himself from the shadow that the giant Rodin had cast over the younger men.

Zadkine never denied his derivation from and admiration for Rodin and Bourdelle. His road to Paris (1909) led through London (1907), where he encountered only academic misunderstanding of sculpture. Epstein alone had broken with traditional opinions; his *Strand Statues* for the British Medical Association Building (1907–8) had been executed but undoubtedly were not yet installed. In any case, Zadkine's English experience reinforced his conviction that sculpture had to work its way out of the blind alley of the Renaissance academies. In France, like other gifted young men from Eastern and Central Europe, he discovered the Romanesque: "The white woods of the Romanesque Middle Ages, the ordered excess of the Gothic, the genius of the Greeks—and even now I still recall vividly the deep and

disturbing experience of discovering the Egyptians and Sumerians."

It was in 1924 or thereabouts, when his work was already formed and mature, that Zadkine went more deeply into the problem the Cubists had set, first for painting, then for sculpture. Until about 1924 there is in his works something of Archipenko, Lipchitz, Picasso, Duchamp-Villon, of the Futurists. Certain simplified facial curves and postures in his work of 1911 suggest Brancusi, the only contemporary who could have influenced him, but the likeness is so superficial, so unrelated to Brancusi's purism, that there can be no thought of any actual connection. The basis of Zadkine's initial drive was rather a novel and expressive carving of wood and an innate feeling for the nature of wood and stone.

151

In 1912 a freer, less aesthetic handling of wood can be seen in *Les Vendanges;* there is a fresh and direct manner that evokes African sculpture. In 1914 he executed the marvelous *Job* group of five figures in wood, in which the kneeling figure unmistakably recalls the figures of the Belgian sculptor Georges Minne, and the others suggest old Byzantine postures in a modern stylization. In any event, Zadkine, along with Mendes da Costa in Holland and Minne in Belgium, was on the way, via an architectonic monumentality, to a lyric style [150].

Zadkine's background explains the fact that he first became well known chiefly in Holland and Belgium. But the Zadkine whose style unfolded in accordance with his own nature was not the Zadkine of earlier years, of 1918–19; the new Zadkine handled the forms and proportions of the body more freely, with an Expressionism that was no longer Latin but was not German or Flemish either. In the figures of mythical women rising out of the material and in the simple heads built up out of large surfaces, there is enough myth to give the figures airiness, the free flight of the poetic soul, but not enough to destroy belief in reality. About 1924 Zadkine fully adopted the convex-concave principle that had come to the fore in the sculpture of the Cubists, a principle which had not been unknown to him but which he had not yet really applied. He did not handle it in a doctrinaire way; he used the principle more pictorially than Lipchitz. His work was more lyrical and had an element of the narrative—indeed of the epic—that was completely in keeping with his personality.

Zadkine's literary gifts appear in poems and in his *Voyage en Grèce* and *Trois Lumières*.[55] A steady flow of etchings, drawings, and gouaches accompanied his work as a sculptor. Color plays a great role in his

pictorial power, but the sculptor dominates the composition. It is not that a third dimension originates from his gouaches: on the contrary, the sculptor is truly to be found in the gouaches. For this sculptor, space is not only form but also color.

The figurative in Zadkine remains basic; the enclosed volume is all-important. Concavity is used with moderation, and it never affects the volume essentially. He likes to associate volume with the graphic by incising on the surface a hand, a flower, or, in the manner of the Sumerians, a poem. From time to time, preoccupied with the interpenetration of surfaces, the convex and concave, and the transparent—all of which elements derive from Cubism—he also makes Baroque figurative constructions with a relief character corresponding to his emotional nature, which in later years manifests itself in a dramatic, sometimes stormy, expression.

His range is very wide and includes simple, powerful heads [167] in stone or wood, single, female figures [168], also in stone or wood; groups of two or three figures, sometimes in ebony; and the expressive, colorful Baroque of *The Sculptor* (1930), *Homo Sapiens* (1934 [166]), *Homage to Bach* (1930–36 [165]), the *Project for Rimbaud Monument* (1938 [164]), *The Birth of Forms* (1949), and *The Labyrinth* (1950).

Whatever may be said of his later Baroque and its slackened power of form, Zadkine will always be known as a sculptor who lived in indissoluble unity with the inspiring forces of wood and stone. In his best works we perceive something of the aura of the material as well as the image of the man who identified himself with it.

153

[169]

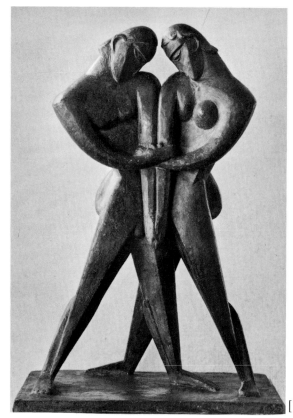

[170]

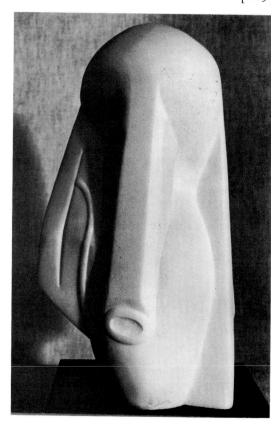

[171]

6

Cubism in Sculpture

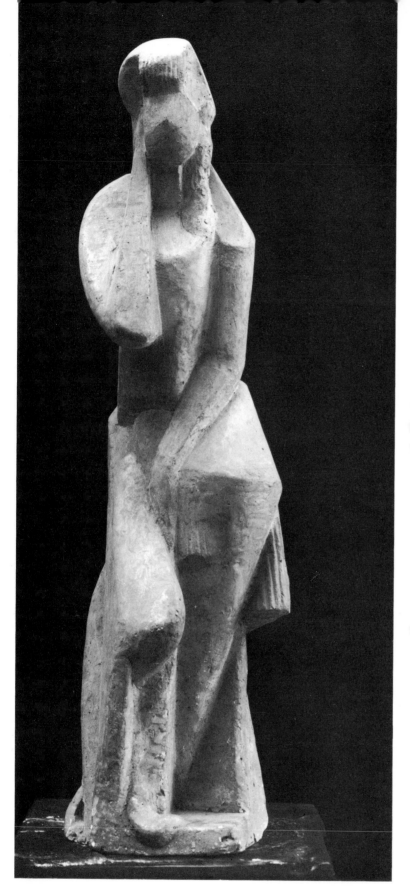

[172] JOSEPH CSAKY. *Standing Woman*. 1913. Bronze (proof). Musée National d'Art Moderne, Paris. [173] JOSEPH CSAKY. *Head of a Man*. 1914. Bronze. Musée National d'Art Moderne, Paris

In the artistic milieu created by Braque and Picasso and maintained by others—Jacques Villon, Raymond Duchamp-Villon, Jean Metzinger (1883–1956), Albert Gleizes (1881–1953)—only a few courageous figures resolutely entered the domain of the three-dimensional. The year 1912, when, as noted, Braque and Picasso started to make out of paper objects that they called constructions or sculptures, and that influenced their drawing and painting, was the year in which the twentieth century demonstrated, in a modest but clear way, that its leading painters were no longer satisfied with the two-dimensional plane. The timid attempts actually to create space in what until then had been flat painting have since developed into a general phenomenon. Until well into the nineteenth century, relief had been considered a fundamental aspect of sculpture; as Adolf Hildebrand asserted, it was for centuries a dominating element in sculpture. From Cubist painting developed a basically new relief with not the slightest relation to the conventional relief of sculpture. By their delicate handling of space, Picasso and Braque achieved cylindrical, cubelike, and conical forms, but the art of sculpture was not involved in their pursuits. Archipenko experimented with his sculpto-paintings; Boccioni and Duchamp-Villon posed the problem of space in close connection with that of motion.

A young Hungarian, Joseph Csaky (born 1888), came to Paris in 1908 and, with Duchamp-Villon and Archipenko, took part in the 1911 *Salon d'Automne* as a Cubist sculptor. If we view Cubism exclusively in its doctrinaire aspect, Csaky appears to be the only one who then

[169] HENRI LAURENS. *Woman with a Fan*. 1919. Bronze, $10\frac{3}{4} \times 24 \times 10\frac{1}{2}$". Galerie Louise Leiris, Paris. [170] JACQUES LIPCHITZ. *The Meeting*. 1913. Lead, height $31\frac{1}{2}$". Collection the artist
[171] JOSEPH CSAKY. *Head*. 1920. Marble, height $10\frac{3}{4}$". Rijksmuseum Kröller-Müller, Otterlo

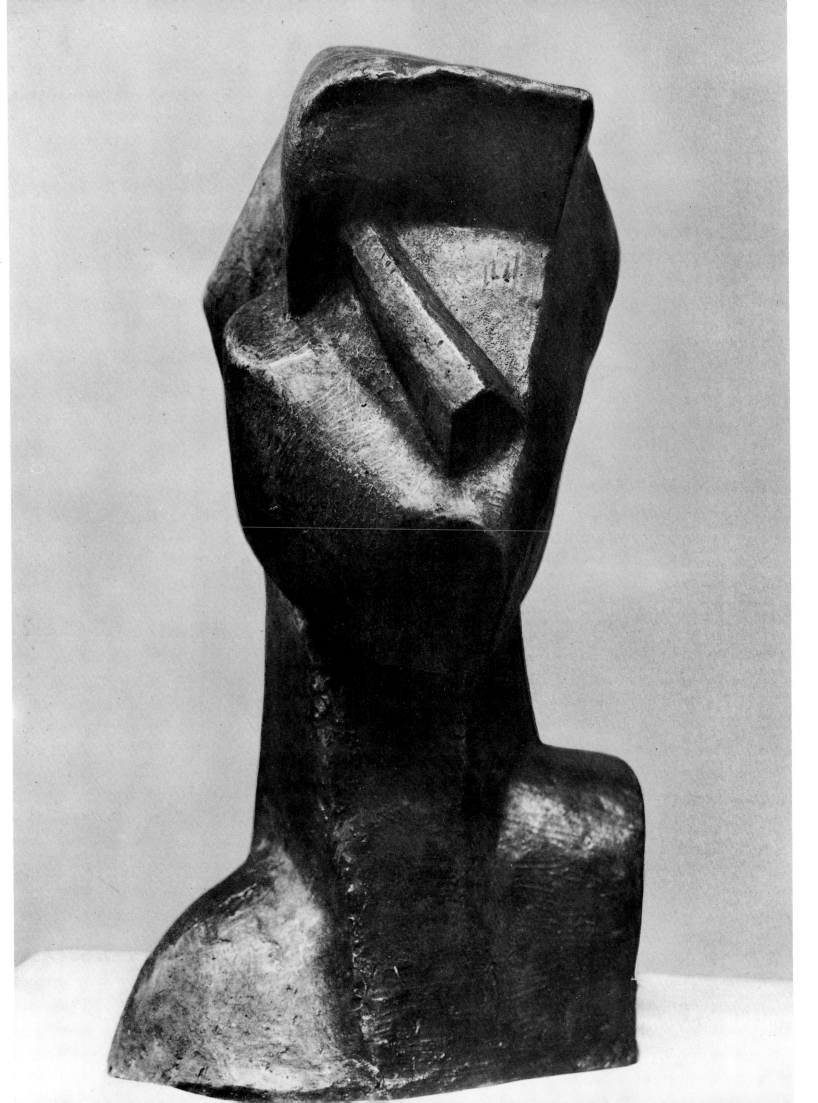

157

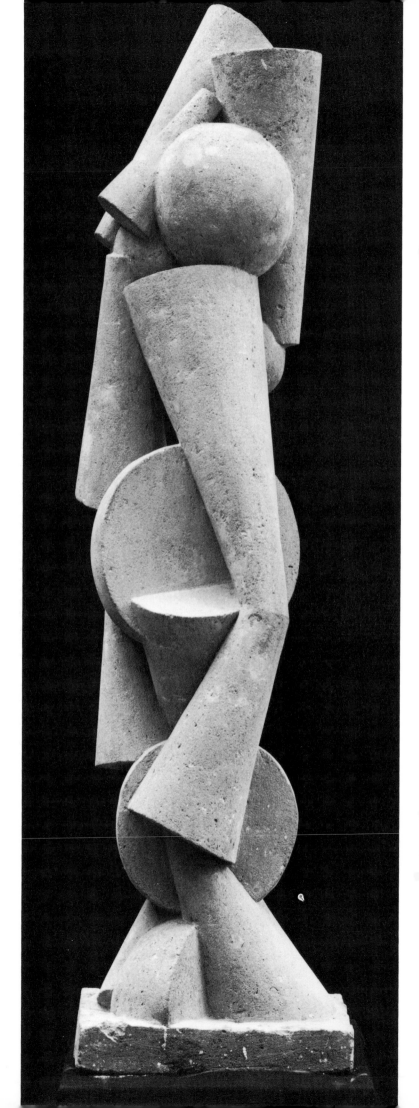

developed, if in a somewhat introvertedly obstinate way, a three-dimensional Cubism in plaster and stone. He worked along this line until about 1925. In 1919 he had arrived at a pure abstraction of geometrical forms—cylinders, half and complete spheres, cones, planes [174]. In 1920 such works were followed by particularly delicate polychrome reliefs, and by 1922 the human figure had timidly bloomed amidst this absolute abstraction. It was then that Csaky was perhaps at his best. The vertical, which was inherent in his artistic nature, led him by way of abstraction to the column, and finally his hands turned the column into a figure again.

Csaky effected the transition from abstraction to a more figurative form characterized by a delicate, almost feminine, reserve. His sculptures of the period of the transition are distinguished by their graceful refinement [171]. In 1922 came the reaction to this: a more architecturally severe style, a monumentality, which was always relieved, as his Cubist works had been earlier, by a quiet decorative element. His later, slowly developed rejection of abstract art was reinforced by a trip to Greece; his taking the past as point of departure in his effort to arrive at a new conviction is comprehensible if one understands the humane, harmonious accents in his earlier Cubist and abstract periods [172, 173]. His organic development was, after all, that of a man essentially averse to the violence and explosiveness of the expressive character of his time; at a certain point he undoubtedly felt that abstract forms no longer enabled him to express himself fully. Csaky's role in those hard and strenuous early years from 1911 to 1921 was, and remained, that of a true initiate, an initiate who, preserving his own introvert character and attitude, led sculpture to a state of deeply pondered purity. Also characteristic was the element of harmony that Csaky succeeded in keeping alive in all his work—a statement not always applicable to many of his contemporaries. The *Clad Woman* (1913) is typical of his approach: the transformation of bodily forms into geometric forms is accomplished with simplicity and a splendid rhythmic sense of space.

Henri Laurens (1885–1954) and Csaky knew each other well, and although Csaky acted upon strict Cubist principles in sculpture some years earlier than Laurens, a certain stylistic relation between the two came to be observed [169]. It was Laurens, however, rather than Csaky, who received a number of important commissions in later years. But Jacques Lipchitz (born 1891) actually, in 1913–14, carried the new conception of space beyond surface effects into the very core of sculpture. Lipchitz did not regard Cubist sculpture as a game, as mere experimentation: it was not a brief fascination but, like everything he tackled, the subject of a penetrating search

[174] JOSEPH CSAKY. *Abstract Sculpture*. 1919. Stone. Musée des Beaux-Arts, Liège. [175] JACQUES LIPCHITZ. *Man with a Guitar*. 1915. Limestone, height 38¼". Museum of Modern Art, New York (Mrs. Simon Guggenheim Fund [by exchange])

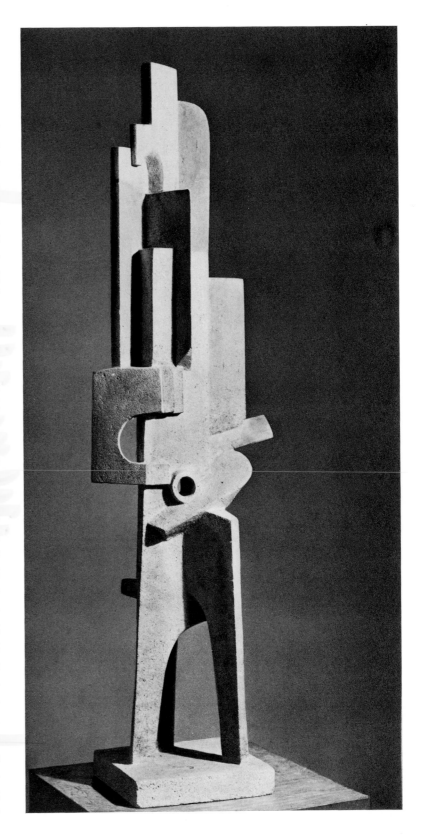

involving the full concentration of his great sculptural genius. He never practiced Analytical Cubism, under Picasso's influence, as is sometimes erroneously asserted in the literature. In the *Woman with Serpent* and *The Dancer*, both of 1913, as well as *The Acrobat on Horseback*, of 1914, we find a smooth surface, a great simplification of form, a predilection for curves and the spiral (not, however, to the exclusion of an occasional straight line), and, upon careful observation, the beginnings of the Synthetic Cubism of Picasso. The severe geometric structure of *The Meeting* [170], also of 1913, represented, along with the schematic masks, the completion of a sculptural vocabulary which was to be expanded in the following years.

Between 1913 and 1928 we find in Lipchitz' work—which is never pedantically one-sided but always ready to explore new possibilities —an elaboration, in three dimensions and relief, of the spirit, not the letter, of Cubism. The works of 1915 and 1916 are so geometric that they border on abstraction [175]. Curves are reduced to a minimum, and vertical straight lines dominate. The old volume of the sculpture has disappeared and has not—as in the case of Archipenko—been artificially replaced by the sphere, cylinder, and cone. The planes and apertures, disposed on top of or alongside one another, form a figure in space without creating any illusion of physical volume. Everything is formulated concretely and clearly. A rhythmical, almost architectonic, sense of space underlies these new figures [176]; decorative effects are eliminated. This was a phase in the long series of works that never repeated themselves, a phase whose like is not to be found in the other experimental ventures of the same period— for example, the abstractions of Vantongerloo, the Belgian representative of the De Stijl movement [206]—because there is nothing theoretical about it. On the contrary, in this period, Lipchitz' work has the lucidity of a living principle that needs no rationalization in order to become a work of art. We find in Lipchitz, creatively concentrated, the sense of touch as well as the sense of space, an intelligent understanding of structure as well as of shape.

The unhurried patience, the certainty, and, above all, the authenticity of Lipchitz' plastic art—and this at a time when people were tired of the superabundance of sculpture by painters—were recognized by André Salmon, who, as late as 1922, complained that genuine sculpture exhibitions were all too rare and that consequently

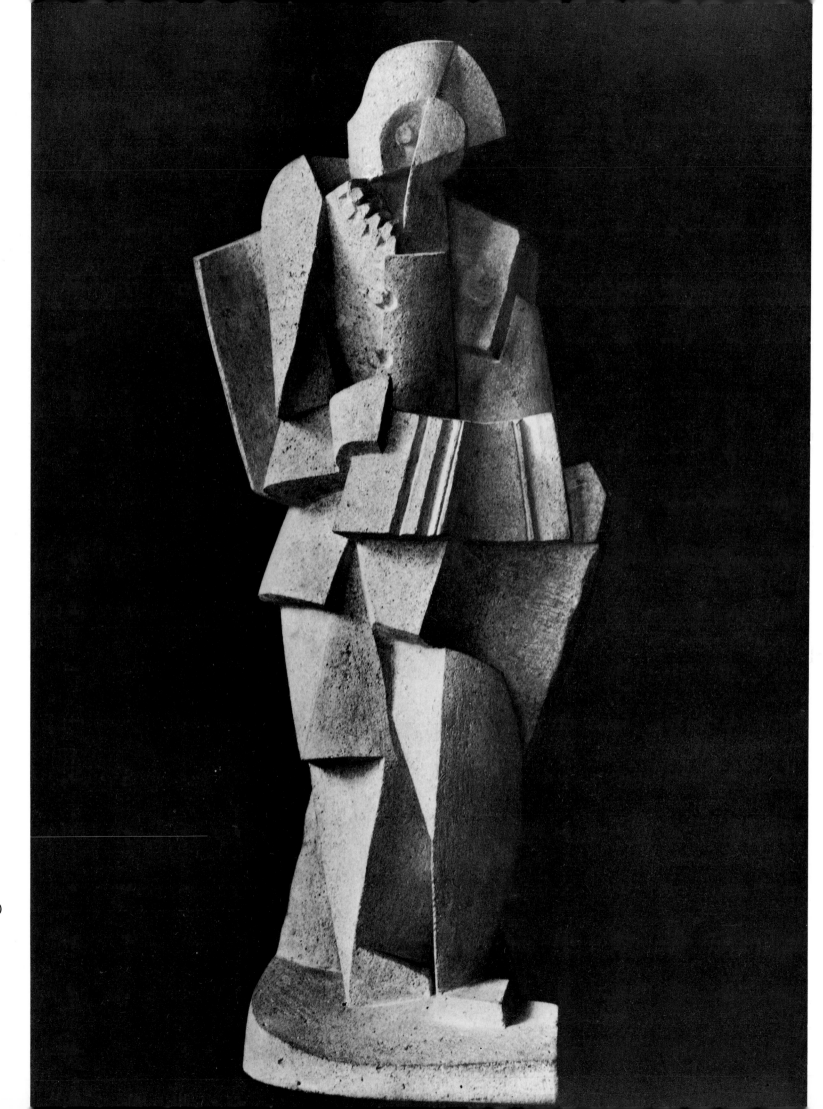

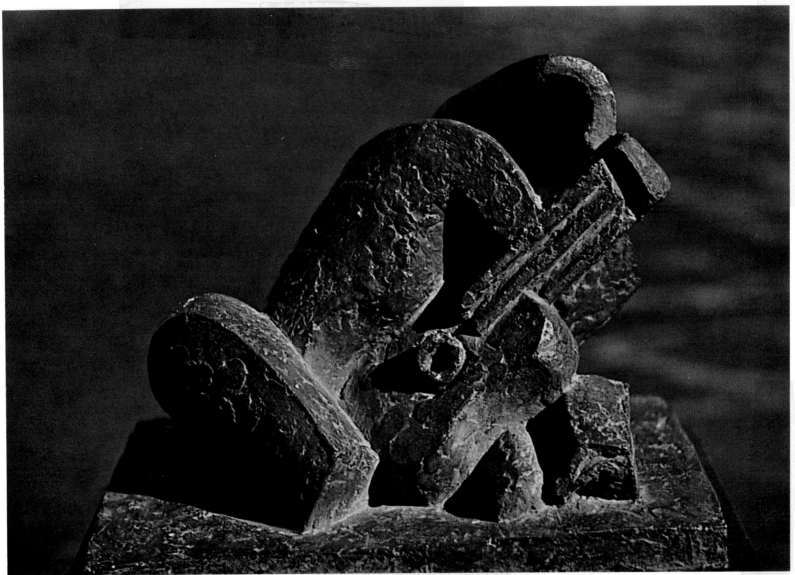

too few people had learned to perceive the sublimity of sculpture. He saw Lipchitz' influence, his power, the already rich lifework of a sculptor "who reasons without systematizing, who, though he knows how to consent to sacrifice, does not completely break with humanity."[56] Maurice Raynal and Waldemar George also drew attention to the great qualities of Lipchitz' work when it began to be exhibited more often.

The experiments of Braque and Picasso in 1912 with collages and *papiers collés* were symptoms of the uneasiness of the painters who felt imprisoned by the flat surface. Lipchitz had always drawn a great deal. In the war year 1918, when he lived in Beaulieu—as did Juan Gris (1887–1927), Marie Blanchard (1881–1932), and Metzinger—

[176] JACQUES LIPCHITZ. *Harlequin with Accordion*. 1918. Stone, height 29 1/2". Present owner unknown. [177] JACQUES LIPCHITZ. *Reclining Nude with Guitar*. 1925. Bronze, 6 1/4 × 8 1/4 × 17 1/4". Stedelijk Museum, Amsterdam

he produced drawings and reliefs, having neither the materials nor the opportunity for sculpture. In these reliefs, or sculptured still lifes, his keen sense of rhythm and composition is coupled with a chiaroscuro that makes them not translated paintings but reduced sculptures.

The transparent structures of 1925–26 were in a sense the spatial sequel to the reliefs: Lipchitz eliminated all confining elements, and

161

the volume was reduced to a minimum. Before long he completely eliminated every link with painting. There is no longer a play of concave and convex. Using thin strips the artist plays on space as if it were a musical instrument; the curves express motion and reveal a lyrical passion.

Lipchitz' transparent structures, which are an extension of Cubist ideas, have become a separate chapter in the evolution of modern sculpture. In a rich variety of works, he explored the problem of the excessively reduced volume and the line in space, about which Boccioni and a number of architects had talked and written and which the Constructivists had carried into the domain of absolute abstraction in their own way. Lipchitz solved these problems by adopting a semifigurative style. The themes that led him to the almost inexhaustible fantasia of grates, railings, little cables, and irregularly

constructed planes are taken from the Commedia dell'Arte—little harlequins in all kinds of attitudes and positions [178–181]. Such themes were cherished by the Synthetic Cubist painters.

The essential characteristic of Lipchitz is that he does not stylize. After the first still emotional and timid attempt to break through the closed compactness of sculpture, he took the enormous stride toward total openness [184, 185]. It is evident that he could afford to take this risk only when he realized from his experience and knowledge of the casting of bronze that it would be possible to achieve what his imagination envisioned. He is one of the few who included the process of the casting of bronze in his conception. The carving in stone or wood, the healthy and splendid reaction against the dead academic practice of letting assistants turn the molded clay model into stone or make a cast of it, signified the reawakening of the spirit of sculpture, but

162

with this came the danger that sculpture might become a replica of architectonic achievements of the past. Zadkine knew how to avoid the pitfall and succeeded in carrying through this revival of stone and wood. And Lipchitz, who was not afraid of the dangers presented by modeling in clay or by the casting of bronze, succeeded—as no one else did—in reviving the possibilities of bronze [183]. No cast left the foundry without his strict supervision, and, even more important, he would often alter the mold or rework the bronze cast. The nostalgia, which began to be felt in 1945, for a plastic art in open space—out of doors, on lawns, in parks—has once more, not always with justifiable intentions or results, induced sculptors of different convictions and tendencies to promote and extend the casting of bronze, to make it an accepted practice.

Ten years after the extremely rigid verticals of Lipchitz' Cubism,

during which time some powerful bathing figures [182] were produced, he became freer and more relaxed, but only to extend his powers to produce Baroque inventions. These all seem to have been miraculously put together in a playful mood; they appear to be the result of some whimsical idea, but in reality nothing is left to chance. From the base upward, the various directions of the planes are harmonized by an unerring intuitive sense of proportion; every curve, every bend is

[182] JACQUES LIPCHITZ. *The Large Bather*. 1923–25. Bronze, height 6′ 7″. City Art Museum, St. Louis. [183] JACQUES LIPCHITZ. *Song of the Vowels*. 1931–32. Bronze, height 12′ 6″. Musée National d'Art Moderne, Paris

[184] JACQUES LIPCHITZ. *Chimène*. 1930. Bronze, height 18″. Collection the artist. [185] JACQUES LIPCHITZ. *Spring*. 1942. Bronze, height 14″. Collection Mr. and Mrs. Bernard J. Reis, New York

resolved in the following movement. After the preceding period of rigid concentration and construction, his sculpture achieved a sureness that signified a new attitude and new freedom. It would be extremely interesting to assemble the complete series, from the *Harlequins* of 1924 to the *Woman with a Harp* of 1930. These works became the starting point for a development in other artists at the exact moment when Lipchitz himself abandoned these pursuits.

When, in 1923, Picasso turned to sculpture again, he worked in a compact style, and his constructions were not transparent; however, according to Daniel-Henry Kahnweiler, his drawings show that he too was preoccupied with the problem of transparent space. It was not until 1930–31 that Picasso's wire constructions appeared, including the rectilinear models that were really designs for architectonic spatial constructions. This was also the time when, as will be seen, Picasso interested Julio Gonzalez in these problems, with the result that the latter was the first to explore the domain of iron sculpture.

It is sometimes asserted that after his first contact with Braque, in 1911, Henri Laurens was a Cubist, but this does not follow. For some time Laurens confined himself to observing what was going on around him, and he continued to be interested, even after his Rodin period, in Gothic archaism. There can be no doubt that he was deeply involved in the Braque-Picasso-Gris brand of Cubism as well as in that of Léger, Metzinger, Gleizes, Villon, and Duchamp-Villon. Picasso's inventiveness and power made the deepest impression on him. It is characteristic of Laurens, and to his credit, that he quietly mastered his immediate environment before starting to apply the new means offered by Cubism, which was already past its Analytical period. He was never a pioneer in Cubist sculpture, but, needless to say, importance does not attach only to pioneers. Indeed, in addition to the immediate revolutionary effects of a new and powerful principle there are infinite subtle possibilities that manifest themselves in the extensions of that principle.

Laurens's polychrome constructions—in wood [186], sheet metal,

wood and plaster, wood and iron, wood and sheet metal [187], and plaster—date from 1915 on. A comparison with Picasso's drawings, paintings, and constructions of 1911–14 (the guitar motifs, for example) makes clear the extent to which Laurens still dealt with the problem of form and color from the Cubist pictorial point of view. His engravings of 1917 and *papiers collés* of 1918 show the same relation to the Cubist aesthetic as those produced by Picasso from 1911 to 1914. Unlike Csaky, who had mastered the Cubist experience earlier, and had expressed himself three-dimensionally from the start, without first turning to painting, Laurens remained deeply involved in the world of color for years; his constructions were still, to some extent, translations of Cubist paintings.

Laurens's steadfast perseverance and his nostalgia for the concrete finally revealed the true sculptor. His attachment to color led him to attempt a compromise: using color on the sculptural form to control the instability of light on the sculptural surface. Lipchitz also experimented with color; his explanation of the polychromy of the past was more rational, and his apology for polychromy in contemporary sculpture was more penetrating. But Laurens was the exception: he wanted to solidify the action of light by means of color, and on this basis he applied polychromy to his reliefs, sculptures, and constructions from 1915 to about 1928.

During a certain period, Laurens can be classified with the sculptors whom one would like to call—in imitation of Archipenko—"sculpto-painters." In Laurens's lifework the engravings, drawings, and *papiers collés* are highly significant. In them he expressed himself in a manner which always makes one realize the common elements of the three media. There is therefore justification for stressing the relief character of his sculpture, even if the works are no longer reliefs in the literal sense of the word.

Laurens produced his first reliefs in 1919, but this date is no more than a formal delimitation, in view of the close relation of the earlier constructions and the *papiers collés* to the reliefs. Laurens's non-polychrome relief in stone with a musical instrument as motif (1919) and Lipchitz' bas-relief in bronze with musical instruments (*Still Life,*

169

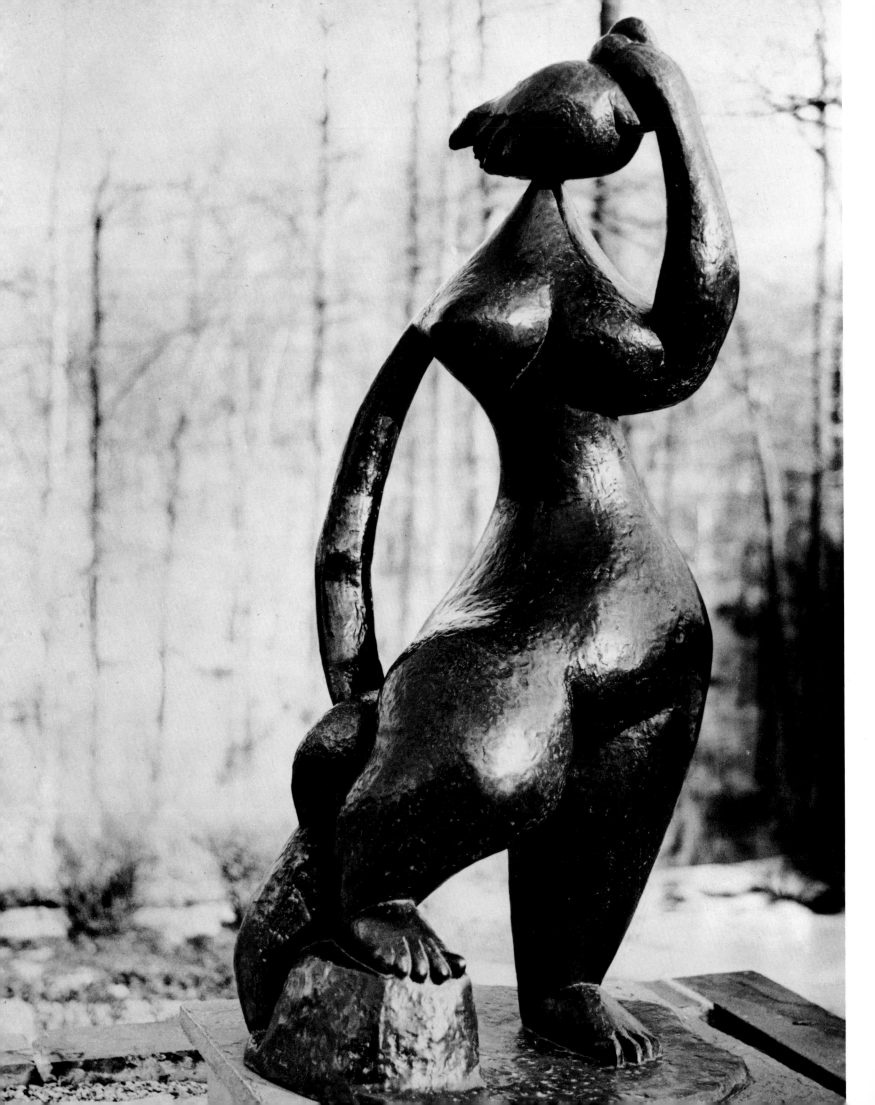

[190] HENRI LAURENS. *Bather*. 1947. Bronze, 63 × 27 ½″. Musée National d'Art Moderne, Paris. [191] HENRI LAURENS. *Large Musician*. 1938. Height 7′. Musée National d'Art Moderne, Paris

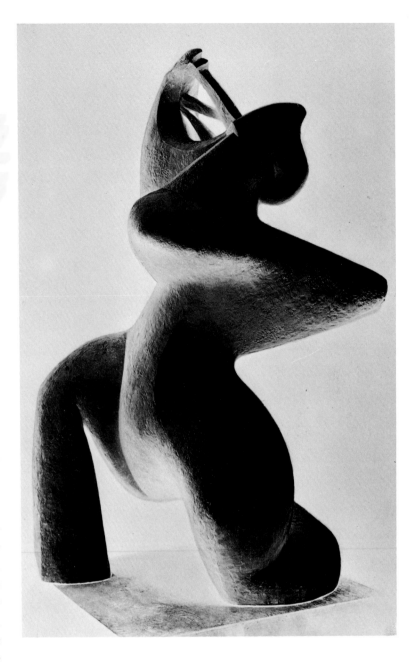

1918) immediately reveal the vast differences between these two artists. In the work of Lipchitz the subjective character of the spatial vision is a complicated, powerful, and at the same time harmonious rhythm, with a lively, almost restless sense of the variety of the planes. In Laurens everything is simpler—harmonious too, but less powerful; the perception of the planes is replaced by a visual and tactile reaction to the surface of the stone. One might say that the whole lies quietly embedded in the plane, which is carved out with sharp edges, the smooth, rugged, or semi-rugged surfaces with little points appealing to the tactile sense by way of the eye. There is no rigid fixing of the composition, no such tension between the planes as is found in the work of Lipchitz. In Laurens's work a thoughtful sensitivity and delicate finesse may be said to have created a skin around his sculptures in stone. The respect with which he treats the stone, bringing out the grain and, to a certain extent, holding the form in check, so that sharp edges never appear as such, gives his work a distinction and, occasionally, a tranquillity that obviate the need for extended dimensions. Laurens seldom impresses the spectator with the largeness of the volume; on the contrary, it is the delicate qualities and the simplicity of the articulations that make his work so appealing [188]. His small sculptures are truly charming.

Laurens was concerned with the contour of his forms in the twenties, when his Cubism showed little decorative detail [189], as well as in the thirties, when his work was characterized by undulating volume and deformation [191]. His Cubism went beyond its Picassoesque origin. The stone is temporarily replaced by bronze. Now and then one has the impression that Matisse's serpentine line and Maillol's poses haunted Laurens during the penultimate period of his career [190]. In his smaller works, the full roundness has a beautiful tension that makes a sculpture such as *The Moon* (1948) much more than simply charming. Laurens, and some of his countrymen, were able to find in Cubism a spirit and an attitude that gave rise to creations so moving as to make it possible once more to use the word tradition in a favorable sense.

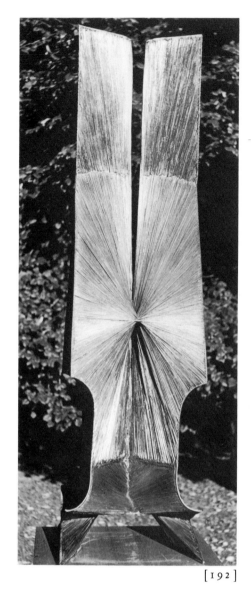

[192]

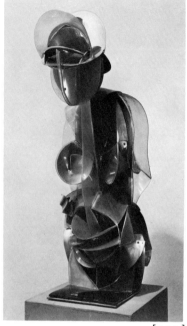

[193]

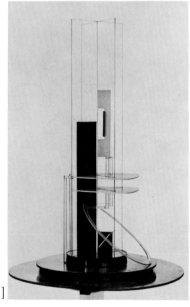

[194]

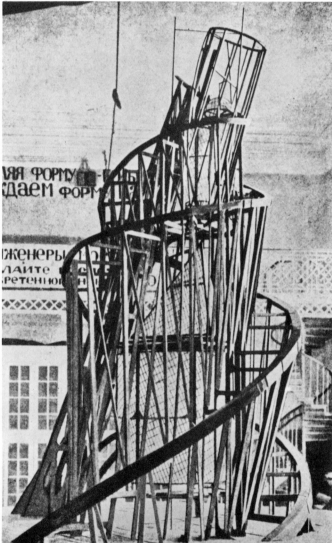

[19

7

The Complex World of the Constructivists

When, as will happen sooner or later, the art of the twentieth century comes to be evaluated, it will, unlike that of the nineteenth, be judged chiefly on the basis of its sculptural achievements, and the evaluation will rest on the work of a few great figures and a number of lesser masters. Moreover, the hydra-headed phenomenon of twentieth-century sculpture will have to be considered in the light of certain trends and tendencies, but never in terms of schools. As a trend Constructivism will occupy an important, if not the most important, place, not because it had the greatest number of followers but because it probed to the core of the complex of problems posed in the first quarter of the century.

It is regrettable that the particulars concerning the appearance of Constructivism and the relations between Russian and West European ramifications of the movement are still incompletely recorded. An instructive book by Camilla Gray, *The Great Experiment: Russian Art, 1863–1922*,[57] has contributed some new data, but we still do not have sufficient material to establish the true relation between Moscow and Western Europe and the real significance of the Futurists, the Cubists, Rayonism, the De Stijl movement in Holland, and abstract art in Poland. George Rickey's *Constructivism: Origins and Evolution* is another useful work.[57a]

Writers have thus far confined themselves for the most part to

describing the personalities of such figures as Naum Gabo (born 1890), Antoine Pevsner (1884–1962), and Vladimir Tatlin (1885–1956) and to defining certain characteristics of their work; these writings have been prudent and accurate. In a more personal, passionate, and partial vision, which is indeed a confession of faith, the American Charles Biederman had arrived at more extreme conclusions in his enlightening book *Art as the Evolution of Visual Knowledge*.[58] But to confine Constructivism to what Gabo, Pevsner, certain Americans, and a number of scattered subordinate figures achieved in sculpture is to view the phenomenon in too limited a way.

Between 1911 and 1914 the relations between certain artists in Russia and Western Europe were close. In the 1920's, for example, El Lissitzky (1890–1941), as a result of his travels and lectures in Europe, established friendly relations with a number of artists and architects, including J. J. P. Oud (1890–1963). It is in the realm of such intellectual exchange that further investigation should be undertaken. We know that the two Cubist groups in Paris, the one around Picasso and Braque and the other around Jean Metzinger (1883–1956) and Henri Le Fauconnier (1881–1946), were joined by Russian artists. But the Russians were not drawn by Cubism alone. The Nabis, too, were attractions, and the Futurists were no less important. (The first Futurist exhibition in St. Petersburg took place in 1915.) Also, the great tradition of icon art fascinated the younger artists. Even Impressionism, which in point of fact had been bypassed in Russia, made an appearance, belatedly, at a time when it had passed its zenith in France. Such artists as Wassily Kandinsky (1866–1944) furnish convincing proof of the great impetus Impressionism gave nineteenth-century art by its reduction of content to a single element, namely, light.

The Russian artists returned to their country from Paris when

[192] ANTOINE PEVSNER. *The Column*. 1952. Bronze, $55\frac{3}{4} \times 15\frac{3}{4} \times 15\frac{3}{4}$". Collection Baron Lambert, Brussels. [193] ANTOINE PEVSNER. *Torso*. 1924–26. Plastic and copper, height $29\frac{1}{2}$". Museum of Modern Art, New York (Katherine S. Dreier Bequest). [194] NAUM GABO. *Column*. 1923. Plastic, wood, and metal, height $41\frac{1}{2}$". Solomon R. Guggenheim Museum, New York. [195] VLADIMIR TATLIN. Model for the *Monument to the Third International*. 1919–20

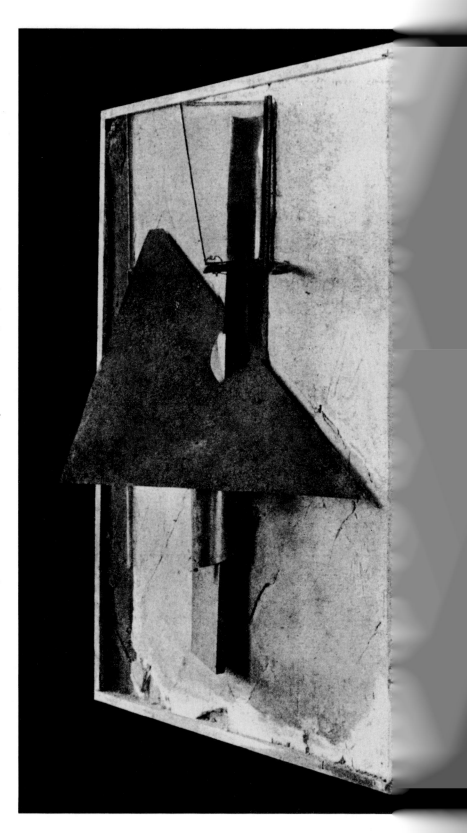

World War I broke out, and in 1917 the Revolution called upon them to join in the collective action for the great renewal. Consequently they were left to their own resources, and only at this point were clearly revealed the enormous possibilities in their own minds—possibilities that at least they themselves thought enormous. These talented younger artists had quickly absorbed what Western Europe had to offer. It was now their turn to produce creative works, not only in painting and sculpture but also in the theater, which was seeking the collaboration of artists. And through the efforts of painters and sculptors a new architecture came into being. At the same time the problem of art and society was posed (in the political sense, too) in a way vastly different from the way it was stated in Western Europe, where it had been kept within the realm of literature and philosophy. When, in 1919–20, the first signs of the Russian government's opposition to the new artistic outlook became perceptible, the fate of the young movement was actually sealed. Nevertheless, it was during this period (1920) that Gabo's and Pevsner's famous manifesto was published and distributed. The opinions of their group concerning the place of sculpture in the new society were vigorously expressed; the declaration exalted the present and its "force of life." The authors called themselves Constructivists—technical engineers. They rejected volume as a definition of space, and mass as a plastic element. Depth was no longer inseparable from perspective; the function of line was to determine direction and no longer to circumscribe or describe. The static was replaced by the dynamic.

It would be an error to regard this manifesto as irrelevant to the other movements in art. Kandinsky's program had already been rejected because he emphasized too strongly the irrational, psychic, and intuitive elements in creative work. But division became ap-

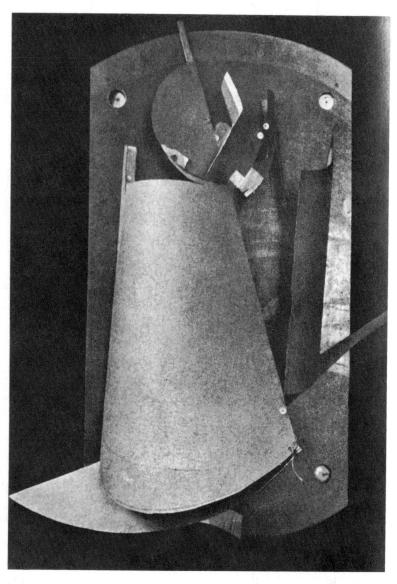

role—a stand that Gustave Courbet (1819–1877) had earlier defended in France. Despite these ideas, the Pevsner brothers continued to believe—and in this respect they were closely allied to Kandinsky—in the creative basis of art, which in all times had played and would continue to play its peculiar role, a role that, from the point of view of the machine and the engineer, might even be called useless.

Even before these theses had been formulated Tatlin had created important works. In his first "painting-reliefs," dating from 1913–14 [196], he had tried to free sculpture from the restraint of the compact mass and attempted to make constructions, all within the scope of the relief. He used the materials—among them tin, wood, iron, glass, plaster—that Boccioni had proposed earlier. He abandoned confining frames in order to eliminate the idea of isolation [197]. His model for the *Monument to the Third International* (1919–20; the project was never executed) is, in principle, the most remarkable example to be found in our century of a union of all the arts in a total composition that embraces everything—sculpture, painting, architecture, cinematography, light, and, particularly, motion [195]. Shortly afterward, Gabo displayed designs for a radio transmitter (1919–20). Gabo himself gave a clear account of these events in an interview with Ibram Lassaw and Ilya Bolotowsky in 1956.[59] When the authorities callously interfered with the carrying out of their intentions, Gabo and Pevsner left their native country. Kandinsky went to Germany, to teach at the Weimar Bauhaus under Walter Gropius (born 1883). A tragedy had been enacted.

The activities that Gabo and Pevsner were able to continue in Western Europe produced a number of works that gave a fundamentally new direction to sculpture. The triad of Tatlin, Gabo, and Pevsner freed sculpture from so-called natural representation, from the old limitation imposed upon it by the subject, the materials, and the volume imprisoned in the compact mass. At the same time, they brought sculpture into the realm of architecture, thereby making it clear that the architecture of their period could no longer arbitrarily include or reject sculpture in accordance with the whim of the architect. Sculpture had acquired a new objective and function in time and space. The aftereffects of the Gothic ideas in Rodin's work and of the Romanesque in Bourdelle's—the movement to revive monumentally the relation between the two arts on the basis of a subordination of the figurative to the structural—now came to an end. At the same time a new road was opened toward the union of architecture and sculpture. An identical conception of time and space was sought, a relation between the means, a mutual recognition rather than a subordination of one to the other—to state the case

parent even among the rationalist proponents of the new, experimental "laboratory art," whose leader in the beginning was the Suprematist Kasimir Malevich (1878–1935); on the one hand there were those who advocated carrying on with the traditional artistic means in the service of the new ideology and on the other hand the advocates of "production art," that is, of an art using the materials and tools of modern production. To this was added the complication that Tatlin and Rodchenko (1891–1956) were supporters of a purely material art produced by engineers, an art pointed toward the cult of the machine. This ultimately implied the disappearance of art, which Mondrian (1872–1944) had also predicted. According to the theories of Tatlin and Rodchenko, the artist had to play a social

[197] VLADIMIR TATLIN. *Relief.* 1917. Various materials
[198] NAUM GABO. *Head of a Woman.* c. 1917–20. Celluloid and metal, 24½ × 19¼". Museum of Modern Art, New York

[199] NAUM GABO. *Construction* (detail of fig. 201). 1954–57. Concrete, steel, and bronze wire. In front of the Bijenkorf Building, Rotterdam
[200] NAUM GABO. *Construction in Space (Crystal).* 1937. Plexiglass, height 22½". Courtesy Marlborough-Gerson Gallery, New York

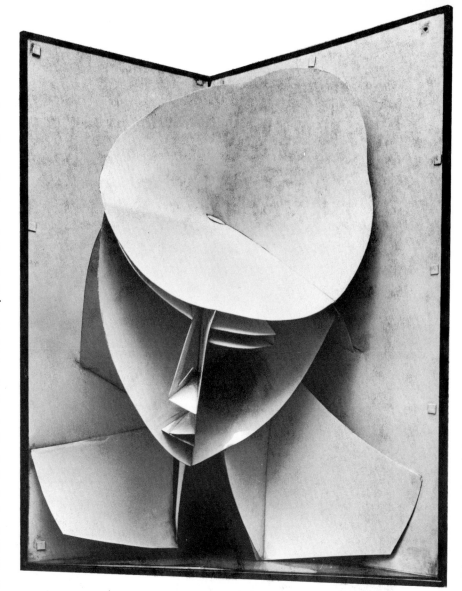

without having recourse to that much-abused word "integration."

The characteristic Constructivist aim of imbuing sculpture with an architectonic quality is also found in Picasso and in Kurt Schwitters (1887–1948). (Their starting point had nothing to do with that of the Constructivists; in the case of Schwitters it was a Surrealist fantasy, in the case of Picasso an audacious dream.) In creating works so motivated, they did not resolve a problem. On the other hand, in the works of Frank Lloyd Wright (1869–1959) and Le Corbusier (1887–1965 [299])—to say nothing of Gaudí (1852–1926 [300–304]) in the Art Nouveau atmosphere—the architectonic form, because of what was perhaps an excess of imagination, veered in the direction of a visually attractive sculptural form, which, however, presupposed a loss of architectonic purity. The conception of space in our own day is complicated by the abundance of divergent possibilities, which makes it impossible to define the twentieth-century conception in a single simple formula. There are times when sculpture and architecture are not satisfied with themselves: the mathematical and organic spaces war with each other and involve architects and sculptors in their quarrel. The Constructivists were the only ones who explored the field intelligently. They alone had an orientation which—if it had been understood and sensibly interpreted by architects at an early date—might have led to original achievements.

Constructivism, as the Pevsners conceived it, was an ideology that might have performed its function in the great interrelationship of society, had society been ripe for it. The political developments in the Soviet Union definitely destroyed this possibility, and the advocates of the Constructivist ideology went to Western Europe and America. Capitalist society as now constituted gave these pioneers a chance only incidentally and sporadically. One such occasion was the awarding to Gabo of a commission to design a monument [199, 201] to be erected near the Bijenkorf Building in Rotterdam, designed by the American architect Marcel Breuer (born 1902).

The carrying out of a big project designed by Gabo makes great demands on engineers and builders. It should be stressed that the background of these works involves much more than can ever be gathered from mere aesthetic criticism. Any serious study of the Constructivists' principles demonstrates ineluctably that these men were aware of the essence of the sculptor's craft in the present period and, to a degree, of the relation between art and society in terms of time and space.

The development of art after 1945, with its background of Dadaism and Surrealism, turned toward the "informal." In such a context the art advocated by Gabo and Pevsner, and by Biederman in America and Jean Gorin (born 1899) in France, stood out even more than before in opposition to the general trend. When, in 1937, Gabo, writing in the review *Circle*, had rejected shading of reality and the subconscious or superconscious perception of it that clung to an immediate and obvious image, he reduced everything rationally to the single reality of existence, of being. He thereby excluded a whole

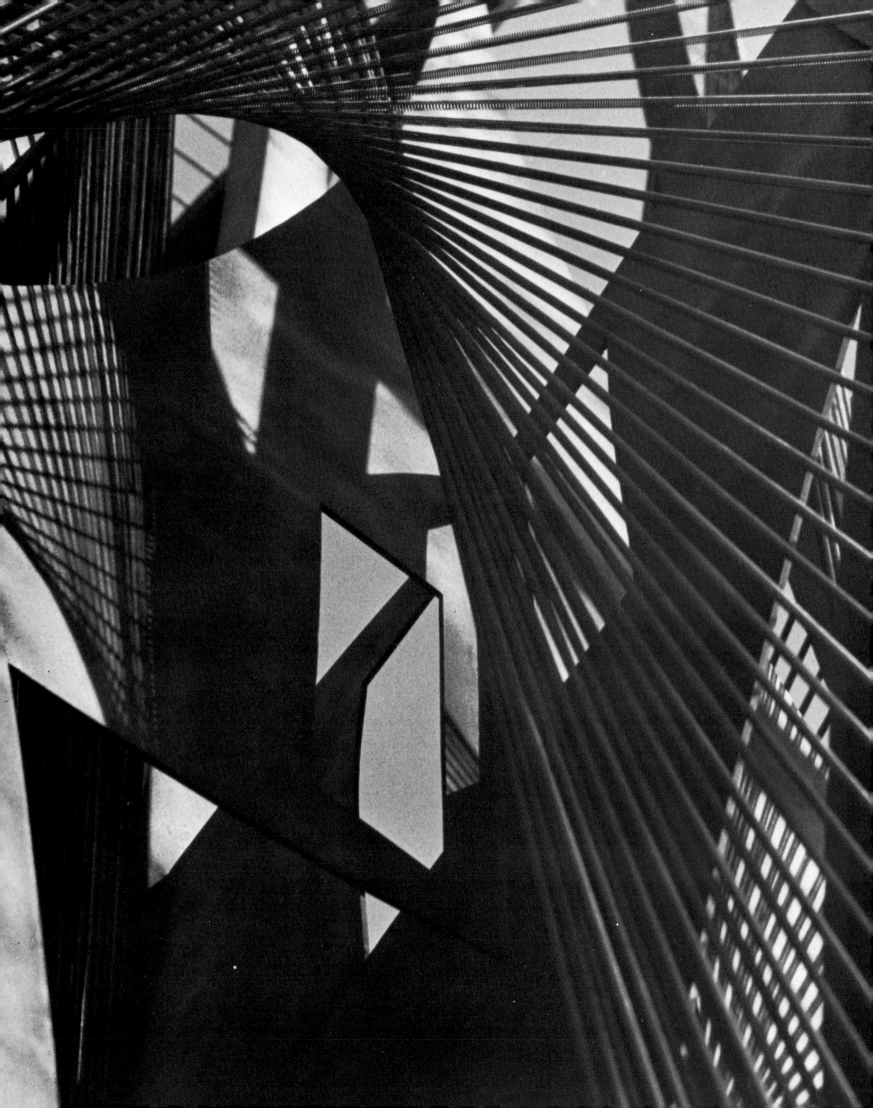

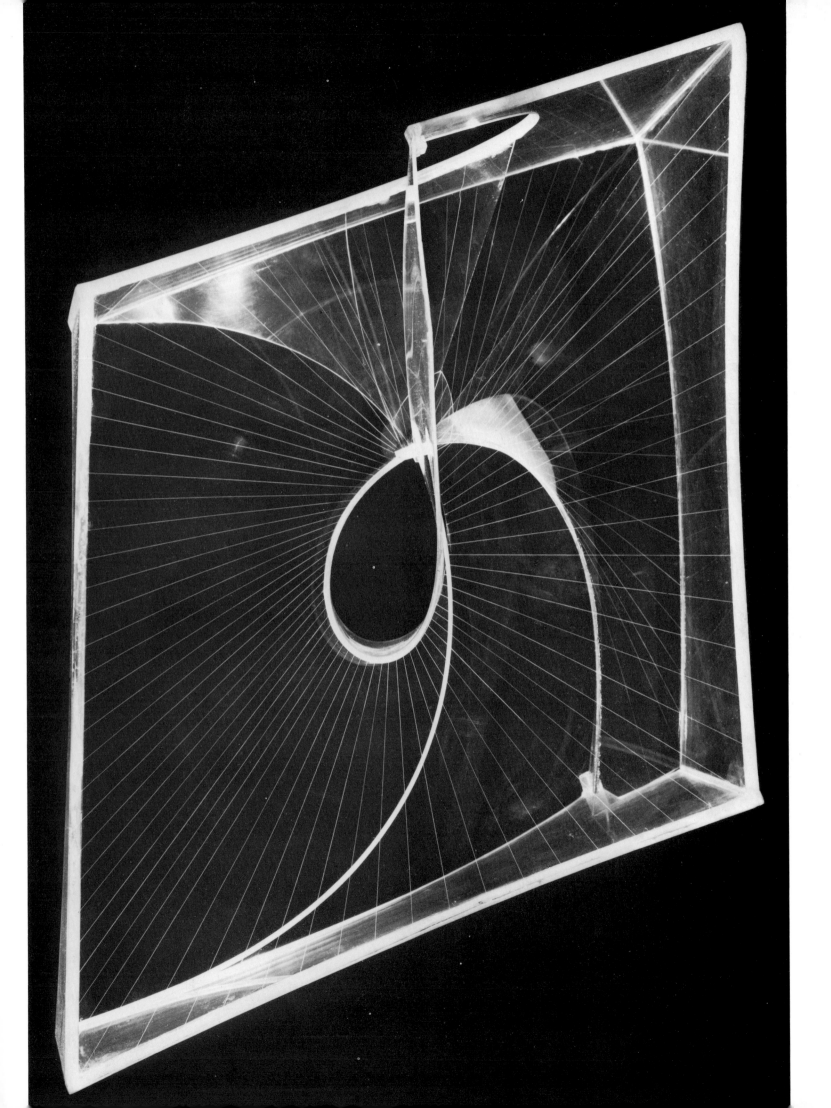

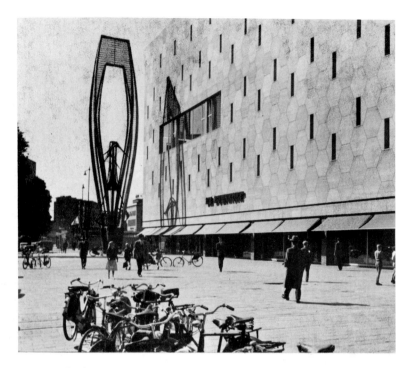

[201] NAUM GABO. *Construction*. 1954–57. Concrete, steel, and bronze wire, height 85'. In front of the Bijenkorf Building, Rotterdam
[202] ANTOINE PEVSNER. *World* (detail). 1947. Bronze. Musée National d'Art Moderne, Paris

area in which our century is deeply interested. In his defense of the special philosophy of life that is the basis of Constructivism, there are overtones of the ethical creed of a generation older than Gabo's, a creed that made Tolstoi go so far as to repudiate art altogether.

In any case, Pevsner and Gabo expressed themselves in their works, whose conception was far more emotional than intellectual, with sublime clarity. This clarity was the result of a perfect elaboration of the structure of the work. They were not inspired by beauty or by fixed images or notions; their art was nurtured by the emotional experience of the human mind in the domain of art and science. They did not use allegory, as Rodin had done in his *Gates of Hell* [51]; rather, they evoked creatively in space—by means of planes and lines that indicate directions—modern man's unceasing, all-embracing flight of thought. Their works are concrete, genuine, and, above all, clear structures, independent of the elucidations of the artist himself; the creative being can never be completely conscious of the deeper urges that activate him to produce this or that work and no other.

It is interesting to contemplate the works of Gabo in their fundamental relation to the personality of the respective authors. Gabo is an artist who, starting from a multiplicity of perceptions and considerations, has the ability to clarify highly complicated constructions in which tensions between forces, originally invisible, become visible [194, 200]. These tensions are felt because the artist transposes and arranges them in materials that give them a vivid reality.

In doing so, Gabo attains a precision and refinement that sometimes border on the feminine. His refinement, as seen in the architectonically sculptural projects of the decisive years of the Russian Revolution, should no doubt be viewed in relation to the reality of Western Europe, where the tensions inherent in the revolutionary complex of ideas on government are on the whole transmitted to the creative artist modified by the tranquillity of his studio or workshop. The use of plastics (nylon strings, etc.) is only a means, but it places an unmistakable accent on light and transparency. This, however, yields immediately in larger work—for example, the *Construction* [199, 201] for the Bijenkorf Building in Rotterdam—to the power of the large composed form, in which an inside and an outside are thought out with the greatest care.

Pevsner studied painting earlier than his brother, and it was not until 1923 that he turned to sculpture, although he had, as noted, signed the manifesto of 1920 containing the Constructivists' fundamental ideas about sculpture. But Pevsner's past as a painter was always evident. Less productive than his brother, he confined himself, after a period of experimentation with materials (celluloid, tin, galvanized iron, zinc, crystal, bronze), to the use of thin little metal bars (brass, copper, bronze) from which he slowly built up a construction by hand, a process which demanded great imagination. He cast in bronze only a limited number of works which he himself thought were right for that medium [192, 205].

The works of Gabo and Pevsner have only a superficial affinity; fundamentally they are very different. What fascinated Pevsner most was the possibility of a depth other than the one dictated by Euclidean space. In his youth in Russia, visiting a monastery where rare icons were displayed on the walls, he had experienced the shock of discovering a depth not determined by a start from a single fixed point. In terms of perspective, the eyes of the Pantocrator and the Madonna were not directed at the spectator but embraced infinity. At certain moments, the eyes even seemed to be closed; their gaze disappeared. In reality the gaze was not directed outward but inward. Young Pevsner, who had asked to be left alone with the icons, experienced an utterly new spatial effect, which struck him so forcefully that he was some time absorbing the impression. In recounting the experience to me, he did not use the word mystical, but there seems

little question that for him it contained an element of the mystical.

A matter of great importance to Pevsner was the significance of light for sculpture. During a discussion about Rembrandt, he stated his conviction that, all historical interpretations to the contrary notwithstanding, Rembrandt's chiaroscuro was clearly an attempt to escape from perspective. He deeply admired Rembrandt's works because of the space, which had acquired, through the use of light and shade, an indefiniteness and a spirituality going far beyond the possibilities of the fixed and closed space of perspective. It was evident that Pevsner projected his own personality into this vision. His early experience with the icons, as well as his views on Rembrandt, proves the ambivalent nature of his own position.

Pevsner's personality transcended Constructivism. A less able theorist than Gabo, he was nevertheless receptive to the new concept of reality, but he found his own path. The personal basis of his creative power was an emotionally experienced depth, a mystic and devout assimilation of space in which light and color played important parts. Lines become curved planes, and curved planes become open forms. Other lines end in points, but the points do not at all signify an end; they are the last visible instance of the infinite. Pevsner's world is not that of Gabo's diaphanous imagery. Instead he creates, by means of the interplay of light and shade over the closed surface of the curved planes, a vibration full of varied effects, according to the hour of the day and the quality of the illumination [193]. At the same time, a darkness, even a gloom, pervades his work. Yet there is a complete absence of vagueness; his work came into being firmly. An ardent and unshakable conviction is testified to by the deep, penetrating look in his eyes. His works radiate a great, mysterious, sober energy. His forms, which often tend more to relief than to three-dimensional mass, always give the impression of being at the service of the realization of an essential, more introverted than extroverted, experience of space. He lived a dedicated life, never free of nostalgia for his native country. His constructions, like the instruments of an exact science, introduce us to invisible space. In his isolation, Pevsner reached the most profound depths possible in the Constructivist atmosphere.

It is in the nature of creative power that the artist, growing older, is seldom preoccupied with the formulation of styles and trends—for example, Cubism, Futurism, Constructivism. Since such formulations are, after all, derived from the deeper motives of individuals, gathered into groups that are necessarily only temporary, the later work, if it is good, will advance beyond the earlier artistic decrees. In his development, Pevsner was unable to forsake his past, but it is impossible to confine his best works within the limits of the earlier

definitions. The term Constructivism has had the merit of evoking a world of sculpture that rigorously rejects an undisciplined self-expression, a world that is free from archaism and that accepts the reality of present-day life with its new themes and possibilities. Gabo had always advocated this conception. But there were groups behind his manifesto; we can go farther and say that similar ideas were being expressed outside the circle of the Russians. An era had begun to express itself.

Georges Vantongerloo (1886–1965), though he cannot be identified wholly with Constructivism or the De Stijl movement in Holland, should nevertheless be included here. It is utterly impossible, however isolated he may want to be, for an artist to be unaffected by the time and space in which he is living; he is a part of his period. In fifty years the present will be seen not as a confused crowd of individuals, each seeking something different, but rather as a generation, a complicated one, bearing the marks of its time and place. Vantongerloo, a lonely worker all his life, was a man of his time, however aloof he kept himself.

In 1914, when World War I broke out, Vantongerloo, a Belgian, went to Holland. It was there that, as a painter with a divisionist touch and a palette reminiscent of Rik Wouters, he developed his ideas about space, time, volume and hollow, line, and color. At the Antwerp Academy, Vantongerloo had been dissatisfied with the theory of Euclidean geometry; at the same time, he felt that working from nature prevented the development of consciousness of space. On the basis of his unsatisfactory experiences, he began, in Holland, to record and elaborate his reflections. There can be no doubt that he was in contact with Theo van Doesburg, who was living in Leyden, and with other contributors to the magazine *De Stijl*, for between 1918 and 1920 he was given the opportunity to publish what he had to say. As a result, there arose the erroneous notion that he was exclusively a sculptor. In the De Stijl circle he was the only one who not only publicly analyzed the idea of space but realized abstract sculpture in an absolute way. Reproductions of his constructions were also published.

187

[206] GEORGES VANTONGERLOO. *Construction in Sphere.* 1917. Yellow painted mahogany, diameter 2¾″. [207] GEORGES VANTONGERLOO. *S×* $\frac{R}{3}$. 1936. Mahogany, 22×27½×22½″. [208] GEORGES VANTONGERLOO. *Construction in Sphere.* 1965. Marble, 20½×17¼×11½″. Musée Henreaux, Querceta, Italy. (Original, 1917. Plaster, diameter 6¾″.)

Three very different constructions were executed in The Hague in 1917: *Construction in Sphere* [206], *Composition Emanating from the Ovoid*, and *Construction in Sphere* [208]. The first was based on a cross and curves; the second, in accordance with the then prevalent Mondrian-Van Doesburg conception, was a vertical and horizontal composition; and the third was a curvature of volumes and hollows, like a small, early Arp. After World War I, Vantongerloo continued along these lines in Brussels, Menton, and Paris, and, like Tatlin and Gabo, he eventually reached that borderland where sculpture is in danger of becoming architecture, that is, of bearing a false resemblance to architecture. Real architecture is never created in this way. During the Renaissance, when sculptors' concern with architecture was normal, an artist like Michelangelo, who also executed architectural commissions, was keenly aware that he was working from the point of view of a sculptor.

Like the Russians, Vantongerloo also made designs for architectonic projects, for example, a bridge across the Scheldt in Antwerp (1928 [306]), airport buildings (1928), skyscrapers (1930). It is possible to imagine enlarged versions of certain sculptures in a park or garden, where, because of their spatial proportions, they could also serve as a gate or a shelter for visitors. Half building, half sculpture, they belong to that remarkable period between 1920 and 1930 when the Constructivists and the supporters of De Stijl worked along these lines. Victor Servranckx and the architect Robert van 't Hoff in Belgium should also be mentioned.

Vantongerloo's constructions in iron and mahogany (1933–36) are fundamental and extremely controlled [207]. In the Netherlands, after 1945, this style of sculpture found a direct continuation in the work of Carel Visser (born 1928). Vantongerloo's influence is also clearly visible in some of the work of Marino di Teana (born 1920 [308]) in France, for example the *Homage to Nervi*, though Di Teana did not continue in this direction.

[209]

[210]

8

*The Struggle between Archaism
and Abstraction:
Arturo Martini*

[211] ARTURO MARTINI. *The Dream.* 1931. Terra cotta. Collection Holenghi, Acqui. [212] ARTURO MARTINI. *Nativity.* 1933. Terra cotta, height 16″. Collection Pinghelli

While the Constructivists and the De Stijl artists were paving the way to new spatial forms, the particular kind of neo-archaism that was manifest in the attempt to rejuvenate sculpture at the beginning of the twentieth century had a second powerful and important sequel in Italy. The uneven production of Arturo Martini (1889–1947) has caused many critics to underestimate his significance. His work bears traces of the fierce and pathetic struggle between two great tendencies, the two irreconcilable worlds which, because of their very irreconcilability, provided sculpture with its tension, its power, its perturbation. The urge to escape from nature and find pure spatial forms can never serve a dramatically expressive sculpture, which has to maintain the human figure, though it be deformed and disfigured. The whole drama of Martini's career as a sculptor was a struggle between the two tendencies, a struggle that led him inevitably to artistic heights and depths. Although he eventually rejected the figure, he was unable to break with the past completely.

Outliving Boccioni, Martini became the leading Italian sculptor of the period between the two World Wars, but he had none of Boccioni's youthful and ardent belief in a new world, and was in continual agitation. He keenly felt the great traditions of the Etruscans, the Romans, the Middle Ages, the Renaissance, particularly Michelangelo, and he reacted against the Futurist suppression of the past. He was not the least bit interested in the fact that Medardo Rosso had abolished historical and heroic themes and that the Futurists had proceeded inexorably in the same direction. Yet he loved Rosso's

[209] ARTURO MARTINI. *Cavallo allo steccato.* 1943. Terra cotta. Collection Diana Pertile, Padua. [210] ARTURO MARTINI. *Judith and Holofernes.* 1932–33. Stone, height 8′. Rijksmuseum Kröller-Müller, Otterlo

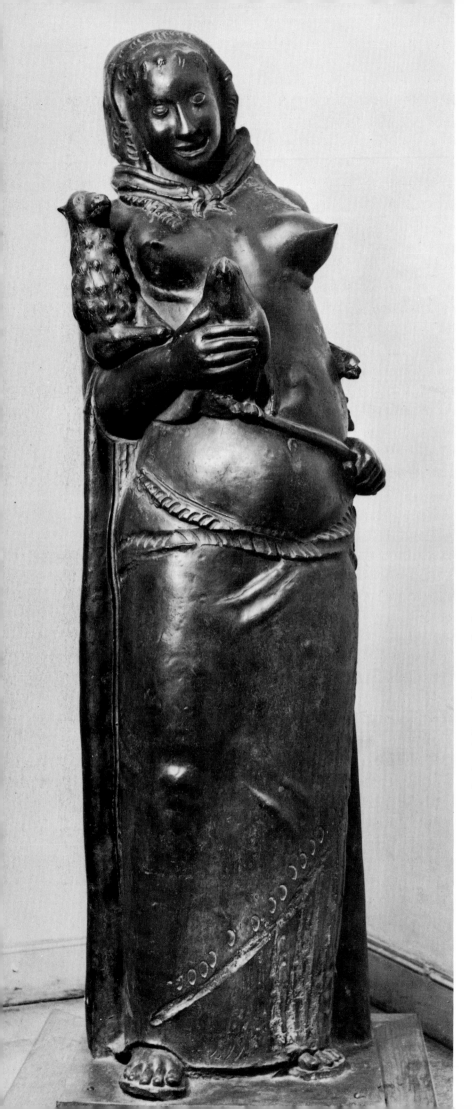

[213] ARTURO MARTINI. *The Gypsy*. 1934. Bronze (unique piece), height 6' 7". Galleria Civica d'Arte Moderna, Milan (Collection Pernoi, on loan). [214] ARTURO MARTINI. *Woman in the Sun*. 1932. Terra cotta, height 24 ½, length 55 ½". Musée de Sculpture en plein air Middelheim, Antwerp, and Collection Dora Bruschi, Milan. [215] ARTURO MARTINI. *The Drinker*. 1935–36. Stone, lifesize. Collection Martini, Vado Ligure

work. In Munich he studied for a short time with Adolf Hildebrand—which, however, does not mean, as has been said, that he believed in and acted upon the latter's ideas. Martini stood aloof from what Paris produced. In 1914 he was there; in 1927, when he was there again, he called Paris a *Babilonia, dove tutti hanno perduta la testa* ("a Babylon where everyone has lost his head").

At first Martini's talent was directed mainly by his intuition rather than his conscious mind. He had thoroughly mastered the art of carving stone, and he rejected the idea of modeling in clay and casting in bronze. He knew the art of pottery too, and later he produced some technically admirable pieces. But his path was difficult. His restlessness showed itself even in the capricious choice of his various studios. He also worked in Carrara, where, in the open air, his sculptures seemed to grow naturally out of the quarries [217–219]. His imagination knew no bounds; he could create not only almost abstract forms but also grand, rugged, simple ones, and even excessively brilliant Roman heroic figures—which was ultimately to be his undoing. With the rise of Fascism he was given a number of generous commissions that provided him with a steady income, something he had never known before. After the first allurements of Fascism had lost their hold, he realized that Fascism, though it had helped him personally, could only mean catastrophe for his beloved Italy. What he wanted was work and peace, but his many anxieties and conflicts began to affect his mind and eventually they destroyed him, mentally and physically.

Martini was possessed by the spirit of Greek paganism but realized that he belonged essentially to the Christian world. He lived in a constant state of turmoil, had a number of erotic adventures, yet wanted to be true to the faith of his early years, when—remembering the *Monk's Prayer* of the medieval Flemish philosopher Jan van

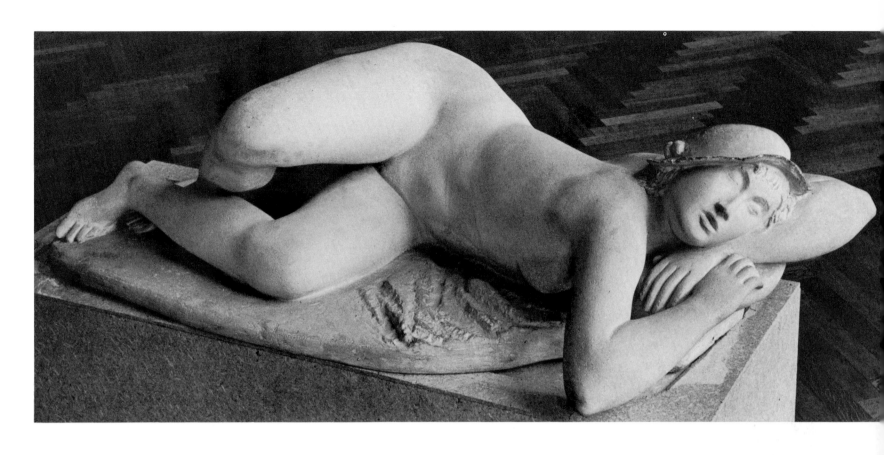

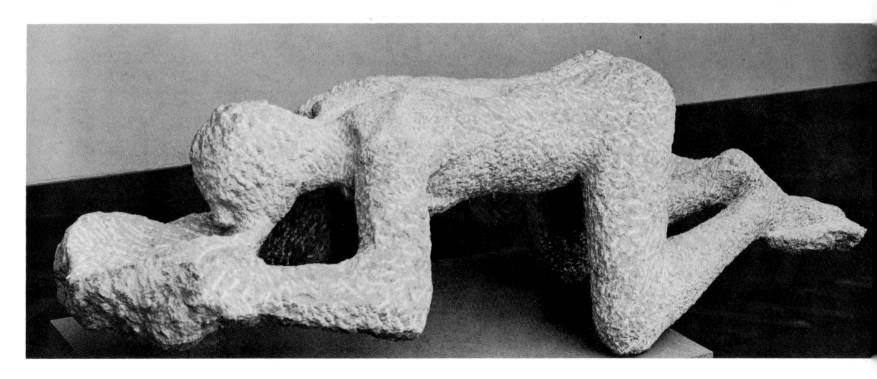

195

Ruysbroeck—he had written his *Contemplazioni* (1918). He felt that the period in which he lived was "nauseously modern" (*que fu moderna fino alla nausea*). He longed to return to primitive and virginal arts, which meant archaism—a longing shared by many others. Yet he yearned to belong to the present, for the past was dead. He was violently critical of his contemporaries who more or less *abbiamo fatto dell'archeologia* ("had dabbled in archaeology"), even Archipenko and Brancusi, not to mention Maillol. He said banteringly but with some malice that they all had cast a furtive eye at the Greeks and the followers of the Greeks. His intuition led him to a modern concept of modeling, although, fascinated and animated by the myth of antiquity as he was, he knew that to a certain extent he had mastered the ancient standards. He tortured himself bitterly with attacks of enfeebling self-criticism. He knew that he had too fertile an imagination: he realized that in his earliest and most foolish years his ambition had been to become the sculptor *par excellence*, whereas later, after forty years of work and struggle, when at least he was a sculptor among many others, he came to the bitter conclusion that he was nothing but a *statuario*—an artisan. On the positive side, his inclinations led him to fiercely intensified effects, which were always held in check by an innate sense of proportion and shape; some of his faces are masks, fixed features full of violent passion [221].

Martini dreamed of a sculpture that would make people tremble (*la mia scultura farà tremare*). At times he had an intuition of the romantic religious message of sculpture. But the Church did not understand him. Out of touch with society, the sculptor lived too much in isolation. In Italy art is admired, especially the art of the past, but often the living artist is permitted to struggle, suffer, and starve. And yet Martini's sculptures emerged from that struggle as from a dream.

196

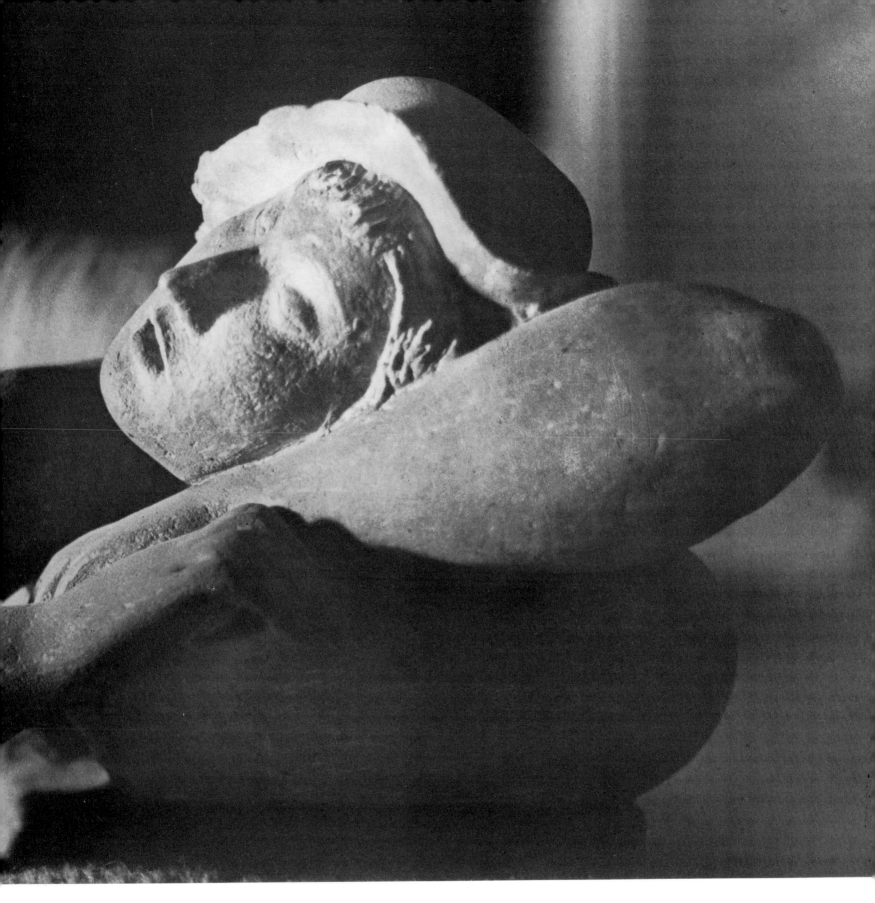

197

Martini's students in Venice, where he was appointed professor in 1942, were in despair, for they realized that their master had lost his belief in sculpture and viewed everything negatively. The necessity of choosing between antiquity and the present had torn his mind apart. He could not see his pupils as growing individuals with a personality of their own; he made alterations in their work. Yet even today the legend of his fascinating and imposing personality lives among them.

For Martini the past was dead; the Greek sensibility had disappeared. He felt that at all costs one must belong to one's own time, but he was opposed to distortion in sculpture, to extravagance and exaggeration, and he felt that abstraction to which one is forced in point of fact would irrevocably lead to a dead end. Tortured by these problems, he wrote, in 1944–45, *La Scultura, lingua morta* (Sculpture, a Dead Language), and during this period he made an attempt to find peace in painting. The implications of his pronouncement of the death sentence of all sculpture, which (aside from being the pronouncement of his own death sentence) was basically the dramatic ending of the archaic renewal, became the subject of a violent quarrel with the architect Gino Scarpa.

Martini's work could not possibly be pure and sound because of his turbulent temperament and his struggle with two different worlds. He was the point of collision between basically contradictory elements, and of this impact a number of grand and poignant images were born —grand because, over and above the modern, nervous terror of life that they manifest, they evoke the looming vision of antiquity, the old world of the Greeks, of the Etruscans, and of Michelangelo. In the rugged, passionate figure of *The Drinker* [215], in the romantic dreaminess of *The Dream* [211] and *Moonlight* (both 1931), in the nude figure against a wall of *The Watch* (1936)—Henry Moore recently

took up this remarkable theme again—in the perplexing *Judith and Holofernes* [210], Martini revealed his artistic spirit. Leaving his stylistic problems behind, he uttered his message via the myth of the old and the myth of modern life [209, 212, 213, 214, 216, 220]. He took every risk, always accepting the consequences of his convictions; he paid for his sculpture with his life. After Boccioni, it was Martini who, to a certain extent in opposition to Boccioni, resuscitated the vital power of the old sources of sculpture. More than anyone else, Martini was dominated by the demonic element of sculpture. His great positive qualities, no less than the weak points in his dynamic, militant sculpture, helped many younger artists in Italy to clarify their own position, regardless of whether they admired or rejected him.

Martini established what was to be the future of sculpture in Italy. In writing *La Scultura, lingua morta* he hoped that he would act as a balance (*fa che io non sia impeso, ma una bilanzia*), would not be the prisoner of one style, but an unrestrained force (*fa che io non sia prigioniero di uno stile, ma una disinvolta sostanza*). With Martini, in fact, there reappeared in sculpture, however sketchily, a personality unrelated to any group, trend, or school and uncommitted to any particular style. He always maintained his critical attitude toward the modern movements, though he could not bypass or ignore them. Martini exemplifies the fact that archaism, Cubism, Futurism, and Constructivism had become a background that could not be disregarded but that no longer constituted decisive criteria. Groups and manifestoes had become things of the past. Though they might reappear from time to time, they no longer provoked or disturbed the soul.

Between 1920 and 1930 the attitude toward the recent past changed in Italy and elsewhere. Sculpture was endowed with a new personal content. With Martini, everything that had been declared taboo

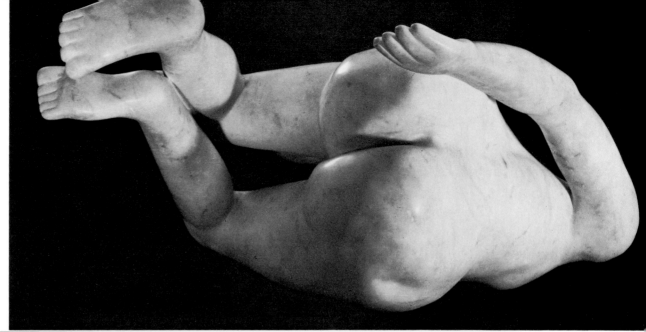

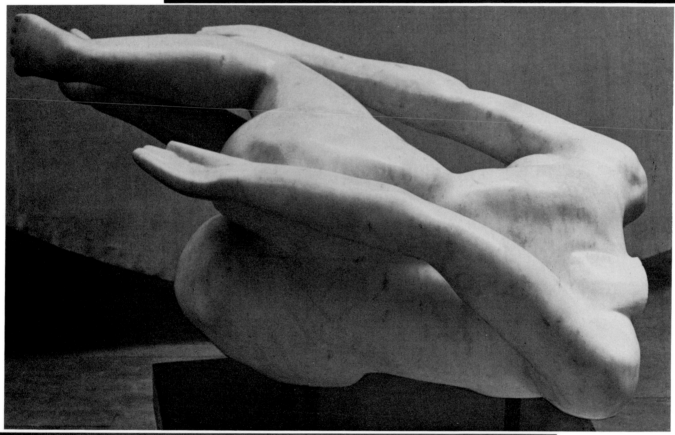

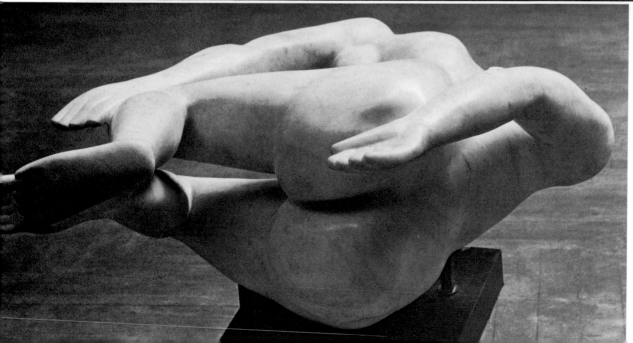

199

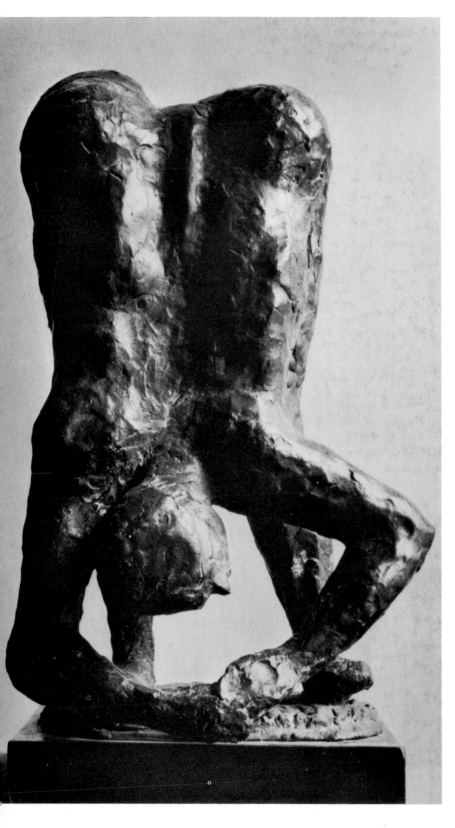

[220] ARTURO MARTINI. *The Swimmer*. 1943. Bronze, height 15¾". Collection Spotorno, Milan. [221] ARTURO MARTINI. *Il Ossesso*. 1941. Bronze (unique piece), 11½×6¼×10¼". Collection Garibaldo Marussi, Milan

reappeared—dream, mystery, drama, story. There was an unquenchable nostalgic craving for content in sculpture, which was to emerge not so much from the subject as from the very scope of the form. The most talented artists realized that in our period form need no longer have a translatable content to be able to evoke an essential image of life. It is the very untranslatable quality of the content that gives the form its full scope, its range of action, its force of expression.

A number of sculptors who, between 1925 and 1930, manifested themselves as independent artists and profited from Cubism, Dadaism, Surrealism, and Constructivism, nevertheless felt at times some of the aftereffects of archaism. They enjoyed the advantages of a recent past and imbued form with a vital content typical of the second quarter of the twentieth century. They were less concerned with proclaiming principles than with broadening and deepening them, as if the principles were already assimilated and silently accepted.

It was Henry Moore who became the most characteristic and complex example of this development. Four years younger than Martini, he did not have to bear the burden of the Italian tradition, which was not only an artistic but also, during the Fascist regime, a political and cultural burden. Moore's interest in what was happening on the Continent, his longing to grasp the richness of life, and his creative effort to elicit a deep, expressive power of form presented excellent conditions for the immediate future of sculpture.

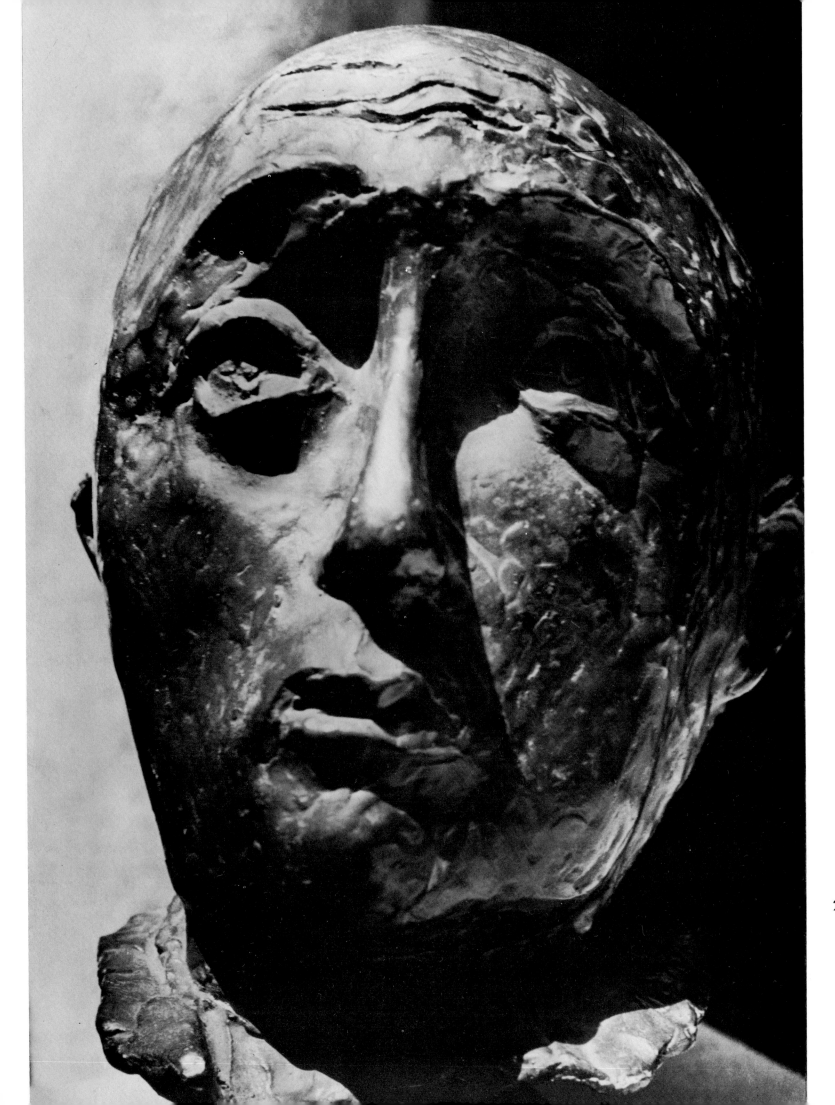

[222]

[223]

[224]

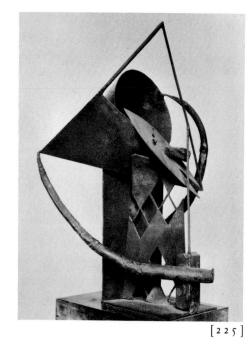

[225]

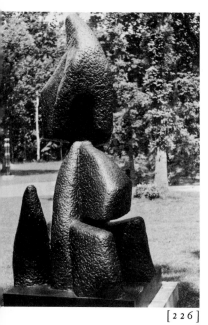

[226]

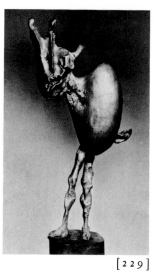

[227]

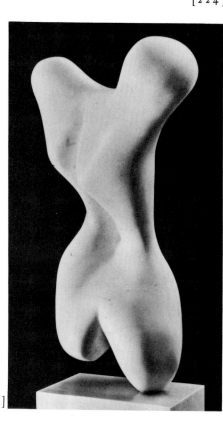

[228]

[229]

[230]

9

The Evolution of the Younger Sculptors between 1925 and 1940

The years 1925–30 were fertile ones. Henry Moore, Arturo Martini, Alberto Giacometti, Germaine Richier, Barbara Hepworth, Jean Arp, Julio Gonzalez, Otto Freundlich, Fritz Wotruba, still unknown to the public, were readying for their appearance on the sculptural scene; their early work already indicated the character of their future development. During the period of relative peace between the World Wars, these younger sculptors, who had the moral backing, so to speak, of Cubism, Futurism, and Constructivism, were trying to find their own way. Under the leadership of André Breton, Surrealism became a more organized movement. All felt the menace of the im-

pending disaster: the arcadian atmosphere so strongly evoked by Maillol's work, definitely belonged to the past. In the late 1920's, in Lipchitz' work, the joy of living began to yield to the threat of the storm. Between 1930 and 1940 the continued artistic experiments of the masters of Cubism and those close to the Cubists—Picasso, Braque, Léger, Lipchitz, Zadkine—attracted general attention, whereas it was only after the European liberation of 1945 that the younger sculptors, who in the meantime had matured, were widely recognized.

Arp (1887–1966), Gonzalez (1876–1942), and Freundlich (1878–1943) were older, but recognition came to them late in life. Arp had produced sculpture in his Dadaist days in Zurich, but since he destroyed everything made at that time, these works can hardly figure in a historical study. The year 1930 saw a recognizably new beginning which had a specific character and values of its own and which testified to a previous important artistic experience.

Otto Freundlich was already a consummate artist with experience in sculpture when, in 1926, he had begun making a small but important series of semiabstract and, later, wholly abstract pieces. These works, which were free from Cubist ideas, achieved through their heavy, accumulated forms an archaic expressiveness that has remained unique in sculpture [226, 231]. They reveal a Celtic power of expression. Freundlich did not achieve a clear verticality; instead, starting from a wide base, he accumulated forms. In these works the virile

[222] MARINO MARINI. *Head of Etruscan Warrior*. 1927. Clay, height $12\frac{1}{2}''$. Collection Berthold Beitz, Essen. [223] BARBARA HEPWORTH. *Contemplative Figure*. 1928. Polyphant stone, height $17\frac{1}{2}''$. Private collection, St. Ives, Cornwall. [224] HENRY MOORE. *Girl*. 1931. Ancaster stone, height 32″. Whitechapel Art Gallery, London. [225] JULIO GONZALEZ. *Harlequin*. 1927–30. Wrought iron, height $17\frac{1}{8}''$. Private collection, Paris. [226] OTTO FREUNDLICH. *Sculpture*. 1933. Bronze, $90 \times 39\frac{1}{2} \times 39\frac{1}{2}''$. Rijksmuseum Kröller-Müller, Otterlo. [227] FRITZ WOTRUBA. *Torso*. Stone. Marlborough Fine Art Ltd., London [228] JEAN ARP. *Torso*. 1931. Marble, $24 \times 15\frac{3}{4} \times 7\frac{1}{2}''$. Collection Müller-Widmann, Basel. [229] GERMAINE RICHIER. *Chessboard Figure*. Bronze. [230] ALBERTO GIACOMETTI. *Reclining Woman*. 1929. Bronze, height $10\frac{1}{2}$, length 17″. Kunsthaus, Zurich

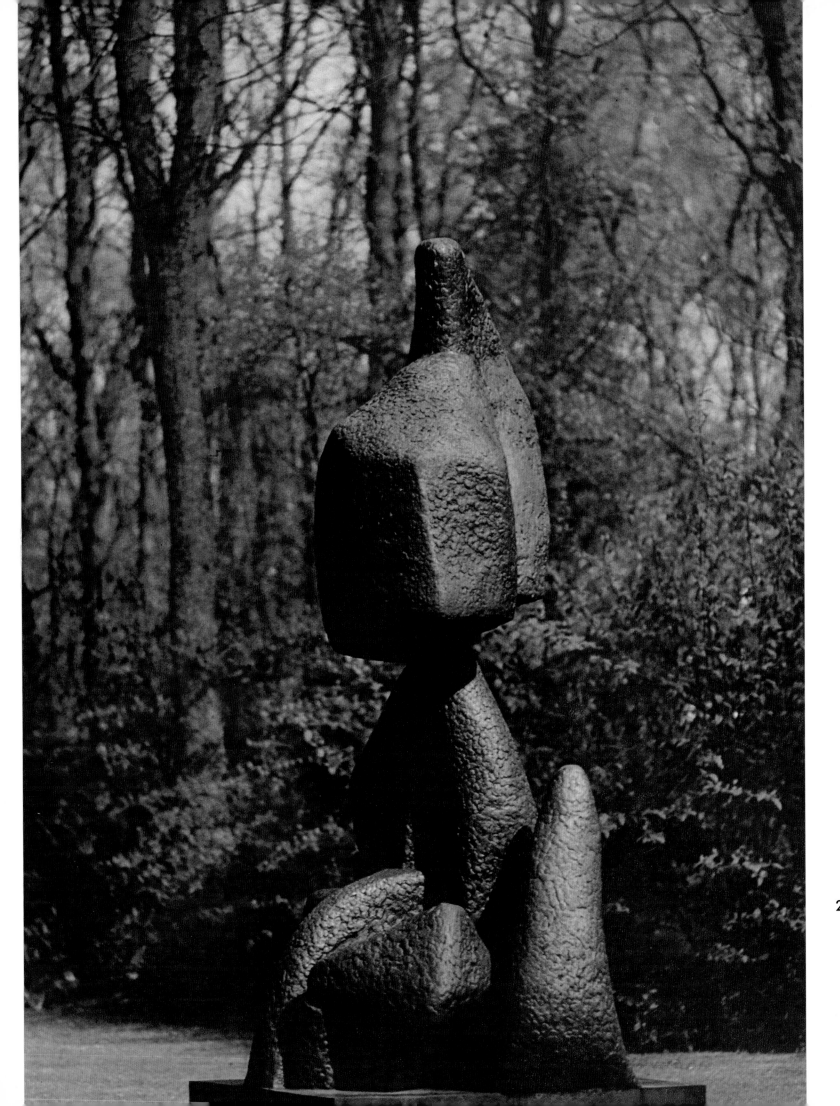

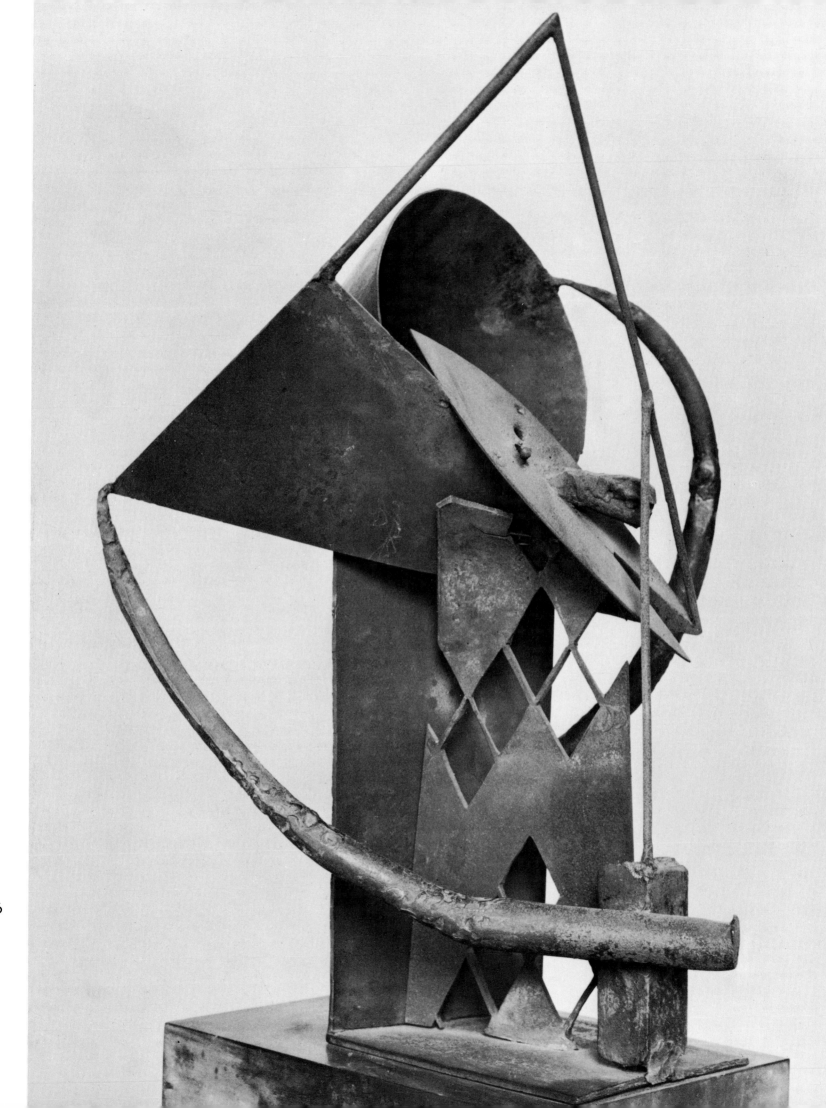

206

[232] JULIO GONZALEZ. *Harlequin.* 1927–30. Wrought iron, height 17 1/8". Private collection, Paris. [233] JULIO GONZALEZ. *Standing Peasant Woman.* 1934. Silver, ht. 6 1/4". Collection Roberta Gonzalez, Paris

verticality struggles laboriously against all that is weighty and earthy.

Julio Gonzalez, the oldest of these three sculptors, had been through a long, uncertain, and not particularly significant period of painting in which echoes of Puvis de Chavannes were perceptible. He began to work in *bronze repoussé* around 1910, but it was not until 1927 that he devoted himself definitively and exclusively to sculpture. In 1930 his friend Picasso asked him to collaborate in making wrought-iron figures, an idea that had haunted Picasso ever since his temporary discontent with his painting. No one will ever know the true story of what happened in the course of the joint activity of these two Spaniards so utterly different in character. The direct contact with Picasso may have made Gonzalez feel freer and may have helped him to overcome his anxiety. From that period until his death, in 1942, the depressed, penniless, hypersensitive Gonzalez executed, with great creative passion, a series of works in wrought iron that were known to only a few and that were not at all appreciated on the rare occasions when they were exhibited.

Like Picasso, Gonzalez was deeply disturbed by the civil war in Spain, and during the years 1936 and 1937 he expressed the pain of his tortured heart in his work. Though naturally disposed to conceal his feelings, he could no longer contain himself, and so he spoke out in the nonabstract form of the *Montserrat*. As if in a trance, he created the poor Catalan woman, a figure both defenseless and fierce, and around it smaller works of art, among others the magnificent mask entitled *Crying Montserrat*. He emerged from this atmosphere with greater determination and worked a little female figure in silver. His treatment of the material and the size of the work recall the ancient tradition of smithing, which had been the craft of his father and grandfather, in whose workshop he had, when still a boy, learned its techniques as they had come down from medieval times. His production of small silver figures, resumed for a short time in 1936, had begun in 1929. They were very free in their conception but were clearly figurative and realistic [233].

Gonzalez' work up to 1932 had been marked by the aftereffects of Cubism. In *The Prayer*, of that year, and in the motifs of women and of maternity of the following year, the concave and convex are reduced to a minimum. These are perfectly linear structures based on curved, undulating, and straight lines. These are works of unusual boldness and assurance. However, the period of absolute linear forms

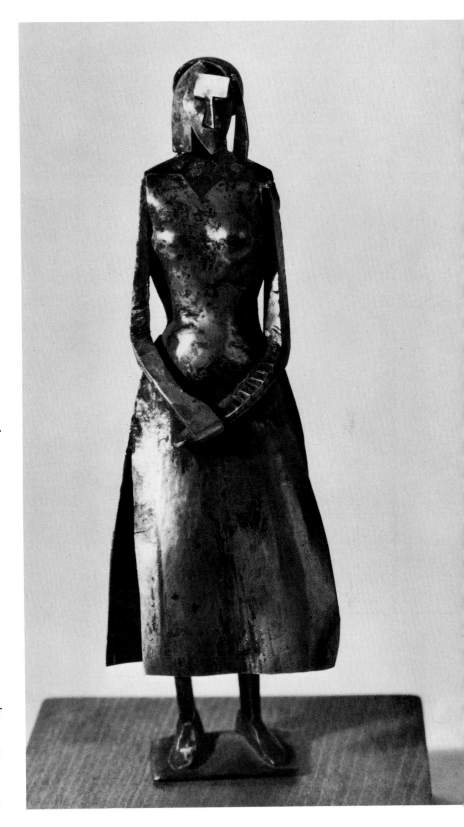

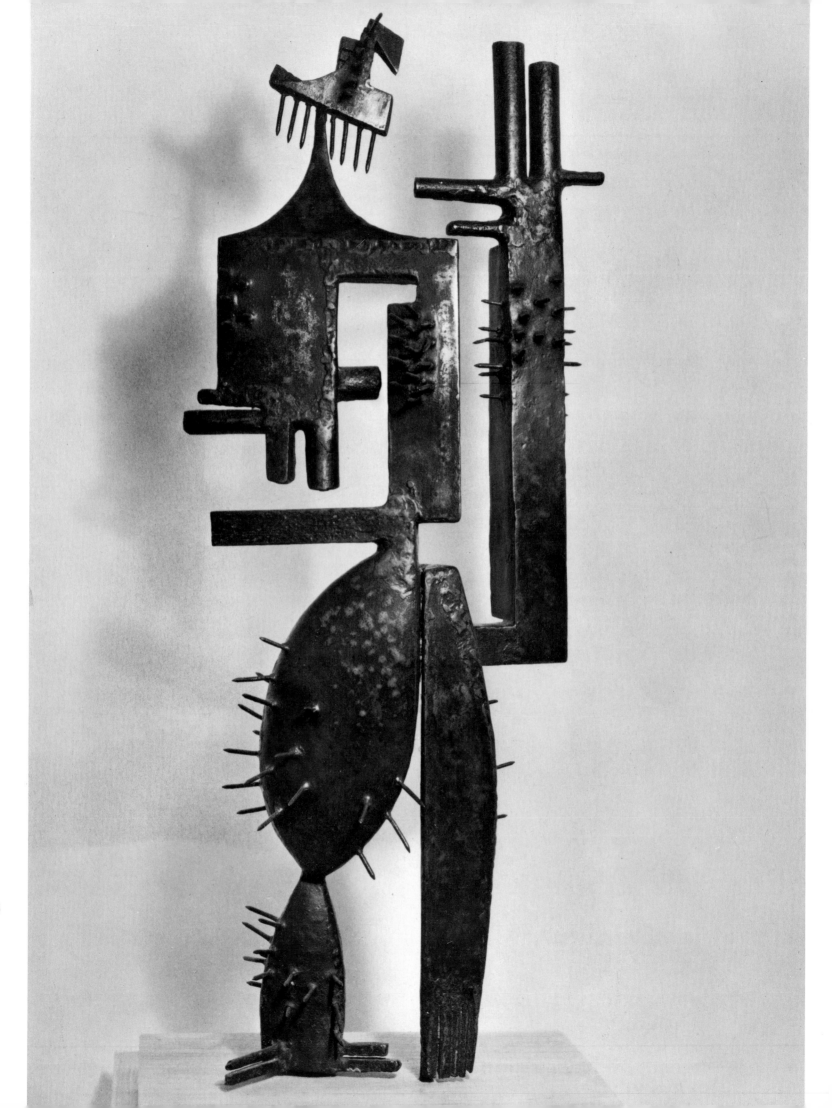

[234] JULIO GONZALEZ. *Cactus Man I*. 1939–40. Wrought iron, height 26″. Private collection, Paris. [235] JULIO GONZALEZ. *Angel*. 1930–32. Wrought iron, ht. 66″. Musée Nationale d'Art Moderne, Paris

was of short duration. In 1933–34 the plane and the volume were reaffirmed, and in 1939–40 appeared *Cactus Man I* [234] and *Cactus Man II*, both bristling with nails.

After World War II, when his work became well known, Gonzalez greatly influenced younger sculptors. The possibilities of iron and of other materials had been discussed and partially investigated earlier, but it was Gonzalez who, as a result of his special concentration upon iron, gave figuration a new and profound value. Ultimately what made his work so deeply impressive, I believe, was his asceticism and fierce passion, which found an unprecedented spatial expression. In his sculpture asceticism assumed a plastic quality that necessitated the choice of iron as a sculptural medium (as is confirmed by the scanty notes he left behind). However, the same does not apply to all his imitators and followers.

These pieces came to be understood after the war as the expression of an artist whose mind was directed toward the absolute, who knew how to use severe iron with a philosophically poetic feeling for the creation of aesthetic, violent, demonic works related to Cubism, to Lipchitz' transparent wire constructions, and to the work of Picasso —above all, works that reflected his own personality. He invented an emaciated, direct, ascetic style that, fundamentally, was not abstract. The figurative foundation is not stylistically reduced to a minimum; it is transformed into symbols. These are signs, written symbols, which can be regarded, as Louis Degand rightly observed, as absolutely abstract, until suddenly one discovers that they are fundamentally figurative [235, 236].

The background of Jean Arp was quite different. Now that we are able to survey his sculptural work from 1930 onward, we are struck by its harmonious relation to his reliefs, collages, fabrics, and graphic work and to his poetry and other writings. We are all the more impressed by this artistic unity because there were few European artists between 1904 and 1926 who traveled so much and had so many contacts with different artistic circles. His youth in Strasbourg, his contact with the romantic literary Sturmer group (about 1904), his sojourn in Weimar (1905–7), where he made the acquaintance of Henry van de Velde and Count Harry von Kessler, his stay in Paris in 1908, and later, between 1911 and 1913, his visits to Switzerland, Munich (Der Blaue Reiter), and Berlin, where he was in contact with Herwarth Walden and the Sturm movement—all these experiences

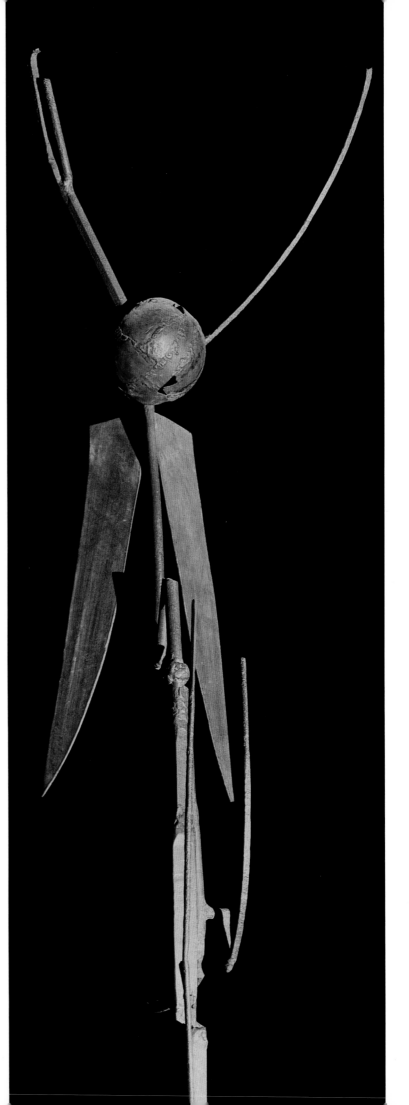

provided Arp with a rich and varied background. It is clear that during these years the chief influence on him was not French but German. However, by 1914 the Paris scene was once again very important, for Cubism was in full swing. Arp spent the war years in Zurich, where he met an artist named Sophie Taeuber [238], who later became his wife, and where he was an active and important member of the international Dada movement, to which he continued to adhere later on in Cologne. He met the Dutch theorist Theo van Doesburg (1883–1931) and joined the De Stijl movement, of which Van Doesburg was a leading figure. In 1925 he became a supporter of the Surrealist movement in Paris, and in 1926 he settled in Meudon, on the outskirts of the city. By this time his artistic personality had definitely been formed. His collages and reliefs foreshadowed his three-dimensional expression in 1930 in the Paris climate.

Arp had seen and experienced much, yet it seems not particularly important to analyze the influences upon him of this varied background. It is clear that his mercurial mind, his need for human contacts, and his extrovert character hardly interfered with his poetic attitude. Dada gave Arp his freedom. In Paris, Brancusi, even more than Cubism, showed him that sculpture could free itself from archaism and arrive at pure geometrical forms which do not conflict with nature but are parallel to it. Mondrian's hostile attitude toward nature was alien to Arp, and it is certain that Arp did not want to follow Constructivism in its breaking open of mass and volume, its experiments with new materials, and its predilection for the transparent construction. Yet nature was never very important to him in a direct sense.

It might have been expected that Arp, who in the Dadaist atmosphere of Zurich had seen art break away from its conventional functions, would be a supporter of Surrealist painting, with its unexpected combinations, associations, and whims, rather than an advocate of organic geometric terms. The secret of Arp's artistic character is, I think, to be found in the very fact that he was not an outright Surrealist. His craving for a simplicity in which the complexity of his mind might lose itself and for a compact and sometimes open form (the *Star* of 1939, the *Ptolemy* of 1953, the *Small Theater* of 1959 [241], and the *Crown of Buds I* of 1936 [242] are among the relatively rare examples of the open form) led his creative mind, which was so closely affined to the Surrealist mentality, to develop a remarkably personal style. The titles of his works, to which he gave a great deal of attention, and some of which he later changed, suggest that his literary work cannot be separated from his sculptures [237, 239, 240]. This is important because it is a clue to the miracle of Arp's creations. Arp

[236] JULIO GONZALEZ. *Woman with Mirror*. 1936. Wrought iron, height 6' 10". Collection Roberta Gonzalez, Paris. [237] JEAN ARP. *Dancing Flower*. 1957. Polished bronze, 47×9 ½ × 10 ½"

[238] SOPHIE TAEUBER-ARP. *Parasols*. 1938. White painted wood, 35 ¾ ×25". Rijksmuseum Kröller-Müller, Otterlo. [239] JEAN ARP. *To Be Lost in the Woods*. 1932. Granite base, wood, and marble; height of base 18". Dunkelman Collection, Toronto (courtesy Sidney Janis Gallery, New York)

actually performed the poetic feat of transforming shape into organism [228]

In a certain sense, Henry Moore (born 1898) was free of any burden of tradition because his country had been little involved in the history of sculpture. However, to regard Moore and Barbara Hepworth as artists who created an English sculptural style on the basis of a meager past is to adopt a too limited, too national view of the genesis of style. What might have been possible in the nineteenth century, namely the creation of a national sculpture, is utterly impossible in the twentieth, unless sculpture is reduced to folklore. Wherever a sculptor works, be it Iceland, Sweden, or England, he cannot but be conscious of a supranational artistic life. When Moore started working, he had to consider the significance of archaic sculpture as well as of works by Picasso, Brancusi, Pevsner, Gabo, and Lipchitz. Every beginning is illuminating, less because of "influences" (the favorite hunting ground of art historians) than because of the chance encounters that lead an artist in a specific direction or even dominate him for a longer or shorter time; this is, after all, always included in the idea of influence. The Temptations of St. Anthony is a more complex but clearer clue to what goes on, with respect to influence, in the mind of the young artist trying to find himself. An example is Moore's discovery of the archaic and the so-called primitive. In his early years he did not feel the attraction of African Negro art so much as that of Pre-Columbian South American art. This was the world he would have to conquer. No one will ever be able to explain why it was the contact with Mayan art that led him to find himself. It had nothing to do with England or the Continent; his free and universal orientation testified immediately to a total independence of fashion in Europe.

The great shock experienced by the new century when it discovered and recognized its roots in what is still erroneously called the primitive ceased to be felt after Cubism. But it was by no means the end. Investigations were carried back into the prehistoric past—the logical retrospective sequence. A second wave of creativity, stim-

211

213

[240] JEAN ARP. *Arrow Cloud.* 1932. Painted wood, 43 ¼ × 55 ⅛".
Collection Müller-Widmann, Basel. [241] JEAN ARP. *The Small Theater.*
1959. Bronze, 41 ¼ × 26 ½ × 3 ⅜"

[242] JEAN ARP. *Crown of Buds I.* 1936. Original plaster, 19 × 15 × 11 ½"
[243] HENRY MOORE. *Mother and Child.* 1936. Ancaster stone

214

217

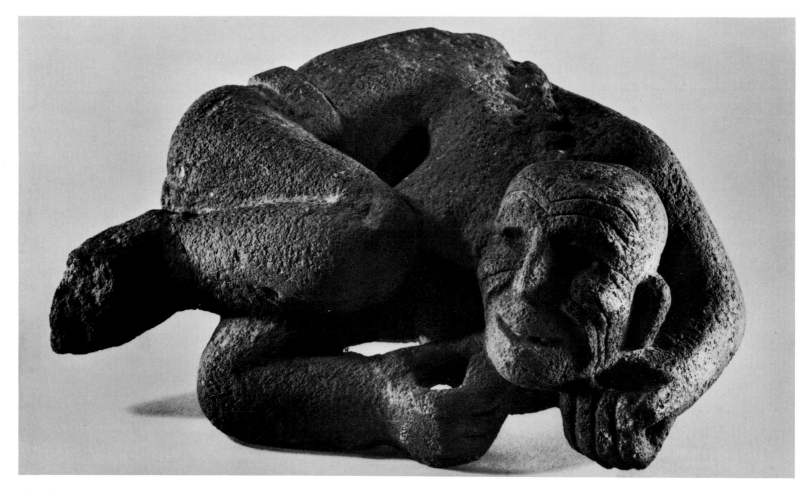

ulated by non-European cultures, was a result of the influence of Africa and the South Sea Islands. In the earlier period it was mainly the painters who were excited by African Negro sculpture; in the later, it was the sculptors who were the pioneers in the continued exploration. Mexico loomed larger and larger. The Mayan and Incan began to appear. Finally, in 1952, the first great exhibition of the rich complex of Mexican and South American cultures was held at the Musée National d'Art Moderne in Paris. The exhibition ranged from the beginnings, through the destructive Spanish conquest, to a point well into the nineteenth century. But this event had been preceded by a quarter of a century during which artists and sculptors—Lipchitz, for example—had included Mexican art in their collections. Moore, however, had a special relation with Mayan sculpture, for as a young man he had become familiar with Mexican, along with Sumerian, Egyptian, ancient Greek, and Peruvian art in the rich collection of the British Museum in London.[60] This interest is apparent in his work. Moore himself feels that it was perhaps a particular feeling for the

[244] *Figure* (Huaxtec), from Mexico. 13th–15th century. Gray lava, $6\frac{3}{4} \times 13\frac{3}{8}''$. Collection Baronne E. de Rothschild, Paris. [245] HENRY MOORE. *Girl* (detail). 1931. Ancaster stone. Whitechapel Art Gallery, London

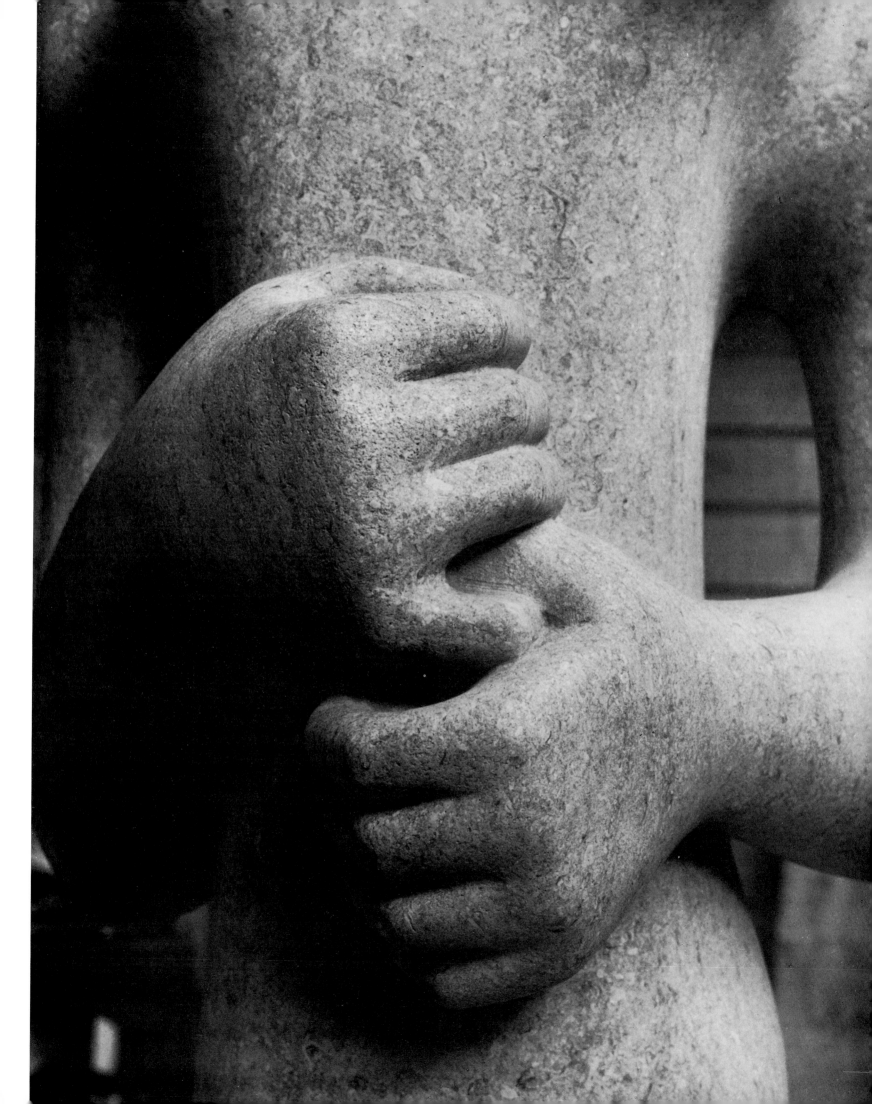

[246] HENRY MOORE. *Bird Basket*. 1939. Wood and string, length 17".
Private collection. [247] HENRY MOORE. *Head*. 1937. Hopton-wood
stone, height 21". Martha Jackson Gallery, New York

eleventh-century sculpture he often saw as a child in the old churches
of Yorkshire that led him to discover values in the Mexicans, whose
work, for him, was unsurpassed in any other period of stone sculpture.

In 1953 I met Moore quite by chance in New York, in the art gal-
lery of Curt Valentin, who was deeply interested in sculpture and
foresaw the keen interest modern sculpture was going to arouse in
the near future. Moore had just returned from his first trip to Mexico,
his mind filled with vivid impressions, which, however, only confirmed
what he had discovered in the British Museum many years earlier.
Between 1924 and 1928 Moore had already shown clearly that ancient
Mexican cultures inspired his own latent powers. Pre-Columbian
sculpture made him aware of forces deeply embedded in the stone,
forces that await the hand of the sculptor to endow them with life,
always being careful not to disturb or destroy them by forcing them
into wrong directions. An earlier generation had rediscovered,
through Romanesque and Gothic art, the methods of carving stone,
and there was not a single sculptor who, apart from carving stone
directly, did not regard his relation to architecture as a fundamental
one. This led to a conception of monumental sculpture which, be-
cause it depended on architecture, and a congenial architecture
did not exist, proved ineffectual.

In Pre-Columbian art this problem had been treated in a different
way. Sculpture was less integrated into a central architectonic idea.
The great vital fullness of these sculptures, the irresistible vehemence
of their forms, and at the same time the wide scale of sensibility,
tenderness, tragedy, terror, and even cruelty, all infused with the
supernatural belief that there is something stronger than life and
death, gave this art a peculiar structure that was more independent
of a supporting or sustaining architecture. Moore understood this,
at first intuitively and later consciously.

Whenever Moore designs a sculpture or relief for a specific architec-
tural site—Underground Relief, London, 1928; St. Matthew's Church,
Northampton, 1943–44; Time and Life Building, London, 1954;
Bouwcentrum, Rotterdam, 1955; UNESCO Building, Paris, 1957–
58; Lincoln Center, New York, 1963–65—it is immediately clear that
he produces the image itself and its autonomous world with great
love and care. The problem is no longer the same as in the days of
Bourdelle, when sculpture served and obeyed Mother Architecture.
To Moore the landscape is more important than any architecture.

220

[248] HENRY MOORE. *Animal Head.* 1951. Bronze, height 8½". Private collection. [249] HENRY MOORE. *Three Motives against Wall No. 2.* 1959. Bronze, length 42". Private collection. [250] HENRY MOORE. *Upright Motives Nos. 1, 2, and 7.* 1955–56. Bronze, height c. 11'. National Park, Otterlo

His architectonically conceived relief has more of a sculptural than an architectural, space-enclosing character.

The wall that he showed in 1963 in London is not the wall surface projected by an architect, the background for a sculpture, but a sculpture in itself, a plastic creation with its own story on its surface. Curious too in this respect is the succession of the four sketches for the wall of the Time and Life Building. The whole process, as indicated in these designs, clearly points to the fact that Moore started from architectonic premises and in each consecutive stage wanted to strengthen and finally to enrich the sculptural elements by suggesting a revolving movement (never executed, revolving only in the model). The figures which he projected in later years (1960–63), seen on a flight of stairs or against a wall, readily remind one of Martini's attempts in the same vein, though the latter's work is still reminiscent of the Giotto past, at any rate more so than Moore's. It is clear, however, that these walls are never architectural fragments; they are sculptured unities, their proportions, thickness, and curves determined by the sculptor, who thus creates an element—an envelope—against which or in front of which his human figure becomes alive. These walls, or screens, are very characteristic of Moore's art; like the walls of the rooms in a house—the setting in which people live, often under emotional stress—they seem to have assimilated this life. They are not merely passive witnesses of what is going on; they participate in life's rhythms. Occasionally Moore's themes are psychoanalytically inspired (according to Erich Neumann, among others, they derive from Jung) and therefore invite symbolic analysis, but this does not explain the remarkable development and growth of his sculptural form.

Although Moore entered the field of European sculpture later than Lipchitz, he quickly absorbed everything of importance. He was as receptive to neolithic and old Mexican forms [244] as to Lipchitz, Picasso (not only the sculptor but the total artistic personality), and Brancusi; he also knew Arp. He became acquainted with Constructivism before and during World War II through a small circle of artists in London, which later included Mondrian and Gabo and which clarified his tendencies in that direction. However, it would be misinterpreting to view Moore's artistic character as alternating between

the abstract and the figurative. Between 1930 and 1940 he did, at times, go very far in the direction of a severe geometric simplification [224, 243, 245, 246, 247], and the works of that period invite comparison with those of Barbara Hepworth. Since the oeuvre of both artists shows an absolutely personal, logical, and consistent development, it is superfluous to emphasize the points they may have in common. The starting point in the work of the two was similar, but what followed in each case provides a better interpretation of the earlier works than any comparison between the two artists.

So far as Moore is concerned, it is now sufficiently clear that the ample reserve of forms he accumulated with the help of the data offered by his time does not warrant his being characterized as an

adherent of abstract art. In 1937 he felt—and he proved, in retrospect, to be correct—that abstraction was increasing in his work. But what was of supreme importance, then as now, was his original starting point, which continued to be the human figure with its forms and the psychical associations of these forms; the work was always full of an intense life feeling and charged with an energy rooted in the present. Moore's art by no means involves the reconciliation of abstraction and figuration, which has always led to hybridism. His assurance as a sculptor is attributable to the fact that he assigns abstraction its proper role in his work. Moore's conviction that approximation to or imitation of nature is never the essential element derives from the development of abstraction in the first quarter of the present century.

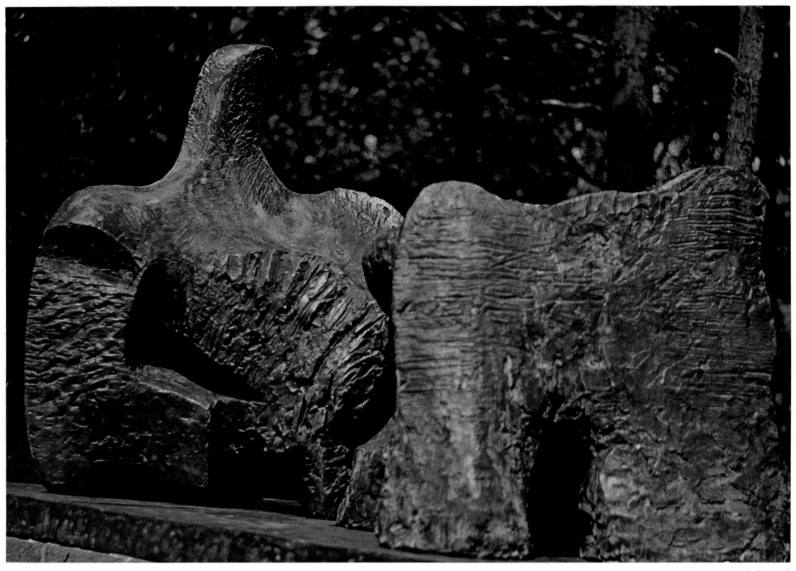

[251] HENRY MOORE. *Reclining Figure.* 1945–46. Elmwood, length 45″. Cranbrook Academy of Art, Bloomfield Hills, Michigan
[252] HENRY MOORE. *Reclining Figure II.* 1960. Bronze, 51 × 102″. Rijksmuseum Kröller-Müller, Otterlo

This is apparent even in the works in which he seems to have gone astray, the works which most closely approach naturalism. According to his artistic credo, a work of art if it is to transcend sensual charm and facile beauty must be able, whatever it may represent, to transmit something of the richness and profundity of life by means of its form, which should be charged with energy and psychic content [248, 249]. In this formal independence lies the secret of his power. Too abstract for the figurative artists, too figurative for the abstract, Henry Moore's figurative art has, despite his fame, not always been understood as representing the myth of the human rather than the human figure itself.

In his recumbent figures [251, 252] all the phases of Moore's sty-

listic alterations can be followed. He has seen these figures, from the point of view of his study of bones, as transformed skeletons risen up from a prehistoric landscape [52, 385, 386]. He has seen them in draperies evolving toward the half-divine, half-human creations of the late Greeks or the Romans and fitting into a classical landscape. He has transformed them into troglodytic formations, suddenly evoking the powerful rocky images that Bernini used as the starting point

225

[253] HENRY MOORE. *Head and Hand*. 1963. Bronze, height 7″. Private collection. [254] HENRY MOORE. *Locking Piece*. 1962. Bronze, height 42″. Private collection

[255, 256] MARINO MARINI. *Rider*. 1945. Bronze, height 41 $\frac{1}{2}$″. Konstmuseum, Göteborg

for his animal and human fantasies in the fountain decorations [22, 25]. The figure is hewed into two parts, then into three. At first this seemed arbitrary, but, curiously enough, the procedure was the same as that employed in the more abstract and rigorous studies dating from before 1940. The relation between two or three forms in space is also to be seen in drawings of the same period. The recent rocklike translation of these forms reveals what was potential in the more abstract shapes, namely the myth of the human figure. This grows into something that emerges into the light of day from the depths of the earth for the first time, an apparition from the earliest days of man—or his last. It is a formidable formation, which, unfinished, is more majestic, more threatening, more corroded than any landscape and bears witness to the rediscovered relation of twentieth-century man to his origins. When Moore finds a motif, he is not one to relinquish it casually. He has to exhaust it: he is impelled by his creativity and by the awareness that man can never entirely complete any task.

After these potentially gigantic and rudimentary shapes, Moore is able to turn back, as if driven by a surprisingly sudden impulse, to more abstract formal relations [254], recalling forms that occupied his mind about 1937. The great surprise, however, was the series of distinct and lucid but smaller forms dating from 1963 [253] that were released from the strange hold of the physical human drama that seemed to have imprisoned his work a few years before. That Moore is always able to turn back and make alterations is further proof of the unity of his work. His forms, both figurative and more abstract, acquire, independently of what they represent, that character of vital genuineness which underlies Moore's career as a sculptor. He has seen something which nobody else has seen and which is alive in and among men in the present period, a period that threatens the human being mercilessly, that destroys many who are not equal to the strain, and that nevertheless is shaping the characteristic form of contemporary man. Rodin summarized it for the nineteenth century not in *The Burghers of Calais* but in one vertical figure, his *Balzac* [58]. Moore summarizes it in the verticals of the totem-like forms [250], which, with their animal, phallic, and human qualities, contain all that he has to say. The archaistic elements are now in the melting pot of

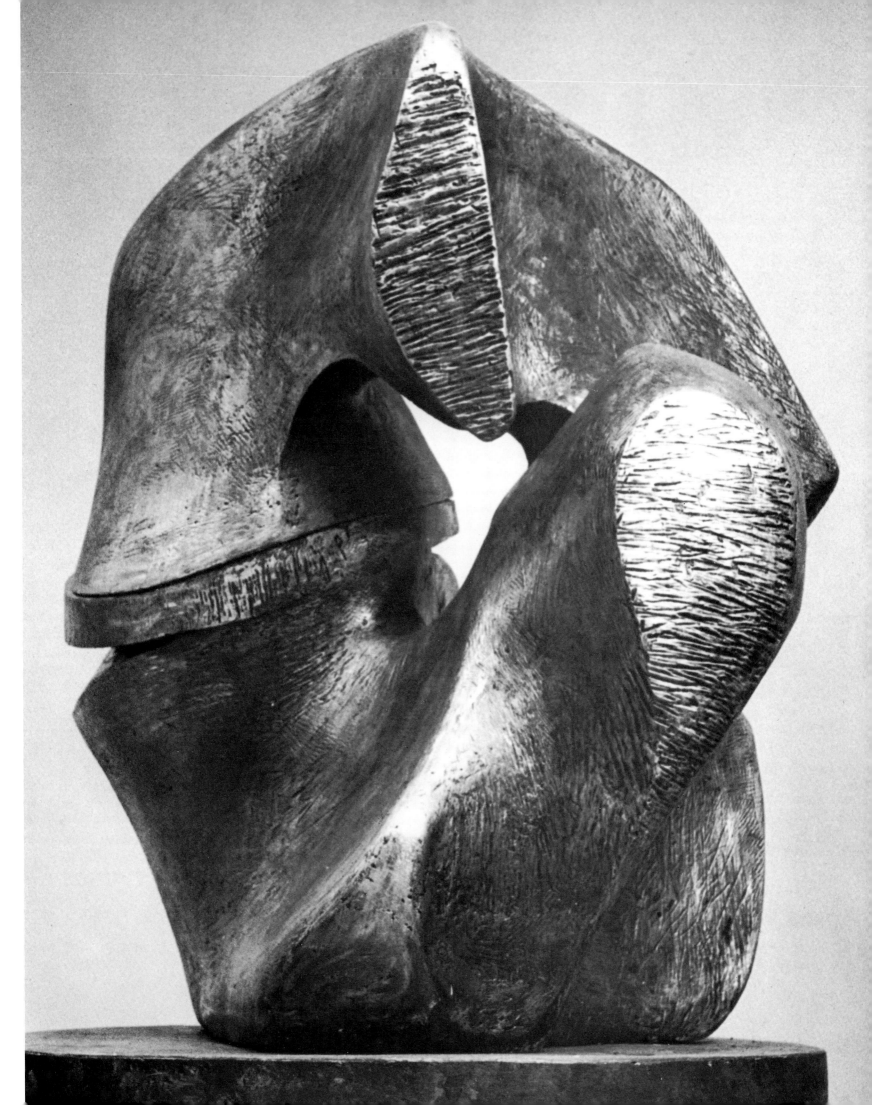

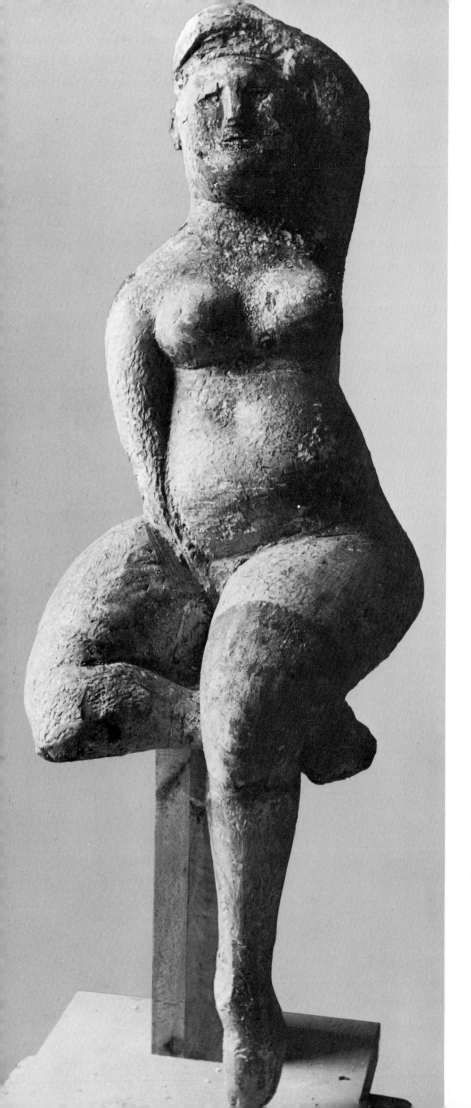

the most important modern sculptural discoveries and nearing a synthesis.

Marino Marini (born 1901) is three years younger than Henry Moore. As a child he saw not only the little Romanesque churches of Pistoia but also the Giovanni Pisano and Jacopo della Quercia sculptures, the equestrian statues in and outside the churches of Lucca, and, later, the Gothic art of Lombardy. He studied at the Academy of Fine Arts in Florence and spent time in the rich archaeological museum, where the large collection of Etruscan works made its impression [222]. He absorbed a great deal there. He was no longer afraid of the past before the Renaissance, before the Romans [262]. What remained for Martini an unresolved struggle—the choice between archaism and abstraction— was an ordinary logical problem for Marini. Shortly before 1930, when young Henry Moore was already assimilating the ancient Pre-Columbian art in England, Marini turned from painting to sculpture, though without entirely giving up the former. He never abandoned color; on the contrary, he had the courage to treat color as an important element in his sculpture. What characterizes Marini—as it does Moore, who developed a greater number of more varied motifs and who, as has already been observed, was not burdened with a historical tradition— is his subjecting his sculptural form to basic primeval motifs that, in their shape and content, reflect a definite attitude toward life. Marini also shared the modern aim of creating a formal symbol of his own time rather than an object of self-expression. Marini's horses and horsemen are symbols that gradually emerged from a particular attitude toward life, one that embraced the sensual world. His feeling for life is warm and full of emotion. His personal experiences in the period of World War II (from 1942 to 1946 he lived in Switzerland) created an inner tension and a deep spiritual attitude that produced the vision to which his sculptures gave veiled form.

Marini should not be judged solely by his horses and riders [255, 256, 259, 261]. At least equally important is his comparatively long and serious preparation for them. His portraits have become a special chapter in the history of sculpture [258, 260]. His dancers are, after Degas's [88] and Rodin's, the most important sculptural realization of this motif in the twentieth century [257]. The marvelous quality of Marini's work is the seeming simplicity of his forms, which do not appear to have any complications, but are "full," in the literal sense

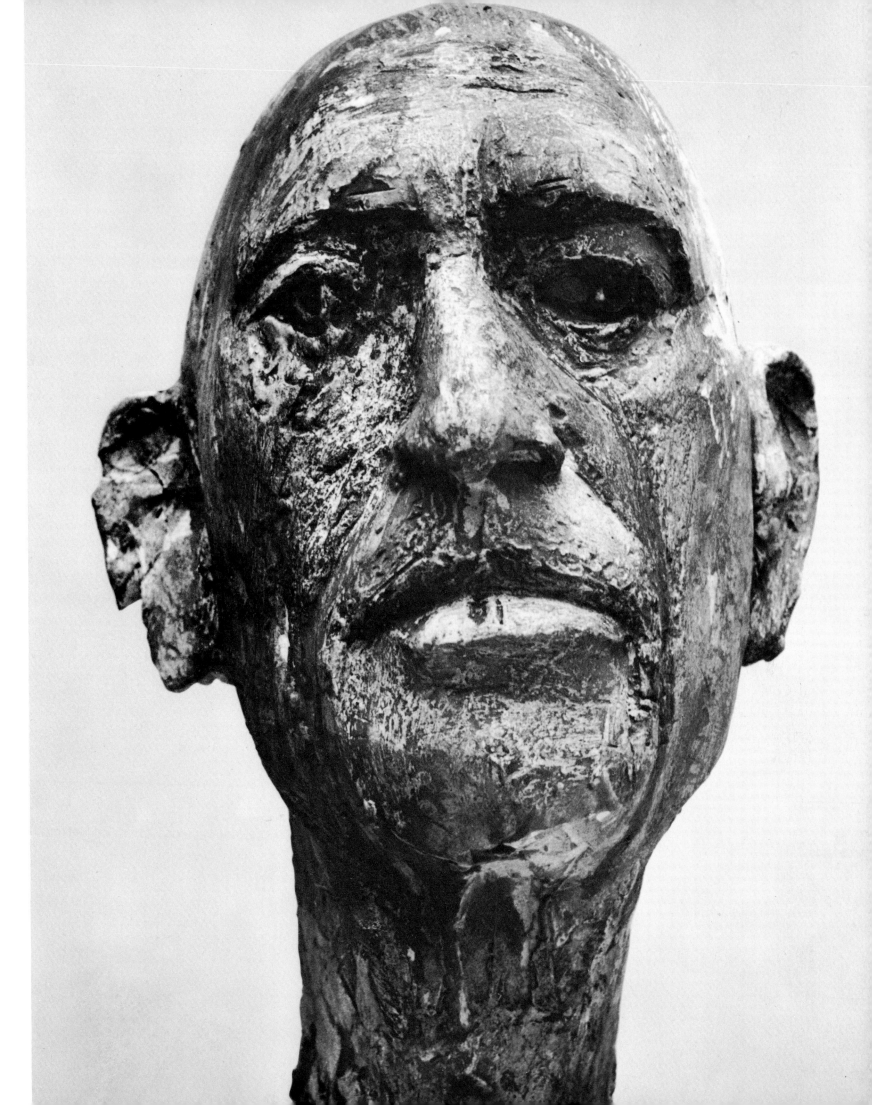

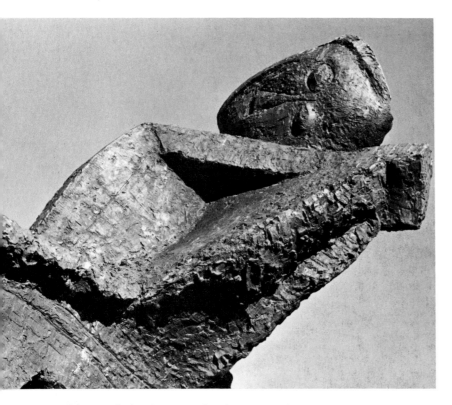

[259] MARINO MARINI. *Rider* (detail). 1957–58. Bronze. Bouwlust Park, The Hague. [260] MARINO MARINI. *Portrait of Jean Arp.* 1962. Bronze, height 11 ½". Private collection, Milan

The theme of the horses, with or without riders, shows the same relative freedom and formal independence with regard to reality, developing in a number of stages, which are not actually variations but which are grouped in series to correspond to psychic attitude. The dominating element is invariably the problem of the sculptural form, in which everything is concentrated. Occasionally it is the vertical and horizontal that fascinate Marini and express in themselves a sort of equilibrium. Then the diagonal makes its appearance. The countermovement of the animal had numerous possibilities until Marini proceeded to find more violent effects. He expresses the catastrophic, and the form acquires an expressive abstraction that almost obliterates the motif.

Speaking of Marini's occasional portraits, Lipchitz has maintained that portraits are not real sculpture—or not sculpture in the sense that Marini's other images are sculpture. Lipchitz is here defending the function of the portrait that involves resemblance; referring to the so-called Cubist portraits, he objected to the method of subjecting the portrait to a style in which the likeness becomes problematical. This is clear and forceful reasoning, and Lipchitz himself has acted in accordance with it.

Without making the slightest concession in his modeling, Marini succeeds in making the portrait a characteristic Marini and at the same time a likeness. His sensitivity has rendered his power of observation so subtle, so keen and critical, that he can translate the makeup and mental attitude of a person into a form which becomes a true portrait. In doing this, Marini dispenses with traditional respect for the subject; his criticism, his irony, his sense of humor, and his warmth, which add emotion to his observation, end in creating his particular style without detriment to the subject. He occasionally also has given function to color, notably in the *Portrait of Carl Heise*, a likeness of a former museum director in Hamburg. Of the early portraits, it is the *Stravinsky* (1951) that belongs among the rare examples of the portrait in the grand style [258].

Marini's passion for painting manifests itself in some images to such an extent that sculptors have objected that the form is blurred, that there comes into play an element which, though visually attractive, corrupts the sculptural form. Of course, if color is strongly alive in his mind, Marini has the right to include it. His talent lies in the fact that he does not *add* it to the sculpture; he does not

of the word, that is to say, they have a peculiar tension which manifests itself on the surface. Still, Marini does not treat the figure naturalistically, whether it be a dancer, a horseman, or a horse. He loves volume and mass, and there is the presence of contour. In this respect he is anti-Constructivist. Yet Marini does not strive for beauty, for sensual rapture, which, after all, is alive in his typically Italian temperament. Beauty is not foreign to his work, but it is a beauty different from that seen by Antonio Canova [33] or, today, by Emilio Greco (born 1913 [398]) or Marcello Mascherini (born 1906).

Marini makes his figures seem heavy. Actually they are not heavy, but have a full and strained volume. The physical element of these forms is released from representation, from the obvious image. Marini's dancer is not elegant, not light as a feather in keeping with the conventional fiction of the classical ballet. The figure is simplified, not deformed, but it does not have ideal proportions. In an indescribable way Marini succeeds in obviating the impression of matter. In the carriage of the head, in the direction of the look, in the attitude, and especially in the emphatic yet unexaggerated tension of the forms, there is tenderness and at the same time enormous energy. The delicate, sensitive vision, perceptible in the very tips of the fingers, would have become precious and manneristic in any other artist; in Marini it develops into a great spatial poem.

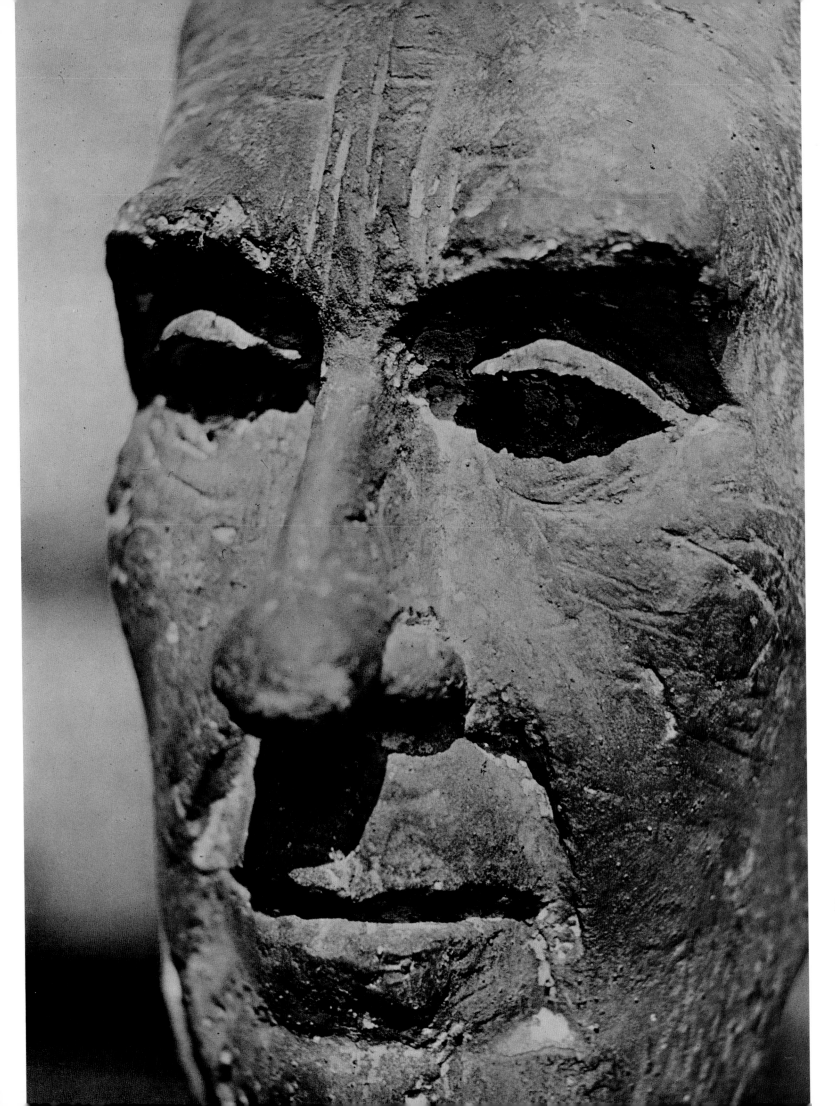

233

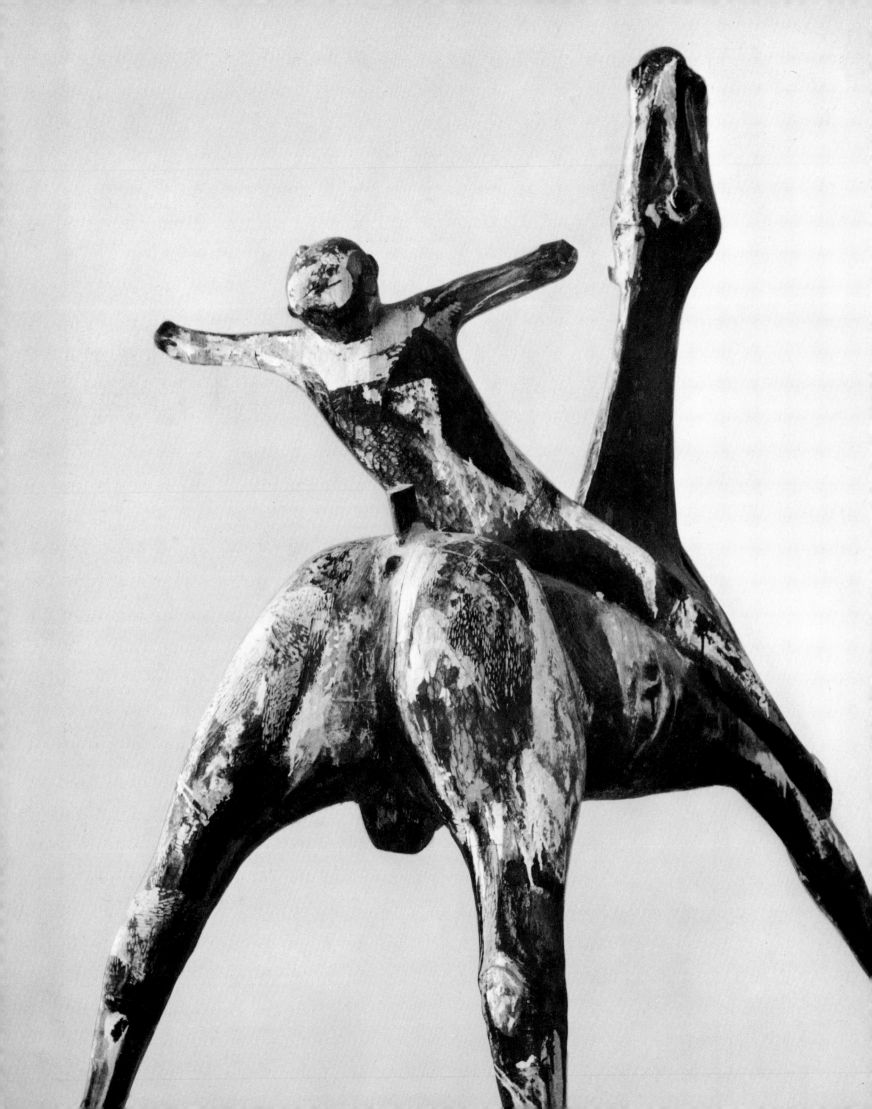

[261] MARINO MARINI. *Rider*. 1951–53. Painted wood, height 6' 10".
Rijksmuseum Kröller-Müller, Otterlo. [262] *Horse and Rider*, from
Greece. Last third, 6th century B.C. Marble, height 30 1/4". Ceramicus
Museum, Athens

color the image; for him the color is part of the whole. Color can
intensify or weaken the form to the extent required by the conception.
The cunning patinas, which in fact are typically Italian, occasionally
conjure up a feeling of antiquity. At times there is a nostalgic longing
for archaism, but in a positive sense; the patinas may affect the light
on a form to such a degree that under certain circumstances the
form becomes more exact. If the patina is wrong, bronze often im-
pairs the exactness of the impression of the form.

Thus it was given to an Italian to achieve an amalgamation of the
still-active past (which is now only a means and no longer an end in
itself) and the modern sense of life. It is in the latter that Marini's
creative passion is rooted. He knows the terror of the present. He is
aware of the tensions and the frightening powers of this century, of
its unlimited destructive inventions. But by means of the symbolic
figures that arose in his mind and the slight archaic touch he imparted
to them, he succeeded in attaining a state of detachment that made
them appear to have escaped from the world of reality and to belong
to a dream. In this dream they have become calmer; even in their
violence they are still moderate. It is from this world of dreams that
the images have returned to the half-waking dreamer. At times it
seems as if Marini had never really relinquished them, as if they had
never left him but remained within reach of his hands, which, directed
by his loving vision, raised them slightly from the ground so that,
half immersed in the mystery of dream, they could begin to live in
the light of day. Marini's lifework is remarkably pure and whole.

Like Marini, Germaine Richier (1904–59) comprehended the
element of terror in her sculptures. Although her work seems to be
more revolutionary, she, unlike Marini, never deviated from a
traditional basis; rather, she adapted it to a realm rarely explored by
sculpture. In Germaine Richier's work the frightening image of man
emerged more directly than in Marini's but without his always
apparent feeling of detachment and without the delicate charm of
his forms. The slight veiling of form characteristic of even the most
passionate Marini is completely absent from the work of Germaine
Richier. She achieved a direct expression that made use of the ex-
pressiveness of the skeleton, which in the tradition of sculpture has
always been enveloped in the modeled form. Germaine Richier saw
its possibilities; she used the schematic, the overt character of the

structure as a means of expression [264]. By discontinuing the con-
struction halfway between start and finish, she exploited the element
of incompleteness to convey impressions of a ravaged, lacerated life.

It was after a rather academic training that Germaine Richier
discovered the appropriate means for expressing her perturbed
feelings about existence. The training she received in Montpellier
and then with Bourdelle in Paris, and the war years spent in Switzer-
land, where she was intimately associated with Herman Hubacher
(born 1885), were fundamental experiences; together with the
tradition of the craft, they contributed to her ability to check the
explosiveness of the tensions in her mind. What she wanted to evoke
was the hallucinatory images of the threat of death that becomes an
inescapable reality, affecting man physically and mentally, to the
very depths of his soul. But to describe in literary terms the effect of
Richier's figures (*The Bat, The Locust, Shepherd of the Wastelands* [264])
distracts attention from the fact that the Surrealist content of her
art, as well as the literary associations, took form from her inventive
technique, which was born of the craft of sculpture itself. In this she
went to the very limits, to the boundaries of fragility, of transiency.
Her technique became more and more refined through the pressure
of her anxieties. There is no doubt that at first this was only a game,
but, as in the Dances of Death in the period of transition from the
Middle Ages to the Renaissance and as with Bernini, who suddenly

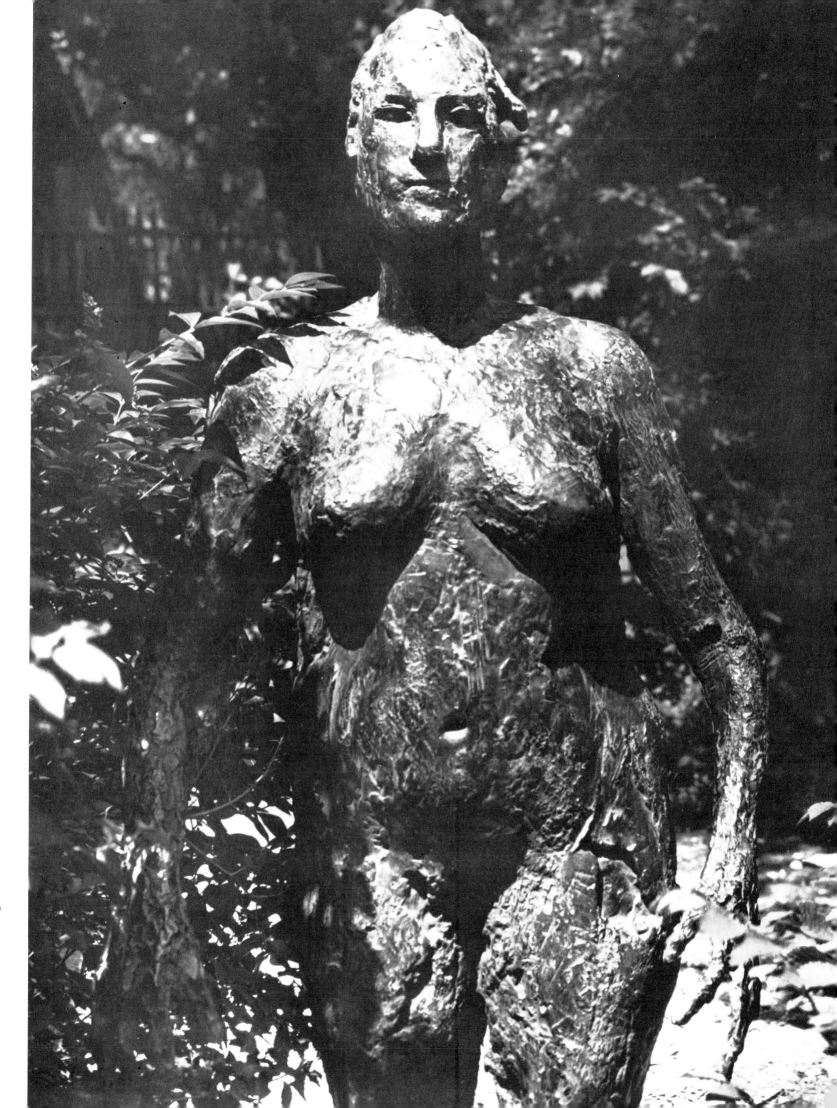

[263] GERMAINE RICHIER. *The Storm.* 1949. Bronze, height 69 ¼".
Musée National d'Art Moderne, Paris. [264] GERMAINE RICHIER.
Shepherd of the Wastelands. 1951–56. Bronze, height 60". Collection Bo
Boustedt, Kungälv, Sweden

replaced the image of pious, liberating death with the image of up-
rearing, menacing death, Germaine Richier imparted to the old
agonizing fear a new shape, not as a figure, but as an "anti-form."

In every art and every period the shock element is soon exhausted;
an ever-increasing dose is required in order to maintain its effect.
That which fascinates even when the effect of the shock has passed
away must necessarily contain something else, something deeper.
In the sculpture of the twentieth century, Germaine Richier's
peculiar talent created, by traditional means combined with the
possibilities explored by the artistic vanguard of the previous genera-
tion, a number of figures whose origins can be traced to the dynamism
of the destructive forces in man, forces that are always ready to strike
and to destroy the texture of life. There is a deep significance in the
fact that, fascinated by the structure of the sculptural figure, she
made it subserve the feeling of decomposition. As a result, these
figures enter our mind all the more forcibly. Under the spell of form,
they desperately make themselves known as inimical to form [229,
263–266].

Richier's experimental efforts in the last years of her life, when she
was working with painters in an attempt to create a background with
the use of color, were too problematic to break ground for new hori-
zons. However, the field which she had opened up to sculpture with
her mature works was later cultivated successfully by certain other
artists.

Alberto Giacometti (1901–66) occupied an uncertain position in
the development of sculpture between 1925 and 1930. Later, how-
ever, he developed a personal idiom that was intentionally limited in
its means. Between 1922 and 1925 Giacometti had frequented
Bourdelle's studio, where Germaine Richier was then working. The
old master encouraged independence of thought in younger artists
and students. Giacometti learned enough about monumental sculp-
ture, the archaism of the ancient Greeks, and Romanesque and
early Gothic sculpture to turn for enlightenment to Cubism [270],
to seek advice from Lipchitz, among others, and to make a profound
study of Surrealism. But nobody who knew only his *Spoon Woman*
(1926–27 [267]), his *African Exercise* (1926), and his *Invisible Object*
(1935 [268]) would have been able to predict—even though the basic
character of Giacometti's later work is altogether apparent in these

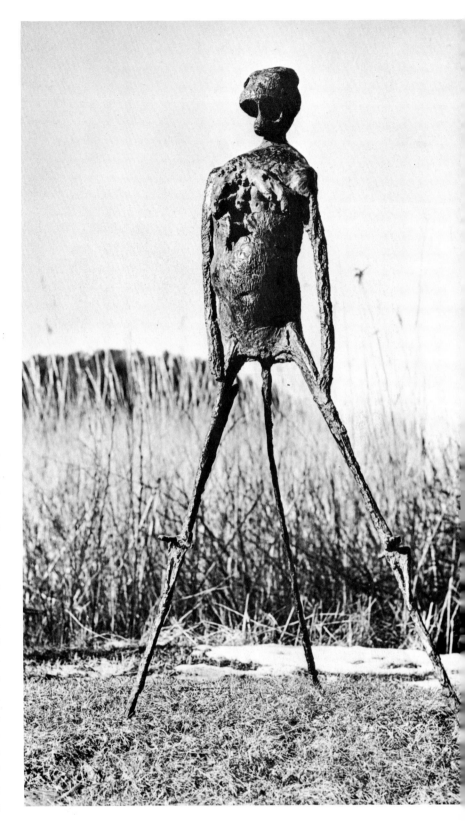

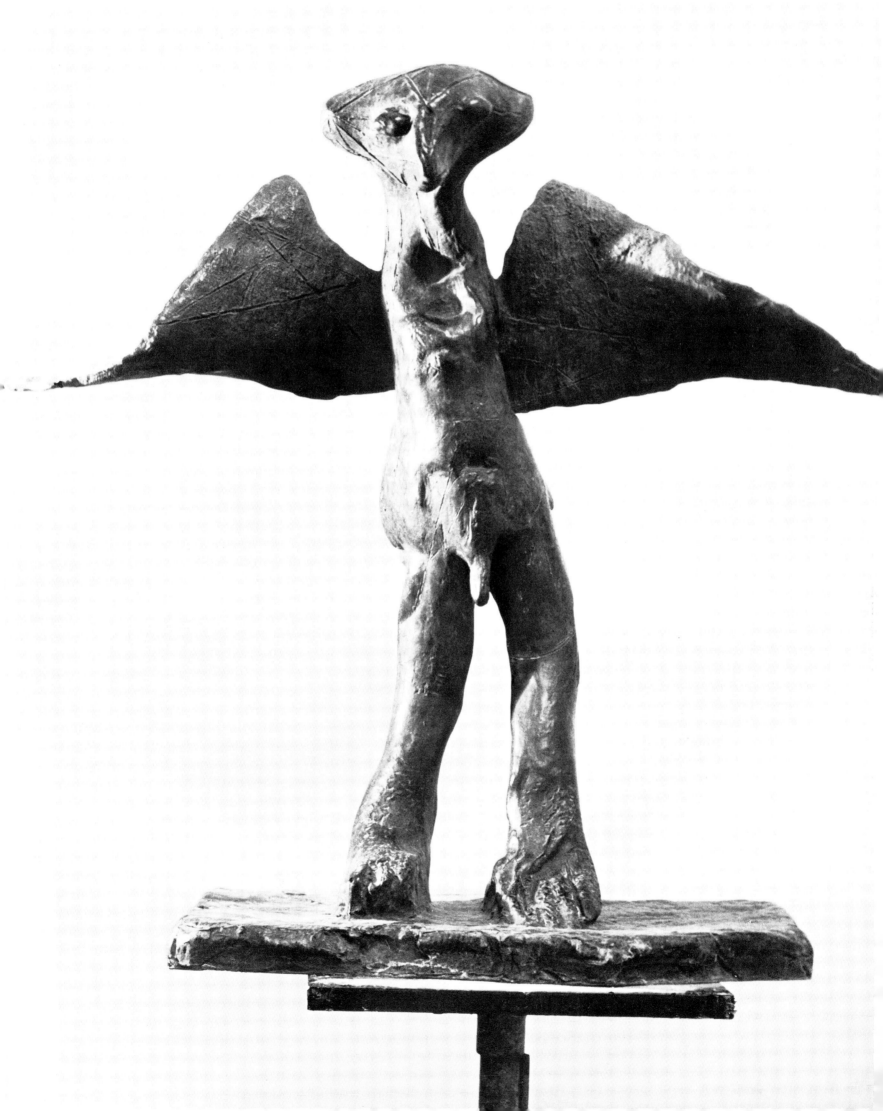

[265] GERMAINE RICHIER. *Man of the Night*. 1954–55. Bronze, height 28″. Rijksmuseum Kröller-Müller, Otterlo. [266] GERMAINE RICHIER. *Chessboard Figure*. 1955. Painted plaster, height 14″. Private collection

pieces—the special contribution to sculpture of this Swiss Parisian. In 1932–33 he constructed out of little wires *The Palace at 4 A.M.* [269], a work indubitably inspired by Surrealism. And there is also the *Little Egyptian Carriage*. Giacometti had to work out the problem of his own archaism, but there was more that occupied his mind. Like many other sculptors, he also painted and drew, but his paintings and drawings were more than an accompaniment to his plastic preoccupations. A true evaluation of Giacometti must be based on an acquaintance with all three of his modes of expression. Only if the three facets of his creativity are included can a public collection give a complete idea of his artistic personality, as the convincing exhibitions at the Venice Biennale of 1962 and in the Kunsthaus in Zurich, 1962–63 [275], amply proved.

In considering his form and technique, it must be admitted that after the contributions of Boccioni, Brancusi, and Lipchitz, to mention only three, Giacometti approached sculpture from a very narrow avenue. One must look elsewhere for the secret of his significance. Giacometti's paintings and drawings prove his deep interest in Cézanne: in them the problem of space and perspective plays an important part. The development of diaphanous planes (which touch, and are only bordered by, the contacting points or planes), the avoidance of all outline, the reduction of color and its inclusion in the plane in the purest possible state and in conformity with the spatial effect, are factors that can be traced back to Cézanne and to Cubism.

Giacometti's sculpture, too, is born of these elements and forms an indissoluble whole with his drawings and paintings. However, certain of his best paintings and drawings express something more than this tradition. They make the experience of an infinite space immediately perceptible, so that a room, a cabinet, a table, a chair, a few little apples are, as it were, discovered as elements in space, where they are only temporarily admitted [271, 272]. The objects are no longer objects but chance encounters; in these encounters an utterly tranquil, voiceless sensation of space becomes concrete in the objects transpierced by Giacometti's space-saturated eye. He does not unravel any mystery; the secret of the objects remains, but they lose something of their material ponderousness, their substance, whereas their spatial existence becomes infinite.

Giacometti's forte lies in reducing man, object, and space to a com-

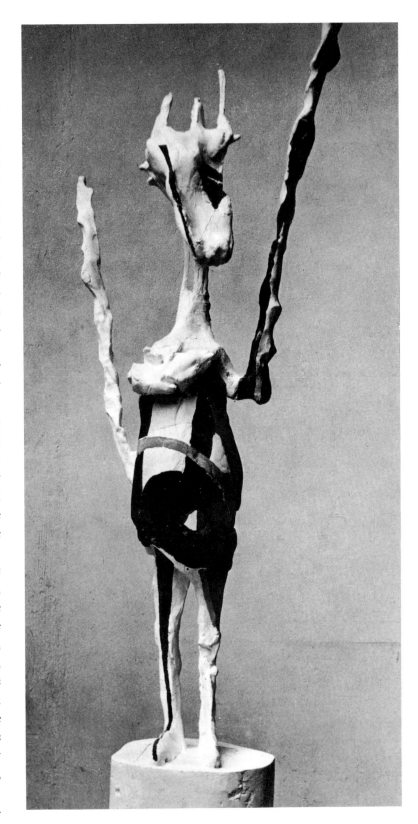

239

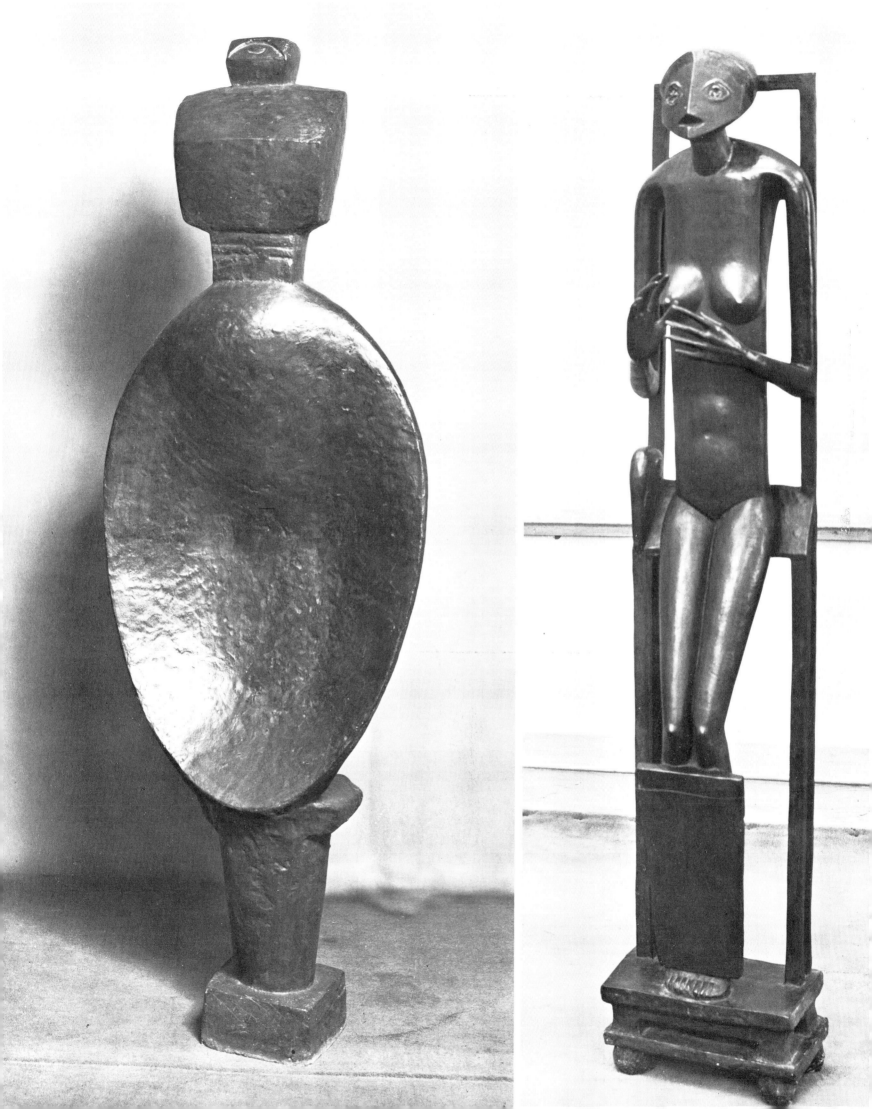

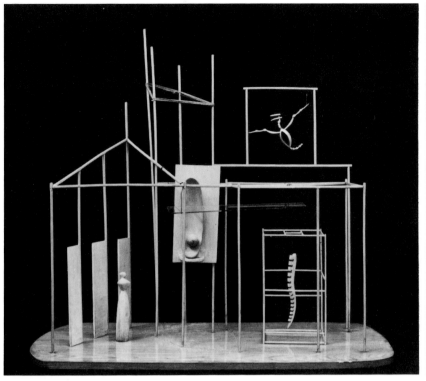

mon denominator. As architect, man partitions space, and the human figure moving inside these compartments loses the awareness that he himself created them. They gradually dominate him, and he accepts them as an objective world. Giacometti re-establishes the original relation with space: he links the human being to the miracle of the time and space in which he is born. A masterpiece in this respect is his *Palace at 4 A.M.* [269]: a platform with vertical opaque planes at one end and, suspended above the middle of the platform, a horizontal glass plane; a small female figure inhabits the structure. The work is extremely simple, but in this reduced figure and space is the condensation of thousands and thousands of rooms, passages, and courtyards with which Giacometti was in close contact and which he here sees at a distance, spaces in which human beings move without being aware of the connection between, on the one hand, *their* time (movement) and *their* space and, on the other, Time and Space. Giacometti sees the connection. He restores the connecting links. This achievement can only be the result of countless quiet and solitary observations and experiences.

Giacometti's thin, elongated little figures [273, 277] bring to mind the work of certain other artists. In addition to Jacques Callot, whom Giacometti himself mentioned, one thinks of some of the graphic works of James Ensor (1860–1949), which so fascinated Paul

[267] ALBERTO GIACOMETTI. *Spoon Woman.* 1926–27. Bronze, height 48″. Private collection, Paris. [268] ALBERTO GIACOMETTI. *Invisible Object.* 1935. Black bronze, 61 × 12 5/8″. Private collection, Paris [269] ALBERTO GIACOMETTI. *The Palace at 4 A.M.* 1932–33. Construction in wood, glass, wire, and string, 25 × 28 1/4 × 15 3/4″. Museum of Modern Art, New York. [270] ALBERTO GIACOMETTI. *Cubist Head.* 1935. Bronze, height 10″. Galerie Maeght, Paris

[271] ALBERTO GIACOMETTI. *Annette in the Studio.* 1961. Oil on canvas, 57 1/2 × 25 3/4″. Galerie Gimpel & Hanover, Zurich [272] ALBERTO GIACOMETTI. *Caroline on White Background.* 1961. Oil on canvas, 72 3/4 × 31 1/2″. Galerie Gimpel & Hanover, Zurich [273] ALBERTO GIACOMETTI. *Man Walking II.* 1960. Bronze, height 6′ 2″. Galerie Beyeler, Basel

Klee (1879–1940) that for a while he continued in the same style. Furthermore, there are reminiscences of the tenuous little figures by Picasso dating from 1931 [105]. And in the background of all this are the slender, long-legged little Etruscan figures [274], some of which are depicted holding the thin sticks with which they practiced divination with entrails. Our insight would be increased if we could discover what the basic significance of these figurines was for the

241

Alberto Giacometti

242

243

[274] *Etruscan Votive Statuette*. c. 100 B.C. Bronze, height 22½″. Museo Etrusco Guarnacci, Volterra. [275] ALBERTO GIACOMETTI. Exhibition, 1962–63, Kunsthaus, Zurich

Etruscans. Even given these forerunners, archaic and modern, it was an original discovery on the part of Giacometti that he could compress the volume of the figure and of the portrait bust almost completely and that he could alter the proportions by enlarging the feet and make the body rise from those feet and soar upward, like the elongated leaf that shoots up from the cactus plant. By these means he was able to arrive at the exact form of expression of his philosophy of space.

The long preparation that Giacometti required for the elaboration of his own style is explained by his shyness vis-à-vis everything that presents itself in space with a full and positive shape. He continually sought to express the intervals between volumes, the objects in space, and was intuitively conscious of the fact that what he was going to create would be articulations of space. This timidity in the face of volumes explains his preference for the smallest possible volume. Everything suggests that, fundamentally, he was creating reliefs all the time.

On the other hand, it is sufficient to look carefully at a single one of Giacometti's portrait busts to understand how peculiar, but at the same time how complete, is his sensation of space. As a rule, he puts the head in an axial relation to the bust (or the torso in an axial relation to the feet), thus creating the impression of planes that are continued in space, instead of a static relief. The excessively thin fronts of the compressed heads not only have their formal value in profile but may also be said to be cutting frontally into space. In Giacometti's work the rising of the figures has a psychical rather than spatial importance. There is a sense of ecstasy, as if some force in space were carrying the figure aloft.

Invariably one comes to the conclusion that the basic principle of Giacometti's painting, drawing, and sculpture proves to be one and the same experience of space. Giacometti's reduction of the human figure is not, as has sometimes been supposed, the expression of destruction, such as we find in Germaine Richier. Giacometti's creations make a ghostly impression, but the totality of his work proves that they have an entirely different quality. His reduction to the minimum, his simplicity, are the results of a distinct philosophy of space through which he restores an intuitive link between, on the one hand, motion and volume and, on the other, time and space.

As this artist may be said to live in the miracle of space and does not,

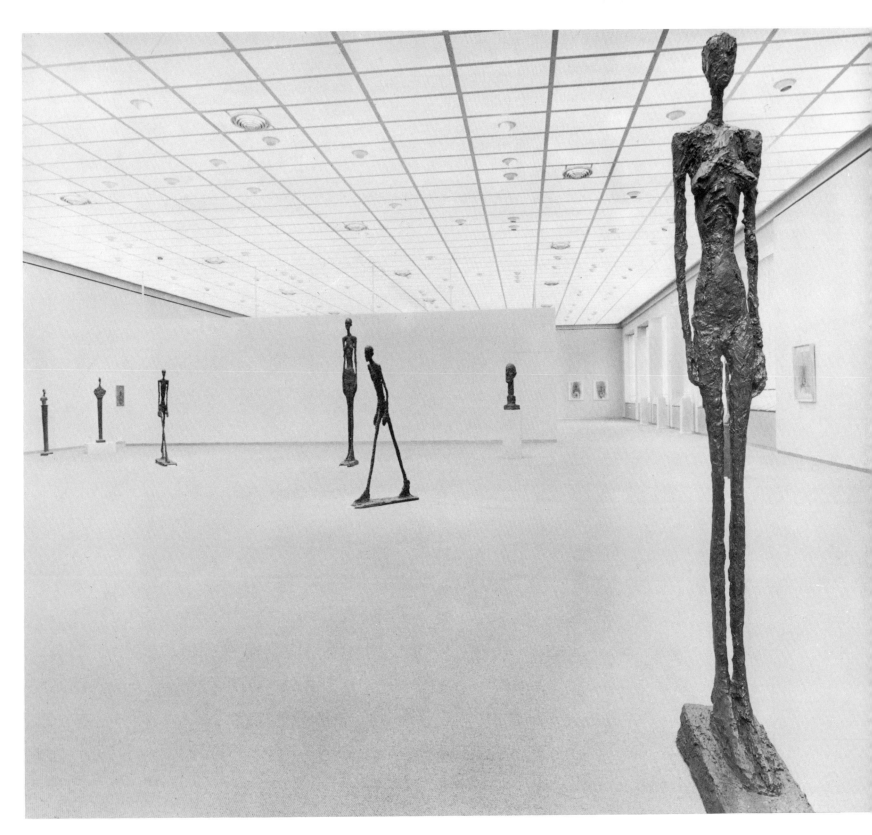

245

in an opposite sense, start from the object to arrive at an abstract space, he must necessarily discover an infinite quantum in objects by concentrating on something small—a foot, a leg, a knee. Long before Giacometti, the American Gaston Lachaise (1882–1935) carved his marble *Knees* [276]. Nothing could be more conducive to a clear understanding of Giacometti than a comparison of his rendering with that of Lachaise. In Lachaise's image the perfect fullness of the volume has as a starting point the knees themselves, which, separated from the whole to which they belong, produce an effect as a compact mass with a fine tension and a form tending toward abstraction. In actual fact, Lachaise's point of departure did not differ greatly from that of the traditional academies, where, according to the old engravings and drawings of the eighteenth and the early nineteenth century, plaster models of feet and legs of ancient masterpieces were displayed in order to enable industrious students to master the true classical form. By contrast, Giacometti looks upon the foot or the leg not as

[276] GASTON LACHAISE. *Knees*. 1933. Marble, height 19″. Museum of Modern Art, New York (Gift of Mr. and Mrs. Edward M. M. Warburg). [277] ALBERTO GIACOMETTI. *Woman in Chariot*. 1950. Bronze, 56 1/4 × 23 1/2″. Kunsthaus, Zurich

something physical or geometrical but as something miraculous which has a function in space and which, during one's very contemplation of this function, loses the designation by which it is ordinarily denoted: it loses its name and returns to the time before it was baptized. The element of surprise—in fact, one should use the word admiration in its archaic sense—saves the object in Giacometti's works from the wear and tear of convention, from the deadly certainty of the name that has lost its meaning. He revives everything he touches not by analyzing it but by denuding it.

Thus Giacometti slowly emerges from the modern trends as well as from Surrealism; he is the only artist who tried to express clearly what is alive between positive objects in space. In doing this, he could not refrain from being positive himself, but to a minimal extent and with every indication that the other element, the domain from which the form arises and to which it will always return, is essential.

It has become customary to mention the work of Henry Moore and that of Barbara Hepworth (born 1903) in the same connection, namely the revival in England of the style of sculpture which, coming shortly after Epstein and Gaudier-Brzeska, bore a certain relation to that of the Continent. Although they are of about the same age and have a similar educational background (Hepworth attended the Leeds Art School and, from 1920 to 1924, the Royal College of Art in London), Moore and Hepworth represent two different trends. There are common features in their inclination toward abstraction, but the significance of the abstract tendency is quite different so far as the work of each, taken as a whole, is concerned. That the differences between them are fundamental has been lucidly demonstrated by J. P. Hodin in his study of Hepworth.[61]

While the question of national character is immaterial in the general plan of the present book, the question as to whether the English development had its roots in the Continental movements, and, if so, what the specific results have been, is of great significance.

It is evident that Barbara Hepworth early succeeded, through her alertness and ability, in finding the road that led her from the sculptural conventions [223] as taught in the academies to the sources of the avant-garde. Travels in France and Italy led her not to Donatello and Michelangelo but rather to the Etruscans, among others. From Ardini she learned thoroughly the art of carving marble. Of no less

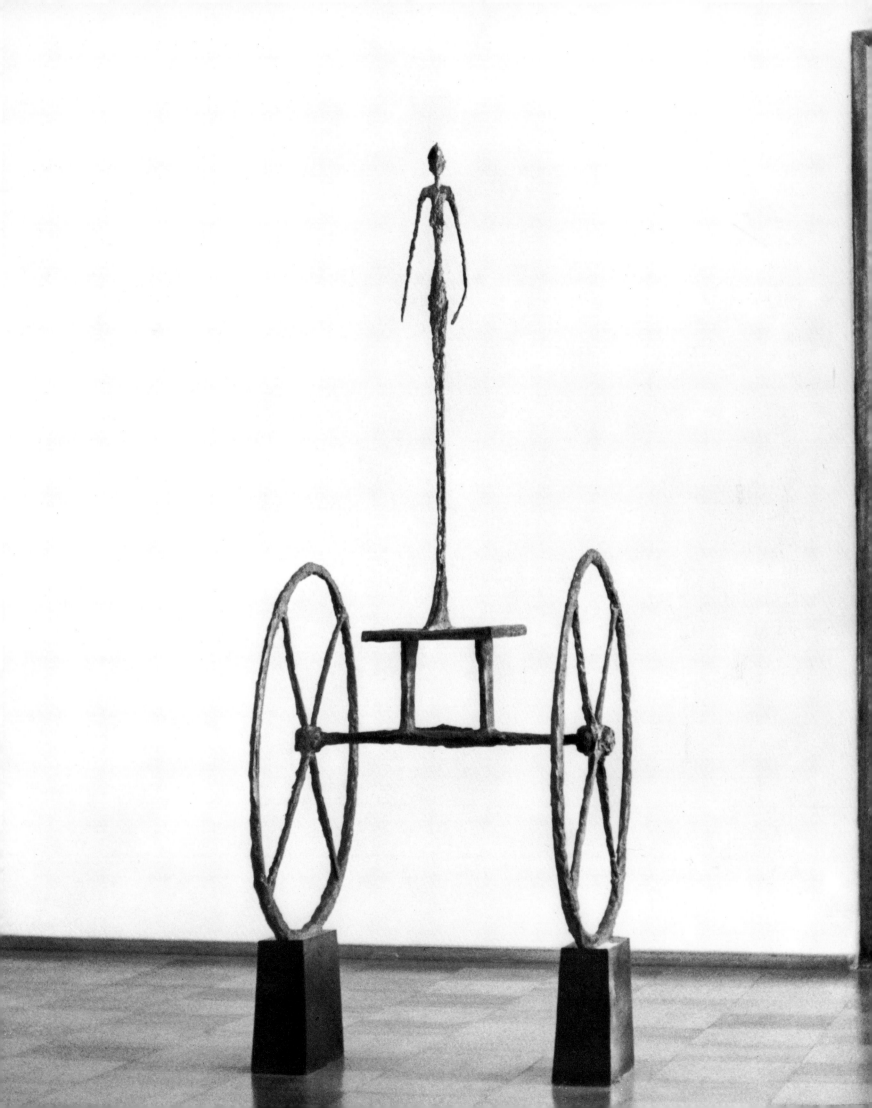

importance was her interest in the frescoes of Masaccio, Cimabue, and Giotto. Thus Hepworth too was interested in the treatment of space in painting; the dignity and grandeur of Masaccio's figuration in perspective and the clarity, concentration, and monumentality of Giotto's figures deeply penetrated the mind of the young sculptor. The history of the development of sculpture reveals again and again (in the case of Barbara Hepworth rather unexpectedly) its connections with painting. The connections with regard to Hepworth's work can indeed be stated in specific terms. The productivity of the years of her marriage to the painter Ben Nicholson (born 1894), from 1931 until shortly after the hard war years in Cornwall, are incontestable proof of a mutual exchange of inspiration, the effects of which did not end with the marriage. In some later drawings made in a hospital operating room there was a recurrence of the Italian influence. The penetrating effectiveness of Hepworth's style can be seen as the result of her experience of translucent painting and of abstract sculpture.

Between 1930 and 1940 London was an important international meeting place. The circle of Ben Nicholson and Barbara Hepworth, which included Herbert Read, was extremely alive and interesting. Moreover, a few of them had contacts during this period with artists on the Continent—among them Picasso, Arp and his wife, Brancusi, and Calder—and, in London, with the architects Gropius, Marcel Breuer, Eric Mendelsohn, and, as war became more imminent, with Mondrian and Gabo, who had moved to London from Paris. The group Unit One tended to propagate the active application of the new possibilities of style. In spite of its short life, Unit One was the most important manifestation of what the preceding generation had achieved between 1920 and 1930, as well as of the conclusions at which the more mature had arrived.

Here, too, the short life of the group was foreordained. The division between what might be classified respectively as Surrealism and Constructivism made itself felt. Circle (1935) was a stricter group, in which architects participated and abstraction was predominant; what was started in this group later acquired an increased cultural significance. It was a program that had an important influence, though it did not achieve anything beyond the individual creations of its members and contributors. Mondrian's presence in London, before he managed to leave for New York, thus escaping the bombing of the English capital, imported the purist influence of the Dutch De Stijl spirit. But, above all, the Unit and Circle movements had the effect of inducing the English to develop a clear attitude toward the still perceptible influence of romantic expression. The spiritual

[278] BARBARA HEPWORTH. *Forms in Echelon.* 1939. Tulipwood, height 40″. Collection the artist, St. Ives, Cornwall

power of Moore and Barbara Hepworth and the criticism that was ardently stimulated by Herbert Read imparted vigor and force to the new attack. It was positive and had the restrained ardor of true conviction.

These various events and personalities explain why the background of Barbara Hepworth's work is complicated, though her work shows coherence in its ramifications. Few artists have followed so strictly and consistently the road toward abstraction. She was continuously involved in struggle and tension in her effort to prevent the dissipation of abstraction; it was her constant effort to inject it with the sap of life and to take account of the relation between nature and man. Hodin stresses the fact that she was the first artist in England who, with psychological conviction, pierced a form in marble (1931).[62] Indeed, she had succeeded earlier in imparting to the compact block of stone a great spatial tension. The "tunnel" indicated new possibilities, which developed gradually but still, many years later, show their relation to this first venture [278–286]. Yet the fact remains that after 1931 the human figure continues to guide her modulations; again and again her love of line tempts her to inscribe a melodious profile or a spiral on the curved surface.

During the Cubist period Lipchitz had cut a tunnel through one of his figures, *Man with a Guitar* (1916 [175]), and he too remembers the emotion accompanying this act. In the case of Lipchitz the hole came into existence altogether irrationally in a severely composed human figure: this was an emotional release from the formula of the compact mass by the vital desire to open it.

Barbara Hepworth's pierced form also had its emotional foundation, but, because of the central position of the piercing in the over-all shape, it would seem to be more consciously harmonious and the result of an aesthetic selection. In principle we are already faced here with the difference between an earlier and a later generation. In the case of Barbara Hepworth, the indication is that she will proceed toward a devout exploration of the inside of matter and of shape.

Hepworth began to apply stretched strings to her forms in 1939. In art, when there is something "in the air," it is always an attractive game to decide who was the first to work out a method. Fortunately, the value of a work is not decided by priority in time. However, every invention indicates a particular mentality, one that is open to discoveries; thus, the question of who went farthest and deepest in exploring a certain means is important.

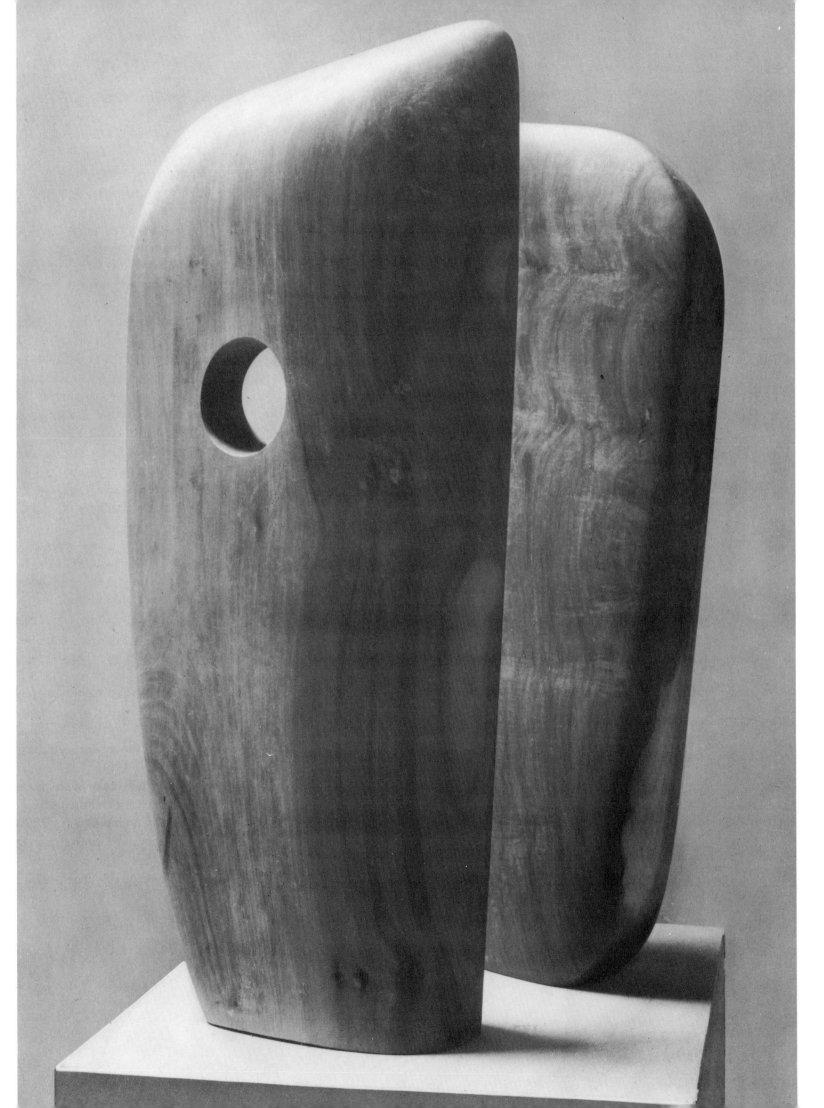

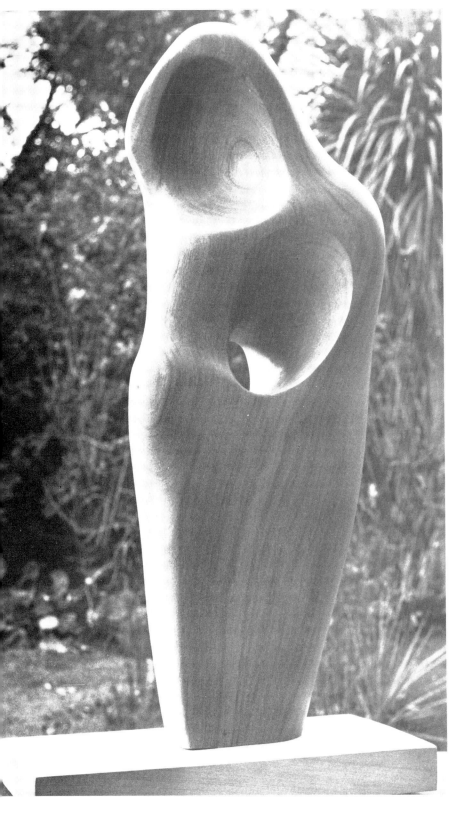

The stretched string motif, which Hepworth began to apply to her forms in 1939, brings us again to the subject of the artistic idea that is "in the air" at a particular time, for somewhat earlier in the same year Moore used taut wires as an important means of expression [246]. But one must first go back to 1924, when the strings of a harp led Lipchitz to develop his series of experiments with transparent structures in bronze [177–181]. In 1937 Gabo [200] and Pevsner, starting from a point that was utterly different from that of Lipchitz, used the thin stretched line in order to create a transparency of curved surfaces. In Constructivism the tightly stretched line made its appearance as a spatial factor at an early date, and this was one of the reasons why the use of strings has been more or less associated with its birth. Moore and Hepworth, however, always use the strings in a work with an open inner form (cavity or tunnel), as if to invoke the music of space. They arouse the most subtle tactile response. They do not construct the main form, which has its compactness and its curves, in transparent or nontransparent structures, as do Gabo and Pevsner; they create an interplay. With their rectilinearity, and by means of the convergence toward one, two, or more points, which are to be found usually inside but occasionally outside the form, they define a second sense of space which is tense and diaphanous.

The strings shut off the entrances to the interior form in a transparent way. They achieve a delicate contrasting effect because they produce a center different from that of the compact form. The strings as Barbara Hepworth elaborated them in the course of the years [281, 282] are a continuation of the "opening up" of the volume and counteract the compact "closed" form. Together the two devices create a spatial image with an intensified geometric accent. In a sense the line which the sculptor graphically "wrote down" as a human profile on the marble forms led these forms back to the figurative. With the strings the opposite took place. They translate the organic abstraction of the form to geometric abstraction.

Finally, just as consciously, Hepworth included color in sculpture, but in her application of color the pictorial element is entirely absent. As we have seen, the sculpto-painting of Archipenko [157] and the painting-reliefs of Tatlin had their origin, like Picasso's coloring of certain sculptures, in painting and collage. The colored relief produced by Laurens was derived directly from painting. Zadkine,

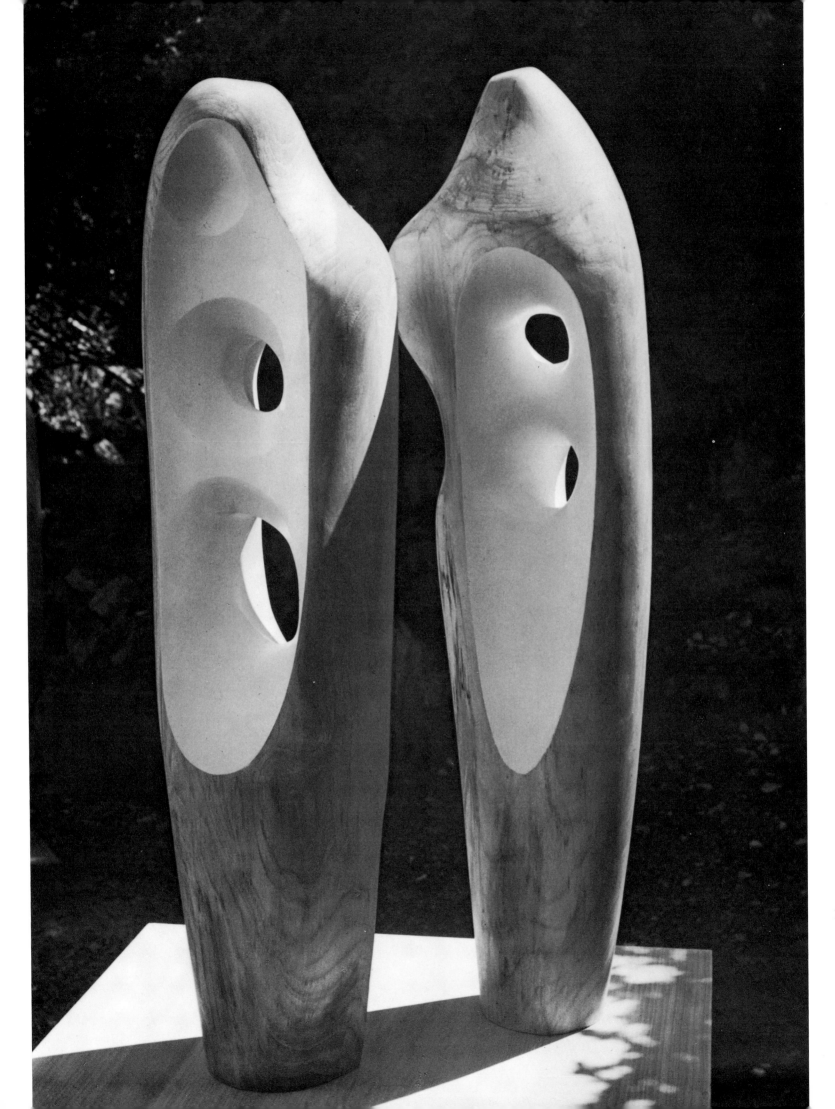

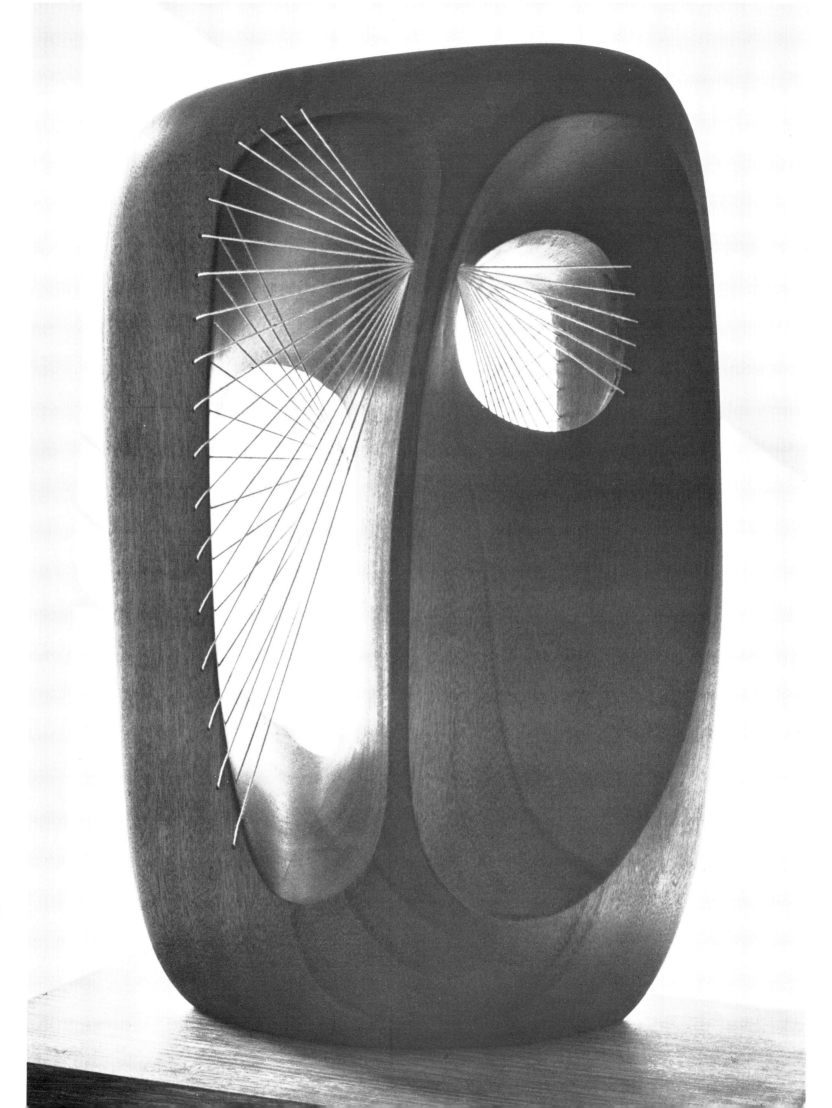

252

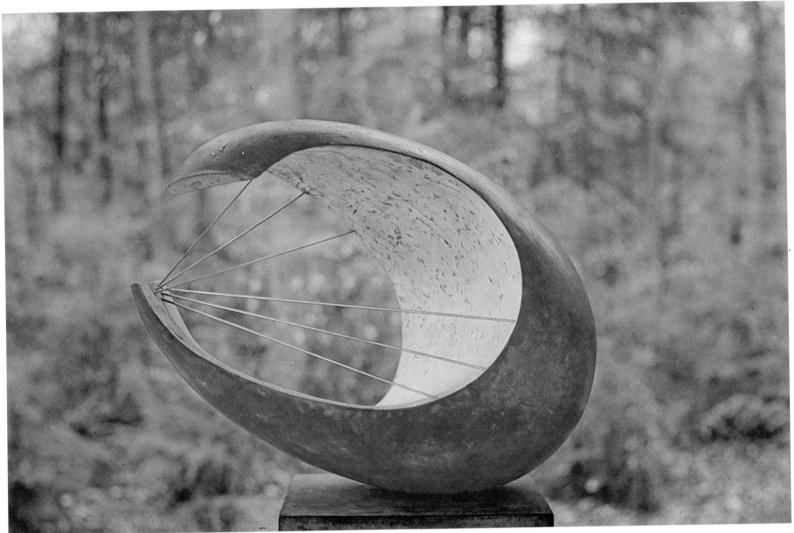

too, applied color with an emotional, pictorial sense. In the work of Hepworth, however, the color has the function of dimming or intensifying the light which reveals the form. Often the color is used on the inside of an open form to achieve the exact level of light dictated by the artist's formal conception. The longing for color must have developed in the light near the seacoast of Cornwall, in the garden and the workshop of the artist's Trewyn Studio in St. Ives. The ancient artists who worked near the sea in the brilliant light of the Greek islands experienced their need for color as a result of the intensity of the light and of their own search for a stable form.

For many years Barbara Hepworth avoided working in bronze, not for any reason inherent in the material but because she did not like the idea of relinquishing the inspiring application of energy required for the direct shaping of wood or stone. It is undeniable that

[281] BARBARA HEPWORTH. *Head (Elegy)*. 1952. Mahogany and strings, height 17″. Joseph W. Hirshhorn Collection, New York
[282] BARBARA HEPWORTH. *Curved Form, Wave II*. 1959. Bronze with steel strings, height 18″. Collection the artist, St. Ives, Cornwall

an important value in her work stems from the fact that she was able by means of her forms and her technique to bring to the surface the mystery of the life hidden in the block of marble or in the majestic, menacing, dramatic, exotic substance of wood. However, she could not entirely resist the liberty afforded by bronze, and when, in 1955, she finally decided to work in that medium, she still managed, by the direct and personal tooling of each separate piece [282, 285, 286], to maintain something of the old principle of truth to material, to which the renovation of twentieth-century sculpture unquestionably

253

owes so much. In any case, the use of bronze and the rejection of modeling in soft substances also increased the possibilities of her art with regard to dimension and within the limits of the technique she imposed upon herself. This increased freedom and expanded spatial imagination became visible in her drawings as well.

The balanced steadiness, clarity, and harmony of Barbara Hepworth's finest creations have been called classic. This is a term that it hardly seems possible to apply in our century. It may be reasonable to think of abstract art as exemplifying the principles of classicism, but here a warning is in order. It is unthinkable that the term be applied, for example, to Kandinsky. In Mondrian's case there is a possibility. What about the Constructivists? Not everything that is composed and constructed and that approaches architecture can logically be called classic: the spiral and the curves of motion in the works of Tatlin, Gabo, and Pevsner are not classic; on the other hand, the urge toward the classic elements of clarity, perfection, and balance seems characteristic of Arp. Occasionally the works of Hepworth bear some relation to what was done by these artists, and, as Michel Seuphor has demonstrated,[63] the opposite is also true. As we now know, Arp began to devote himself fully to sculpture in 1930. Hepworth visited him in 1932 and during that visit she gained lasting

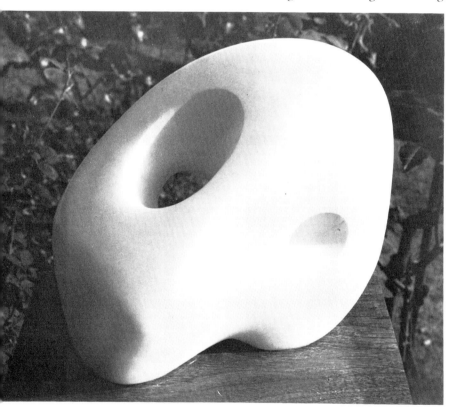

[283] BARBARA HEPWORTH. *Landscape Figure.* 1959. White alabaster, length 14″. Collection the artist, St. Ives, Cornwall
[284] BARBARA HEPWORTH. *Pastorale.* 1953. White marble, length 45″. Rijksmuseum Kröller-Müller, Otterlo

impressions, but she most certainly did not find a classic character in Arp's work, which is not really classic. His plastic creations seem classic because of their uncomplicated and harmonious external aspect. His talent is, rather, romantic; his is not an expressive but an introverted, tranquil, poetic romanticism. In sculpture he has no pronounced affinity with matter, as can be seen in his attitude toward dimensions. Arp worked in plaster and left it to assistants to render the form in stone or bronze; consequently, there is an important difference between his work and that of the carvers Brancusi and Hepworth, and of the Greeks. The unmistakably pastoral quality of his mind is romantically Arcadian; Poussin's Arcadia is not that of Arp! When dealing with the twentieth century, we can never be satisfied with the term "romantically classic." As for functionalism in architecture, which seems to us an expression of classic equilibrium, because of its glaring limitations and prejudices, as well as its exclusion of other artistic elements, it is not really classic—or, if one must use the expression, it is classic only in a very limited sense. In a wider context, we are compelled to realize that the sense of order in space that the architects and the city planners strive for today and the sense of simplicity and centrality, a balance which is latently or patently present in the art of abstraction, have not yet found each other. The mutual respect, the cautious reflection, and the rapprochement of the two positions have not yet brought about a veritable, convincing communion. Real manifestations of balance are thus far nonexistent in the visual world of the twentieth century. The emergence of the underdeveloped nations, the revolutionary leaps and bounds made by science, and the only half tamed technical appliances and machinery of everyday social life evoke tensions, storms, and resistances that are not conducive to a natural and organic equilibrium but cause an artificial and convulsive order.

If in our century there is nothing that might be called classic in the full sense of the word, it is because the classic element has to struggle with adverse forces as soon as it manifests itself. Twentieth-century man, lacerated by two World Wars and threatened by atomic destruction, is, even in the laboratories of science, faced with a disturbed, mutilated world. By virtue of its spiritual genesis, Barbara Hepworth's work belongs to the world of order and balance. But honesty compels us to add at once that in its crystalline aspect it is

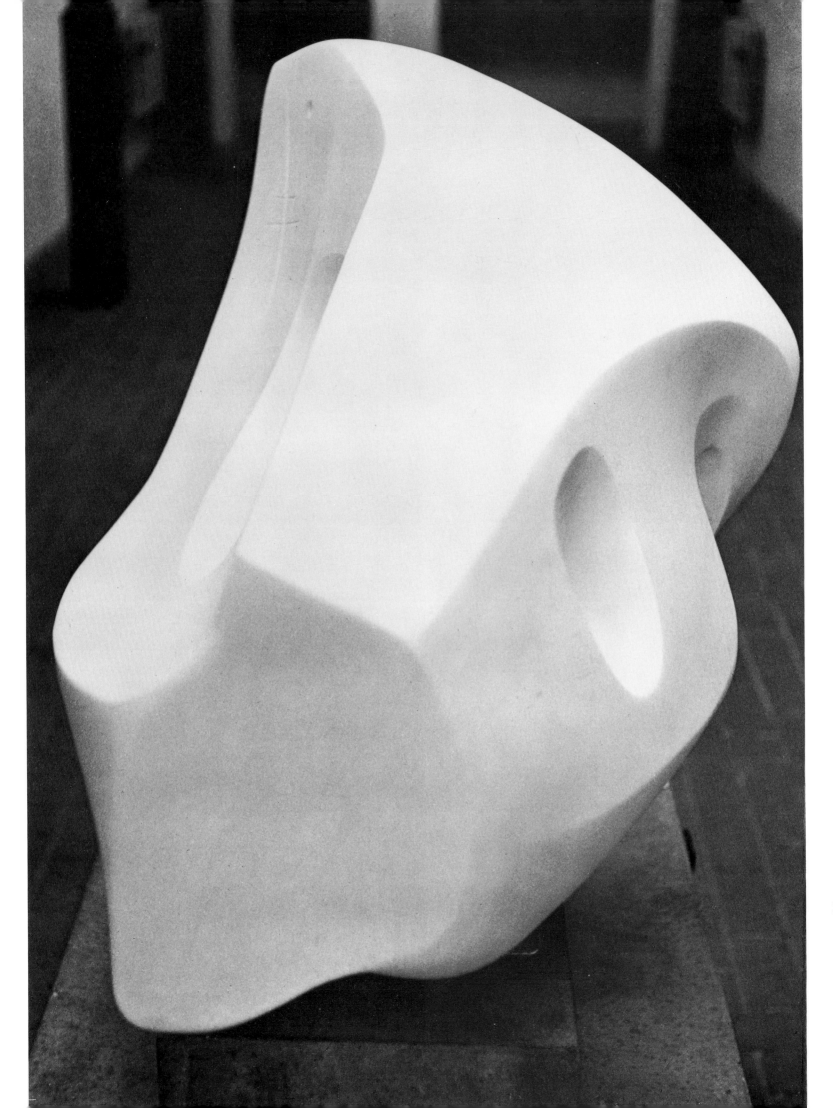

[285] BARBARA HEPWORTH. *Curved Form with Inner Form* (*Anima*). 1959. Bronze, length 27 ¾". Rijksmuseum Kröller-Müller, Otterlo
[286] BARBARA HEPWORTH. *Square with Two Circles.* 1963. Bronze, height 8' 6". Rijksmuseum Kröller-Müller, Otterlo

branded with the marks of our time and our life. As a result of the dimensions of the large-sized forms and of the material, it has, especially in the wooden sculptures, a dark, threatening quality—not at all incompatible, however, with simplicity.

The caverns that Hepworth opens up in the mass, however shapely they may be, have the fascination of an eye or a mouth in a magic mask. Some of her elongated figures have the objectivity of a litany, a lament for the world. In contrast with this is the radiant, unerringly exact clarity of a number of colored or pure white marble forms—a prospect of Arcadia, a nostalgia for a lost Greek world, but fortunately not exclusively nostalgic. Above all, her work is a valid tribute to present-day life, which again and again, in its highest scientific and architectonic activities, succeeds in emerging from the labyrinth of humdrum occupations into the clarity of filtered light, into the relative precision of a formula. Precision and exactitude are equivalent to transparency; they have entered into the sculpture of the present century and, as a result, certain values which until now pertained only to science and music have become not only visible but palpable. In Barbara Hepworth, abstraction has achieved a style that, because it is a style, does not dissipate its richly varied contents but condenses them in the tangible perfection of a form. This form succeeds in so purifying and clarifying light that we are enabled to participate in the miracle which occurs whenever the external light is changed within us into the light that knows not of "external" and "internal." Here we are reminded of the thirteenth-century aesthetic theory of light, according to which light emanates from two sources, namely, conscience and the outside world.

Fritz Wotruba (born 1907) belongs to the number of those who continued the work of the pioneers in direct carving and, starting from this foundation, rebuilt the human figure. Between 1920 and 1930, he too—as a result perhaps of his contact with Maillol, who praised his work—set out to find his way in the sculpture of his time, a time crowded with archaisms. Like Giacometti, Germaine Richier, and Marini, he sought refuge in Switzerland during World War II, refusing to submit to Hitlerism. Like his contemporaries, he was ignored during his early, exploratory years. In the 1940's, public attention was still centered on the Cubist masters, who were then in their later stages of development. It was only after 1945, when his

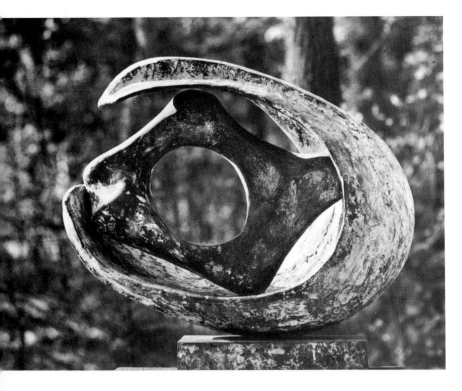

256

258

art was entering the period of its powerful growth, that Wotruba came into full view.

Wotruba has unbreakable ties with Vienna. In the late nineteenth and the early twentieth century, Vienna, by virtue of the activities of the architects Joseph Hofmann (1870–1956) and Adolf Loos (1870–1933) and the painters Gustave Klimt (1862–1918), Egon Schiele (1890–1918), and young Oskar Kokoschka (born 1886), was the scene of a brief artistic resurgence. Wotruba alone, in defiance of Viennese taste, maintained his severe style, which was the opposite of the Baroque: he needed the resisting force of stone to arrive at his form, and, in like manner, he needed the hostile atmosphere of Vienna to find his own mode of expression. When he returned to Vienna after the war, he was entrusted with the direction of the sculpture class at the Academy of Fine Arts. In this capacity, and as the result of exhibitions of his work, he has had great influence on younger artists.

The high quality of his work enabled him to re-establish the bond between Vienna and the international art world. Wotruba is the artist who has entered most completely into the "soul" of the stone, who has identified himself with it entirely. He rigorously drew the conclusion from what the generation of Maillol, Bourdelle, and, later, Martini felt: that the road to sculptural revival was direct carving, which entails a stimulating contact between the concept of the artist and the material. Yet modeling in clay and plaster was going on unabatedly, and the ancient Gothic practice was looked upon as lost. Bourdelle still had a vision of the possibility of reviving sculpture as an extension of architecture; the time was still too immature to see that such a relation could not be repeated and that historical examples could not be transplanted, technically or spiritually, into the twentieth century. The first to look upon direct carving critically had been Brancusi. His comment, cited earlier, was to the point: direct carving is the true road to sculpture but at the same time the wrong way for those who haven't the knack of it. He did not want to turn the idea into a dogma. Basically, no single object is dependent on any truth or fallacy; it is the object itself that is decisive. When, at a given moment, Wotruba thought fit to use bronze [287], he did so because he was convinced that ultimately it is the form that provokes the effect, although this does not alter the fact that the origin of the form lies clearly in the sculptor's will and the resistance of the stone.

The tendency of sculpture to change into architecture has entered our discussion a number of times. This does not mean what Bourdelle

referred to when he wrote: "Architecture is the core of sculpture, and sculpture, to be effective, must simply extend it."[64] The Constructivists conceived architectonic creations originating in their new sculpture; in his time, Michelangelo did the same thing in the same way. Wotruba did something else. His sculpture contains certain architectonic elements in all their purity. His point of departure was the human figure: he analyzed it slowly and carefully, observing measurements and proportions, but—and this is of great importance—not fixing them in a formula. He approached geometrical principles and observed nature—in the manner of the Greeks—but he was not doctrinaire. Indeed Wotruba's way is closer to the Egyptian, for the Egyptian amalgamation of architecture and sculpture was more organic than the Greek. Michelangelo, in his later works, relinquished rule and dimension in favor of an anatomical conception, and in this too he showed his independence. He handled dimensions and proportions in a free way. As Boccioni observed in his criticism (which is, as noted, full of contradictions) that in Michelangelo "anatomy becomes music, the human body architectonic material."[65] The *Rondanini Pietà* [6, 7, 8, 9, 12] is the ultimate example of a wholly introverted sculpture in which ratio and the laws of gravitation are transgressed. Never was such tenderness and compassion made tangible by so much ruggedness on a stone surface. Like Henry Moore, but for different reasons, Wotruba admired the *Rondanini Pietà* as a summit in sculpture.

In Wotruba's work the rugged surface, which may readily suggest the archaic, plays an important part. However, it is not the use of the *infinito* as an aesthetic means but rather the new archaic sentiment, the discovery of fundamentals, and the release from what the world of Maillol still clung to, that gave Wotruba's sculpture its tension and completeness of form. He attained a new liberty that strove so vigorously and absolutely for purity and sincerity that it manifested the greatest possible restraint.

It should be remembered, however, that the archaic quality in Wotruba is the opposite of what the archaic Greeks tried to achieve. He does not discover the movement or gesture or anatomy of the body. He sees the cube, the cylinder, the sphere. And once again his secret is rooted in the fact that he succeeds in escaping geometry and uses the cylinder, cube, and rectangle freely [290, 291]. He constructs the figure, and we perceive not the mathematical proportions but rather the miracle of upright man, the beginning of verticalism.

From 1950 to 1955 Wotruba's work became more and more simple, until he finally arrived at the naked cylinder. He succeeded in rendering the unity of the figure without hiding the articulations. Starting

[288, 289] FRITZ WOTRUBA. *Reclining Figure*. 1960. Limestone, 23 ½ × 15 ¾ × 55"

from this primordial sentiment, he created squatting and recumbent figures [290, 291], but the upright attitude came first—erectness, standing. We are reminded of the Old Testament story of Jacob, which culminates in the erection of a stone on the spot where, in his dream, he saw the ladder that reached from earth to Heaven, and the angels of God ascending and descending on it, and where he be-

held the Lord. In his dream, Jacob had an architectonically monumental feeling, for the stone was a token ("set for a pillar"), which was to become "God's house."

There is an early sculpture by Wotruba, a female figure, in whose structure the body is still the predominating element. Frontality is here of supreme importance. However, the standing pose is, as in the later figures, strongly introverted, estranged from the outer world; this might be the figure of a Druid. During the following stages of his work, when the architectonically sculptural principle became more important, this quality disappeared: Wotruba arrived at the idea of the wall. The relief, which had always been latent in his work because of the emphatic frontality of the figure, appeared later in a mature phase of his creative activity [287]. The idea of the column began to emerge. Here we think of the Greeks, in particular of that exquisite fragmentary statue of a woman from Samos dedicated to Hera, in the Louvre.

Wotruba's work evokes the idea that it is the human figure that has led sculpture again and again, over many thousands of years, toward structures relating man to space. Essentially, it is not strange that the stylization of a body enveloped in the pleats of the peplos

should lead, visually, to a column, which in turn suggests the idea of the caryatid. We have seen that Brancusi, starting from the male-female image [143], created a supporting structure. We have seen that Modigliani drew splendid caryatids, though the drawings make us suspect that they were inspired by the observation of nude women in real life rather than by an intellectual conception. With Wotruba we penetrate the core. As we have seen, he rediscovered the original standing attitude. In Giacometti's work, standing and moving have a different origin, which is not architectonic; the postures are ecstatically expressive and are divorced from matter [273, 275]. Wotruba reduces the figure to a semi-geometrical volume with a structure. He superimposes, but this piling up, this accumulation, is also involved in the function of buildings—a special kind of architecture. If he created only the transitional form leading to architecture, his work would become irrevocably decorative. He discreetly puts his reliefs in front of wall fragments; nevertheless they are emphatically autonomous reliefs. In the end, everything in his figures and in his reliefs goes back to a central inner principle, which is the invisible core of his work. Sculpture is perceived through haptic and visual sensations; the imperceptible is contained in the impenetrability of the stone. The perceptible and the imperceptible are interdependent.

Wotruba cannot go far into space because that imperceptible core, that inner principle, holds everything close together. The only expansion he permits himself is the use of light, which in recent years he has employed abundantly in his large reliefs. It is light that lifts Wotruba's figures from their immediate palpability to, or in the direction of, a second, contiguous palpability.

263

[292]

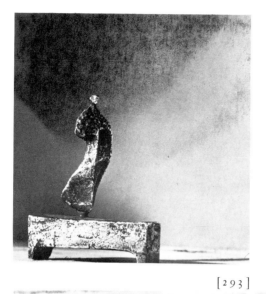

[293]

[294, 295]

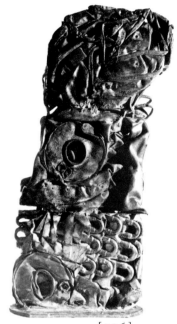

[296]

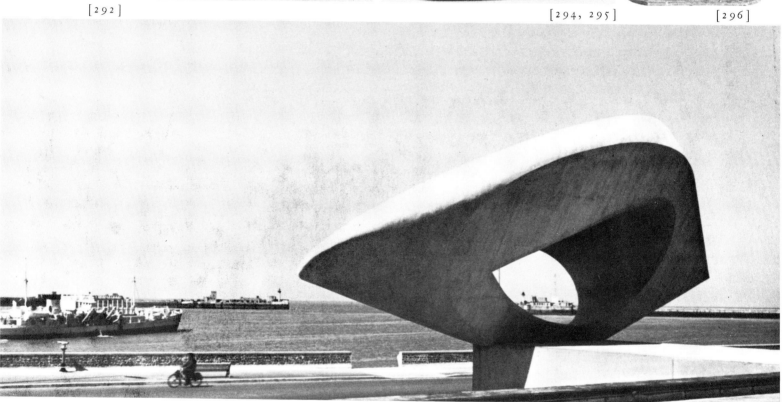

[297

10

Sculpture from 1945 to 1960

The sculptors Moore, Marini, Hepworth, Arp, Wotruba, Richier, Giacometti, and Gonzalez were all emotionally tied to the period between the two World Wars: they shared, as we have seen, the sense of doom resulting from the rise of the Nazi and Fascist dictatorships. They had a common artistic background in Cubism, Futurism, Constructivism, Dadaism, and Surrealism, and the artistic freedom acquired through the efforts of the previous generations gave them a considerable advantage. Proclaiming this freedom as an unwritten code, each went on to develop his own personal means of expression, in the process enriching the scope and possibilities of sculpture. In point of fact, each of these artists developed a facet of an undefined whole. Thus between 1925 and 1945, roughly, many sculptors appeared who, though contemporaries, have not manifested a unity of style in the sense that a homogeneous style existed, for example, in the Gothic and Baroque periods. At least we cannot as yet discern a

stylistic unity, though affinities are apparent in the various external and internal reactions of these artists to life and the world. Production is so abundant and diversified that we have not yet been able to assimilate it, despite the accelerated pace at which we live and perceive today. Whatever the surprises and disappointments that our century may still have in store, this powerful and varied development has determined its essential sculptural character.

Looking back over the centuries, art historians, notably Gisela M. A. Richter, have discerned a great stylistic unity in the Greek archaic period; one of the explanations offered for this phenomenon is the many journeys undertaken by the artists.[66] The commissions they received from distant cities (distant, that is, in terms of the ancient Greek world) made it necessary for them to travel. An artist often had to spend a long time in a foreign country or island, where other artists would see how he worked and he in turn would see how they worked. The multitude of small city-states presented no obstacle to such artistic communication, for they were not swayed by local or "national" chauvinistic considerations with regard to art. In this respect present conditions are quite different: whenever an important work is to be commissioned, national and local preferences and prejudices must be overcome before a foreign artist is called upon. But, fortunately, commissions are occasionally so awarded. At any rate, modern artists travel more easily and frequently than those of the past; international artistic traffic has become virtually unlimited.

[292] ISAMU NOGUCHI. *Mortality*. 1959. Balsa wood, height 6′ 4 1/2″. Cordier & Ekstrom, Inc., New York. [293] MARIO NEGRI. *Donna al Vento*. 1958. Silver, height 5 1/8″. Collection William S. Lieberman, New York. [294, 295] MARTA PAN. *Balance en deux*. 1957. Walnut, 7 7/8 × 20 7/8 × 17″. Collection the artist. [296] CÉSAR BALDACCINI. *The Third Compression*. 1961. Bronze, 34 1/4 × 15 7/8″. Galerie Claude Bernard, Paris. [297] HENRI-GEORGES ADAM. *Arrow*. 1954–55. Concrete, 4 × 23′. Musée du Havre, Le Havre

Moreover, modern techniques of reproduction guarantee the dissemination of new ideas and achievements, so that every artist can see and study what others have created.

Stronger in our century, however, than it was, for example, in the Greek archaic period, when the new and original was not so highly esteemed as in our day, is resistance on the part of artists to the influence of the work of others, which some artists find psychically inhibiting. Indeed the easy and uninhibited acceptance and assimilation of an influence is hardly known at present. And yet reciprocal interaction, even from a historical point of view, is something that can never be ignored. One of the greatest sources of conflict in present-day creative life is the craving for the distinction of being new, original—of being the first. Wiser artists, not necessarily always the older ones, surmount this: Lipchitz, Moore, Nicholson.

Since the twentieth century has not yet officially become part of art history, it is art criticism that points out influences. The dominating influence of a particular artist waxes and wanes. For a time Zadkine was in the ascendancy, partly because of the large number of his pupils. Lipchitz is also a prime source of influence from time to time, as are Arp, Hepworth, Marini. And of course there is Moore, who evokes "lunar phases" as far away as Poland and America. Many were the followers of Gonzalez in ironwork, after his death, until suddenly his attraction subsided. All this will eventually be charted, and the result will perhaps give a clearer view of the facts. For the moment, to reiterate, the only possible generalization is that there is an absence of even superficial stylistic unity, a total absence of schools that might exercise an influence within the present diversity. We can only speculate as to why this is so. Perhaps it is because the old traditions of handicraft no longer offer a general foundation for artistic production. Certainly the variety of possible techniques available to the artist today cannot be covered in the academies and other institutions. However, while diversification of techniques minimizes opportunity for the growth of a unity of style, it does not preclude such a development. It may be that the shaping of a prevailing style is checked by the superabundance of personal styles or manners, the rapid pace of modern life in general, and the hurried assimilation of forms and influences, which too quickly exhausts any source. The character of the present period, in sum, tends to suppress the formation of a style and of schools rather than to encourage it. It is possible that years hence the very diversity of present artistic production will be regarded as its strength. Schools always entail imitation. Rodin, surrounded by his numerous assistants, seemed pre-eminently qualified to found a school in the old sense. But all the younger artists, devotees of Cubism, Futurism, and the other movements, objected: all, without a single exception, praised him when he no longer presented this danger.

Despite the lack of stylistic unity in our era, it can be predicted that before the twenty-first century is very old, sculptures by

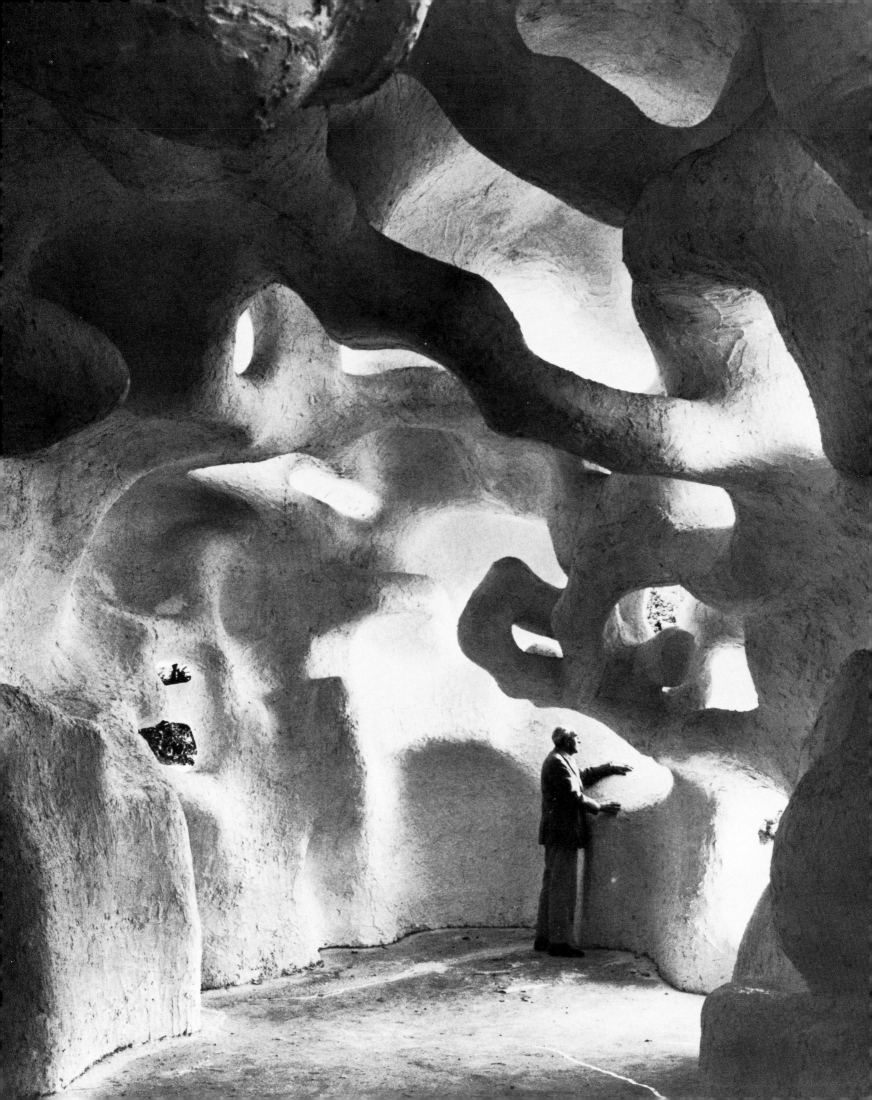

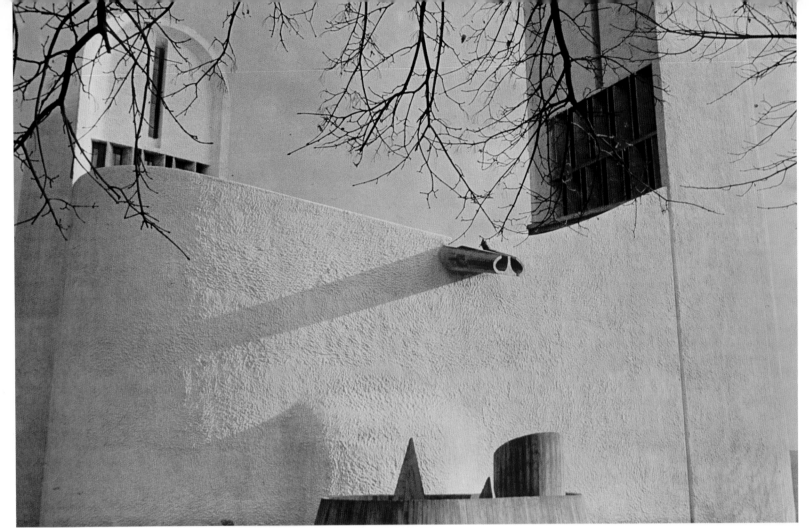

Richier, Arp, Wotruba, Hepworth, Moore, Lipchitz will be recognizable as products of a particular period. There are no timeless forms. Forms regarded as timeless have neither force nor character. Nor can space, once it goes beyond the undefined and theoretical state and becomes a concrete phenomenon, escape being timebound. But the fact that the time and space to which a certain work of art belongs, as a visually tangible symbol, can be established does not justify applying the idea of stylistic unity, at least in the old sense of clear identity of technique and form. All we are able to do is to try to discover spatial problems in sculpture; though approached from a totally different starting point, they have the same roots in time as spatial problems in architecture. These problems common to sculpture and architecture create—to use an unscientific term—an ambience that evokes the vague feeling of a unity in our century which is not based on any idea of style or any school but definitely suggests a single source of the problems.

Individual solutions in the actual grappling with particular or general problems are legion. The comprehensive and deeper explanations of the heterogeneous character of these solutions lies in

[298] ANDRÉ BLOC. *Sculpturally Conceived House*. 1962. Plaster, height 20′. In the artist's garden, Meudon, France
[299] LE CORBUSIER. Notre-Dame du Haut, Ronchamp, France. Completed 1955

[300, 301] ANTONIO GAUDÍ. Church of the Holy Family, Barcelona (details). Begun 1884. [302, 303] ANTONIO GAUDÍ. Chimneys, Casa Battló, Barcelona. 1907. [304] ANTONIO GAUDÍ. Ventilator cover, Casa Milá, Barcelona. 1910

the absence of external coercive and conventional demands as to modeling, as well as in the acceptance of complicated, highly personal attitudes that preclude homogeneity. Time and again we see some small group engaged in intensive exploration of areas that have already been opened up but not thoroughly cultivated. The notion of an experimental art is an obvious development, provided we never forget that experiments disclose in many cases a lack of creative power and are apt in general to assume an academic character. If real schools, that is, homogeneous groups, should come into being—and

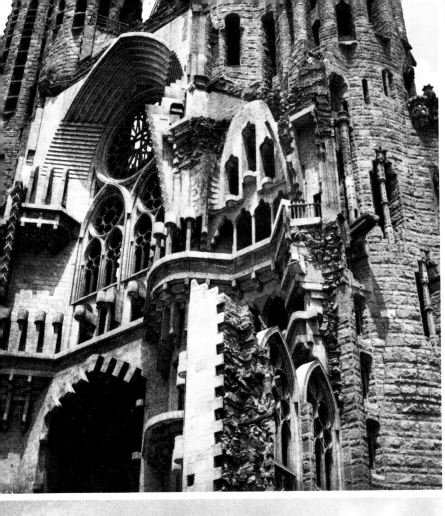

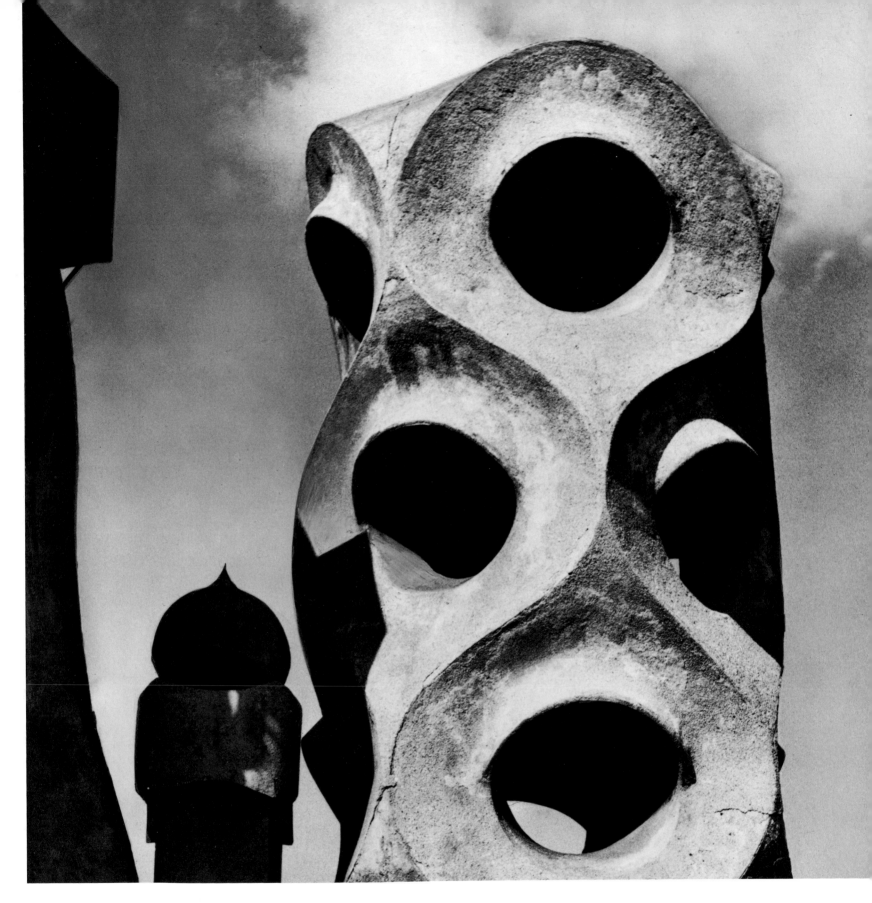

at times they seem about to do so—the power and vitality of twentieth-century art might be destroyed. By and large, what we perceive of the development thus far in the second half of the twentieth century can, in its experimental character, be traced back to its source: everything seems to be tied, as if by Ariadne's thread, to the labyrinth of the first quarter of the century. The thread will certainly snap sooner or later.

The general outline of sculpture after 1945 first became perceptible in the retrospective exhibitions arranged after the defeat of Nazism and Fascism. These exhibitions revealed the development and persevering activity of the older artists—first and foremost Lipchitz [170, 175–185], who still seemed a direct descendant of the Cubists; then Picasso [76, 84, 98, 105–109], though he showed sculpture only occasionally, and long avoided exhibiting the whole of his sculptural work; then Laurens [169, 186–191], the French representative of a supranational Cubism, who gradually left collages and experiments behind to turn to sculpture proper; and finally Matisse [78, 99–104], who, before and on the threshold of Cubism, displayed a freedom and a style all his own. Gradually the emphasis fell on those whose artistic character had developed between 1925 and 1940 and who, after the war, could show a mature body of work: Moore, Hepworth, Marini, Arp, Wotruba, Giacometti.

Firm of principle, conscientiously accepting certain limitations, these artists individually evolved their motifs and forms in markedly personal styles. The stylistic affinities perceptible among artists between 1911 and 1920—Cubism, Futurism, Constructivism—hardly exist today. Not a single one of those younger artists grown older ever aimed at a general stylistic unity, except within the logic of his own development. Nothing was forced or affected, and, happily, these younger artists freed their era from the dogma that unity of style was a supreme blessing and that a fermenting, conflict-ridden culture unable to achieve such unity was doomed to impotence. Giving this dogma the lie, the phenomenon of abstraction in art, combined with a creativeness more than ever rooted in the biological, psychic, and spiritual and revealing itself as a natural function dominating all objective formal reality, has become a positive achievement of our century as it has developed up to the present.

Sculpture and Architecture

The subject of stylistic diversity brings us again to architecture and its relation to sculpture and art in general. In this respect, too, a remarkable process of purification has taken place in the twentieth century. In the first quarter of the century the sculptor Duchamp-

Villon defined the situation correctly: architects have lost their grip on sculpture and content themselves with decorative elements that are born of no architectonic conception and that, from the viewpoint of the sculptor, altogether lack rational architectonic consistency. In Bourdelle the idea of sculpture as married to architecture—and also the nostalgia for Romanesque and Gothic times—was still alive. A younger artist like Duchamp-Villon was dreaming of the gradual revival of the qualities that would make sculpture live again in open air and daylight. This is something different from a sculpture suitable for architecture.

Though architecture and sculpture were never entirely separated, they have followed their own paths. Since 1945 they have more and more developed a mutual respect and have begun to draw closer. The word "integration" is, as has been said, prematurely applied to attempts that are still far from achieving a real interrelating of all facets of sculpture and architecture. The complex life of the present period, its heterogeneous experiments, and its ramified researches and investigations in the social and spiritual fields militate against the birth of a comprehensive *Gestalt*; the strength of the period is rather to be found in the absence of such comprehensive synthesis, in the continually repeated evocation of tensions, in the constant to-and-fro between polarities. Yet sculpture has followed the path sought by Duchamp-Villon, the path leading toward the great light of open air and landscape. He speaks of *la sculpture architecturale de plein air* as the objective of a revision of the whole artistic education; he does not speak of an architectural integration. The artists took care of this re-education themselves. After 1945, without the dictates of a modern Louis XIV, without pressure from great landscape gardeners and designers such as Le Nôtre, parks began to admit sculpture. Despite the inevitable mistakes as to what is and what is not suitable for public open-air display, the world discovered that the modern sculptor has regained the great qualities that enable forms to retain their effective force outside of buildings. The architectural landscape rather than the isolated building has become the home of a portion of the sculpture of this century.

Today's sculpture is, in fact, very much a part of the outdoor scene. The Musée de Sculpture en plein air Middelheim, in Antwerp, was established for this purpose, and there are sculpture gardens connected with many museums of art. A few parks have been specially arranged to show sculpture out of doors; in the Netherlands, permanent collections are seen in parks in Amsterdam, in Otterlo, and in Sonsbeek, near Arnhem, for example. In addition, there are frequent temporary outdoor exhibitions of sculpture, some, like those in

[305] HANS AESCHBACHER, MARTA PAN, FRITZ WOTRUBA, JEAN ARP. Sculptures in the sculpture garden of the Rijksmuseum Kröller-Müller, Otterlo

Battersea Park and Holland Park, in London, and the Dokumenta exhibitions in the German town of Kassel, held with regularity. Finally, many works belonging to private collectors are installed in outdoor settings. Apart from the parks and gardens dedicated to sculpture, sculptural form can serve an inspirational end in the building of cities, if the notion that sculpture can play a role only in relation to a particular building is not permitted to interfere. Town planners, discarding the traditional notion that public squares must contain monuments, are discovering new ways of making it possible for the sculptures of our century to perform a function and to be part of the life of the community.

The spatial poetry of sculpture is currently being related to squares as centers of traffic; to the approaches to large cities (Mathias Goeritz in Mexico [360]); to airports (Pevsner); to schools, public playgrounds, seaside promenades. All this is new because space is now more consciously seen as a unity in which a complex of objects, signals, and symbols can participate. But this modern, independent aspect must not be allowed to blind us to the fact that the public fountains of the past, which we now enjoy as romantic or aesthetic, had a practical function as well in city and village. The water that was a necessity for daily existence was supplied by the magnificent fountains of Bologna and Perugia and Rome. The works of Bernini in Rome's Piazza Navona still supply water for general use, and on hot summer days little boys swarm to the fountains to play, their nude young bodies adding living forms to the creations, in themselves sublime, of Bernini [18, 21-25].

In Mondrian's time, functional architecture withdrew into itself, as did abstract painting and sculpture, which Mondrian saw as ends in themselves or as means of self-expression. He thought they were gradually diminishing in importance, and predicted that they would dissolve in a new architecture that would be all-embracing. Here again we are confronted with the old idea of Mother Architecture. Architects were once happy in their devotion to an architecture that sought purity in itself, as was the case with Gerrit Rietveld (1888–1964) in the Netherlands. Subsequent generations have seen the problem in a new light: the whole situation has become significantly different. Mondrian did not prove to be a sound prophet: sculpture proved that it could be autonomous. Starting from plastic effects

adapted to the interiors of the houses of the wealthy nineteenth-century bourgeoisie, sculpture, without any help from architecture, succeeded in assuming a character that enabled it to exist freely in the open air. Sculpture has become a partner; it is no longer a beggar asking for architectonic shelter.

In France, credit is due André Bloc [298] for his continual investigation, in his lectures and writings, of the spatial status of architecture and sculpture. It is true that the old idea of an association or merging of the two activities made some artists seek, in the beginning, for a valid formula governing co-operation between architect and sculptor. This was to signify a mutual absorption and consequently a common organic growth; the sculpture was to be included in the architectural conception as early as possible. It has become clear in the last few years that the solution cannot be a synthesis but must result from reciprocal inspiration and an interaction of the architectonic and sculptural concepts of space—an approach much more daring, risky, and problematical but by the same token all the more capable of surprising results. There are architects whose work has a strong sculptural quality. Gaudí (1852–1926 [300–304]) and Le Corbusier (1887–1965 [299]) always had a natural tendency in this direction because painting and carving were potentially present in them from the outset. A number of younger sculptors (Alain Bourbonnais, Claude Parent, Georges Patrix, Emile Gilioli, Pierre Szekely, Marino di Teana [308], Mathias Goeritz [359, 360], Paul Herbé, and Etienne-Martin [310]) are mentioned by Michel Ragon in his book *Où vivrons-nous demain?*.[67] There are sculptors (Wotruba [288–291], Hans Aeschbacher [381, 382]) whose forms have so architectonic a direction that they are reminiscent of building elements. Nicolas Schöffer (born 1912) goes so far as to create designs for cities [307]. Etienne-Martin makes his forms so symbolically habitable that they fully merit his designation *demeures*, or "dwellings" [310]. In the Netherlands, Constant (born 1920), though not an architect, continually derives his inspiration from his vision of urban life [311].

The Polish sculptor Aline Slesinska (born 1926) aims at inspiring architects with her sculptures. Her works clearly stem from architectural forms, which she has stylized. There are also among recent works occasional instances of a kind of symbiosis in which either the sculpture follows from an architectonic conception or the architecture is based on a sculptural conception. All these recent examples—which should not be lumped together—are part of the accelerated development of a trend that appeared as early as the first quarter of the twentieth century: in Kurt Schwitters (1887–1948), in Pablo Picasso, and in the Constructivist Georges Vantongerloo, whose oeuvre in-

[306] GEORGES VANTONGERLOO. *Perspective of a Bridge for Antwerp.*
1928. Drawing, 157½ × 31½″. [307] NICOLAS SCHÖFFER. *Project
for the Cybernetic City.* [308] MARINO DI TEANA. *Project for a Port.* 1965.
Plaster. [309] ANDRÉ VOLTEN. *Composition.* 1962. Brass, 5⅞ × 29½ ×
9½″. Collection the artist, Amsterdam. [310] ÉTIENNE-MARTIN.
Demeure No. 3. 1960. Plaster, 16′ 4″ × 7′ 4½″ × 8′ 2″. Galerie Breteau,
Paris. [311] CONSTANT. *Surroundings of a Future City.* 1958. Plexiglass
and wire, 11¾ × 14¾ × 14¾″. Gemeentemuseum, The Hague (on
loan)

cludes bridges [306] and airports as well as paintings and sculptures.

For all that, the space problem of architecture is obviously not the
same as that of sculpture. The tendency to merge the two, in these
new aspects, has not yet given rise to a successful fusion; whether
such a fusion is possible remains a question. The examples cited are
divergent and sometimes contradictory in nature. In Etienne-Martin
the ancient grotto and tent idea dominates—man building himself
a shelter. Prehistoric affiliations are perceived; an archaism laden with
symbolic meanings is reborn. The primeval power of this work sug-
gests the image of man's primitive dwelling and the expression of a
primeval longing, the longing to return to the womb, to the safety
of life in a shell, sac, or rind. Etienne-Martin's earlier work was frankly
figurative [374], with an archaic and monumental quality; there
was a belated echo of Gauguin and of the Moore of the early period
of Mayan influence. But the broad outlines of the basic form were
still recognizable in Etienne-Martin's figurative production. Man,
no longer the starting point for the form, became the invisible core
of the imagined image. At the opposite pole, Schöffer rationally con-
structs his complexes of dwellings [307] and strives to achieve a
scientific and technological mastery of the elements of sound, light,
and temperature, an extension of which effort culminated in his spatio-
dynamic constructions [317]. His work represents, to some extent,
a resumption and continuation of what was developed by Con-
structivism in the 1920's.

The exchanges that took place between sculpture and architecture
make it clear that there was a certain failure on the part of architects
to create a human ambience, and a lack of architectonic structure in
the work of sculptors. The interchange of influence is unquestionable,
and yet—to repeat—with regard to space, architecture must always
follow different directives from those of sculpture. Sculpture should
never be able to turn into actual architecture. "The usefulness of a
house consists in what is not there," says Lao-tse. A piece of sculpture
that satisfies such a concept of habitability ceases to be sculpture.

275

The points that the works of Etienne-Martin and Schöffer raise, to mention only two extremes, are, in the one case, the recollection (by means of a sculpture) of the primeval function of the human dwelling and, in the other, a vision of a technical perfection, a technical paradise of habitation. Both artists deal with the architectonic problem and also with other factors that are essential to post-1950 sculpture.

Motion in Sculpture: Kinetics

In addition to the remarkable shift from the problem of the relation between sculpture and architecture to the problem of a fusion by means of a symbiosis (whose outlines are still unclear), the second half of this century is marked by an intensive elaboration and reworking of the element of motion—a theme that can only be touched on here. The problem of motion arose for sculpture as early as the first quarter of the century. Actually, sculpture in the past had not ignored motion, any more than it had ignored the closed volume: as we have seen, there was a definite affinity even in Canova, and later in Degas, Rodin, and Bourdelle, with the movement of the dance. In the nineteenth century the dance could evoke motion only by the suggestion given by attitude and gesture. The German sculptor Ernst Barlach (1870–1938) carried to the extreme the suggestion of speed and passionate gesture through a closed volume [312]. It was a solution that had repercussions in modern sculpture for a long time. German Expressionism in sculpture, insofar as it was primarily the work of painters, did not go far beyond the field of African wood sculpture in its search for solutions, and it therefore came to a dead end. Barlach did at least subject his medievalistic form to the violent gesture.

Belgium, which had seen Expressionism come into full flower chiefly in Flemish painting, produced the painter Constant Permeke (1886–1952), whose limited output included sculptures with highly plastic qualities and a sensitive feeling for large expressive and distorted volumes [314] that match in power the works of trained sculptors. Oscar Jespers (born 1887) is a sculptor who has devoted himself exclusively to *taille directe*—carving the stone directly. Although, in general, Expressionism had hardly enriched sculpture, Jespers, for example in his monument for the tomb of the poet Paul van Ostayen in Antwerp [313], found an Expressionistic closed volume that rendered the human form directly and simply. His finest works have an impressive strength: in them a definite attitude or a modest gesture is fixed for all eternity.

Jespers subordinates the theme of his sculptural vision to the material and the form. In addition to this expressivity, which in the

end became stylized, there developed an entirely different exploration of the representation of movement in space. To understand this development we must bear in mind the changed feeling for space that was already apparent in Futurism. Boccioni assails space, as it were, with his sharp, strong, formal elements, evoking a sensation of movement. But he could not go farther. He wanted to achieve a genuine relation between sculpture and life in motion, and to imbue his sculpture with that motion, but he expressed his aims more successfully in his manifestoes than in his work [113, 127–130, 132]. And what he formulated emotionally in words is better stated by the American philosopher Susanne K. Langer[68]: "Space as we know it in the practical world has no shape. Even in science it has none, though it has a 'logical form.' There are spatial relations, but there is no concrete totality of space." Going on to deal with sculpture, she says: "A piece of sculpture is a center of three-dimensional space. It is a virtual kinetic volume, which dominates a surrounding space. . . . Sculpture is literally the image of kinetic volume in sensory space. . . . sculptural form is a powerful abstraction." This seems to me to describe not all sculpture but, rather, the evolution of the element of movement in twentieth-century sculpture.

Langer's aesthetic and philosophical formulation actually comes close to the essence of the message that Gabo and Pevsner proclaimed in their famous 1920 manifesto on Constructivism. On the basis of experiences, experiments, and reflection, they developed their kinetic theory into a principle of sculpture that Gabo implemented between 1920 and 1922 by using a vertical shaft with a motor as a moving element, and in 1932 by producing a form in space without volume by means of the vibration of a rod. The weak point in the manifesto was that it held Futurism up to ridicule. Admittedly, the latter had become staid, creating feeble images of motion that did not always evoke movement. But the fact remains that Futurism had boldly attacked the static in sculpture.

Since Futurism, the principle of motion has led again and again to experiments, some more successful than others, and many involving only the superficial aspect of the kinetic principle. Here too a critical history remains to be written, one that will distinguish between the imitative and the creative. Questions as to priority were raised by the supporters of Futurism, Dadaism, and Constructivism. The year 1920 was an important one. Marcel Duchamp and Man Ray worked together for some time. Man Ray made his mobile spiral in an open frame, Duchamp his optical machine, and Gabo his vibrating rod.

277

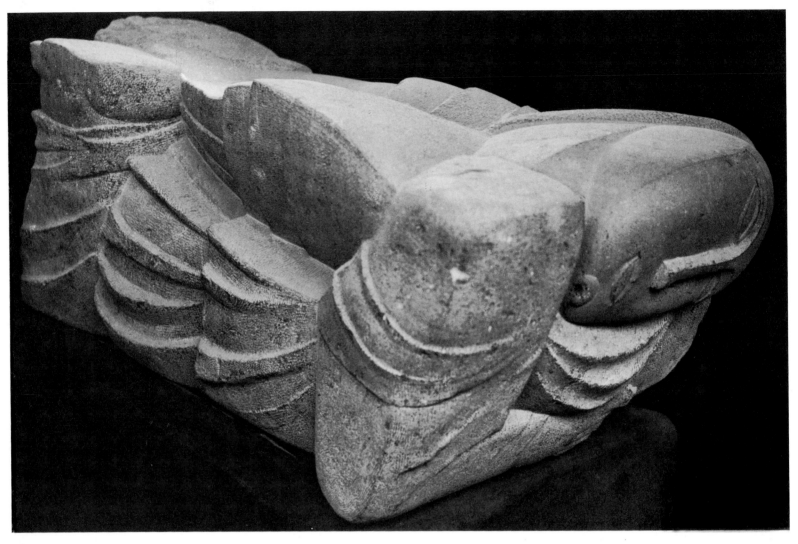

The simple kinetic construction that later became popular and that brought about the sudden wide dissemination of the idea did not come into being until ten years later (1931) in the work of the American sculptor Alexander Calder (born 1898). First mechanically, then naturally, and later with subtle refinements, Calder used abstract means to create an image of motion whose appeal is not so much rational as aesthetic. He brought the problem out of the realm of aggressive manifestoes and theoretical principles into the domain of play, awaking feelings of beauty by means of an innate harmony and grace [319].

In an American film on Calder, his work is shown in relation to various examples of motion in nature—trees in the wind, reeds stirring by a pond, leaves falling, the ebb and flow of water. Rejecting the theoretical and doctrinaire aspects of Constructivism, Calder exploit-

ed natural laws and chance by creating a play of movement through the accurate calculation of rising, falling, and swinging motions. In an undogmatic spirit, Calder chose elements that he could transform. In his initial period, from 1926 to 1931, he aimed at transparency, as can be seen in the wire figures. As we have seen, Lipchitz had already embodied transparency in the splendid series of playful works he produced after the strictly disciplined Cubist activity. In his wire figures, Calder introduced the elements of play and humor; he made Paris laugh with his famous miniature circus (1927). It was in the midst of the essentially dynamic abstraction of Mondrian's studio that, in 1930, Calder got the inspiration for his discovery, which made the reality of movement visible through nonrepresentational colored forms in space. Characteristic of Calder is the fact that his mobiles grew out of his original vision; they did not grow out of Mondrian's

278

[313] OSCAR JESPERS. *Design for Grave Monument of Paul van Ostayen.* 1929–30. Granite, length 67". (Actual monument, 1930–31, at Antwerp-Schoonselhof). [314] CONSTANT PERMEKE. *Torso.* After 1936. Plaster. Private collection, Belgium

[315] LÁSZLÓ MOHOLY-NAGY. *Light-Space Modulator.* 1922–30. Movable metal construction. Busch-Reisinger Museum, Harvard University. [316] NICOLAS SCHÖFFER. *Microtemps 11.* Steel, duralumin, and plexiglass, motorized. Galerie Denise René, Paris

Neo-Plasticism (which was the source only of the nonrepresentational idea), nor out of Constructivism, but rather out of Calder's efforts to bring together abstraction, construction, and nature so as to produce something else—a something that is also the embodiment of his sense of fun and play.

A mobile at rest is a rhythm of lines and colored surfaces with no volume; in movement a slight suggestion of form, undefined and more or less fortuitous, arises around several centers. Between 1931 and 1940 Calder went through a transitional period, and, as with so many of his gifted contemporaries, his work reached a wider public only after 1944. Followers simply embroidered on his discoveries. Calder's later work is marked even more by the comic spirit, an element that he developed with great skill and enjoyment.

Nineteenth-century dance and ballet, as we have seen, inspired certain sculptors; today the ballet itself responds actively to elements of motion in sculpture. Calder worked for the Martha Graham Company in 1935 and in 1939 received a commission for a water ballet at the New York World's Fair. But, it seems to me, a fact more historically important is that Calder as a sculptor contributed to the production of Erik Satie's *Socrate*. Satie's place in music, anchored in the circus and the music hall, altogether removed from pompousness and self-importance, anti-Romantic and unconventional, is related to Calder's role in sculpture as representing free and unpretentious spatial play in life. The era in which Satie's music was performed was the age of Cubism and Neo-Cubism.

It is worth pointing out that in the course of this development of sculpture, the ballet, the opera, and the theater repeatedly enlisted the collaboration of sculptors. As we know, Rodin had drawn inspiration from the primeval movements of the dancers of Cambodia, and Bourdelle from Isadora Duncan, who even performed for him privately and whose dancing is reflected in his reliefs for the Théâtre des Champs-Élysées in Paris. In both cases we see the sculptural form freeing itself in a rapidly delineated dynamic line: the plastic element

280

itself is in the suggestion of movement. In 1926 Diaghilev recruited Pevsner and Gabo for his ballet *La Chatte.* For the Russians, the collaboration of artists was an old tradition. Diaghilev, to be sure, thought in terms of painters rather than sculptors. Léger worked for the ballet *La Création du monde,* and Picasso sketched costumes and scenery for such ballets as *La Tricorne* and *Parade.* In England, Barbara Hepworth created the designs for Sophocles' *Electra* at the Old Vic in 1931, and in 1934 designed the costumes and sets for Michael Tippett's opera *Midsummer Marriage.* Wotruba designed sets and costumes for *Electra* in Vienna. With regard to the sculpture of movement in the ballet, countless new possibilities were opened up; in these efforts Maurice Béjart had an important part.

This technical development had its theoretical propagandist. What Van Doesburg accomplished for De Stijl in Europe, the Hungarian László Moholy-Nagy (1895–1946) achieved for the spatial techniques of light and movement. Constructivism was the idea closest to the doctrine he advanced with tireless energy until his death. Berlin (Der Sturm, under the direction of Herwarth Walden), Dessau, and Weimar (the Bauhaus under Walter Gropius, until 1928), then Paris and London, and finally Chicago saw him work—in every technique, from photography and film to ballet and drama. His writings have an authoritative tone, especially his last book, *Vision in Motion,* almost a text. His sculptures, his experiments with light, and his "light-space modulators" [315] illustrate his writings, if they do not possess the convincing power that characterizes true works of art. They clearly show their makeup, which, to be sure, is a normal phenomenon in the case of so tireless a combatant, one who released so much that had got into a rut of routine and convention. In any event, it was Moholy-Nagy who demonstrated, in addition to the technique of creating motion, how to manage light and color in a way that had been envisaged perhaps only by the French painter of Orphic Cubism, Robert Delaunay (1885–1941). Speaking of his experiments of 1912–13, Delaunay said: "I played with colors as one might express himself in music by a fugue, by colored *fugato* phrases." The sound-color ensemble was the fascinating element that Moholy-Nagy brought to films.

After 1950 more and more efforts were made in the area of kinetics. In 1955 the first of the exhibitions on the theme "Le Mouvement"

was presented at the Galerie Denise René in Paris. In 1961 the international exhibition "Movement in Art" (*Bewogen Beweging*) was held in Amsterdam (Stedelijk Museum), Stockholm (Modern Museum), and Copenhagen (Louisiana). This exhibition brought together a vast, if uncritically selected, amount of kinetic material; the catalogue contains a great deal of valuable information. Years earlier an interesting and still expanding collection in this field had been initiated in Krefeld, Germany (Museum Haus Lange), by Dr. Paul Wember.

The Hungarians have made a remarkable contribution in the kinetic field. The later phase of this development is exemplified by Nicolas Schöffer, the younger compatriot of Moholy-Nagy whose designs for cities have been mentioned above. In making his spatiodynamic constructions [316, 317] Schöffer utilized the achievements of technology. He too inspired ballet: Maurice Béjart used one of his spatio-dynamic constructions as the starting point of human rhythmic movement in ballet (1956). Schöffer composes skeletons that

consist of rectangles (transparent and closed) at right angles to one another. These are based more or less on the principles of Mondrian as extended to space, combined with mechanical elements of movement.

This reference is, of course, not entirely fair to the echoes of the Tatlin-Gabo idea, given the rigorous development by Schöffer of the projection of light, color, and movement in space. This transforms the original composition into a broadcasting station in space, or a projection on a screen. Schöffer is thus able to point up different aspects, all of which depend on conscious, artificial controls. The element of change, the flowing of one movement into another, and the vague suggestion of depth constitute a controlled game, one that can bring the spectator into relation with, say, fields of clouds, reflections of airplanes, or suggestions of submarine life. But the artist is not involved in these associations. It has been pointed out in another connection that Schöffer, starting from his three-dimensional constructions, always arrives at architectonic conceptions that relate not only to

cybernetic towers (at Liège-sur-Meuse, for example) but to a city plan [307].

It is noteworthy that the spectator involved in this impressive technical development of the idea of light and motion is immobilized; this situation is comparable to the fixed standpoint of the spectator in the Renaissance theory of perspective, in an age when painter-sculptor-architects were obsessed with the scientific development of spatial projection (e.g., Brunelleschi and Uccello). Cubism also preached this doctrine. In the case of Schöffer's constructions, if the viewer wishes to enjoy the changing projection of color and form on a surface, he must not move around the object but must remain fixed in space. In other words, the technical objectivation of the motion and light immobilizes the individual-subject. Schöffer's surfaces, set at right angles to one another, do not yet create three-dimensionality; essentially he comes back at every turn to projection on a surface, as in the abstract film with experiments in sound. He gives a visual representation of the scientific aspect of our age, a concrete order that ostensibly has clarity but operates with invisible formulas that escape the understanding of any but the technologically initiated. The question of whether Schöffer's work is sculpture is both interesting and important. It was, at one point, seriously asked whether Mondrian could be included in the history of painting—a question that seems absurd to us now: anyone who has outgrown the idea that only Impressionism is painting recognizes that Mondrian was a painter in the fullest sense of the word. The fact that Schöffer, in order to construct and compose in space, uses the instruments or technical organisms that he has created is no reason to deny him the title of sculptor; we must accept his changed function just as we have long since accepted that of the twentieth-century architect.

An entirely different contribution to motion in sculpture was made by another Hungarian sculptor, Marta Pan (born 1923). Her work has twice served as the starting point for a ballet by Maurice Béjart; her task was not to design sets or costumes but rather an object that could be a point of departure and a point of return for the dance movement [320]. Like Calder, she calls upon nature for assistance—wind, movements of the hand. The discovery prompted by the floating Otterlo sculpture [321–325], so called after the park for which this polyester sculpture was made, was that floating in water is compatible with self-movement and that the form is related to the surrounding space and the lines of the landscape. The case is very

284

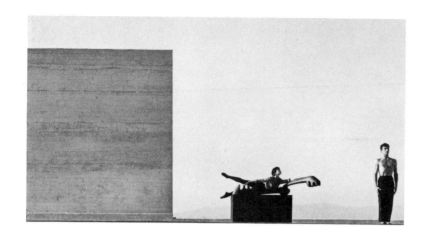

[320] MARTA PAN. *Ballet Le Teck.* 1956. Teakwood, 17×55×7⅛″
[321–325] MARTA PAN. *Floating Sculpture.* 1960–61. Polyester, 7′ 5″×
6′×7′ 1″. Rijksmuseum Kröller-Müller, Otterlo

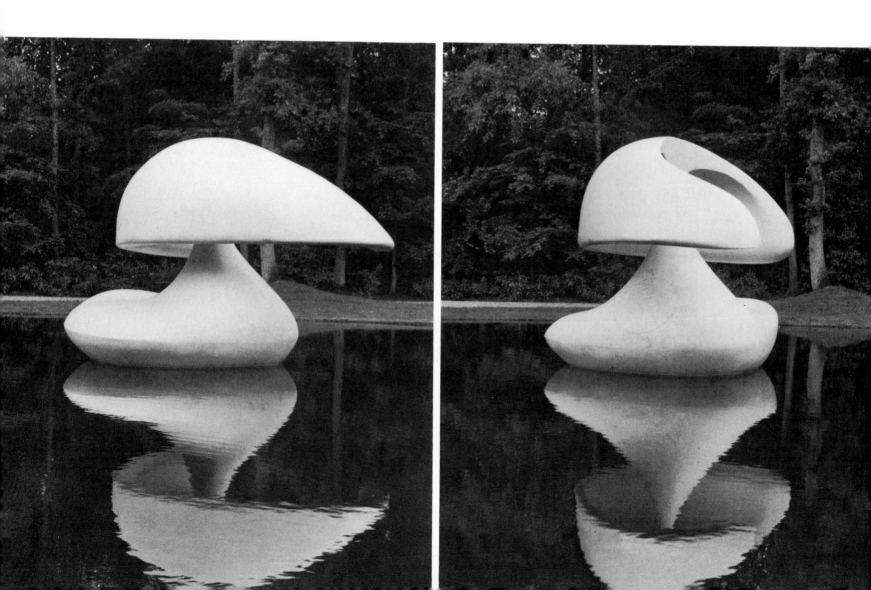

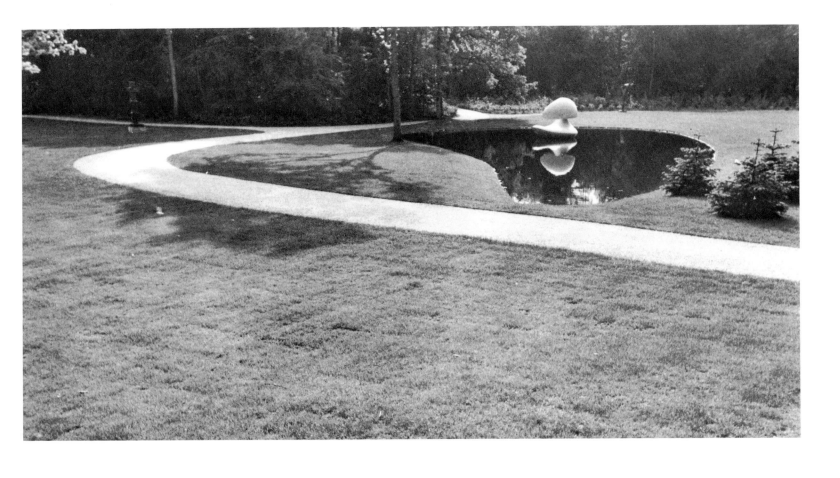

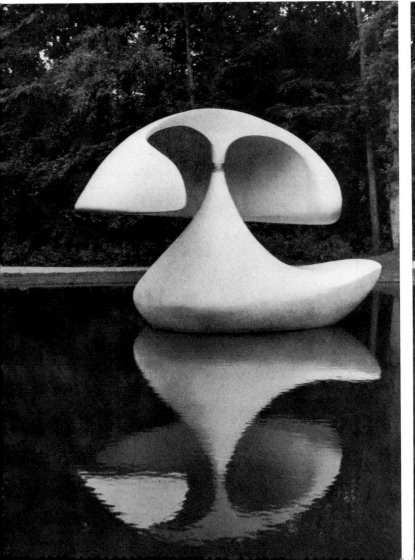

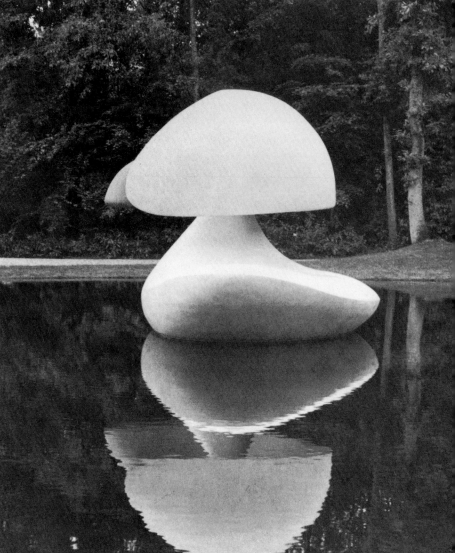

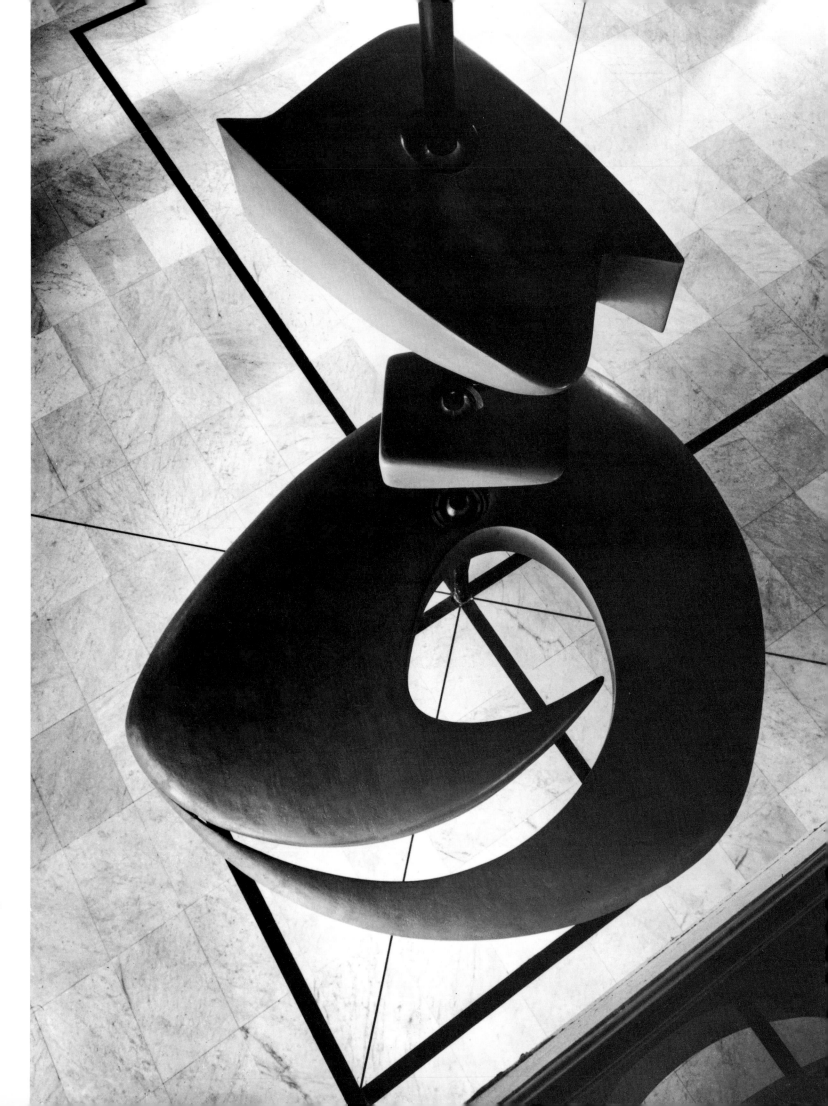

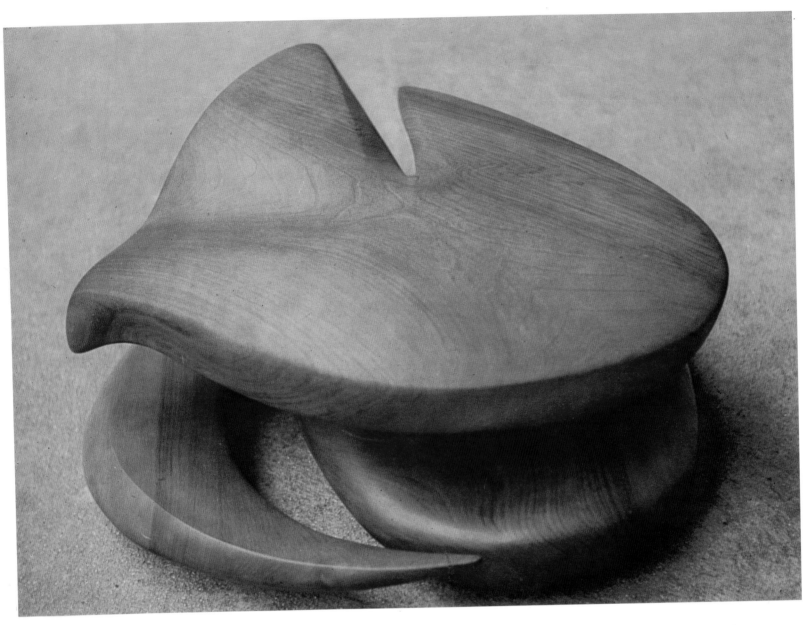

different from Calder's, in that the movement is more controlled and the abstraction is manifested in a closed volume rather than in surfaces and lines. Pan's form is organic and is based on the old craft of cutting and carving in wood—true sculpture. (The work is later cast in bronze, aluminum, or polyester.) In Marta Pan's sculpture, a sober volume, with firm tension in arching line and surface, arises out of the conception of the function of movement. It is not that a shape is brought into motion, but that what the form should be emerges from the representation of a movement [326]. The apparent simplicity of her work always turns on the disposition of two entities

[326] MARTA PAN. *Mobile Sculpture*. 1966. Balsa wood, covered with red polyester, height 23′. Centre Hospitalier Universitaire de l'Hôpital Saint-Antoine, Paris. [327] MARTA PAN. *Balance en deux*. 1957. Walnut, 7 7/8 × 20 7/8 × 17″. Collection the artist

so that they can unite as a closed form or coexist in a changing relation in which tensions remain directed toward each other, attracting and repelling as if in a sublimated eroticism. The point at which two elements meet or touch is at the same time the point where the possibility of movement is concentrated. In this way—abstractly, organ-

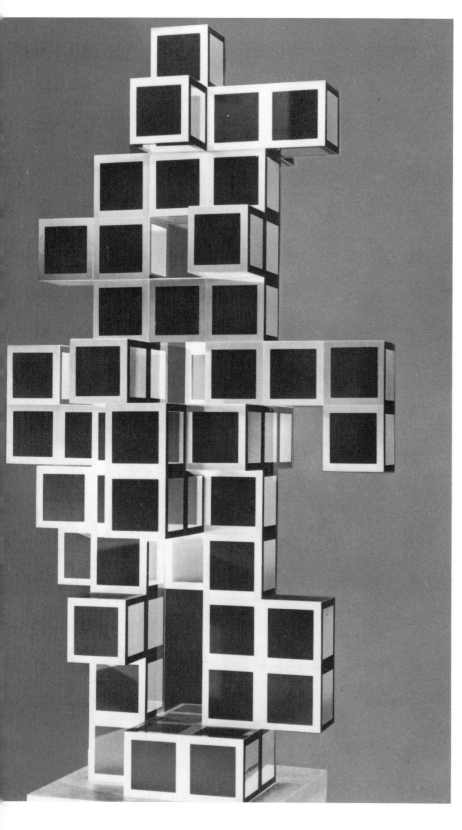

[328] VICTOR VASARELY. *Manhattan II.* 1965. 47¼ × 27½ × 19½".
Galerie Denise René, Paris. [329] JEAN TINGUELY. *Machine*, surrounded by spectators, Stedelijk Museum, Amsterdam

ically—the concept of the hinge, as in sea shells, emerges in Pan's work [294, 295, 327]. Sometimes there is an analogy with tightly clenched jaws and teeth. There is in the style of this work a nobility of scope that makes it a splendid link between man and architecture, or between man and landscape.

Very different from Marta Pan, closer to Schöffer and with a comparable attitude toward change as it appears in the work of art, Victor Vasarely (born 1908), also a Hungarian, has provided kinetic sculpture with a theoretical basis, in which, clearly, the ideas of Mondrian and Moholy-Nagy are components. His interest in the possibilities afforded by modern technology is at least as great as Schöffer's, and he too draws far-reaching conclusions from it. In his work, however, he restricts himself as to means; he finds optical effects of motion and transparency in which the element of movement is often limited to the surface or combination of surfaces [328]. He is an advocate of the integration of the arts in communal life, and he dreams of a polychrome city. His work and his comprehensive view of life have strongly influenced younger artists.

Many other artists who are concerned with movement offer variants of these main orientations. In this field, too, the individual character of a given solution is not lost in the general character of the technical means. Solid subjective techniques are developed. What a Pol Bury (born 1922) does with mechanically moving reliefs creates sensual impressions that, despite the hardness of his materials, sometimes suggest the movements of jellyfish and sea anemones, or a shimmering sky full of stars. In contrast, the reliefs of Yaacov Agam (born 1928) are definitely cooler and are marked by an optical play of geometrical patterns that occasionally suggest Vasarely.

In England, Kenneth Martin (born 1905), who has concerned himself intensively with motion, is notable among those involved in this development. He is closer to Calder than to the artists who use machines. Martin's small, concentrated sketches are sober and serene.

Jean Tinguely (born 1925), a Swiss, is one of a group of artists preoccupied with a kind of motion that makes consistent use of the means of the mechanized world. The most crypto-Romantic of the group, Tinguely uses his "méta-matics" to set the viewer thinking in a definite direction. But the world he evokes for us is the opposite of Schöffer's. Tinguely's spasmodically operating little machines cer-

[330] PETER AGOSTINI. *Open Box*. 1963. Plaster, height 28″. Collection Joseph H. Hirshhorn, New York. [331] MARISOL (MARISOL ESCOBAR). *The Mural*. 1963. 7′ 11″ × 8′ 11″. Collection the artist, New York. [332] JOHN CHAMBERLAIN. *Colonel Splendid*. 1964. Painted steel plate, 24 ¾ × 26 × 22″

[333] GEORGE SEGAL. *Dining Room Table*. Plaster and real objects. Collection Mr. and Mrs. Seymour Schwebber, New York
[334] CLAES OLDENBURG. *Sundae*. 1963. Painted plaster, glass, plastic, metal, and paper, 9 × 4 × 4″ (excluding tray and spoon). Sidney Janis Gallery, New York

tainly do not evoke—rather, they attack or mock—aesthetic feelings. They have, despite his denial of Dada inspiration, an unmistakable Dada air, along with the charm of the old eighteenth-century mechanisms seen in old prints and in museums of technology. They are, in a sense, a bitter satire on the wretched technical world; at the same time they charm us with their amateur workmanship. In other words, the work is ambivalent, and, ultimately, it is archaic, with the archaism of the machine. Typical of Tinguely is the fact that he leaves the spectator uncertain about his position: for example, in his *Homage to New York* (1960) he took great pleasure in the wild fireworks, but perhaps on a deeper level he was ridiculing the Constructivists' faith in new materials and the machine. The aesthetic formal elements that still play a part in his work in the theater in Gelsenkirchen (1959) disappear in his later production, only to reappear about 1965. Tinguely's works are springboards for ironic thought; they induce an attitude that is not the usual contemplation of a work of art. These objects no longer claim to be spatial projections. They could be called "introverted" machines; nevertheless they act upon the spectator.

The ambiguous aspect of these productions is, as always, the fact that, despite the disdain of the creators for museums and the traditional forms of art, they use and need museums and the traditional art exhibitions. They are seen to full advantage only in immediate contact with a large audience gathered as if around a magician or prestidigitator [329]. The shock, the amazement, the mild amusement of the spectator are constituents of the demonstration, which actually is not a display of a form but a performance, with objects rather than words, intended to stimulate critical thought. These apparatus effect a single act of protest, prophecy, or scorn and are soon thereafter played out—but one may question their relation to sculpture.

Assemblage, Junk Art, Pop Art

Herta Wescher has presented exact data relating such manifesta-

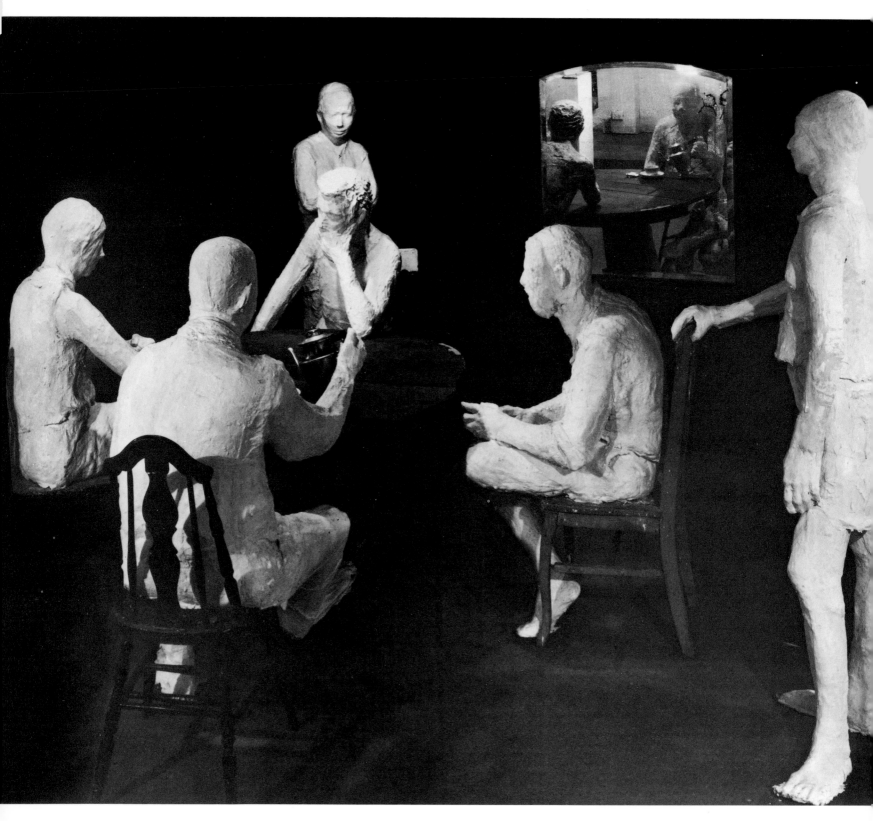

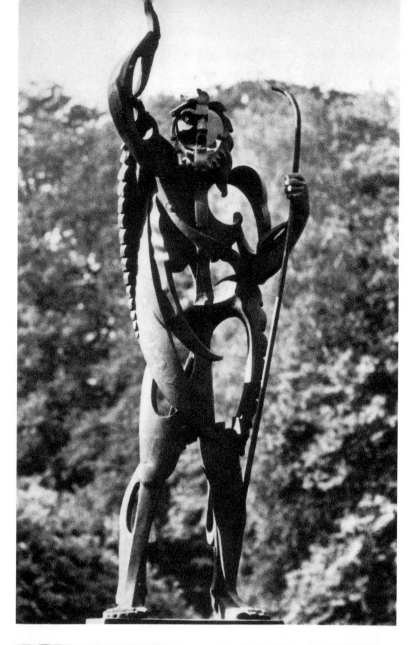

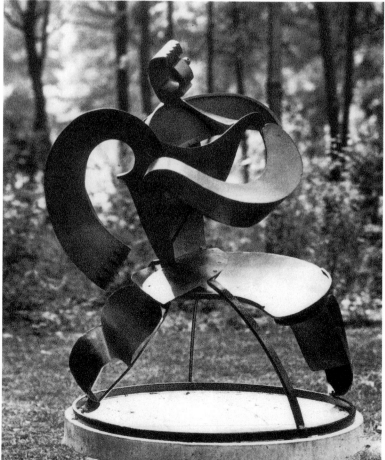

[335] PABLO GARGALLO. *Prophet.* 1933. Bronze. Musée de Sculpture en plein air Middelheim, Antwerp. [336] SIEM VAN DEN HOONAARD. *Fighter.* 1936. Iron, height 43⅜". Rijksmuseum Kröller-Müller, Otterlo. [337] DAVID SMITH. *Saw Head.* 1933. Painted steel, height 17⅛"

tions as Tinguely's to the Dadaist and Surrealist past, and Dore Ashton has ventured an aesthetic and philosophical analysis of junk art and Pop art.[69] There is no doubt that if we did not know the date of Marisol's *The Mural* (1963 [331]) we might think it had been designed between 1920 and 1925 for music by Erik Satie; Claes Oldenburg's *Sundae* (1963 [334]) can be connected with Picasso's *Absinthe Glass* (1914 [98]); and Peter Agostini's *Open Box* (1963 [330]) would not be out of place next to Arp's basket wrapped in newspaper, entitled *Mutilé et apatride* (1936). These works and the reactions of an interested audience in New York and London are convincing evidence that the clinging to the brute object is a far cry from scientific, philosophical, and Expressionistic abstraction, which does not so much deprive men of the world of objects as place men and objects in their relative positions.

Partly as an aftermath of Dada (vainly rejected by artists because they do not want to be anti-art), partly as an expansion of the world of Kurt Schwitters, who discovered the poetry of worn, discarded things and re-evaluated them in new compositions, there have come into being two developments: a new presentation of commercial or industrial objects in which the creative aspect, insofar as the term can be applied, has dwindled into a choice (that can be very interesting from the point of view of the subconscious), and an assemblage of objects, or the choosing and fixing of already assembled objects, in the course of which the artist sometimes makes very subtle changes. When objects are taken out of context and set up in the art gallery or in the collector's home, it is precisely this isolation that produces astonishment that objects are as they are. Despite their almost too particular appearance, they undergo loss of identity and, now nameless, represent the world of commercial things formerly rejected by aesthetics. Much of this production still lies in the borderland of creative, formative activity; the frontier has not yet been crossed.

This, obviously, is the controversial point between critics and Pop artists. Rightly maintaining that he is producing art, the Pop artist has embraced elements hitherto rejected in art: advertisements, containers, readymade clothing—in short, the many objects that the machine has made so large a part of our daily life as an industrialized group. The ordinary consumer suddenly sees the storeful of objects,

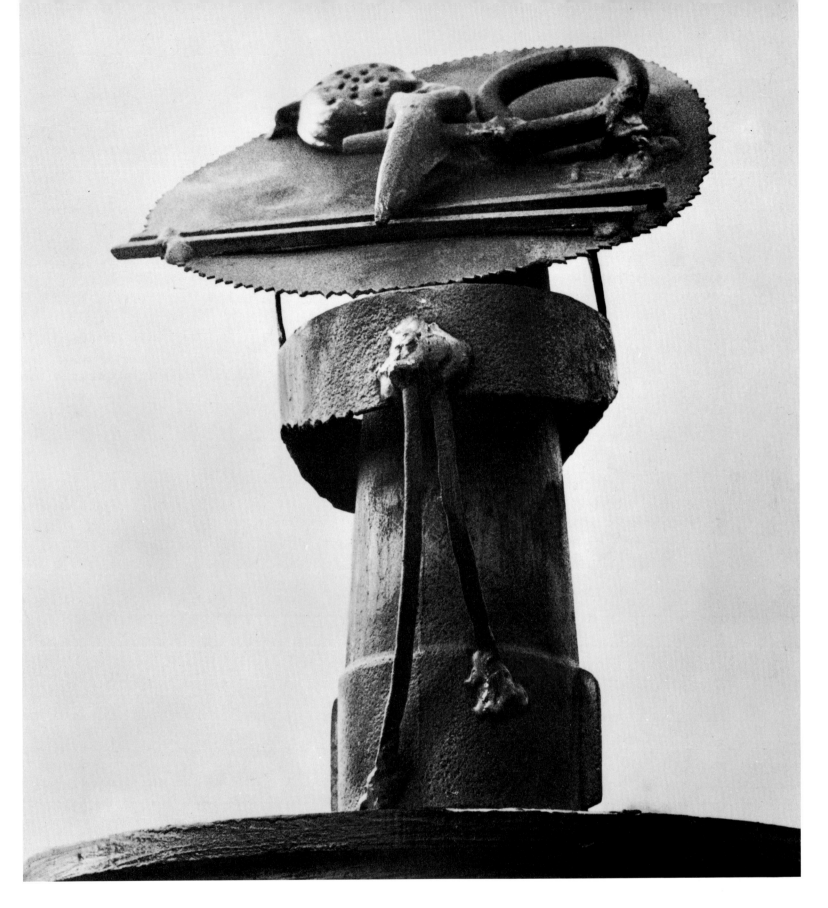

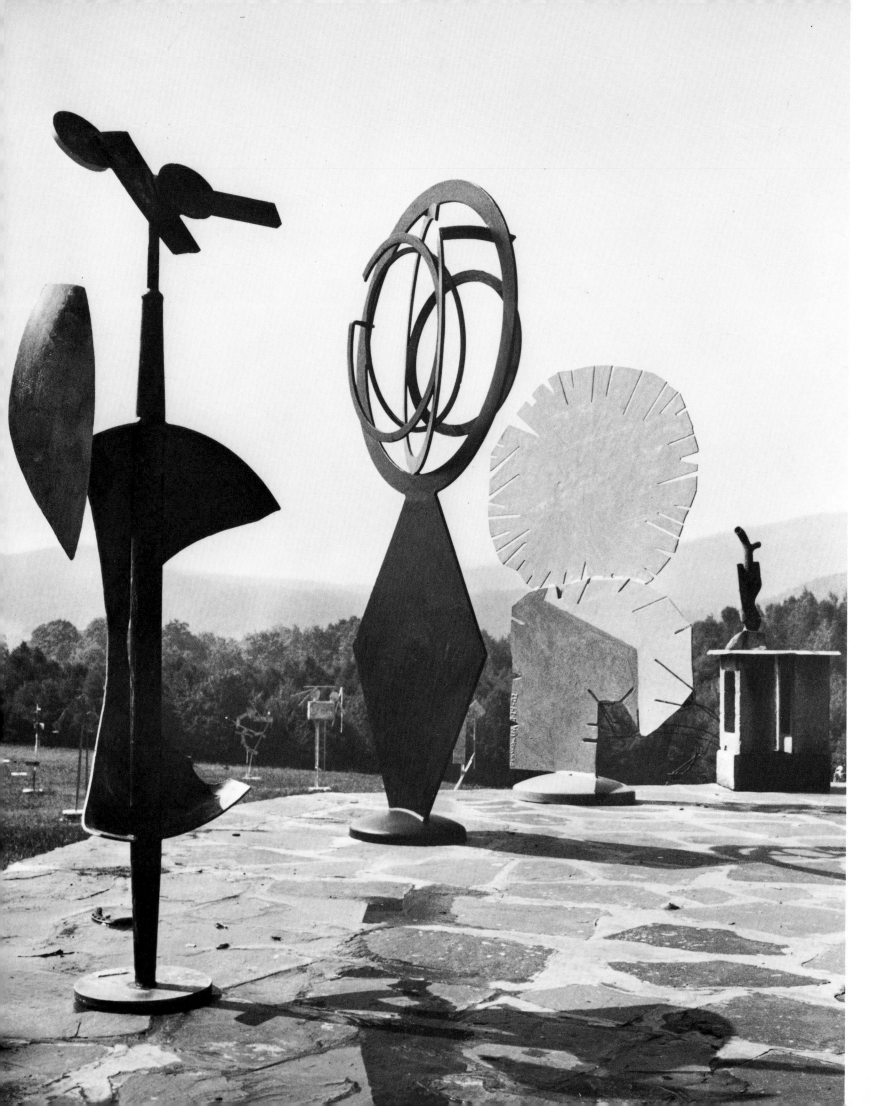

[338] DAVID SMITH. View at the artist's studio at Bolton Landing, New York. [339] DAVID SMITH. *Landscape*. 1949. Steel and bronze, 15×24″. Marlborough-Gerson Gallery, New York

[340] EDUARDO CHILLIDA. *Dream Anvil*. 1953–58. Bronze with wooden base, height 20″. Collection Bo Boustedt, Kungälv, Sweden [341] EDUARDO CHILLIDA. *Place of Silences*. 1958. Iron, height 21″. Galerie Maeght, Paris

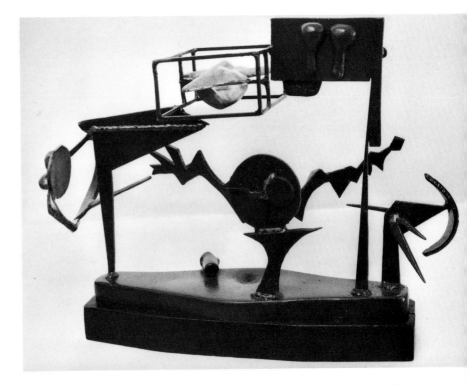

which he was familiar with but had never regarded as a source of wonder and joy, brought into the world of painting and sculpture. There are precedents for this. In Japan the makers of the Ukiyo-e woodcuts did something of the sort in abrogating the aesthetic taboo on themes from ordinary life, and Courbet did the same in the French bourgeois civilization of the nineteenth century, with consequences that were shocking at the time and out of all proportion to his actual pictorial innovation. Pop art does not present itself as a style but rather as a "stylistic intensification of the excitement which the subject matter has. . . ."

However, Pop art does not in every respect live up to this formulation. It is an art that instead of transforming, in the old sense, produces, in its own terms, a theatrical transformation. Pop art is the name given to the framing of an object and its transfer from ordinary life to the artistic life of a museum or art gallery, a step based on something beyond the seeing of the physical object. Does the collector of old clocks, stones, or shells behave differently when he places them in a glass case or (as I saw a nightclub owner in Tokyo do with clocks in his establishment) proudly promotes them to the rank of wall decorations? In any event, Pop art has enlarged the motifs and vocabulary of creativity. It is, in fact, the inevitable reaction—not entirely unexpected, but unexpected in this particular form—to pictorial Abstract Expressionism, not to sculpture. There is no relation whatsoever to the great spatial values of the sculpture produced between 1912 and 1940. Even in three dimensions, Pop art is more pictorial than sculptural. Tinguely really represents the end of archaism in that he introduces the last possible archaism—the outworn machine. The element of motion, too, now loses spatial value. It is the appearance rather than the essence that is emphasized.

Scandal and shock were in the very nature of Dada and Surrealism. Today there is less provocation, since the public is in on the game and artists have no need to throw down any gauntlets. The reputations of Max Ernst, Dali, Duchamp, and Satie have not been matched by the generation that is now making its bid, the generation of

Robert Rauschenberg (born 1925), Martial Raysse (born 1936), Yves Klein (1928–62), George Segal (born 1924 [333]), John Chamberlain (born 1927 [332]), Peter Agostini (born 1913 [330]), Claes Oldenburg (born 1929 [334]), Marisol (born 1930 [331]). But we shall have to wait and see.

The question now arises as to whether the development of these phenomena, in which a bizarre, more or less weakened, Baroque element is discernible, is in any way comparable with the development of the remarkable border region of the Baroque in the great century of Bernini, when diversion and ceremony, in life and death, at the court and among the people, took advantage of the artificial technical possibilities of the time. Machines raised the element of play to unprecedented heights; they particularly inspired the vivid imagination of the Italians (who were eagerly invited to Paris) and were used in opera, ballet, processions, plays, and water pageants to surprise and amaze the public. Personages came down from clouds or disappeared mysteriously, shells opened, fabulous monsters stalked, ancient ruins and dream palaces came into being. This variegated world was made possible by machines; the *festa* depended upon engineers. As early as 1472, Valturio de Rimini wrote a "Book of Machines," and in the second half of the seventeenth century Giacomo Torelli was famous for combining mathematics and poetry to give form to refined spectacles. A ballet by Maurice Béjart, produced

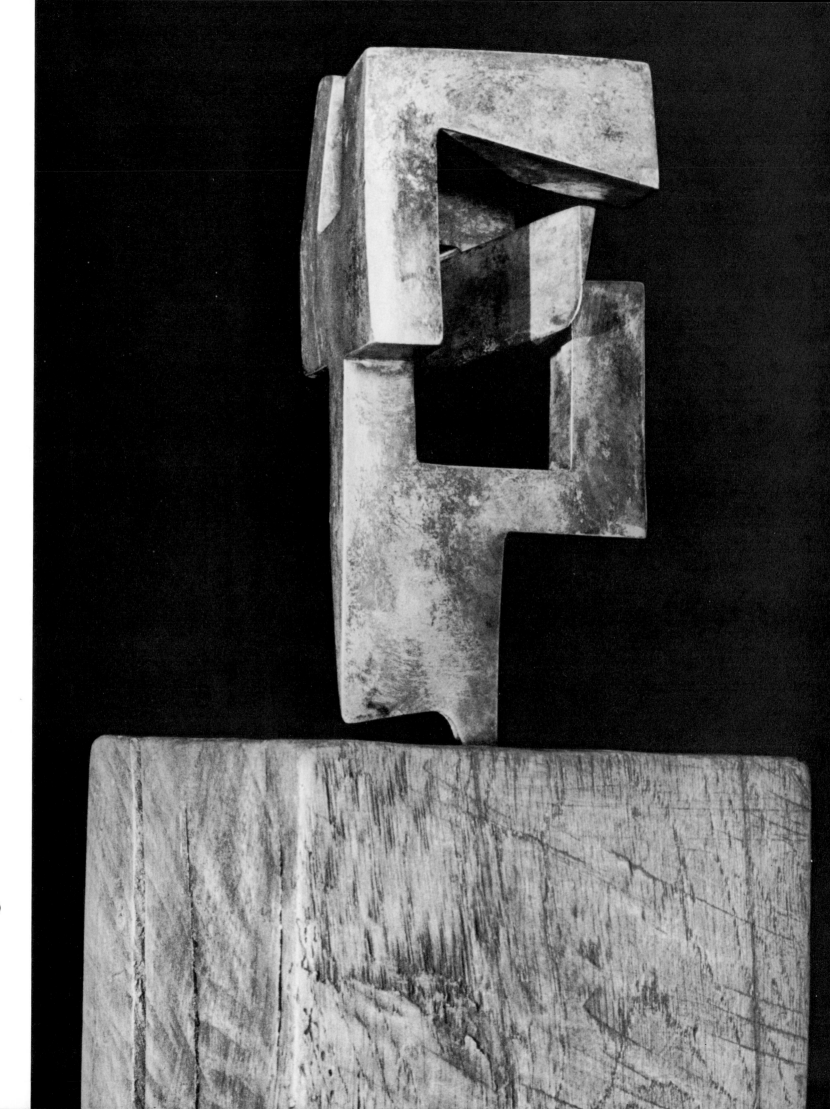

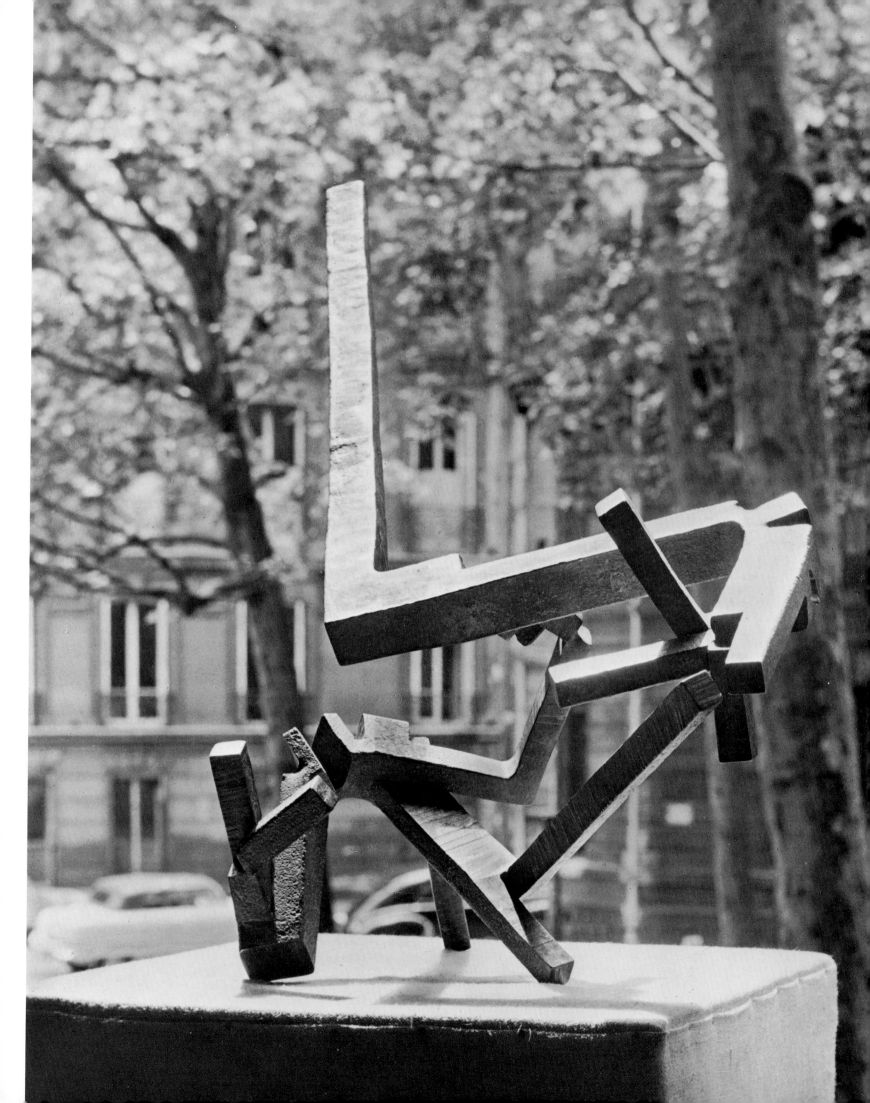

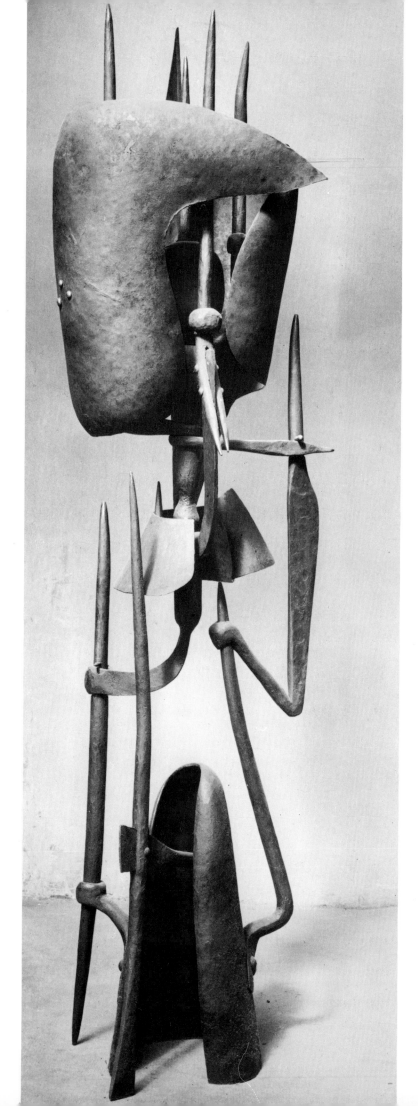

[342] ROBERT MÜLLER. *Ex Voto*. 1957. Iron, height 7'. Museum of Modern Art, New York (Philip C. Johnson Fund)
[343] ROBERT MÜLLER. *The Pyre*. 1959. Assembled iron, height 41 ¾". Collection Myriam Prévot, Paris

with the help of Salvador Dali, would not have been regarded as eccentric or bizarre in the seventeenth century.

Colorful imaginative forms were also given architectonic structure by the Art Nouveau movement and Gaudí. But the contemporary symbiosis of architecture and sculpture is less influential than the aforementioned production of machines and objects, in which architectonic elements were entirely absent. In the seventeenth century the court, the nobility, and the people all participated in the *festa*. The art dealers and collectors of today are not involved to the same extent. With respect to the contemporary production of curious and often very strange objects, a typically French aesthetic nostalgia is expressed by Edouard Jaguer: "One falls into a reverie and dreams of a museum to house all these feverish figures, and one would like them to be assembled in a building that borrowed its essential part from those two matchless peaks of poetic architecture: the Dream Palace of Cheval the postman, in which the cement and cobblestones yielded to quixotic dreams, and the polychrome undulations of Güell Park in Barcelona, which is the work of Gaudí, one of the true promoters of modern art, who was, at one and the same time, architect, sculptor, and city planner."[70]

We thus return, despite the ideas of young Duchamp-Villon in 1917, to the much-abused museum. But Jaguer's dream conjures up a curious kind of museum. It reveals a certain nostalgia for the days of Queen Victoria, coupled with explicit admiration for the imaginative genius of Gaudí. We are once again in the realm of sculpture-architecture, which has become a remarkable intermediate medium between making houses and making statues. This is the only answer, for the moment, to the dream that is still alive in so many people, a dream of an integration, a living together, a symbiosis of architecture and sculpture; it is certainly not the final or definitive answer. In the background of this intermediate form looms the architecture of Gaudí [300–304]. His work, at the end of the nineteenth and the beginning of the twentieth century contributed to an Art Nouveau architecture, based on the old craftsmanship, in which the individual imagination was the dominant factor. In Gaudí the fusion of the arts consists in a free merging of color, line, materials, and forms which is the product not of the collaboration of many people but of one man's creativity; as noted, the same phenomenon was later seen in Le

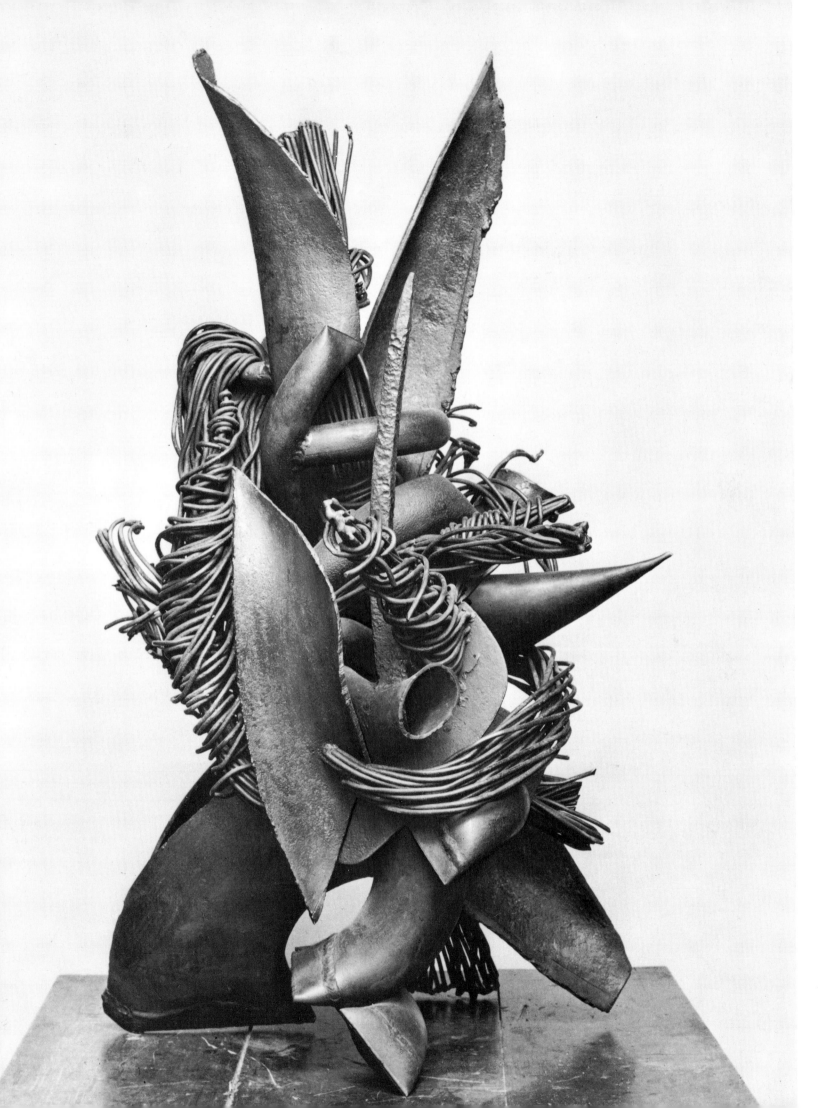

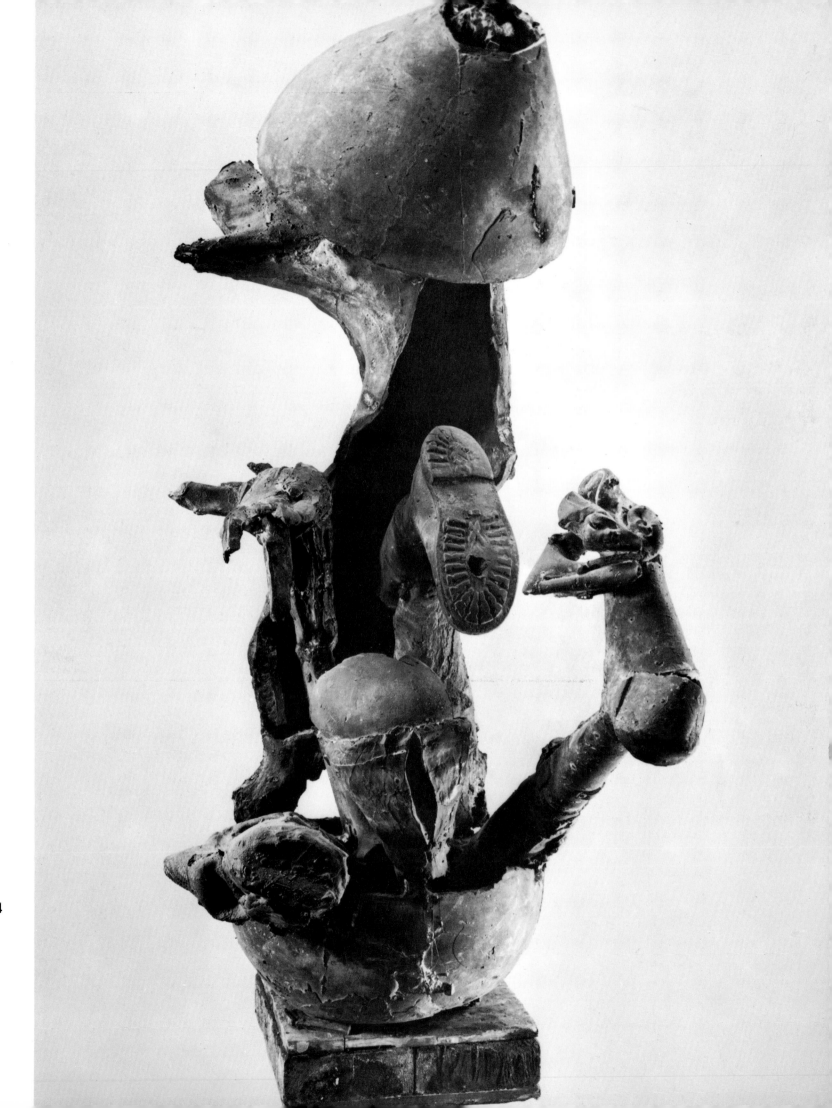

[344] ROËL D'HAESE. *To Lumumba.* 1961. Cast bronze, height 56″. Galerie Claude Bernard, Paris. [345] CÉSAR BALDACCINI. *The Venus of Villetaneuse.* 1962. Bronze, ht. 41 ½″. Galerie Claude Bernard, Paris

[346] CÉSAR BALDACCINI. *Large Plaque "Marseilles".* 1960. Bronze, 8′ × 57″. Galerie Claude Bernard, Paris. [347] CÉSAR BALDACCINI. *The Venus of Villetaneuse* (detail). Galerie Claude Bernard, Paris

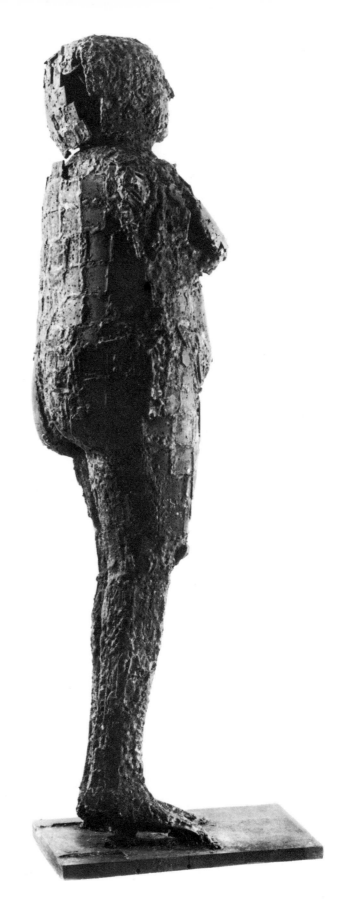

Corbusier, who was armed with the technology of modern construction [299].

Figurative Sculpture and Organic, Geometrical, and Symbolic Abstraction

As we have seen, around 1950 there emerged in force the sculpture of a number of young artists born between 1920 and 1927, together with the later work of some older artists. This burst of work was, of course, an aftermath of what the first half of the century had brought forth, but at the same time it led to a turning point where men and animals assumed a new aspect. To regard this development solely as a reaction to abstraction would be to view it fractionally. Just so in painting the COBRA group turned violently away from the world of Mondrian, but its reaction signified more than a rejection, which was only incidental. Insofar as many younger sculptors concentrated their spatial experiments on the human figure (which such older masters as Lipchitz and Moore had never neglected), the renewing element is not the human figure itself; it is the extension attained through the human figure, which gives sculpture the means of converting a primarily psychical process into something that is communicated through spatial sensation.

From the visual point of view, the striking common denominator obtainable from the rich diversity of personal styles is a Mannerist-Baroque kind of form. There are Surrealist overtones in the literary virtuosity with which titles were devised (Arp was particularly inventive). The artists attributed great importance to these titles. As a random selection indicates, they combine more or less psychological motifs with a literary refinement worthy of the age of Mannerism: *Le Pilote de l'onde vive, Fétiche anti-fertilité, Le diable s'y prend mal, Petit Soir le matin, Broyeuse de peur, Sympathie sanglante, Rencontre dans la nuit, Cathédrale de la douleur.*

Spatial sensation is linked in this sculpture with three psychological reactions to the external world: amazement, *Angst*, and protest. Each of the three is a source of disturbance in the form and on the surface of the material. It was in the work of Boccioni that we saw for the first time the sharp, aggressive metal projections of forms. Half a

305

[348] EDUARDO PAOLOZZI. *St. Sebastian III.* 1958–59. Bronze, height 7' 3". Rijksmuseum Kröller-Müller, Otterlo

[349] EDUARDO PAOLOZZI. *Hermaphroditic Idol I.* 1962. Aluminum, 72×27½×22½". Collection the artist

century later these are in the arsenal of a group of young artists with a different conception of sculpture. The playfulness with materials of Tatlin (1913) and, later, of Schwitters was confined, for the most part, to sculpture in relief, where it is the material and structure that count and not the mass and volume.

Of the pioneers of the Cubist era, only Picasso and Lipchitz, more especially the latter, between 1920 and 1930, after a period of working in accordance with a strict formula, made caprice possible in sculpture. They did so not incidentally but as a matter of principle, by means of their technically experimental transparencies; they worked in bronze and made it serve a new purpose. Picasso playfully used a variety of materials, but his forms and motifs remained linked to archaism as he created the modern magic statue. His sculpture gives the impression of constituting an interlude in his work. It was not until about 1930 that Gonzalez [225, 232–236] developed the linear wire figure and expressed himself directly in small metal sculptures. As has been said, the exhibitions of his work after his death doubtless showed many younger sculptors the possibilities of metal construction, not in the Boccioni-Tatlin structural manner but rather by the use of the greatly reduced figure that nevertheless suggests volume. The work of other artists, for example Robert Jacobsen, a Dane who lives in France, and the American David Smith, represent transitional phenomena ranging from abstraction to veiled symbolic representation. In the Netherlands, Siem van den Hoonaard (1900–38), who unfortunately died young, at first made metal sculptures like those of Pablo Gargallo (1881–1936 [335]) and later produced more personal and dynamic transparent metal representations [336].

David Smith (1906–65) inscribed his tensions and fury in space by means of semi-abstract symbols. Highly emotional, without the disciplined playfulness of which Picasso, Max Ernst, and Lipchitz have been masters, he achieved a direct symbolic expressiveness that gives his work a strangely relentless disharmony—a stylistic embodiment of contradiction and as such an essential feature of our era [337–339]. Smith, with his influence on young English sculptors, has posthumously been recognized as the first real American sculptor, the fame of Calder being considered to have a more European accent. Seymour Lipton (born 1903) is another American experimenter; his

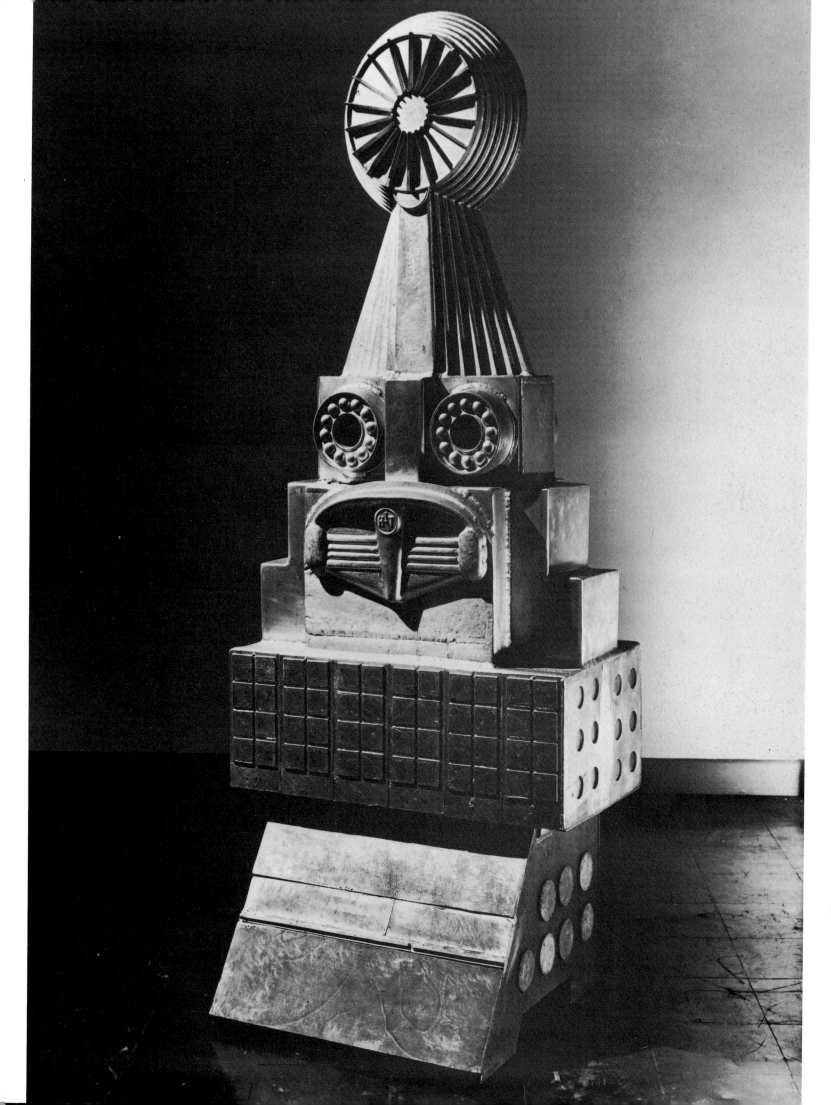

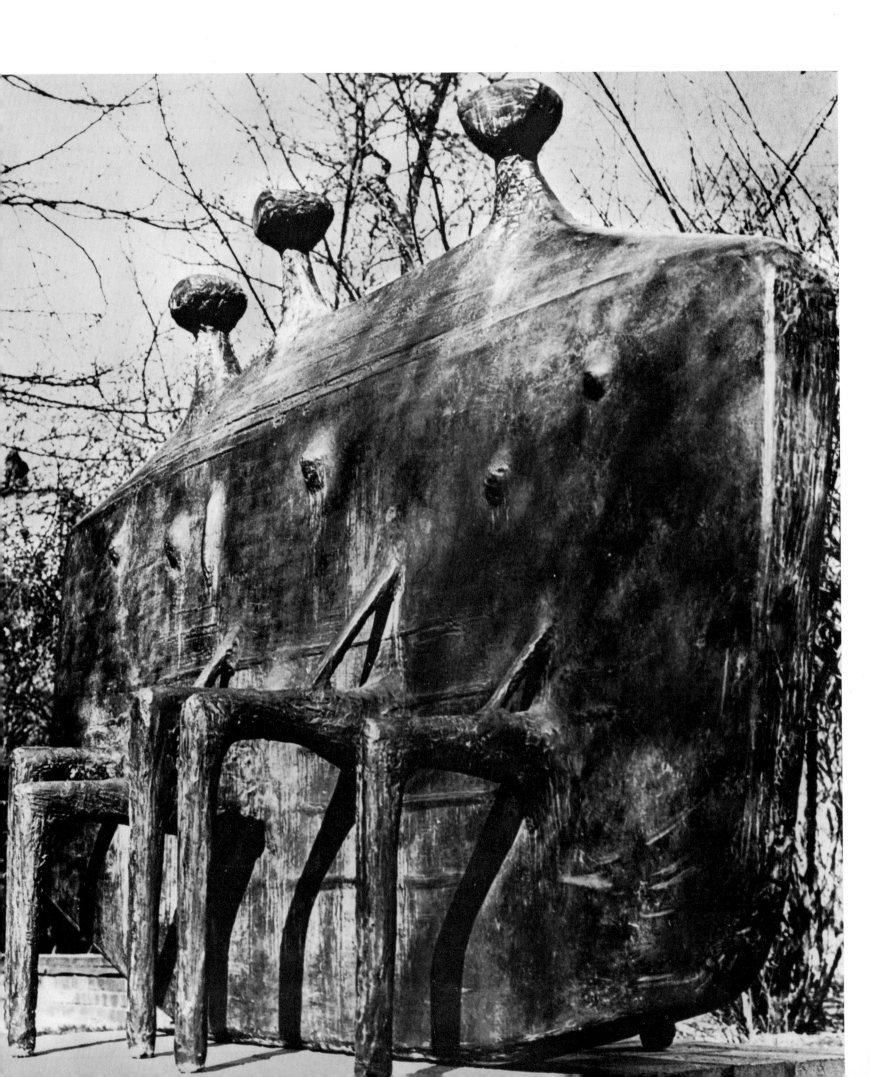

materials are steel and alloys of nickel and silver; his shapes are derived from the animal and plant worlds (as are, to some extent, those of Penalba in France). Lipton is less abstract than Smith. His style, which is always reminiscent of the organic world of forms, has a tendency toward symbol. The tensions in the work of Robert Jacobsen (born 1912), who appeals emphatically to instinct and cultivates an anti-machine attitude, are the result of the contradiction between the nature of his materials, which determine his technique (both in the wholly and in the partly abstract works, as well as in the iron dolls), and of his revolt against the mechanized world. The conflict and contradiction that have a certain grimness in David Smith assume milder forms in the Danish sculptor.

In the hands of the younger sculptors, the mastery of metal has led to great freedom. Robert Müller (born 1920), a Swiss who lives in Paris, was, like César Baldaccini, a pupil of Germaine Richier's. Müller has worked out a vocabulary of his own in scrap metal [342, 343]; it expresses an extremely personal Baroque eroticism with aggressive and defensive attributes that suggest the insect world. His recent work shows increasing simplicity and clarity of form.

Outstanding among the Spaniards who have been producing metal sculpture in recent years is Eduardo Chillida (born 1924 [340, 341]), who was the surprise of the Venice Biennale in 1958; he is still the simplest and strongest of the younger Spanish artists, even in his wood constructions, which introduce the effect of volume. There have been others who have produced powerful structures, but they are never totally independent of tradition or free of archaism. Echoes of the craftsmanship of the country blacksmith, of the forging of farm tools in the old craft way, preserve the ambience of antiquity in the work of these Spaniards; as we have seen, Gonzalez knew the craft of the smith at its most authentic. The youngest of these sculptors, Miguel Berrocal (born 1933), who had his Venice Biennale debut in 1964, evokes once more, with his compound sculptures, the union of handicraft background and modern fanciful invention.

With similar aims Roël d'Haese (born 1921), a Fleming, still adheres to a figurative vocabulary [344]. His work has a wanton richness of invention that links him in spirit with Tyll Eulenspiegel, the hero of a work by his countryman Charles de Coster, and the world of Hieronymus Bosch. A man of eternal protest, of untiring revolt, he does not allow himself time for his forms to mature. But because he has never abandoned the guiding principles of his craft and constantly endeavors to perfect it through personally invented and executed techniques, he finds in it a point of attachment (as well as of contradiction) for his adventurous spirit, which is oriented toward

[350] KENNETH ARMITAGE. *Triarchy.* 1958–59. Bronze, length 9'. New London Gallery, London. [351] LYNN CHADWICK. *Tokyo I.* 1962. Steel, height 18". Collection The British Council

[352] LYNN CHADWICK. *Later Alligator.* 1961. Bronze, height 48". [353] LYNN CHADWICK. *Cage Construction for Angels II.* 1961. Iron, height 25 ½". Collection the artist

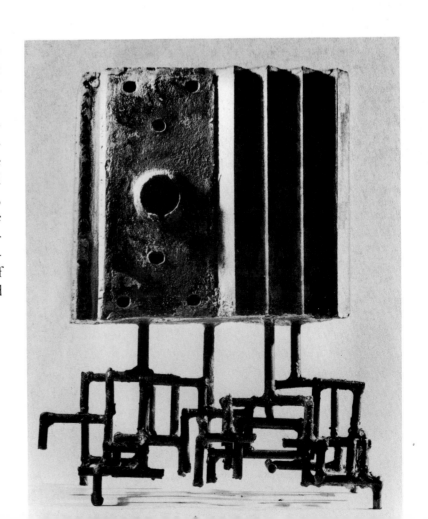

311

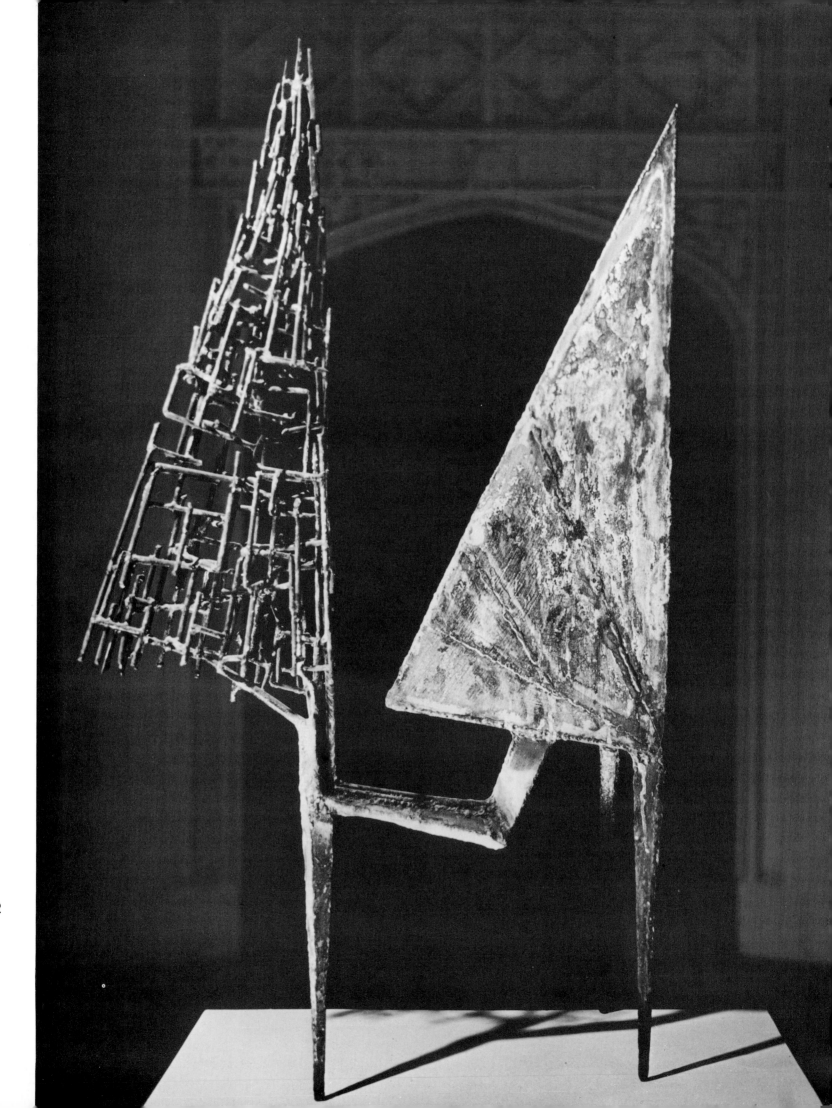

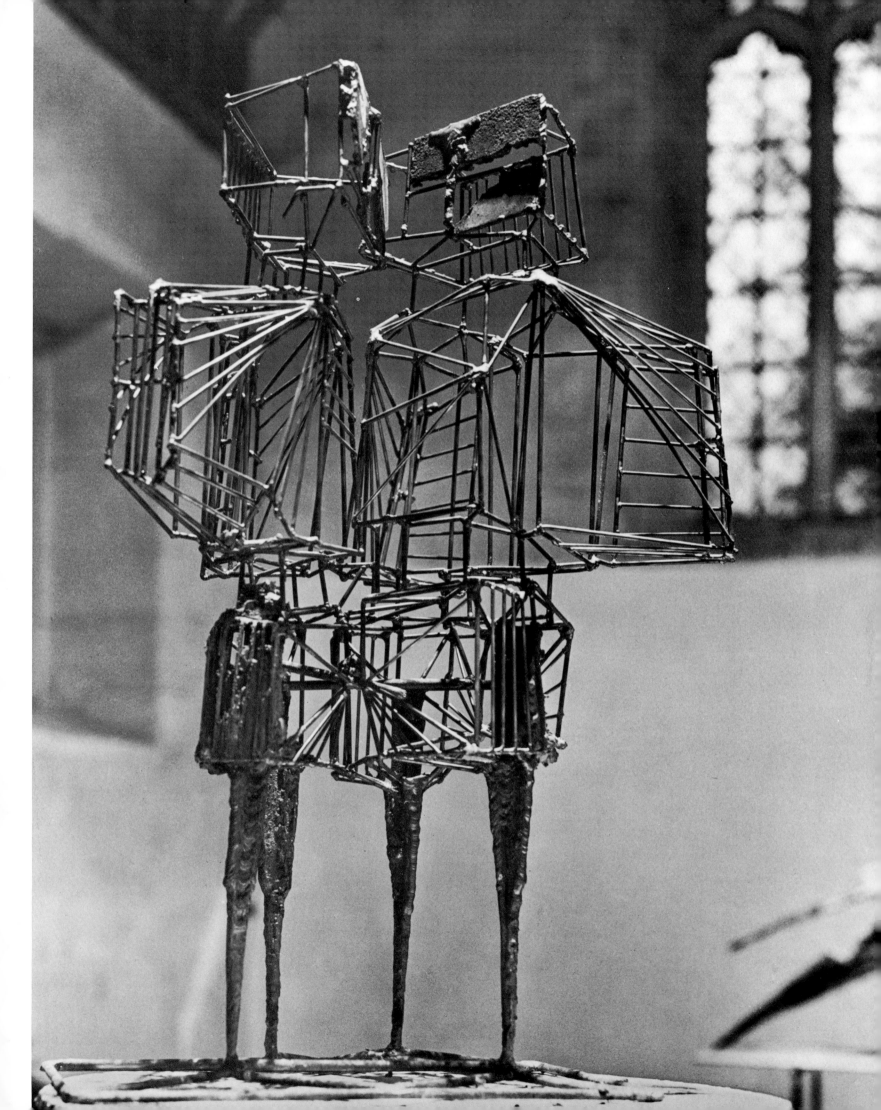

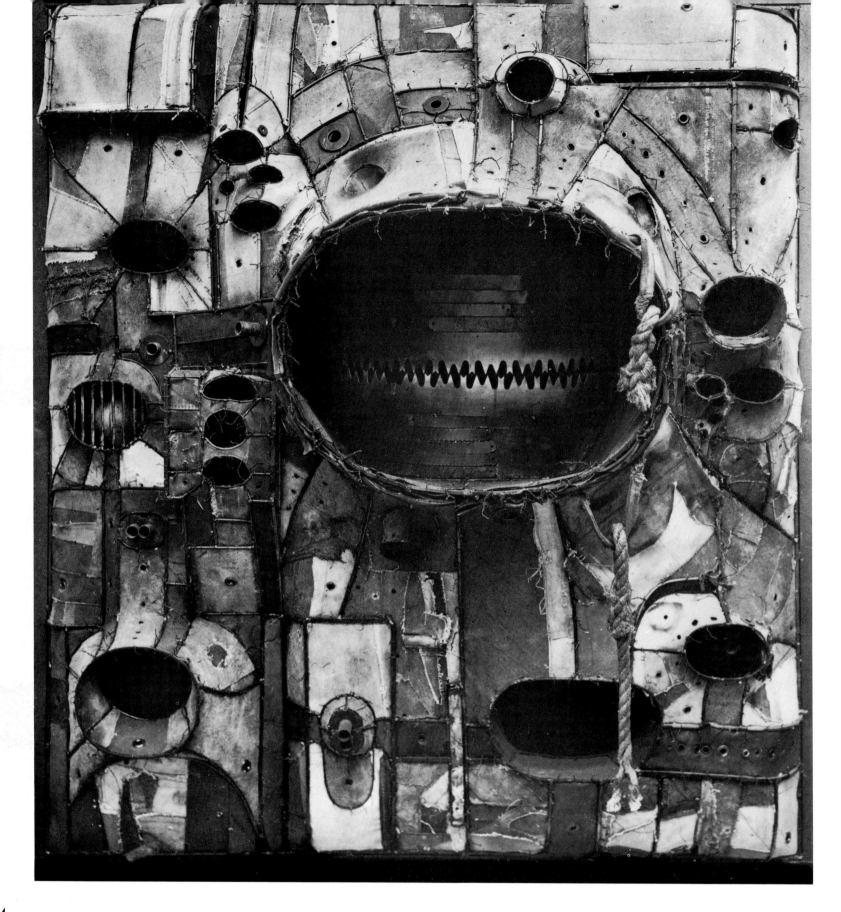

[354] LEE BONTECOU. *Untitled.* 1961. Welded steel and canvas, 72 × 66 × 25″. Whitney Museum of American Art, New York

[355] LOUISE NEVELSON. *Shadow Panels.* 1961. Black wood, each 86 × 22 ½ × 5″. Martha Jackson Gallery, New York

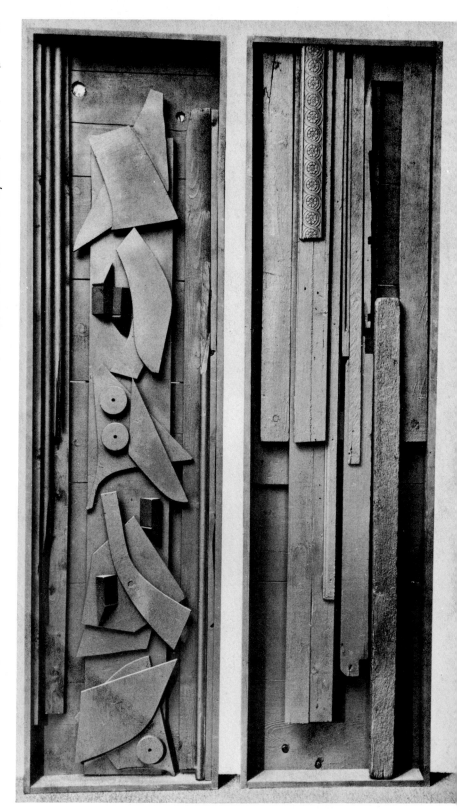

reality. His extremely emotional sense of reality uses figures to produce a shocking and free rhythm in the mass.

The production of these various artists is rooted in a hard, mechanized world. They use both junk and new materials. Their work is far removed from that of the Constructivists. The abandonment of the Constructivist and structural idea even involves a certain regression. Such work grows out of resistance to and criticism of the modern age; it uses the enemy's materials to revert to the essential world of human emotions and instincts. This is not a world of sculpture that seeks structures, that makes machines for light and movement in order to concretize abstract images. It is a world that once again uses volume and mass, though in a different way, a way that includes the figurative, the ornamental, the playful, the dreamy, the aggressive, and the defensive. The element of newness is not in the materials, which were used as early as 1911–13 (especially in Italy and Russia); nor is it in the dynamics or formal modifications of the shapes.

However, the element of emotional renewal is not strange to this world. The newness lies (for example, in the case of Germaine Richier) in the intention to shock, to surprise, in the spectacular new combinations, materials, and forms, in the criticism of life. This kind of sculpture relies very much on the tactile sensibility of the observer. Technically and emotionally, the sense of touch enlarges its domain here.

Perhaps it is the spirit of negation and self-assertion characteristic of Mannerist representation that is the most striking feature in the work of César Baldaccini (born 1921). César was moved by the spectral figures of Richier's corroded world and found in them a point of departure for his essentially more positive reactions [296, 345–347]. For him, Dali's Surrealism was an example in painting of an attitude toward life that should be the foundation not only of the artist's work but also of his personal conduct. César is the first sculptor in whom something of the sort, in the Surrealist tradition, takes place. His work grew out of the discovery of what he could do in sculpture with a wrecked automobile: here the quality of accident that is inherent in present-day life found its symbol. César's discovery sublimated accident; his reaction was typically aesthetic. The destructive power of life destroys the shape; collision is a result of far-reaching antithetic movements that end in formlessness. César has felt the

315

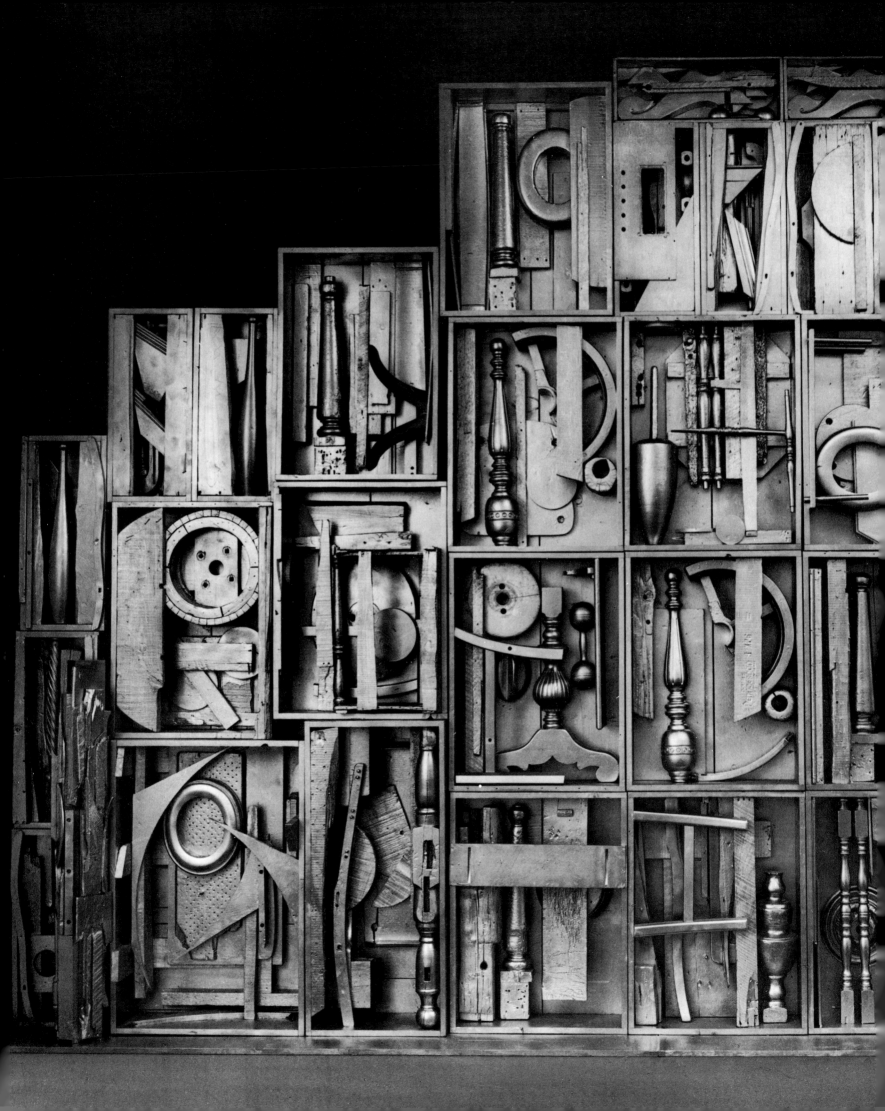

menace of doom in life and has objectified it; his sculpture makes a symbol of it and comments upon it. Perhaps there is involved a quasi-sadistic pleasure in seeing a machine no longer able to work and in giving it (as does Tinguely) a function in another domain, where the machine as such no longer plays a part. Thus we can say that César is a master innovator in sculpture not so much through his forms as through his power to shock. This explains the capricious, abrupt evolution of his work. It shocks aesthetically not the way lightning or storm shocks but as the news in the daily papers shocks. It is the poetry and the transient emotion of the events of contemporary life.

Eduardo Paolozzi (born 1924) is the British exemplar of this second phase of the century, the phase of the 1950's, in which the sculptor returns to volume and mass and in which the product of the machine, turning against itself, takes on a new shape that is created with cast-off elements [348, 349]. Paolozzi is very inventive. He uses the spatial form of a relief as something that is meant not merely to be seen at a distance but to be read, as an assemblage of signs from the mechanized world of the word. Letters and numbers from a printing press are endowed by him with their original mystery; comprehensible hieroglyphics are made incomprehensible by their new context. Man, with his multiplicity of still unarticulated sounds, is a tangible and visible vessel of communications waiting for the secret of intelligibility. Paolozzi began with sculpture that was inspired by Tristan Tzara and Giacometti; it had no connection with England but stemmed, rather, from Parisian Surrealism. The latter offered a magical tradition, which Paolozzi used, and transformed, until he found in his own culture the signs that could express his emotional life more directly. He proceeded to build human forms out of objects juxtaposed arbitrarily, around which he melted bronze. His recent production shows a new development: closed masses and anachronistic architecture of furniture or houses, objects that evoke the nineteenth century and yet, through their titles, have other associations. He thus works mysteriously and ambiguously with thoroughly clear and tangible forms. This is in contrast with D'Haese and César, who, for all the capriciousness of their protesting imaginations, remain, like Richier,

317

318

319

within the realm of the rational and the logical: it is the irrational that is Paolozzi's strength. He himself seems to be constantly surprised as he develops forms in each new phase of his creativity, forms that have no apparent connection with what went before. After exhausting a motif, he miraculously becomes attached to new and different objects: this is a psychic state rather than a development. He uses a subjective spatial language that is always surprisingly readable.

Kenneth Armitage (born 1916), on the other hand, created during this period a repertory of formidable figures which are walls that repel and shut us out at the same time that they assert their relationship to our human kind. Man becomes monolith and non-man, yet the personal presence of the pieces is uncanny [350].

Because the work of Lynn Chadwick (born 1914) is not based on shock, caprice, or the element of surprise, it is only half at home among these figures of the post-1950 Baroque. Still, his sculpture is related to that of the others whom we have been discussing. He presents the antihuman world of the animal, with which he attempts to identify, as did the German Expressionist painter Franz Marc (1880–1916), somewhat more poetically. Chadwick creates demoniacal figures that are both threatening and threatened. In this he is archaistic. We have seen formal archaism arise out of an unconscious romantic nostalgia for the earliest times; this is a recurrent pheonomenon in twentieth-century sculpture. There is also a psychical archaism, which, as in Chadwick, discloses the great dark drives that link and repel. Such archaistic manifestations should be called animistic rather than metaphysical, it seems to me. The difference between Chadwick and other creators of the dark world of attack and defense, of self-preservation and violent death, is that he is a prodigious constructor. Chadwick goes a step farther than Germaine Richier, who built her terrorized, corroded figures on the macabre Romantic foundation of the skeleton. With the unfaltering touch of the architect (he worked for years in an architect's office), he creates entire figures that are carefully built up out of angular surfaces—immobilized beings that are a fusion of the human, the animal, and the inanimate [351–353]. It is not motion that counts for him; it is immobility, not as rest but as tension, the tension of watchfulness. The form clearly has an expressive power that is determined by structural elements.

Chadwick's creatures are complete expressions of the age; they

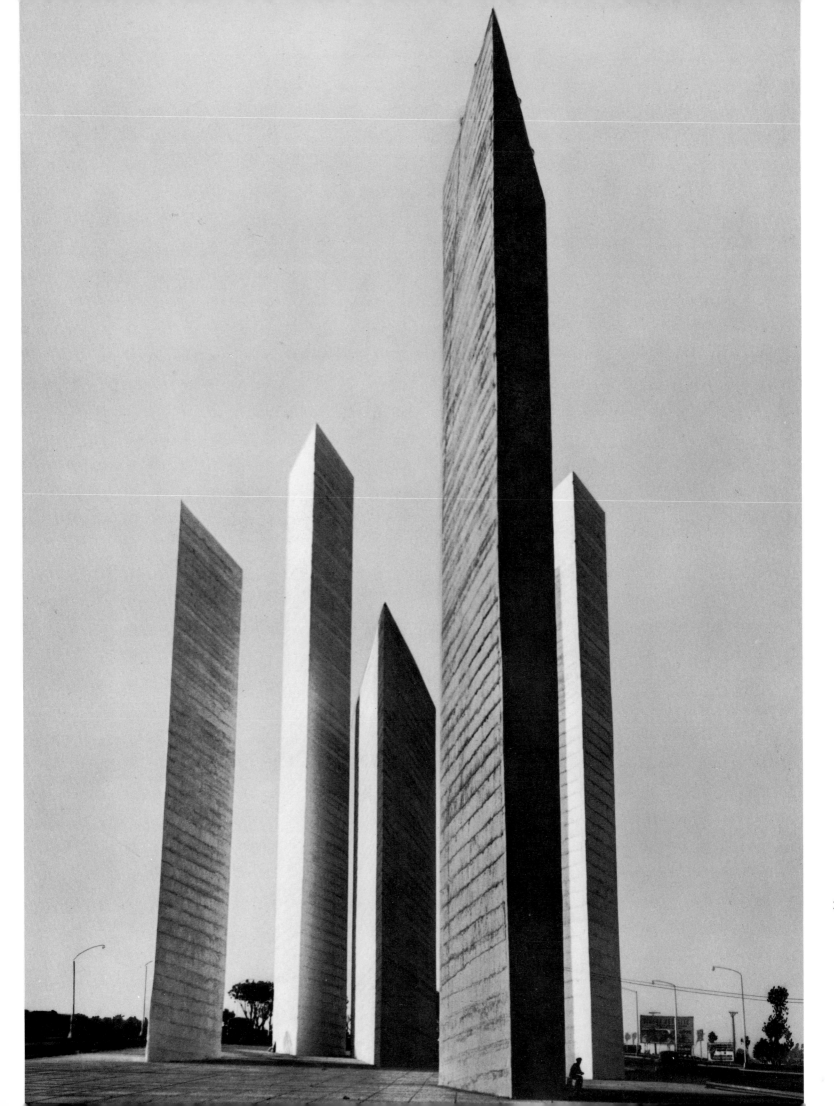

321

evoke primeval feelings which we no longer experience in a prehistoric manner but which we symbolize by means of modern mythical animals. In this way, schematic patterns come into being, patterns that have an abstract effect and that, at the same time, are forms. If Chadwick's power to create form had been slighter, the intellectual content of his work might have led him to a Baroque Surrealism. He has avoided this through the paradox of a mathematical metamorphosis that is completely sculptural. His work contrasts with that of Tinguely, which, with its machines, its mingling of organic and mechanical shapes, and its disquieting games, carries Surrealism into the second half of this century.

Manneristic Surrealism came to the fore in the first and second quarters of this century, primarily in painting, but it did not renovate form. In the third quarter of the century a new development in Surrealism appears possible in sculpture, even after Giacometti.

Surrealist and Expressive Abstraction

America, which developed a climate of its own for Surrealism as a result of the arrival of Marcel Duchamp during World War I and of André Breton during World War II, has given incomparable form to the Surrealistic attitude toward life through the work of Louise Nevelson (born 1900). Just as a certain kind of sculpture became an autonomous point of departure for architecture rather than a subdivision of it, so Louise Nevelson has converted fragments of the room and its furniture into sculpture-furniture or sculpture-wall

[361, 362] ANDRÉ VOLTEN. *Design for a Highway* (scale 1:3). 1963–64. Steel DIN 10, height 10′ 6″. Collection the artist, Amsterdam
[363, 364] HANS UHLMANN. *Sculpture.* 1961. Chrome-nickel steel, height 66′. In front of Deutsche Oper, West Berlin
[365, 366] BARBARA HEPWORTH. *Winged Figure.* 1962. Aluminum, height 19′ 3″. John Lewis Building, London

[355, 356]. Her work is not a variant of traditional relief. It looks like relief, but its origin is different. The little pieces have the effect of a metamorphosis of furniture-in-space, and the big composite surfaces that of a disturbing wall in an imaginary interior. Depending on the particular period of the artist's life, her work takes on a homogeneous gold, black, or other color. Here too a sculptural renewal took place against the historical background of what Tatlin, Schwitters, Braque, and Picasso had done with the fortuitous or fragmentary object in the collage. Her arsenal of fragments of wooden furniture can be compared with Robert Müller's scrap iron. Nevelson's almost obsessive devotion to definite profiles and to single-tone effects must not be regarded, as it sometimes is, as merely decorative; the works are really assemblages that have a deeply felt content. They are vehement and at times horrifying; they are filled with the events of a life. They are the settings and symbols of a psychic happening that is one of the most important utterances of New York Neo-Surrealism.

The sculpture of Louise Bourgeois (born 1911), a Frenchwoman who has been working in New York for years, has a more direct three-

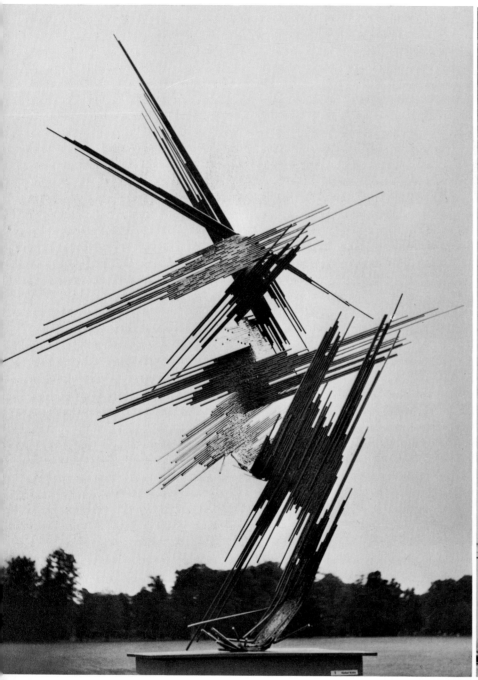

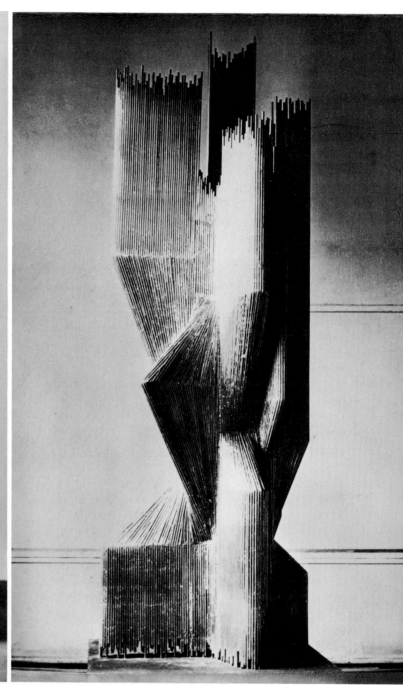

324

[369] FRANÇOIS STAHLY. *Tree of Life*. 1961. Wood
[370] FRANÇOIS STAHLY. *Model for a Fountain at St. Gall*. 1962. Mahogany, height 10′ 8″. Galerie Jeanne Bucher, Paris

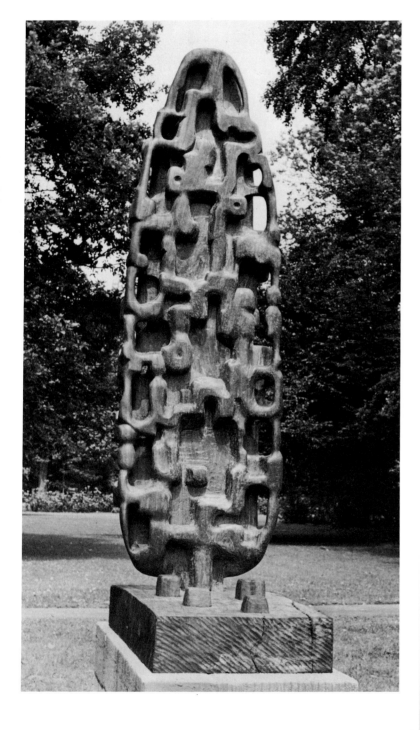

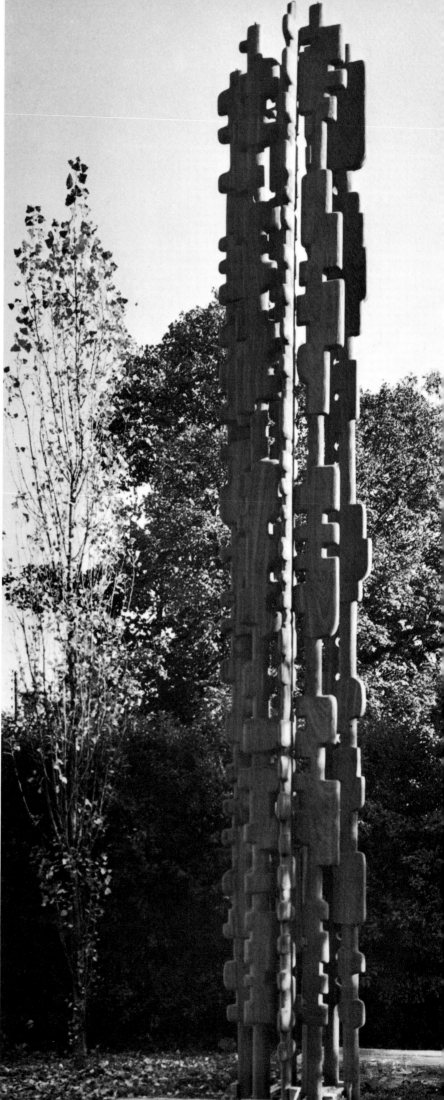

[371] MAX BILL. *Construction with Thirty Similar Elements*. 1938–39. Chrome-nickel steel, 60″×15′×30″. Collection the artist
[372] MAX BILL. *Continuity*. 1947. Reinforced plaster with oil-paint coloring, height 10′. (Destroyed?)

[373] BERTO LARDERA. *Sculpture*. 1952. Iron, height 9′ 10″. Private collection. [374] ÉTIENNE-MARTIN. *Couple d'eux*. 1956. Wood, 73×33 ½×21 ½″. Collection Mme Darthea Speyer, Paris

[375] WESSEL COUZIJN. *Africa*. 1960–61. Bronze, 10′ 7″. Stedelijk Museum, Amsterdam. [376] HENRI-GEORGES ADAM. *The Bow*. 1959. Bronze, 41 ½×8×39 ½″. Musée Royal des Beaux-Arts, Brussels

dimensional formal effect; units are grouped into ensembles, each unit maintaining itself as an enclosed volume in a relation to other units that is purely spatial. The spectator has the experience of spatial solitude.

The curious reliefs of Lee Bontecou (born 1931) arouse the tactile sense and at the same time reject it. An entire set of means is devised for taking advantage of the material and the form in order to create an active spatial effect, which, though visually weak, does arouse the tactile imagination [354]. At the same time, rejection creates a tension and a feeling of distance. Here too the psychic effects are predominant. Sculpture of this kind gives us the feeling that our awareness (through the sense of touch) of the space in which we are moving is similar to that of a blind person.

The remarkable production of the Hungarian-Swiss Zoltan Kemeny (1907–65) also dates from about 1950. His choice of form and material can be explained by the fact that he began as a painter. His work is enriched by the formal idiom of a subtle tactile sense. Unequaled in his fusion of color, material, and form, in his grouping on the plane, and in his manipulation of differences of level, Kemeny used iron, tin plate, wood, nails, zinc, lead, cement, wax, aluminum, and, particularly, copper, in red, yellow, and other colors. But his power lies in the transformation of materials and shapes into compositions in which the flowing, the bumpy, the sharp, the hard, the smooth, and the rough make as great a demand on perception through the fingertips as through the eye. He creates, as it were, autonomous walls that use the lines of structure, the differences in level of urban groupings, open places, and streets to evoke the visual dream of a city plan. Virtuosity and an almost decorative refinement mar some of his works, but no other sculptor has achieved so harmonious a fusion of the optic and the haptic [357, 358].

Abstract Sculpture: Space and Substance

The world of surprise and terror and protest has provided the sculpture of the second half of the century with its phantoms and monsters. It is the abstractionists who continue to develop the structural quality of sculpture, whether in organic development of form as derived from nature or in geometrical structures that defy nature. Because of their tendencies and attitudes they were the first to be led to the problem of the relation between architecture and sculpture, a problem that arose anew, as so-called "integration," in the second half of the century. The century is not far enough advanced, and architecture is not open enough, for us to be able to do more in this connection than become more keenly aware of the essence of our sculpture and of the coexistence of the two arts of space.

The rigorous development of the functional in architecture, as we have seen, had for many years made any dialogue with sculpture or painting undesirable, even impossible. But the old relationship has now come up again to point to new possibilities, though functionalism's taboo has not entirely disappeared. In some cases, the renewed interest appeared as a nostalgia welling up out of suppression, in others as an experimental investigation of reciprocal positions. In this our Space Age, architecture and sculpture have as yet hardly achieved anything in the way of a real dialogue because the conditions for fruitful collaboration have not existed. (The work of Gaudí and Le Corbusier is, of course, exceptional.)

The two spatial revelations must come not from one side only, but from two. Architects of today are tending more and more to think of a large building not as an isolated problem but as part of a city; they are beginning to build in relation to a district or a square. Thus there is less emphasis on the element of sculpture or painting. The new structures will take the place of the old monuments, which honored the individual as citizen, scientist, or artist. They will have to take into consideration not the quality of a particular man but the forces that are active in the life of the community, that make the lives of all easier or harder, more free or more confined.

When Barbara Hepworth sets up, on the side wall of a big store in London, a huge shield with a transparent play of strings (1963 [365, 366]), it is not an allegory of commerce or industry or any of the crafts. It is an elevated light effect whose abstraction summons up not physical but metaphysical light. The shield links the building

[378] ÖDÖN KOCH. *Sculpture.* 1959. Porphyry, 23 ¼×36 ¼″. Kunsthaus, Zurich. [379] SHAMAÏ HABER. *Five Monoliths.* 1962. Pink granite, height 20′. Nahal Rubin, Israel. [380] SHAMAÏ HABER. *Composition.* 1960–61. Gray granite, height 59″. Collection the artist

[381] HANS AESCHBACHER. *Figure III.* 1964. Carrara marble, 12′ 10″ ×26 ½″×26 ½″. Theaterplatz, Ingolstadt, Germany
[382] HANS AESCHBACHER. *Figure I.* 1961. Cresciano granite, 10′2″×46″×19″. Rijksmuseum Kröller-Müller, Otterlo

with the unorganized crowd below. Working in other dimensions in Mexico, where the light is different from that of London, Mathias Goeritz (born 1915) has expressed his passion for towers in the form of modern obelisks that are intended to relate to a city [359, 360].

Wessel Couzijn (born 1912) creates an abstract image of the world's tumult [375]. In his sculpture for the Unilever Building in Rotterdam (1962), he limited his work in order to relate it to the totality of the structure. This was no more a city-planning job than was Hepworth's in London. Couzijn's forms are utterly different from Hepworth's. But the expressive, even Baroque world of Couzijn's openly churning forms is a way of approaching the problem: it gives the building a moving brazen voice in space. His sculpture literally escapes from the wall assigned to it and shoots out of the water, reminding us of Bernini. Instead of being a wall statue, the work becomes a statue for the entire structure. In such cases the old concept of "architectural sculpture" no longer has meaning.

André Volten (born 1926) is closer to Hepworth in his abstractness [309]. The influence of the De Stijl movement is evident. His solutions, in relation to architecture, are characterized by a strong, sober style that is full of tension [361, 362]; he creates geometrical signs that link the building to a lighter, more transparent, and more ordered world than the mass of architecture itself can ever be. His work is in harmony with the architecture. Town planning is now also making itself felt in Volten's open-square signs, for example, the one in the shopping center in Rijswijk (1964).

If true harmony is often lacking, this is generally due to the fact that the architecture and the sculpture are not of the same artistic quality. In Germany, Hans Uhlmann (born 1900) is the strongest figure exploiting the abstract possibilities that exist spatially between architecture and sculpture. Uhlmann [363, 364] lacks the poetry and the ethereal quality that make Hepworth [365, 366] so remarkable, but he develops an almost absolute force whose violence is accentuated by the choice of reflecting materials.

[383] JOANNIS AVRAMIDES. *Five-Figure Group*. 1964. Plaster on aluminum, height 64⅛". [384] JOANNIS AVRAMIDES. *Large Figure*. 1958. Bronze, height 6′ 5″. Rijksmuseum Kröller-Müller, Otterlo

François Stahly (born 1911) often finds the vertical accent congenial to his clustered motifs. They are articulated so that the eye grasps their communal and their independent movements. But the dominant feeling that arises from his handling of the material is the interdependence of these motifs in the greater unit that consumes them [369, 370].

The work of Berto Lardera (born 1911), an Italian sculptor who lives in Paris, has evolved consistently from figurative relief to the figurative pattern in an open space, and from there to the vertical and horizontal combination of cut-out intersecting iron and copper surfaces [373]. He creates an abstraction in space which stands out as a vertical silhouette traversed by a second silhouette and sometimes by one or more horizontal stencils. There is no other sculptor in whom the elements of surface and space are so clearly analyzed; and yet he is able, by means of flatness, to create the wonder of space. He employs differences of direction with a masterly feeling for measure and proportion. The result is that in each of his works there is a striking contradiction between the simple and clear and the extremely complicated, the latter expressed primarily in the crossing points of directions and the interruptions—sources of tension, sources of power for the structure of the whole.

Lardera is a classicist in abstraction. Sculpture like his can produce a true revelation of space vis-à-vis architecture when the two are in perfect accord as to their relation. If the marvel of Greek art was based on the numerical relation that was considered to be the basis of all the arts, including music, then our age (Lardera in particular) awaits a similar key to the living relations among manifestations that now present only a heterogeneous picture.

Brigitte Meier-Denninghoff (born 1923), a student of Pevsner's, displays a remarkable poetry in her abstract constructions [367]; her forms, though derived from Pevsner's technique, have an entirely different value from his. She imparts to cambered surfaces a fine, quiet structure and form.

Norbert Kricke (born 1922) originally worked with Pevsner's rods (as did Meier-Denninghoff); a powerful example is the way Kricke used rods on the walls of the theater in Gelsenkirchen. He then proceeded to abandon strict horizontality in favor of daring contrasting structures in which the lines are defined not by form in space but by flight and movement in space [368].

339

[385, 386] Stonehenge. c. 1800–1400 B.C. Diameter of circle 97′, height of stones above ground 13′ 6″. Salisbury Plain, Wiltshire, England

[387] EUGÈNE DODEIGNE. *Head.* 1960. Black granite, 23 ½ × 13 ½ × 10″. Collection P. Sanders, Rotterdam. [388] EUGÈNE DODEIGNE. *Figure.* Stone. Collection the artist

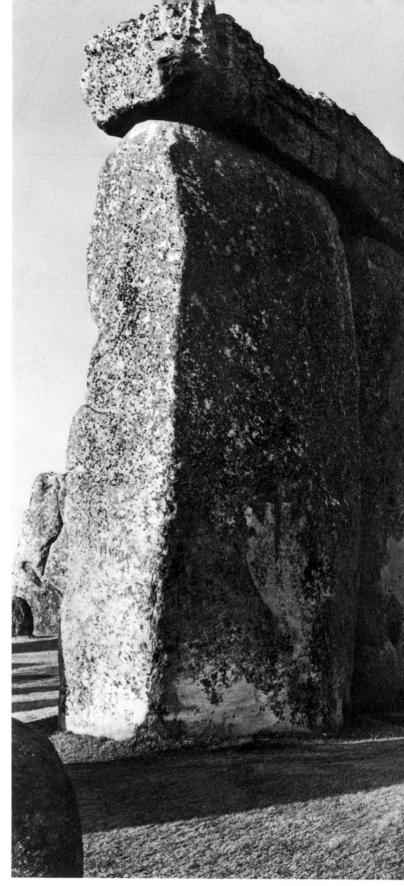

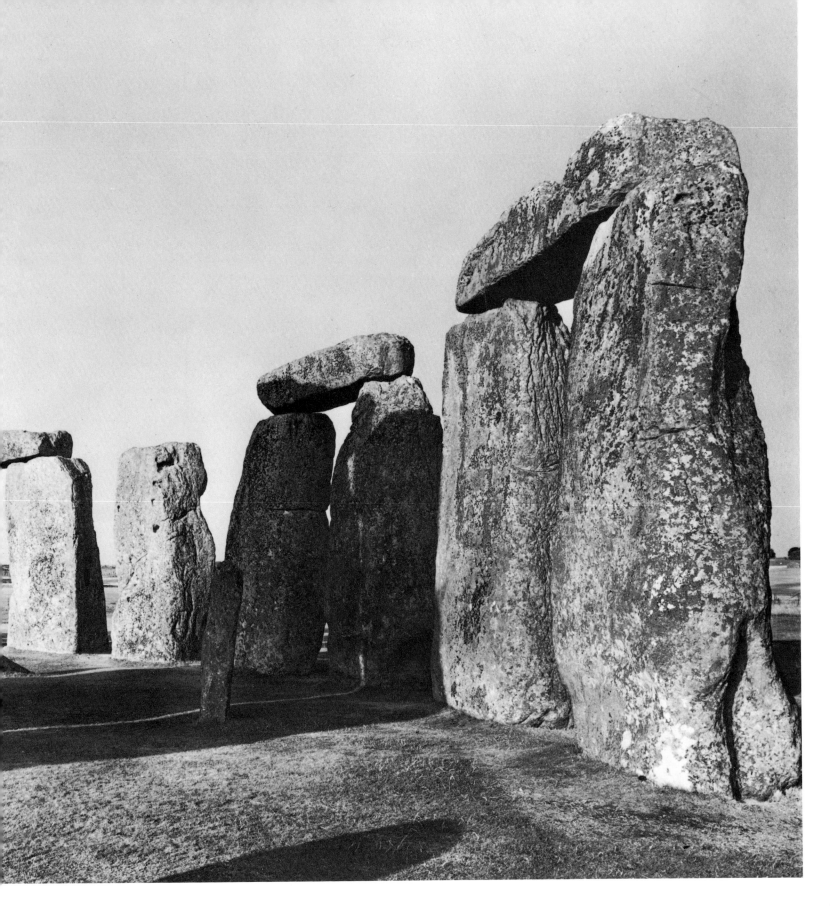

342

A different reaction to the excitement aroused by the elements and the flight of birds in space is that of Henri-Georges Adam (1904–67), who expresses his feelings in abstract forms. In the work of Adam everything becomes form, either linear or enclosed volume; he is engraver and sculptor in one [376]. Especially successful was the work he was commissioned to do for the museum in Le Havre [297, 377]; perfect in mass and scale, it is one of the few felicitous examples of a free sculpture conceived in relation to architecture.

Megalith and Matter

The abstraction of the second half of the century is having difficulty in freeing itself from that of the first half. Nevertheless, there is an international expansion of the possibilities of abstraction. The Americans have made an important contribution. There are more gradations and changes in the very nature of abstraction; in the course of this development, the Swiss have shown a remarkable affinity for the possibilities of abstraction. The development of abstraction is inconceivable without a background of architectonic ideas; it is equally unthinkable without the background of Mondrian, Vantongerloo, and Van Doesburg.

The influence exerted by the work and writings of the architect Sigfried Giedion and of Carola Giedion-Welcker helped to create a typically Swiss climate for abstraction. The varied activities of Max Bill (born 1908), architect, industrial designer, painter, sculptor, and theoretician, are all governed by a central idea that bears the mark of the Bauhaus generation: the idea of the reality of the absolute formula. Bill has not remained fixed in the old abstraction. The famous exhibitions of Concrete art that he organized in Basel in 1944, 1949, and 1960 showed the consequences of abstraction. His sculpture is a reflection on spatial essence [371, 372]. He reduces the material and the volume to a minimum and, at the same time, thinks in broad architectonic terms. His work is made possible by modern technology: he boldly and deliberately produces forms in stone that are essentially at variance with the nature of stone. Bill is not intimidated by the risks involved. His work is based on numerical relations and sound planning. The cool precision of his sculpture has a Platonic quality.

The sculpture of Hans Aeschbacher (born 1906), which was originally representational and was produced by the old method of direct carving in hard stone, now embodies an extreme of strict

344

[391] ALICIA PENALBA. *Absent.* 1961. Bronze, 26⅜ × 27⅛ × 14⅝″.
[392] SHINKICHI TAJIRI. *Mountain.* 1958. Bronze, height 40″. Collection Mrs. A. Orlow, Amsterdam. [393] FRANCESCO SOMAINI.
Horizontal III. 1959. Iron, 11 × 18⅛″

[394] UMBERTO MASTROIANNI. *Lovers.* 1956. Bronze, 59 × 118 × 40″. Central Station, Rotterdam. [395] ARNALDO POMODORO.
Sphere. 1965. Bronze, diameter 47″. Marlborough Galleria d'Arte, Rome

abstraction. Aeschbacher works more intuitively than Bill. His form does not violate the nature of stone: he works the material so that it seems to transcend its inherent nature. The tension derives largely from the opposition between the volume and the pure geometrical form, which compels the material to go to the limit of its bearing power and equilibrium. Aeschbacher also achieves, through the chinks or openings that he creates, an extreme tension between the parts. He produces lines and surfaces that are so exact and perfect, not only as definitions of volume but as spatial values, that they "sing the forms of his work into space." The beauty of his work lies in a rare feeling for the potentialities both of the material and of geometrical form [381, 382].

Ödön Koch (born 1906), a Hungarian-Swiss who creates sensitive and monumental forms, remains, in his abstraction, within the limits of the stone's natural laws. His sculpture is characterized by an introverted feeling for space and a remarkable sense of enclosure [378].

But the Swiss are not the only ones who deal with hard stone— lava, granite, marble—within the strict framework of abstraction. Marble retains its fascination for the Italians owing both to its availability and the tradition of their country. It was an Italian associate of Arp's who executed in stone the forms that Arp conceived in plaster. Closely related to Arp's world is that of Alberto Viani (born 1906), who has developed a specifically Italian organic abstraction that is sometimes on the verge of becoming representational. Carlo Sergio Signori (born 1906), who works in Paris as well as in Italy, creates precious forms that tend toward the decorative, in the nonpejorative sense of the word. He incorporates marble, his favorite material, into his vision.

Still another kind of abstraction based on the tradition of direct carving in stone and exploiting the resistance of stone has been achieved by Shamaï Haber (born 1922). Haber started as a refined craftsman with small, gemlike sculptures whose effect was based upon the contrast between polished and rough surfaces. He also devises

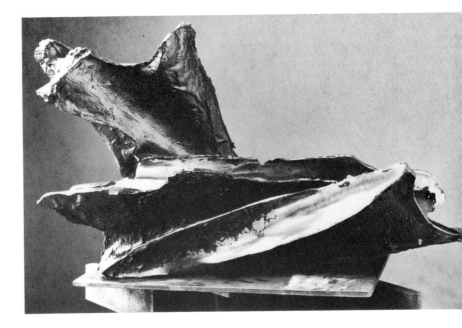

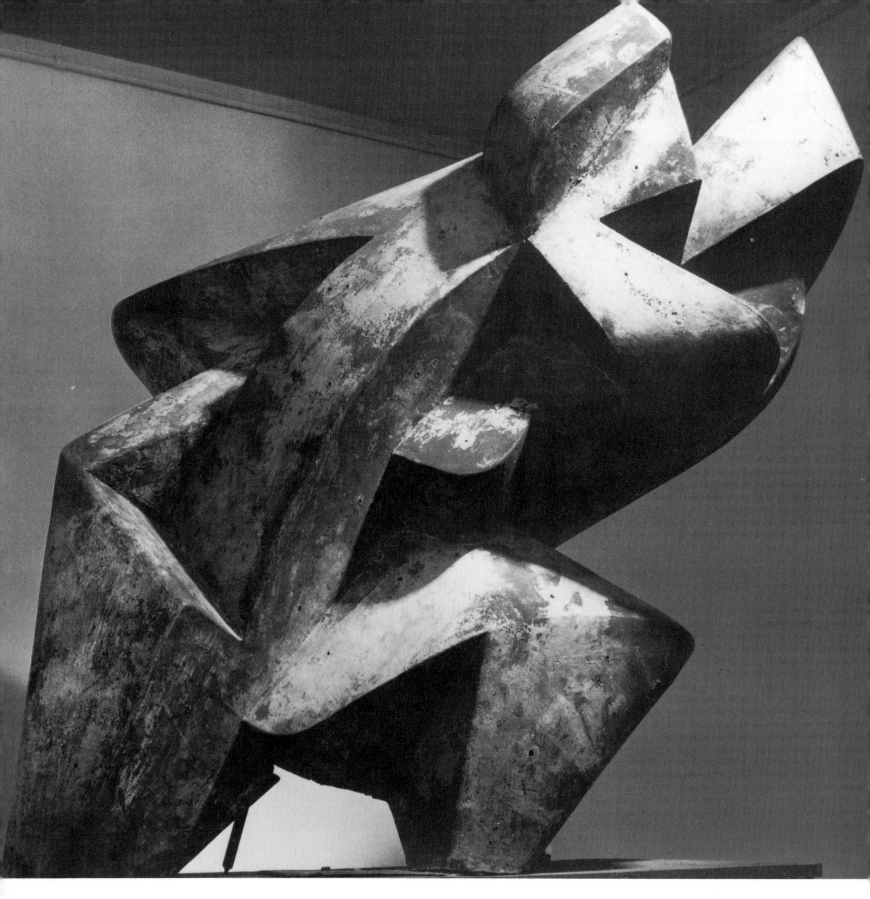

348

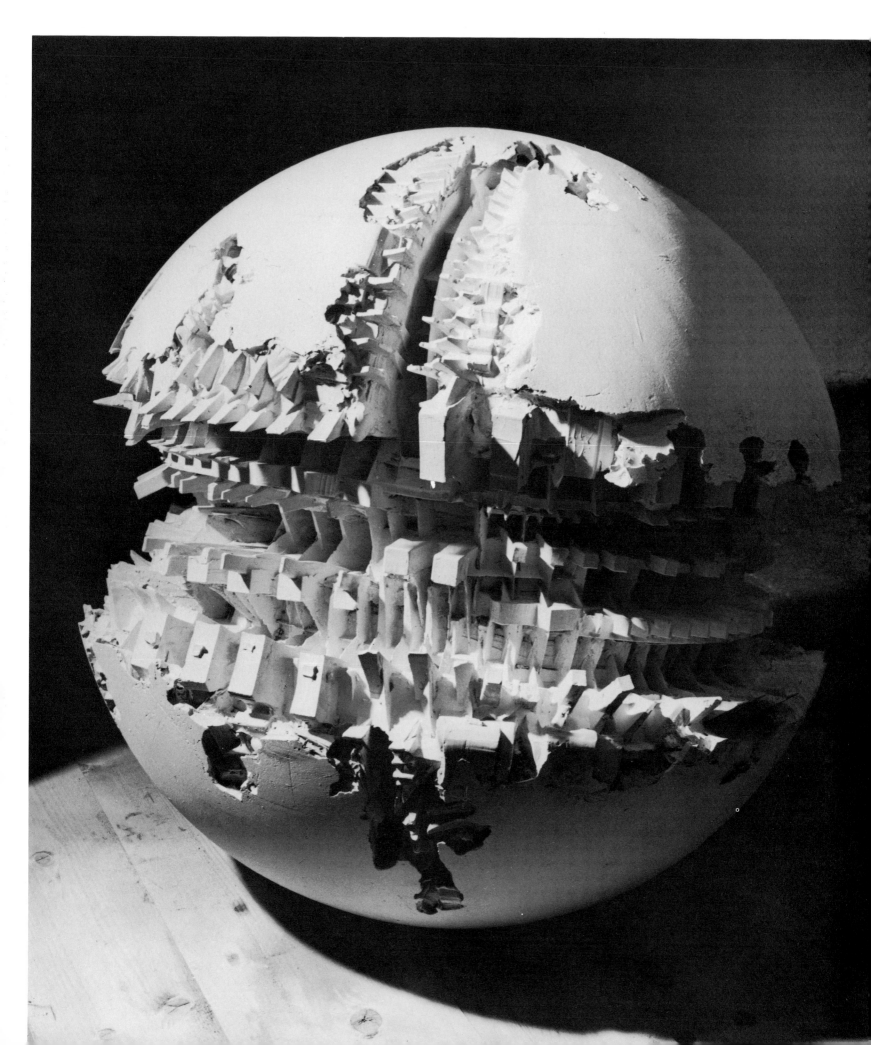

balanced combinations of stones which give an impression of weight and of weightlessness [380]. This kind of sculpture also relies on the tactile sense. At the same time, Haber has an almost prehistoric feeling for stones in landscape. The old stone landscape of Israel was given archaic forms in the monument [379] he made at Nahal Rubin, where the American architect Philip Johnson designed the atomic research center. This monument reintroduces into sculpture the archaism of broken or truncated pillars or columns. For years Brancusi's *Endless Column* had remained a relatively isolated phenomenon, but after 1950 the column began to tempt sculptors, both young and old: Max Bill; Stahly; younger artists in Italy, including Balderi, the Pomodoros, and, especially, Mario Negri (born 1916), who added quiet figures on taut, thin verticals [401]; H. de Vries in the Netherlands; Arp (a sculpture in Basel at the Neue Gewerbeschule); and, recently, Kricke.

The almost manic concentration with which Joannis Avramides (born 1922), a former student of Wotruba's in Vienna, designs columnar shapes [383, 384] is highly interesting. There is a superficial resemblance between his heads and figures and the rigid human figurations in De Chirico's paintings of about 1917. Avramides has produced, on the basis of a geometrical system of calculation (that is, not visually *a priori*), heads and vertical figures in the round. These objects became fixed human icons in space. They were columns, not cylinders, and they evolved regularly into a state of complete repose.

With the exception of Max Bill's Neo-Greek cylinders, the works of these sculptors, by reason of their complex nature—half architectonic and half sculptural—arouse associations with upright megaliths, for example Stonehenge [385, 386], or with the archaic beauty of ancient columns in general, or perhaps with the columns of San Marco in Venice. In any case, they express a theme, whether romantic or abstract, that seems to be evolving in a way similar to that of the torso in the nineteenth century. The sculptured torso was bequeathed to us by antiquity in mutilated form. In the work of Rodin it became an autonomous motif that established the *infinito* as an aesthetic aim in itself. As we know, many young sculptors now have a similar attitude toward rough wood or rough stone. Abstraction is not the essential concern; in fact, play with the material is oriented toward the animistic. Artists have begun to surmise the potentialities of what is called dead matter, of the inorganic world. Even to the layman with a superficial knowledge of the constantly advancing discoveries of experimental science regarding the composition of inorganic and organic matter, it appears that the old certainty as to the absolute difference between the organic and the inorganic has

[396] REG BUTLER. *Study for a Great Tower*. 1963. Plaster model, height 11″. Collection the artist

been undermined: the decision as between the dead and the living seems to be a relative matter.

When a contemporary sculptor works in stone or wood, he no longer works with the nineteenth-century attitude that he is imposing a formal problem on amorphous material. The world of the new sculptors is not that of the stone-carvers who worked on the cathedrals, the world of monumental sculpture which had formed the inspirational setting for artists down to Bourdelle and even Martini. These artists no longer think in terms of forcing a preconceived shape on inert material. One of the great surprises of the second half of the century is the revival of interest in stone and stone-carving, which seemed, at first, to be losing ground as artists became more and more attracted by the advantages of casting in bronze and by experimentation with new materials calling for entirely different techniques. The importance of carving has been newly recognized, and there is a perceptible change in the attitude toward the powers of the stone itself.

The generation of the Moores and Hepworths, having studied in their youth the traditional craft of working marble, had early begun to discern how the material itself can help a form that is alive in the artist to find its way to realization; they learned what it means to penetrate to the core of material; in a sense they did not limit themselves, as Brancusi had, to the surface. As we have seen, Moore was one of the first to be deeply affected by the stone sculpture of Mexico. Other, younger people followed. There was more involved than the discovery of a new realm of forms. Sculptors who cut stone themselves recognize, from the way the stone is worked, the attitude of other artists toward the material. As a result of their own attitude toward stone they have had access to realms of life and death, dormant in the material, which are revealed by the creation of certain forms. Their attitude toward the stone sculpture of Mexico and the sculpture of Africa and the South Sea Islands is no longer one of aesthetic admiration alone.

But this experience, which once was novel, is changing in the case of younger artists. It is as though some of them were even more submissive to the material than their elders, as though their form were not so much an overcoming of resistance as an inconclusive struggle in which the world of stone or wood, with its structure and potentiality, is of an importance equal to that of the artist's inner world.

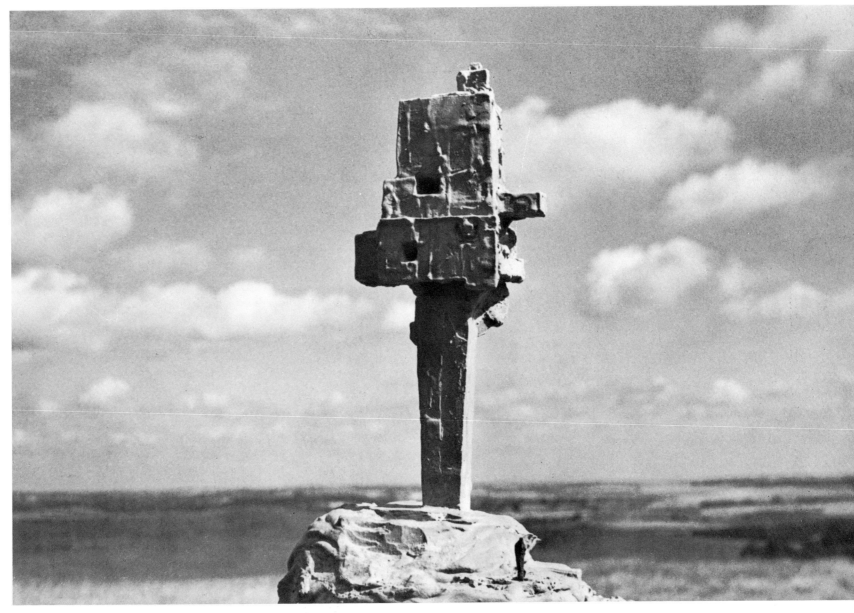

Haber has already been mentioned as one of the sculptors in whom something of the sort has been taking place. There are others, for example, William Turnbull (born 1922) in England and Eugène Dodeigne (born 1923) in Belgium. Dodeigne's work, though not properly called abstract, must be considered here in connection with the new feeling for stone. Dodeigne has the megalithic imagination, which seems a little archaistic to us. But there is no mistaking the fact that we are dealing here with more than a megalithic archaism. The way in which Dodeigne makes a half-human figure loom up out of stone is evidence that very real dialogues with the spirit of the stone

are now taking place [387, 388]. This phenomenon is related to what began to manifest itself after 1945, particularly in the painters of the COBRA movement—a concern with the significance of the earth and man's relation to it.

Henry Heerup (born 1907) was the first of the young sculptors in Denmark to appreciate these new experiences with material. In a way, he brings sculpture back into a primeval relation with the earth. He is concerned with the sources, with the obscure origin of his art. Museum floors and pedestals had divorced the statue, the worked stone, from its sources. The possibilities of what might be called

351

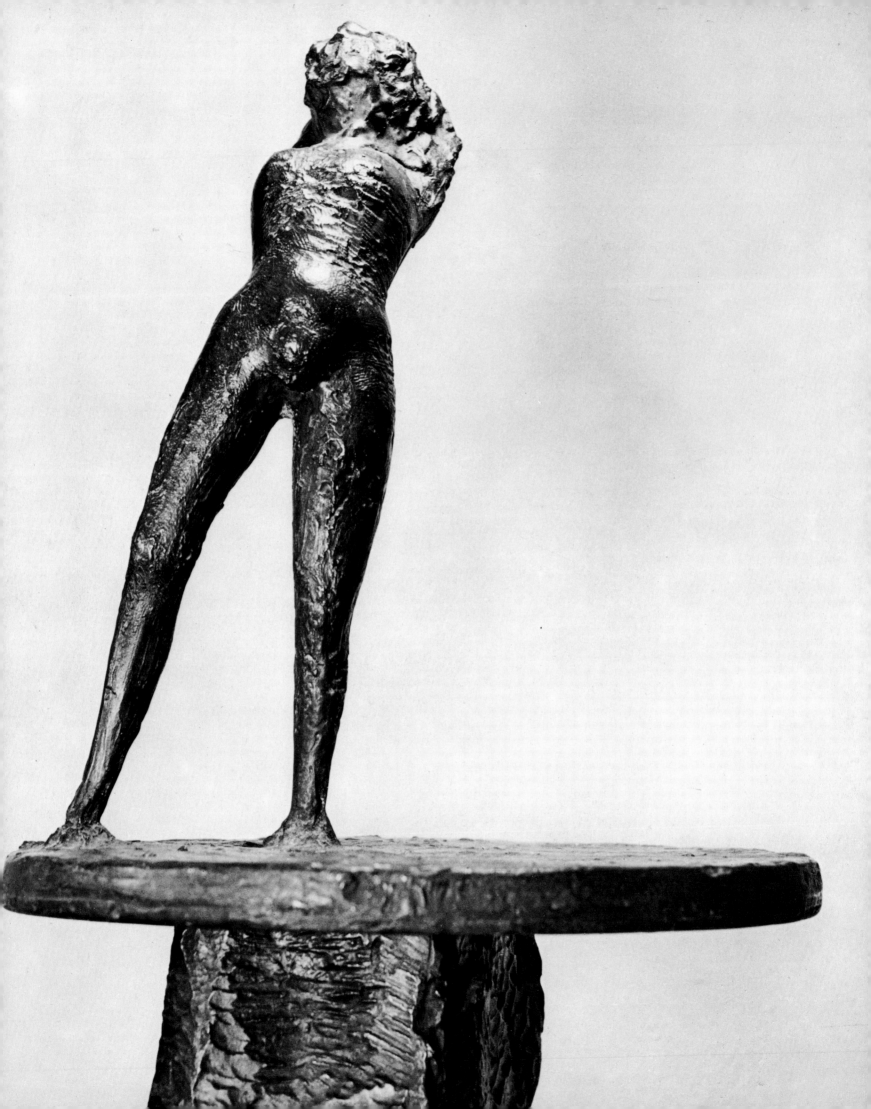

[397] REG BUTLER. *Girl on a Wheel II.* 1959. Bronze, height 18⅞".
Collection Bo Boustedt, Kungälv, Sweden. [398] EMILIO GRECO.
Bather. 1956–57. Bronze, 89×26×22". Musée Royal des Beaux-Arts
Brussels

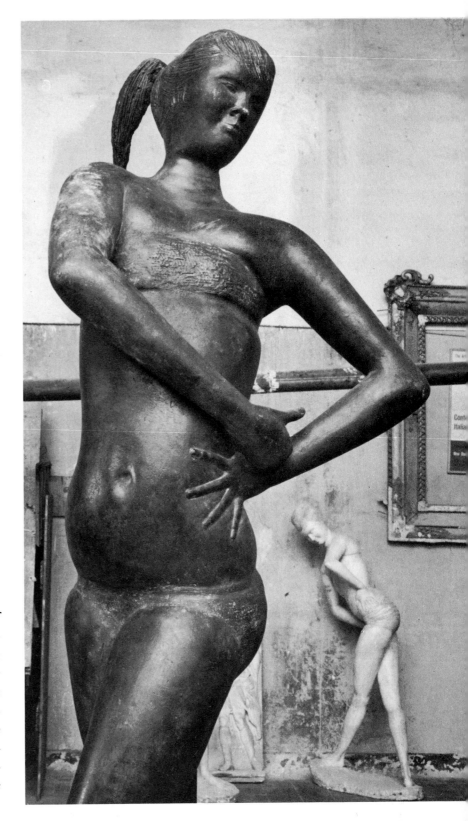

"eruptive" sculpture—sculpture that seems to grow from the stuff
of earth and unknown forces—have remained limited, but within
limits they give post-1945 sculpture as a whole the dark, deep
undertone that is essential for understanding the tensions that exist
between these sources and the purer and clearer forms.

The most powerful postwar manifestation of a new organic world
of forms is the sculpture of Alicia Penalba (born 1918). The direction
of her work is determined by its preponderant verticals and the dark-
ness that is confined within the complicated design. Penalba's abstrac-
tion is not absolute. The form has a parallel in the exotic plant world,
and in the almost-human [389–391]. Out of a realm of luxuriant fertil-
ity spring tense but fluent forms with an outer as well as an inner
life. They are never really complete in a geometrical sense. They
seem, before reaching completion, to draw back, as if to avoid any
aggressivity and to redefine themselves, before ultimately returning
to and facing the light. Between two successive stages of a form
there is the connecting link, not of a form, but of a darkness and
a stillness. The sculpture of Penalba is a breathing in and out, a
splitting and reuniting of forms. It is a spatial rhythm not directly
attached to either human or plant representation, an autonomous
world of forms born of a single principle, that of rising vertically or
aslant from a primordial darkness and of absorbing the light. Com-
pletely sculptural, it is warm, moving, and controlled even in its
details. Penalba's works are sculptures that have grown, that are
finished, but that have not thereby lost their original drive and spirit.
Their force lies in the underivative and convincing quality of a form
that can be referred back only to the creative power of man and nature.

Umberto Mastroianni (born 1910) shows in his work a pattern of
organic design that is made possible by forms abstracted from the
human figure [394]. His sculpture can be seen as a body of abstract
organic forms that have been caught up in a turbulent rhythm or
as an extreme metamorphosis of a recognizable human datum. As
has been suggested, his mastery of irresistible motion and the disquiet-
ing Baroque quality of his work—a Baroque on the verge of the
chaotic—justify his being regarded as a descendant of Bernini. Mas-
troianni prefers to use bronze that is not given a patina; it is char-
acteristic that he chooses to leave the bronze as it was when it came
out of the consuming fire of the furnace.

353

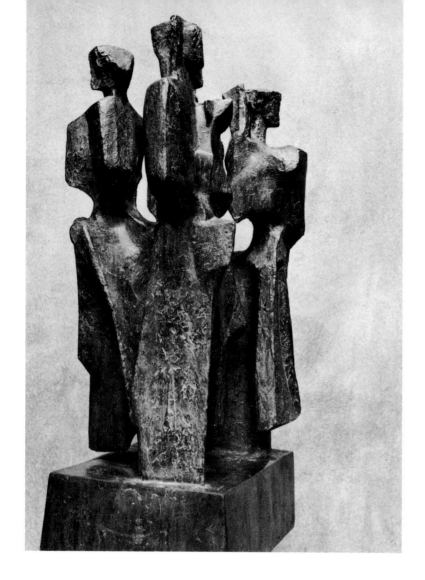

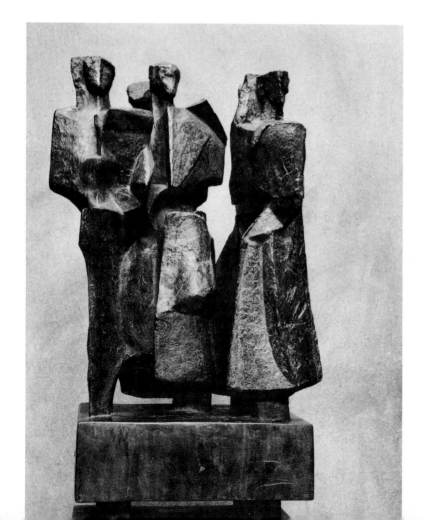

[399, 400] MARIO NEGRI. *Stele delle Amazzoni.* 1965. Bronze, height 69″. Collection Fumagalli, Sirtori, Italy. [401] MARIO NEGRI. *Colonna araldica.* 1961–62. Bronze, height 9′. Collection Bo Boustedt, Kungälv, Sweden

The Italians excel in working with bronze, and they achieve with it technical effects that go beyond attractive surface treatment. With such artists as Pietro Consagra (born 1920), Francesco Somaini (born 1926), Arnaldo Pomodoro (born 1926 [395]), and Gio Pomodoro (born 1930), we come to a domain of relief and related three-dimensional design that, through the possibilities of bronze, have given abstraction a powerful, rugged expressiveness. Somaini's work is volcanic, eruptive—fragments of a world that has just solidified [393]. Consagra creates compelling compositions with rough and polished surfaces or with half-burnt wood. In general, these artists are capable of releasing from the bronze or wood potentialities that are related to a primeval, Promethean feeling for fire and matter. This gives the work a certain ruggedness and directness; it is brought to birth by the scorching power of fire, of hot lava, of everything that is part of the earth's heat.

Aside from its use by Italian sculptors, bronze has assumed a different and more independent character through a renewal which is of technical as well as aesthetic interest. Shinkichi Tajiri (born 1923) has been more than merely inventive in this respect; his imagination has created objects that are a manneristic fusion of plant and artificial forms. Tajiri introduced the element of the precious and rare into sculpture, at first in smaller works that recall a dream world and later in larger bronze creations, which are sometimes simple but which are always organisms with an unexpected logic of their own [392]; his recent production shows the working of a masterly, controlled erotic-aggressive imagination.

The expressive abstraction of Etienne Hajdu (born 1907) has a craftsmanlike base that links him to the ancient Chinese workers in jade. His extremely refined little objects in marble and other materials (which predate those of the early Haber) and his large hammered-copper reliefs bear witness to this.

Not only in Italy and France but in America as well the professional approach to a renewed abstraction has always been related to Brancusi [112, 135–140, 143, 144, 147, 148] and the Cycladic figures [85, 111, 141, 142]. Among the younger sculptors James Rosati (born 1912), who works in New York, has produced not only exciting portrait heads but also abstract shapes in marble. He too clearly loves the slow work of carving marble until the form emerges.

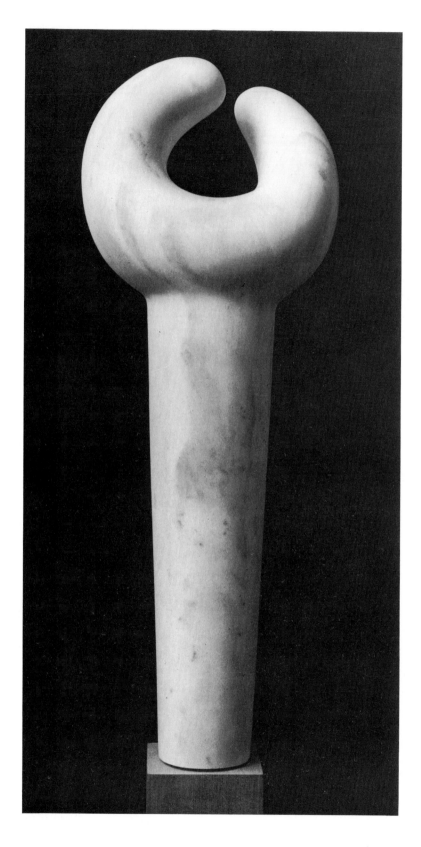

[402] ISAMU NOGUCHI. *Bird C (Mu)*. 1952–58. Greek marble, height 22 ¾". Museum of Modern Art, New York. [403] ISAMU NOGUCHI. *Orpheus*. Aluminum, height 6' 6". Cordier & Ekstrom, Inc., New York

With constantly increasing mastery, Isamu Noguchi (born 1904) has produced not so much a new abstraction of form as a symbolism that, though personal, is inconceivable without the philosophical and aesthetic foundation of Japanese calligraphy, a tradition hardly comprehensible in the West. Noguchi's works in marble or wood are spatial calligraphic signs [292, 403]. When he makes a circle, or a round hole in a marble disk [402], our Western minds relate it to the quiet forms of Brancusi and, with more conviction, to the masklike Cycladic heads. Actually his severe forms are not, when viewed in the historical context of the first half of the twentieth century, abstract: they have a secret significance (secret for us), an undefined presence felt as a fascinating silence emanating from them, a silence of the spirit welling up from a rare concentration. Noguchi is one of the few sculptors who, apparently through an Oriental capacity for concentration, can attain a radius of expansion capable of producing an invisible yet measurable integration of space. These works have no genuine nuclei; they are nuclei in themselves, not of a natural space losing itself in vagueness but of a transposed space bounded by perceptible, if invisible, lines.

Noguchi's work perhaps exemplifies most eloquently the height to which a twentieth-century abstract-symbolic sculpture can rise on the basis of the Eastern tradition of intuitive thinking and the Western tradition of formative action.

Return of the Figure?

The course of the development of sculpture since 1945 cannot possibly be summarized in the way that the sculpture of the first half of the century can be summarized. To find a way through the multiplicity of talents, I have stressed the links between various phenomena. Contrary to what might have been expected, the diversity manifest in the evolution of sculpture from 1910 to 1940 did not actually increase after 1945, despite the greater number of sculptors; the real increase was in the number of nuances. This is due to the fact that, though fortunately we are still a long way from the formation of schools, there is a greater tendency for artists to act as a group. It is not the historical and traditional but the reciprocal and simultaneous links that increase in importance; the heterogeneous element in sculpture is less in revolt against the unmistakably homogeneous.

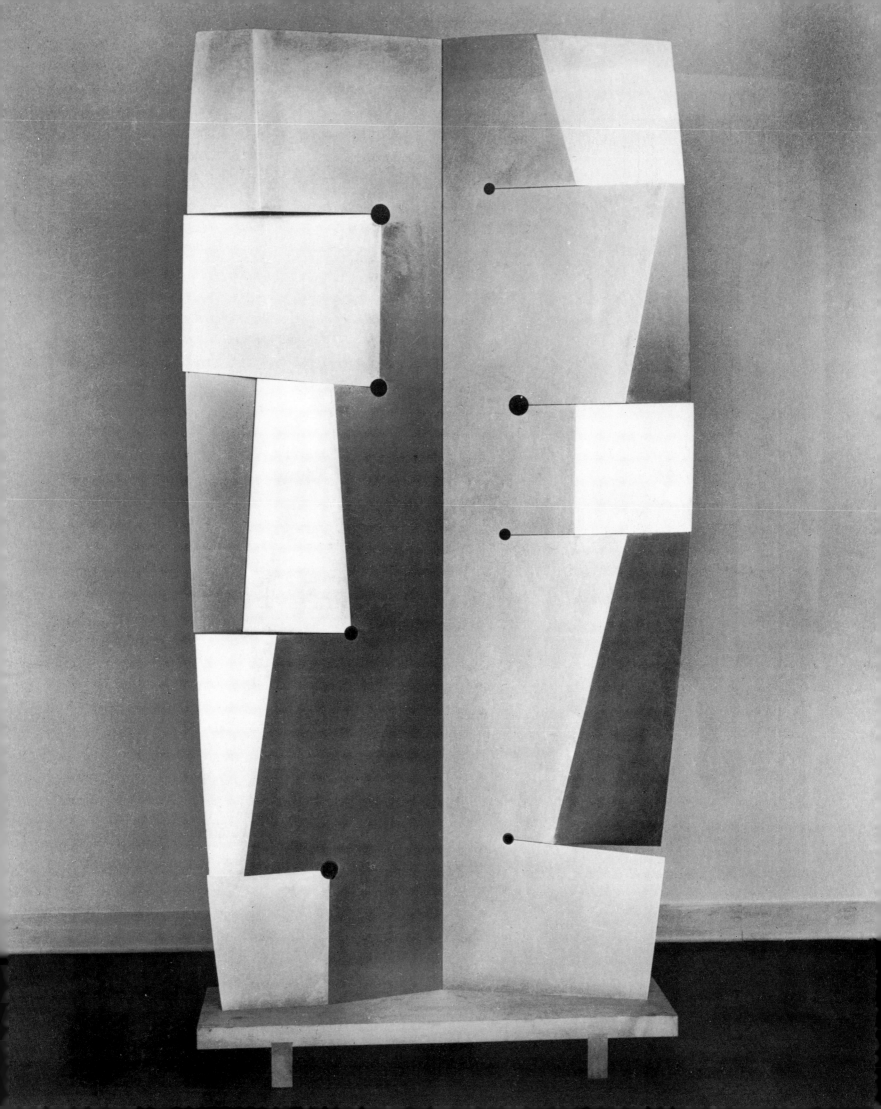

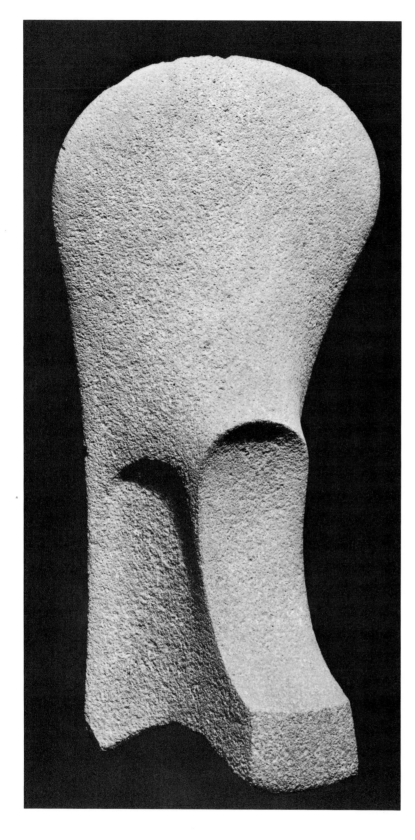

[404] *Palmate Stone,* from Mexico (east coast). Basaltic rock, height 14″. Philadelphia Museum of Art (Louise and Walter Arensberg Collection)

The horizontal links that exist in the contemporary sculptural milieu manifest themselves in the form of definite problems. These collective problems link personal styles concentrically but do not necessarily prevent individual sculptors from being involved in other circles than their own. Thus, it is possible, after Calder and Moholy-Nagy, for sculptors like Marta Pan to be concerned with the problem of absolute abstraction and, at the same time, with the problem of movement. Schöffer is preoccupied with both these problems and also with that of light. Dodeigne can be studied in connection with the problem of the new attitude toward matter and the new representation. The truth is that abstraction after 1945 did not, as its opponents in the figurative camp hoped, find an antipode of equal quality and power and that the occasional appearance of representation, hailed by critics as the beginning of a new trend, resulted simply from a reduction of conflict between abstraction and representation. Absolute abstraction has always been rare. What happened after 1945 was that the range of abstraction widened. This made for a number of nuances that undoubtedly re-established the relations of abstraction with the objective world.

It is interesting to examine some examples of outright representation. The work of Emilio Greco (born 1913), who lives in Rome, demonstrates what tradition can achieve with a single theme and a personal talent capable of complementing all the charm of modern woman with a Pompeian air [398]. Greco's manifest power lies in a bold mannerism that involves moderate deformation; his work is more Roman than Hellenistic. Giacomo Manzù (born 1908) has shown great virtuosity while adhering in certain aspects to a tradition, that of the early Renaissance. There is no doubt that his sometimes striking inventions, witness *The Seated Bishops* and *The Standing Naked Youths,* recall the work of certain nineteenth-century artists— Degas, for example. But Manzù is pre-eminently a man of his time; his work, though based on old rules, is distinctly personal. The issues that impelled Martini to join battle are no longer a problem for Manzù. He has made his decision and put aside the concerns that preoccupy others.

Mario Negri (born 1916), who turned to sculpture rather late, after a career as an architect, could not break loose from the human form. His work retains an animated, spiritual, centrifugal form that is in constant conflict with the monumental quality and the grandeur of style that he strives for. His little statue of a pregnant woman

[293] is great by virtue of the concentration on the noble, lonely form. At times his forms seem to have a kind of Hellenistic background (witness the figure that suggests the *Victory of Samothrace*), but Negri's work is simpler, more direct, and firmer. It displays power, sobriety, and sensitivity, and there is an element of new human dignity [399–401].

Finally, there is the remarkable figure of Reg Butler (born 1913). His famous and prize-winning design for the *Unknown Political Prisoner Monument* (1952) is a work—both abstract and figurative—in which abstraction appeared to determine the representation, and not vice versa. This can be explained not so much on the basis of principle as on the basis of the fact that the schematic indication of the shape was to be worked out in full scale (which has not yet happened). Butler's later works, however, which include the figure of a girl undressing, as well as figures in acrobatic motion [397], show clearly that the human shape, with its structure and attitudes, is his starting point. This is the core that Butler's relative abstraction grows out of, never departing from it significantly. Hence his towers [396], which appear to be very abstract, are really not very different from his figures. Indeed they offer no essential contrast to the figures.

Butler, who as a theoretician is cognizant of all the problems of contemporary sculpture, is representative of many sculptors of the 1950's and 1960's for whom abstraction and representation, instead of being polarities, are concurrent possibilities of style that often seek, if unsuccessfully, a solution in the domain of sensory reality. It should be noted that Butler revived the tradition of iron, and then of bronze, in England.

Such variants of abstraction as these have made the realm of abstract experiences more concrete. At the same time materials (stone, wood, bronze, etc.) have had an influence on abstraction and have given rise to an increasing number of sensory and psychical experiences. Running counter to the abstract mentality, these experiences have been a source of conflict, and this has usually resulted either in the artist's losing himself once more in the unconvincing object and the figure or in his accepting the conflict and thereby renewing and enriching his abstract vision with the vital psychic values in which his sensory knowledge of the material is concentrated.

The examples cited illustrate a transformation of matter into forms that are more realistic than the pure abstractions of the first half of the century and, at the same time, are submissive to the sculptor's psychic world. Formerly (and we need only think of the once highly honored portrait art of Charles Despiau), this inward world could make itself known only through what could be objectively perceived or through the subjective interpretation of things or people; it has now been freed from objective reality without becoming fixed in the individual's subjective particularity. It is clear: the unconvincing-object situation tends toward new orientations, away from expressionistic distortions. Averse to subjective exteriorization, the "new Byzantines," striving for a more impersonal awareness of "presence," are in search of a new object-relation.

Often the abstract geometric formula was not effective or concrete enough: in too many cases it led to figuration disguised as abstraction; it provided academic pseudo solutions in sculpture, which unfortunately are plentiful. This has proved to be the sole blind alley. The danger that sculpture may become ensnared in principles that, in and of themselves, are strong and sound has decreased in recent years, now that a number of younger men (especially in England and America, with repercussions on the Continent) are actively testing color and form simultaneously with respect to their spatial potentialities, freeing themselves from previous axioms and taboos. They are now passing beyond the frontiers that exploration up to about 1960 had established.

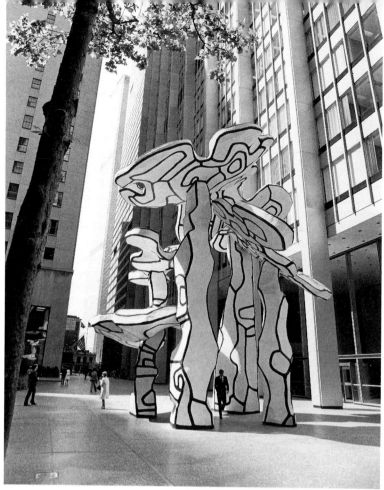

[405]

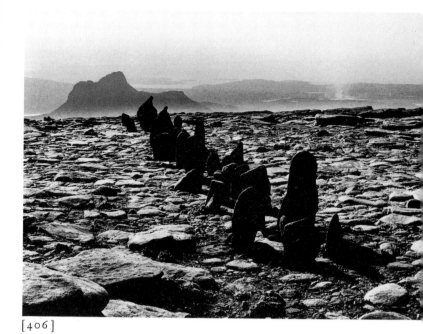

[406]

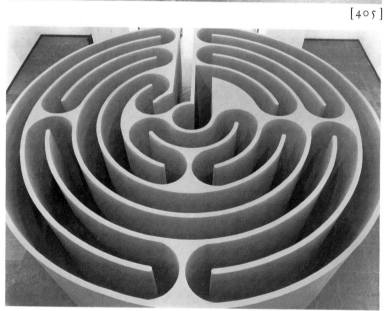

[407]

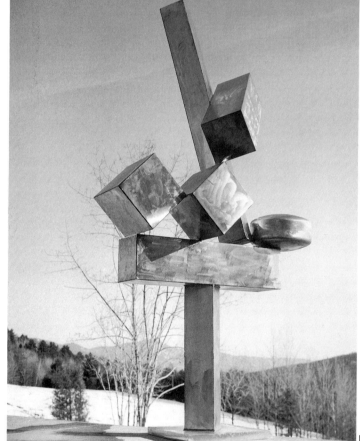

[408]

11

Space Exploded—Spaces Explored: Trails since 1960

Did sculpture around 1960 mark a turning point, a revolution? It was more like a fresh point of departure toward several areas of spatial consciousness. Pioneers made themselves known and they became aware of industrial areas, deserted sites, and undeveloped and wild landscapes; they redefined gardens, parks, squares, and neighborhoods, where until recently only property ownership, urbanization, and the economy had rules, and where the artist remained an alien. The period image for 1960 to the present is not harmonious in its totality, but it is characteristic in that continuity and discontinuity make themselves felt simultaneously. The homogeneous and heterogeneous no longer exclude each other.

I have attempted to stress a number of trends without according too much weight to schools and groups. The young artists of the pre-1960 period, now more mature, have a right to show the continuity of their

[405] JEAN DUBUFFET. *Group of Four Trees*. 1974. Epoxy paint on polyurethane over metal structure, 38 × 40 × 34'. Chase Manhattan Plaza, New York City. [406] RICHARD LONG. *A Line in Scotland*. 1981. Framed work, photography and text, 34½ × 49". Private collection, London. [407] ROBERT MORRIS. *Labyrinth*. 1974. Painted masonite, plywood, and two-by-fours, 96 × 360" (diam). Institute of Contemporary Art, University of Pennsylvania, Philadelphia.
[408] DAVID SMITH. *Cubi XIX*. 1964. Stainless steel, height 113⅛". Tate Gallery, London

work, but not as a category. Where appropriate, I have dealt with authentic contributions to sculpture in relation to others or on their own. This was the case with Picasso. It is well known that, although Picasso had no reservations about disclosing his work as a painter at exhibitions, he was, for reasons we can merely guess at, reluctant to show his sculpture. It was therefore impossible to study his work in its continuity and discontinuity, and only those with regular access to his studios could be up to date. In the art trade, even Kahnweiler showed just a few of Picasso's sculptures. Only now, with the aid of the catalogue raisonné of 664 pieces, written by Werner Spies (in association with Christine Piot),[71] can one gain a reliable impression of Picasso's contribution to twentieth-century sculpture. It was a noncontinuous output, in which semitraditional pieces alternated with audacious and inventive experiments. Although it remained largely experimental, Picasso's work as a whole compels us to reconsider briefly the evolution of twentieth-century sculpture.

An unmistakable urge to create sculpture manifested itself in Europe and America after 1960, but painters showed only a fluctuating interest in sculpture. The problem of color and sculpture was a separate issue. The crucial factor was, in the past and now, whether a painter can genuinely make the transition from painting to three-dimensional sculpture. The fundamental question remains: is there any blurring of the line dividing the traditional disciplines of sculpture and painting? Is what the Futurists around 1909 were predicting now

happening—that is, a departure from the classic limits of materials with their relevant techniques and an expansion in which all is permitted?

Sculpture has without a doubt witnessed the slow and far from easy weakening of its age-old underlying principles, though not their complete disappearance. Interpretations shifted and sought fresh standards. We are left with the question in the minds of us all, artists as well as spectators: where is the collective sense of direction that is shown in the broadening spatial perceptions in artists' works? Aesthetic style analyses of works of art are no longer adequate to give us some insight into these problems. It is necessary to include a hasty, perhaps too hasty, review of the recent past, a course in time and space that sculptors, guided by intuition and responding to subconscious workings, have marked out with their signs, that is, their works.

In a sense, Rodin completed such a course in the last century. The terrain was France, the French countryside, and the signs were the cathedrals that he studied with great affection. He called himself "un chemineau de France" (a tramp of France) and referred to the sky as the principal landscape. He took a close-up sculptor's view of the cathedrals and liked particularly the "moulures" (moldings) chiseled in stone, which he drew on small sheets of paper. Space to Rodin did not mean empty geometric space but breathing nature. It was a geographic and natural space, the rhythm of which was determined by geometry as by an invisible source. The poet Rilke, who acted as Rodin's secretary for six months in 1905, was in a position to observe the artist and his works. He never wrote that Rodin's sculptures dealt with space, but did mention "die Luft" (the air), which Rodin "wanted to draw as close to the surface of his objects as possible." By means of air, Rodin drew space into stone or marble, thus, as it were, absorbing it. From Carpeaux to Rodin, the image was one of volume that attracts and confines light and air, along with the characteristics of the psychologic drama of man.

It was not until after 1906, after Rosso had made an initial attempt, that some pioneers in Italy and France were engaged in releasing volume from its former absolute closure and rendering its surface more sensitive to light, as a result of which the limits of form and anatomy became looser. Structure, constructions, and relationships of forms consequently changed. The way was open to a concept of space in which figuration became of secondary importance and came close to disappearing.

Cubism, Futurism, and Constructivism did not stand a chance with sculpture in public places. Fortuitously, avant-garde authorities were alone in admitting occasionally new sculptors to world exhibitions and related shows, thereby providing some opportunities for them.

The time came when the Futurists opened their attack. Boccioni alone signed the manifesto concerning sculpture (1912). Literally, but above all conceptually, disciplines were shifted from the static to the dynamic and sculpture from closed and often isolated to open forms.

Boccioni's life ended too soon for him to put into effect all that he had evoked, yet a few examples of his work were convincing enough for the new force of this revolutionary spirit to be recognized. He forced sculpture open and allowed space within and without to mingle.

In France, the Futurists met with criticism and suspicion and only Marcel Duchamp and his talented younger brother, the sculptor Duchamp-Villon, were receptive to the Italian passion and reacted positively. The objections that the Futurists and French Cubists had to one another (including foreign artists settled in Paris—Lipchitz, Brancusi, Zadkine, Gonzalez, Picasso) did not arise from a starting point, i.e., the need for a thorough reappraisal of ancient principles, which, by the end of the nineteenth century, had had their day. The will to change the principles was tested with discussions among the artists; words shared in the works' genesis.

In Russia, developments were different from those in Western Europe. Contacts with Paris, Munich, and Milan did not alter the circumstances in which modernism manifested itself in Moscow and St. Petersburg. The historic background was totally different: in socio-political respects there was an isolated fermenting society in Russia that saw its revolution, as though erupting from a crater, destroy the *ancien régime*. Pioneers from the world of art fought for their ideas with manifestos and in exhausting discussions with the new leaders. Some of the strongest personalities emigrated to Western Europe: Pevsner and Gabo defined principles in manifestos; Kandinsky became fundamentally contemplative.

Outside Italy, verbal aggressiveness was moderate. In Britain, Blast, a group of artists including Wyndham Lewis, Gaudier-Brzeska, Epstein, and Pound, was theoretically worthwhile, but there was little radiation from it. Paris was the place where principles were steadily being put into controlled practice. The relationship between volume and space changed: the significance of structures and constructions increased as the anatomy of the human body declined in value. Irrational piercings of three-dimensional figures (Lipchitz among others) were seen. Linear constructions became important, liberating volume from its closure and thus introducing openness as transparency. Experiments by Lipchitz and then by Gonzalez, who initially helped Picasso with the technical aspects of his work, were of paramount importance between 1920 and 1930. Following a different course, Gabo and Pevsner developed techniques that made sculpture as a mass appear lighter, more transparent, and purely abstract.

There was a conflict between sculpture that retained the figurative element (albeit strongly reduced) in the presentation of reality (Brancusi) and sculpture that demanded total abstraction (Vantongerloo).

Closer, however, to absolute abstraction than Van Doesburg in the early years of the Dutch de Stijl movement, Vantongerloo did not have any noticeable influence at the time. Sculpture was passing through a difficult phase.

At the risk of occasionally repeating something from my original text, I believe it is desirable, precisely at this juncture, to reconsider the position of Brancusi, who has now reached the zone of a myth. Of all the artists to present themselves as explorers of the problems of sculpture and space, Brancusi is, and has been since his early days in Paris, the only one whose authority is still invoked. A sense of modernity came from his studio, diverse aspects and interpretations of sculpture. Brancusi's isolation in Paris was relative. A widening artistic circle of admirers, selected by himself, formed at an early date, with Modigliani foremost among them. Epstein, Nadelman, and Noguchi visited him. Later on, in the 1920s and early thirties, several of the younger British artists—Moore, Hepworth, Nicholson—came to his studio.

Considered objectively, Brancusi was never purely abstract, nor was he a supporter of the Cubists and Futurists. He hardly ever felt inclined to pierce volume, and he remained faithful to the age-old tradition of working in stone, wood, and bronze. Noguchi wrote that Brancusi had quite deliberately mentioned how deeply he felt bound to something recognizable in nature and how he lacked the freedom that the younger generation had in this matter. Wherein did the magical appeal of the man and his work really lie? It was inherent in the unity of his powerful and independent existence, physically, psychically, and spiritually always his own, in an artistically seductive Paris. Part of this was his devotion, unremitting until the end, to "le lieu"—his studio and his home. With a rigorous concentration, he reviewed the awakening of a new spatial sensibility. His limits were clear. By stylizing contours and simplifying stereometric form, which still retained a suspicion of figuration, volume acquired a smooth surface. The piece might be polished to such an extent that it could ally itself with the light beyond it, so that a distorted image of the environment, and not the environment as in a normal mirror, formed part of the sculpture. Brancusi realized that this would give rise to problems with the pedestal. With a minimum number of motifs, his sculpture developed into a spatial lyric that still evokes the sublime and universal in people's consciousness.

After Rodin, this was the birth of a *sense of place*, which developed into a *sense of space*. This phase continued for a remarkably long time. As a concept, the sense of space was given a boost by the vehement American spatial sensations and by the knowledge of the younger

[409] EDUARDO PAOLOZZI. *Thunder and Lightning, Flies and Jack Kennedy.* 1971–75. Wood, aluminum, and oil on canvas, 24 × 24′. Palazzo Reale, Milan

artists, who, for a while, experienced deserts, chasms, and high mountain ranges. Brancusi was mentioned rarely in their writings. He is present, nevertheless, in their own codifications, definitions, interpretations; there is a definite continuity in these spatial explorations since the beginning of the twentieth century—not always a conscious,

logical bond, but a silent, and sometimes audible, rapport between successive events.

Before taking a closer look at some of the personalities from the American laboratories of spatial art around 1960, we shall encounter a small number of link figures, not precursors but artists drawing on the two sources, America and Europe. The post-1945 generation of British artists, already dealt with earlier, needs reappraisal. More familiar with work produced after 1960, we now view artists such as Chadwick, Armitage, Butler, and Paolozzi differently from the way they appeared when their fresh and free contributions swept us along into a lighter, more playful, zone for sculpture than the one dominated by the great period of Moore's monumental, organic, and reduced figuration and Hepworth's pure, lyrical, and serene abstraction. There was an undeniable ambivalence: semiabstractions linked with figurative elements. Structures permitting openness as well as closure, and a reduction of volume, became the language for what we now tend to regard as an intermezzo. That those generations wished to rid themselves of Moore's limits was not a revolution, nor Dada, but a less doctrinaire, delightful, free, new playground, open to humor and inventions.

Besides this British intermezzo, other liberties, capable, in principle, of later germination, were seen on the Continent and with hindsight contained more dynamite than was suspected at the time. I am thinking of Jean Tinguely and Takis (born 1925). Tinguely had the courage to mention three impulses that started him on his way: Calder, Dada, and Surrealism. The Anglo-Italian Eduardo Paolozzi [409], with his Surrealist curiosity, left the British mainstream early on. Unencumbered by tradition, Tinguely and Takis started a trend that was to gather momentum. The fixed codes disintegrated. We see the art of sculpture stepping outside itself. The sacrosanct disciplines of art criticism and art history lost some of their authority. Artists, deeply rooted in their need for word consciousness, started to write about their own orientation, especially after 1960. In Britain, discussions about art were revived in the volumes of *Studio International*, published in the 1960s and seventies. A medley of artists and art critics took part in the debates, in which many an artist, less inhibited by the need for art historical exhaustiveness, made his mark.

The writings of artists of the 1960s in America seem systematic, more laborious, and deeply searching. In Holland, the writers led by Van Doesburg, who contributed to the Dutch periodical *De Stijl* during World War I, with Mondrian and his dialectic leanings as a center, were a prelude. Apart from the contributions by Van Doesburg, who was open to other influences, many dialogues possessed that remark-

[410] DANIEL BUREN. *The Two Plateaus.* 1,000-square-foot sculpture for the Cour d'Honneur of the Palais Royal, Paris. 1985–86. Black marble, granite, iron, cement, electricity, and water

able undercurrent of inner monologues noticeable so often in the case of some American Minimalists and Conceptualists. They wrote for themselves, as did Mondrian. Of the writers of the 1960s I value above all Daniel Buren as a Marginalist, whose scepticism, criticism, and irony were rooted in his French intelligence [410–413]. Unfortunately, the epigones continue to write in a boring fashion.

Twice around 1960, art critics, rather than artists, wrote of approaching changes in Europe. The first to do so was Pierre Restany, who still kept to the style of manifestos and expositions when he announced a new orientation, entitled Les Nouveaux Réalistes, in Milan (1960) and in Paris (1961). It was a provisional grouping, a rallying call proving that ancient Europe was still capable of making militant efforts on behalf of a spirit that was not only aesthetic but also sociological. He disposed critically of earlier and more recent movements, of the Zero group, and of numerous "isms" in order to advocate the autonomous aspect of new expressions. His pugnacious analyses give an emotional account of his crusade.[72]

New York replied soon in 1962, when the active art dealer and protagonist Sidney Janis merged Europe's Nouveaux Réalistes with Americans, including Pop artists, in an exposition introduced by Restany. In 1961, Restany had exhibited Klein, Tinguely, Arman, César, Niki de Saint Phalle, and several others in Gallery J, and this gallery provided an introduction to Neo-Dada Americans. A second grouping was made by Germano Celant in 1969 (Tübingen-Milan), entitled Ars Povera. Celant argued about his selections and reflections, and documented them with artists' writings and illustrations that seemed incoherent initially, but, when compared with Les Nouveaux Réalistes, turned out to be more to the point and were clearly concerned with three-dimensional spatial experiments. There were also considerably more Americans in this presentation—Eva Hesse, Walter de Maria, Robert Smithson, Robert Barry, Dennis Oppenheim, Joseph Kosuth, Egon Weiner, Carl Andre [414, 415], Robert Morris, Richard Serra, Michael Heizer, the Dutchman Dibbets, and others. A brief comparison with Michel Tapié's *Un Art autre* (1952)[73] is interesting, when he presented l'Informel: Wols, Jean Fautrier, Mark Tobey, the early Jean Dubuffet, Henri Michaux, Pierre Soulages, Gianni Dova, also Vincent Arnall, Graham Sutherland, Brauner, Giuseppe Capogrossi, Georges Mathieu, Germaine Richier, and paintings by Marino Marini, and others. Pollock was almost the sole

367

[411] DANIEL BUREN. *Photo Souvenir Untitled Paris.* 1968.
[412] Katsura Palace. Interior. 17th century. Kyoto, Japan.
[413] Katsura Palace. Stone Walkway. 17th century. Kyoto, Japan.

American whom Tapié regarded, quite rightly, as "de tout première ordre" (of the very first order). Tapié felt early that America had become a "carrefour géographique réel" (a true geographic crossroad).

These loose groupings, according to art critical verbalism in Europe, should not detract from the actual work of sculptors in the 1960s. Link figures such as David Smith (1906–65) absorbed what was going on both in America and in Europe to such an extent that there was no question of separatism. He became a full-time student of painting in 1927 and

studied sculpture from 1931 to 1933, creating his first works in welded steel and then introducing painted steel in 1933. Through his work as a painter and sculptor, he raised the old problem of painted sculpture. In his view, there was no problem. "My sculpture grew from painting and my analogy and reference is with color." "I have been painting sculpture all my life."

How did Smith's first trip to Paris affect him? A painter called Graham introduced him to the circles where important developments in painting

and sculpture were taking place. The wire figures of Gonzalez and Picasso—for which Gonzalez had given Picasso technical assistance—were a revelation to him. Smith felt as though the days of his apprenticeship as a craftsman in the Studebaker Plant in South Bend, Indiana, had returned. There, in the car assembly works, he had been given a thorough grounding in welding techniques and now, stimulated by Picasso and Gonzalez, he could use them to great artistic effect. Neither a theoretician nor a dogmatist, Smith was responsive to Cubism and Surrealism, and had an eye for Giacometti. His work derived its quality from his interest in other people, from his sense of landscape, and above all from his concentration, which enabled him to assimilate much. He withdrew to a remote corner of the American countryside, partly for financial reasons, and this isolation bore rich fruit. After his death, his work became a source of inspiration to others. As Anthony Caro testified, "More radically and constantly than any sculptor before him, Smith opened sculptural form to the space it occupied"[74] [416, 417].

Seemingly attracted as by a magnet to what subsequently proved to be a genuine and vital kind of activity in America, Caro left Britain in 1959 to study American abstraction. When Caro was working as a part-time assistant to Moore, he did not find any disapproval of abstraction, although Moore found his strength in organic semiabstract, semifigurative conceptions. Nicholson, Hepworth, and others, including painters, had adopted a severe, pure line, recognized by eminent critics, such as Herbert Read, Adrian Stokes, and Joseph Paul Hodin. And Mondrian's and Gabo's stay in Britain in the years leading up to 1940 had a considerable effect.

Uncontrollable individual elements occasionally play a considerable part in chance meetings and this was the case in the historic confrontation between David Smith, Clement Greenberg, and Caro. In the 1950s, when Greenberg had an open mind about sculpture, he thought that although David Smith was a pictorial sculptor he was "the best sculptor of his generation." But Greenberg also had misconceptions of Smith's

371

[418] ANTHONY CARO. *Floor Piece C38*. 1975–76. Steel rusted and varnished, 28 × 58 × 36″. Collection Paul Caro. Anthony Caro Studios, London. [419] ANTHONY CARO. *After Emma*. 1977–82. Steel rusted, blacked, and painted, 96 × 108 × 74″. Anthony Caro Studios, London

[420] ISAMU NOGUCHI. *Momo Taro.* 1977. Granite, 9″ × 35½″ × 22′ 8″. Storm King Art Center, Mountainville, New York

[420] ISAMU NOGUCHI. *Momo Taro.* 1977. Granite, 9″ × 35½″ × 22′ 8″. Storm King Art Center, Mountainville, New York

work.[75] Caro's meetings with Greenberg were stimulating, but those with Smith were even more so. As we have seen, the dialogue about painting and sculpture (color and form) did not constitute a problem to Smith. To others, however, such an attitude was unacceptable. Smith provided the stimulus that induced Caro to incorporate color in his sculpture, although he did not become a pictorial sculptor in Greenberg's sense of the word.

Greenberg rejected the British group consisting of Chadwick, Butler, Paolozzi, Armitage, Turnbull, and others almost en bloc, but Caro was not among his targets. The distance between the British group and the Americans was certainly important, and Caro drew attention to himself by resolutely entering several American camps. He did not imitate Smith, a verticalist, whereas Caro was more of a horizontalist at the time. He was not against landscape,[76] but could envisage his work placed anywhere, "except that I prefer to think of my sculpture indoors." This statement indirectly indicates the distance between Caro's evolution and that of the Americans after Smith's death. The environment as an element remained outside Caro's abstraction and this partly determined the beautifully self-contained character of his compositions, masterpieces of balance and proportions. Consequently, the opening up of his sculptures was less, as was the case with many of his contemporaries, an invitation with passages and tunnels to an undefined space. Caro's interpretation of Smith as one who "opened sculptural form to the space *it occupied*" is almost a self-projection. Caro's compositions in steel and bronze are, to employ an apparent contradiction, an open closure, transparent or combined with parts that are almost volume [418, 419].

Because of his association with modern techniques, particularly welding, it was easier for Smith to appeal to young artists than it was for Isamu Noguchi (born 1905), who did not rule out any of the materials or techniques that a sculptor might employ, but who still felt closest to "the awareness of an inner reality" in the ancient world of stones [420]. Noguchi touched on fundamentals in his experiments, but they never led him to adhere to any dogmas. On the contrary, they opened up wide prospects enabling him to delve deeply into history and to probe the myriads of possibilities in space. Unlike many of the younger sculptors, he does not seem to be the kind of artist who instantly links his conception and perception with sites. Craftsmanship, as he saw it in 1928 when he was with Brancusi, was a legacy of the old world in the service of new intentions regarding form; "perception of space," sculpture's main

problem and "the continuum of our existence," extended it with modern technical needs.[77] In contrast to nineteenth-century undefined space, Noguchi in the twentieth century thinks that "movement, light and time itself are qualities of space." The sculptor "animates space, gives it meaning," but, at the same time, the artist is "the channel through which ghosts, visions, portents, the twinkling of bells" enter.[78] Smith restricted his travels and the places where he worked to Europe and America; Noguchi spread his wings wider, across the whole world, never forgetting his partly Japanese origin. He received many commissions for geographic spaces, including parks, gardens, and vacant land. Smith's sculpture is permeated with an American dynamism; in Noguchi's works I find a different kind of dynamism: precision but no geometric purity; they are like an interrupted succession of hushed sounds, and have the stillness of simple forms born of a contact with what is potentially present in stone, marble, and wood. Noguchi uses a variety of materials and techniques serving a changing vision and linked in an indefinable harmony. There are signs, rising from the earth as their base, that refer to what Noguchi calls a "world consciousness." As far as I know, he has not yet acquired the same kind of magnetic appeal for young artists as Smith possesses. He kept his distance, which created further distance. Now his garden gallery is situated in an isolated spot near New York City, away from built-up areas, in a "terrain sauvage." It should remain so. Precisely in that environment, his museum-garden may exert the magnetic force resulting from order and spatial inspiration.

Jean Dubuffet (1901–83) and Lucio Fontana (1899–1968) belonged to the same generation as David Smith and Noguchi. Amid changing concepts in a changed climate, these four remarkable artists played a vital part until far into the second half of the century, each working on a distinctive aspect of space. Dubuffet was past forty when he decided to pursue his passion for painting. His interest in music, literature, and philosophy, and an unsatisfying spell in industrial design at Buenos Aires, had been interrupted by a commercial period in the wine trade. "The desire to construct habitable sites—or more precisely *mental interpretations of sites realized in three dimensions* and on the scale of real sites evoked in such a way as to render the interpretations habitable," began in 1962, starting with the *Streets of Paris* in the Coreus Cycle—gouaches

and paintings that were evocations of the streets of Paris.[79] These "painted sculptures" he preferred to describe more correctly as "dessins s'élançant et s'expansant dans l'espace" (designs soaring into and expanding in space). Dubuffet knew the limits of passing from painted canvas via cut-out contours to constructions, from "illusion virtuel" to "matériel effectif" (real material). This distinguished him favorably from a number of renowned artists, who wanted to create sculpture without paying tribute to the problems of a different discipline (De Kooning, Horst Antes, and Georg Baselitz [421, 422]). To put it briefly, Dubuffet combined three elements: Art Brut (1947)—collecting anonymous objects created outside the order of society and disciplines of art; graffiti; and the street. Such elements were arguments against a kind of art and society that failed to use special forces, ignored or rejected them. These were sources of inspiration for his own kind of art, which gradually passed from painting to open space but never severed the umbilical cord attached to his pictorial source. He literally went "into the streets" where he wished to see his artificial trees amid the gigantic skyscrapers of New York City [423]. Following a commission from the Chase Manhattan Bank, he confronted society with the fruits of his creative and combative life. In *Le Jardin d'Email*, his creation at Otterlo (1973–74), Dubuffet succeeded, against the nature of the landscape, in constructing a second, mental kind of nature set within the first one—a strange way of evoking an odd, unstable sense of space. The slightly undulating floor, to which the visitor has access from a narrow staircase just wide enough for one person, has the soft, cool, light color that conjures up an association with moonlight.[80]

His work reached a culminating point at Périgny-sur-Yerres—creations of perfect Dubuffet spaces: *La Closerie Falbala* [424]. The open space is enclosed, as at Otterlo (the old idea of the Refuge of Paradise). Open and closed are spatially complementary to one another: the two aspects of Dubuffet's struggle to subdue the powers of the chaotic. The walls of the closed *Villa Falbala*, and the floor of the enclosed, open black and white space, are no more than a thin veneer underneath which there is the threat of a volcanic Noah's Ark housing people, animals, and monstrous creatures making life uncertain. A storm of forms, colors, and contours arose in his mind, random phantoms not limited by surface-line-color in painting. Order never was more than an armistice; dream and imagination became the guarantee. It is a delusive refuge, with silence and light that do not soothe but evoke fear.

Shortly after Dubuffet's death, the French started work on something that had been neglected far too long, i.e., the construction of his design, begun in 1968, for *La Tour aux Figures*, which is to be erected near the Seine River and will be visible from the Boulevard Périphérique. It is an

extremely baroque example of monolithic sculpture, which is meant to be its own closed architecture and also habitable with restrictions and no furniture. The problem has obsessed sculptors—André Bloc, Etienne Martin, Fritz Wotruba, Pietro Consagra, Dubuffet, Niki de Saint Phalle —for about half a century; conversely, architects have been tempted to create sculpture (Frank Lloyd Wright, Le Corbusier).

In Dubuffet, Europe before 1960 had an artist-painter-sculptor who neither argued nor felt the need to reach a group with manifestos. He was nonetheless a writer who described what he intended to do factually and from a cultural-critical point of view. He felt a greater affinity to Futurism than to Cubism, and he came close to a Dadaist delight in adventurous experiments that had technical risks near or beyond the limits of what could be realized.

To do justice to Europe, the Argentinian-born, Italian Lucio Fontana should be mentioned here. Even before the American fascination with deserts erupted, Fontana, with his warm Italian lyricism, felt called upon to awaken younger generations to an expanding space consciousness. In his work, he was aesthetic in an Italian way, although he perceived that there were complex scientific and sociologic driving forces in life. While Fontana was in Buenos Aires during World War II, a younger generation heard his response to that challenging development. He began his series of initiatives in spatial consciousness on his return to Italy in 1946, and from 1950 onward he called himself the "iniziatore e fondatore del Movimento Spaziale del mondo" (initiator and founder of the world Space Movement). He scattered his ideas about profusely, too profusely, in short discourses and manifestos, with many fine distinctions: "movimento spaziale, concetti spaziali, arte spaziale, era spaziale." The concept "scultura" did not vanish altogether, but it was ousted in his vocabulary by "spazio": "Gli spaziali vanno al di là di questa idea" (the spatials go beyond this idea). He evoked the unconscious and also "l'uomo della strada" (the man in the street) as the possible bearer of a new conception of life (1951) (see Dubuffet's activities in 1947 with Art Brut, page 379).

Fontana's inventions had two aspects: first, "ambiente spaziale," closed environments where darkness or light (neon tubes) evoked physical reactions; and, second, rhythmic piercings that profaned the inviolable surface of paintings and constituted a destruction limited only by an almost elegant stylization. His aesthetics put a distance between his concepts and the American spatial experiments, and his efforts were little recognized.

Joseph Beuys (1921–86) appeared on the scene in Europe after Fontana. His talent for sculpture and drawing formed part of an ideology with which, in writing but above all in the spoken word, he exhorted his listeners to reject the prevailing foundations of society, including art. A rethinking of culture occupied him and found expression in his work. He activated the consciousness of many young people. Extending even to his behavior—his clothes, his inseparable hat, his laugh, his pleasant and persuasive voice—his image conveyed a socio-political, though non-party, idea. Unattached to any *métier* in the sense accepted both in and outside the academies, he sought "the hidden forces," "the waiting forces which can save the world." He thus offered a challenge in his sculpture [425] by experimenting with unconventional materials (clay, butter, felt). He even went so far as to proclaim that every human being was a potential artist, but this contestable view was corrected by his drawings. They proved that his complex make-up contained a rich supply of sentiments. America did not respond greatly to Beuys, as was apparent at the magnificent retrospective exhibition organized by the Guggenheim Museum of New York as a tribute to the sculptor. Yet he was not remote from the activities of the 1960s in America, but his somber, catastrophic background was rooted in Europe.

The generations born mostly in the 1930s and starting work around 1960 scarcely mention the names of artists such as Fontana, although they are otherwise well informed; this does not mean that the principle, dating back to Boccioni, of opening up the old spatial limits failed to radiate. Sculptors of the 1960s in Europe, and above all in America, are all neighbors, who neither see nor consult one another, belong to more than one generation, and carry different equipment, but are all on their way to the same adventures. The terminology that appeared included a multitude of labels: Minimalists, Conceptualists, A-B-C-Sculptures, Structuralists, Abstract Expressionists, Abstract Geometric Art, Land Art, Earthworks, Ars Povera, and Kinetic Art. Such an abundance of parochialism neither was, nor is, helpful to anyone interested in the main problems in a wider context.

If we confine ourselves to a few main features, we find that these are still so varied and complex that we can merely propose approximation of the underlying connections. I give such a limited approach, without investigating who was the first—not necessarily the best—artist to apply certain techniques or to show a preference for deserts, for geographic spaces, or for certain fashionable materials such as Cor-Ten steel.

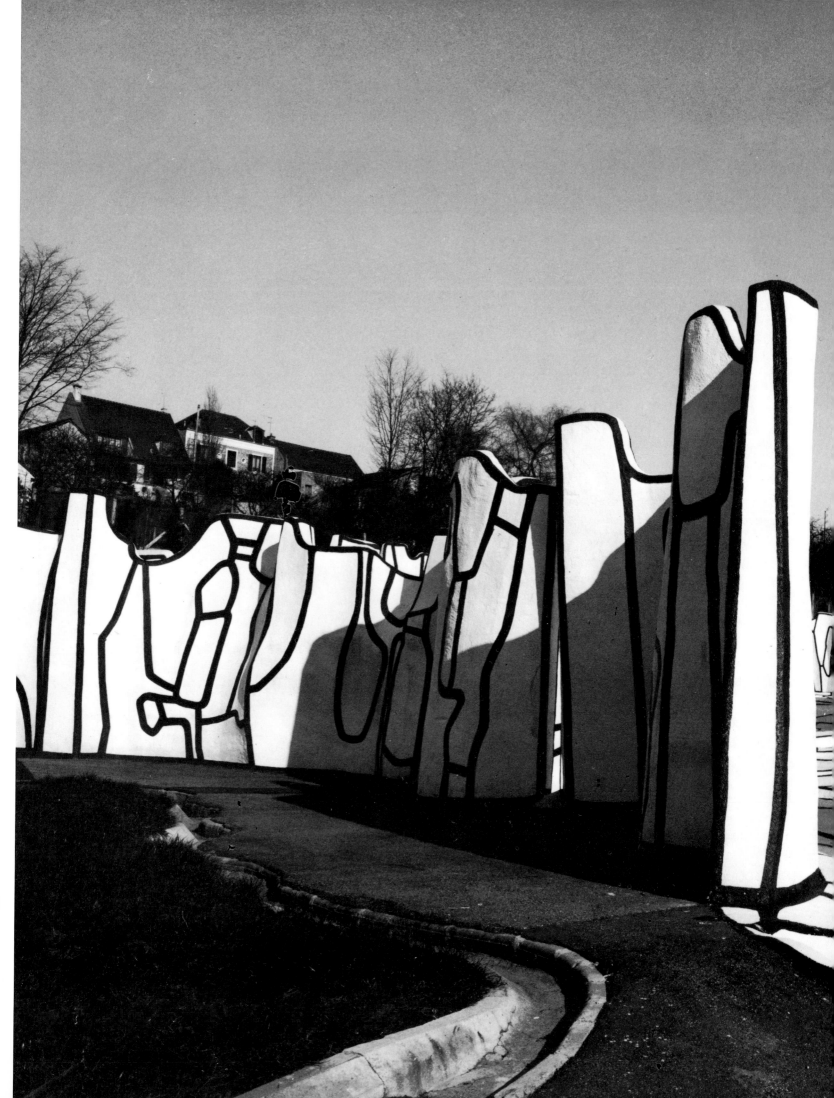

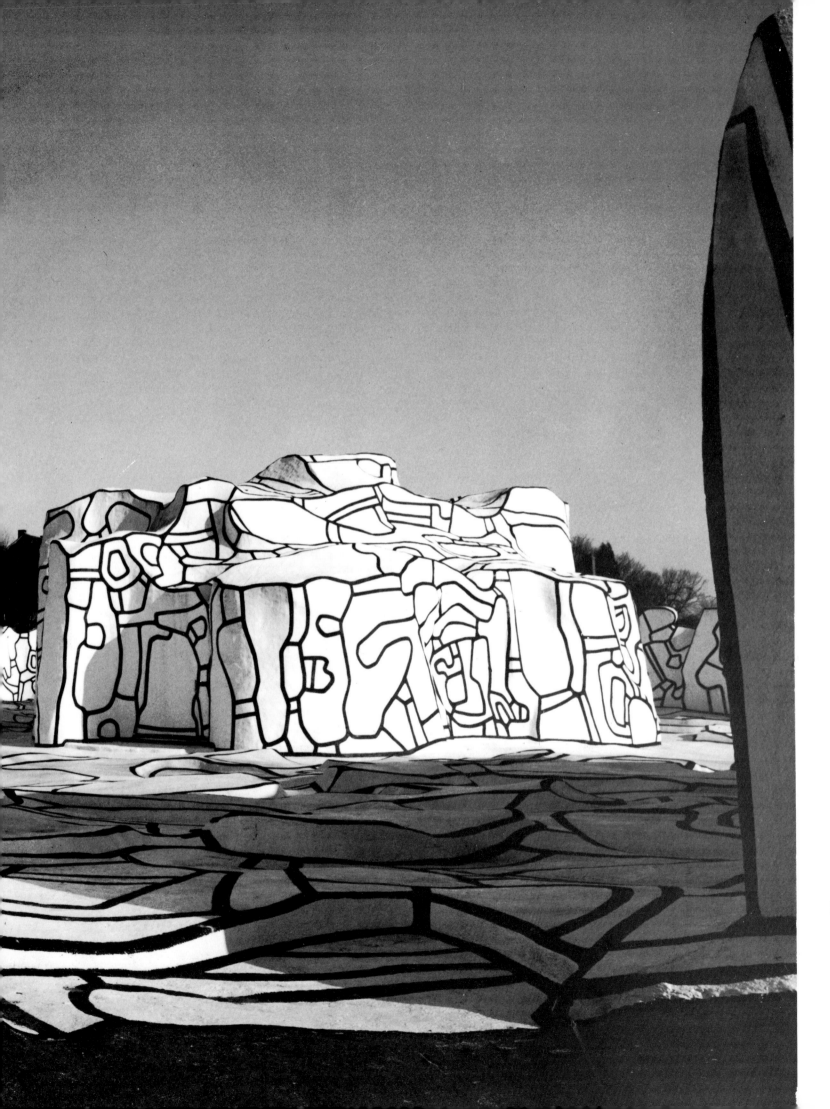

383

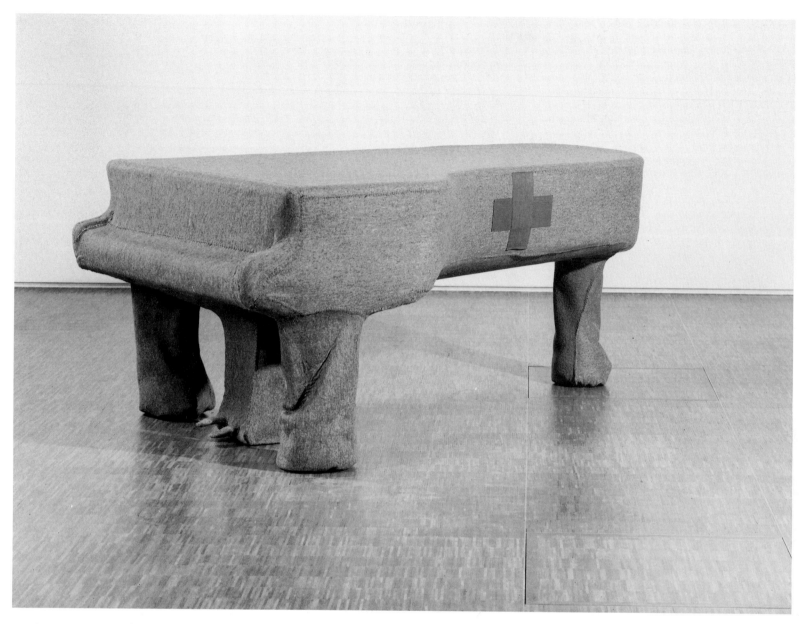

The rejection of what was dominant in painting or sculpture for whatever reason, and the rejection of obligatory taboos only to admit new ones soon afterward, have played a major part. The reasons, I suspect, are not merely aesthetic or a matter of style, but included reactions of a psychic nature. Anyone looking beyond facts and dates will find in works of art a collective rejection and suppression of individual feelings, which, without being in any way exhibitionist, express the artist's personality. The elimination of anything personal in order to arrive at objectively essential elements, in this case in sculpture, was a common practice.

[425] JOSEPH BEUYS. *Infiltration homogène pour piano à queue.* 1966. 65 × 28″. Centre National d'Art et de Culture Georges Pompidou, Paris. [426] DONALD JUDD. *Untitled.* 1971. Hot-rolled steel, 32¾ × 180 × 180″. Solomon R. Guggenheim Museum, New York City

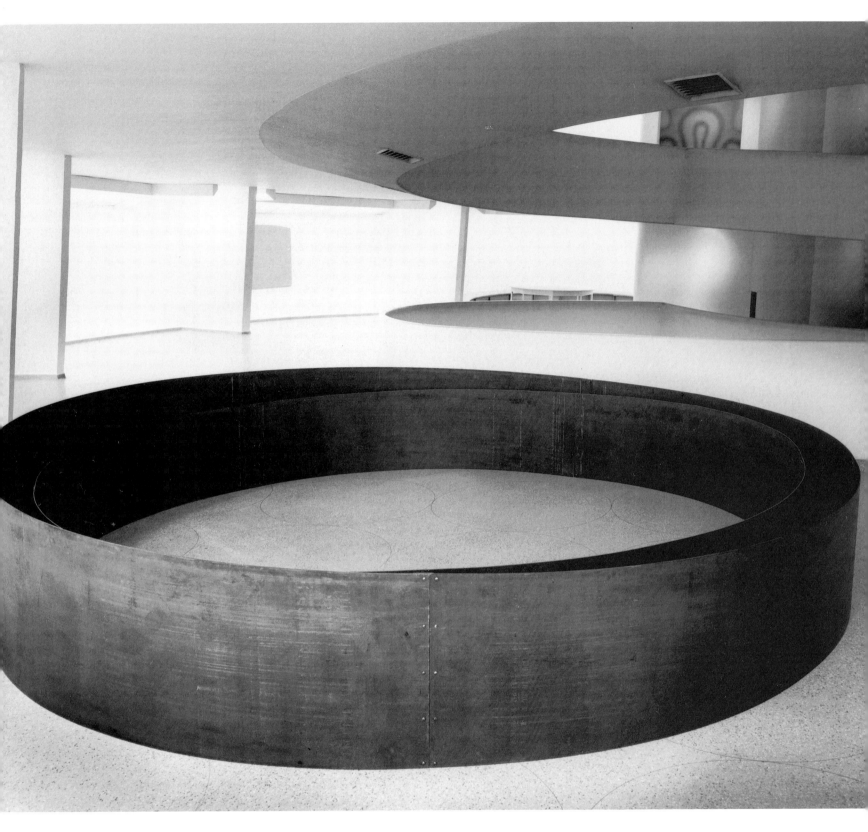

The younger American artists of the 1960s continually stated—as well as substantiated their statements—that they devoted the full measure of their efforts not to the end product but to the supposedly more important process, occasionally to the detriment of the end product. This process phase was a transition from the old to a different state of sculpture. In fact, it was a double transition, since the passage from the old to the new is impossible without the transition from an unconscious to a conscious image by way of the subconscious source. The Freudian construction is that the passage of the image, in this case the birth of new spatial forms, from the unconscious to the conscious was enacted by linking it through association to the word. A remarkable flood of artists' writings ensued, much different from David Smith, who did not need his own verbal definitions, being a great reader of books.

Repression in sculpture avoided displaying personality by reducing, or totally eliminating, pictorial aspects, and by ignoring color or accepting it solely in an impersonal industrial quality. Ancient craftsmanship was disregarded for the sake of mechanical productions and modern techniques. Artists felt uncomfortable vis-a-vis monolithic sculpture and also vis-a-vis the base, since it suggested isolation. The problem was how isolation could be broken. The list of efforts to eliminate undesired elements was a long one. This negative process was, however, indispensable and no less important than the positive imagination that began to shape new spatial perceptions. Repression was accompanied by regression to the genesis of the earth and/or to pure mental geometry. As a consequence, sculpture should no longer be intended for the confined environment of museums, or rooms and galleries of private collectors; new undeveloped, deserted, or neglected industrial or mining land had to be discovered as less formal and more potential to inspire artists to design works on a monumental scale, a scale familiar only in ruins of ancient civilizations.

With David Smith, open to new mechanical techniques but not rejecting ancient skills, the series became, also for younger sculptors, a dominant idea. The conception of works in numbered series based on specific themes (e.g., the Sentinel, the Cube) signified that the isolated monolithic image was abandoned; the series became a unifying stream.

Younger artists, such as Sol LeWitt, Donald Judd [426], Robert Morris, Dan Flavin, Robert Smithson, Tony Smith, and Michael Heizer, were engrossed at the time in the problem of how to make their universal—rhetorically speaking—and overwhelming spatial euphoria determinative. An internal process was at the origin and they thought, felt, and acted in extremis. The physical aspect occasionally became deliberate; spatial definition also included the return to one's own

[427] JEAN TINGUELY. *Elvira.* 1984. Iron, rope, bones, electric motor, 28″. Galerie Bruno Bischofberger, Zurich

body; Body Art was a passing, but consistent, phase. I recall what Richard Wollheim wrote about Freud's *The Unconscious and the Ego*: "Freud committed himself to a view of the mind as *physically spatial*."[81]

Minimal-Conceptual work contained radically reduced motifs. The problems were not concerned with a new type of sculpture by way of style. Nor was there any conflict between figurative and abstract art. Since space signified the dynamic problem of mass and void, rather than that of the gap between art and reality with which Giacometti had wrestled, the technique of reduction as he knew it was abandoned.

Like Smith in America, Giacometti in Europe came close to, but never crossed, the threshold where the artists of the 1960s began. Giacometti isolated and reduced the human figure down to its skeleton. He was not interested in the anatomy of the figure, only in the way it moved, sat, stood. To him, these aspects were not individual, but in a general sense represented spatial movement and silence; they were above all psychological. As in Egyptian art, there is an element of timelessness in his works, which is rare among modern artists; they did not allow anything to come between themselves and the Spatial Void, evoking its subjectless mysteriousness. Before returning to some of these artists, we must first consider Marcel Duchamp, Nicolas Schöffer, and Tinguely so as to find out how the idea of space can be formed via the *société machine* instead of by way of nature and primeval landscape.

The artificial world of science and industry has penetrated culture and in so doing has stimulated artistic imagination. We cannot consider this infiltration without assessing Marcel Duchamp and the effect of his ambivalent personality as the principal influence on many subsequent generations. Unlike Fontana, Duchamp was averse to starting a movement or conducting propaganda for an idea. What kept him occupied was a series of varied experiments constituting an oeuvre that is hard to summarize. He was too sceptical, too French-rational to express himself in any way except with irony, formulating commentaries on a development in the art world in which he diagnosed the course of a disease while failing to believe in the prospects that it opened up. This ambiguity did not preclude his active observation of what was going on, and he has retained the gift of engrossing the world, right up to the present day, with a few inventions and inspired acts such as the *Ready-Mades*, the *Coffee Mill*, and the *Large Glass*, which were introduced like injections just at the right moment to the world of art. Although he was averse to developments in art including those instigated by the avant-garde, it

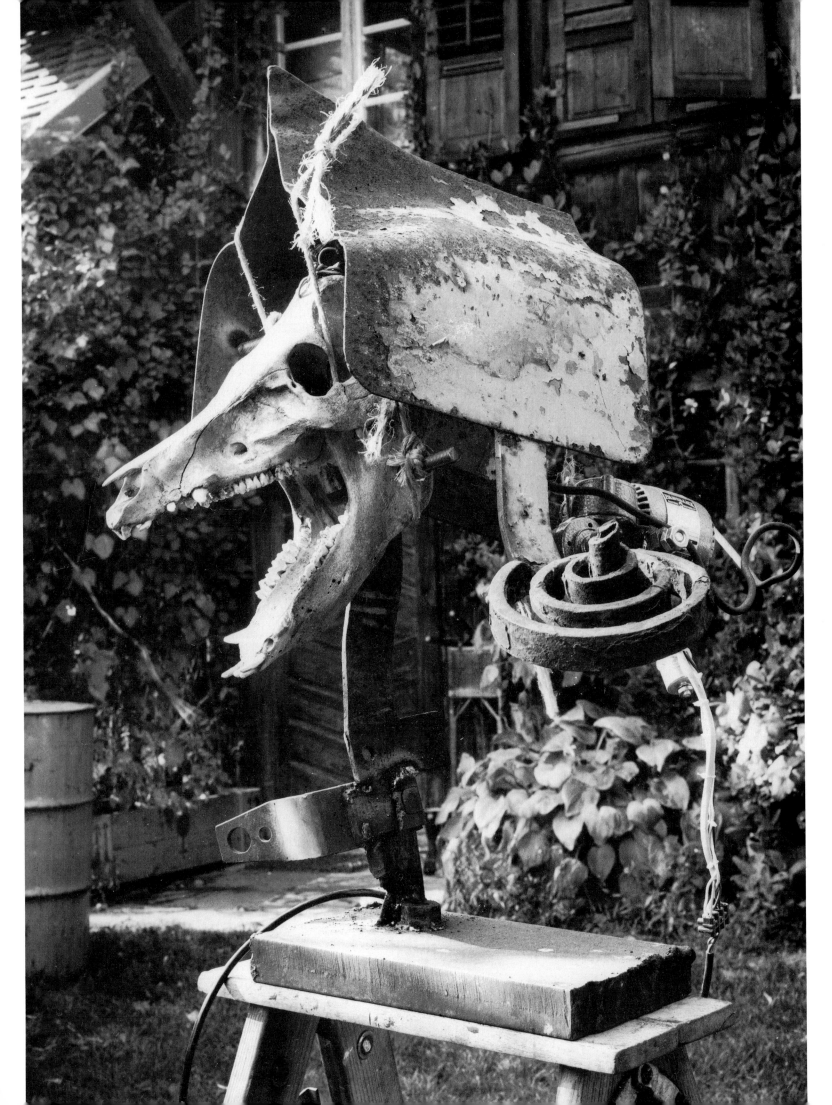

was ironic that he could be a source of inspiration for avant-garde slogans. Again, the Word was there, a sign of a genesis.

Nicolas Schöffer (born 1912) is confident in a rebirth of art which sees its ancient foundations crumbling. A rationalist, engaged in critical reorientation, he accepted photography and the cinema as substitutes for painting (*peinture de chevalet*). With his scientific mind, he assessed the potential value of many cultural elements. Literature was discarded. Craftsmanship disappeared as a result of industrial processing and manufactured materials. His constructions are carefully finished instruments with a cultural function that is part of urban planning. Light, sound, and space direct his constructions in the sense of "valorizing" certain features in town and countryside. Schöffer sees in space the potential sources of energy that can be activated through his "spatial dynamism." These are extensive programs, which have reminded me distantly of Tatlin's Tower of Culture and of the Bauhaus, for which Schöffer does not appear to have the respect imposed by their possibly overrated fame. Like Moholy-Nagy and Marta Pan, Schöffer left his native Hungary to work out almost methodically the spatial message that sculpture can give to culture. His severe rectilinear constructions and mechanisms share certain negative aspects with the Americans in the 1960s; the latter, however, differ in emotional research and intentions. With Schöffer's work, we are near the ambiance of a modern *Gesamtkunstwerk*. The soaring flight of ideas, which alone can activate the imagination, is noticeable in Schöffer's writings when he speaks of a diversity of spatial vibrations.

After some early efforts, Jean Tinguely (born 1925) became absorbed in the accelerated evolution of the machine in post-1945 society. When he began painting, he had some Surrealist qualities, but a Constructivist approach also did not appeal to him. It is often disregarded that as a boy of thirteen or fourteen he was fond of playing in the woods with water and two dozen small wheels. During a searching apprenticeship, he made laborious progress until finally, around 1951, he was working both seriously and playfully with objects and machinery. He observed the machine's behavior in life and invented malfunctions as functions of his critical machine consciousness [427].

Tinguely has always worked in that border zone. Just before and during his stay in Paris in 1953, he used wire, motors, and things to create sculptural objects, inventing the name "métamécaniques."

These experiments provided his ludicrous or macabre fancies with whatever technique he happened to require. Inwardly, he has developed a vision of the absurdity of social and individual life, ruled by an indefinite number of manipulations, not dominated by form or rules of composition, but by an uninhibited and passionate feeling for life, a capacity for commitment that recognizes neither repression nor regression. On the contrary, the image-forming is a mixture of playfulness, entertainment, humor, aggression, and destruction, extending into the dark regions in which imagination lets love and death act in a scene that Tinguely turns into fireworks or in which, creaking grimly, the carcass of ancient Europe is almost allowed to fail—almost, because he does not run away but plays the distant melody of those years of childhood. He remains positive, lives for the present: "Don't let yourself be terrorized by notions of passing time. Let go of the minutes, seconds and hours. Stop resisting change . . ."[82] In 1976, we hear deeper undertones: "*The total absurdity*, the self-destructive repetitive folly and the fun as well as the sisyphean aspects of machines whose reciprocating motion is jammed. I feel I can act quite validly as a partner in this society."[83] Both Schöffer and Tinguely gave the world of engineers and manufacturers an answer to the machines that are different from those used for utility and trade. Unlike Tinguely, Schöffer still aided the engineers in that he, beguiled by the machine, desired perfection from their appearance and behavior; dynamics, speed (time), sound, and kinetic forces were victorious. With strips of wood, ribbons, and bits of nonsense Tinguely's work became a symbol of imperfection with random machines.

Vassilakis Takis, born in the same year (1925) as Tinguely, began creating sculpture about 1946 [428]. He disregarded volume from the very first in order to incorporate telemagnetic effects in wire structures. It was a curious combination, in one and the same person, of artistic talent and a specialized preoccupation with radar systems not for making further inventions but for examining how they could be used to produce spatial effects in art. A link was thus forged that extended from a quasi-scientific interest to aesthetics, from an unconscious to a conscious endeavor. The elements of time as well as space are among the conditions of these invisible workings, in which sculpture in the old sense is excluded. In 1960, Takis met other adventurers, including Tinguely, Buren, Klein, in what was then the avant-garde circle of Iris Clert. She provided them with an opportunity to enter the world of publicity as well as the art trade. On the cover of the catalogue to Takis's first exhibition is a text by Gregory Corso, who juggled amusingly with the concepts of time and space and then went on to say of the artist: "They will judge right, when Time proves wrong. They no longer want your Time, they want your Space." In other words, new aesthetics

[429] JANNIS KOUNELLIS. *Cotoniera*. 1967. Steel and cotton, Sonnabend Gallery, New York City. [430] JANNIS KOUNELLIS. *Live Horses*. 1969. Installation Galleria l'Attica, Rome. Sonnabend Gallery, New York City

should be found which would make humanity aware of the complex forces, opened up by science but still unsurveyable, in universal space. Neither should the demands on the spectator be underestimated. The apparent confusion arising from the transition from a single notion of space to a number of different concepts, which at first appear to be incoherent technically, is ameliorated when the spectator is capable of progressing to a more dynamic conscious understanding. Schöffer mentions "Dynamik-spatio," Fontana is lavish with the term, and in 1959 Tinguely let his tracts rain down over Düsseldorf in an attempt to persuade citizens to give up their resistance to movement, to give up their petrifying inertia. In America, the revelation occurred when the sense of "site" was applied to sculpture; in Europe, a sensitivity to "site" was rare in the sixties, but experimenting led to creating images inspired by space.

The Greco-Roman Jannis Kounellis (born 1936) is on the periphery of post-sixties sculpture, working at a changing number of themes with varied materials. Celant included him in the Ars Povera grouping because of his work in steel, cotton, and charcoal, as well as his horses [429, 430], although I have come to believe more and more that his personality should be described as unique and essentially as that of a poet. It is impossible to detect any continuity in his spatial experiments. Within the context of this chapter, Kounellis is a poet of images who, because of their three-dimensional character, realizes, in theatrical scenes and without special techniques and style, the topsy-turvy broken-open culture of the twentieth century. Is it sculpture? The question becomes less important because Kounellis is driven by a cultural imagination that time and again manages to move historical perspective backward and forward and to concentrate it in a dramatic happening in space. It may be said of him, as of other artists of the 1960s, that the cultural process, the cultural disease, the birth of culture, occupies him more than the outcome.

When I said that he has no special style, this tallies with his own words: "People thought that I had found my style. I wanted to avoid this; I started on new things and I'm still doing so." He too considers that new can never be new in an absolute sense. A second quotation from the catalogue to his first one-man exhibition in the Netherlands (1977) reads: "My works of art are considerations, explanations, dialogues, and commentaries on historical facts from all facets of human life in the present and the past."[84] His entire life nourishes his schemes: he is a man of the theater without a theater. Living in Rome, he is likely to be obsessed with ruins, with the dark undertones of his feelings of doom about this Europe that is called old, but is it so old? "Our hero," wrote Rudi Fuchs in his catalogue, his poetic lines dedicated to Rublov,

"wandering Odysseus, our friend, what did you see in the green eyes of the Nymph?"[85]

Is Duchamp after all a progenitor of Kounellis, as he is of so many reasoning artists? Duchamp left the problems of painters and sculptors alone and succeeded in using his three-dimensional objects to ask disconcerting questions about traditions in which he no longer believed but which occupied him all the same. Now, about half a century later, Kounellis is creating evocative images different from Duchamp's, while experiencing the certainties and doubts of his day and bringing about a fusion in which literature, music, and the philosophy of art are burnt to a complex new substance.

Kounellis is undoubtedly familiar with the road from the unconscious to the conscious. His own image is already perpetuated in history: his eleven living Roman horses at the Galleria l'Attica in Rome (1969) express a chained and ruttish existence, snorting and pawing, as they wait, tethered and taut, in an inert society [430].

Geographic Spaces

Near Capalbio, a spot not far from the Italian coast near Grosseto, Niki de Saint Phalle (born 1930) found a deserted quarry on an undulating private estate, the use of which was governed by olive growing and tillage, and by the rules of cultivation and property rights. Artists had no say on this land, but Niki can now carry out her scheme, designed in 1980, for a settlement consisting of about twenty architectonic sculptures based on twenty-two symbols of the ancient card game Tarot. About five of them were nearly completed when I discovered them, rising just above the olive groves. It looks as though the scheme will become her major work if she can complete the series with her devoted group, which is joined by Tinguely from time to time. This *Giardino dei Tarocchi* [431] will bring all her talents together and give her fascinating personality the place it did not clearly have when Restany included her somewhat belatedly among the Nouveaux Réalistes, thereby increasing the incoherence of that group at the time. Now, about twenty years later, all that is of minor importance. In the company to which Takis, Kounellis, and Tinguely belonged, the production of her earlier Nana figures was in an important way extended by creating fantastic architectural sculptures for children and adults in Stockholm, Jerusalem, Hannover, and Knokke in Belgium (private initiative of Roger Nellens).

Critics writing rather too glibly at the time were quick to bracket Niki's name with Surrealism or with naive and weekend painters, whereas she is neither naive nor sentimentally sweet, like writers of children's books, nor fully Surrealist. Unlike earlier architectural sculptors (Bloc, Martin, Consagra, and several others), she was not a product

[431] NIKI DE SAINT PHALLE. *High Priestess and Magician.* 1980. Sprayed cement over iron, ca. 53′. Giardino dei Tarocchi, Capalbio, Tuscany

of distinct disciplines. I attribute her early awakening to art to the revelation brought about by Gaudí's work: his deviations from strict Neo-Gothic revivalism according to the rules laid down by Viollet-le-Duc, his libertine structures that seemed akin to Piranesi's dreams, and his Spanish-oriental mosaics were strong influences. Unencumbered by academic training, she became receptive to color, form, decoration, and figuration, drawing on sources close to the art world (fairs, jugglers, travesties, fortune-tellers). Her links with the nonidyllic reality of children's lives (quarrels, fears, aggression, admiration, cruelty, tender-

ness) produced a fruitful anti-geometric fusion in her creative work. Combinations of human beings, animals, insects, snakes, birds, sex superlatives, and elements of play were motifs which were strengthened by her fascination with Tarot symbols. She studied pagan and Christian beliefs, which persisted well into the late Middle Ages, in a fairly extensive literature. The repressive elements of reason tried in vain to exorcize mystic and occult esoteric developments, and Tarot symbols were a specialized part of these areas of study, on which Niki based her aesthetics. The silence of this natural scenery with its ancient olive groves, the age-old land, which at St. Rémy reminded Van Gogh of the Passion, undoubtedly played a part during her difficult work on these repellent, threatening, and protective architectural ornamentations, which resemble the gargoyles of Sino-Japanese temples. Along with the gardens at

[432] FAUSTO MELOTTI. *Tema II e Variazioni*. Stainless steel, 19½'.
Parc Celle, Pistoia

Bomarzo, near Orvieto, with their mysterious anonymous late Medieval sculptures, Italy here, in this brilliant light, will have its *Giardino dei Tarocchi*—a disconcerting progeny of a modern dream world.

Celle at Santomato di Pistoia

Giulio Gori is the owner of a villa with a large walled landscape-garden. He loves his wooded park as well as the sculpture of his day, and he has effected a metamorphosis of his undulating grounds with an independent selection of works from Europe and America. Far from being one-sided, his commissions were even contradictory, and yet they have an invisible and strange coherence resulting from a number of time-linked problems. Strict rules were imposed to protect the ancient layout of the densely wooded grounds: not a single tree was to be felled for purposes of either design or transport. A highly developed geographic sense of space, combined with subtle considerations about siting, made the grounds into an example of "site sensitivity," or, as Serra phrased it, "refinement of the site." It was therefore not a museum scheme, and the familiar fear of gaps was ruled out in the case of these international works all executed in situ.

The relationship between nature, sculpture, and architecture (park and buildings) was to be modern, that is to say, the siting solution was not that practiced from the seventeenth to the nineteenth century when sculpture was intended to enhance a fixed style of park architecture. The autonomous sculpture that has now been developed disturbs that hierarchy, and this has often caused architects to stand aloof from sculpture and has rendered artists indifferent to architecture. At Celle, a vital dialogue has begun. Giulio Gori did not buy individual finished works, units for a museum collection, but invited artists to take part in a joint venture whereby diverse pieces sited in relative isolation could create the surprising impression of what I would like to call mental coherence.

The oldest artist is Fausto Melotti (1901–86). He was given the opportunity of creating his vertical open abstraction on the edge of a woodland lake where absolute silence and water reigned, like the Pelléas and Mélisande lake in the opera by Maeterlinck and Debussy, and with a link to the magic ballet set in homage to Stravinsky a few years ago in Florence [432]. His early work as an abstract artist started during the thirties, but was suppressed under Mussolini. He resumed his work on structures and *teatrini* after the war, which developed toward a mature style between playful fantasy and geometric sculpture.

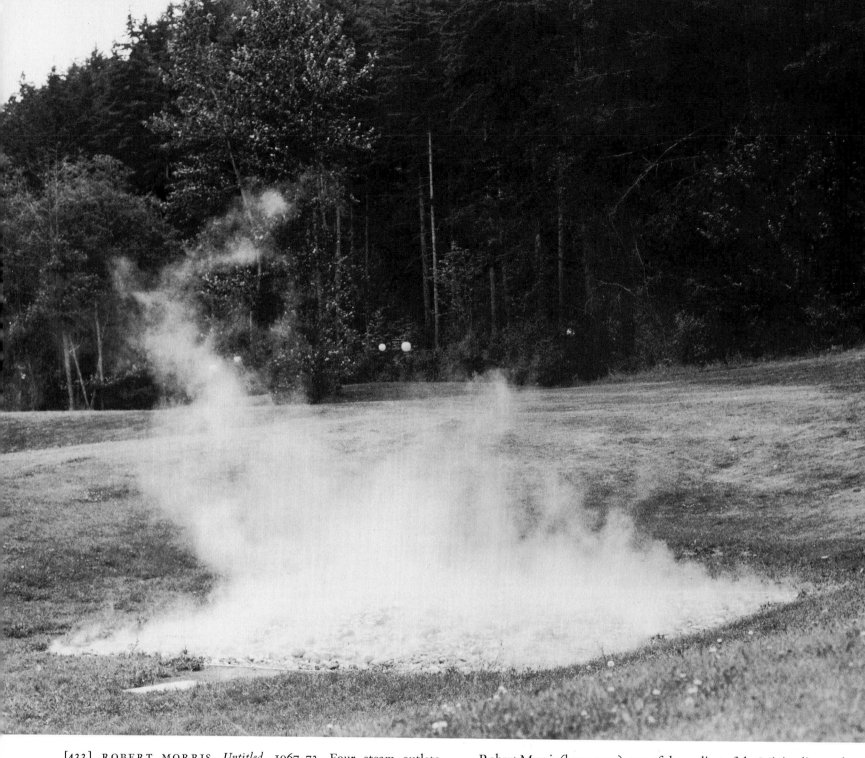

[433] ROBERT MORRIS. *Untitled*. 1967–73. Four steam outlets placed at corners of square, 25 × 25′. Collection University of Washington, Bellingham. [434] ROBERT MORRIS. *Labyrinth*. 1974. Painted masonite, plywood, and two-by-fours, 96 × 360″ (diam). Institute of Contemporary Art, University of Pennsylvania, Philadelphia

Robert Morris (born 1931), one of the earliest of the Minimalists and Conceptualists [433, 434], needed words to help him gain sculptural consciousness. He rejected much, but, dialectically, was not afraid of acting counter to his own pronouncements, as with his suspended felt strips (1967). His repressions, a kind of defense mechanism, were mostly based on fears—fear of color, size, fear of anything that was not tactile. Spectators' rapport and intimacy with a work of art should be avoided.

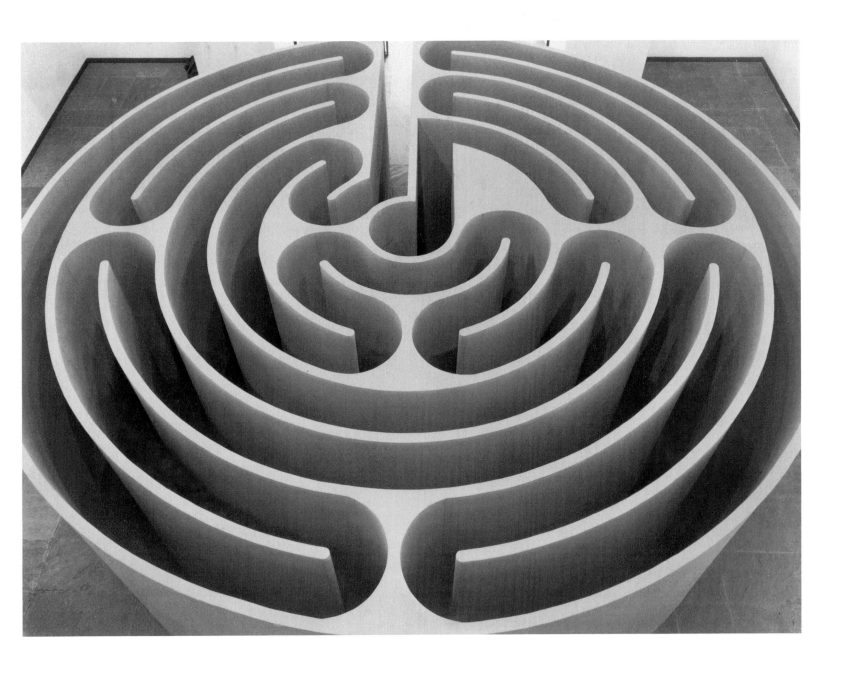

These are all very personal repressions and sources of escape. His recent production (1984–86) showed again his capacity to escape earlier formulae as with his pictorial-sculptural reliefs, dominating the space of a room, in the 1987 Dokumenta in Kassel.

For Celle, Morris created a rectilinear labyrinth—a triangle—a theme that has occupied him time and again for years and has inspired drawings as well as completed works [435]. It is essentially an age-old symbolic space, which Morris turned into a personal emblem. Because of its mixture of psychic and spatial elements, this work raised him far above the general level of Minimalist. After the traditional circle and square based on ancient examples, Celle now has its triangle on a gently undulating open space in the midst of trees. An architectonic construction carried out in handsome materials, it is neutrally separated from nature by means of a closure. If the spectator wishes to share in this closure, he must enter the labyrinth to discover that there is open sky above him and that the narrow corridors, resembling those of a bank

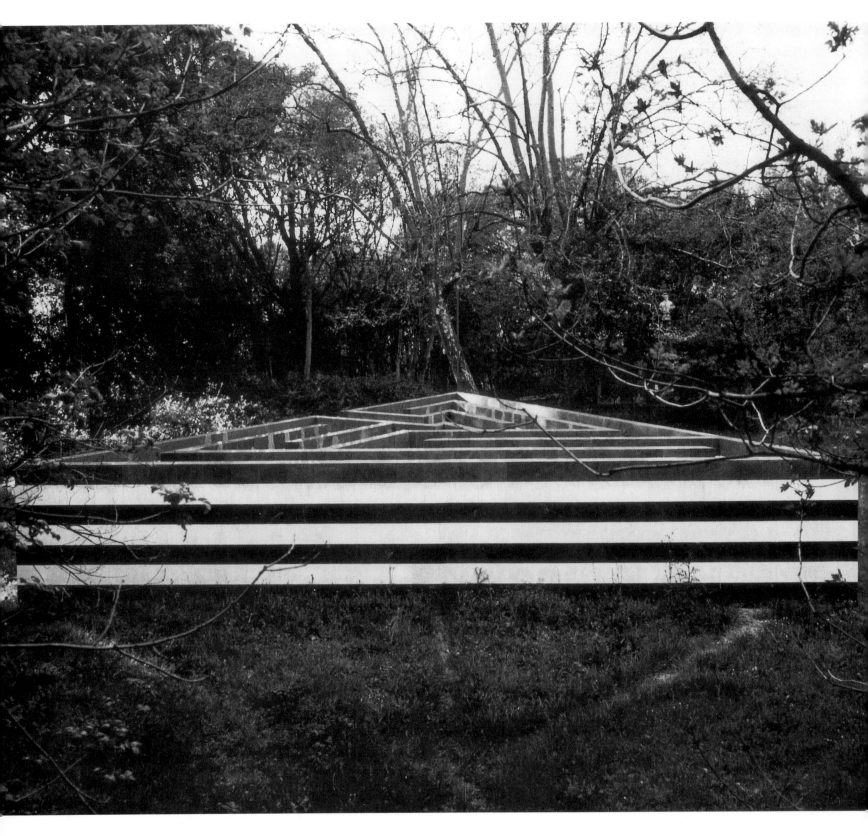

[435] ROBERT MORRIS. *Labyrinth*. 1982. Green marble, 36 × 36 × 36'. Parc Celle, Pistoia

vault, compel him to become the victim of a road without choice. It is an ambivalent course, dominated by the severe stereometric structure which, as I can testify, evokes unpleasant fear. This classical and mysterious construction, on its Tuscan site, causes one to recognize Morris's personality; at the same time—I believe it to be a compliment—it has a modern anonymity stemming from a rich cultural past.

Dani Karavan (born 1930) and George Trakas (born 1944) have succeeded in proving themselves with their spatial lineations on this site. Anyone familiar with Morris's work other than his labyrinth cannot help seeing some similar aspects in Karavan's and Trakas's sculptures. Karavan's artistic roots are in Israel of the 1950s (youthful experience with his father's occupation as a landscape architect, and the desert, mountains, sea, and primordial feel of the Old Testament land) and subsequently in Italy with its complex culture. As a painter, he became involved in the problems that arise as soon as painters and sculptors start producing work for architectural schemes. In the twentieth century, these problems remained unsolved—hampered by an increasing autonomy in sculpture and purely functional architecture. Karavan distanced himself from, but could not forget, architecture. Similar to the development of some of his contemporaries in America, he found that his strength lay in tackling the widening problems of space in relation to landscape and culture. Viewed from his angle, Karavan, along with some Americans, belongs to that small group in which individual development, psychic make-up, and personal talent prevent the formation of a "school." Time-bound and reacting to a postwar world situation, they share several fundamental features. There is no doubt that Karavan analyzes the individual geographic spaces carefully and achieves a freely inspired and complex idea, meaningful as structures. Karavan is aware that up to now his executed works were based mostly not on choice but to a greater extent than anyone else's on commissions and geographically determined places in town and countryside.[86] He does not produce drawings, has no code of theoretical generalities, does no special research into prehistoric time and space, but has a passion to find inspiring elements in the site. I cannot find any links with the backgrounds of Heizer, Smithson, or Walter de Maria, often mentioned in the relevant literature. These individual formulae come from the simultaneous complex change and broadening of space consciousness, and from a changing relationship with nature and away from the undifferentiated sense of form for space in which sculpture appeared up to and including the days of Rodin.

Karavan's metamorphosis of the Italian pavilion at the Venice Biennale, in 1976, made a great impression. He designed luxuriant, culturally sophisticated tracery when he was temporarily able to use the Belvedere near Florence and the castle at Prato (1978). For the difficult environment of the new Ludwig Museum in Cologne (1986), he found sober, functional solutions [438]. At Celle, he was successful in moving with pure geometric rectilinearity between the shrubs, trees, and bamboo canes of the given site [437]. He brings back something of the once almost sacrosanct "number and measure" belief, which inspired the monumentally inclined sculptors of the 1920s and thirties, aided by Matila C. Ghyka's historical research.[87]

The new orientation perceptible in the 1970s may have influenced some of the major artists: they needed a new type of spectator, a moving one along paths, not only among dealers and collectors but also among those with an unselfish interest. In spite of people's addiction to mechanical means of transport, this new type of spectator was to be a regenerated version of the age-old wanderer, best-known to us from the Romantic movement. It is impossible to deny, though hard to admit, the existence of a certain nostalgia with which sculptors, counters of footsteps, tracers of footpaths, such as Richard Long [436], Smithson, Morris, Serra, and the operators Karavan and Trakas, long for a wanderer. As one strolls around the constructions and wanders through the streets and landscapes, one becomes aware of a new enchanting interpenetration of the Full and the Void.

Trakas is the youngest artist at Celle. He brought landscape experience with him when he arrived from Canada in New York to continue his development. Mathematical ability, geologic knowledge, and psychology have determined his progress. His site projects create an evocative tension, as does the one at Celle, which descends mysteriously to a concealed hollow where he places his meeting of Adam and Eve.

The Poiriers (Patrick and Anne, both born 1942) depart even further from "site definitions." They consider sculpture in relation to a site without geometric abstract intentions but in a manner subservient to historical cultural imagination and a passion for ruins and ancient cultures [439]. Whereas in the eighteenth century, artists, writers, archaeologists, and geologists tried to revivify Pompeii and longed to reconstruct the city, the present wave of interest relates not to reconstruction, but, at least in the Poiriers' case, to a mythically inspired fantasy not necessarily tied to a single place or period.

In our dangerous and unstable society, the Poiriers and associated artists should not be underestimated. All too easily relegated to Romanticism, which, with its grandiose elements and powerful poetics, never really came to an end, the work of artists such as the Poiriers, Morris,

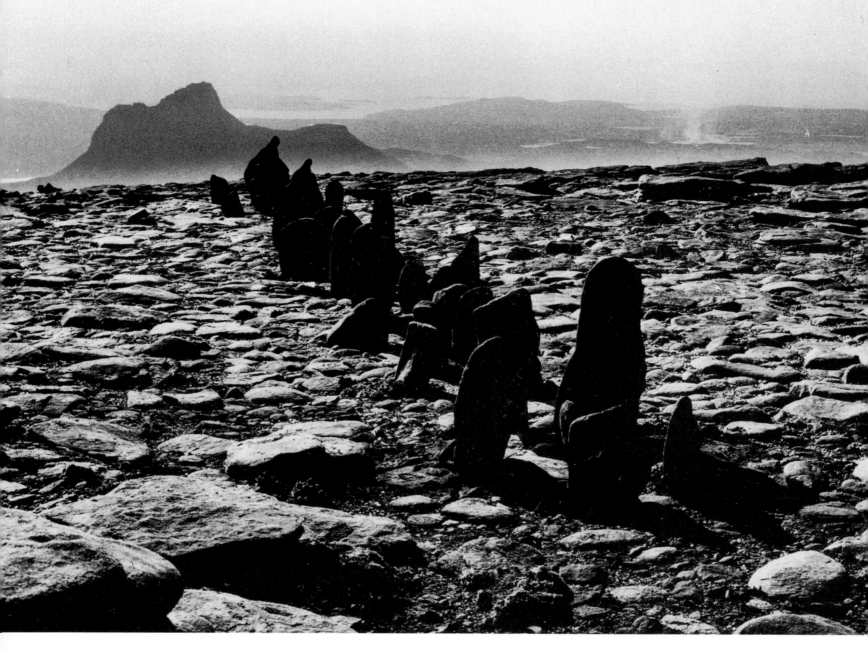

Smithson, LeWitt, and Serra, with their divergent solutions, forms part of the same problem—including their affinities toward the past, seeking something to hold on to and drawing on the neglected sources of human existence. Not one of these artists is competent to carry out modern scientific research, but the gifted pick up what is going on, nourished by looking, hearing, seeing.

In a gorgelike valley in Celle, Tuscany, near a small bridge across a narrow river, the Poiriers created a scene with a mighty block of stone treated in sculptural baroque style and with bronze pillars engraved with Virgilian texts invoking Zeus and the Giants [440]. After seeing the ruins of the Domus Aurea in Rome, and after their Olympic visions

[436] RICHARD LONG. *A Line in Scotland*. 1981. Framed work, photography and text, 34 ½ × 49″. Private collection, London. [437] DANI KARAVAN, *Linea 1, 2, 3*. 1982. White concrete, 70 × 40 × 128′. Parc Celle, Pistoia. [438] DANI KARAVAN. *Ma'alot*. 1979–86. Tower, cast iron and granite, height 35′; iron plate, 3 × 3′. Courtyard of the Ludwig Museum, Cologne

of Titans, they have found inspiration in this ancient Tuscan soil.

The work by the Polish Magdalena Abakanovicz (born 1930), on a magnificent open site in this typical Tuscan setting of mountain contours and woodland, shows how essential it is to work independently from the now numerous site explorers who do not operate collectively in accordance with just one spatial formula. Magdalena created thirty-three vertical figures, which one can take in at a glance without looking at them individually [441]. They seem like a threatening army, advancing across the harmonious countryside. I have known Magdalena Abakanovicz since she made a name with her relief textiles. She has been working on figurative sculptures since 1975 [442], apparently impervious to the taboos that serve to defend neutrality, lack of personality, lack of intimacy, lack of color, absence of small sizes and noncollectible

[439] ANNE and PATRICK POIRIER. *La Naissance de Pégase*. 1985. Wood, charcoal, plaster, covered with gold leaf, 47 × 100 × 62″. Galerie Daniel Templon, Paris. [440] ANNE and PATRICK POIRIER. *La Mort d'Ephialte*. 1982. Carrara marble, 46 x 69′. Parc Celle, Pistoia

[441] MAGDALENA ABAKANOVICZ. *Katarsis*. 1985. 33 pieces in bronze, height 2′ 60″. Parc Celle, Pistoia. [442] MAGDALENA ABAKANOVICZ. *Cage*. 1981. Burlap, glue, wood; back, 28 ¼ × 23 ¼ × 27 ¼″; cage, 66 × 46 × 61″. Museum of Contemporary Art, Chicago. Gift of Ralph I and Helyn D. Goldenberg

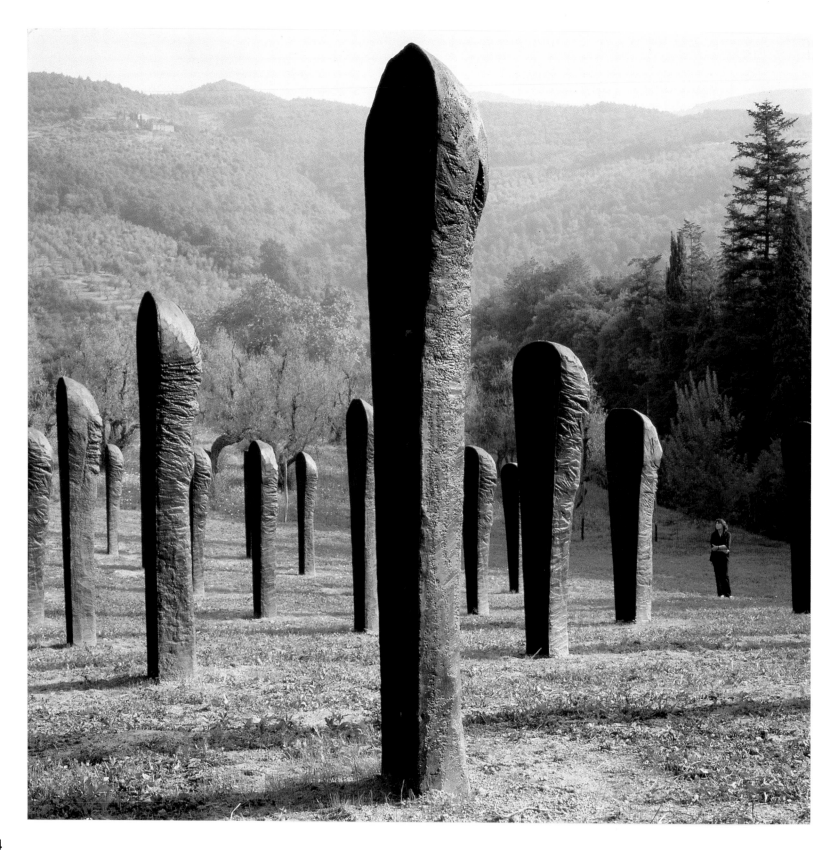

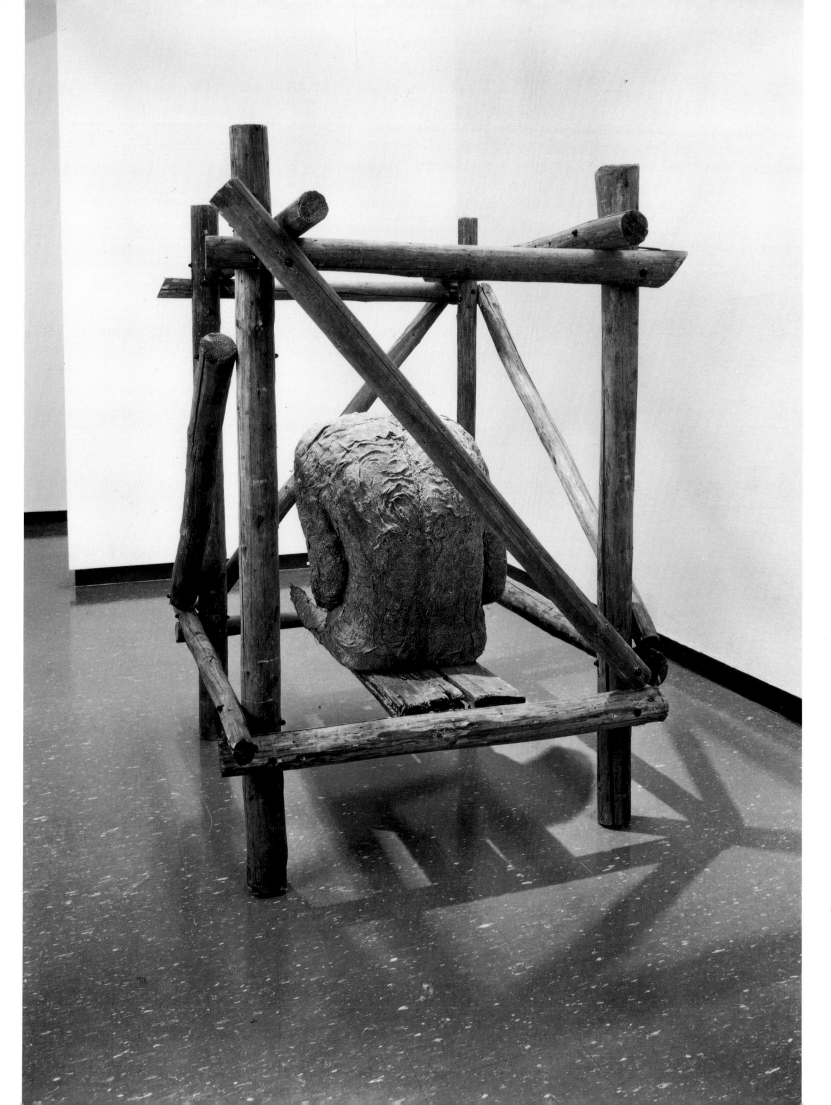

405

objects. Her thirty-three figures form an entity made up of convex and concave elements, born of light and darkness—a motif not unexpected in the Polish community, and an impressive *canzone* of life and death. Before I had read her title *Katarsis* and her comments on it, the group on this ancient land appeared to me like an articulation brought forth from a deep psychic layer of tensions, an incantation in a geographically defined space. Her commentary clarifies technically the group's relationship to her older work and how it represents inward growth.[88] "My work is not a statement about fiber. It is a statement about the human condition, about *space*, about men's brains." Her "truth to material" appears to be different from that of the generations preceding and continuing the Moore-Hepworth phase. She found her own medium, became attached to it, but remained aware of other image-forming forces. "To all most ancient fears of men I add my own 'Catharsis'—the decision came abruptly, in the way that excess must boil over." She did not prepare any sketches. "With a big kitchen knife I cut out figures in blocks of white styrofoam." There are nine different models in the group, and she finished the internal parts by hand at the foundry. Her technical statements are striking: "If I create art out of stone or clay or threads, that doesn't have to do with the result. My work is not the result."

Richard Serra (born 1939) has gradually become the sculptor who, since the American Minimal-Conceptual phase, developed pure, not isolated monumental form. After showing his work in Amsterdam (Stedelijk Museum), Otterlo (Rijksmuseum Kröller-Müller), and Rotterdam (Stedelijk Museum Boymans-van Beuningen), he has now established his reputation in Europe with two recent examples of his work in Italy (Celle) and in France (Paris, Centre Pompidou).

Serra's views of his own sculpture go hand in hand with an aloofness toward, or at most a tolerance of, certain elements in the work of Minimalists. He believes that siting sculpture remains a complex problem. "The site is redefined" by appropriate positioning, but not "represented." His delicate sense of scale is not merely a matter of "size," of "enlarging small models." He immerses himself in analyzing and creating the right setting for his work, and, instead of producing sketches, he starts off with "handmade manipulations," "full-scale make-up models," and experimental "steel models in the sandbox."

Serra relates his sculptural problem to the environment in a way that differs from the one common among architects, and this may cause difficulties. We see a contrast between Serra and a sculptor such as David Smith, who did a great deal of drawing, not just to prepare for his sculpture but because he enjoyed it.[89] Serra is on the whole opposed to pictorial sculpture (what Smith had just developed). "Pictorial sculp-

[443] RICHARD SERRA. *Open Field Vertical Elevation.* Eight pieces in form of parallelepiped, 6½′ above ground. Parc Celle, Pistoia

ture" has its roots in "canvas nostalgia." Serra is also opposed to anything laid out on the floor and purporting to be sculpture—a more recent fashion. Two of his recent works seem to reinforce the impression that he is one of the few artists to have mastered, in *classic* style, the experimental nature of the new sculptural grammar, if one does not take that term in too formal a sense. The simplicity of his work, with its grandiose effects, often using Cor-Ten steel, seems sophisticated.

The site at Celle made available to Serra is a gently undulating, open field where he could position his eight stone units at some distance from each other [443]. His sensitivity to the site is visible and palpable. The sloping surfaces of the stones, for example, are in total harmony with the contour of the terrain. The elements of sculpture join with those of nature to make this site scan. Serra has evoked an Arcadia. There is an unequivocal silence, a mysterious stillness, about Serra's sculpture. At a given moment one can forget about the environment and disappear, absorbed into the sculpture, only to return to the two of them, sculpture and nature, just seconds later.

The story of the problems surrounding the siting of Serra's *Clara-Clara* in Paris, in 1984–85, and the detailed art historical reflections it has inspired will be found in Yves Alain Blois's *Promenade autour de Clara-Clara*, a report by the ideal kind of wanderer desired by the new sculptors.

Clara-Clara [444] is the convergence of two immense curves experiencing the tension of an awaited encounter. Serra is not dogmatic about the excessive rectilinearity aspired to in the circles from which he emerged. By using curves of this size and on this scale, he achieved an evocation of halted movement, subtle in its placing, in its lineation, and in its deviation from the vertical. The work was originally destined for the entrance hall of the Centre Pompidou in Paris, where the open lower ground-floor area invited the spectator to see it first from above and then, as one descended, from nearby. Technically unacceptable because of its weight, the sculpture was given a temporary permit for a superb location in the Tuileries, perhaps a more spectacular site than Serra desired. The final choice of a park at Choisy, in the 13th arrondissement, presents a challenge to a modest, unpretentious bourgeois environment. Those who are shocked, not by its siting but by the work itself, do not fail to publicize their rejection of it on hoardings and blank walls—signs of street users that once fascinated Dubuffet, though only as suggestions of unchanneled feelings.

Serra's piece of monumental purism did not have to wait nearly so

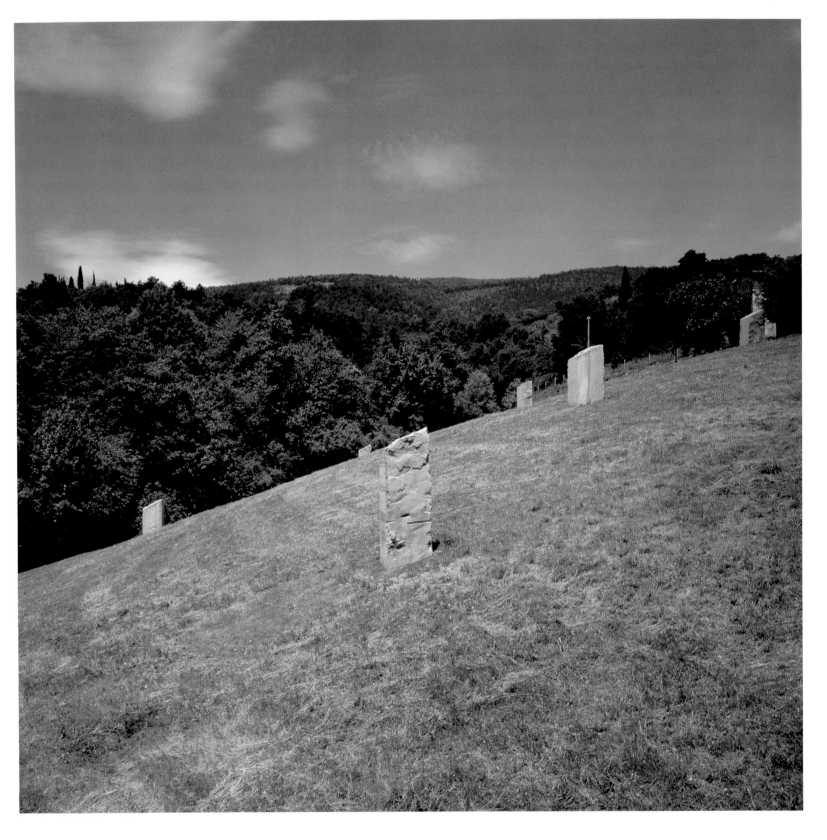

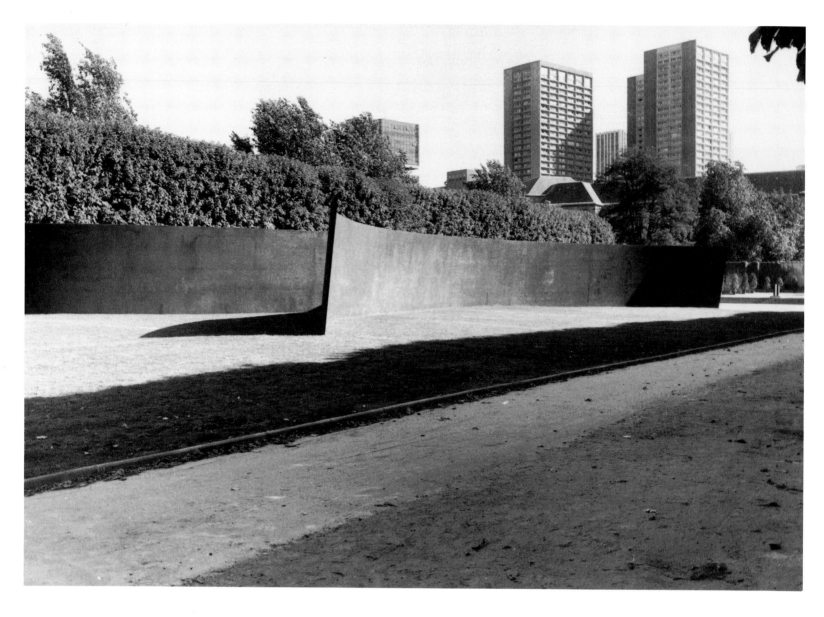

long for official acceptance as Rodin's *Balzac* before it was admitted to a public space. In those days, vexed problems concerning politico-cultural aesthetics were only a matter of officialdom, but now the situation has been reversed. It is the anonymous citizen who expresses, in popular terms, his aversion to a work of art which, following decisions taken by mayors and museum directors, was supposed to adorn a public place [445].

Sculpture in Public Places

The temporary sculpture exhibition in Battersea Park, London, shortly after World War II, signified a change in museum authorities' views on

[444] RICHARD SERRA. *Clara-Clara.* 1985. Parc Choisy, Paris.
[445] RICHARD SERRA. *Shift.* 1970–72. Six rectilinear cement sections, height 5'. King City, Canada

[446] MARIO MERZ. *Igloo.* 1982. Steel and slate, 89 × 177". Sculpture Park, Rijksmuseum Kröller-Müller, Otterlo. [447] CLAES OLDENBURG. *Trowel.* 1971. Steel, spray painted, 460½ × 143¾". Sculpture Park, Rijksmuseum Kröller-Müller, Otterlo

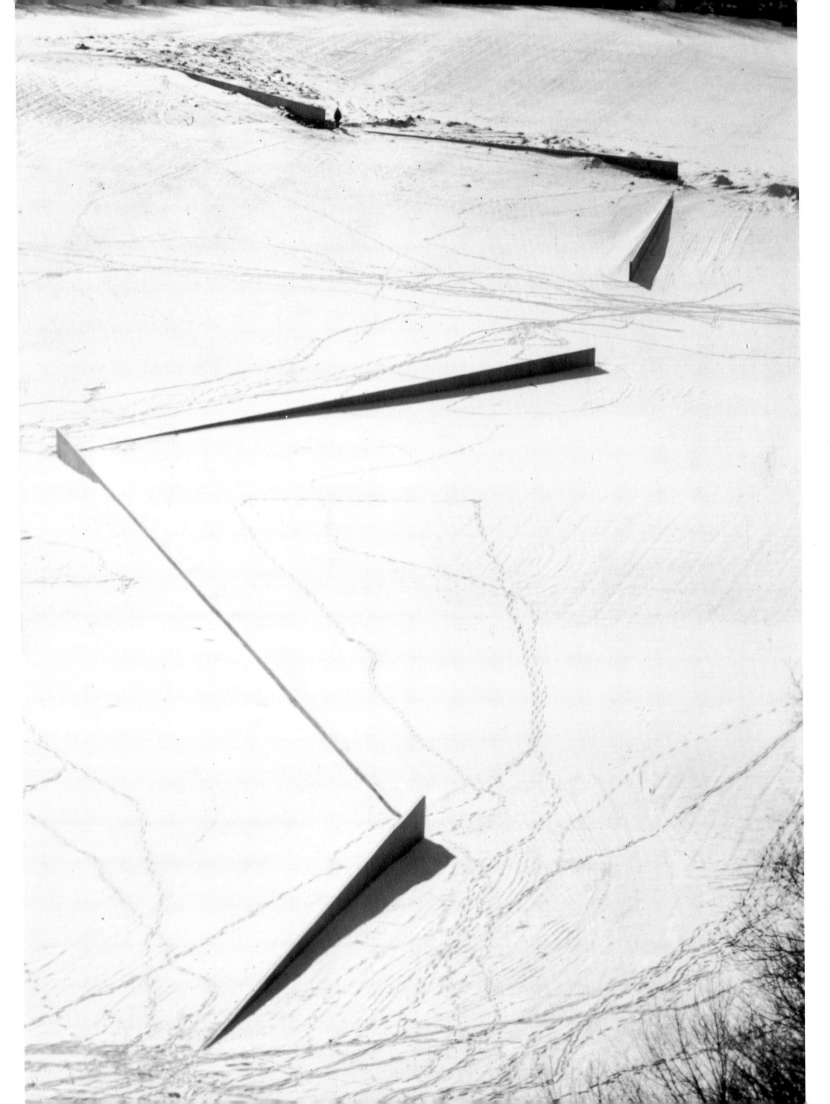

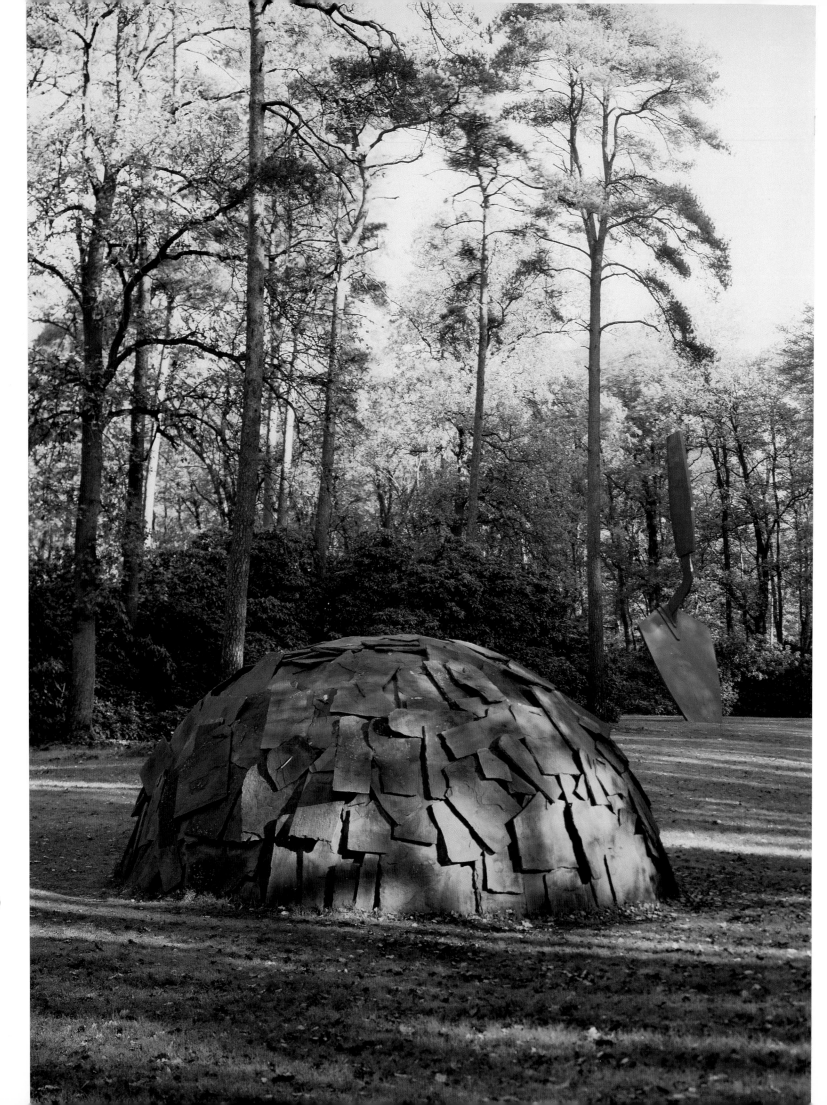

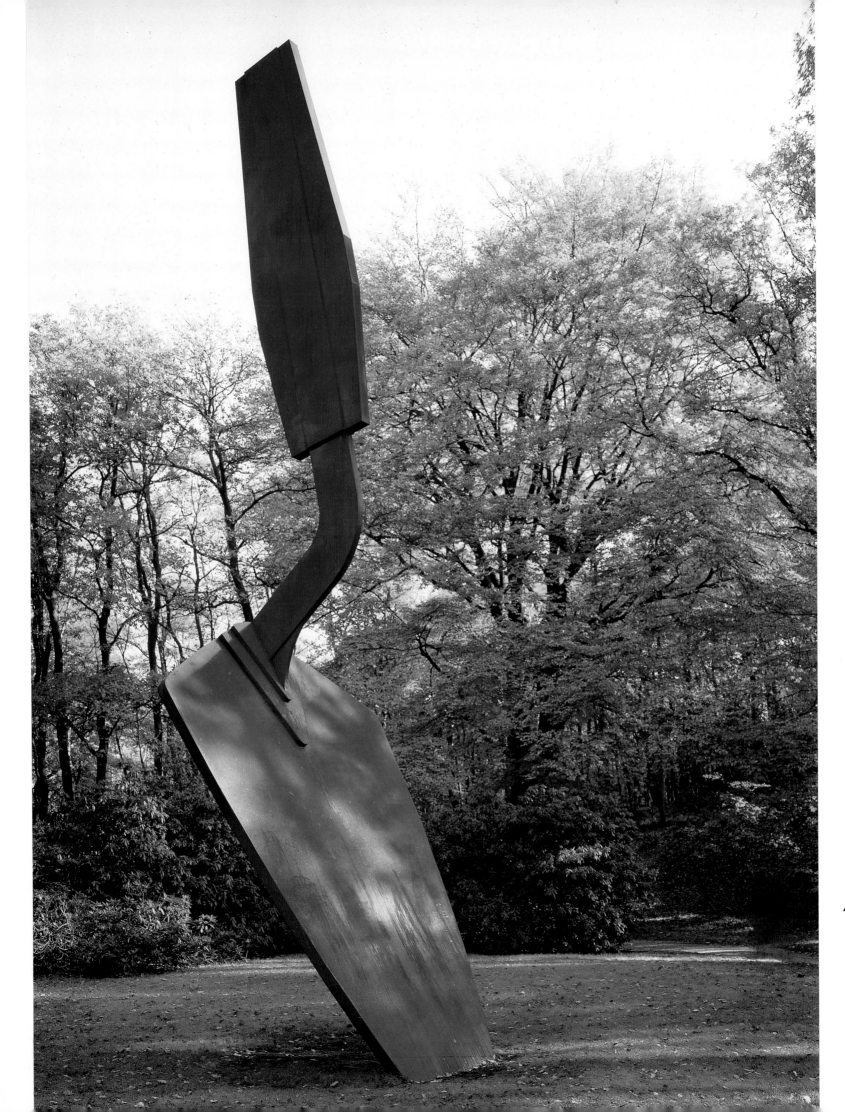

411

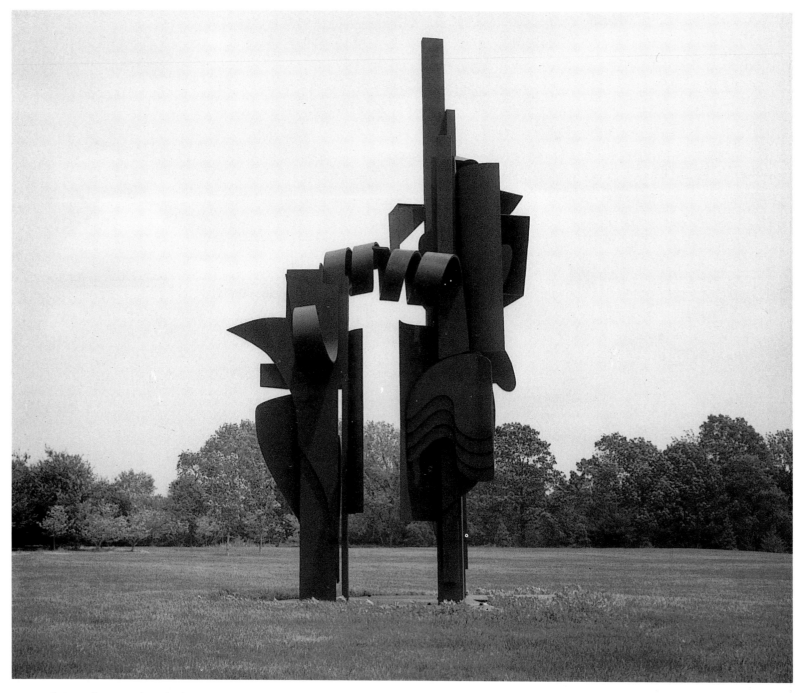

presenting sculpture: they had come to favor displays in parks not originally intended for such works. It was a test for the chosen works, which, placed in open spaces, were confronted with existing trees and plants. Battersea was soon followed by Middelheim near Antwerp. The Rijksmuseum Kröller-Müller was the first museum that, instead of having to make use of an existing park, was in a position to designate an

[448] LOUISE NEVELSON. *Celebration II.* 1976. Painted Cor-Ten steel, 28 × 16½ × 3½'. Pepsico Park, Purchase, New York.
[449] LOUISE NEVELSON. *Shadow and Flags.* 1977–78. Seven Cor-Ten steel sculptures painted black. Louise Nevelson Plaza, New York City

413

[450] CHRISTO. *Wrapped Coast*. 1969. Little Bay, Australia

overgrown area of undeveloped countryside for the siting in the open of sculpture to be acquired. When purchases were made, it was necessary to take into account the fact that the environment was still in the process of development. Two of the large, major works in the sculpture garden are *Igloo* by Mario Merz and *Trowel* by Claes Oldenburg [446, 447]. Of course Claes Oldenburg needs more than these few words. At first he was one of the most important members of the Pop Art movement, participating in happenings, assemblages, and environments. In 1962 he began his oversized soft sculptures, which parodied, seriously, consumer goods. By a process of metamorphosis, he took off on his winged flight, starting from everyday objects (lipstick, switch, eraser, teddy bear, trowel) transformed into visions of monumental space.

The idea of outdoor sculpture became a challenge for organizers, who initiated developments in many places, mostly existing gardens or parks. *Great Sculpture Gardens of the World*, a book published in New York in 1984,[90] shows how the appreciation of sculpture increased to an unprecedented extent over a period of about thirty-five years. It indicates how many problems still have to be identified in order to distinguish between the indoor and outdoor qualities of sculpture before a reasonably practicable method of selection can be made. It also demonstrates that the complex problems of siting and the lack of basic purchasing plans still give rise to disparate standards in endeavors to carry out initiatives that are otherwise good.

There are numerous examples of new institutions collecting outdoor sculpture and two landscaped areas outside New York City can be mentioned here: the Storm King Art Center, along the Hudson River above West Point; and the site of the Pepsico Company's headquarters at Purchase. Landscapes for sculpture have been developed there since 1960 and 1981 respectively, and developments are continuing with internationally minded enthusiasm. H. Peter Stern is the inspiring president of the 400-acre site at Storm King, and intensive operations, including exhibitions, are taking place amid romantic hilly surroundings. Some 130 sculptures, many of monumental size, are placed on landscaped terraces, fields, and woodlands [420]. The problem there, paradoxically, seems to be how to adapt to almost too much natural charm, against which sculpture has to hold its own. It involves a fascinating kind of orchestration that must also accommodate an audience.

The Pepsico Collection, under the direction of Donald M. Kendall, commands the use of the corporation headquarters' extensive grounds, where the British landscape architect Russell Page created an attractive park with many potential sites for sculpture. The collection is still

relatively modest. There is a fine nucleus of works by artists such as Pomodoro, Ernst, Noguchi, Moore, Rickey, Calder, Miro, Nevelson [448], and Lipchitz, but additions raise problems of quality and planning. The initiative augurs well for the future provided rigorous guidelines are adopted.

The interaction between public, artist, and entrepreneur on geographic sites of this size is something new. In a sense, it is a response to younger artists' spatial experiments. The development of a sense of space is becoming a more complex matter, and geographic settings and sculptures, the two basic elements, require extended insight when it comes to outdoor display. The general public plays an anonymous part and it does so on an unprecedented scale. No one knows whether sculpture in areas distinct from collections and museums has become more popular with spectators who merely look but do not purchase [449]. The signs are encouraging. But looking back at Cubism and its effect on artists and spectators after more than half a century, one cannot say that it ever became popular, even though the recently opened Picasso Museum in Paris attracts tourists from all over the world. It is certain that a worldwide consensus about space developed among just a few artists. A larger number of epigones, some with talent, signifies that there has been some radiation. The limits set for my essay unfortunately preclude more than a brief consideration of some artists whose principles and performance made this overture to spatial consciousness particularly fascinating.

Christo (Javachef, born 1935), because of his early period in Paris (after art training in Sofia, Prague, and Vienna) and his definite views on geographic space that he developed in America, has always kept somewhat aloof from artists such as LeWitt, Heizer, de Maria, Tony Smith, and Smithson. Christo began with packaged objects in 1958, after Man Ray, an American in Paris, had in 1920 packaged the sewing machine described in Isidore Ducasse's presurrealist text or, as the case may be, had provocatively presented the Duchamp sphere as an art object. Thirty-eight years later, these led Christo to an idea in which he discovered non-Man Ray possibilities. His packages evolved from furniture to barrels (*Dockside Packages*, 1961), and then to public buildings, streets (Rue Visconti, Paris, 1961), and vehicles, developing scale, site, and space ideas. After interiors, he started on trees. His progress toward the outdoor world did not lead through deserts, but proceeded gradually until he ventured to tackle the South Pacific coast of Australia [450]. This gave rise to unprecedented problems, born of a grandiose vision

but, in fact, relating to technical matters such as organization, funding, materials, and confrontations with conventions and legislation that made no provision for nonutilitarian schemes, even temporary ones. Restraints imposed by people in positions of political power had to be overcome. In the course of his travels and undeterred by difficulties, Christo discovered the magnificent scenery that inspired him. Keeping to the academic principles so typical of him, he realized superb drawings. Of course, misunderstandings about his transient superhappenings sometimes occurred. Performances in which momentariness and nothingness produce shock are distinct in Christo's creations. He is like the conductor of a self-composed symphony: taking the elements of a landscape, he determines his work and reduces, accentuates, and conceals structures, colors, forms, and lines, and recreates them on a different plane. They are pictorial-spatial-dynamic experiments with space, which, through concealment and nonconcealment of natural surroundings, evoke strange spatial sensations. What is left, in films, photographs, drawings, and lucid factual texts, bears the mark of Christo's rare ability to impose his personality on every detail of the work's execution. He has the watchful mind of a creator-conductor who keeps control of the performance despite the multitude of instruments [451].

Robert Smithson (1938–73) was Christo's antithesis in a number of ways. He began to devote himself entirely to sculpture in 1962, and he soon realized that his impulsive nature pushed him beyond the limits in carrying out his ideas. He may be contrasted with an artist such as Joseph Kosuth (born 1945), who wished to examine the potentials of a single substance, such as water, and did so systematically with the analytical mentality of a man who keeps himself under control, even when writing. Smithson's restlessness, his many journeys, and his mental agility deterred him from contemplation and destined him to be at the crossroads of what was happening in American spatial research between 1960 and 1973. He experimented with asphalt, coal, sand, lava, wood, steel (including painted steel), glass, and mirrors, and the results were either experiments in informality or in strict geometry (in Belgium they drew a response from Marcel Broothaers). Works such as *Spiral Jetty* [452], *Broken Circle, Spiral Hill,* and *Monuments of Passaic* attracted a variety of visitors.

Smithson was one of the most impassioned, if not the sole, seeker of postindustrial sites to use as space training grounds. His dialectic way of thinking developed into the sight-non-sight obsession; earthworks resulted. He was less interested in redefining sites (see Serra, page 406) than in acquiring sites that had been left deserted in the community because of the policies of industrial giants. Christo wished to occupy sites on a temporary basis and even then had to overcome

unprecedented obstacles. Smithson rarely gained the cooperation of the relevant authorities, desiring more permanent projects.

Sol LeWitt (born 1928) is an undogmatic spirit who, in his Minimal as well as Conceptual phase, seemed to identify with what had begun as an unformulated program and led to analogous forms of expression [453, 454]. Each time there must have been some kind of reserve, a place of refuge that he allowed himself for deviations. These were developments of different spatial aspects as a result of seeing things from a historical and a contemporary point of view simultaneously. In other words, LeWitt not infrequently abandoned earlier definitions. He was never afraid of taking a critical look at what lay behind him and revising his most apodictic statements or putting them in perspective. Recent publications insist that LeWitt is a Conceptual artist.[91] In spite of a few dictionary-style generalities, I have never read a correct, comprehensive definition of a Conceptual artist. In view of the work by LeWitt, as well as by his contemporaries, in more than a quarter of a century, it would be wrong to continue nailing to the mast of a specific category the name of an artist who has demonstrated that he could detach himself from his own categorical pronouncements. LeWitt once said, "Conceptual artists are mystics," only to correct himself by adding, "It is better to substitute 'nonrationalists' for mystics." This weakens the definition, but at the same time it provides a way of finding out the affinity with artists who fundamentally opposed the rational dominant—Breton and his circle of Surrealists. LeWitt's work has certainly not evolved haphazardly. The fact that "the site almost always plays a part in the works" has become more and more evident in his openminded approach

[452] ROBERT SMITHSON. *Spiral Jetty*. 1970. Rocks, salt crystals, earth, algae. Coil, length 1,500′, width ca. 15′. Great Salt Lake, Utah. [453] SOL LEWITT. *Floorpiece No. 1*. 1976. 43 × 43″. Stedelijk Museum Boymans van-Beuningen, Rotterdam. [454] SOL LEWITT. *Wall Drawing No. 14* (on floor); *Wall Drawing No. 344* (on left wall, detail); *Wall Drawing No. 354* and *No. 295* (on right wall, detail). 1981. Wadsworth Atheneum, Hartford

to contemporary and older architecture. The magical way in which he temporarily converted the late nineteenth-century museum architecture of the Stedelijk Museum in Amsterdam demonstrated convincingly how he managed, respectfully, to do justice to a building of sound, if not spectacular, merit by using subdued colors, surfaces, lines, and simple geometric compositions. A team of workers under his direct supervision executed a kind of spatial writing on surfaces divided into panels, which, to me at least, suggested an aesthetic approach to Uccello, the fifteenth-century master who, apart from his obsession with mathematics and perspective, was associated with an "irrational, whimsical social style, full of poetry."[92] The distance between earlier work and these *Wall Drawings* seems great, but in retrospect there was some undeniable continuity up to the 1960s. LeWitt then designed his *Modular Wall*

419

Structures (1966–68), *Open Cube Constructions, Modular Floor Structures, Cube Structures* based on five modules, and *Cubes with Hidden Cubes* (1977). These works show a consistent development with a subtle attractiveness that gives surfaces a quiet and transparent spatial value.

The cubes became an emblem for the entire movement, not only through LeWitt's work but, in my view, especially through that of Tony Smith (1922–80). Smith did not take up sculpture until he was about forty, after an interesting period of architectural training and practice with Frank Lloyd Wright as well as a spell as a painter. His contacts were Mark Rothko, Barnett Newman, and Ad Reinhardt. He spent the time when he was "fully sculptor" somewhere on the fringes of Minimal research. A further indication of his breadth of vision is the fact that he was almost the sole artist to feel attracted to Jacques Lipchitz. When they met, he was impressed by Lipchitz's affinities to myths. This is easier to understand if we realize that in Smith's Jesuit upbringing myths as well as language were important. As a teacher, Smith was open to the world of his students. His fascination with geometric forms did not minimize the emotional origins of his severe, black constructive metal projects [455]. He was aware, in a Freudian sense, that the idea of the cube had germinated as a child during a long period in bed with tuberculosis. Concentrated gazing at small medicine boxes occupied him interminably, and later this interest came to include cigarette cartons, a card-index box on a desk, and Alka Seltzer boxes. His *Black Box* (1962) was the result of those experiences.

[455] TONY SMITH. *Spitball.* 1961. Steel, 11′6″ × 14′ × 14′. Paula Cooper Gallery, New York City. [456] TONY SMITH. *Smug.* 1973. Full-scale wood mock-up. 11 × 78 × 64′. Paula Cooper Gallery, New York City.

Tony Smith provided some rare evidence that the process of developing a spatial discipline for geometric sculpture can be nourished by a literary source. Without his own admission, no one would have ventured to suggest that there is a cohesion between the *Grace-Hope* sculpture (1961) and James Joyce's *Finnegan's Wake.* Smith was a great reader of Joyce's works, which presumably had also something to do with their similar Jesuit training and attitudes of life.

Smith was mentally mature and a complete personality when he began to master the disciplines of sculpture. He expressed the sources of his creativity in the following lines: "I suppose that at a very deep level I am not entirely able to summon, they have a kind of eroticism. And there is something erotic in all my work."[93] This brings us closer to his devious fusion of geometry, architecture, myth, and language, as evident in such titles as *Smug* [456], *Smog,* and *The Snake Is Out. Smug* is almost his last design in wood for execution in steel (1973), a sequel to two versions, one noncomposite and horizontal (1969), the other consisting of two corresponding parts that grip one another and determine the rhythm of an undulating articulation, clearly constructed in sections.

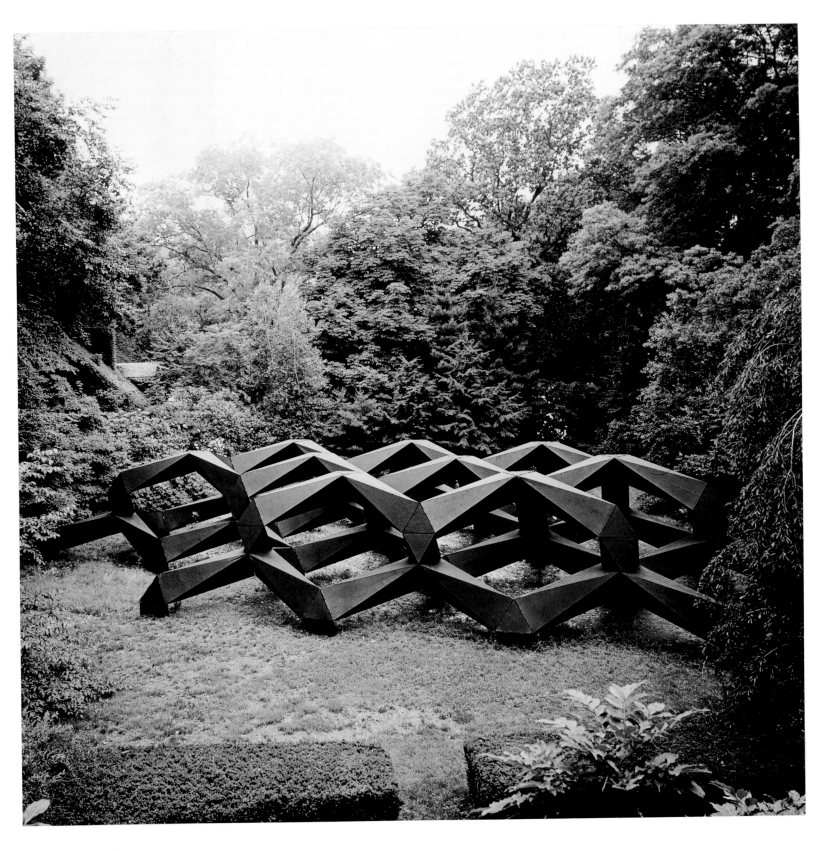

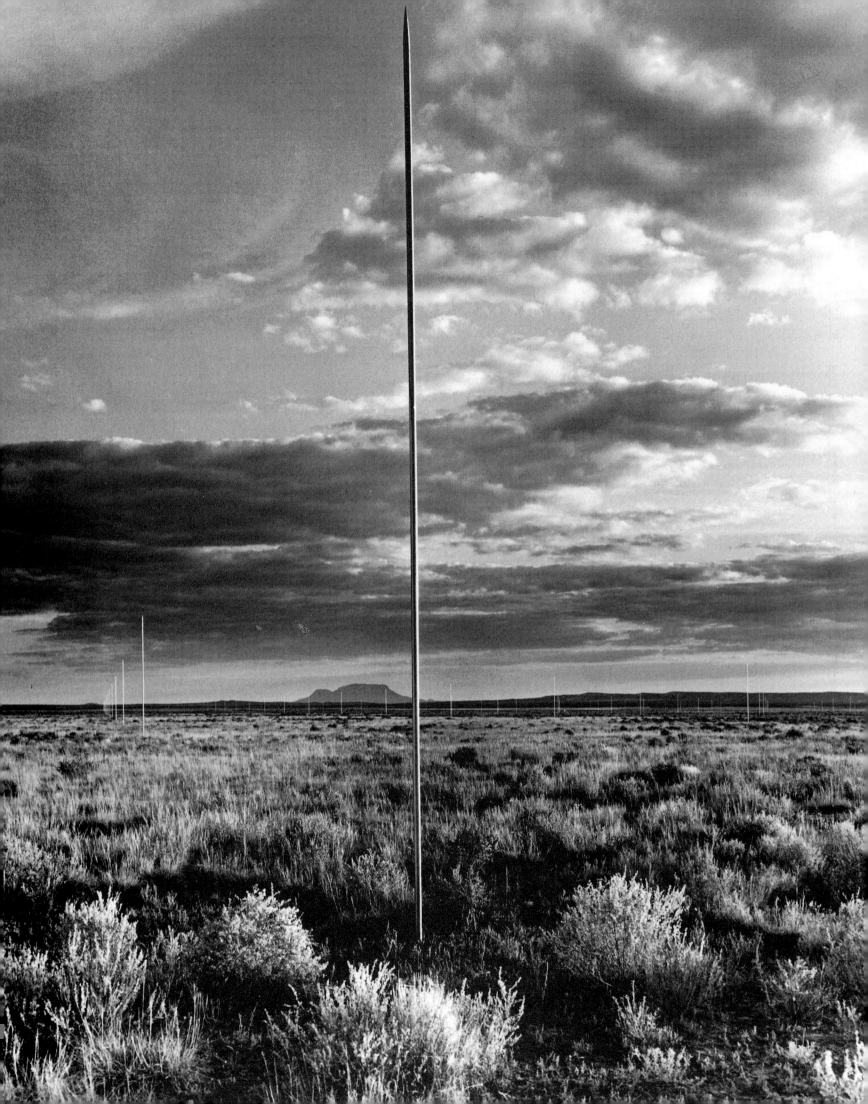

[457] WALTER DE MARIA. *The Lightning Field* (detail). 1971–77. New Mexico. DIA Foundation. [458] WALTER DE MARIA. *Large Rod Series: Circle/Rectangle 7.* 1986. Stainless steel, seven-sided rods, length 69⅝". Private collection.

Walter de Maria (born 1935) created his *Box* about 1961, when Tony Smith's *Black Box with Cubes* was also shown. De Maria's vertical and predominantly horizontal geometric conceptions, which are rigorous abstractions (*The Box*), were in part foreshadowed by *Walls in the Desert* (including a dried-up lake in Nevada). His recent large work for Rotterdam's Museum Boymans-van Beuningen (1984) again raises questions about the source of De Maria's sense of space and spatial imagination, himself referring to Euclid. To the artist, the equivocal name *The Desert* is after all merely a global indication of his source and does not convey anything about the nature and quality of his reactions to it. His sensitivity to locations (the Mohave Desert in New Mexico, Nevada, but also museums and galleries), as well as his sense of a "Genesis" atmosphere, must be regarded as being in harmony with an abstract spatial imagination that requires a rare precision [457]. Here again the Minimalist-Conceptual label is an impediment to experiencing the intrinsic unity of De Maria's complex spatial ideas.

The work produced at Rotterdam in 1984, with the hermetic name *A Computer Which Will Solve Every Problem in the World*, consists of seventy-five stainless steel bars cut into equal lengths of one meter and laid out in ten rows, each one slightly longer than the next. Only the cross sections vary between three and twelve centimeters in polygons. The act of looking at it, I concluded, soon became dominated by an urge to detect the layout scheme and by the metamorphosis affecting the

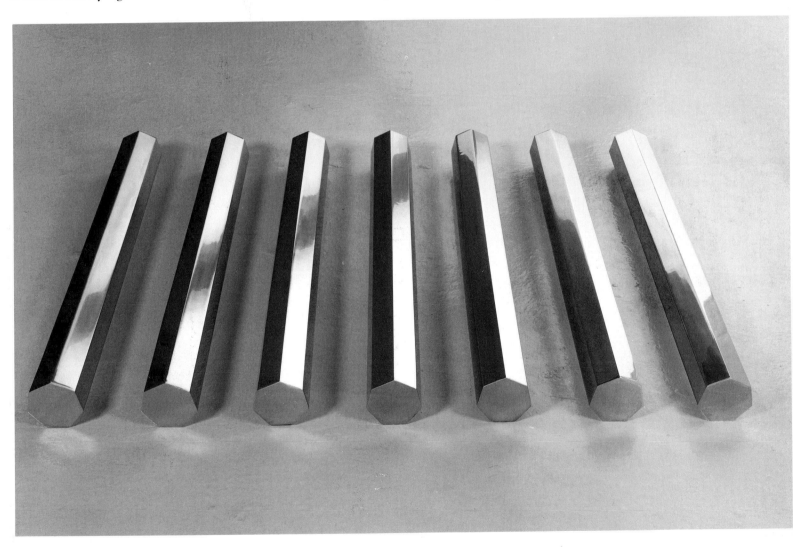

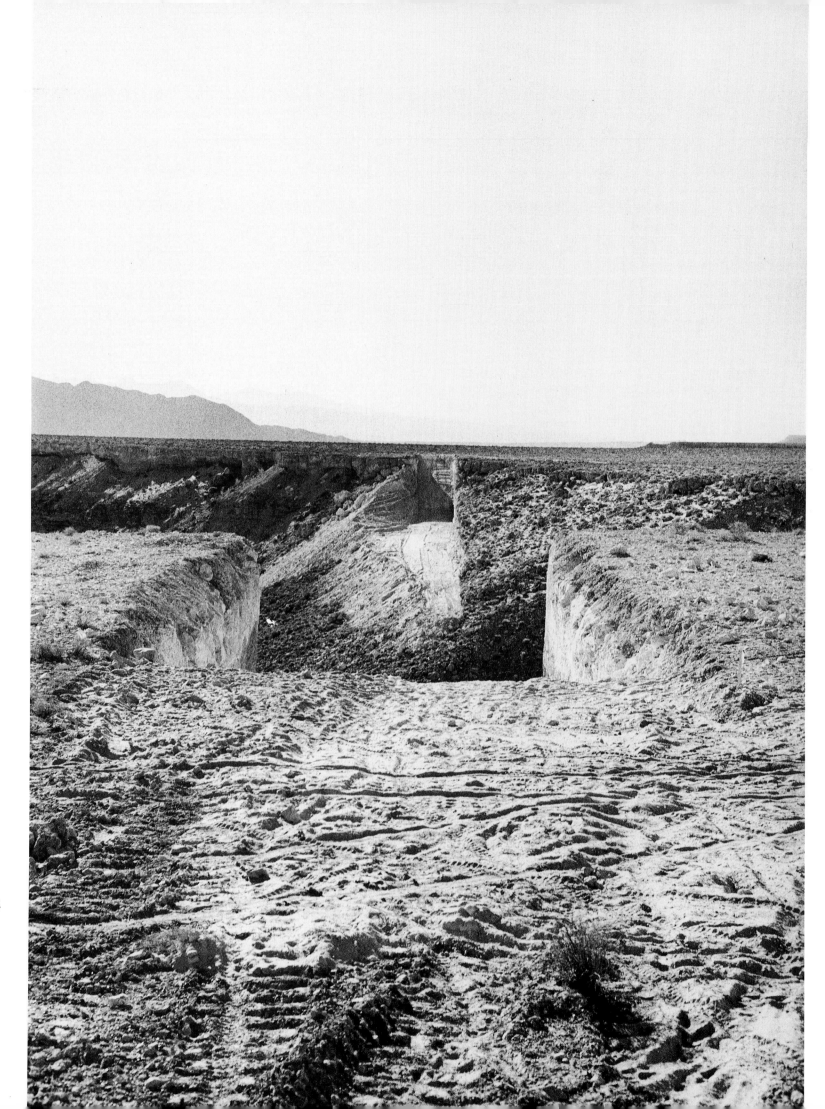

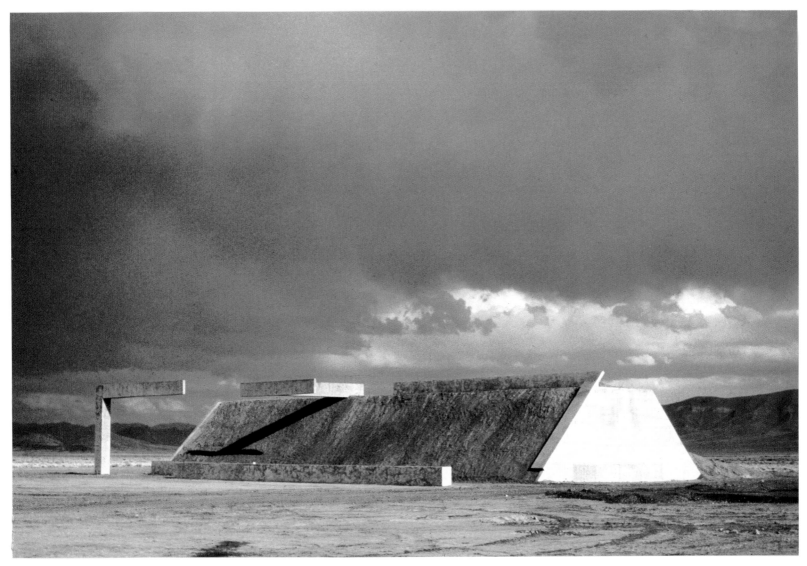

[459] MICHAEL HEIZER. *Double Negative*. 1969. 40,000 tons displaced 1,100 × 42 × 30′. Virgin River Mesa, Nevada.

[460] MICHAEL HEIZER. *The City-Complex One*. 1972–76. Earth mound with concrete framing, height 23½′, width 140′. South Central Nevada.

floor itself. During this process of mental viewing, the total area—walls, ceilings, height—acquired a serenity that aroused a half-rational, half-irrational joy of contemplation, an indefinable sensation. This kind of abstraction did not exist in this manner in the days of Mondrian, when "exact" was different. In the 1960s, this value, neither purely geometric nor purely conceptual, was occasionally achieved. De Maria's former lines became stripes, his stripes became bronze or steel bars, and these,

relating to one another like recreated matter, open up a space [458]. Previous manipulations with earth, used either for surfaces in a geographic space or as a mass in a gallery, constituted a primitive method of proceeding from earth as a substance to an abstraction.

Although his work is exhibited more frequently than that of others, Michael Heizer (born 1944) is not unique among artists in making things far from easy for his critics, including artists, as a result of his unpredictable changes from discipline to discipline and from technique to technique. His work includes paintings, sculpture, etchings, and projections. He started his Earthworks in 1968 [459, 460], with four illustrations in *Ars Povera*.[94] He is well known for his elliptical way of expressing himself, for his petulance and often scarcely defensible pronouncements, such as "sculpture is a study of materials." This

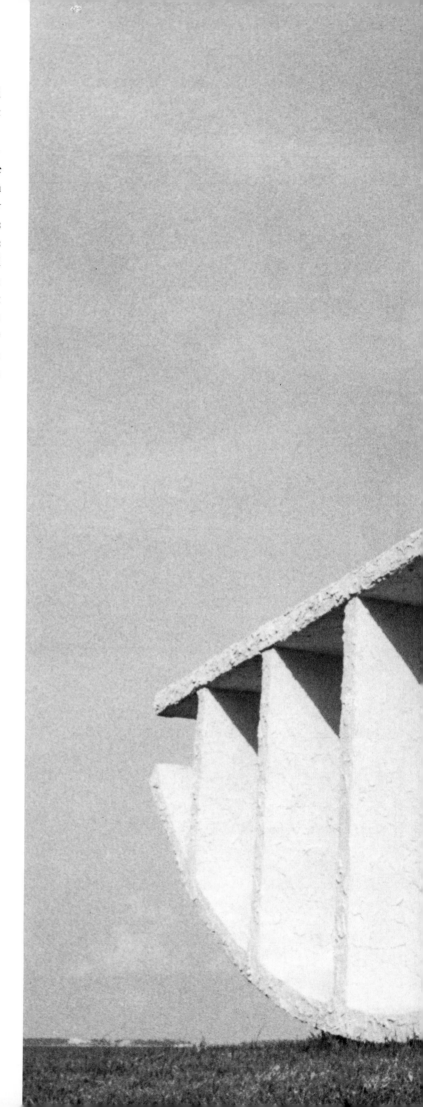

[461] WILLIAM TUCKER. *The Promise*. 1982. Concrete, stucco, and steel, 114″ × 31′ × 41″. Collection Martin Z. Margulies, Coconut Grove, Florida.

statement is untenable as a generalization and merely contends that he is "more interested in the structural characteristic of materials than in their beauty." Explosively, emotionally, his work reveals an artistry that shares his generation's fundamental problems. On reflection, he is an expressionist who, to avoid the designation, creates order in his paintings. Despite all the theories about eliminating expression and individual characteristics, Heizer's psychic structure is detectable in his technical solutions to problems; his childhood with an archaeologist father was presumably significant. Ellen Joosten rightly alludes to this in her essay "Displaced—Replaced."[95] At all events, I regard Heizer as a late and strong example of an artist with an awareness of space, a spatial dizziness that could only develop in boundless geographic spaces —boundless being correct only in contrast to confined surroundings. On that basis only, we may assume that the spatial experience has become a decisive factor for him in the long term, even in the limited production of objects and paintings. His inversion of forms, and his discovery and handling of emptiness, vacuums, and voids, were the result of powerful sensations scarcely covered by the inadequate nuances of our terminology.

William Tucker (born 1935) has lectured and written about his work. Early examples are found in the period, starting about 1966, when for about a decade *The Studio International* provided a remarkable forum where critics and artist-writers created an awareness among themselves and their readers of ideas that had not yet crystallized. Tucker described his views and orientation in *The Language of Sculpture*.[96] Presumably he wished to stand aloof as a writer from the American researches of his age group and contemporaries. He appears to have affinities to Rodin, Degas, Brancusi, Gonzalez, Picasso, Duchamp (not the sculptor Duchamp-Villon), Matisse, and the architect Rietveld; there is not a word about English artists such as Epstein, Moore, Hepworth, Caro, and King. Although Tucker moved to America, he took also an independent and, to me, special ambience with him. His technique, including that of his drawings, is impressive as the basis for a monumentality and simplicity that indicate a complex, restrained expressiveness— quite a rare phenomenon these days. He is unafraid of closed volume in abstractions, unafraid of modeling; there is neither true rectilinearity, nor linear geometry, nor stereometry in his works. His fleshed-out abstractions control a sensuality, with animal elements, in his heavy, powerful constructions. Something in them is reminiscent of the backs

426

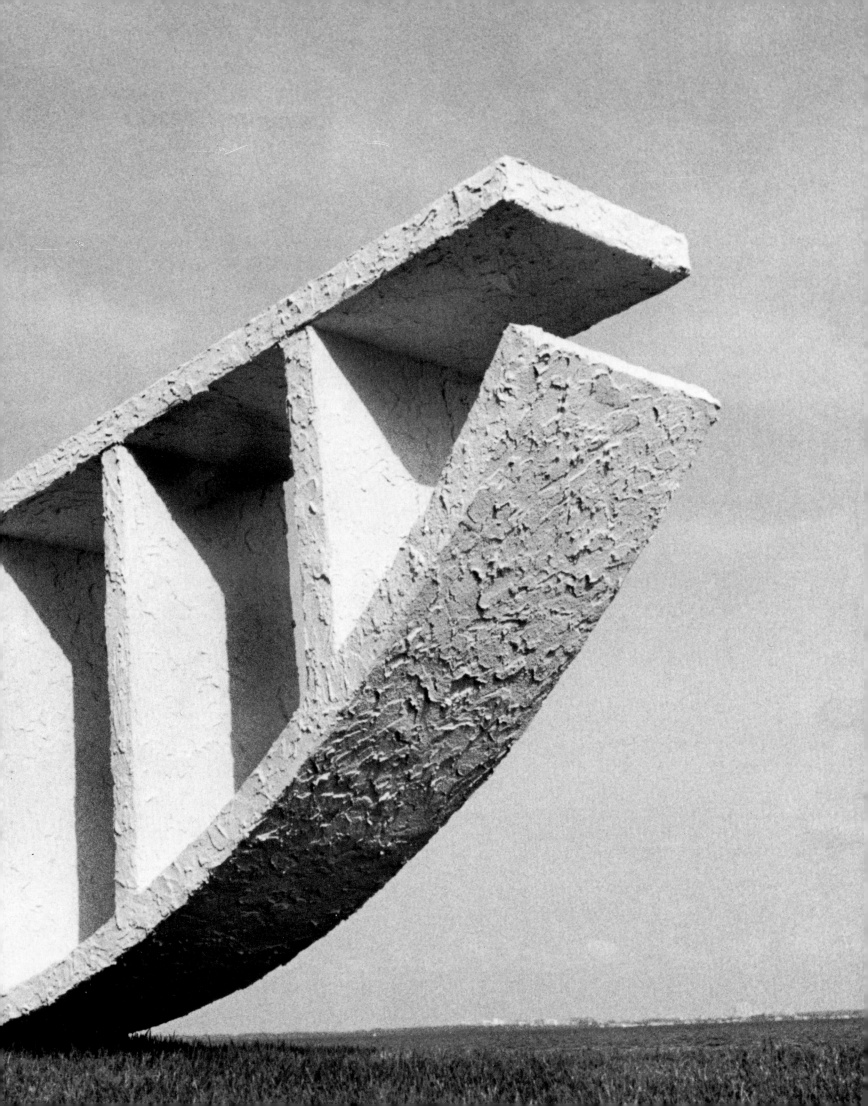

[462] MARTA PAN. *Patio Fountain Water Wall*. 1980–82. Granite wall, 66 × 23'. Champs Elysées, Paris.

in Matisse's bronze reliefs [101–103]. His works are monoliths, evoking deep spatial tension not bound to an environment, although not closed in on themselves either. His open slender constructions [461] are not linear but have a palpable skeleton; although they have obviously developed away from Moore, something of the latter's sculpture comes through to me. Tucker's work has a great interior force. He thus holds on to something of great worth in sculpture of public commissions.

Fountains and the New Concepts of Space

The revival of sculptural commissions for public purposes was bound to return to the ancient, but conventional, theme of fountains. Some recent examples will complete my tour. What could provide a better conclusion than the element of water, which, as far as spatial researches were concerned, inspired artists to create fountains or simply use water as a space element [463].

Marta Pan, as we have already seen (p. 273), made her bipartite sculpture an essential part of site architecture in Otterlo (design by Bijhouwer). Water was conceived as a supporting element, and this had a far-reaching effect on the layout of the modest lake and several paths, which were also designed by Marta Pan, in association with the architect André Wogensky.

When a fountain was to be included in the scheme for a new arcade in the Champs Elysées in Paris, and the fire service authorities unexpectedly disapproved of its flow, Marta Pan saw the water's function as vertical, a mighty cascading curtain guided by a rear wall of hard granite, slightly undulating with an accentuated rib [462]. The reascending water is conducted artificially, sometimes accompanied by music by Pierre Boulez. The dynamic rushing water and impressive wall create a grandiose spectacle in this commercial, mundane arcade.

In Duisburg, Germany, the Dutchman André Volten (born 1925) produced for a city fountain a scheme that was free from architectonic links but showed his sensitivity to the site's qualities, or lack of them. The composition consists of cylinders, pure, simple, and abstract, as he has used ever since he began producing his own "things" with soldering techniques early in 1950. These "things" turned out to be globes, cubes, semicircles, curves, and cylinders. In a former cattle market, now a parking place in Utrecht [465], he designed a four-group sculpture that creates an intensive interplay between verticality (tall thin columns) and horizontality.

Pol Bury (born 1922) was given an almost sacred site in the center of

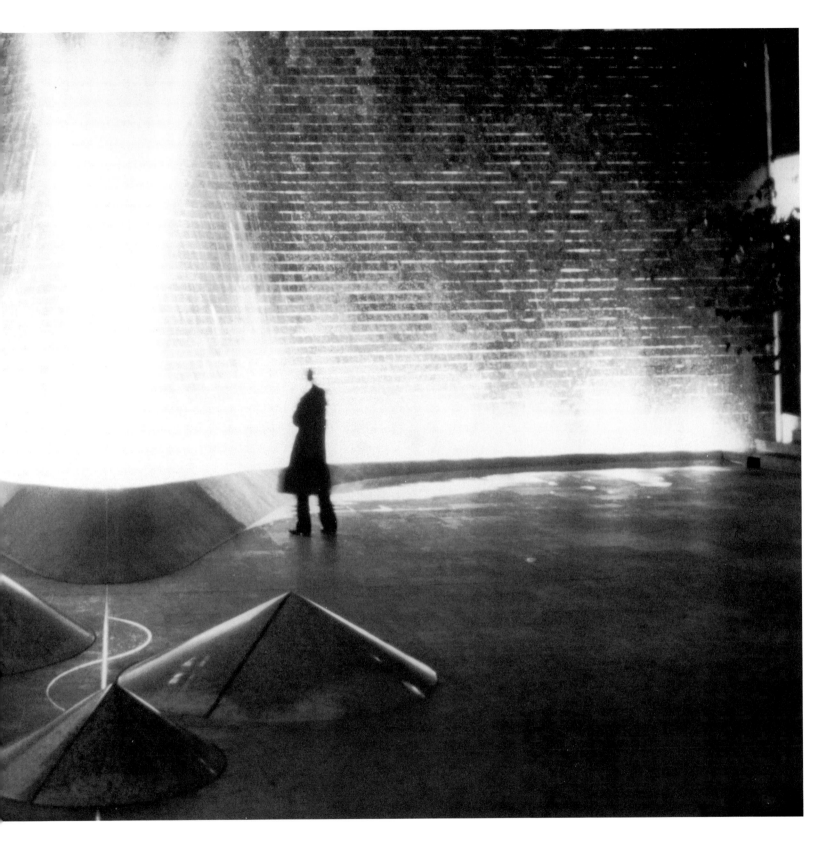

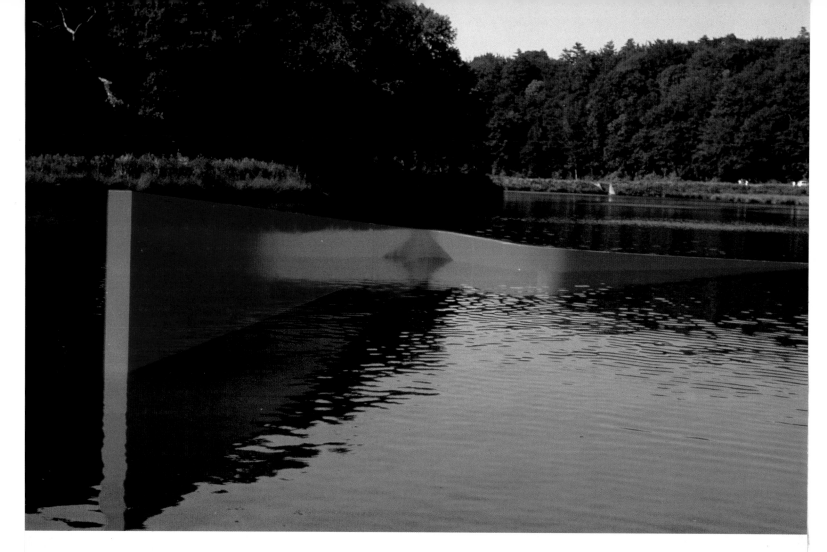

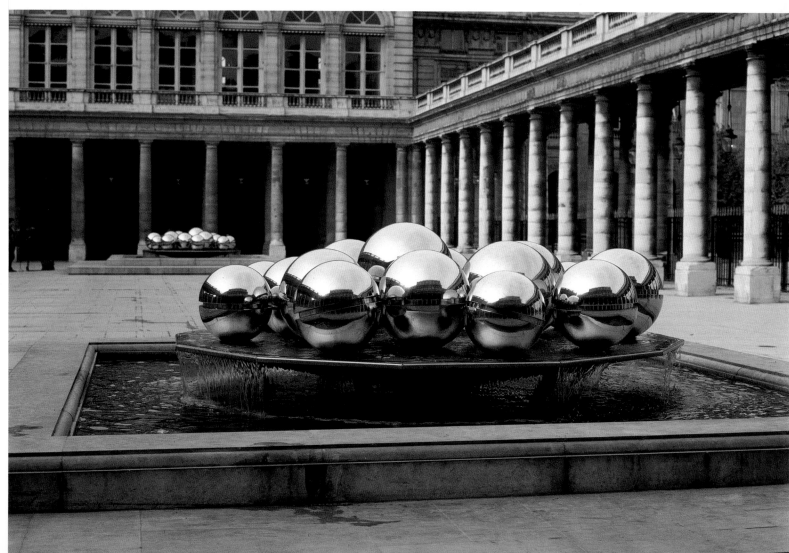

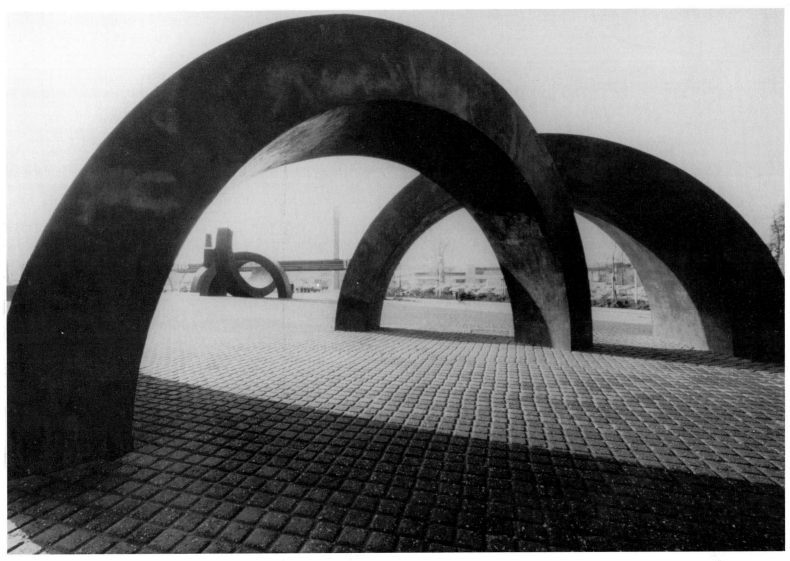

[463] MARTA PAN. *Floating Sculpture.* 1986. Polyester, 66'. Domaine de Kerguehennec, France. [464] POL BURY. Fountains in the Palais Royal, Paris. 1985. [465] ANDRÉ VOLTEN. Forecourt with column and stainless steel sculptures. 1980–82. Utrecht.

Paris, the courtyard within the severe architecture of the Palais Royal [464], where there were two basins from the days of André Malraux on which he had to base his *boules* composition. Dore Ashton wrote: "In most of the struggles, Bury, I believe, takes the part of the bowl."[97] It is true that other official commissions proceeded not without struggles. Bury solved his problem by using semispheres, different in scale, and together forming a low-level composition with the distorting mirroring surfaces; these are constantly moving in relation to each other. The

static columns become an impermanent image of life, labile and unstable (evoking Piranesi), involving sky and clouds in an interplay of movement. The water wells up and flows quietly back over the rim. This polyphony requires great attention to detail and creates the sensation of living on the edge of a threatening earthquake.

In his youthful days, Bury, with his nervous introverted tensions, took a seemingly silent part in Iris Clert's exciting activities along with Jean Tinguely and Yves Klein. Tinguely and Niki de Saint Phalle, who have already been considered in some detail, must be mentioned again as the joint creators of the fountain group *Homage to Stravinsky* (1983). It consists of some basic motifs from the work of the two artists, who have often collaborated. The fountain is old-fashioned in that it spouts. Situated in Paris between the facade of the Centre Pompidou and the

431

Gothic church of St. Merri, the group with its many figures provides a colorful sight, recalling twirling conjurors, acrobats, fire eaters, and fortune-tellers—folklore halfway between culture and religious faiths and close also to the musical experiments of Pierre Boulez in his underground institute. The large fountain involves a witty concentration of "site-defining" factors unlike anything else in Paris.

Final Reflections

In the search for the identity of sculpture, the problem arises of reorientation in a universal space which, while concretizing and articulating, resolves itself into spaces and segments. Initially there is an incomprehensible and indefinable reality which, with a new articulation, an unwritten grammar, creates an intelligibility, an order, an enhanced clarity, without density.

This is neither a conclusion nor the evasion of a conclusion: it is the resonance of several moments in post-1960s sculpture. More than any time since Cubism, Futurism, and Constructivism, some experiments were simply sprung upon us and gained hold of the spectator. Discussions among artists replaced all critical guidance. My tour turned out to be an approach to spaces created consciously in a number of artists' minds. It was an approach which, as far as sentiment was concerned, became somewhat euphoric. There are moments that pass, are repeated, recalled, and, without becoming associated with any specific works or personalities, give one a feeling of participating in an amazing sense of space brought about by sculpture. As a result of my most recent encounters with sculpture, Castel del Monte [466], the mysterious castle with its massive cylindrical towers, built by Emperor Frederick II in Apulia in the thirteenth century, has become in my memory, by its situation and appearance, one of the finest examples of sculpture in a landscape setting.

Unity, coherence, collective possession of space in a form that gives a figure and a face to man and his emotions, thoughts, and sufferings as these were known in the eighteenth and nineteenth centuries, from the time of Houdon, Carpeaux, and Rude, up to Rodin—all this seems to have been eliminated (temporarily?) in favor of a new freedom. Occasionally there have been some exceptional instances of filiation in the twentieth century since Rodin. Some sparks of smouldering tradition have already flared up. When the generations born after 1930 carried out the great work of making sculpture totally open, with all the attendant risks of destroying disciplines, this was not only a problem of form but chiefly an inward and outward exploration of space. Freedom erupted in all directions in a manner that Cubists and above all Futurists had foreseen but had not achieved. They wrenched loose foundations here and there without causing structures and architecture to collapse. The freedom that brought openness had beguiled sculptors into an idea of personal freedom, which could not possibly be included in the values that had been acquired up to approximately 1960. In other words, history was considered to be temporarily in abeyance. Zero was of course an illusion. The discovery of affinities in the reversed historical sequence of cultural and stylistic periods ultimately led to prehistory; sculpture was reassessed, without any concern for matters of style. A large-scale anatomical and analytical search for the basics of sculpture inevitably ended with limitations. Space ideas were formulated and led to a revision of the grammar of sculpture. Mathematics of spatial scale were introduced and structures were revised. Research on new techniques relating to materials and other devices time and again opened up briefly impersonal, objective experiments.

It may be considered suspect to bring in also the subject of literature. Suspicion is allayed, however, as soon as we recognize that the many space experiments were not only a source for sculpture but also for literature, not, it is true, as an interpretation, but as an autonomous formulation of spatial sensations hitherto unexplained in the realm of letters. When, for reasons unconnected with sculpture, I read Henri Michaux's description—partly as a result of his deliberate drug-taking—of his longing to "reveal the complex mechanisms which make man above all an 'operator,'"[98] then there is no doubt that he was trying to describe "despoliation by space." Michaux opened up a new area of experience. Rereading what sculptors had written, I found corresponding passages in Michaux: "The space was permanent but not unchanging. In fact it was changing all the time. Spaces beyond this space reformed, spaces which after some time generated other spaces, and so on. The space did not meet with any response but responded to the essential, to everything. . . . One receives space as a purification. The writer, not knowing in what to believe, received—I can see no other word for it—something like a sacrament, the spatial sacrament."

After her work for Celle (p. 402), the Polish sculptress Abakanovicz used the word "catharsis" to refer to a process that included her work aims. Spatial euphoria, an ecstatic experience without form, without an image; abstraction, cool, geometric, or emotionally vibrant: this is what some sculptors working in America and Europe achieved in the years from approximately 1960 to 1985 in the course of gauging each other's creativity and to the accompaniment of tightly formulated statements about what are, after all, indefinable experiences of space. They longed, romantically, for a new, modern wanderer, a slow one, not the passerby.

432

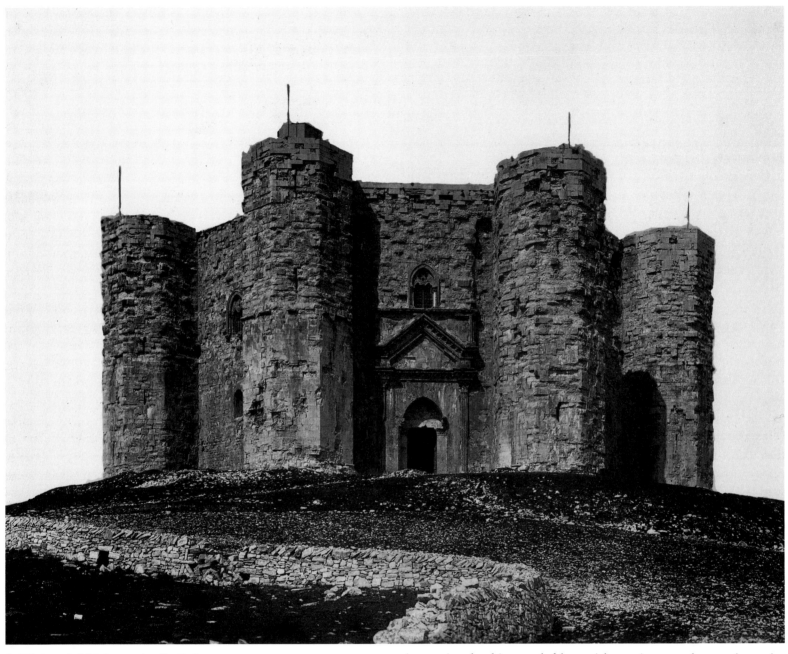

[466] Castel del Monte, Apulia, Italy.

They themselves were walkers. They wrote for themselves and forgot that for reading, as well as for seeing, the spectator required a discipline calling for a greater diversity of consciousness if it were to stimulate the resonance, the reflection that the post-1960s sculptors needed—and still need—in order to live.

Reading what Georges Perec (1936–82) had to say, I cannot avoid the impression that his remarkable spatial experiences and researches—the antitheses of Michaux's—were attuned to the sculptors' concerns. Perec mentions everything: cities, fields, city districts, rooms, parks, streets, staircases, architecture (but neither sculpture nor townscapes), pyramids, and paintings. While perusing all this, I decided that my reflections about Perec's spaces and voids seemed absorbed by a recognition of what I had experienced over the years when looking at sculpture, sometimes with aversion, sometimes with too much pleasure in the case of

433

work by epigones, and now and again with a sense of tremendous revelation. When Perec evokes, but does not describe, uninhabitable, unusable space, space not designed for any purpose, then it is not an abstraction but a concretion of what is void, not filled with anything, a kind of inorganic existence. In *Espèces d'espace* Georges Perec writes of "a useless space." "I have always tried to think of an apartment in which there would be a useless room, absolutely and quite deliberately unusable. It would have been a space without a function, it would not have served any purpose, nor would it bear any relation to anything. . . . A space without a function, not without a precise function but simply without one; not plurifunctional—anyone can do that—but non-functional. . . . I wanted neither the unusable, nor the unused, but the non-usable."[99]

During a fruitless search, Perec's mind reeled from reading Jorge Luis Borges: he remembered Borges's novella "The Immortal," as well as René Magritte, Pieter Saenredam's church interiors, and a house without a door by Frank Lloyd Wright. This kind of text is concerned with sensitivity and the mental systematics from which things, such as Judd's series of open aluminum or wooden boxes, were derived before he used sophisticated tinted materials to make them look attractive. Tony Smith's emotional and obsessive spatial vision, which gave rise to his cubes, a few other site artists evoking space essence, different from those striving for autonomy above all else, are close to Perec's experiences.

The evolution from 1960 up to the present day has also developed the dangers of site preponderance through an excess of open-air sculpture. Serra, who has now come closer to consolidating the abstract experience, also proved to have the critical awareness of the situation in which autonomous sculptors, using abstraction, simple materials, and space, must reduce a site's significance in order to maintain the strength of the autonomous. As part of these open-space revelations, let me mention the periphery of freedom and overstepping the limits. Since Tinguely's audacious and increasingly profound contributions, the element of play has been subject to all kinds of minor deviations, which are libertine carryings-on rather than experiments. (In the case of British artists such as Armitage and Barry Flanagan, this "fun" aspect was less a matter of principle.) Perec too was aware of play and space ("jouer avec l'espace"). Ironical and genuinely jocose, he added to his *Espèces d'espace* a section on his amused preoccupation with figures in a cosmic context and also with distances and sizes. In the course of his reflections, he gives advice about living: "In doing so, forget about the verticals and horizontals."

Finally, there was a special development in the relationship between sculpture and nature, particularly in Britain (Nash and others) and starting with Alan Sunfist in New York, who also wrote about principles in "Art in the Land." The discovery of forests, prehistoric tent experiments, and contemporary stylization of trees and shrubs sited in gardens and landscapes, shows a modernistic growth, but these are essentially sidetracks. Sometimes with a nostalgic dream of nomadic life, travelers in undefined spaces are open to imagined mixtures of past and present. Everywhere in museums and gardens where we might find a Mario Merz sculpture, we feel with pleasure how the title of one of his works, *My Home's Wind*, adds a symbolic fragrance to the amazing world of modern sculpture. Whatever we may come upon, past and present activities of sculptors have given the twentieth century a confidence that is an enduring hallmark of its artistic production.

Notes

1. Charles de Tolnay, "'Michelange dans son atelier' par Delacroix," *Gazette des Beaux-Arts*, Jan. 1962, pp. 43–52.
2. Joseph Gantner, *Schicksale des Menschenbildes, von der Romanischen Stilisierung zur modernen Abstraktion*, Bern, 1958, p. 105.
3. Jacob Christoph Burckhardt, *Der Cicerone*, Leipzig, 1925, p. 824.
4. Michel Dufet, ed., *Correspondance d'André Suarès et Antoine Bourdelle*, Paris, 1961.
5. Arturo Martini, *Lettere*, ed. Giovanni Comisso, Treviso, 1954.
6. Burckhardt, op. cit., pp. 630–38.
7. Judith Cladel, *Auguste Rodin pris sur le vif*, Paris, 1903.
8. Auguste Rodin, *Cathedrals of France* (Eng. trans. by E. C. Geissbuhler of *Les Cathédrales de France*, Paris, 1914), Boston, 1965, p. 74.
9. Rudolf Wittkower, *Studies in Western Art*, Vol. III, Princeton, 1963.
10. A. M. Hammacher, *Jacques Lipchitz: His Sculpture*, New York, 1960, p. 72.
11. *Minotaure*, no. 3–4 (Dec. 12, 1933), pp. 76–77.
12. *Minotaure*, no. 1 (June 1, 1933), pp. 48–52.
13. Rodin, op. cit., p. 78.
14. Ibid., p. 149.
15. Arturo Martini, *La scultura, lingua morta: pensieri*, Verona, 1948.
16. Rodin, op. cit., pp. 10–11.
17. Ibid., p. 146.
18. Ibid., p. 191.
19. Ibid., p. 191.
20. Ibid., p. 57.
21. Ibid., pp. 184–85.
22. Ibid., p. 191.
23. Ibid., p. 195.
24. Ibid., p. 207.
25. Ibid., p. 133.
26. Antoine Bourdelle, *Ecrits sur l'art et sur la vie*, ed. Gaston Varenne, Paris, 1955, p. 89.
27. Ibid., pp. 66–67.
28. Ibid., p. 57.
29. Ibid., p. 50.
30. Ibid., p. 67.
31. Ibid., pp. 11–18.
32. Judith Cladel, *Aristide Maillol: sa vie—son oeuvre—ses idées*, Paris, 1937, p. 97.
33. Alphons Diepenbrock, "Melodie en gedachte" (Melody and Idea), in *Ommegangen*, 2nd ed., Amsterdam, 1924.
34. G. M. A. Richter, *Archaic Greek Art*, New York, 1949.
35. *Tagebücher von Paul Klee, 1898–1918*, ed. Felix Klee, Cologne, 1957.
36. Emil Nolde, *Jahre der Kämpfe, 1902–1914*, Flensburg, 1957, pp. 179–81.
37. John Golding, *Cubism: A History and an Analysis, 1907–1914*, New York, 1959, pp. 55ff.
38. Umberto Boccioni, *Pittura, scultura futuriste*, Milan, 1914, p. 54.
39. Ibid., p. 132.
40. Ibid., pp. 399–400.
41. Ibid., p. 28.
42. Ibid., p. 291.
43. Carola Giedion-Welcker, *Plastik des XX. Jahrhunderts: Volumen und Raumgestaltungen*, Stuttgart, 1955; idem, *Brancusi*, New York, 1959, p. 43.
44. Boccioni, op. cit., p. 406.
45. Ibid., p. 407.
46. Giedion-Welcker, *Brancusi*, p. 13.
47. David Lewis, *Constantin Brancusi*, London, 1957, p. 43.
48. Ibid., p. 43.
49. Robert Rosenblum, *Cubism and Twentieth-Century Art*, New York, 1961.
50. André Salmon, *Propos d'Atelier*, Paris, 1922, pp. 178–81.
51. Alexander Archipenko et al., *Archipenko: Fifty Creative Years, 1908–1958*, New York, 1960, Chap. VII.
52. *Sunday Times*, London, August 23, 1959.
53. Hans Trier, *Jahres-Ring 1955–56*, Stuttgart, 1955, pp. 144–52.
54. Werner Hofmann, *Wilhelm Lehmbruck*, Amsterdam, 1957.
55. Ossip Zadkine, *Voyage en Grèce/Trois Lumières*, Amsterdam, 1955.
56. Salmon, op. cit.
57. Camilla Gray, *The Great Experiment: Russian Art, 1863–1922*, New York and London, 1962.
57a. George Rickey, *Constructivism: Origins and Evolution*, New York, 1967.
58. Charles Biederman, *Art as the Evolution of Visual Knowledge*, Red Wing, Minn., 1948.
59. "Russia and Constructivism," in Herbert Read and Leslie Martin, *Gabo*, London, 1957, p. 156.
60. Henry Moore, "Primitive Art," *The Listener*, London, April 24, 1941.
61. J. P. Hodin, *Barbara Hepworth*, London, 1961.
62. Ibid., pp. 11, 19.
63. Michel Seuphor, *The Sculpture of This Century* (Eng. trans. H. Chevalier), London, 1959, p. 97.

64. Pierre Descargues, *Bourdelle*, Paris, 1954, p. 3.

65. Boccioni, op. cit., p. 313 (quotation from a lecture of 1911).

66. Richter, op. cit.

67. Michel Ragon, *Où vivrons-nous demain?*, Paris, 1963.

68. Susanne K. Langer, *Feeling and Form: A Theory of Art*, New York, 1953, pp. 71, 91.

69. *Cimaise*, no. 65, Paris, 1964.

70. Edouard Jaguer, *Poétique de la sculpture, 1950–1960*, Paris, 1960, p. 66.

71. Werner Spies with Christine Piot, *Picasso: Das plastische Werk*, 2nd ed., Stuttgart, 1983.

72. Pierre Restany, *Les Nouveaux Réalistes*, Paris, 1968.

73. Michel Tapié, *Un Art autre*, Paris, 1952.

74. Michael Fried, *Anthony Caro*, catalogue, London, 1969.

75. Clement Greenberg, *Art and Culture*, Boston, 1961, p. 204.

76. Anthony Caro, interview with Lawrence Alloway, London, *Gazette No. 1*, 1961.

77. Isamu Noguchi, *A Sculptor's World*, London, 1962.

78. Ibid., p. 40.

79. Daniel Abadie, *Fasciente Arte*, catalogue XXXI, Paris, 1981, p. 92.

80. See Robert Morris, p. 396.

81. Richard Wollheim, *S. Freud: The Unconscious and the Ego*, London, 1971, p. 167.

82. *Machines de Tinguely*, catalogue, Paris, 1971.

83. Charles Goerg and Rainer Michael Masson, *Parole d'artiste*, catalogue, Geneva, 1976.

84. *Jannis Kounellis*, catalogue, Rotterdam, 1977.

85. Rudi Fuchs, *Jannis Kounellis*, catalogue, Eindhoven, 1981.

86. Interview with Karavan, *Scultura*, No. 13, Milan, 1978.

87. Matila C. Ghyka, *Les Rythmes—les rites*, Paris, 1931.

88. Magdalena Abakanovicz, *International Sculpture*, No. 2, Washington, 1985, p. 24.

89. Paul Cummings, *Serra*, catalogue, Washington, 1979.

90. Sydney Laurens and George Foy, *Music in Stone: Great Sculpture Gardens of the World*, New York, 1984.

91. Sol LeWitt, *Wall Drawings 1968–84*, catalogue, Amsterdam, 1984.

92. Mario Monteverdi, ed., *Italian Art to 1850*, New York, 1965, pp. 159–60.

93. Martin Friedman and Lucy Lippard, *Tony Smith*, catalogue, New York, 1971.

94. Michael Heizer, "Minimal/Conceptual," *Ars Povera*, 1969.

95. Ellen Joosten, "Displaced—Replaced," *Michael Heizer*, catalogue, Otterlo-Essen, 1979.

96. William Tucker, *The Language of Sculpture*, London, 1981, reprint.

97. Dore Ashton, *Pol Bury*, Paris, 1970, p. 43.

98. Henri Michaux, *Les Grandes épreuves de l'esprit*, Paris, 1966, pp. 119–23.

99. Georges Perec, *Espèces d'espace*, Paris, 1974, pp. 47–49.

Artists' dates are given in the text. Since 1969, when the first edition was published, the following persons have died: Ilya Bolotowsky (1907–81); Marcel Breuer (1902–81); Reg Butler (1913–81); Alexander Calder (1898–1976); Wessel Couzijn (1912–84); Jean Dubuffet (1901–85); Max Ernst (1891–1976); Naum Gabo (1890–1977); Alberto Giacometti (1901–66); Walter Gropius (1883–1969); Erich Heckel (1883–1970); Barbara Hepworth (1903–75); Oscar Jespers (1887–1970); Oskar Kokoschka (1886–1980); Henri Laurens (1885–1954); Jacques Lipchitz (1891–1973); Marino Marini (1901–80); Robert Melli (1885–1958); Henry Moore (1898–1986); Ben Nicholson (1894–1982); Pablo Picasso (1881–1973); Karl Schmidt-Rottluff (1884–1976); Graham Sutherland (1903–80); Hans Uhlmann (1900–75); Fritz Wotruba (1907–75).

Selected Bibliography

GENERAL WORKS

ARNASON, H. H. *History of Modern Art.* 3d ed. New York, 1986.

ASHTON, DORE. *Modern American Sculpture.* New York, 1968.

BEAL, GRAHAM, et al. *A Quiet Revolution: British Sculpture since 1965.* London, 1987.

BEARDSLEY, JOHN. *Earthworks and Beyond: Contemporary Art in the Landscape.* New York, 1984.

BURNHAM, JACK. *Beyond Modern Sculpture: The Effects of Science and Technology on the Sculpture of This Century.* New York, 1968.

CELANT, GERMANO. *Art Povera.* New York, 1969.

DAVAL, JEAN LUC, and RESTANY, PIERRE. *L'Art et la ville: urbanisme et art contemporain.* Paris, 1986.

Deutsche Kunst seit 1960. Catalogue. Munich, 1985.

DE VRIES, GERD ed. *Über Kunst—On Art.* German-English edition of statements by artists. Cologne, 1974.

The Donald M. Kendall Sculpture Gardens at PepsiCo. Purchase, New York, 1986.

EINSTEIN, CARL. *Die Kunst des 20. Jahrhunderts.* Rev. ed. Berlin, 1931.

ELSEN, ALBERT E. *Modern European Sculpture 1918–1945: Unknown Beings and Other Realities.* New York, 1979.
———. *Origins of Modern Sculpture: Pioneers and Premises.* New York, 1974.

GIEDION-WELCKER, CAROLA. *Contemporary Sculpture: An Evolution in Volume and Space.* Rev. ed. New York, 1961.

GOHR, SIEGFRIED. *Museum Ludwig, Köln.* Catalogue. Munich, 1986.

HAMMACHER, A. M. *Modern English Sculpture.* New York, 1966.

HIBBARD, HOWARD. *Masterpieces of Western Sculpture from Medieval to Modern.* New York, 1977.

HOFMANN, W. *Die Plastik des 20. Jahrhunderts.* Frankfurt-am-Main, 1958.

JANSON, H. W. *Nineteenth-Century Sculpture.* New York, 1985.

JOACHIMEDES, C. M., et al., eds. *German Art in the Twentieth Century: Painting and Sculpture, 1905–1985.* Catalogue. London. 1985.

KRAMER, HILTON. *The Art of the Avant-Garde: An Art Chronicle of 1956 to 1972.* New York, 1973.

KRAUSS, ROSALIND E. *Passages in Modern Sculpture.* New York, 1977.

KULTERMANN, UDO. *The New Sculpture: Environments and Assemblages.* New York, 1968.

LAURANCE, SIDNEY, and FOY, GEORGE. *Music in Stone: Great Sculpture Gardens of the World.* New York, 1984.

LÉVY, FRANÇOISE P. *Anthropologie de l'espace.* Paris, 1984.

LICHT, FRED. *Sculpture: 19th and 20th Centuries.* Greenwich, Connecticut, 1967.

MARCHIORI, G. *Modern French Sculpture.* New York, 1963.

MICHAUX, HENRI. *Les Grandes épreuves de l'esprit.* Paris, 1966.

Modern Sculpture from the Joseph H. Hirshhorn Collection. Catalogue. New York, 1962.

NAIRNE, SANDY, and SEROTA, NICHOLAS. *British Sculpture in the Twentieth Century.* Catalogue. London, 1981.

NASH, STEVEN A., ed. *A Century of Modern Sculpture: The Patsy and Raymond Nasher Collection.* New York, 1987.

LE NORMAND-ROMAIN, A., et al. *The Adventure of Modern Sculpture in the Nineteenth and Twentieth Centuries.* New York, 1986.

NEUBERT, G. W. *Public Sculpture/Urban Environment.* Catalogue. Oakland, California, 1974.

PAN, MARTA, et al. *Sculptures for Public Places.* Tokyo, 1984–85.

PEREC, GEORGES. *Espèces d'espace.* Paris, 1974.

POPPER, E. *Origins and Development of Kinetic Art.* Greenwich, Connecticut, 1968.

RAYMOND, HENRI. *L'Architecture: les aventures spatiales de la raison.* Paris, 1984.

READ, HERBERT. *Modern Sculpture.* London, 1964. Reprint 1985.

RESTANY, PIERRE. *Les Nouveaux Réalistes.* Paris, 1968.

ROBINETTE, MARGARET A. *Outdoor Sculpture: Object and Environment.* New York, 1976.

ROWELL, MARGIT. *Sculpture in the Twentieth Century.* Catalogue. New York, 1986.

SALVINI, ROBERTO. *Modern Italian Sculpture.* New York, 1962.

SEITZ, W. C., ed. *Contemporary Sculpture (Arts Yearbook 8).* New York, 1965.

SELZ, J. *Modern Sculpture: Origins and Evolution.* New York, 1963.

SEROTA, N. *Transformations: New Sculpture from Britain.* London, 1983.

SEUPHOR, MICHEL. *Sculpture of This Century.* New York, 1960.

SMITH, EDWARD LUCIE. *Art in the Seventies.* Oxford, 1980.

STERN, H. PETER, and COLLINS, DAVID. *Sculpture at Storm King.* New York, 1980.

SUNFIST, A., ed. *Art in the Land: A Critical Anthology of Environmental Art.* New York, 1983.

TRIER, EDUARD. *Form and Space: Sculpture of the Twentieth Century.* Rev. ed. New York, 1968.

TUCKER, WILLIAM. *Early Modern Sculpture.* New York, 1974.

WALDMAN, DIANE. *Transformations in Sculpture: Four Decades of American and European Art.* Catalogue. New York, 1985.

WORKS ON ARTISTS

ABAKANOVICZ
JACOB, MARY JANE, et al. *Magdalena Abakanovicz.* New York, 1982.

AESCHBACHER
FISCHLI, H., and SEUPHOR, M. *Hans Aeschbacher.* Neuchâtel, 1959.

ANDRE
BOURDON, D. *Carl Andre: Sculpture, 1959–1977.* New York, 1978.

WALDMAN, DIANE. *Carl Andre.* Catalogue. New York, 1970.

ARCHIPENKO
ARCHIPENKO, A., et al. *Archipenko: Fifty Creative Years, 1908–1958.* New York, 1960.

KARSHAN, DONALD. *Archipenko: Sculpture, Drawings, and Prints, 1908–1964.* Bloomington, Indiana, 1985.

ARP
Arp. Stuttgart, 1986.

GIEDION-WELCKER, CAROLA. *Jean Arp.* New York, 1957.

RAU, B. *Jean Arp: The Reliefs, Catalogue of Complete Works.* New York, 1981.

TRIER, EDUARD, ed. *Jean Arp: Sculpture—His Last Ten Years.* New York, 1968.

BARLACH

CARLS, CARL DIETRICH. *Ernst Barlach*. Rev. ed. New York, 1969.

Ernst Barlach. Catalogue. Cologne, 1975.

SCHULT, F. *Ernst Barlach*, 2 vols. Hamburg, 1958–60.

BASELITZ

Georg Baselitz. Selection of texts. Braunschwaig, 1981.

Georg Baselitz: Skulpturen, Zeichnungen, 1979–1987. Catalogue. Hanover, 1987.

RUSSELL, JOHN. "Georg Baselitz and His Upside-Downs." *New York Times*, April 8, 1983.

BEUYS

ADRIANI, GÖTZ, et al. *Joseph Beuys: Life and Works*. Woodbury, New York, 1979.

TINDALL, CAROLINE. *Joseph Beuys*. Rev. ed. London, 1987.

BILL

HÜTTINGER, EDUARD. *Max Bill*. New York, 1978.

STABER, MARGIT. *Max Bill*. London, 1964.

BOCCIONI

BALLO, GUIDO. *Boccioni: La vita e l'opera*. Milan, 1964.

CALVESI, MAURIZIO, and COLN, ESTER. *Boccioni*. Milan, 1983.

BOURDELLE

BOURDELLE, ANTOINE. *Ecrits sur l'art et sur la vie*. Paris, 1977.

COGNIAT, RAYMOND. *Hommage à Bourdelle*. Paris, 1961.

JIANOU, IONEL, and DUFET, MICHEL. *Bourdelle*. 2d ed. Paris, 1975.

BRANCUSI

GEIST, SIDNEY. *Brancusi*. New York, 1975.

GIEDION-WELCKER, CAROLA. *Brancusi*. New York, 1959.

HULTEN, PONTUS, et al. *Brancusi*. New York, 1987.

BUREN

BUREN, DANIEL. *Travaux Pratiques, Position, Proposition: Entretien*. Paris, 1983.

CLADDERS, H. *Daniel Buren*. Catalogue. München-Gladbach, 1975.

BURY

ASHTON, DORE. *Pol Bury*. Paris, 1970.

Pol Bury: Miroirs et fontaines. Paris, 1985.

Pol Bury: Oeuvres de 1963 à 1978—Arles. Catalogue. Arles, 1979.

CALDER

ARNASON, H. H. *Calder*. Princeton, New Jersey, 1966.

BRUZEAU, MAURICE. *Calder*. New York, 1979.

Calder: An Autobiography with Pictures. London, 1966.

CARANDENTE, GIOVANNI, ed. *Calder*. Catalogue. Milan, 1983.

CARO

Anthony Caro: Catalogue raisonné. 4 vols. Cologne, 1981.

FENTON, TERRY. *Anthony Caro*. New York, 1986.

RUBIN, WILLIAM. *Anthony Caro*. Catalogue. New York, 1975.

WALDMAN, DIANE. *Anthony Caro*. New York, 1982.

CESAR

RESTANY, PIERRE. *César*. New York, 1976.

CHADWICK

Chadwick: Recent Sculpture. Catalogue. London, 1974.

CHAMBERLAIN

SYLVESTER, J. *John Chamberlain: A Catalogue Raisonne of the Sculpture: 1954–1985*. New York, 1986.

WALDMAN, DIANE. *John Chamberlain: A Retrospective Exhibition*. Catalogue. New York, 1971.

CHILLIDA

SELZ, PETER, and SWEENEY, JAMES JOHNSON. *Chillida*. New York, 1986.

CHRISTO

BOURDON, DAVID. *Christo*. New York, 1972.

Christo: Surrounded Islands. New York, 1985.

SPIES, WERNER, and VOLZ, W. *The Running Fence: Christo*. New York, 1977.

CONSAGRA

ARGAN, GIULIO CARLO. *Pietro Consagra*. Neuchâtel, 1962.

LE CORBUSIER (Charles-Edouard Jeanneret)

Le Corbusier et Pierre Jeanneret: oeuvre complète. 6 vols. Zurich, 1937–1957.

LE CORBUSIER. *Towards a New Architecture*. 2d ed. New York, 1946.

GARDINER, S. *Le Corbusier*. New York, 1975.

DAUMIER

Daumier: Sculpteur. Catalogue. 2 vols. Paris, 1979.

WASSERMAN. JEANNE L., et al. *Daumier Sculpture*. Greenwich, Connecticut, 1969.

DEGAS

REWALD, JOHN. *The Complete Sculptures of Degas*. Catalogue. London, 1976.

WILLARD, CHARLES W. *The Sculpture of Edgar Degas*. Princeton, New Jersey, 1976.

DE KOONING

CUMMINGS, PAUL, et al. *Willem de Kooning: Drawings, Paintings, Sculpture*. Munich and New York, 1983.

GAUGH, H. *Willem de Kooning*. New York, 1983.

DE MARIA

MEYER, FRANZ. *Walter de Maria*. Catalogue. Basel, 1972–73.

Walter de Maria. Catalogue. Rotterdam, 1984–85.

D'HAESE

MEURIS, JACQUES. *Roël d'Haese*. Brussels, 1964.

DI SUVERO

Mark di Suvero. Catalogue. New York, 1975–76.

COLLINS, DAVID R., et al. *Mark di Suvero: 25 Years of Sculpture and Drawings*. Mountainville, New York, 1985.

DUBUFFET

FRANZKE, ANDREAS. *Dubuffet*. New York, 1981.

LOREAU, MAX, ed. *Catalogue des travaux de Jean Dubuffet*. 34 vols. Paris, 1964–84.

DUCHAMP

CABANNE, PIERRE. *Dialogues with Marcel Duchamp*. New York, 1971.

CLAIR, JEAN. *Marcel Duchamp: Catalogue raisonné*. Paris, 1977.

SCHWARZ, A. *The Complete Works of Marcel Duchamp*. New York, 1969.

DUCHAMP-VILLON

CABANNE, PIERRE. *The Brothers Duchamp: Jacques Villon, Raymond Duchamp-Villon, Marcel Duchamp*. Boston, 1976.

HAMILTON, GEORGE H., and AGEE, WILLIAM. *Raymond Duchamp-Villon*. New York, 1967.

EPSTEIN

BUCKLE, RICHARD. *Jacob Epstein, Sculptor*. New York, 1963.

Epstein, an Autobiography. 2d ed. New York, 1964.

ERNST

RUSSELL, JOHN. *Max Ernst: Life and Work*. New York, 1967.

SPIES, WERNER, et al. *Max Ernst: Werke 1906–1925*. Cologne, 1975.

———. *Max Ernst: Werke 1925–1929*. Cologne, 1976.

———. *Max Ernst: Werke 1929–1938*. Cologne, 1979.

FAUTRIER

Jean Fautrier. Catalogue. Hamburg, 1973.

RAGON, M. *Fautrier*. New York, 1958.

FONTANA

BALLO, GUIDO. *Lucio Fontana*. New York, 1971.

FONTANA, LUCIO. *Manifesto Tecnico. . . .* Milan, 1951.

VAN DER MAREK, JAN, and GUSPOLTI, ENRICO. *Fontana: Oeuvre catalogue*. Brussels, 1974.

GABO

NEWMAN, TERESA. *Naum Gabo: The Constructive Process*. London, 1976.

READ, HERBERT, and MARTIN, LESLIE. *Gabo: Constructions, Sculpture, Drawings, Engravings*. Cambridge, Massachusetts, 1957.

438

GAUDI

DESCHARNES, ROBERT. *Gaudí, the Visionary*. New York, 1971.

SWEENEY, JAMES J., and SERT, J. L. *Antoni Gaudí*. Rev. ed. New York, 1970.

GAUDIER-BRZESKA

POUND, EZRA. *Gaudier-Brzeska: A Memoir*. London, 1916. Reprint, New York, 1970.

SECRÉTAIN, ROGER. *Un sculpteur maudit*. Paris, 1979.

GAUGUIN

GRAY, CHRISTOPHER. *Sculpture and Ceramics of Paul Gauguin*. Baltimore, 1963.

GIACOMETTI

Giacometti: Sculptures, Paintings, Drawings. Catalogue. London, 1980.

LORD, JAMES. *Giacometti: A Biography*. New York, 1985.

MATTER, MERCEDES, et al. *Alberto Giacometti*. New York, 1987.

GONZALEZ

ROWELL, MARGIT. *Julio Gonzalez: A Retrospective*. Catalogue. New York, 1983.

WITHERS, J. *Julio Gonzalez: Sculpture in Iron*. New York, 1983.

GRECO

HODIN, J. P. *Emilio Greco: Sculpture and Drawings*. Greenwich, Connecticut, 1971.

HEIZER

BROWN, JULIA, ed. *Michael Heizer: Sculpture in Reverse*. Los Angeles, 1984.

FELIX, Z., and JOOSTEN, ELLEN. *Statements: Michael Heizer*. New York, 1979.

HEPWORTH

BOWNESS, ALAN, ed. *The Sculpture of Barbara Hepworth, 1960–1969*. New York, 1971.

HAMMACHER, A. M. *Barbara Hepworth*. Rev. ed. London, 1987.

HESSE

JOHNSON, ELLEN H., ed. *Order and Chaos: From the Diaries of Eva Hesse. Art in America*, Vol. 71, 1983.

LIPPARD, LUCIE R. *Eva Hesse*. New York, 1976.

JUDD

JUDD, D. *Complete Writings, 1959–1975*. New York, 1975.

SMITH, ROBERTA, ed. *Donald Judd*. Catalogue. Ottawa, 1975.

KARAVAN

BROCKHAUS, CHRISTOPH. *Dani Karavan: Ma'alot, Museumsplatz Köln, 1979–1986*. Cologne, 1986.

Dani Karavan: Two Environments for Peace. Florence, 1978.

KEMENY

RAGON, MICHEL. *Zoltan Kemeny*. Neuchâtel, 1960.

Zoltan Kemeny, 1907–1965. Catalogue. Bergamo, 1967.

KOSUTH

KAISER, W. M. H. *Joseph Kosuth: Artworks and Theories*. Amsterdam, 1977.

KOUNELLIS

FELIX, Z., ed. *Jannis Kounellis*. Catalogue. Essen, 1979.

FUCHS, R. H. *Jannis Kounellis*. Catalogue. Eindhoven, 1981.

KRICKE

MORSCHEL, JÜRGEN. *Norbert Kricke*. Stuttgart, 1976.

LACHAISE

KRAMER, HILTON, et al. *The Sculpture of Gaston Lachaise*. New York, 1967.

NORDLAND, GERALD. *Gaston Lachaise: The Man and His Work*. New York, 1974.

LARDERA

JIANOU, IONEL. *Lardera*. Paris, 1968.

SEUPHOR, MICHEL. *Berto Lardera*. Neuchâtel, 1961.

LAURENS

HOFMANN, WERNER, ed. *The Sculpture of Henri Laurens*. New York, 1970.

RUCKHABERLE, D. *Henri Laurens*. Monumental Catalogue. Berlin, 1967.

LEHMBRUCK

HELLER, REINHOLD. *The Art of Wilhelm Lehmbruck*. Catalogue. Washington, 1972.

SCHUBERT, DIETRICH. *Die Kunst Lehmbrucks*. Worms, 1981.

LEWITT

LEGG, ALICIA, ed. *Sol LeWitt*. Catalogue. New York, 1978.

SINGER, SUZANNA, ed. *Sol LeWitt: Wall Drawings, 1968–1984*. Hartford, 1985.

Sol LeWitt: Incomplete Open Cubes. Catalogue. New York, 1974.

LIPCHITZ

HAMMACHER, A. M. *Jacques Lipchitz*. New York, 1975.

LIPCHITZ, JACQUES. *My Life in Sculpture*, with H. H. ARNASON. New York, 1972.

LONG

FUCHS, R. H. *Richard Long*. London, 1986.

LONG, RICHARD. *Countless Stones*. Eindhoven, 1983.

MAILLOL

Aristide Maillol. Catalogue. New York, 1975.

GEORGE, WALDEMAR. *Aristide Maillol*. Greenwich, Connecticut, 1965.

MARINI

HAMMACHER, A. M. *Marino Marini: Sculpture, Painting, Drawing*. New York, 1970.

WALDBERG, PATRICK. *Marino Marini: Complete Works*. New York, 1970.

MARTINI

BELLONZI, FORTUNATO, ed. *Arturo Martini*. Rome, 1975.

MARTINI, ARTURO. *La scultura, lingua morta: pensieri*. 3d ed. Milan, 1960.

MASTROIANNI

PONENTE, NELLO. *Mastroianni*. Rome, 1963.

MATISSE

SCHNEIDER, P. *Matisse*. New York, 1984.

MELOTTI

HAMMACHER, A. M. *Melotti*. Milan, 1975.

VALCANOVER, F., et al. *Melotti*. Milan, 1986.

MERZ

CELANT, GERMANO, et al. *Mario Merz*. Vienna, 1985.

KRANZ, SUZAN. *Mario Merz: Paintings and Constructions*. New York, 1984.

MODIGLIANI

FIFIELD, WILLIAM. *Modigliani*. New York, 1976.

MANN, CAROL. *Modigliani*. London, 1980.

MOHOLY-NAGY

KOSTELANETZ, RICHARD, ed. *Moholy-Nagy*. New York, 1970.

MOHOLY-NAGY, LÁSZLÓ. *The New Vision, 1928* and *Abstract of an Artist*. New York, 1949.

MOORE

FINN, DAVID. *Henry Moore: Sculpture and Environment*. New York, 1976.

JAMES, PHILIP. *Henry Moore on Sculpture*. New York, 1967.

MITCHINSON, DAVID. *Henry Moore: Sculpture*. London, 1981.

READ, HERBERT EDWARD. *Henry Moore: A Study of His Life and Work*. London, 1965.

MORRIS

Robert Morris: Selected Works, 1970–1981. Catalogue. Houston, 1981.

TUCKER, MARCIA. *Robert Morris*. New York, 1970.

NADELMAN

KIRSTEIN, LINCOLN. *Elie Nadelman*. New York, 1973.

The Sculpture and Drawings of Elie Nadelman. Catalogue. New York, 1975.

NASH

David Nash. Catalogue. Otterlo, 1982.

NEVELSON

ALBEE, EDWARD LEE. *Louise Nevelson*. New York, 1980.
GLIMCHER, A. B. *Louise Nevelson*. New York and Washington, 1972.
LIPMAN, JEAN. *Nevelson's World*. New York, 1983.
WILSON, LAURIE. *Louise Nevelson: Iconography and Sources*. New York, 1981.

NICHOLSON

Ben Nicholson: Drawings, Paintings and Reliefs, 1911–1968. New York and London, 1969.

NOGUCHI

GROVE, NANCY, and BOTNIK, DIANA. *The Sculpture of Isamu Noguchi: 1924–1979*. New York and London, 1980.
HUNTER, SAM. *Isamu Noguchi*. New York, 1978.
NOGUCHI, ISAMU. *The Isamu Noguchi Garden Museum*. New York, 1987.

OLDENBURG

JOHNSON, E. *Claes Oldenburg*. Baltimore, 1971.
OLDENBURG, CLAES, and LEGG, ALICIA. *Claes Oldenburg*. Catalogue. Amsterdam, 1970.
OLDENBURG, CLAES, et al. *Claes Oldenburg: Large Scale Projects, 1977–1980*. New York, 1980.

OPPENHEIM

Dennis Oppenheim: Retrospective de l'eouvre, 1967–1977. Catalogue. Montreal, 1978.

PAN

HAMMACHER, A. M. *Marta Pan*. Paris, 1961.
JIANOU, I., and PELY, A. *Marta Pan*. Paris, 1974.

PAOLOZZI

KONNERTZ, WINFRIED. *Eduardo Paolozzi/Winfried Konnertz*. Cologne, 1984.
SCHNEEDE, UWE M. *Paolozzi*. New York, 1971.

PEVSNER

MASSAT, RENÉ. *Antoine Pevsner et le constructivisme*. Paris, 1956.
PEISSI, PIERRE, and GIEDION-WELCKER, CAROLA. *Antoine Pevsner*. Neuchâtel, 1961.

PICASSO

FAIRWEATHER, SALLY. *Picasso's Concrete Sculptures*. New York, 1982.
PENROSE, ROLAND. *The Sculpture of Picasso*. Catalogue. New York, 1967.
SPIES, WERNER. *Picasso: Das Plastische Werk*, Stuttgart, 1984.
ZERVOS, C. *Pablo Picasso: Oeuvres*. 19 vols. Paris, 1942–67.

POIRIER

POIRIER, ANNE and PATRICK. *Domus Aurea: Fascination des ruines*. Paris, 1977.

POMODORO

HUNTER, SAM. *Arnaldo Pomodoro*. New York, 1982.

RODIN

CANETTI, NICOLAI. *The Rodin Museum of Paris*. New York, 1977.
CHAMPIGNEULLE, BERNARD. *Rodin*. New York, 1967.
DESCHARNES, ROBERT, and CHABRUN, JEAN-FRANÇOIS. *Auguste Rodin*. New York, 1967.
ELSEN, ALBERT E. *Rodin Rediscovered*. Washington, 1981.
RILKE, RAINER MARIA. *Auguste Rodin*. Salt Lake City, 1979.
Rodin on Art. New York, 1971.

ROSSO

BARR, MARGARET SCOLARI. *Medardo Rosso*. Catalogue. New York, 1963.

ROTHKO

ASHTON, DORE. *About Rothko*. New York, 1983.
WALDMAN, DIANE. *Mark Rothko, 1903–70: A Retrospective*. New York, 1978.

NIKI DE SAINT PHALLE

JOLAS, ALEXANDRE. *Réalisations et projets d'architecture de Niki de Saint Phalle*. Paris, 1974.
Niki de Saint Phalle: Retrospective 1954–80. Catalogue. Duisburg, 1980.
NIKI DE SAINT PHALLE. *Tarot Cards in Sculpture*. Milan, 1985.
SCHULZ-HOFFMANN, CARLA, et al. *Niki de Saint Phalle*. Munich, 1987.

SCHOFFER

SCHÖFFER, NICOLAS. *La Tour lumière cybernétique*. Paris, 1973.
SERS, PHILIPPE. *Nicolas Schöffer*. Paris, 1971.

SERRA

KRAUSS, ROSALIND E. *Richard Serra: Sculpture*. Catalogue. London, 1986.
WEYERGRAF, CLARA. *Richard Serra: Interviews, 1970–1980*. Yonkers, New York, 1980.

SMITH, DAVID

KRAUSS, ROSALIND E. *The Sculpture of David Smith: Catalogue Raisonné*. New York, 1977.
MARCUS, STANLEY E. *David Smith: The Sculptor and His Work*. Ithaca, New York, 1983.
WILKIN, KAREN. *David Smith*. New York, 1984.

SMITH, TONY

HUNTER, SAM. *Tony Smith*. Catalogue. New York, 1979.
LIPPARD, LUCY R. *Tony Smith*. New York, 1972.

SMITHSON

HOBBS, ROBERT CARLETON. *Robert Smithson: Sculpture*. Ithaca, New York, 1981.

HOLT, NANCY, ed. *The Writings of Robert Smithson*. New York, 1979.

SUTHERLAND

ARCANGELI, FRANCESCO. *Graham Sutherland*. New York, 1975.

SOMAINI

APOLLONIO, UMBRO, and TAPIÉ, MICHEL. *Francesco Somaini*. Neuchâtel, 1960.

TAEUBER-ARP

LANCHNER, CAROLYN. *Sophie Taeuber-Arp*. New York, 1981.
STABER, MARGIT. *Sophie Taeuber-Arp*. Zurich, 1970.

TAKIS

Takis: Portfolio I. Geneva-Paris, 1966.
Takis. Catalogue. Paris, 1972.

TATLIN

MILNER, JOHN. *Vladimir Tatlin and the Russian Avant-Garde*. New Haven, 1983.

TEANA, MARINO DI

CLAY, JEAN. *Marino di Teana*. Neuchâtel, 1967.

TINGUELY

BISCHOFBERGER, CHRISTINA. *Jean Tinguely: Catalogue Raisonné, Sculptures and Reliefs, 1954–1968*. New York, 1982.
CASSOU, J. et al. *Two Kinetic Sculptors: Nicolas Schöffer and Jean Tinguely*. New York, 1965.
Machines de Tinguely. Paris, 1971.

TUCKER

LYNTON, NORBERT. *William Tucker: Sculpture*. Catalogue. London, 1977.
TUCKER, WILLIAM. *The Language of Sculpture*. London, 1981. Reprint.

VANTONGERLOO

Vantongerloo: A Traveling Retrospective Exhibition. Catalogue. Brussels, 1980.
VANTONGERLOO, GEORGES. *Paintings, Sculptures, Reflections*. New York, 1948.

VASARELY

SPIES, WERNER. *Vasarely*. New York, 1969.
Vasarely: Plasticien. Paris, 1979.

WOTRUBA

HEER, FRIEDRICH. *Fritz Wotruba: Humanity out of Stone*. Neuchâtel, 1961.

ZADKINE

Hommage à Zadkine. Catalogue. Paris, 1972.
JIANOU, IONEL. *Zadkine*. Paris, 1964.

Index

Photograph Credits

(Numbers refer to plates)

A.C.L., Brussels: 314, 315; Hans Aeschbacher, Russikon, Switzerland: 381, 382; Aurelio Amendola, Pistoia, Courtesy Fattoria di Celle: 432, 435, 440; Masao Arai, courtesy *The Japan Architect*, Tokyo: 413; Archives Photographiques, Paris: 52, 135, 139, 144, 186, 187, 188, 189, 191; Bacci Attilio, Milan: 214; Bahier and Migeat, Paris: 425; Bauhaus-Archiv, Darmstadt: 316; Leonardo Bezzola, Bätterkinden, Switzerland: 427; Bo Boustedt, Kungälv, Sweden: 190, 265, 276, 290, 291, 340, 352, 353, 369, 373, 375, 397, 401; Bernard Boyer, Courtesy Daniel Buren, Paris: 411; Brassaï, Paris: 40, 67, 230, 264, 266, 267; Brenwasser, New York: 109, 200; Brompton Studio, London: 272, 273, 274; Bulloz, Paris: 41; Rudolph Burckhardt: 106, 294, 339, 354, 356, 402; Cameraphoto, Venice: 210; Anthony Caro Archives, London: 419; Leo Castelli Gallery Archives, New York: 433, 445; Michel Chilo, Paris: 389, 390, 391; John Cliet, Dia Art Foundation Archives, New York: 457; Commune di Milano: 409; Renée Cooley, Courtesy Martin Z. Margulies, Coconut Grove, Florida: 461; Paula Cooper Gallery Archives, New York: 415; Robert Descharnes, Paris: 311, 313; Sala Dino, Milan: 395; Walter Dräyer, Zurich: 101, 102, 103, 121, 126, 169, 357; Dubuffet, Courtesy Secretariat de la Fondation, Périgny-sur-Yerres: 424; Ed van der Elsken, Amsterdam: 329; David Farrell, Gloucester, England: 348, 349, 350; Fattoria di Celle Archives, Pistoia: 443; Roland Federn: 160; Helga Fietz: 161; G. Fini, Treviso, Italy: 4, 28; David Finn, New York: 416; Fiorentini, Venice: 31; Fondazione Giorgio Cini, Istituto di Storia dell'Arte, Venice: 29; Xavier Fourcade, Inc., New York: 442; Phyllis Freeman, New York: 410; Frequin-Photos, Voorsburg, Holland: 453; Gabinetto Fotografico Nazionale, Rome: 27, 466; Galerie de France, Paris: 234, 235, 237, 394; R. F. Ganley, New York: 153; Giacometti, Venice: 216; Giraudon, Paris: 83, 145, 146; Gnilka, Berlin: 363, 364; Marianne Goeritz: 360; Gianfranco Gorgoni, New York: 460; Carlos Granger, London: 418; Tom Haartsen, Oudenkerk a/d Amstel, Holland: 446, 447; Arno Hammacher, 3, 18, 21, 22, 23, 24, 25, 46, 47, 48, 51, 60, 64, 92, 94, 123, 124, 129, 132, 147, 165, 177, 199, 201, 202, 203, 204, 208, 210, 212, 216, 220, 221, 231, 252, 259, 260, 277, 282, 284, 285, 286, 294, 295, 299, 305, 309, 318, 321, 322, 323, 324, 325, 327, 361, 362,

380, 387; Michael Heizer, New York: 460; Friedrich Hewicker, Kaltenkirchen, Germany: 313; Hirmer Verlag, Munich: 32, 80; Gérard Ifert: 320; Institute of Contemporary Art, University of Pennsylvania, Philadelphia: 407, 434; Interfoto Leis: 218, 219; Leni Iselin, Paris: 319, 370, 372; Peter W. Johnson, Susanne Singer Archives: 454; Pierre Joly-Véra Cardot, Bures-sur-Yvette, France: 376, 377; Jonals Co., Copenhagen: 35, 36; Luc Joubert, Paris: 74, 81, 245, 342, 343, 344, 345, 347; D. Karavan, Paris: 437, 438; Paul Laib: 95; Claude Lambert, Paris: 444; Arthur Lavine, Chase Manhattan Bank Archives, New York: 405, 423; Marc Lavrillier: 66; Lidbrooke, London: 247; David Lubarsky, Xavier Fourcade Gallery Archives, New York: 458; Galerie Maeght, Paris: 268, 269, 271; Jean de Maeyer, Antwerp: 215; Christian Manz, Zurich: 229, 241; Foto Marburg, Marburg/Lahn, Germany: 44, 59; Robert E. Mates and Mary Donlon, New York: 426; Maywald, Paris: 68; Mercurio, Milan: 114, 127, 128, 217; Paolo Monti, Milan: 399, 400; André Morain, Paris, Courtesy Galerie Daniel Templon: 439; Otto E. Nelson, New York: 355, 402; Sidney W. Newbery, Oxsted, Courtesy Anthony d'Offay, London: 406, 436; Taisuki Ogawa, courtesy *The Japan Architect*, Tokyo: 412; d'Oliveira, Amsterdam: 206, 336, 384; The Pace Gallery, New York: 449; Marta Pan, St. Remy les Chevreuses: 462, 463; PepsiCo Archives, Purchase, New York: 448; Photo Studio St. Ives Ltd., St. Ives, Cornwall, England: 280, 284; Photo Studios Ltd., London: 365, 366; Guilio Pietromarchi, Rome: 432; Eric Pollitzer, New York: 328; Walter Reiser, Stuttgart: 383; Jean Roubier, Paris: 38, 50; John D. Schiff, New York: 331; Schneider-Lengyel, Vanves (Seine), France: 58, 62; Shunk-Kender, New York: 450, 451; Hans Sibbelee, Nederhorst den Berg, Netherlands: 75, 170, 183; Gian Sinigaglia, Milan: 130; Sonnabend Gallery, New York: 428, 429, 430; Elisabeth Speidel, Hamburg: 289, 293; Arthur Starewicz, Warsaw: 441; Studio 22, Milan: 295; Adolph Studly, Pennsburg, Pennsylvania: 90, 105, 175, 180, 185; Ivan Dalla Tana, courtesy Paula Cooper Gallery, New York: 456; Turiddo, Volterra, Italy: 275; Ulkoja, Amsterdam: 361, 362; Marc Vaux, Paris: 118, 150, 164, 166, 168, 172, 173, 174, 176, 178, 179, 181, 182; Lamberto Vitali, Milan: 61, 72, 73, 263; John F. Waggaman, Del Mar, California: 131; John Weber Gallery, New York: 452; Cor van Weele, Amsterdam: 465; Wehmeyer, Hildesheim, Germany: 49; Etienne Bertrand Weill, Paris: 238, 242, 243; Hermann Weishaupt, Stuttgart: 149; Hans Wild: 77, 96; Bram Wisman, Amsterdam: 312